Women Artists and

Designers in Europe Since 1800

An Annotated Bibliography

Women Artists and Designers in Europe Since 1800

An Annotated Bibliography

PENNY McCRACKEN

G.K. Hall Library Reference

An Imprint of Simon & Schuster Macmillan
New York

Prentice Hall International
London Mexico City New Delhi Singapore Sydney Toronto

G.K. Hall Library Reference
An Imprint of Simon & Schuster Macmillan
1633 Broadway
New York, NY 10019

Library of Congress Catalog Card Number: 97–39199

Printed in the United States of America

Printing Number
10 9 8 7 6 5 4 3 2 1

Library of Congress Cataloging-in-Publication Data

McCracken, Penny.
 Women artists and designers in Europe since 1800 : an annotated
bibliography / Penny McCracken.
 p. cm.
 Includes bibliographical references and indexes.
 ISBN 0–8161–0596–0 (v. 1 : alk. paper). — ISBN 0–7838–0087–8 (v.
2 : alk. paper)
 1. Women artists—Europe—Bibliography—Catalogs. 2. Women
designers—Europe—Bibliography—Catalogs. I. Title.
Z7963.A75M33 1997
[N6757]
016.704′042—dc21 97–39199
 CIP

This paper meets the requirements of ANSI/NISO Z39.48-1992 (Permanence of Paper).

Contents

Graphic Art, Illustration, Printmaking

REFERENCE

1870 BRENNI, VITO. *Book illustration and decoration: A guide to research. Art reference collection no. 1.* Westport, Conn. and London: Greenwood Press, 1980, 191pp.

A bibliography covering technical and historical material through which it is possible to locate material on the considerable number of women who have been involved in book illustration. Most useful are the chapters on the history of illustration in different countries and the illustration of children's books. There are also author and subject indices.

1871 BRENNI, VITO. *Bookbinding: A guide to the literature.* Westport, Conn. and London: Greenwood Press, 1982, 199pp.

A useful bibliography on the arts of bookbinding, bookplates, book jackets and various technical processes. The chapter on the history of bookbinding generally and then by country is the most useful.

1872 ENGEN, RODNEY. *Dictionary of Victorian Wood Engravers.* Cambridge: Chadwyck-Healey, 1985, 297pp., illus.

Entries include detailed biographical accounts which incorporate the artist's publications and give further references. Fewer women are included than in similar publications on this area.

1873 FANELLI, GIOVANNI, and E. GODOLI. *Dizionario degli illustratori simbolisti e Art Nouveau.* 2 vols. Florence: Cantini, 1990, vol. 1: 302pp., many text illus.; vol. 2: 302pp., many text illus.

Includes c. 1200 artists from Europe and North America who produced Symbolist and Art Nouveau illustrations between 1880 and 1914. Each entry contains a biographical outline, lists of books illustrated and journals to which the artist contributed on a regular basis. The majority of artists are

European, including Russian and East European. It is an excellent source for women.

1874 HORNE, ALAN. *Dictionary of 20th Century British Book Illustrators.* Woodbridge: Antique Collectors Club, 1994, 456pp., illus.

This is in the same format as the partner volume on nineteenth-century illustration (see Houfe below), with details of publications by the artist, a short biography and bibliography.

1875 HOUFE, SIMON. *Dictionary of 19th Century British Book Illustrators.* 3rd rev. edition. Woodbridge: Antique Collectors Club, 1996, 368pp., illus.

An invaluable source of women active in this area. Entries are informative but artists on which there is little information are included. Painters who produced illustrations, such as Laura Alma-Tadema, are also listed. Each entry provides, where possible, a brief biography, titles of books and periodicals to which the artist contributed, exhibition venues, public collections and a bibliography.

1876 *Lexikon der zeitgenössichen Schweizer Künstler. Dictionnaire des artistes suisses contemporains. Dizionario di artisti svizzeri contemporanei.* Stuttgart: Verlag Huner, 1981, 538pp.

Text in German, French and Italian. This book includes Swiss painters, sculptors, graphic artists and photographers born after 1900. The language of each entry is determined by that used by the artist. There is an outline biography, an indication of the type of work produced, lists of prizes won, exhibitions. Entries are brief and there are indices by place of residence and medium. A reasonable number of women are included.

1877 LISTER, RAYMOND. *Prints and printmaking: A dictionary and handbook of the art in nineteenth century Britain.* London: Methuen, 1984, 385pp., illus.

Introductory essays provide a history of the different processes involved. The author takes a broad view of printmaking and includes lithography, wood engraving, security printing and steel engraving. The principal section consists of a dictionary of individuals, including some women about whom some biographical information is provided.

1878 MARTIN, JULES. *Nos peintres, sculpteurs, graveurs et dessinateurs. Portraits et biographies suivis d'une notice sur les Salons Français depuis 1673, les Sociétés des Beaux-Arts, la propriété artistique etc.* Paris, 1897.

Text in French. Provides information about women artists active in the late nineteenth century in France.

1879 MILNER, JOHN. *A Dictionary of Russian and Soviet Artists, 1420–1970.* Woodbridge: Antique Collectors Club, 1993, 483pp., illus.

Contains many women among the hundreds of artists included, since all artists who exhibited at least once in certain venues are included. The entries vary in length and detail but normally contain a list of collections and an individual bibliography in addition to a short biographical account.

1880 OSTERWALDER, M., G. PUSSEY and B. MOISSARD. *Dictionnaire des illustrateurs 1800–1914.* Paris: Hubschmid & Bouret, 1983, 1221pp., illus.

Text in French. An international dictionary in which each entry contains at least one illustration. The text for each individual varies in length but in addition to a biographical outline there are lists of books illustrated by and magazines to which the person contributed.

1881 PEPPIN, BRIDGET, and LUCY MICKLETHWAITE. *Dictionary of British Book Illustrators in the 20th Century.* London: John Murray, 1983, 336pp., illus.

Many women feature in this volume. For each entry there is a biography, a select list of books illustrated, examples of periodicals worked for and a select bibliography.

1882 SERVOLINI, LUIGI. *Dizionario illustrato degli incisori italiani moderni e contemporanei.* Milan: Görlich, 1955, 871pp., illus.

Illustrated usually by a photograph of the artist. A dictionary of modern Italian engravers which contains a short biography for each. There are relatively few women included.

1883 *Who's Who in Graphic Art.* 2 vols. vol. 1: Zurich: Amstutz and Herdig Graphis Press, 1962, 574pp., illus.; vol. 2: Duebendorf: De Clivo Press, 1982, 892pp., illus.

Text in German, French and English. The emphasis is on commercial graphic artists and relatively few women are included, particularly in volume 1. It covers Eastern and Western Europe and can therefore be a source for women who may not be accessible in other publications.

PUBLICATIONS

1884 AUREGLI, DEDE, and CRISTINA MARABINI. *Figure dallo sfondo 3.* Ferrara: Galleria Civica d'Arte Moderna, 1988, 137pp., illus.

Text in Italian. In all, forty-nine women are included—thirty-eight Italians, two of whom are designers, and eleven women from other countries. The range of work is very wide but a majority is concerned in some way with the experience of being female and living in a female body.

1885 *Avanguardia russa dalle collezioni private sovietiche origini e percorso 1904–1934.* Milan: Palazzo Reale in association with Edizioni Bolis, 1989, 172pp., illus.

Text in Italian. The exhibition takes a broad view of avant-garde works in a number of media produced in Russia in the first three decades of this century. Most of the work is two-dimensional—painting and graphic art—but some painting on porcelain is also included.

1886 BALSTAN, THOMAS. *English Wood Engraving, 1900–1950.* London: Art & Technics, 1951.

A survey of the subject which includes at least nine women: Dorothy Braby, Tirzah Garwood, Joan Hassall, Gertrude Hermes, Clare Leighton, Gwenda Morgan, Agnes Miller Parker, Margaret Pilkington and Gwen Raverat.

1887 BARON, WENDY. *The Sickert Women and the Sickert Girls.* London: Michael Parkin, 1974, n.p., illus.

An essay examines the artistic activities of five women who worked with Walter Sickert: Therese Lessore, who became his wife, Sylvia Gosse, and the 'girls'—Wendela Boreel (qq.v.), Majorie Lilly and Christiana Cutter, who all met at the Slade School of Art. Short biographies are included for each and a chronology of the years 1905–1969 shows the exhibitions and other relevant events in the lives of these artists.

1888 BERALDI, HENRI. *Les graveurs du XIXe siècle: guide de l'amateur d'estampes modernes.* 12 vols. Paris: L. Conquet, 1885–1892. Reprint: Nogent-le-roi, Jacques Laget, 1981, 12 vols. in 10.

Extensive listing of engravers active in nineteenth-century France in which a small percentage of women occurs. Each entry gives a brief biography followed by details of any published engravings and/or painters whose work the artist engraved. A useful introduction to a less familiar field in which the numbers of women were relatively small.

1889 BOULTON-SMITH, JOHN. *Modern Finnish Painting and Graphic Art.* London: Weidenfeld and Nicholson, 1970, 62pp., 62 pp. of plates.

A survey of postwar art in Finland in which a number of women are included.

1890 BRAMBATTI, ALBERTA, DONATA MACELLI and LUCIA TONINI. *Grafica Art Nouveau nelle riviste russe.* Florence: Canini, 1989, 129pp., 178 illus.

Text in Italian. A study of the literary and artistic content of the five principal Russian Art Nouveau journals. Short biographical outlines of the forty men and three women are given.

1891 BRUNHAMMER, YVONNE, ET AL. *Art Nouveau: Belgium, France.* Chicago: Institute of the Arts, Rice Uiversity, and the Art Insitute, 1976, 512pp., illus.

An overview essay of the movement is followed by catalogue entries in sections by medium. Biographies of artists are included. A few women are featured.

1892 CALVERT, GILL, JILL MORGAN and MOUSE KATZ (EDS.). *Pandora's Box.* Bristol: Arnolfini Gallery, 1984, 120pp., illus.

This exhibition arose out of an earlier exhibition, *Women's Images of Men* (1980), and shares some of its organisers. Women artists were invited to submit works on the theme of Pandora's Box and offer varied reworkings of this myth. Each of the thirty-two women has written a statement about her reactions to the myth and the generation of the work exhibited. No biographical information is given.

1893 CAREY, FRANCES and ANTONY GRIFFITHS. *The Print in Germany 1880–1933.* New York & London: Harper & Row in association with the British Museum, 1984, 272pp., illus.

Based on the collection of prints and illustrated books in the British Museum. Only four women are included: Kollwitz, Modersohn-Becker, Sintenis and Else Lasker-Schüler, who was primarily a poet. There are introductory essays and detailed critical notes on each of the items selected for this publication.

1894 CAREY, FRANCES. *Modern Scandinavian Prints.* London: British Museum Press, 1997, 176pp., illus.

Focussed on the British Museum's collection of Scandinavian prints. Only three women are included: Mariana Manner, Inger Sitter and Siri Rathsman. For each there is a detailed critical biography and full discussion of the works.

1895 CASTERAS, SUSAN and LINDA H. PEARSON. *A Struggle for Fame: Victorian Women Artists and Writers.* New Haven, Conn.: Yale Center for British Art, 1994, 89pp., illus.

Essays analysing the sociocultural context in which women artists and writers practised their art in nineteenth-century Britain precede the carefully annotated entries to the exhibits. Forty-three women artists are included. The essay "From 'Safe Havens' to 'A Wide Sea of Notoriety'" examines art education, 'cultural captives,' critics, mentors and patrons, support groups, marriage and motherhood and women's subject matter.

1896 CAWS, MARY ANN, RUDOLF KUENZLI and GWEN RAABERG. *Surrealism and Women.* Cambridge, Mass.: MIT Press, 1991, 240pp., illus.

A series of critical essays originally published as a special issue of the journal *Dada/Surrealism* no. 18 (University of Iowa). They analyse the work

of women writers and artists within the Surrealist movement. Three introductory essays examine questions of misogyny in the movement and the problematics of women in relation to it. The later essays examine closely the imagery of some of the women artists and writers.

1897 CRANE, WALTER. *Of the Decorative Illustration of Books Old and New.* 2nd ed. London and New York: G. Bell and Sons Ltd., 1921, 341pp., illus.

An early survey of the art of illustration from manuscripts to the nineteenth century. Brief information on the style of the artists is given. Women included are Kate Greenaway, E.V.B., Mary Sargant Florence, Alice Woodward and a group from Birmingham: Mrs Gaskin, Miss Bradley, Winifred Smith, Mary Newill and Celia Levetus.

1898 *Das Haus der Frau: Auf der Weltausstellung für Buchgewerbe und Graphik.* Leipzig: Verlag des Deutschen Buchgwerbereins, 1914, 33pp.

Text in German. Describes a "women's house" designed by a female architect as part of a large exhibition of the arts of the book. Within it were exhibited no fewer than 2226 works by women artists and designers. The enterprise appears to resemble the women's pavilion at the World's Columbian Exposition in Chicago in 1893.

1899 *De vrouw in de kunst.* Leiden: Pand Caecilia, 1987, 27pp., illus.

Text in Dutch. Twelve Dutch women are included in this exhibition. A chronology and a brief statement are given about each.

1900 DEEPWELL, KATE. *Ten Decades: Careers of Ten Women Artists Born 1897–1906.* Norwich: Norwich Gallery, Norfolk Institute of Art and Design, 1992, n.p., illus.

A scholarly and comprehensive essay analyses the art practice of ten British women over the decades of their careers and within the social and political contexts of the time. It considers, inter alia, educational and employment opportunities, travel and study abroad and the impact of World War II. Under the individuals there are chronologies, lists of exhibitions, public collection and publications.

1901 EVORS, E. M. "Some Women Illustrators of Children's Books." *Girl's Realm* 5 (1903): 455–463.

Identifies and discusses several women who specialise in illustrating children's books. Argues that much "clever" work is produced in this area and it should not be scathingly dismissed. Included are Hilda Cowham and Sybil Reid, who both work for the magazine *Girl's Realm*, Mary Ames, Winifred Austen, Gertrude Bradley, Mabel Dearmer, Emma Farmiloe, Helen Stratton, Alice Woodward, Evelyn Sharp and Florence Upton.

1902 GARRETT, ALBERT. *A History of British Wood Engraving.* Tunbridge Wells: Midas Books, 1978, 407pp., illus.

Examines the evolution of wood engraving in Britain and includes many women in the survey.

1903 GARRETT, ALBERT. *British Wood Engraving of the Twentieth Century: A Personal View.* London: Scolar Press, 1980, 223pp., illus.

Preface by the engraver Borothy Braby. Contains an essay about the development of British wood engraving this century. This is followed by biographical entries which also list the principal books illustrated by the artists. Many women are included.

1904 GARVEY, ELEANOR, ET AL. *The Turn of a Century, 1885–1910: Art Nouveau Jugendstil Books.* Cambridge, Mass.: Department of Printing and Graphic Arts, Harvard University, 1970, 124pp., illus.

Describes various aspects of book production in western Europe. The number of women included is not large. The emphasis is mainly on illustration, whether the production of designs or their execution through wood engraving or other techniques, but there is also some information about bookbinding. The Austrian Bertha Czega is mentioned in this repect; illustrators included are the Scots Jessie King, Frances and Margaret Macdonald, the Belgians Juliette Wytsman and Marie Danse, Suzanne Lepère of France and Elena Luksh Makovsky from Vienna.

1905 GARVEY, ELEANOR, and PETER WICK. *The Arts of the French Book, 1900–1965.* Dallas: South Methodist University Press, 1967, 119pp., illus.

Looks at book design, illustration and bookbinding in France at a period when there were many outstanding practitioners. A number of women are mentioned.

1906 GLEISBERG, D. *Deutsche Künstlerinnen des zwanzigsten Jahrhunderts.* Altenburg: Staatlichen Lindendau-Museum, 1963.

Text in German. An early exhibition of the work of German women artists in which thirty painters, sculptors and graphic artists are included. Two introductory essays examine the broad issues before individual artists are examined.

1907 HIESINGER, KATHRYN (ED.). *Art Nouveau in Munich: Masters of Jugendstil from the Stadtmuseum, Munich and other collections.* Munich: Prestel in association with the Philadelphia Museum of Art, 1988, 180pp., illus.

An essay on the origins and development of Art Nouveau is followed by a listing of the artists included in the exhibition together with detailed comments on the works, which are in graphics and several areas of design. Only two women are included: Margarete von Brauchitsch and Gertraud von Schnellenbühel (q. v. vol. 1).

1908 HUNNISETT, BASIL. *Steel Engraved Book Illustration in England.* London: Scolar Press, 1980, 263pp., 65 illus.

A thorough analysis of the organisation of steel engraving, which was largely a male preserve. Two sisters, daughters of a landscape engraver, became known in this field: Letitia Byrne, known mainly for her etchings, and her younger sister, Elizabeth, who specialised in engraving fruit and flowers. However, they also provided other subjects when required.

1909 JAFFE, PATRICIA. *Women Engravers.* London: Virago, 1990, 128pp., mainly illus.

Gives an account of women's involvement with wood engraving in Britain from the mid-nineteenth century until about 1950, with a brief look at subsequent work.

1910 JAKIMOWICZ, IRENA. *Wspótczesna grafika polska* [Contemporary Polish graphic art]. Warsaw: Arkady, 1975, 206pp., 172 illus.

In Polish and English. Published in conjunction with an exhibition. After an introductory essay on postwar graphic art in Poland, every work in the exhibition is listed and illustrated. Useful biographies of the seventy-nine artists are included. Of these, seventeen are women, some very distinguished.

1911 JAMES, PHILLIP. *An exhibition of French book illustration 1895–1945.* London: Council for the Encouragements of Music and the Arts, 1945, 24pp., 13 illus.

The introductory essay examines the arts of the book in Britain and, especially, France and identifies links between poets and artists who illustrate books. Two women are included: Marie Laurencin and Marietta Lydis.

1912 *Jugendstilillustration in München.* Munich. Published by Albert Langen and Georg Müller Verlag: Stuck-Villa, 1970, 71pp., illus.

Text in German. An introductory essay surveys the Art Nouveau journals of the turn of the century in Germany and looks at the main figures in book art and illustration. The catalogue entries are organised first by periodical and then by artist. Three women are included: Mathilde Ade, Hedwig von Branca and Otolia Gräfin Kraszewska.

1913 LAMERS DE VITS, MARIA. *Les femmes sculpteurs et graveurs et leurs oeuvres.* Paris: Referendum littéraire, 1905, 212pp.

Text in French. The author's overtly feminist aim is to work for the equality of the sexes and, in order to contribute to this, she is presenting material on women artists. This is the first of two intended volumes, the second is to deal with painters. Initially she lists ninety-seven women sculptors and engravers who have either recently exhibited in salons or whose work has been purchased by the state. There follow lists of women sculptors who have won medals, sculptures by women which have been erected in public places, women whose work has been bought by the state, towns or administrations,

and women whose work is owned by public museums. This is an invaluable record of the activities of late-nineteenth-century women sculptors and engravers. The planned second volume appears not to have been published.

1914 *L'avant-garde au féminin: Moscou, St. Petersbourg, Paris.*
See below under MARCADE.

1915 LEITGEB, HILDEGARD, ELIZABETH SCHMUTTERMEIER and ANGELA VÖLKER. *Wiener Werkstätte: Atelier viennois, 1903–32.* Brussels: Galérie CGER, 1987, 263pp., illus.
Text in French. Catalogue of an exhibition held on the anniversary of the publication of a booklet by Mathilde Flögl of the Wiener Werkstätte. She initiated the idea and edited the publication, which was bound by Vally Wieselthier and Gudrun Baudisch. It mentioned five women graphic designers. This catalogue contains an overview of the workshop before separate sections dealing with different media and projects. Eight women feature in the text of the fashion and fabrics sections: Lotte Frömel-Fochler, Maria Likarz, Mathilde Flögl, Fritzi Löw, Hilda Jesser, Gertrude Weinberger, Mitzi Friedmann and Leopoldine Hirsch. Several of these and a small number of others have work in ceramics and glass included.

1916 MARCADE, JEAN-CLAUDE, and VALENTINE MARCADE. *L'Avant-Garde au Féminin: Moscou, Saint Petersbourg, Paris (1907–1930).* Paris: Artcurial, 1983, 64pp., illus.
Text in French. Looks at the activities of women artists in the Russian avant-garde in the early decades of the twentieth century. In all, twenty-two artists are included, each with biographical essays of varying lengths. There are general and individual bibliographies.

1917 McQUISTON, LIZ. *Women in design: A contemporary view.* London: Trefoil Publications, 1988, 144pp., many illus.
Profiles of forty-three women, mainly from Europe and the United States, who are engaged in various kinds of design. Maintains that women involved in craft and decorative art activities have received more attention than those in design areas more closely related to industry and production. The emphasis here is on women involved in fields such as furniture design, product design, architecture, animation, television and computer graphics, graphic design, advertising and textile design.

1918 *Meisterwerke Französischer Buchkunst der letzen 50 Jahre: le livre biblio- phile français moderne.* Berne: Kunstmuseum, 1945, 36pp.
Text in German and French. A short introduction is followed by a list of the 187 books exhibited which were illustrated by well known painters. Six women artists are included: Marie Laurencin, Jeanne Rosay, Germaine Labay, Alicia Halicka, Hermine David, Marietta Lydis.

1919 NEUE GESELLSCHAFT FUR BILDENDE KUNST E.V. *Das Verborgene Museum. Dokumentation der Kunst von Frauen in Berliner öffentlichen Sammlungen.* Berlin: Edition Hentrich, 1987, 364pp., illus.

Text in German. After five scholarly essays which examine different aspects of women's art practice over the past two centuries, there are biographical essays for each of the women represented in the collections of the Berlin Museums and who therefore are included in the exhibition. For the nineteenth- and early-twentieth-century artists there are longer essays but for contemporary artists there are photographs and a biographical outline. In all, over 100 women, most of whom are German, are featured in the catalogue.

1920 PABST, MICHAEL. *Wiener Grafik um 1900.* Munich: Verlag Silke Schreiber, 1984, 348pp., many illus.

Text in German. A detailed analysis of graphic art in Vienna at the turn of the century, which includes journals, bookbinding, printmaking, posters and book illustration. The final section consists of biographies of the artists and designers. There are seven women: Bertha Czegka, Nora Exner von Zumbusch, Marianne Frimburger, Broncia Koller, Minka Podhajska, Mileva Roller and Maria von Uchatius.

1921 SCHAUER, GEORG. *Deutsche Buchkunst 1980 bis 1960.* 2 vols. Hamburg: Maximilian-Gesellschaft, 1963, 1:304pp.; 2:167pp. mainly illus.

Text in German. Only four women are included in this detailed study of different facets of the arts of the book in Germany over a period of seventy years: Anna Simins, Renée Sintenis, Frieda Thiersch (a bookbinder) and Eva Aschoff.

1922 SCHWEIGER, WERNER. *Auerbruch und Erfüllung: Gebrauchsgraphik der Wiener Moderne 1897–1918.* Vienna and Munich: Edition Christian Brandstätter, 1988, 224pp., 835 illus.

Text in German. A thorough survey of a broad spectrum of graphic art, including commercial graphics, in Vienna over the first two decades of the twentieth century. It is arranged alphabetically according to the type of work, and within each entry an account of its development and chief practitioners during the period is given. A considerable number of women are mentioned, although the format of the book does not enable the reader to locate them easily.

1923 SEDDON, JILL, and SUZETTE WORDEN (EDS.). *Women Designing. Redefining Design in Britain between the Wars.* Brighton: University of Brighton, 1994, 140pp., illus.

A collection of essays on women designers active in the 1920s and 1930s. The essays are in three main sections: Women and art and design education, Women, industry and institutions while the last, Women designing, is devoted to studies of individuals. They worked in many different media including textile design, graphics and interiors.

1924 SKETCHLEY, R. E. D. *English book illustration of today: Appreciations of the work of living English illustrators with lists of their books.* London: Kegan Paul, Tench, Trübner & Co. Ltd., 1903, 173pp., illus.

Organised into four thematic sections: decorative, open-air, character and children's book illustrators. After a discussion of the merits and specialities of artists within each category, the specific artists are listed with details of the books which they have illustrated. There are two women in the first section, one in the second, while there are eleven under the final one, including several artists based in Birmingham.

1925 *The Last Romantics: The Romantic Tradition in British Art. Burne-Jones to Stanley Spencer.* London: Barbican Art Gallery, 1989.

Consists of several sections, arranged chronologically, under titles such as Burne-Jones and his followers, the Birmingham group, the early academic tradition, the Celtic dimension, Rome Scholars, muralists and others. Such an approach allows the inclusion of many artists hitherto omitted from the histories of art. Women are well represented, from the Pre-Raphaelite circles and their offshoots in the Midlands and the early Newlyn artists. A number are well known for their illustration work.

1926 UZANNE, OCTAVE. *L'art dans la décoration extérieure des livres en France et à l'étranger; les couvertures illustrées, les cartonnages d'éditeurs, la reliure d'art.* Paris: L.H. May et la Société française des éditions d'art, 1898, 275pp., illus.

Text in French. Essentially a survey, the book is divided into four sections: illustrated covers, commercial bindings, contempoary masters and artists decorations for bindings. A number of works by women are illustrated but often with the absence of any mention in the text. Chapter 1 illustrates works by Mlle Bertrand and Mlle A. Poidevin in this way but Kate Greenaway is commented on; no women occur in chapter 2, while chapter 3 includes Mme J.-M. Belville, Mme M. Jacquinot, Irene Nichols, Sarah Prideaux, Eva Sparre and Elizabeth MacColl. Women providing artist bindings are listed, such as Eva Sparre, A. Wallgren and Mme Waldeck-Rousseau.

1927 *Valentina Alimova, Nina Evlanova, Mariia Kuznetsova, Nora Levinson, Aleksandra Petrova: grafika skul'ptura: katalog vystavesk* [Graphics and sculpture: catalogue]. Moscow: Moskovskaia organizatsiia soiuza khudozhnikov RSFSR, 1985, 55pp., illus.

Text in Russian. Each of the artists is treated separately and is given a biographical outline, a short essay on their work, a list of the works in the exhibition and several illustrations.

1928 VERONESI, GIULIA. *Into the Twenties: Style and Design 1909–1929.* Florence: Valecchi Editore, 1966. English Translation: London: Thames and Hudson, 1968, 371pp., 10 pl., 246 illus.

Seeks to map the history of design in Europe from Art Nouveau to 1930 as two principal strands: continuity from earlier traditions and revolt from those traditions. Chapters are devoted to Germany, Paris and Italy before World War I, design during the war, the postwar period in Paris, Germany, England, America and Italy, the International Exhibition of the Decorative Arts in 1925 and its aftermath. A glossary and brief biographies of the main participants ends the book. A small number of women are included.

1929 WARNER, MARINA, ET AL. *Women's Art at New Hall.* Cambridge: New Hall, 1992, 55pp., illus.

An exhibition of twentieth-century, and mostly post-1970, works donated by women artists to the permanent collection at New Hall, a women's college at Cambridge University. As Warner recounts in her introductory essay, Mary Kelly's *Extase*, a donation following her residency in Cambridge, was the catalyst for the formation of the collection. For practical reasons all the works are two dimensional, so sculptors who are represented have usually submitted prints. Some artists from the earlier part of the century are also included.

1930 YABLONSKAYA, MIUDA. *Women Artists of Russia's New Age, 1900–1930.* London: Thames and Hudson, 1990, 248pp., illus. Trans. Anthony Parton.

Consists of a series of biographical accounts of women artists. In addition to the better known figures of the revolutionary period there are informative sections on earlier and later figures. The author has chosen depth of treament rather than including a larger number of artists. There are useful individual bibliographies which include material in Russian.

INDIVIDUALS

1931 ADELBORG, OTTLIA (née EVA OTTLIA ADELBORG) (1855–1936)
Swedish graphic artist.

Exhibitions

Kvinnor som målat. Stockholm: Nationalmuseum, 1975.

Other Sources

Fanelli, Giovanni, and E. Godoli. *Dizionario degli illustratori simbolisti e Art Nouveau.* Florence: Cantini, 1990.

1932 ADE, MATHILDE (1877–?)
German graphic artist, noted for her book illustration.

Other Sources

Jugendstil Illustration in München. Munich: Stuck-Villa, 1970.

1933 ADSHEAD, MARY (1904–1995)
 English mural painter, illustrator and graphic artist.

Publications

Adshead, Mary, and Stephen Bone. *Travelling with a Sketchbook: A Guide to Carry on a First Sketching Holiday.* London: Adam and Charles Black, 1966.
The Little Boy and His House. London, 1936.
The Silly Snail. London, 1942.
The Little Boys and Their Boats. London, 1953.

Main Sources

Powers, Alan. "Mary Adshead: Art on a Grand Scale." *The Guardian,* 7 September 1995. Obituary.

Exhibitions

Deepwell, Katy. *Ten Decades: Careers of Ten Women Artists Born 1897–1906.* Norwich: Norwich Gallery, Norfolk Institute of Art and Design, 1992.

Other Sources

Dunford, Penny. *A Biographical Dictionary of Women Artists in Europe and America since 1850.* Hemel Hempstead: Harvester Wheatsheaf and Philadelphia: University of Pennsylvania Press, 1990. Contains a bibliography.

1934 AIJA, ZARINA (1954–)
 Latvian painter and graphic artist.

Main Sources

Aija. Riga: Jana Seta, 1989, 62pp., mainly illus. Text in Latvian.

1935 ALBÉNIZ, LAURA (1890–1944)
 Spanish graphic artist.

Other Sources

Fanelli, Giovanni, and E. Godoli. *Dizionario degli illustratori simbolisti e Art Nouveau.* Florence: Cantini, 1990.

1936 ALEXEYEVA, OLGA VIKTOROVNA (1895–?)
 Russian painter and graphic artist.

Exhibitions

Paris-Moscou 1900–1930. Paris: Centre national d'art et de culture Georges Pompidou, 1979.

Other Sources

Aguitatsionno-massovoe iskusstvo pervykh let Oktiabria [Art of the masses and Propaganda Art in the First Years of October]. Moscow, 1971, pp. 88–124.

Milner, John. *A Dictionary of Russian and Soviet Artists, 1420–1970.* Woodbridge: Antique Collectors Club, 1993.

1937 ALLINGHAM, HELEN (née PATERSON) (1848–1926)
　　　English painter and graphic artist who specialised in depicting idealised rural life.

See Painting section.

1938 ANGUS, PEGGY (née MARGARET McGREGOR ANGUS) (1904–1993)
　　　English painter, graphic artist and designer; also a teacher.

Main Sources

Cook, Oliva. "Everyone Is an Artist, Including the Greengrocer. Peggy Angus: Obituary." *Guardian,* 2 November 1993, 17.

Harrod, Tanya. "Peggy Angus." *Independent,* 2 November 1993, 27. Obituary.

1939 ANNESLEY, MABEL (LADY) (1881–1959)
　　　Irish graphic artist who trained in London, specialising in wood engraving.

Exhibitions

Irish Women Artists from the Eighteenth Century to the Present Day. Dublin: National Gallery of Ireland, Douglas Hyde Gallery and Hugh Lane Gallery, 1987.

Other Sources

Jaffé, Patricia. *Women Engravers.* London: Virago, 1988.

1940 ASSE, GENEVIÈVE (1923–)
　　　French graphic artist and painter.

Main Sources

Asse. Paris: Editions Galanis, 1976, 32pp., 3 illus. Contains three essays and two poems on Asse by five different writers.

"Geneviève Asse au C.N.A.C." *Plaisir de France* 384 (December 1970): 76. Enthusiastic exhibition review.

Estéban, Claude. "Geneviève Asse et les charpentes de la lumière." *Preuves* 214 (January 1969): 60–63.

Gross, John. "Current and Forthcoming Exhibitions." *Burlington Magazine* 638 (May 1956): 178. A not very favourable review of an early exhibition of Asse's work.

Levêque, J.-J. "L'Espace totale de Geneviève Asse." *Le Nouveau Journal,* 8 March 1969, 11. Review of her exhibition at Rheims.

Mason, Rainer. "Le mystère de la peinture." *Tribune de Genève,* 5 January 1972, 37. Exhibition review.

Pély, Annick. "Deux peintres du 'presque rien': Geneviève Asse et Léon Zack." *Le Quotidien de Paris,* 13–14 November 1976.

Vellay, Dominique. "Geneviève Asse à Genève; une musicien du silence." *Le Monde,* 15 November 1974, 62. Exhibition review and an interview with the artist.

Exhibitions

Geneviève Asse. Oslo: Kunstnernes Hus, 1965, n.p., illus. Text in Norwegian with a French summary. Contains introductory essays.

Geneviève Asse: la Lumière. Rheims: Musée de Reims, 1968, 45pp., illus. Contains a short essay by Jean Leymarie. Catalogue of a retrospective exhibition which includes her work for stained glass. Includes an annotated biography and bibliography.

Faux, Monique. *Le vitrail et les peintres à Reims.* Rheims: Maison de la Culture, 1969.

Geneviève Asse: l'oeuvre gravé. Catalogue raisonné. Paris: Musée d'Art Moderne de la Ville de Paris and Geneva: Cabinet des Estampes, 1977, 80pp., 170 illus.

Paris 1937–Paris 1957: création en France. Paris: Centre national d'art et de culture Georges Pompidou, 1981.

Other Sources

Ceysson, B., et al. *25 ans d'art en France, 1960–1985.* Paris: Larousse, 1986. Includes a select list of exhibitions for each artist.

1941 BACH-LIMAND, AINO GUSTAVOVNA (Alt. BACH) (1901–after 1976)
 Estonian graphic artist who produced prints and illustrated books.

Other Sources

Bern, B. *Aino Bach.* Moscow, 1959.

Dunford, Penny. *A Biographical Dictionary of Women Artists in Europe and America since 1850.* Hemel Hempstead: Harvester Wheatsheaf and Philadelphia: University of Pennsylvania Press, 1990.

Mandel, W. *Soviet Women.* New York: Anchor Books, 1975.

1942 BINYON, HELEN (1904–1979)
 English graphic artist and teacher.

Other Sources

Garrett, Albert. *A History of British Wood Engraving.* Tunbridge Wells: Midas Books, 1978.

———. *British Wood Engraving of the 20th Century: A Personal View.* London: Scolar Press, 1980.

Horne, Alan. *Dictionary of Twentieth Century Book Illustrators.* Woodbridge: Antique Collectors Club, 1994.
Jaffé, Patricia. *Women Engravers.* London: Virago, 1990.

1943 BOESENBACHER, MARIA ANNA
German graphic artist who worked as an engraver for Elector Max Francis.

Other Sources

Ellet, Elizabeth. *Women Artists in all Ages and Countries.* New York: Harper and Brothers, 1859.

1944 BRABY, DOROTHY
English graphic artist.

Other Sources

Balstan, Thomas. *English Wood Engraving, 1900–1950.* London: Art & Technics, 1951.
Garrett, Albert. *A History of British Wood Engraving.* Tunbridge Wells: Midas Books, 1978.
————. *British Wood Engraving of the 20th Century: A Personal View.* London: Scolar Press, 1980.
Jaffé, Patricia. *Women Engravers.* London: Virago, 1990.

1945 BRASIER, JENNY
English painter of flowers, often for botanical publications, and graphic artist.

See Painting section.

1946 BRICKDALE, ELEANOR (née MARY ELEANOR FORTESCUE BRICK-DALE; alt. FORTESCUE-BRICKDALE) (1872–1945)
English painter of historical and literary scenes and a prolific graphic artist who illustrated books.

See Painting section.

1947 BRUNI, TATIANA GEORGIEVNA (1902–after 1970)
Russian graphic artist and designer for the theatre.

Other Sources

Milner, John. *A Dictionary of Russian and Soviet Artists, 1420–1970.* Woodbridge: Antique Collectors Club, 1993.

1948 BRÜCK, TRUDE (1902–)
German painter and graphic artist.

Exhibitions

Trude Brück: Gemälde—Graphiken. Dusseldorf: Stadtmuseum, 1982, n.p., illus. Text in German. Includes an autobiographical essay.

1949 BYFIELD, MARY (SENIOR) (1795–1871)
English graphic artist specialising in wood engraving.

Other Sources

Engen, Rodney. *Dictionary of Victorian Wood Engravers.* Cambridge: Chadwyck-Healey, 1985.

Jaffé, Patricia. *Women Engravers.* London: Virago, 1988.

1950 BYRNE, LETITIA (1779–1849)
English graphic artist, who produced etchings and illustrations; painter of landscapes and architectural scenes.

Other Sources

Engen, Rodney. *Dictionary of Victorian Wood Engravers.* Cambridge: Chadwyck-Healey, 1985.

Hunnisett, Basil. *Steel engraved book illustration in England.* London: Scolar Press, 1980.

1951 CANZIANI, ESTELLA STARR (1887–1964)
English painter of portraits, landscapes and figure subjects; also a graphic artist who illustrated books and muralist. She was the daughter of the famous painter Louisa Starr (q.v.).

See Painting section.

1952 CASSATT, MARY STEVENSON (1844–1926)
American Impressionist painter of figures who worked in Paris.

See Painting section.

1953 CECHOVÁ, OLGA (1925–)
Czechoslovakian graphic artist.

Exhibitions

Art tchèque contemporain: gravure, céramique, verre. Freiburg: Musée d'Art et d'Histoire, 1973.

1954 CHROSTOWSKA, HALINA (1929–)
Polish graphic artist.

Other Sources

Jakimowicz, Irena. *Wspótczesna grafika polska.* Warsaw: Arkady, 1975.

1955 CLARK, PAULINE (1944–)
English graphic artist.

Other Sources

Garrett, Albert. *British Wood Engraving of the 20th Century: A Personal View.* London: Scolar Press, 1980.

1956 CLAUDÉ, ANNICK (1961–)
French graphic artist who uses a variety of print-making techniques.

Exhibitions

Annick Claudé. St. Etienne: Académie des Beaux-Arts, 1992, n.p., mainly illus.

1957 CLAXTON, ADELAIDE (Alt. TURNER) (1835/40–after 1900)
English graphic artist who specialised in illustration and wood engraving; sister of Florence Claxton (q.v.).

Main Sources

Clayton, Ellen. *English Female Artists.* London: Tinsley, 1876.

Exhibitions

Sellars, Jane. *Women's Works.* Liverpool: Walker Art Gallery, 1988.
Casteras, Susan, and Linda H. Peterson. *A Struggle for Fame: Victorian Women Artists and Authors.* New Haven, Conn.: Yale Center for British Art, 1994.

Other Sources

Cherry, Deborah. *Painting Women: Victorian Women Artists.* London: Routledge, 1993.
Dunford, Penny. *A Biographical Dictionary of Women Artists in Europe and America since 1850.* Hemel Hempstead: Harvester Wheatsheaf and Philadelphia: University of Pennsylvania Press, 1990. Contains a bibliography.
Mallalieu, Hugh. *Dictionary of British Watercolour Artists.* Woodbridge: Antique Collectors Club, 1976.
Nunn, Pamela Gerrish. *Victorian Women Artists.* London: Women's Press, 1987.
Wood, Christopher. *The Dictionary of Victorian Painters.* Woodbridge: Antique Collectors Club, 1978.

1958 CLAXTON, FLORENCE (Alt. FARRINGTON) (1835/40–?)
English graphic artist who was the first woman employed to make draw-ings on wood for a weekly magazine; older sister of Adelaide Claxton (q.v.).

See under Adelaide Claxton.

1959 CZEGA, BERTHA (1880–)
Austrian graphic artist.

Other Sources

Pabst, Michael. *Wiener Grafik um 1900.* Munich: Verlag Silke Schreiber, 1984.

1960 DABOWSKA-TARASIN, ZOFIA (1924–)
Polish graphic artist, painter and stage designer.

Other Sources

Jakimowicz, Irena. *Wspótczesna grafika polska.* Warsaw: Arkady, 1975.

1961 DARBOVEN, HANNE (1940/1–)
German graphic artist who is concerned with scripto-visual work and pro-duces artist's books.

Exhibitions

Künstlerinnen des 20. Jahrhunderts. Wiesbaden: Museum Wiesbaden in asso-ciation with Verlag Weber & Weidermeyer GmbH, Kassel, 1990.
Graw, Isabelle. "Work Ennobles: I'm staying Bourgeois (Hanne Darboven)." In *Inside the Visible: An Elliptical View of 20th Century Art—In, Of and From the Feminine,* edited by Catherine De Zegher. Ghent: the Kanaal Foundation, 1996.

Other Sources

Evers, Ulrike. *Deutsche Künstlerinnen des 20. Jahrhunderts. Malerei—Bildhauerei—Tapisserie.* Hamburg: Ludwig Schultheis Verlag, 1983. Contains an individual bibliography.

1962 DAVIDOVA, NATALIA JAKOVLEVNA (1873/4–1926)
Russian graphic artist.

Other Sources

Brambatti, Alberta, Donata Macelli, and Lucia Tonini. *Grafica Art Nouveau nelle riviste russe.* Florence: Cantini, 1989.
Milner, John. *A Dictionary of Russian and Soviet Artists, 1420–1970.* Woodbridge: Antique Collectors Club, 1993.

1963 DAVID, HERMINE (1886–1971)
 French graphic artist, painter and book illustrator.

Exhibitions

Dufresne, Jean-Luc and Olivier Messac, eds. *Femmes créatrices des années vingt.* Granville: Musée Richard Anacréon, 1988. Wide-ranging catalogue with a short biographical account on each woman included.

Other Sources

Bunoust, Madeleine. *Quelques Femmes Peintres.* Paris: Librairie Stock, 1936.

Edouard-Joseph, R. *Dictionnaire biographique des artistes contemporains, 1910–1930.* Paris: Art et Editions, 1930–1934.

1964 DE GROOT, GARDIEN (1940–)
 Dutch graphic artist.

Exhibitions

De Vrouw in de kunst. Leiden: Pand Caecilia, 1987.

1965 DELLA-VOS-KARDOVSKAYA, OLGA LYUDVIGOVNA (1875–1952)
 Russian painter of portraits and a graphic artist.

See Painting section.

1966 DONAGH, RITA (1939–)
 English painter and graphic artist of Irish descent whose works are formal and restrained but also political.

Main Sources

Greenan, Althea. "Have You Heard the News Today?" *Women's Art Magazine* 62 (January–February 1995): 27–28.

Exhibitions

Haywood Annual, 1978. London: Hayward Gallery, 1978.
The Women's Art Show 1550–1970. Nottingham: Castle Museum, 1982.

Other Sources

Dunford, Penny. *A Biographical Dictionary of Women Artists in Europe and America since 1850.* Hemel Hempstead: Harvester Wheatsheaf and Philadelphia: University of Pennsylvania Press, 1990. Contains a bibliography.

Parry-Crooke, Charlotte. *Contemporary British Artists.* London: Bergstrom and Boyle, 1979.

1967 DUNCAN, MARY (1885–1960)
Irish graphic artist who specialised in etching; also a painter.

Exhibitions

Irish Women Artists from the Eighteenth Century to the Present Day. Dublin: National Gallery of Ireland, Douglas Hyde Gallery and Hugh Lane Gallery, 1987.

1968 DYMSHITS-TOLSTAYA, SOFIA ISAAKOVNA (Alt. PESSATI) (1889–1963)
Russian painter and graphic artist.

See Painting section.

1969 E.V.B. (Pseudonym of ELEANOR VERE BOYLE; née GORDON) (1825–1916)
English amateur graphic artist.

Main Sources

Clayton, Ellen. *English Female Artists.* London: Tinsley, 1876.

Exhibitions

Casteras, Susan, and Linda H. Peterson. *A Struggle for Fame: Victorian Women Artists and Authors.* New Haven, Conn.: Yale Center for British Art, 1994.

Other Sources

Peppin, Bridgid. *Fantasy Book Illustration 1860–1920.* London: Studio Vista 1975.

1970 FARMILOE, EDITH (née PARNELL)
English graphic artist who specialised in sketches of Cockney children. She used the multinational parishioners of her husband as models.

Publications

Rag, Tag and Bobtail. London: Grant Richards, 1899.

Main Sources

Sparrow, Walter Shaw. "Some drawings by Mrs Farmiloe." *Studio* 18 (1899): 172–179.

1971 FARRER, ANN
English botanical painter and graphic artist.

See Painting section.

1972 FISHER, BETH (1944–)
American-born painter and graphic artist working in Scotland whose works deals with the figure.

See Painting section.

1973 FLIN, STEFANIE DRETLER (1909–)
Polish graphic artist, painter and designer of ceramics.

Other Sources

Jakimowicz, Irena. *Wspótczesna grafika polska.* Warsaw: Arkady, 1975.

1974 FORBES, ELIZABETH ADELA (née ARMSTRONG; alt. ELIZABETH STANHOPE FORBES) (1859–1912)
Canadian-born painter of rural genre who depicted many scenes from the fishing community in Newlyn, Cornwall; also a graphic artist.

See Painting section.

1975 FRESE, VARVARA PETROVNA (Alt. FREZE) (1883–1968)
Russian painter, graphic artist and painter on porcelain.

See Painting section.

1976 FRIMBURGER, MARIANNE (1877–1965)
Austrian graphic artist.

Other Sources

Pabst, Michael. *Wiener Grafik um 1900.* Munich: Verlag Silke Schreiber, 1984.

1977 FULIEROVÁ, KVĚTOSLAVA (1932–)
Czech graphic artist.

Exhibitions

Kvetoslava Fulierová. Brno: Moravská Galerie, 1972, one folded sheet, illus.

1978 GABAIN, ETHEL LEONTINE (Alt. COPLEY) (1883–1950)
English graphic artist and painter of portraits, especially of women; also an official war artist.

Exhibitions

Paintings and Drawings by Some Women War Artists. London: Imperial War Museum, 1958.

Other Sources

Dunford, Penny. *A Biographical Dictionary of Women Artists in Europe and America since 1850.* Hemel Hempstead: Harvester Wheatsheaf and Philadelphia: University of Pennsylvania Press, 1990. Contains a bibliography.

Harries, M., and S. *The War Artists.* London: 1983.

Waters, Grant. *Dictionary of British Artists Working 1900–1940.* Eastbourne: Eastbourne Fine Art, 1975.

1979 GARWOOD, TIRZAH (née EILEEN LUCY GARWOOD; alt. RAVILIOUS) (1908–1951)
English graphic artist known particularly for her wood engravings.

Main Sources

Ullmann, A. *The Wood Engravings of Tirzah Ravilious.* London, 1987.

Other Sources

Balstan, Thomas. *English Wood Engraving, 1900–1950.* London: Art & Technics, 1951.

Dunford, Penny. *A Biographical Dictionary of Women Artists in Europe and America since 1850.* Hemel Hempstead: Harvester Wheatsheaf and Philadelphia: University of Pennsylvania Press, 1990. Contains a bibliography.

1980 GÉRARD, MARGUERITE (1761–1837)
French painter and graphic artist.

See Painting section.

1981 GOSSE, SYLVIA (née LAURA SYLVIA GOSSE) (1881–1968)
English graphic artist and painter of figures and still lifes; daughter of Nellie Gosse (q.v.) and niece of Laura Alma-Tadema (q.v.).

Main Sources

Fisher, Katherine. *Conversations with Sylvia.* London, 1975.

Stokes, H. "The Etchings of Sylvia Gosse." *Print Collectors' Quarterly,* 1925, 314–338.

Exhibitions

Baron, Wendy. *The Sickert Women and the Sickert Girls.* London: Parkin Gallery, 1974.

Hedley, Gill. *Let Her Paint.* Southampton: University Art Gallery, 1988.

Sellars, Jane. *Women's Work.* Liverpool: Walker Art Gallery, 1988.

Other Sources

Dunford, Penny. *A Biographical Dictionary of Women Artists in Europe and America since 1850.* Hemel Hempstead: Harvester Wheatsheaf and Philadelphia: University of Pennsylvania Press, 1990. Contains a bibliography.

Thwaite, Ann. *Edmund Gosse: A Literary Landscape, 1849–1928.* London: Secker & Warburg, 1984, 567pp., illus. A biography in which Sylvia Gosse and her mother, Nellie (q.v.), both feature.

Waters, Grant. *Dictionary of British Artists Working 1900–1940.* Eastbourne: Eastbourne Fine Art, 1975.

1982 GREENAWAY, KATE (née CATHERINE GREENAWAY) (1846–1901)
English graphic artist, illustrator, writer and painter, especially of books for children.

Publications

Holme, Bryan. *The Kate Greenaway Book.* London: Frederick Warne and New York: Viking Press, 1976, 144pp., illus. Publishes in full the texts of two stories with a selection of her illustrations. There are also extracts from her main publications of verse and illustrations. Analyses of reviews, notably French publications, and a biography follow. There is also a list of books written and illustrated by Greenaway, as well as lists of her illustrations in periodicals. See also Engen, below, for similar information.

Main Sources

Engen, R. *Kate Greenaway.* London and New York, 1976.
Moore, A. *A Century of Kate Greenaway.* London, 1946.
Spielmann, Marion Harry, and George S. Layard. *Kate Greenaway.* British Artists Series. London: Adam & Charles Black, 1905. This includes her correspondence, autobiographical notes and contains several recollections by people who knew her.

Exhibitions

Johnson, Diana. *Fantastic Illustration and Design in Britain, 1850–1930.* New York: Cooper Hewitt Museum and Museum of Art, Rhode Island School of Design, 1979.
Sellars, Jane. *Women's Work.* Liverpool: Walker Art Gallery, 1988.
Casteras, Susan, and Linda H. Peterson. *A Struggle for Fame: Victorian Women Artists and Authors.* New Haven, Conn.: Yale Center for British Art, 1994.

Other Sources

Bachmann, Donna, and Sherry Piland. *Women Artists: A Historical, Contemporary and Feminist Bibliography.* Metuchen, N.J.: Scarecrow Press, 1978.

Clement, Clara. *Women in the Fine Arts.* Boston: Houghton Mifflin, 1904.

Dunford, Penny. *A Biographical Dictionary of Women Artists in Europe and America since 1850.* Hemel Hempstead: Harvester Wheatsheaf and Philadelphia: University of Pennsylvania Press, 1990. Contains a bibliography,

Muir, Percy. *Victorian Illustrated Books.* London: B.T. Batsford Ltd., 1971, 287pp., illus. Greenaway is one of only two women included in this book and is treated in a somewhat condescending manner.

1983 GREG, BARBARA (1900–1984)

English graphic artist producing mainly engravings but also book illustrations.

Other Sources

Garrett, Albert. *A History of British Wood Engraving.* Tunbridge Wells: Midas Books, 1978.

———. *British Wood Engraving of the 20th Century: A Personal View.* London: Scolar Press, 1980.

Horne, Alan. *Dictionary of Twentieth Century British Book Illustrators.* Woodbridge: Antique Collectors Club, 1994.

1984 GRIBBLE, VIVIEN

English graphic artist specialising in wood engraving.

Other Sources

Jaffé, Patricia. *Women Engravers.* London: Virago, 1988.

1985 GRIERSON, MARY

English botanical painter and graphic artist.

See Painting section.

1986 GRUNDIG, LEA (née LANGER) (1906–1977)

German graphic artist who produces mainly prints and drawings dealing with political subject matter.

Publications

Gesichte und Geschichte. Berlin, 1958, 2nd edition Berlin, 1978.

Exhibitions

Gleisberg, D. *Deutsche Künstlerinnen des zwanzigsten Jahrhunderts.* Attenburg: Staatlichen Lindendau Museum, 1963.

Lea Grundig. Berlin: Landengalerie, 1973.

Das Verborgene Museum. Dokumentation der Kunst de Frauen in Berliner öffentlichen Sammlungen. Berlin: Edition Hentrich, 1987.
Meskimmon, Marsha. *Domesticity and Dissent: The Role of Women Artists in Germany 1918–1938. Haüsliches Leben und Dissens.* Leicester: Leicestershire Museums Publication no. 120, 1992.

Other Sources

Dunford, Penny. *A Biographical Dictionary of Women Artists in Europe and America since 1850.* Hemel Hempstead: Harvester Wheatsheaf and Philadelphia: University of Pennsylvania Press, 1990. Contains a bibliography.
Evers, Ulrike. *Deutsche Künstlerinnen des 20. Jahrhunderts. Malerei— Bildhauerei—Tapisserie.* Hamburg: Ludwig Schultheis Verlag, 1983. Contains an extensive individual bibliography.
Krichbaum, J., and R. Zondergeld. *Künstlerinnen: von der Antike bis zur Gegenwart.* Cologne: DuMont, 1979.
Meskimmon, Marsha, and Shearer West. *Visions of the 'Neue Frau': Women and the Visual Arts in Weimar Germany.* London: Scolar Press, 1995.

1987 GUSTOWSKA, IZABELLA (1948–)
Polish graphic artist and painter.

Exhibitions

Morawińska, Agnieszka. *Voices of Freedom: Polish Women Artists of the Avant-garde, 1880–1990.* Washington, D.C.: National Museum of Women in the Arts, 1991. Includes a list of her main exhibitions and a bibliography.

1988 HAIGH, DOROTHY
English graphic artist specialising in wood engraving.

Other Sources

Jaffé, Patricia. *Women Engravers.* London: Virago, 1988.

1989 HANSEN-KRONE, JOHANNE MARIE (1952–)
Norwegian painter and graphic artist who exhibits many drawings.

Exhibitions

Wichstrøm, Anne. *Rooms with a View: Women's Art in Norway, 1880–1990.* Oslo: Ministry of Foreign Affairs, 1989.

1990 HASSALL, JOAN (1906–)
English graphic artist specialising in wood engraving.

Publications

"A Four-Colour Bookplate from Hand Engraved Wood Blocks. How It Was Done—How You Can Do It." *Printcraft* 9 (1950): 67–68.

"My Engraved Work." *The Private Library,* 2nd series, 7, no. 4 (winter 1974): 139–164. Includes 27 illus.

Main Sources

Chambers, David. *Joan Hassall: Engravings and Drawings.* Pinner, 1985.
McLean, R. *The Wood Engravings of Joan Hassall.* Oxford: Oxford University Press, 1960.

Other Sources

Balstan, Thomas. *English Wood Engraving, 1900–1950.* London: Art & Technics, 1951.
Garrett, Albert. *A History of British Wood Engraving.* Tunbridge Wells: Midas Books, 1978.
————. *British Wood Engraving of the 20th Century: A Personal View.* London: Scolar Press, 1980.
Jaffé, Patricia. *Women Engravers.* London: Virago, 1990.

1991 HASSE, SELLA (1878/80–1963)
German graphic artist, influenced by Käthe Kollwitz, who used a socio-critical approach to portray working people.

Exhibitions

Gleisberg, D. *Deutsche Künstlerinnen des zwanzigsten Jahrhunderts.* Attenburg: Staatlichen Lindendau Museum, 1963.
Das Verborgene Museum. Dokumentation der Kunst von Frauen in Berliner öffentlichen Sammlungen. Berlin: Edition Hentrich, 1987.
Meskimmon, Marsha. *Domesticity and Dissent: The Role of Women Artists in Germany 1918–1938. Haüsliches Leben und Dissens.* Leicester: Leicestershire Museums Publication no. 120, 1992.

Other Sources

Evers, Ulrike. *Deutsche Künstlerinnen des 20. Jahrhunderts. Malerei—Bildhauerei—Tapisserie.* Hamburg: Ludwig Schultheis Verlag, 1983. Contains an individual bibliography.
Krichbaum, J., and R. Zondergeld. *Künstlerinnen: von der Antike bis zur Gegenwart.* Cologne: DuMont, 1979.

1992 HAVLIKOVÁ, DANIELA (1946–)
Czech graphic artist.

Exhibitions

Art tchèque contemporain: gravure, céramique, verre. Freiburg: Musée d'Art et d'Histoire, 1973.

1993 HEISKANEN, OUTI (1937–)
Finnish graphic artist.

Exhibitions

Akt 83: suomalaista nykytaidetta. Helsinki: Ateneum, 1983.

1994 HERMES, GERTRUDE (1902–)
English graphic artist and designer.

Main Sources

Russell, Judith, ed. *The Wood Engravings of Gertrude Hermes.* Aldershot: Scolar Press, 1993, 128pp., illus. A survey of her work between 1924 and 1983 with biographical notes by the artist's daughter.

Exhibitions

The Thirties: British Art and Design Before the War. London: Hayward Gallery, 1979.
Hogben, C. *British Art and Design 1900–1960: A Collection in the Making.* London: Victoria and Albert Museum, 1983.
Sellars, Jane. *Women's Works.* Liverpool: Walker Art Gallery, 1988.
Deepwell, Katy. *Ten Decades: Careers of Ten Women Artists Born 1897–1906.* Norwich: Norwich Gallery, Norfolk Institute of Art and Design, 1992.

Other Sources

Balstan, Thomas. *English Wood Engraving, 1900–1950.* London: Art & Technics, 1951.
Blunt, Wilfrid. *The Art of Botanical Illustration.* New Naturalist Series. London: Collins, 1950.
Dunford, Penny. *A Biographical Dictionary of Women Artists in Europe and America since 1850.* Hemel Hempstead: Harvester Wheatsheaf and Philadelphia: University of Pennsylvania Press, 1990. Contains a bibliography.
Garrett, Albert. *A History of British Wood Engraving.* Tunbridge Wells: Midas Books, 1978.
———. *British Wood Engraving of the 20th Century: A Personal View.* London: Scolar Press, 1980.
Jaffé, Patricia. *Women Engravers.* London: Virago, 1990.
Mackay, J. *Dictionary of Western Sculptors in Bronze.* Woodbridge: Antique Collectors Club, 1978.

1995 HERVIEU, LOUISE (1878–1954)
French painter, graphic artist and writer.

See Painting section.

1996 HESKE, MARIANNE (1946–)
Norwegian sculptor, video and installation artist, graphic artist and photographer.

See Performance and Video Art, Mixed Media and Installations section.

1997 HISZPAŃSKA-NEUMANN, MARIA (1917–)
Polish graphic artist, engaged in engraving, printmaking and book illustration; also a painter.

Exhibitions

Zwei polnische Malerinnen: Maria Jarema, Maria Hiszpańska-Neumann.
Bern: Kunstmuseum, 1963. Contains a biographical account and some critical discussion of the work.

Other Sources

Jakimowicz, Irena. *Wspótczesna grafika polska.* Warsaw: Arkady, 1975.

1998 HORGAN, SARA (1942–)
Irish graphic artist.

Exhibitions

Irish Women Artists from the Eighteenth Century to the Present Day. Dublin:
National Gallery of Ireland, Douglas Hyde Gallery and Hugh Lane Gallery, 1987.

1999 JAKUBOWSKA, TERESA (1930–)
Lithuanian-born graphic artist who worked in Poland, notably in engraving.

Other Sources

Jakimowicz, Irena. *Wspótczesna grafika polska.* Warsaw: Arkady, 1975.

2000 JAKUNCHIKOVA, MARIA VASIL'EVNA (1870–1902)
German-born graphic artist who was brought up in Russia.

Other Sources

Brambatti, Alberta, Donata Macelli, and Lucia Tonini. *Grafica Art Nouveau nelle riviste russe.* Florence: Cantini, 1989.

2001 JAREMA, MARIA (1908–1958)
Polish abstract painter, sculptor, stage designer and graphic artist.

See Painting section.

2002 JIŘINKOVÁ, LUDMILA
 Czech graphic artist.

Other Sources

Lamač, Miroslav. *Contemporary Art in Czechoslovakia.* Prague: Orbis, 1958.

2003 JORIS, AGNESE (sometimes used the pseudonym ALTISSIMI) (1850–1922)
 Italian painter and graphic artist.

See Painting section.

2004 JUNG, EDITH (1953–)
 German painter and graphic artist.

Other Sources

Evers, Ulrike. *Deutsche Künstlerinnen des 20. Jahrhunderts. Malerei— Bildhauerei—Tapisserie.* Hamburg: Ludwig Schultheis Verlag, 1983. Contains an individual bibliography.

2005 KAGAN, ANNA ALEXANDROVNA (1902–1974)
 Russian graphic artist, painter and decorator of ceramics.

Exhibitions

Avanguardia russa dalle collezioni private sovietiche origini e percorso 1904–1934. Milan: Palazzo Reale, 1989.

Other Sources

Elliott, David, and V. Dudakov. *100 Years of Russian Art.* London: Lund Humphries, 1989.
 Milner, John. *A Dictionary of Russian and Soviet Artists, 1420–1970.* Woodbridge: Antique Collectors Club, 1993.

2006 KESERÜ, ILONA (1933–)
 Hungarian painter, graphic artist and theatre designer.

See Painting section.

2007 KESSELL, MARY (1914–)
 English painter of landscapes and figure subjects, graphic artist and designer of jewellery; also an official war artist.

See Painting section.

2008 KHLEBNIKOVA, VERA VLADIMIROVNA (Alt. MITURICH-KHLEB-NIKOVA)
Russian painter and graphic artist who produced some work commenting on women's role in Soviet society.

See Painting section.

2009 KIDSTON, ANNABEL (1896–)
Scottish graphic artist specialising in engraving.

Other Sources

Garrett, Albert. *A History of British Wood Engraving.* Tunbridge Wells: Midas Books, 1978.
Jaffé, Patricia. *Women Engravers.* London: Virago, 1990.

2010 KING, JESSIE MARION (1975–1949)
Scottish graphic artist best known for her illustration of children's books; also a designer of textiles.

Publications

How Cinderella was able to go to the ball: A brochure on batik. London, 1924. For a list of the books which she illustrated, see White or Oliver, below.

Main Sources

Watson, R. "Miss Jessie Marion King and Her Work." *Studio* 36 (1902): 176–188.
White, Colin. *The Enchanted World of Jessie Marion King.* Edinburgh: Canongate, 1989, 164pp., illus. A biographical account which in the last chapter mentions other Scottish women artists who were her contemporaries. Lists all the books which King illustrated.

Exhibitions

Oliver, Cordelia. *Jessie Marion King, 1875–1949.* Glasgow: Scottish Arts Council Gallery, 1971. Contains a full list of works illustrated by King and a detailed bibliography.
Johnson, Diana. *Fantastic Illustration and Design in Britain, 1850–1930.* New York: Cooper Hewitt Museum and Museum of Art, Rhode Island School of Design, 1979.
Sellars, Jane. *Women's Works.* Liverpool: Walker Art Gallery, 1988.
The Last Romantics: The Romantic Tradition in British Art: Burne-Jones to Stanley Spencer. London: Barbican Gallery, 1989.

Other Sources

Callen, Anthea. *Angel in the Studio: Women and the Arts and Crafts Movement.* London: Architectural Press, 1979.

Clement, Clara. *Women in the Fine Arts.* Boston: Houghton Mifflin, 1904.

Dunford, Penny. *A Biographical Dictionary of Women Artists in Europe and America since 1850.* Hemel Hempstead: Harvester Wheatsheaf and Philadelphia: University of Pennsylvania Press, 1990. Contains a bibliography.

Peppin, Bridgid. *Fantasy Book Illustration 1860–1920.* London: Studio Vista 1975.

Sparrow, Walter Shaw. *Women Painters of the World.* London: Hodder and Stoughton, 1905.

2011 KLAR, CONCORDIA (1938–)
Estonian graphic artist.

Other Sources

Rosenfeld, Alla, and Norton Dodge, eds. *Nonconformist Art: The Soviet Experience, 1956–1986. The Norton and Nancy Dodge Collection.* London: Thames and Hudson in association with the Jane Voorhees Zimmerli Art Museum, State University of New Jersey, Rutgers, 1995.

2012 KLINGHOFFER, CLARA (1900–1970)
Austrian-born painter and graphic artist who worked in England and America.

See Painting section.

2013 KNIGHT, LAURA (née JOHNSON) (1887–1970)
English figure painter especially of beach, ballet and circus themes.

See Painting section.

2014 KOCK, ANNEKE (1944–)
Dutch graphic artist and painter.

Exhibitions

De Vrouw in de kunst. Leiden: Pand Caecilia, 1987.

2015 KODASSEVICH, VALENTINA MICHAILOVNA (1894–1970)
Russian painter, graphic artist and stage designer.

See Painting section.

2016 KOHLER, MELA
Austrian designer and graphic artist.

See volume 1.

2017 KOLLER, BRONCIA (1867–1934)
Austrian graphic artist.

Other Sources

Pabst, Michael. *Wiener Grafik um 1900.* Munich: Verlag Silke Schreiber, 1984.

2018 KOLLWITZ, KÄTHE (née SCHMIDT) (1867–1945)
German graphic artist and sculptor known for her commitment to a social and political art.

Publications

Kollwitz, Hans, ed. *Diary and Letters of Käthe Kollwitz.* Trans Richard and Clara Winston. Evanston, Ill.: Northwestern University Press, [c. 1988], 200pp., illus.

Main Sources

Fächt, Tom. *Käthe Kollwitz: Works in Colour.* Translated by A. S. Wensinger, and R. Wood. New York: Schocken Books, 1988, 112pp., 134 illus. Contains an introductory essay and a bibliography.

Gore, Anonina Filonov. "The Modernist Poetics of Grief in the Wartime Works of Tsvetaeva, Filonov and Kollwitz." In *Russian Narrative and Visual Art: Varieties of Seeing,* edited by Roger Anderson and Paul Debreczeny, 148–172. Gamesville: University of Florida Press, 1994.

Schaefer, Jean Owens. "Kollwitz in America: A Study of Reception, 1900–1960." *Woman's Art Journal* 15, no. 1 (spring–summer 1994): 29–34.

Schaefer, Jean Owens. "The Kollwitz Konnection." *Women's Art Magazine* 62 (January–February 1995): 10–16. Discusses the reception of Kollwitz in America between 1900 and 1960.

Exhibitions

Käthe Kollwitz: Grafik, Techningar, Skulpturer. Stockholm: National-museum, 1967, n.p., illus.

Harris, Anne Sutherland, and Linda Nochlin. *Women Artists 1550–1950.* Los Angeles: County Museum of Art, 1976.

Künstlerinnen International, 1877–1977. Berlin: Schloss Charlottenburg, 1977.

Käthe Kollwitz (1867–1945): The Graphic Works. Cambridge: Kettle's Yard, 1981, 77pp., illus. Contains two critical essays, one of which contains biographical information.

Das Verborgene Museum. Dokumentation der Kunst von Frauen in Berliner öffentlichen Sammlungen. Berlin: Edition Hentrich, 1987.

Schmidt, Werner. *Die Kollwitz-Sammlung des Dresdener Kupferstich-Kabinettes: Graphik und Zeichnungen, 1890–1912.* Cologne: Käthe Kollwitz Museum in association with DuMont, 1988, 212pp., illus.

Backhaus, Annie, Jutta Bohnke, Hannelore Fischer, and Gerd Thur. *Käthe Kollwitz: Katalog der Handzeichnungen.* Cologne: Käthe Kollwitz Museum, 1989,

240pp., mainly illus. There are three critical essays followed by an annotated catalogue of the exhibits.

Meskimmon, Marsha. *Domesticity and Dissent: The Role of Women Artists in Germany 1918–1938. Haüsliches Leben und Dissens.* Leicester: Leicestershire Museums Publication no. 120, 1992.

Prelinger, Elizabeth. *Käthe Kollwitz.* Washington, D.C.: National Gallery of Art in association with Yale University Press, London and New Haven, 1992, 192pp., illus. The essays by the Curator and Alessandra Comini provide a scholarly critical analysis while that by Hildegarde Bachert discusses the collectors and the reception of Kollwitz's work. There are detailed notes on the exhibits and an extensive bibliography.

Fischer, Hannelore. *Käthe Kollwitz: Meisterwerke der Zeichnung.* Cologne: Käthe Kollwitz Museum in association with DuMont, 1995, 255pp., illus.

Griffith, Fiona. *Käthe Kollwitz: Artist of the People.* London: South Bank Centre, 1995, 47pp., illus.

Other Sources

Bachmann, Donna, and Sherry Piland. *Women Artists: A Historical, Contemporary and Feminist Bibliography.* Metuchen, N.J.: Scarecrow Press, 1978.

Behr, Shulamith. *Women Expressionists.* Oxford: Phaidon, 1988.

Betterton, Rosemary. *Intimate Distance: Women, Artists and the Body.* London: Routledge, 1996.

Dunford, Penny. *A Biographical Dictionary of Women Artists in Europe and America since 1850.* Hemel Hempstead: Harvester Wheatsheaf and Philadelphia: University of Pennsylvania Press, 1990. Contains a bibliography.

Evers, Ulrike. *Deutsche Künstlerinnen des 20. Jahrhunderts. Malerei— Bildhauerei—Tapisserie.* Hamburg: Ludwig Schultheis Verlag, 1983. Contains an extensive individual bibliography.

Meskimmon, Marsha, and Shearer West. *Visions of the 'Neue Frau': Women and the Visual Arts in Weimar Germany.* London: Scolar Press, 1995.

Tufts, Eleanor. *Our Hidden Heritage: Five Centuries of Women Artists.* New York and London: Paddington Press, 1974.

2019 KRASZEWSKA, OTOLIA GRÄFIN (1859–?)
German graphic artist.

Other Sources

Jugendstil Illustration in München. Munich: Stuck-Villa, 1970.

2020 KROPIVNITSKAYA, VALENTINA (1924–)
Russian painter and graphic artist.

See Painting section.

2021 KRUGLIKOVA, ELIZAVETA SERGEEVNA (Alt. KROUGLIKOVA) (1865–1941)
 Russian graphic artist, specialising in etching, and painter.

Exhibitions

Paris-Moscou, 1900–1939. Paris: Centre national d'art et de culture Georges Pompidou, 1979

Other Sources

Milner, John. *A Dictionary of Russian and Soviet Artists, 1420–1970.* Woodbridge: Antique Collectors Club, 1993.

2022 KUBICKA, MARGARETHE (née STANISLOVA) (1891–?)
 German painter and graphic artist who often addressed social and political themes.

See Painting section.

2023 KULAGINA, VALENTINA (Alt. KLUTSIS)
 Russian graphic artist.

Exhibitions

Künstlerinnen International, 1877–1977. Berlin: Schloss Charlottenburg, 1977.

Other Sources

Tupitsyn, Margarita. *The Soviet Photograph, 1924–1937.* New Haven, Connecticut and London: Yale University Press, 1996.

2024 KURYLUK, EWA (1946–)
 Polish painter and graphic artist who has lived in America since 1988.

Exhibitions

Morawińska, Agnieszka. *Voices of Freedom: Polish Women Artists of the Avant-garde, 1880–1990.* Washington, D.C.: National Museum of Women in the Arts, 1991. Includes a list of her main exhibitions and a bibliography.

2025 LANDSEER, JESSICA (1807–1880)
 English painter, graphic artist and miniaturist.

See Painting section.

2026 LAUENSTEIN, PAULA (1898–1980)
German painter and graphic artist who was based in Dresden and whose work often dealt with social outcasts.

See Painting section.

2027 LEIGHTON, CLARE (née VERONICA HOPE CLARE LEIGHTON) (1898–1989)
English graphic artist and painter who specialised in wood engraving and illustration.

Publications

How to Do Woodcuts and Wood Engravings. London, n.d.
The Musical Box. London, 1932.
Four Hedges. London, 1935.

Main Sources

"Clare Leighton." *The Independent,* 8, 9 and 10 November 1989. Obituaries.

Other Sources

Balstan, Thomas. *English Wood Engraving,* 1900–1950. London: Art & Technics, 1951.
Dunford, Penny. *A Biographical Dictionary of Women Artists in Europe and America since 1850.* Hemel Hempstead: Harvester Wheatsheaf and Philadelphia: University of Pennsylvania Press, 1990. Contains a bibliography.
Garrett, Albert. *A History of British Wood Engraving.* Tunbridge Wells: Midas Books, 1978.
———. *British Wood Engraving of the 20th Century: A Personal View.* London: Scolar Press, 1980.
Jaffé, Patricia. *Women Engravers.* London: Virago, 1990.
Waters, Grant. *Dictionary of British Artists Working 1900–1940.* Eastbourne: Eastbourne Fine Art, 1975.

2028 LEIS, MALLE (1940–)
Estonian painter of figures, plants, flowers and vegetables with occasional landscapes; also a graphic artist.

See Painting section.

2029 LERMONTOVA, NADEZHDA VLADIMIROVNA (1885–1921)
Russian painter and graphic artist.

Exhibitions

Avanguardia russa dalle collezioni private sovietiche origini e percorso 1904–1934. Milan: Palazzo Reale, 1989.

Other Sources

Milner, John. *A Dictionary of Russian and Soviet Artists, 1420–1970.* Woodbridge: Antique Collectors Club, 1993.

2030 LESZCZYNSKA-KLUZA, DANUTA (1926–)
Polish graphic artist and painter.

Other Sources

Jakimowicz, Irena. *Wspótczesna grafika polska.* Warsaw: Arkady, 1975.

2031 LESZNAI, ANNA (1885–1966)
Hungarian painter, graphic artist and designer of embroidery who exhibited with the Eight, an avant-garde group.

See Painting section.

2032 LEX-NERLINGER, ALICE (1893–)
German graphic artist and photographer who used new techniques, including photomontage and the photogram, and whose work often contained a political dimension.

See Photography section.

2033 LIIVA, SILVI (1941–)
Estonian graphic artist.

Other Sources

Rosenfeld, Alla, and Norton Dodge, eds. *Nonconformist Art: The Soviet Experience, 1956–1986. The Norton and Nancy Dodge Collection.* London: Thames and Hudson in association with the Jane Voorhees Zimmerli Art Museum, State University of New Jersey, Rutgers, 1995.

2034 LOHMANN, JULIA (1951–)
German painter and graphic artist who studied with Josef Beuys.

See Painting section.

2035 LUCANDER, ANITRA MARIA INGEBORG (1918–)
Finnish painter and graphic artist of atmospheric abstractions.

See Painting section.

2036 LYDIS, MARIETTA (née RONSPERGER) (1894–?)
Austrian-born painter and graphic artist who worked in France.

See Painting section.

2037 ŁUSZCZKIEWICZ-JASTREBSKA, MARIA (1929–)
Polish graphic artist.

Other Sources

Jakimowicz, Irena. *Współczesna grafika polska.* Warsaw: Arkady, 1975.

2038 MADDEN, ANNE (Alt. LE BROCQUY) (1932–)
English-born painter, sculptor and graphic artist who moved to Ireland as a child.

See Sculpture section.

2039 MAMMEN, JEANNE (1890–1976)
German graphic artist and painter who depicted Berlin society in the 1920s.

See Painting section.

2040 MANNER, MARIANA (1943–)
Swedish graphic artist, painter and sculptor.

Other Sources

Carey, Frances. *Modern Scandinavian Prints.* London: British Museum Press, 1997.

2041 MANTA, MARIA CLEMENTINA VILAS-BOAS CARNEIRODE MOURA (1898–)
Portuguese graphic artist and designer of tapestries who also paints.

Other Sources

Tannock, Michael. *Portuguese Artists of the Twentieth Century: A Biographical Dictionary.* Chichester: Phillimore & Co. Ltd., 1988.

2042 MATTON, IDA (1863–1940)
Swedish sculptor, medallist, landscape painter and graphic artist.

See Sculpture section.

2043 MELNYCHENKO, VALENTINA (1946–)
Ukrainian graphic artist and illustrator.

Other Sources

Rosenfeld, Alla, and Norton Dodge, and eds. *Nonconformist Art: The Soviet Experience, 1956–1986. The Norton and Nancy Dodge Collection.* London: Thames and Hudson in association with the Jane Voorhees Zimmerli Art Museum, State University of New Jersey, Rutgers, 1995.

2044 MERZ, MARISA (c. 1945–)
Italian conceptual sculptor and graphic artist.

See Sculpture section.

2045 MILLS, ERNESTINE EVANS (1871–1959)
English graphic artist.

Exhibitions

Johnson, Diana. *Fantastic Illustration and Design in Britain, 1850–1930.* New York: Cooper Hewitt Museum and Museum of Art, Rhode Island School of Design, 1979.

2046 MORGAN, GWENDA (1908–1991)
English graphic artist specialising in engraving.

Main Sources

Randle, John. "Gwenda Morgan." *The Independent,* 12 January 1991, 10. Obituary.
Sandford, C. "Gwenda Morgan: An Engraver of the Countryside." *Studio* 140, no. 688 (July 1950): 16–19.

Other Sources

Balstan, Thomas. *English Wood Engraving, 1900–1950.* London: Art & Technics, 1951.
Garrett, Albert. *A History of British Wood Engraving.* Tunbridge Wells: Midas Books, 1978.
———. *British Wood Engraving of the 20th Century: A Personal View.* London: Scolar Press, 1980.
Jaffé, Patricia. *Women Engravers.* London: Virago, 1990.

2047 MÖLLINGER, FRANCISZKA (1817–1880)
German photographer and graphic artist.

See Photography section.

2048 MUIŽULE, MALDA (1937–)
Latvian painter and graphic artist.

See Painting section.

2049 MUNGAPEN, SHIRLEY (1933–)
English graphic artist.

Other Sources

Garrett, Albert. *British Wood Engraving of the 20th Century: A Personal View.* London: Scolar Press, 1980.

2050 NAGEL, HANNA (Alt. FISCHER) (1907–1975)
German graphic artist.

Exhibitions

Meskimmon, Marsha. *Domesticity and Dissent: The Role of Women Artists in Germany 1918–1938. Haüsliches Leben und Dissens.* Leicester: Leicestershire Museums Publication no. 120, 1992.

Other Sources

Evers, Ulrike. *Deutsche Künstlerinnen des 20. Jahrhunderts. Malerei—Bildhauerei—Tapisserie.* Hamburg: Ludwig Schultheis Verlag, 1983. Contains an individual bibliography.

2051 NISBET, NOEL LAURA (1887–1956)
Scottish painter and graphic artist who illustrates legendary, mythological and imaginary scenes.

Exhibitions

Memorial Exhibition of Harry Bush (1883–1957) and Noel Laura Nisbet (1887–1956). London: Leighton House, 1969.
The Last Romantics: The Romantic Tradition in British Art: Burne-Jones to Stanley Spencer. London: Barbican Gallery, 1989.

Other Sources

Dunford, Penny. *A Biographical Dictionary of Women Artists in Europe and America since 1850.* Hemel Hempstead: Harvester Wheatsheaf and Philadelphia: University of Pennsylvania Press, 1990. Contains a bibliography.

2052 O'CONNELL, EMILIE (née FREDERIC EMILIE AUGUSTE MIETHE; alt. O'CONNEL) (1823–1885)
German-born painter and graphic artist who lived in Belgium and, from 1853, Paris, where she opened an atelier and had many pupils.

See Painting section.

2053 OLIVEIRA, ANA MARIA SOARES PACHECO VIEIRA NERYDE (1940–)
Portuguese painter, mixed media and graphic artist.

See Painting section.

2054 ORLOFF, CHANA (1888–1968)
Russian-born figurative sculptor and graphic artist who lived in France and later Israel and was influenced by Cubism.

See Sculpture section.

2055 OROVIDA (Pseudonym of OROVIDA CAMILLE PISSARRO) (1893–1968)
English painter and graphic artist who specialised in animal subjects.

Main Sources

Erickson, Kristen. "Orovida Camille Pissarro." *Women's Art Magazine* 41 (1991): 12–13. Biographical account.
————. "The Art of Orovida: Looking beyond the Pissarro Family Legacy." *Woman's Art Journal* 15, no. 2 (fall 1994–winter 1995): 14–20.

Exhibitions

Orovida. London: Leicester Gallery, 1935. Contains a brief biography and a list of exhibits.
Three Generations of Pissarros, 1830–1954. London: Ohana Gallery, 1954, n.p., illus. Introduction by John Rewald. Essentially a list of works.
A Catalogue of Etching and Aquatints by Orovida. Oxford: Ashmolean Museum, 1969, 31pp., illus. Useful analysis of her subject matter, techniques and use of inscriptions. Her etchings from 1914 to 1954 are divided into five periods and detailed notes on the exhibits are given.
Three Generations of the Pissarro Family. London: Leicester Gallery, 1973.

Other Sources

Dunford, Penny. *A Biographical Dictionary of Women Artists in Europe and America since 1850*. Hemel Hempstead: Harvester Wheatsheaf and Philadelphia: University of Pennsylvania Press, 1990. Contains a bibliography.

Read, Nicholas. *Pissarro in Richmond: Camille Pissarro and his Artistic Family in Kew, Chiswick and Richmond.* London: Lilburne Press, 1989, 25pp., illus. Orovida is among the family members discussed.

Waters, Grant. *Dictionary of British Artists Working 1900–1940.* Eastbourne: Eastbourne Fine Art, 1975.

2056 OSTROUMOVA-LEBEDEVA, ANNA PETROVNA (1871–1955)

Russian graphic artist and watercolour painter who specialised in town scenes.

Publications

See Milner below.

Exhibitions

Paris-Moscou 1900–1939. Paris: Centre national d'art et de culture Georges Pompidou, 1979.

Other Sources

Brambatti, Alberta, Donata Macelli, and Lucia Tonini. *Grafica Art Nouveau nelle riviste russe.* Florence: Cantini, 1989.

Dunford, Penny. *A Biographical Dictionary of Women Artists in Europe and America since 1850.* Hemel Hempstead: Harvester Wheatsheaf and Philadelphia: University of Pennsylvania Press, 1990. Contains a bibliography.

Fanelli, Giovanni, and E. Godoli. *Dizionario degli illustratori simbolisti e Art Nouveau.* Florence: Cantini, 1990.

Mandel, W. *Soviet Women.* New York: Anchor Books, 1976.

Mamanova, T. *Russian Women's Studies.* Oxford and New York, 1988.

Milner, John. *A Dictionary of Russian and Soviet Artists, 1420–1970.* Woodbridge: Antique Collectors Club, 1993.

2057 OZOLINA, AIJA (1932–)

Latvian graphic artist.

Other Sources

Šmagre, Rita. *Latviešu Pastelis* [Latvian pastel painting]. Riga: Liesma, 1990. Includes a brief account of her career.

2058 PANKHURST, SYLVIA (née ESTELLE SYLVIA PANKHURST) (1882–1960)

English painter and graphic artist whose artistic practice was integrated with her political activities until c. 1914, when she gave up art to devote herself to social and political campaigns, in particular that of women's suffrage.

See Painting section.

2059 PANNO, LAURA
Italian painter and graphic artist.

See Painting section.

2060 PARKER, AGNES MILLER (1895–)
Scottish graphic artist and painter.

Exhibitions

Burkhauser, Jude. *Glasgow Girls: Women in Art and Design 1880–1920.* Edinburgh: Canongate, 1990.

Other Sources

Balstan, Thomas. *English Wood Engraving, 1900–1950.* London: Art & Technics, 1951.
Blunt, Wilfrid. *The Art of Botanical Illustration.* New Naturalist Series. London: Collins, 1950.
Garrett, Albert. *A History of British Wood Engraving.* Tunbridge Wells: Midas Books, 1978.
————. *British Wood Engraving of the 20th Century: A Personal View.* London: Scolar Press, 1980.
Jaffé, Patricia. *Women Engravers.* London: Virago, 1990.

2061 PAULUKA, FELICITA (1925–)
Latvian painter and graphic artist.

Other Sources

Šmagre, Rita. *Latviešu Pastelis* [Latvian pastel painting]. Riga: Liesma, 1990. Includes a brief account of her career.

2062 PAYNTER, HILARY (1943–)
Scottish graphic artist, specialising in wood engraving.

Other Sources

Garrett, Albert. *A History of British Wood Engraving.* Tunbridge Wells: Midas Books, 1978.

2063 PERANI, DANIELA (1969–)
Italian graphic artist.

Exhibitions

7 Biennale Donna. Vanessa Bell e Virginia Woolf: Disegnare la Vita. Ferrara: Padiglione d'Arte Contemporanea, 1996.

2064 PETROVA-TROTZKAIA, EKATERINA MICHAILOVNA (1900/1–1932)
 Russian painter and graphic artist.

See Painting section.

2065 PILKINGTON, MARGARET (1891–)
 English graphic artist, specialising in wood engraving.

Other Sources

Balstan, Thomas. *English Wood Engraving, 1900–1950.* London: Art & Technics, 1951.
Garrett, Albert. *British Wood Engraving of the 20th Century: A Personal View.* London: Scolar Press, 1980.
Jaffé, Patricia. *Women Engravers.* London: Virago, 1988.

2066 PLIŠKOVA, NADEZDA (1934–)
 Czech graphic artist.

Exhibitions

Art tchèque contemporain: gravure, céramique, verre. Freiburg: Musée d'Art et d'Histoire, 1973.

2067 POOLE, MONICA (1921–)
 English graphic artist specialising in wood engraving.

Other Sources

Garrett, Albert. *A History of British Wood Engraving.* Tunbridge Wells: Midas Books, 1978.
———. *British Wood Engraving of the 20th Century: A Personal View.* London: Scolar Press, 1980.
Jaffé, Patricia. *Women Engravers.* London: Virago, 1990.

2068 POPOVA, LIUBOV SERGEEVNA (1889–1924)
 Russian pionéer abstract painter and textile designer.

See Painting section.

2069 POTTER, BEATRIX (1866–1943)
 English painter, graphic artist and writer best known for the children's stories about animals, which she wrote and illustrated.

See Painting section.

2070 RANTANEN, ULLA (c. 1940–)
 Finnish painter and graphic artist.

Main Sources

Pallasmaa, U. "Beauty Is Irrelevant, Disturbing." *Look at Finland* 4 (1985): 6–11.

Exhibitions

Akt 83: suomalaista nykytaidetta. Helsinki: Ateneum, 1983.

Other Sources

Dunford, Penny. *A Biographical Dictionary of Women Artists in Europe and America since 1850.* Hemel Hempstead: Harvester Wheatsheaf and Philadelphia: University of Pennsylvania Press, 1990. Contains a bibliography.

2071 RATHSMAN, SIRI (1895–1974)
Swedish graphic artist and painter who worked mainly in France.

Other Sources

Carey, Frances. *Modern Scandinavian Prints.* London: British Museum Press, 1997.

2072 RAVERAT, GWEN (née GWENDOLEN MARY DARWIN) (1885–1957)
English graphic artist who specialised in wood engraving.

Publications

Period Piece. London: Faber & Faber, 1952, 282pp., illus. Reprinted several times by 1958. Autobiography of her late-Victorian childhood in the form of thematic reminiscences of her family life until the age of twenty-two. Her grandfather was Charles Darwin.

Main Sources

Fletcher, J. "The Woodcuts of Gwen Raverat." *Print Collectors' Quarterly* 18 (1931): 330–350.
Stone, Reynolds. *The Wood Engravings of Gwen Raverat.* London: Faber & Faber, 1959, 136pp., mainly illus. A short introductory essay is followed by a list of titles of her engravings and the books which she illustrated.
Stone, Reynolds, and S. Brett. *The Wood Engravings of Gwen Raverat.* Cambridge: Silent Books, 160pp., 1989. New edition of previous publication.

Exhibitions

Clark, B. *Shall We Join the Ladies? Women Wood Engravers of the Twentieth Century.* Oxford, 1979.

Other Sources

Balstan, Thomas. *English Wood Engraving, 1900–1950.* London: Art & Technics, 1951.

Dunford, Penny. *A Biographical Dictionary of Women Artists in Europe and America since 1850.* Hemel Hempstead: Harvester Wheatsheaf and Philadelphia: University of Pennsylvania Press, 1990. Contains a bibliography.

Garrett, Albert. *A History of British Wood Engraving.* Tunbridge Wells: Midas Books, 1978.

————. *British Wood Engraving of the 20th Century: A Personal View.* London: Scolar Press, 1980.

Jaffé, Patricia. *Women Engravers.* London, 1987.

Waters, Grant. *Dictionary of British Artists Working 1900–1940.* Eastbourne: Eastbourne Fine Art, 1975.

2073 RICHARDS, FRANCES (née CLAYTON) (1901–1985)
English graphic artist, painter and collagist in textiles who also wrote poetry; wife of the painter Ceri Richards.

Exhibitions

Frances Richards. London: Leicester Gallery, 1964. Contains a brief biography and list of exhibits.

Other Sources

Dunford, Penny. *A Biographical Dictionary of Women Artists in Europe and America since 1850.* Hemel Hempstead: Harvester Wheatsheaf and Philadelphia: University of Pennsylvania Press, 1990. Contains a bibliography.

Dunthorne, Katherine. *Artists Exhibited in Wales, 1945–1974.* Cardiff: Welsh Arts Council, 1976.

2074 RISSA (1938–)
German painter and graphic artist.

See Painting section.

2075 ROSA, ROSÀ (Pseudonym of EDITH VON HAYNAU; alt. ARNALDI) (1884–after 1980)
Austrian painter, graphic artist, sculptor, designer of ceramics and poet who worked in Italy.

See Painting section.

2076 ROTERMUND, GERDA (1902–1982)
German graphic artist.

Exhibitions

Das Verborgene Museum. Dokumentation der Kunst von Frauen in Berliner öffentlichen Sammlungen. Berlin: Edition Hentrich, 1987.

2077 ROZANOVA, OLGA VLADIMIROVNA (Alt. ROSANOVA) (1886–1918)
 Russian abstract painter, graphic artist and collagist.

See Painting section.

2078 ROZENDORF, ELIZAVETA BERNGARDOVNA (1898–after 1932)
 Russian painter, graphic artist and designer of ceramics.

Exhibitions

Paris-Moscou 1900–1939. Paris: Centre national d'art et de culture Georges Pompidou, 1979.

Other Sources

Milner, John. *A Dictionary of Russian and Soviet Artists, 1420–1970.* Woodbridge: Antique Collectors Club, 1993.

2079 RÖSLER, LOUISE (1907–)
 German painter, collagist and graphic artist.

See Painting section.

2080 SANDFORD, LETTICE (1902–)
 English graphic artist specialising in engraving.

Other Sources

Garrett, Albert. *A History of British Wood Engraving.* Tunbridge Wells: Midas Books, 1978.
 ———. *British Wood Engraving of the 20th Century: A Personal View.* London: Scolar Press, 1980.
 Jaffé, Patricia. *Women Engravers.* London: Virago, 1990.

2081 SCHRAG, MARTHA (1870–1957)
 German graphic artist and painter of industrial landscapes and the local working people.

See Painting section.

2082 SELLARS, PANDORA
English botanical painter and graphic artist.

See Painting section.

2083 SEVEROVÁ, JAROSLAVA (1942–)
Czech graphic artist.

Exhibitions

Art tchèque contemporain: gravure, céramique, verre. Freiburg: Musée d'Art et d'Histoire, 1973.

2084 SIMONOVICH-EFIMOVA, NINA (1877–1948)
Russian painter and graphic artist who worked mainly in puppet theatre after 1918.

Main Sources

Yablonskaya, Miuda. *Women Artists of Russia's New Age, 1900–1935.* Edited and translated by Anthony Parton. New York: Rizzoli & London: Thames and Hudson, 1990. Contains a chapter on each artist, while notes and an individual bibliography provide access to material in Russian.

Other Sources

Milner, John. *A Dictionary of Russian and Soviet Artists, 1420–1970.* Woodbridge: Antique Collectors Club, 1993.

2085 SITTER, INGER (1929–)
Norwegian painter and graphic artist.

See Painting section.

2086 SJOO, MONICA (1938–)
Swedish-born spiritual feminist painter, graphic artist and writer who lives in Wales.

See Painting section.

2087 SOFRONOVA, ANTONINA FYODOROVNA (1892–1966)
Russian painter, who in the 1920s and 1930s also took up graphic art.

See Painting section.

2088 SOLTESZOVÁ, MILENA (1939–)
Czech graphic artist.

Exhibitions

Art tchèque contemporain: gravure, céramique, verre. Freiburg: Musée d'Art et d'Histoire, 1973.

2089 STEPANOVA, VARVARA FEODOROVNA (1894–1958)
Lithuanian-born abstract painter, graphic artist and designer who worked in Russia.

See Painting section.

2090 ŠUVINSKA, EWA (1909–)
Polish graphic artist and painter.

Other Sources

Jakimowicz, Irena. *Wspótczesna grafika polska.* Warsaw: Arkady, 1975.

2091 TAMEGÃO, MARJARIDA YOLANDA BOTELHO DE MACEDO (1901–)
Portuguese painter and graphic artist.

See Painting section.

2092 THOMPSON, ELIZA (née ELIZABETH)
English graphic artist of the nineteenth century specialising in wood engraving, which she was taught by her father, John.

Other Sources

Engen, Rodney. *Dictionary of Victorian Wood Engravers.* Cambridge: Chadwyck-Healey, 1985.
Jaffé, Patricia. *Women Engravers.* London: Virago, 1988.

2093 TIHEMETS, EVI (1932–)
Estonian graphic artist.

Other Sources

Rosenfeld, Alla, and Norton Dodge, eds. *Nonconformist Art: The Soviet Experience, 1956–1986. The Norton and Nancy Dodge Collection.* London: Thames and Hudson in association with the Jane Voorhees Zimmerli Art Museum, State University of New Jersey, Rutgers, 1995.

2094 TOMANOVÁ, EMILIE (1933–)
Czech graphic artist.

Exhibitions

Art tchèque contemporain: gravure, céramique, verre. Freiburg: Musée d'Art et d'Histoire, 1973.

2095 TOTUŠKOVÁ, JARMILA (1937–)
Czech graphic artist.

Exhibitions

Jarmila Tutušková. Brno: Moravská Galerie, 1973, one folded sheet, illus.

2096 UDDEN, INGEBORG (née ESTHER INGEBORG ALICE UDDEN) (1877–1960)
Swedish graphic artist who specialised in illustration.

Other Sources

Fanelli, Giovanni, and E. Godoli. *Dizionario degli illustratori simbolisti e Art Nouveau.* Florence: Cantini, 1990.

2097 UNDI, MARISKA (1877–1959)
Hungarian graphic artist.

Other Sources

Fanelli, Giovanni, and E. Godoli. *Dizionario degli illustratori simbolisti e Art Nouveau.* Florence: Cantini, 1990.

2098 UNWIN, NORAH S. (1907–1982)
English graphic artist specialising in wood engraving.

Main Sources

McGoldrick, Linda Clark. *Norah S. Unwin: Artist and Wood Engraver.* Aldershot: Scolar Press, 1991, 186pp., illus.

Other Sources

Garrett, Albert. *A History of British Wood Engraving.* Tunbridge Wells: Midas Books, 1978.
———. *British Wood Engraving of the 20th Century: A Personal View.* London: Scolar Press, 1980.

2099 UPĪTE, KARĪNA (1951–)
Latvian graphic artist.

Exhibitions

8. Baltijas Republiku Akvareļu Izstāde: Katalogs. Riga, 1989.

2100 ÜKSINE, MARJE (1945–)
Estonian painter and graphic artist.

Other Sources

Rosenfeld, Alla, and Norton Dodge, eds. *Nonconformist Art: The Soviet Experience, 1956–1986. The Norton and Nancy Dodge Collection.* London: Thames and Hudson in association with the Jane Voorhees Zimmerli Art Museum, State University of New Jersey, Rutgers, 1995.

2101 VAN HEEMSKERCK, JACOBA BERENDINA VAN BEEST (1876–1923)
Dutch painter of Expressionist landscapes and portraits; also a graphic artist and designer of mosaics and stained glass.

See Painting section.

2102 VAN REGTEREN, MARIA ENGELINA (née ALTENA) (1868–1958)
Dutch painter and graphic artist who produced still lifes and town scenes.

See Painting section.

2103 VERSTEEG, INA (1945–)
Dutch graphic artist and painter whose subjects are taken from nature.

Exhibitions

De Vrouw in de kunst. Leiden: Pand Caecilia, 1987.

2104 VINCENT, SONJA (1928–)
Dutch painter, graphic artist and designer of tapestries who lives in France.

See Painting section.

2105 VON BRANCA, HEDWIG (1890–)
German graphic artist.

Other Sources

Jugendstil Illustration in München. Munich: Stuck-Villa, 1970.

2106 VON OLFERS, SIBYLLE (1881–1916)
German graphic artist.

Other Sources

Fanelli, Giovanni, and E. Godoli. *Dizionario degli illustratori simbolisti e Art Nouveau.* Florence: Cantini, 1990.

2107 VON UCHATIUS, MIZZI (née MARIA) (1882–1958)
Austrian graphic artist.

Other Sources

Pabst, Michael. *Wiener Grafik um 1900.* Munich: Verlag Silke Schreiber, 1984.

2108 VON ZUMBUSCH, NORA EXNER (1879–1915)
Austrian painter, sculptor and graphic artist.

Other Sources

Pabst, Michael. *Wiener Grafik um 1900.* Munich: Verlag Silke Schreiber, 1984.

2109 WALKER, ELIZABETH (née REYNOLDS) (1800–1876)
English painter, including miniatures, and graphic artist who was taught by her father.

See Painting section.

2110 WOLFTHORN, JULIE (née WOLF) (1868–1944)
German painter of figures, usually women, landscapes and portraits who was also a graphic artist; she died in the concentration camp at Theresienstadt.

See Painting section.

2111 WRØBLEWSKA, KRYSTYNA (1904–)
Polish graphic artist.

Other Sources

Jakimowicz, Irena. *Wspótczesna grafika polska.* Warsaw: Arkady, 1975.

2112 YAKUNCHINOVA-WEBER, MARIA VASILIEVNA (1870–1902)
Russian painter and graphic artist who, under the influence of Elena Polenova, became interested in Russian heritage and also worked in several design specialisms, notably embroidery.

See Painting section.

2113 ZARNOWER, THERESA
Polish painter and graphic artist.

See Painting section.

2114 ZERNOVA, EKATERINA SERGEEVNA (1900–after 1976)
Russian painter of monumental decorative works; also a graphic artist.

See Painting section.

2115 ZIKMANE, LOLITA (1941–)
Latvian graphic artist.

Exhibitions

Reihmane, Laima. *Lolita Zikmane.* Riga: Mūsu Mākslinieki, 1989, n.p., mainly illus. Text in Latvian, Russian and English.

Other Sources

Rosenfeld, Alla, and Norton Dodge, eds. *Nonconformist Art: The Soviet Experience, 1956–1986. The Norton and Nancy Dodge Collection.* London: Thames and Hudson in association with the Jane Voorhees Zimmerli Art Museum, State University of New Jersey, Rutgers, 1995.

2116 ZŁOTNICKA, EULALIA (1946–)
Polish graphic artist and painter.

Other Sources

Jakimowicz, Irena. *Współczesna grafika polska.* Warsaw: Arkady, 1975.

Painting

2117 BERKO, P., and V. *Dictionnaire des peintres belges nés entre 1750 et 1875.* Brussels: Laconti, 1981, 810pp., 112 illus.

Text in French. A useful source for women artists and a surprisingly large number are included. The entries vary in length depending on available information. This results in informative entries on a number of women.

2118 BURBIDGE, R. BRINSLEY. *Dictionary of British Flower, Fruit and Still Life Painters.* 2 vols. Leigh-on-Sea: F. Lewis, 1974, vol. 1: artists born between 1515 and 1849, 40pp. and plates; vol. 2: artists born from 1850 onward, 37pp. and plates.

Many women are included in these two volumes, even where little biographical information was available. It also includes women who mainly painted other subjects and for whom flowers were only an occasional one.

2119 CAMARD, PIERRE, and ANNE BELFORT. *Dictionnaire des peintres et sculpteurs provençaux, 1880–1950.* Ile de Bendor: Editions Bendor for Fondation Paul Ricard, Paris, 1975, 444pp.

Text in French. Over 700 painters and sculptors from the region of Provence are listed. A number of women are listed although for some even the basic biographical information is sparse or absent. Artists who exhibited in any of the major French artistic venues are included. Where information is available, entries have a short biography, the locations of works and a bibliography.

2120 CLEMENT, CLARA ERSKINE. *Women in the Fine Arts from the 7th Century B.C. to the 20th Century A.D.* Boston: Houghton Mifflin, 1904; rev. ed. New York: Hacker Art Books, 1974.

Dictionary of women painters and sculptors active in Europe and America. Entries vary in length and some use Ellett's earlier text (q.v.) as the main source of information.

2121 CLEMENT, CLARA, and LAURENCE HUTTON. *Artists of the 19th Century and Their Works.* 2 vols. London: Trubner, 1879, vol. 1: 386pp., vol. 2: 373pp.
Includes large numbers of artists, although entries are often succinct. It is a useful source for women active in the nineteenth century.

2122 DESMOND, RAY. *Dictionary of British and Irish Botanists and Horticulturalists including Plant Collectors, Flower Painters and Garden Designers.* 2nd rev. ed. London: Taylor and Francis with the Natural History Museum, 1994, 825pp., illus.
This very comprehensive reference work is enhanced by indices by profession of the categories mentioned in the title. These indices are in turn organised into chronological order. The majority of people included are British but those born abroad who worked in Britain or Ireland are also included. Most women occur in the category of flower painting but are also represented under garden designers.

2123 DI PAMPLONA, FERNANDO. *Dicionario de pintores e escultores portugueses ou que trabalharam em Portugal.* 4 vols. Lisbon: Oficina Grafica, vol. 1: 319pp., 32pl., 1954; vol. 2: 291pp., 32pl., 1956; vol. 3: 435pp., 39pl., 1957; vol. 4: 319pp., 35pl., 1959.
Text in Portuguese. A useful source for women artists.

2124 *Dictionnaire des peintres belges du XIVe siècle à nos jours.* 2 vols. Brussels: La Renaissance du Livre, 1995, vol. 1: 587pp., illus.; vol. 2: 1208pp., illus.
Text in French. Comprehensive publication providing names of many women. Entries have a short biographical account and an indication of the type of work, style and ideas of the artist. There is a short bibliography.

2125 DUNFORD, PENNY. *A Biographical Dictionary of Women Artists in Europe and America since 1850.* Hemel Hempstead: Harvester Wheatsheaf and Philadelphia: University of Pennsylvania Press, 1990, 340pp., illus.
Contains biographical accounts of 730 women artists of whom 550 are European. The majority are painters and sculptors. Each entry also contains indications of the location of works and a bibliography.

2126 DUNTHORNE, KATHERINE. *Artists Exhibited in Wales, 1945–1974.* Cardiff: Welsh Arts Council, 1976, 344pp., illus.
Alphabetical listing of artists who exhibited in Wales during the period stated. A number of women, from Wales and elsewhere, are included.

2127 EDOUARD-JOSEPH R. *Dictionnaire biographique des artistes contemporains, 1910–1930.* 3 vols. Paris: Art et Edition, vol. 1: A–E 478pp., illus., 1930; vol. 2: F–Ma 478pp., illus., 1931; vol. 3: Mc–Z 478pp., Librairie Grund, 1934.
An invaluable source for women artists working in France in the early decades of the century. The biographical accounts are usually detailed.

2128 FOSKETT, DAPHNE. *Dictionary of British Miniature Painters.* 2 vols. London: Faber and Faber, 1972, vol. 1: 596pp, 31pp. of pl.; vol. 2: 108pp., 400pp. of pl.

> Covers c. 4500 miniature painters in Britain and Ireland between c. 1520 and 1910. Based on Lang's dictionary of 1929, Foskett has added further names. Miniatures were a genre which were relatively modest in their demands on space and materials and which therefore enabled women to participate in their production. Many women are included for the nineteenth century and the information about them is quite detailed.

2129 FOSKETT, DAPHNE. *Miniatures: A Dictionary and Guide.* Woodbridge: Antique Collectors Club, 1987, 701pp., illus.

> Consists of twelve chapters on the history of British miniatures and a guide to collecting them. There follow 200 pages of a dictionary of British miniature painters. The book is a compilation of two of Foskett's earlier books. The dictionary is the most useful part for women artists.

2130 FOSTER, JOSHUA JAMES. *Dictionary of Painters of Miniatures.* London: Philip Allan & Co. Ltd., 1926, 320pp.

> A posthumous publication from this writer on miniatures. Numbers of women are included. The majority of artists are British but it is a good source for European women, especially French. Aristocratic women who were officially amateurs are present but Fanny Corbaux is omitted.

2131 HARDOUIN-FUGIER, ELIZABETH, and ETIENNE GRAFE. *The Lyon School of Flower Painting.* Leigh-on-Sea: F. Lewis, 1978, 88pp. and 51 pl.

> Commences with a scholarly essay on the reasons for the preponderance of flower painting at Lyon and its relationship to the silk industry. The principal teachers in the city are also discussed. There follows a biographical dictionary of painters of flowers in Lyon. Interestingly there are fewer women involved at Lyon than in the national picture which emerged from the other publications of these authors, a factor which is examined in the initial essay.

2132 HARDOUIN-FUGIER, ELIZABETH, and E. GRAFE. *French Flower Painters of the Nineteenth Century: A Dictionary.* London: Philip Wilson Ltd., 1989, 402pp., illus.

> An excellent source for women artists, many of whom are discussed in the introductory essay in addition to their inclusion in the alphabetical listing. Each entry lists important exhibitions, sales of works through major auction houses and, where available, a bibliography.

2133 HARRIS, PAUL, and JULIAN HALSBY. *Dictionary of Scottish Painters 1600–1960.* Edinburgh: Canongate and Phaidon Press in association with Bourne Fine Art, 1990, 236pp., illus.

> Includes many women among the entries, which are usually succinct.

2134 HOSTYN, NORBERT, and WILLEM RAPPARD. *Dictionary of Belgian and Dutch Flower Painters Born Between 1750 and 1880.* Knokke-Zout: Berko, 1995, 417pp., many illus.
Many women are included in this book. Each entry contains a short biographical outline and a list of collections in which works are found.

2135 JOHNSON, JANE. *Works exhibited at the Royal Society of British Artists 1824–1893 and at the New English Art Club 1888–1917.* Woodbridge: Antique Collectors Club, 1975, 617pp., illus.
A useful reference book which lists all artists exhibiting at the two important venues in London. It allows the tracing of an artist's exhibiting record at these venues. NEAC was initially established as a reaction to the traditional criteria required by the Royal Academy for its exhibitors.

2136 *Lexikon der zeitgenössichen Schweizer Künstler. Dictionnaire des artistes suisses contemporains. Dizionario di artisti svizzeri contemporanei.* Stuttgart: Verlag Huner, 1981, 538pp.
Text in German, French and Italian. This book includes Swiss painters, sculptors, graphic artists and photographers born after 1900. The language of each entry is determined by that used by the artist. There is an outline biography, an indication of the type of work produced, lists of prizes won, exhibitions. Entries are brief and there are indices by place of residence and medium. A reasonable number of women are included.

2137 LOTZ, FRANÇOIS. *Les artistes-peintres alsaciens: de jadis à naguère, 1880–1982.* Kayersberg: Printek, 1987, 383pp., illus.
A biographical dictionary in which the entries are of variable length but each has a bibliography. Overall a useful source for women painters from Alsace during the period indicated.

2138 MARTIN, JULES. *Nos peintres, sculpteurs, graveurs et dessinateurs. Portraits et biographies suivis d'une notice sur les Salons Français depuis 1673, les Sociétés des Beaux-Arts, la propriété artistique etc.* Paris, 1897.
Text in French. Provides information about women artists active in the late nineteenth century in France.

2139 MILNER, JOHN. *A Dictionary of Russian and Soviet Artists, 1420–1970.* Woodbridge: Antique Collectors Club, 1993, 483pp., illus.
Contains many women among the hundreds of artists included, since all artists who exhibited at least once in certain venues are included. The entries vary in length and detail but normally contain a list of collections and an individual bibliography, in addition to the short biographical account.

2140 MITCHELL, PETER. *European Flower Painters.* London: Adam and Charles Black, 1972, 272pp., illus.

A biographical dictionary which includes artists from the seventeenth to the twentieth centuries from many European countries. The biographies vary in length but overall this is a good source of women painters. There is a general bibliography.

2141 OSSORIO Y BERNARD, M. *Galería biográfica de artistas españoles del siglo XIX.* Madrid: Gaudi, 1868, 749pp.

Text in Spanish. Although the majority of artists included are men, this is a surprisingly good source for women active in Spain in the first half of the nineteenth century. Artists are included even when biographical information is minimal and the final index of names makes it easy to pick out the title of Dona, which is given to women.

2142 OSSORIO Y BERNARD, MANUEL. *Galería biográfica de artistas españoles del siglo XIX. Continuacíon del Diccionario de Ceán Bermudez hasta el año 1882.* Madrid: Moreno y Royas, 2nd rev. ed. 1883, 749pp., illus.

Contains biographical sketches of 3000 nineteenth-century Spanish painters and sculptors. There are relatively few women.

2143 PARRY-CROOKE, CHARLOTTE. *Contemporary British Artists.* London: Bergstrom and Boyle, 1979, 350pp., illus.

Photographic portraits of all 200 artists are followed by alphabetical entries for each. These contain a chronology and a short statement by the artist. Twenty-four women are included.

2144 PAVIÈRE, SIDNEY. *Dictionary of Flower, Fruit and Still-life Painters. Vol. 3: The Nineteenth Century. 2 parts: part 1 1786–1840; part 2 1841–1885.* Leigh-on-Sea: F. Lewis, 1964, part 1 82pp., 48 illus.; part 2 125pp., 56 illus.

Each volume deals with artists born between the dates mentioned. Although the majority of artists mentioned are British or French, there are also examples from other European countries included. The second volume also includes the United States. The information on each may vary from the minimal (e.g., French School) to an outline biography, places where they exhibited and where their works were auctioned, lists of works in public collections. No literature is given in the entries. A useful number of women are included so that, for example, in Part 1, sixteen out of the thirty-two artists whose names begin with A are female. For Part 2 the figure is thirty-eight out of eighty-five.

2145 PAVIÈRE, SYDNEY. *Dictionary of Victorian Landscape Painters.* Leigh-on-Sea: F. Lewis, 1968, 143pp., 94 illus.

Unexpected numbers of women feature in this book, which excludes artists who died before 1850 and those born after 1870. The paucity of biographical information for the women is evident.

2146 PAZ, MARIO ANTOLIN (ED.). *Diccionario de Pintores y Escultores Españoles del siglo XX.* 2 vols. of ongoing project. Madrid: Forum Artis, 1994, vol. 1, A 260pp.; vol. 2, B 559pp., illus.

Text in Spanish. The beginning of a large project to provide a biographical dictionary of modern Spanish artists. Each entry contains a short description of the type of work the artist produces and biographical information is sometimes given. Some women are included.

2147 SCHURR, GERALD. *Les petits maîtres de la peinture valeur de demain.* 7 vols. Paris: Les Editions de l'Amateur, 1975–1989.

Each volume consists of an alphabetical listing of lesser known painters whose works have passed through auction houses and sales. There is a variable amount of biographical information and a summary of the type of work for which each artist is known. The volumes have been issued as more material became available so that they do not form an overall alphabetical sequence. There are a considerable number of women included.

2148 SPALDING, FRANCES, and JUDITH COLLINS (EDS.). *Twentieth Century Painters and Sculptors. Dictionary of British Art, vol. 6.* Woodbridge: Antique Collectors Club, 1990, 482pp., illus.

Each of the entries contains a brief biography with a small number of entries also having references to a monograph. Contains the names of a great many women.

2149 TANNOCK, MICHAEL. *Portuguese Artists of the Twentieth Century: A Biographical Dictionary.* Chichester: Phillimore and Co. Ltd., 202pp., 475 illus.

An invaluable source for this area.

2150 UGLOW, JENNIFER. *Macmillan's Dictionary of Women's Biography.* London: Macmillan, 1982, 2nd ed. 1989, 621pp.

Among the entries are a useful number of women artists. As with all the entries, there is a short biographical summary.

2151 WOOD, JEREMY. *Dictionary of Neglected Artists Working 1880–1950.* Billingshurst: Jeremy Wood Fine Art, 1994, 178pp., 280 illus.

Contains over 1500 artists among which are many women, since they frequently fall into the neglected category.

OTHER PUBLICATIONS

2152 *5a Biennale Donna 1992. Vol. 1. Franca Squarciapino—Tra illusione e realtà: Studi, bozzetti e costumi. Vol. 2. Francesca Archibugi: Mignon e partita: percorsi per un film. Vol. 3. La poesia delle cinque dita.* Ferrara: Gallerie Civiche dell'Arte Moderna, 1992, vol. 1: 99pp., illus.; vol. 2: 49pp., illus.; vol. 3: 49 pp., illus.

Text in Italian. The first part of the fifth women's biennale focusses on the costume designs of Squarciapino, the second on the making of a film by Archibugi and the third on the work of three artists: Gisella Meo, Fernanda Fedi and Andreina Robotti.

2153 *8. Baltijas Republiku Akvareļu Izstāde: Katalogs.* Riga, 1989, 120pp., illus.

Text in Latvian, Russian and English. Consists of an alphabetical listing of artists exhibiting in this eighth exhibition of watercolour painters from the three Baltic states. In all fifty-one women are included, twenty-five from Latvia, nineteen from Estonia, six from Lithuania and one from the six artists from other countries. A biographical outline of each is given together with an illustration.

2154 *Abstraction-Création 1931–36.* Paris: Musée d'Art Moderne de la Ville de Paris, 1978, 309pp., illus.

Text in French. It should be noted that the exhibition opened at Münster before it went to Paris. A study of the flourishing period of abstract art of various kinds in the 1930s. A number of women were active in this period and abstraction came from a number of different philosophies and approaches.

2155 *Akt '83: suomalaista nykytaidetta; finsk nutidskonst; Contemporary Finnish Art; Art finlandais contemporain.* Helsinki: Ateneum, 1983, 95pp., mainly illus.

Little information is given about the artists; seven of the thirty-seven are women: Raili Tang, Leena Luostarinen, Marja Kanervo, Ulla Rantanen, Marjo Lahtinenen, Helena Pykkanen and Outi Heiskanen.

2156 ALAUZON DI GENOVA, ANDRÉ. *La peinture en Provence. New enlarged edition with dictionary added.* Marseille: J. Lafitte, 1984, 409pp., illus.

Part 1 consists of a historical account of painting in Provence from the sixteenth century with the main emphasis on the twentieth century. Twelve women are mentioned in the final chapter, on studios since Aubert. Part 2 consists of a biographical dictionary of artists born before 1945. This in turn is followed by a series of longer entries on contemporary artists, with about two pages of text and an illustration. One woman only—the landscape painter, Nicole Guieu—is included.

2157 ALESSON, JEAN. *Les femmes artistes au Salon de 1878 et à l'Exposition Universelle.* Paris: Gazette des femmes, 1878, 31pp.

Text in French. After providing a list of women artists exhibiting at the Salon between 1874 and 1878, the author takes each medium/genre in turn and summarises the numbers of women in each, the subject and gives some critical evaluation. In 1878 762 women exhibited. Overall this provides access to names which are little known today and can therefore act as a platform for further research. There is little space given to artists at the Exposition Universelle.

2158 ALLEMAND, MAURICE. *Art abstrait: les premières générations (1910–1939).* Saint Etienne: Musée d'art et d'industrie, 1957, 47pp., 101 illus.

Text in French. Primarily a list of exhibitors with a biographical outline for each. The women mentioned include Sophie Taeuber-Arp, Marcelle Cahn, Sonia Delaunay, Suzanne Duchamp, Natalia Goncharova and Jeanne Kosnik-Kloss.

2159 ANKER, VALENTINA. *La relève des muses: entretiens avec des femmes artistes.* Lausanne: l'Age d'Homme, 1983, 237pp.

Text in French. This text was based on the premise that there is a specifically female way of painting. The early sections examine feminism and art in Switzerland, women artists in modern Swiss painting and a history of the documentation of women artists in the 1970s. The later part of the book is devoted to a series of interviews conducted in 1978–1979 with women artists living in or near Geneva.

2160 *Art portugais contemporain.* Paris: Musée d'Art Moderne de la Ville de Paris, 1976, n.p., illus.

An exhibition of thirty-five invited artists of whom four are women: Helena de Almeida, Paula Rego, Ana Vieira and Menez. There is a short introductory essay.

2161 AUREGLI, DEDE, and CRISTINA MARABINI. *Figure dallo sfondo 3.* Ferrara: Galleria Civica d'Arte Moderna, 1988, 137pp., illus.

Text in Italian. The third of the series of biennali of women artists. In all, forty-nine women are included: thirty-eight Italians, two of whom are designers, and eleven women from other countries. The range of work is very wide but a majority is concerned in some way with the experience of being female and living in a female body.

2162 *Avanguardia russa dalle collezioni private sovietiche origini e percorso 1904–1934.* Milan: Palazzo Reale in association with Edizioni Bolis, 1989, 172pp., illus.

Text in Italian. The exhibition takes a broad view of avant-garde works in a number of media produced in Russia in the first three decades of this centu-

ry. Most of the work is two-dimensional—painting and graphic art—but some painting on porcelain is also included.

2163 BARBER, FIONNA. "The art year in Ireland: Belfast." *Irish Arts Review Yearbook 1990–1991,* 1991, 239–242.

Survey of exhibitions in Belfast during the period 1989–1990. Barber notes that early in 1990 "the work of women painters and sculptors began to come into its own in the public domain" and cites exhibitions by Deirdre O'Connell, Louise Walsh, Alice Maher and Barbara Freeman. Women who exhibited in private galleries included Noreen Rice, Jacinta Feenhy, Maura Sheehan and Moira McIver.

2164 BARON, WENDY. *The Sickert Women and the Sickert Girls.* London: Michael Parkin, 1974, n.p., illus.

An essay examines the artistic activities of five women who worked with Walter Sickert: Thérèse Lessore, who became his wife, Sylvia Gosse and the 'girls' Wendela Boreel (qq.v.), Majorie Lilly and Christiana Cutter, who all met at the Slade School of Art. Short biographies are included for each and a chronology of the years 1905–1969 shows the exhibitions and other relevant events in the lives of these artists.

2165 BARRON, STEPHANIE, ET AL. *German Expressionism, 1915–1925: The Second Generation.* Munich: Prestel in association with Los Angeles County Museum of Art, 1988, 195pp., illus.

After analyses of the second generation and German Expressionsim, individual biographies are provided as part of the catalogue entries. Only two women are included: Angelika Hoerle (1899–1923) and Katharina Heise whose pseudonym was Karl Luis Heinrich-Salze (1891–1964).

2166 BARRON, STEPHANIE, and M. TUCHMAN. *The Avant-garde in Russia: New Perspectives.* Los Angeles: County Museum of Art, 1980, 288pp., illus.

A scholarly consideration of Russian art during and after the Revolution. A number of women artists are included. Biographies are given.

2167 BARRON, STEPHANIE. *Degenerate Art: The Fate of The Avant-garde in Nazi Germany.* New York: H. Abrams in association with Los Angeles County Museum of Art, 1991, 417pp., illus.

Published in Germany as *Entartete Kunst: das Schicksal der Avantgarde im Nazi-Deutschland.* Munich: Hirmer, 1992. Several scholarly essays reconstruct on a room-by-room basis the 1937 exhibition from documents and surviving works of art. Artists are then presented alphabetically with biographical information and detailed notes on the works. Four women are included: Maria Caspar Filser, Jacoba van Heemskerck, Marg Moll and Emy Roeder.

2168 BECKETT, JANE, and DEBORAH CHERRY. *The Edwardian Era.* London: Barbican Art Gallery, 1987, 176pp., illus.

A scholarly analysis of British art in the early twentieth century which saw the co-existence of Victorian art, early Modernism and the art of the suffrage movement. Women artists are relatively well represented.

2169 BECKETT, JANE, and DEBORAH CHERRY. "Women Under the Banner of Vorticism." *Cahier* 8–9 (1988): 129–144.

Examines the role of women in the Vorticist movement and how femininities were structured by the avant-garde. It warns against viewing women as occupying the same position within different avant-garde movements. Kate Lechmere was a sponsor of the Rebel Art Centre and carried out administration. Jessica Dismorr, Helen Saunders and Dorothy Shakespear were all painters in the movement. The role of Jessie Etchells, who might have joined, is also examined.

2170 BEHR, SHULAMITH. *Women Expressionists.* Oxford: Phaidon, 1988, 79pp., illus.

An essay introduces the ten women Expressionists included here: Käthe Kollwitz, Paula Modersohn-Becker, Gabriele Münter, Clara Anne-Marie Nauen and Olga Oppenheimer from Germany, Marianne von Werefkin from Russia, Sigrid Hjerten and Vera Nilsson from Sweden, Erma Bossi from the former Yugoslavia and Jacoba van Heemskerck from the Netherlands. Following this, individual examples of their work are illustrated and discussed in detail.

2171 BENNETT, CHLOE. *Suffolk Artists, 1750–1930: Paintings from the Ipswich Borough Museum and Galleries Collection.* Woolpit, Suffolk: Images Publications, 1991, n.p., illus.

After a short introduction, the author discusses forty-three individual paintings, all of which are illustrated. Three women are included: Anna Airey (q.v.), Eleanor Every and Rose Mead.

2172 BETTERTON, ROSEMARY (ED.). *Looking On: Images of Femininity in the Visual Arts and Media.* London and New York: Pandora, 1987, 293pp., illus.

An anthology in four sections each of which is introduced by a short analytical essay on the issue concerned. After the introduction, entitled "Feminism, Femininity and Representations," the first two sections look at representations of women, the third at pornography and the politics of representation, while the fourth, in which the activities of women artists are discussed, examines the attempts of women to find a new iconography of the body. One essay is devoted to Suzanne Valadon.

2173 BETTERTON, ROSEMARY. "Brushes With a Feminist Aesthetic." *Women Artists' Slide Library Journal* 66 (September–October 1995): 6–11.

Analyses current debates about women abstract painters in Britain and the question of a feminist attempt to develop a language and aesthetics based on the female body. She examines the work of Eve Muske, Laura Godfrey-Isaacs, Rebecca Fortnum and Rosa Lee.

2174 BĒMS, ROMIS. *Latviešu Mūsdienu Akvarelis. Contemporary Latvian watercolour* [*sic*]. *Das Moderne Lettische Aquarell*. Riga: Liesma, 1984, n.p., mainly illus.

Text in Latvian, English, Russian and German. The brief introductory text describes the upsurge in Latvian watercolour painting from the 1950s but, until the later 1970s, few younger artists worked in the medium. Over twenty women artists are included but the brief biographical outlines are only in Latvian.

2175 BLUNT, WILFRED. *The Art of Botanical Illustration. New Naturalist Series*. London: Collins, 1950, 3–4pp., illus.

Consists of a history of botanical illustration from antiquity. The second half of the book deals with the period from 1800. A small proportion of the women known to be active in this area is included and almost all of them are English despite the European coverage of the male artists.

2176 BOHAN, RUTH. *The Société Anonyme's Brooklyn exhibition. Katherine Dreier and Modernism in America. Studies in Fine Arts: The Avant-garde no. 20*. Ann Arbor, Mich.: UMI Research Press, 1982, 262pp., illus.

Although the text focusses on the activities of Dreier in America, the book provides a list of those artists whose work she exhibited and among these were a number of European women: Feigia Blumberg, Marcelle Cahn, Franciscka Clausen, Suzanne Duchamp, Alice Halicka, Erika Klein, Gabriele Münter and Suzanne Phocas.

2177 BORZELLO, FRANCES. "Leisured Ladies." *Women's Art Magazine* 55 (1993): 10–12.

Examines some British women artists practising in the late eighteenth and early nineteenth centuries and relates art instruction to the writings on education by people such as Maria Edgeworth and Hannah More.

2178 BOULTON-SMITH, JOHN. *Modern Finnish Painting and Graphic Art*. London: Weidenfeld and Nicholson, 1970, 62pp., 62 pp. of plates.

A survey of postwar art in Finland in which a number of women are included.

2179 BOWLT, JOHN. *Russian stage design: Scenic innovation 1900–1930 from the collection of Mr & Mrs Nikita D. Lobanov-Rostovsky*. Jackson, Miss.: Mississippi Museum of Art, 1982, 344pp., illus.

After several short essays concerning the collection and other Russian painters active as stage designers outside Russia, there is a substantial essay on modern stage design in Russia. Catalogue entries in alphabetical order then follow with short biographies, a bibliography and a discussion of the exhibits. Of seventy-three artists, eleven are women, best known as painters, although with the interesting inclusion of the socialist realist sculptor Vera Mukhina.

2180 *British Art Now: A Subjective View.* Setagaya, Japan: Setagaya Art Museum in association with the British Council, 1990, 152pp., illus.
Text in English and Japanese. Catalogue of an exhibition which toured Japan in 1990–1991. It includes several essays by critics from both countries with detailed chronolgies and exhibition listings for each artist. Of the sixteen artists, four are women. No women were included in the sculpture section but Lisa Milroy and Paula Rego are among the five painters and Helen Chadwick and Kate Whiteford among the four mixed media artists.

2181 *British Painting in the Sixties.* London: Tate Gallery and Whitechapel Art Gallery, 1963, n.p., illus.
A small catalogue in which the text is largely concerned with the selection process for the exhibition. The exhibition was staged at two venues and only three women were represented overall: Gillian Ayres, Sandra Blow and Sheila Fell.

2182 *British Painting, 1952–1977.* London: Royal Academy, 1977, 129pp., illus.
A short introduction precedes brief information on the 400 exhibits from the 197 painters included, of whom 21 are women. No biographical information is provided.

2183 BUCK, LOUISA. *The Surrealist Spirit in Britain.* London: Whitford and Hughes, 1988, n.p., illus.
After an introductory essay on the Surrealist movement in Britain, there are detailed notes on each of the forty-seven exhibits which are arranged alphabetically by artist. Several women are included: Agar, Colquhoun, Pailthorpe and Rimmington (qq.v.)

2184 BUNOUST, MADELEINE. *Quelques femmes peintres.* Paris: Librairie Stock, 1936, 127pp., illus.
Text in French. A philosophical essay concerning the weak condition of painting in France concludes that this is partly because women are not accorded their rightful place in society. Bunoust suggests that the word *feminism* ought not to be needed in the twentieth century and identifies the reasons for the exclusion of women. After listing the female winners of the Prix de Rome in sculpture, painting, engraving and music she discusses a number of women artists in a semibiographical way; in addition to some better known figures, she includes Lucie Coustourier (1876–1925), Emilie Charmy, Bessie

Davidson (an Austrian who lived in Paris from 1904), Angèle Delasalle, Louise Hervieu, Olga Bosnanska, Meta Muter, Vera Rockline (1836–1934), Hermine David, Suzanne Lalique, Pauline Peugniez and Valentine Prax. The criteria for inclusion are not indicated and the quantity of information on each individual is variable.

2185 CALVERT, GILL, JILL MORGAN, and MOUSE KATZ (EDS.). *Pandora's Box*. Bristol: Arnolfini Gallery, 1984, 120pp., illus.

This exhibition arose out of an earlier exhibition, *Women's Images of Men* (1980), and shares some of its organisers. Women artists were invited to submit works on the theme of Pandora's Box and offer varied reworkings of this myth. Each of the thirty-two women has written a statement about her reactions to the myth and the generation of the work exhibited. No biographical information is given.

2186 CASTERAS, SUSAN, and LINDA H. PEARSON. *A Struggle for Fame: Victorian Women Artists and Writers*. New Haven, Conn.: Yale Center for British Art, 1994, 89pp., illus.

Essays analysing the sociocultural context in which women artists and writers practised their art in nineteenth-century Britain precede the carefully annotated entries to the exhibits. Forty-three women artists are included. The essay "From 'Safe Havens' to 'A Wide Sea of Notoriety'" examines art education, 'cultural captives,' critics, mentors and patrons, support groups, marriage and motherhood and women's subject matter.

2187 CAVALLI-BJÖRKMAN, GÖREL. *Kvinnor som Målat*. Stockholm: Nationalmuseum, 1975, n.p., illus.

Text in Swedish. An exhibition of Swedish women artists and other women from the permanent collection from 1500 to the early twentieth century. Short essays precede each section: 1500–1800, nineteenth century, those who studied in Paris and three from the early twentieth century.

2188 CAWS, MARY ANN, RUDOLF KUENZLI, and GWEN RAABERG. *Surrealism and Women*. Cambridge, Mass.: MIT Press, 1991, 240pp., illus.

A series of critical essays, originally published as a special issue of the journal *Dada/Surrealism* no. 18 (University of Iowa). They analyse the work of women writers and artists within the Surrealist movement. Three introductory essays examine questions of misogyny in the movement and the problematics of women in relation to it. The later essays examine closely the imagery of some of the women artists and writers.

2189 CHADWICK, WHITNEY, and ISABELLE DE COURTIVRON (EDS.). *Significant Others: Creativity and Intimate Partnership*. London: Thames and Hudson, 1993, 256pp., 76 illus.

Separate chapters consider the effects of a close relationship on creativity in art and literature. Five chapters include European women artists and

designers: Camille Claudel, Sonia Delaunay, Vanessa Bell, Leonora Carrington and Vita Sackville-West.

2190 CHADWICK, WHITNEY. *Women Artists and the Surrealist Movement.* London: Thames and Hudson, 1985, 256pp., illus.

An analysis of the interventions of women across Europe in the various manifestations of the Surrealist movement. It looks at their participation in the formal activities, groups and networks and at their imagery. Short biographies are given at the end with a bibliography.

2191 CHADWICK, WHITNEY. *Women, Art and Society.* World of Art series. London: Thames and Hudson, 1990, 383pp., illus.

Takes a sociological approach to the participation of women in mainstream art from the Middle Ages in Europe and America. Includes details of the activities and bibliographies of some of the principal figures but many others are also mentioned.

2192 CHERRY, DEBORAH. *Painting Women: Victorian Women Artists.* Rochdale: Art Gallery, 1987, 32pp., illus.

This catalogue lays the groundwork for Cherry's later book of the same title. Here many of the same issues—the practice of women as artists in nineteenth-century Britain, their networks, their imagery—are addressed, necessarily more briefly. The questions of imagery of the domestic sphere, of working women and of women from history are particularly emphasised as they lend themselves to an exhibition format. A bibliography is included.

2193 CHERRY, DEBORAH. *Painting Women: Victorian Women Artists.* London: Routledge, 1993, 275pp., illus.

A scholarly examination of the cultural context of women artists in Victorian England. It examines their family backgrounds and education, travel abroad, female networks, exhibition venues, and women's art organisations. It also considers the iconographic differences in the representation of women by women as opposed to that by men. There is a select but useful bibliography.

2194 CLAYTON, ELLEN. *English Female Artists.* 2 vols. London: Tinsley Press, 1976, 438pp., illus.

An invaluable source providing detailed information about a considerable number of women artists, chiefly painters and illustrators. It allowed feminist scholars to begin the reassessment of women's contribution to nineteenth-century art. Volume 1 is historical while volume 2 examines contemporary women. A small number of women from mainland Europe are included if they exhibited in Britain.

2195 CRISPOLTI, ENRICO. *Il mito della macchina e altri temi del futurismo.* Trapani: Editore Celebes, 1969, 938pp., illus.

Text in Italian. Despite the thorough approach to the two phases of Futurism, involving the reproduction of many documentary sources, references to the women involved are sparse. Apart from the ten pages devoted to Rugena Zatkovà, of the female futurists only references to Benedetta occur in the text, although a film by Marisa Mori is mentioned in one of the documents.

2196 DALLIER, ALINE. *Combative Acts, Profiles and Voices. An Exhibition of Women Artists from Paris.* New York: A.I.R. Gallery, 1976, n.p., illus.

An exhibition of works by Bernadette Bour, Maglione, Hessie and Françoise Janicot who all work in Paris although two of them are not French. A useful essay discusses their work.

2197 *Das Verborgene Museum. Dokumentation der Kunst von Frauen in Berliner öffentlichen Sammlungen.* Berlin: Edition Hentrich, 1987, 364pp., illus.

See below under NEUE GESELLSCHAFT FUR BILDENDE KUNST.

2198 DAY, HAROLD. *East Anglian Painters.* 3 vols. Eastbourne: Sumfield and Day Ltd., 1968, vol. 1: 263pp, illus.; vol. 2: 257pp. illus.

Series of essays on painters born or working in the region of East Anglia from Gainsborough to the late nineteenth century. After longer essays on the better known artists, there follows a series of short biographical notes on others and it is here that the majority of women are included. In all, the women included are volume 1: Mary Beale, Ellen Ladell, Emma Smythe, Ann and Jane Tayler; volume 2: Maria Margitson (main section); volume 3: Eloise Stannard, Emily Stannard.

2199 *De la Révolution à la Péréstroika. Art Soviétique de la Collection Ludwig.* St. Etienne: Musée d'Art Moderne in association with Verlag Gerd Hatje, Stuttgart, 1989, 231pp., illus.

Text in French. Also a German edition. Three scholarly essays and an interview with the owner of the collection precede the catalogue entries. Short biographical details on the artists are given together with a list of their exhibitions and a bibliography. The first section includes artists from the Revolutionary period, amongst which are ten women, while the later period includes five: Nina Chilinskaia, Svetlana Kopistianskaia from Ukraine, Tatiana Nazarenko, Galina Neledva and Natalia Nesterova.

2200 DE SALIS, CHARLES. "Petals and Petticoats." *Country Life,* 9 May 1991, 90–91.

Short survey of some women botanical artists in Britian from the eighteenth and early nineteenth centuries.

2201 *De Vrouwe in de Kunst.* Leiden: Pand Caecilia, 1987, 28pp., illus.
Text in Dutch. Catalogue of sixteen contemporary women painters. Each has an outline biography, a list of exhibitions and a short statement.

2202 DEEPWELL, KATE. *Ten Decades: Careers of Ten Women Artists Born 1897–1906.* Norwich: Norwich Gallery, Norfolk Institute of Art and Design, 1992, n.p., illus.
A scholarly and comprehensive essay analyses the art practice of ten British women over the decades of their careers and within the social and political contexts of the time. It considers, inter alia, educational and employment opportunities, travel and study abroad and the impact of World War II. Under the individuals, there are chronologies, lists of exhibitions, public collection and publications.

2203 DEEPWELL, KATY. "Landscape and Feminist Art Practices." *Women Artists' Slide Library Journal* 27 (February–March 1989): 25–26.
Discusses paintings by contemporary women artists in England which deal in different ways with the theme of landscape.

2204 DEEPWELL, KATY. "Paint Stripping." *Women's Art Magazine* 58 (1994): 14–16.
Considers the options open to women painters after Modernism, having viewed the exhibition *Unbound Possibilities in Painting* at the Hayward Gallery, London, in which only three women are included. She points to the liveliness of both the theoretical debates and feminist painting practice which this exhibition has passed over. Deepwell also examines this work and its relation to the writings of Kristeva and Irigaray.

2205 DI PAMPLONA, FERNANDO. *Um seculo de pintura e escultura em Portugal, 1830–1930.* Porto: Livraria Tavares Martins, 1943, 416pp., illus.
Text in Portuguese with a summary in French. A chronological survey of traditional art, concentrating on formal values. No biographical information on the artists is given but a large number of women are included and there is evidence of several female artist dynasties.

2206 DIEGO, ESTRELLA DE. *La mujer y la pintura del XIX español: cuatrocientes olvidadas y algumas más.* Madrid: Cátedra, 1987, 298pp., illus.
Diego deals with the social and educational parameters for women artists in nineteenth-century Spain. A chapter on women artists before 1800 is followed by an analysis of the social expectations and educational possibilities for women in nineteenth-century Spain. The chapter on women and art provides information on the education, exhibiting patterns, subject matter and criticism of women artists. There is little on individual artists and few illustrations.

2207 DOY, GEN. "What Do You Say When You're Looking? Women as Makers and Viewers of Painting in Early Modern France." *Women's Art Magazine* 70 (1996): 10–15.

Examines women art critics and the content of their writings in early-nineteenth-century France. In particular, Doy discusses the reactions of female critics to the male nude and to history paintings by Angélique Mongez.

2208 *Dreams of a Summer Night.* London: Hayward Gallery, 1986, 328pp., illus.

An exhibition of late-nineteenth-century Scandinavian painting which concentrates on the effects of long summer nights on the depiction of landscape. After an introductory essay there are biographical accounts of the artists and commentaries on the works exhibited. Five women are included: Anna Ancher, Harriet Backer, Kitty Kielland, Hélène Schjerfbeck and Ellen Thesleff.

2209 DUFFY, SHIRLEY ARMSTRONG. "Time on Their Hands." *Women's Art Magazine* 52 (1993): 12–14.

Examines the activities of early sketching clubs in Ireland and how they allowed women to participate in art. Duffy relates this to the available art education and identifies several groups of women who formed sketching clubs.

2210 DUNNE, AIDAN. "The art year in Ireland: Dublin." *Irish Arts Review Yearbook 1990–1991,* 1991, 236–239.

Critical survey of exhibitions in Eire over the period 1989–1990 which includes a substantial proportion of women artists: Kathy Prendergast, Vivienne Roche, Eilis O'Connell, Marie Foley, Maighread Tobin, Gwen O'Dowd, Elizabeth Magill and Anne Madden. Short critical summaries of the work exhibited are given.

2211 EDGE, SARAH, and JILL MORGAN. *The Issue of Painting.* Rochdale: Rochdale Art Gallery, 1986, n.p., illus.

Exhibition of work by Sutapa Biswas, Margaret Harrison (qq.v.) and Glenys Johnson. The essay points out their deliberate challenge to male history painting in the choice of subject matter and materials.

2212 ELLETT, ELIZABETH. *Women Artists in All Ages and Countries.* London: Richard Bentley and New York: Harper Brothers, 1859, 346pp., illus.

The earliest book on women artists. Organised chronologically. Artists on whom there is much information are given an individual section while others are grouped together. Because of the time at which she was writing, Ellett had access to a considerable number of artists who were then well known but who even now have not emerged fully. This remains interesting both as a historical document and as a useful source.

2213 ELLIOTT, BRIDGET, and JO-ANN WALLACE. *Women Artists and Writers: Modernist (Im)positionings*. London: Routledge, 1994, 204pp., illus.
Aims to explore more fully women's positions within Modernism using theoretical writers such as Bourdieu and Moi. After consideration of the issues and theoretical material, four case studies are examined in detail. Each of these consists of a writer and an artist practising in the same society and negotiating similar sets of (im)positionings: Natalie Barney and Romaine Brooks, Virginia Woolf and Vanessa Bell, Gertrude Stein and Marie Laurencin, Djuna Barnes and Nina Hamnett.

2214 ELLIOTT, DAVID, and VALERY DUDAKOV. *100 years of Russian art, 1889–1989, from private collections in the USSR*. London: Lund Humphries, with the Barbican Art Gallery, London and the Museum of Modern Art, Oxford, 1989, 152pp., illus.
A number of the better known Russian women artists are included in this survey of a century of Russian art: Danko, Ermolaeva, Exter, Khodasevich, Popova, Serebriakova, Shchekotikina-Pototskaya, Stepanova and Udaltsova. Short biographies of artists are included.

2215 FEHRER, CATHERINE. "New Light on the Académie Julian and Its Founder." *Gazette des Beaux-Arts* 1384–5, 126 (May–June 1984): 207–216.
Presents the early findings of the material which appears more fully discussed in the 1989 exhibition catalogue written by this author.

2216 FEHRER, CATHERINE, ET AL. *The Julian Academy, Paris, 1868–1939*. New York: Shepherd Gallery, 1989, pp., illus.
Contains a thorough history of this Académie where so many women trained. A biography of Julian himself is followed by the catalogue of the exhibition and a list of students. Unfortunately the women's archives were missing when this was prepared. The essays only mention Amélie Beaury-Saurel and Marie Bashkirtseff while the exhibition itself included works by only four women: Bashkirtseff, Käthe Kollwitz, Elizabeth Sonrel and Blanche-Augustine Camus.

2217 *Figuring out the 80s*. Newcastle-upon-Tyne: Laing Art Gallery, 1988, 24pp., illus.
Thirteen figurative painters feature in this exhibition, of whom four are women: Eileen Cooper, Erica Faith Lansley, June Redfern and Suzanne Treister.

2218 FINE, ELSA HONIG. *Women and Art: A History of Women Painters and Sculptors from the Renaissance to the 20th Century*. Montclair & London: Allanfield & Schram/Prior, 1978, 241pp., illus.
Another of the pioneering texts to emerge from America in the 1970s which helped to establish the activities of women artists. Divided into nine chapters, each commences with an overview of issues related to the social

context of women's art practice in the period/country under consideration, before biographical accounts of selected women artists are given.

2219 FLETCHER, JENNIFER, ET AL. *Women's Art Show, 1550–1970.* Nottingham: Castle Museum, 1982, 95pp., illus.

Essays on European women artists from the sixteenth and seventeenth centuries and on British artists in the nineteenth and twentieth centuries precede the catalogue entries. For each a biographical outline of the artists accompanies information on the work exhibited.

2220 FORTNUM, REBECCA, and GILL HOUGHTON. "Women and Contemporary Painting." *Women Artists' Slide Library Journal* 28 (April–May 1988): 4–19.

Discusses the gap seen by the authors between feminist art and art produced by feminists and how this is manifest in the work of six women working in England. Interviews with the six follow the introduction.

2221 FOX, CAROLINE, and FRANCIS GREENACRE. *Artists of the Newlyn School, 1880–1900.* Newlyn: Orion Galleries, 1979, 260pp., illus.

A thoroughly researched exhibition on this group of late-nineteenth-century painters, among whom were several women although only two are featured in the meticulously researched biographies and notes on exhibits: Elizabeth Forbes and Caroline Gotch. The women who arrived after 1900 are included in the expanded exhibition of 1985 by the same authors.

2222 FOX, CAROLINE, and FRANCIS GREENACRE. *Painting in Newlyn, 1880–1930.* London: Barbican Art Gallery, 1985, 169pp., illus.

This catalogue is an expanded version of the earlier exhibition, *Painting in Newlyn 1880–1900,* by the same authors. Three scholarly essays analyse the work of the artists who were drawn to Newlyn, Cornwall, to paint the life of the rural and fishing communities there and to develop their own artistic concerns. The biographies of artists and notes on the exhibits follow in the order in which they arrived in Newlyn. Eight women were amongst the number: Elizabeth Forbes, Gertrude Harvey, Alethea Garstin, Gladys Hynes, Dod Procter, Laura Knight, Eleanor Hughes and Ruth Simpson.

2223 FOX, HOWARD. *A New Romanticism: Sixteen Artists from Italy.* Washington, D.C.: Smithsonian Institution Press in association with the Hirschhorn Museum and Sculpture Garden, 1985, 122pp., illus.

Two essays on contemporary art in Italy are followed by a catalogue in alphabetical order. Three women are included: Patrizia Cantalupo, Paola Gandolfi and Sabina Mirri.

2224 FRIIS, EVA (ED.). *Kunst under Krigen.* Copenhagen: Statens Museum for Kunst, 1995, 159pp., illus.

Text in Danish with an English summary. An examination of Danish art and film-making during World War II. Essays examine various categories of work including abstract painters, domestic scenes and native landscapes, monumental art and occupation culture. Six women are included: Olivia Holm-Møller, Helen Schou, Jane Muus, Helge Nielson, Astrid Noack and Soeren Hjorth Nielsen.

2225 GARB, TAMAR. "'L'art féminin': The Formation of a Critical Category in Late 19th Century France." *Art History* 12, no. 1 (March 1989): 36–65.
Examines definitions of feminine art in the critical languages of France at the end of the nineteenth century. The works of women artists which form the basis of this critical category are analysed together with their reception.

2226 GARB, TAMAR. *Sisters of the Brush: Women's Artistic Culture in Late Nineteenth Century Paris.* New Haven, Conn. and London: Yale University Press, 1994.
Examines the history of the Union des Femmes Peintres et Sculpteurs in Paris from its foundation in 1881 and provides a remapping of late-nineteenth-century art in Paris distinct from the masculine territories so often discussed. Hundreds of academic women painters are mentioned in addition to the founders of the UFPS, amongst whom is the redoubtable Hélène Bertaux. Many different types of source material—medical and scientific writing, art criticism, educational texts, French feminism and the teachings of the Catholic Church—are used to demonstrate shifting identities and meanings in the area of cultural politics.

2227 GARB, TAMAR. "The Forbidden Gaze." *Art in America* 79 (May 1991): 146–152.
Examines the exclusion of women from life classes, the state of art education for women in late-nineteenth-century France and the issue of the admission of women to the Ecole des Beaux-Arts.

2228 GARB, TAMAR. *Women Impressionists.* Phaidon: Oxford, 1986, 79pp., illus.
After an essay which introduces the women painters of Impressionism, a series of individual works are presented and discussed in a way which allows the distinctive approach to subject matter to be identified.

2229 GAUBE-BERLIN, JANINE (ED.). *La femme peintre et sculpteur du 17e au 20e siècle. 86e Exposition de la Société des Artistes Indépendents.* Paris: Grand-Palais, 1975, n.p., illus.
Organised chronologically, the catalogue documents about one hundred works of art. A biographical outline is given for each artist before details of the work are given. It provides information about many less familiar artists.

2230 GIACHERO, LIA. "Futurism." *Women's Art Magazine* 39 (1991): 10.
Reviews the exhibition *Futurism in Flight* in which many women were included. Although the better known ones are discussed in the article, there are also references to other less familiar names: Barbar, Fillia, Adèle Gloria and Leandra Angelucci Cominazzini

2231 GIBBONS, LUKE. "Private Voices, Public Spheres." *Artforum* 31 (May 1993): 97–98.
Examines the issue of sexual politics in contemporary art by Irish women.

2232 GILLETT, PAULA. *The Victorian Painter's World.* New Brunswick: Rutgers University Press and London: Alan Sutton, 1990, 299pp., illus.
Two chapters are of particular relevance and deal with the notion of painting as a respectable profession for women and the progress and problems encountered by women artists in the second half of the nineteenth century.

2233 GILLIAM, FLORENCE. "Paris Women in the Arts." *Charm* (March 1925): 11–13.
A short survey of women artists involved in the avant-garde in Paris since World War I. The author notes the rapid increase in the number of women artists from across Europe. A short paragraph describes the main characteristics first of a number of French painters, then of artists from other countries.

2234 *Glasgow Society of Lady Artists: A Centenary Exhibition to Celebrate the Founding of the Glasgow Society of Lady Artists.* Glasgow: Collins Gallery, 1982, 40pp., illus.
A useful source document for this society. There is an outline history of the Society from 1882, a catalogue, lists of presidents and office holders, special exhibitions, winners of the Lauder award, honorary members and artist members and exhibitors.

2235 GLEISBERG, D. *Deutsche Künstlerinnen des zwanzigsten Jahrhunderts.* Altenburg: Staatlichen Lindendau-Museum, 1963.
Text in German. An early exhibition of the work of German women artists in which thirty painters, sculptors and graphic artists are included. Two introductory essays examine the broad issues before individual artists are examined.

2236 GREER, GERMAINE. *The Obstacle Race: The Fortunes of Women Painters and Their Work.* London: Secker and Warburg, 1979, 373pp., illus.
Attempts to show that women painters had a variety of social obstacles to negotiate. Includes many European women painters from the Middle Ages onward.

2237 GRIMES, TERESA, JUDITH COLLINS, and ORIANA BADDELEY. *Five women painters.* London: Lennard Publishing for Channel Four in association with the Arts Council, 1989, 191pp., illus.

An introduction addresses the problems surrounding the anonymity of many women artists and the reasons for this. A second section looks at women's art education in Britain in the later nineteenth and early twentieth centuries, exhibiting opportunities, women patrons and, briefly, female style. There follow five chapters which provide a thorough evaluation, though a mainly biographical approach, to each of the artists: Laura Knight, Nina Hamnett, Carrington, Winifred Nicholson and Eileen Agar.

2238 HARAMBOURG, LYDIA. *Dictionnaire des peintres paysagistes français au XIXe siècle.* Neuchâtel: Editions Ides et Calends, 1985, 400pp., illus.
 Predictably, only a small number of women are included but, because of the relative rarity of women landscape painters at that time, it is useful to have a source for their names.

2239 HARRIES, MEIRION, and SUSAN. *The War Artists: British Official War Art of the Twentieth Century.* London: Joseph in association with the Imperial War Museum and the Tate Gallery, 1983, 328pp., illus.
 An examination of the different aspects of war art and the official war artists' scheme during the two world wars. The work of the women artists is included and discussed.

2240 HARRIS, ANNE SUTHERLAND, and LINDA NOCHLIN. *Women Artists 1550–1950.* New York: Alfred Knopf in association with Los Angeles County Museum of Art, 1976, 367pp., illus.
 One of the earliest publications to demonstrate the extent of women's art practice. The majority of artists are European painters. There are thorough lengthy introductory essays identifying the ways in which women were able to practice art in different regions of Europe from the sixteenth century. Each exhibitor is then accorded a detailed biographical account with footnotes directing the reader to documentary and other sources. Despite its age, it remains a standard reference work.

2241 *Hayward Annual '78.* London: Hayward Gallery, 1978, 107pp., illus.
 Curated by five women, this exhibition included sixteen women artists out of twenty-three. It resulted in part from the very minor appearances of women artists in previous major shows of British art and a campaign to alter this. This background affected the critical reception of the exhibition and Griselda Pollock analysed the reviews in "Femininity, feminism and the Hayward Annual," reprinted in her anthology *Framing Feminism.*

2242 HÁRS, ÉVA, and FERENC ROMVÁRY. *Modern Hungarian Gallery Pécs.* Budapest: Corvina Kiadó, 1981, 395pp., illus.
 After short histories of the Gallery and its constituent parts, there is a sequence of short texts, of some half page in length, on the work of each artist illustrated on the opposite page. Women included in the collection are Anna Lesznai, Valéria Dénes, Noémie Ferenczy (see volume 1), Anna

Margit, Magda Zemplényi, Piroska Szántó, Lili Ország, Ilona Keserü, Dóra Maurer and sculptors Erzsébet Forgács Hann, Márta Lesenyei and Eerzsébet Schaáar.

2243 HEDLEY, GILL. *Let Her Paint: Ten Women Painters in Southampton City Art Gallery.* Southampton: City Art Gallery, 1988, 28pp., illus.
Focusses on ten women painters in the permanent collection. With the exception of the sixteenth-century Italian Sofonisba Anguisciola, they all worked in England in the nineteenth or twentieth centuries: Helen Allingham, Mary Hayllar, Stanislawa de Karlowska. Gwen John, Vanessa Bell, Sylvia Gosse, Nina Hamnett, Eileen Agar and Ithell Colquhoun. For each there is a short biography and some analysis of their work.

2244 HESS, THOMAS, and ELIZABETH BAKER. *Art and Sexual Politics: Why Have There Been No Great Women Artists?* New York: Collier Books, 1971, 150pp., illus.
Anthology containing one of the seminal articles in the study of women artists, which gives this book its subtitle. Nochlin's article, which includes many references to nineteenth-century European women artists, is followed by replies from ten contemporary American women.

2245 HEYDORN, VOLKER. *Maler in Hamburg, 1886–1966.* 2 vols. Hamburg: Christians, 1974, vol. 1: 193pp., illus.; vol. 2: 104pp., illus.
Text in German. A thorough and detailed aanalysis of the different strands of artistic activity in Hamburg. A number of interesting women artists are included. From the earlier period, the painters Elena Luksch Makowsky (1878–1967), Alma del Banco (1862–?), Anita Ree (1885–1933), Gretchen Wohlwill (1878–?) and Dorothea Maetzel-Johannsen (1886–1930) all worked in avant-garde styles. The later volume includes the painters Eva Hagemann (1908–?), Hildegard Stromberger (1904–?), Marianne Weingaertner, Gaby Weingaertner-Spars (1900–?), Charlotte Voss (1911–?), Gisela Bührmann, Gabriele Daube, Irma Weiland, Charlotte Hilmer, Gabriele Stock-Schmilinsky, Jutta Benecke-Eberle-Pedone, Hannelore Borchers, Gerda Reichert, Margrit von Spreckelsen and Gudrun Piper.

2246 HIGGINS, JUDITH. "Art From the Edge." *Art in America* 83 (December 1995): 37–41.
Examines recent developments in Irish art and discusses the work of several women artists.

2247 HIMID, LUBAINA. *The Thin Black Line.* London: Institute of Contemporary Art, 1985, 11pp., illus.
An exhibition of the work of eleven women artists of colour of which the curator, Himid, is one, working in England, primarily in two dimensions although in various materials. The information on each varies but there is

ususally a chronology and a statement by the artist. The exhibition arose from the lack of documentation on black women artists.

2248 HIRSCH, ANTON. *Die Bildenden Künstlerinnen der Neuzeit.* Stuttgart: Ferdinand Enke, 1905, 232pp., illus.

Text in German. Survey of European women painters in the nineteenth century, contemporary with Walter Shaw Sparrow's *Women Painters of the World* (q.v.).

2249 HOFMANN, WERNER (ED.). *Eva und die Zukunft: das Bild der Frau seit der Französichen Revolution.* Munich: Prestel in association with Hamburg Kunsthalle, 1986, 463pp., illus.

Text in German. Examines images of women in art by theme such as Mother and Madonna, femmes fatales, partners, lesbians. Three scholarly essays examine different aspects of the topic including the sociohistorical context. Some 20 percent of the artists are women. Short biographies of the artists are included.

2250 HOLLAND, CLIVE. "A Lady Art Student's Life in Paris." *Studio* 30 (1904): 225–233.

Describes the lifestyles of women art students in Paris at the turn of the century, providing some interesting details about the academies and ateliers frequented by women. His practical approach is demonstrated by the provision of details of the cost of living.

2251 HOSCHEDE, ERNEST. *Salons 1880 et 1881, les femmes artistes. Exposition de l'U.F.P.S. au cercle des arts libéraux.* Paris: Imprimérie Tolmer et Cie., 1882, 32pp., illus.

An appreciation of the work of women artists of the later nineteenth century by a contemporary critic. He initially summarises the work of some earlier women artists before considering those who exhibited at the Salons of 1880 and 1881 together with those at the Union des Femmes Peintres et Sculpteurs. The overall tone is extremely patronising but the text names many women artists of the period. The large majority are French, with particular attention being given to Morisot, Cassatt and Noémie Guillaume, but there are a few artists from other countries whose work was in these particular exhibitions.

2252 *Hölzel und sein Kreis. Der Beitrag Stuttgarts zur Malerei des 20 Jahrhunderts.* Stuttgart: Württemburgischen Kunstvereins, 1961, 267pp., illus.

Text in German. This exhibition on the artists in Hölzel's circle includes a number of women, the most important of which were Ida Kerkovius and Maria Lemmé. The introductory essay includes documentary photographs of many of the artists. The alphabetical catalogue section provides a brief biographical outline and details of the works exhibited for the two artists men-

tioned above and Luise Deicher, Gertrude Aberz-Alber, Lilly Hildebrandt, Maria Hiller-Foell, Gertrud Koref-Musculus, Clara Lahsbieger-Fausser, Valerie May-Hülsmann and Clara Ruhle.

2253 ILIOPOULOU-ROGAN, DORA. *Three Generations of Greek Women Artists: Figures, Forms and Personal Myths.* Washington, D.C.: National Museum of Women in the Arts, 1989, 71pp., illus.

Exhibition of the work of eleven painters and sculptors born between 1920 and 1949. An introductory essay examines their ideas and themes while individually there are outline biographies and lists of exhibitions. Some of the artists are based in America.

2254 INGELMAN, INGRID. "Women Artists in Sweden: A Two-Front Struggle." *Woman's Art Journal* 5, no. 1 (spring–summer 1984): 1–7.

A survey of the emergence of women artists from the late nineteenth century in Sweden. It documents information about their lives and work.

2255 *Irish Women Artists From the Eighteenth Century to the Present Day.* Dublin: National Gallery of Ireland, Douglas Hyde Gallery and the Hugh Lane Gallery, 1987, 208pp., illus.

The most comprehensive survey of women's artistic activity in Ireland. There is a series of scholarly essays on aspects of women's art practice and its context, including educational facilities, the early sketching clubs and the botanical artists. The catalogue entries follow, while at the end there is a bio-graphical dictionary of Irish women artists.

2256 JOENSSEN, HANNE. *Danske kvindelige kunstnere fradet 19. og 20. aer-hundrede repraesenteret pae Statens Museum for Kunst.* Copenhagen: Statens Museum for Kunst, 1980, 27pp., illus.

Text in Danish with an English summary. Presents works by thirty-seven women artists from the Museum's permanent collection. A number have extensive exhibiting careers and some were well known outside their own country.

2257 JOUIN, HENRY. "L'Exposition des artistes femmes." *Journal des Beaux-Arts et de Litérature* 24 (1882): 66.

After commenting on the—to Jouin—bizarre title in that there are never exhibitions entitled "Expositions hommes," the author reviews the exhibits emanating from the artistic and literary circle of the rue Volney.

2258 KENT, SARAH, and JACQUELINE MORREAU (EDS.). *Women's Images of Men.* London: Writers and Readers Publishing, 1985, 199pp., illus.

A collection of thirteen essays by artists and critics on the issues which arose out of the series of three exhibitions held at the Institute of Contemporary Art in 1980. The first of those, entitled *Women's Images of*

Men, aroused considerable debate and involved the work of a number of the contributors to this book.

2259 KHARIBIAN, LEAH. "Survival in the Arts." *Women's Art Magazine* 38 (1991): 12–14.
Analyses the results of a survey carried out by the journal on the conditions in which women artists train and work in Britain. The headings under which questions were asked and around which this article is structured are: training, family and cultural environment, workspace and material, making a living and survival.

2260 *Kunst door vrouwen.* Leiden: Stedelijk Museum De Lakenhal, 1987, 28pp., illus.
Text in Dutch. A short historical survey of twelve Dutch women artists from the seventeenth century. A short biography and notes on the exhibits are included for each artist.

2261 *Kvinnor som målat.*
See above under CAVALLI-BJÖRKMAN.

2262 *L'art dans les années 30 en France.* St. Etienne: Musée d'Art et d'Industrie, 1979, 141pp., 233 illus.
Gives a chronology of events in the decade. A chapter of the social context for art in the 1930s is followed by others on realism and figuration, surrealism, abstraction, photography, furniture and architecture in Saint Etienne. The 469 exhibits include works by a limited number of women who were active in France during the 1930s: Marcelle Cahn, Sonia Delaunay, Yolande Fieure, Laure Garcin, Hannah Kosnick-Kloss, Marie Laurencin, Tamara de Lempicka, Chana Orloff, Suzanne Roger, Sophie Taeuber-Arp, Suzanne Valadon and Maria Elena Vieira da Silva with the photographers Gisèle Freund, Florence Henri and Germaine Krull.

2263 *L'art en hongrie 1905–1930—art et révolution.* St. Etienne: Musée d'Art et d'Industrie, 1980, 110pp., illus.
Text in French. An examination of twenty-five years of Hungarian art and the philisophy of the avant-garde groups, the Eight and the Activists. Four women are included: Valéria Dénes, Anna Lesznai, Anna Beothy Steiner and Gizella Dömöstör (b. 1898)

2264 *L'avant-garde au féminin: Moscou, St Petersbourg, Paris.*
See below under MARCADE.

2265 *Les femmes artistes modernes.* Paris: Pavillon des Expositions and Buffet and Leclerc, 1937, 16pp.
Text in French. Many well-known artists participated in this early all-women exhibition. Most are living artists who are represented by one or, at

the most, two works. Although it consists of only names and titles of works, it provides an interesting list of women active in Paris in the 1930s.

2266 LIPPARD, LUCY. *Issue: Social Strategies by Women Artists.* London: Institute of Contemporary Art, 1980, n.p., illus.

Examines the work of about twenty British and American artists who use their work to address political and social issues in a direct manner. The media and forms of art which they use are varied.

2267 LOTZ, FRANÇOIS. *Les femmes peintres sous verre.* Pfaffenheim: Musée de l'imagerie peinte et populaire alsacienne de Pfaffenheim, 1984, 16pp., illus.

Exhibition of contemporary women who produce behind-glass paintings, which Lotz describes as an art form of regional importance. He identifies about thirty contemporary artists, both male and female, who practice it and all are cited in his book on Alsatian painters. Some of these individuals are also well known as painters on canvas. Their dates of birth lie between 1924 and 1954.

2268 LOTZ, FRANÇOIS. *Les artists-peintres alsaciens: de jadis à naguère, 1880–1982.* Kayersburg: Printek, 1987, 383pp., illus.

Contains biographies of Alsatian painters varying in length, each of which has a bibliography. A useful source for women artists from the period indicated.

2269 LUCAS, PAULINE. "Pionéers of Education." *Women's Art Magazine* 42 (1991): 14–15.

Discusses the educational work, especially during the 1930s, of three women artists: Evelyn Gibbs, Nan Youngman (q.v.) and Marion Richardson. Compares their contributions to the introduction of a new approach to art education.

2270 LUCIE-SMITH, EDWARD. *Art Deco painting.* Oxford: Phaidon, 1990, 160pp., 108 pl.

This survey of European Art Deco painting is divided into chapters according to the subject of the works. Nine of the fifty-three artists included are women: Marcelle Cahn, Franciska Clausen, Gluck, Florence Henri, Gladys Hynes, Marie Laurencin, Tamara de Lempicka, Marietta Lydis and Dod Procter. In addition to the text, outline biographies are provided.

2271 LUCIE-SMITH, EDWARD, CAROLYN COHEN and JUDITH HIGGINS. *The New British Painting.* Oxford: Phaidon in association with the Contemporary Arts Center Cincinnati, 1988, 112pp., illus.

Essays by the three authors analyse British Modernism and what is here termed as the New British Painting, together with an American view of contemporary painting in Britain. The work of seven women is discussed: Eileen

Cooper, Amanda Faulkner, Gwen Hardie, Mary Mabbutt, Lisa Milroy, Thérèse Oulton and Suzanne Treister.

2272 MARCADE, JEAN-CLAUDE, and VALENTINE MARCADE. *L'Avant-Garde au Féminin: Moscou, Saint Petersbourg, Paris (1907–1930).* Paris: Artcurial, 1983, 64pp., illus.

Text in French. Looks at the activities of women artists in the Russian avant-garde in the early decades of the twentieth century. In all, twenty-two artists are included, each with biographical essays of varying lengths. There are general and individual bibliographies.

2273 MARSH, JAN. *Pre-Raphaelite Sisterhood.* 2nd ed. London: Quartet Books, 1992, 408pp., illus.

Analyses the contrasting fortunes of women within the first generation of Pre-Raphaelite painters in England. Some were wives of artists while others were artists; some, such as Lizzie Siddal were both. Divided into three chapters—Youth, Marriage and Maturity—it avoids a traditional chronological approach in order to analyse the interweaving lives of this group of women.

2274 MATHEY, FRANÇOIS. *Six femmes peintres.* Paris: Editions du Chêne, 1951, n.p., illus.

After an introductory essay there are biographical outlines of up to one and a half pages on the following painters: Berthe Morisot, Eva Gonzales, Séraphine Luois, Suzanne Valadon, Maria Blanchard and Marie Laurencin.

2275 *Meisterwerke Französischer Buchkunst der letzen 50 Jahre: le livre bibliophile français moderne.* Berne: Kunstmuseum, 1945, 36pp.

Text in German and French. A short introduction is followed by a list of the 187 books exhibited, which were illustrated by well-known painters. Six women artists are included: Marie Laurencin, Jeanne Rosay, Germaine Labay, Alicia Halicka, Hermine David, Marietta Lydis.

2276 MELLOR, DAVID. *The Sixties Art Scene in London.* London: Phaidon Press in association with Barbican Art Gallery, 1993, 239pp., illus.

Intended as a new analysis of two of the main focal points of the art scene in London, one culminating in the Situation grouping and St. Martin's School of Art in the early 1960s and the other in an oppositional force of dissent characterised by the use of nontraditional techniques and materials. Although the number of women included is relatively small, new material on Pauline Boty is made available here. Others included are Gillian Ayres, Tess Jaray, Lilian Lijn, Anne Martin, Linda McCartney and Bridgit Riley.

2277 MESKIMMON, MARSHA. *Domesticity and Dissent: The Role of Women Artists in Weimar Germany, 1918–1938. Haüsliches Leben und Dissens. Die Rolle der Künstlerinnen auf Deutschland, 1918–1938.* Leicester: Leicester Museums, 1992, 128pp., illus.

Text in German and English. There are essays on Weimar culture and on the problems for realist women artists operating within that culture. Artists are then introduced individually with a short biography. A select bibliography on individual artists is also provided.

2278 MESKIMMON, MARSHA, and SHEARER WEST. *Visions of the 'Neue Frau': Women and the Visual Arts in Weimar Germany.* London: Scolar Press, 1995, 187pp., illus.

An anthology of essays which grew out of the exhibition *Domesticity and Dissent: the Role of Women Artists in Germany, 1918–1938* curated by Meskimmon (q.v.). They analyse the sociopolitical context for women artists and chapters examine the notion of the artist couple, women sculptors, women photographers, dancers, dealers and women in the film industry. All these are rigorously examined in the context of Weimar Germany.

2279 MITCHELL, DOLORES. "The 'New Woman' as Prometheus: Women Artists Depict Women Smoking." *Woman's Art Journal* 12, no. 1 (spring–summer 1991): 3–9.

Examines the images of three women artists active in the late nineteenth and early twentieth centuries who depicted women smoking. Jane Atché and Louise Lavrut were French painters while Frances Johnston was an American photographer. The author examines the social history of smoking in France and its depiction in literature and art in late-nineteenth-century France.

2280 MORAWIŃSKA, AGNIESZKA. *Voices of Freedom: Polish Women Artists and the Avant-Garde.* Washington, D.C.: National Museum of Women in the Arts, 1991, 55pp., illus.

An essay surveys the activities of women artists in Poland from the nineteenth century and thus introduces more artists than the seventeen featured in the exhibition. Detailed chronologies, lists of exhibitions and bibliographies are provided for the seventeen, thus making material in Polish more widely known.

2281 MORRIS, SYDNEY, and KATHLEEN MORRIS. *A Catalogue of Birmingham and West Midlands Painters of the Nineteenth Century.* Stratford-upon-Avon: S. & K. Morris, 1974, n.p., illus.

An alphabetical listing of painters working in Birmingham and the West Midlands (excluding Bristol) between 1800 and 1900. The artists either worked mostly in the area or were members of the Royal Birmingham Society of Artists (or its predecessors). Each entry provides the artist's dates, where s/he worked, the number of paintings exhibited at the RSBA and London together with any other information such as an indication of their principal subject matter. References are also given but the majority of artists in this work do not feature in standard works. Large numbers of women are

included, although a proportion of them exhibited only a small number of paintings.

2282 *Mothers.* Birmingham: Ikon Gallery, 1990, 38pp., illus.

Organised around the experience of motherhood, as mother or daughter, for fifteen artists. A theoretical context is set in an essay by Hilary Robinson while two of the artists—Jo Spence and Cate Elwes—also provide written commentaries. Each artist includes a statement about her work.

2283 *Movement and the City: Vienna, New York, 1920s.* New York: Rachel Adler, 1987.

Looks at a small group of Austrian artists who were concerned with the imagery of the city and who all visited New York. There are four women: Trude Faschl, Elizabeth Karlinsky-Scherfig (q.v.), Erika Klein (q.v.) and Marianne Ullmann.

2284 *Näkyjä ja haaveita. Ranskalainen symbolismi 1886–1908.* Helsinki: Ateneum, 1994, 162pp., illus.

Text in Finnish with an English summary. Survey of European Symbolism with particular emphasis on the Finnish contribution to the movement. Two Finns are the only women included: Ellen Thesleff and Beda Stjernschantz.

2285 NEUE GESELLSCHAFT FUR BILDENDE KUNST E.V. *Das Verborgene Museum. Dokumentation der Kunst von Frauen in Berliner öffentlichen Sammlungen.* Berlin: Edition Hentrich, 1987, 364pp., illus.

Text in German. After five scholarly essays which examine different aspects of women's art practice over the past two centuries, there are biographical essays for each of the women represented in the collections of the Berlin Museums and who therefore are included in the exhibition. For the nineteenth- and early-twentieth-century artists there are longer essays but for contemporary artists there are photographs and a biographical outline. In all, over 100 women, most of whom are German, are featured in the catalogue.

2286 NÉMETH, LAJOS. *Modern Art in Hungary.* Budapest: Corvina Press, 1969, 187pp., 141 pl.

A survey of Hungarian art, predominantly painting, from 1900. It is mainly organised around groups, both those which had links with international European movements and those which were exclusive to Hungary. About twelve women are included but few are discussed in any detail.

2287 *Nordisk Sekelskifte: The Light of the North.* Stockholm: Nationalmuseum, 1995, 296pp., illus.

Text in Swedish and English. One of the themed sections examines Scandinavian women artists and there are detailed entries on the exhibits. Eight women are included: Anna Ancher, Harriet Backer, Fanny Churberg,

Kitty Keilland, Hanna Pauli, Hélène Schjerfbeck, Hélène Thesleff and Maria Wiik. There are biographies amd a bibliography included.

2288 NUNN, PAMELA GERRISH. *Canvassing: Recollections by Six Victorian Women Artists.* London: Camden Press, 1986, 195pp., illus.

Extracts from the writings of Anna Mary Howitt, Anna Lea Meritt, Elizabeth Thompson Butler, Henrietta Ward, Louise Jopling and Estella Carr Canziani. There is an essay on the debates on women and art in the nineteenth century.

2289 NUNN, PAMELA GERRISH. *Victorian Women Artists.* London: Women's Press, 1987, 242pp., illus.

An analysis of women's access to art training and exhibition venues in London and the provinces is followed by detailed case studies of five women artists: Henrietta Ward, Joanna Boyce, Emma Brownlow, Rosa Brett and Louisa, Lady Waterford. An appendix examines the treatment of women artists in nineteenth-century writings on art.

2290 *Obraz 69* [Picture 69]. Brno: Moravská Galerie, 1969, 11pp., 175 illus.

Text in Czech. A listing of works shown at this second of what was intended as a series of exhibitions of contemporary two-dimensional art. The first took place in 1967. Every exhibit is illustrated with each of the sixty-five artists allowed a maximum of three works. Eleven women participated.

2291 OELE, ANNEKE, MIRIAM VON RIJSINGEN and HESTHER VAN DEN DONK. *Bloemen uit de kelder: negen kunstnaressen rond de eeuwwisseling.* Arnhem: Gemeentemuseum in association with Waanders Uitgevers, Zwolle, 1989, 96pp., illus.

Text in Dutch. An exhibition of nineteenth-century Dutch flower painters in which five women are included: Maris Vos, Sientje Mesdag-van Houten, Maria Bilders-van Bosse, Margaretha Roosenboom and Thérèse Schwartze, Suze Robertson, Lucie van Dam van Isselt, Coba Ritsema and Anna de Graag. There are three essays on the subject followed by a section on each artist.

2292 OPFELL, OLGA. *Special Visions: Profiles of 15 Women Artists from the Renaissance to the Present Day.* Jefferson, N.C. and London: McFarland, 1991, 223pp., illus.

Consists of biographical accounts aimed at school students of fifteen of the best-known women artists, primarily painters. Most are from Europe, and of these, eleven were active in the nineteenth and twentieth centuries.

2293 ORR, CLARISSA CAMPBELL (ED.). *Women in the Victorian Art World.* Manchester: Manchester University Press, 1995, 208pp., illus.

A collection of nine essays in three sections: Women, Art and the Public Sphere; Culture, Criticism and Connoisseurship; The Making of the Women Artist. One essay is devoted to Barbara Leigh Smith Bodichon.

2294 PALGRAVE, F. T. "Women and the Fine Arts." *Macmillan's Magazine* 12 (1865): 118–127, 209–221.

Discusses the possibility that women can be artists by taking a long view from Sappho. Few women artists are actually named. The author maintains that women, even when single, devote more time to household tasks than men, who have their careers to consider.

2295 PARADA Y SANTIN, JOSÉ. *Las pinturas españoles: boceto histórico-biográfico y artístico*. Madrid: Asilo de Huérfanos del s.c. de Jesus, 1902.

Text in Spanish. A chronological treatment of the activities of women painters in Spain from the origins of Spanish painting (pre-tenth century) to the nineteenth century. The total number of women mentioned is about 150. As such, the book represents a considerable achievement in a field where information is not plentiful.

2296 PAMPLONA, FERNANDO DI. *Um seculo de pintura e escultura em Portugal, 1830–1930*. Porto: Livraria Tavares Martins, 1943, 416pp., illus.

Text in Portuguese with a summary in French. A chronological survey of traditional art, concentrating on formal values. No biographical information on the artists is given but a large number of women are included and there is evidence of several female artist dynasties.

2297 PARKER, ROSZIKA, and GRISELDA POLLOCK. *Framing Feminism: Art and the Women's Movement, 1970–1985*. London and New York: Pandora, 1987, 345pp., illus.

Consists of two parts. The first contains two substantial critical essays analysing the women's art movement in Britain from its beginnings and the role of women in Modernism. The second is an anthology of articles and other texts from key moments in that history. These were often in ephemeral formats and would have been lost were it not for this collection. The anthology is divided into sections: Images and Signs, Institutions, Exhibitions and Strategies of Feminism.

2298 PARKER, ROSZIKA, and GRISELDA POLLOCK. *Old Mistresses: Women, Art and Ideology*. London: Routledge & Kegan Paul, 1981, 184pp., illus.

One of the seminal books in debates about women's participation in the art world. Consists of chapters on the language of art and art criticism, on the hierarchy of the arts, on women artists and their reception up to the nineteenth century and on representations of women with an analysis of the ways in which feminist artists dealt with the problems of representation which they inherited.

2299 PASQUALI, MARILENA. *Figure dallo sfondo.* Ferrara and Grafis Editore: Padiglione d'Arte Contemporanea, 1984, 154pp., illus.

Text in Italian. The first of a series of biennial exhibitions of women artists held at Ferrara, this has no particular theme but includes thirty-two Italian women artists. For each there is a short biography, an analysis of their work and a bibliography.

2300 PERRY, GILL. *Women Artists and the Parisian Avant-garde: Modernism and 'Feminine' Art, 1900 to the late 1920s.* Manchester & New York: Manchester University Press, 1995, 186pp., illus.

An analysis of the participation of women artists in avant-garde art in Paris. The first section examines art training for women and the images of women produced by women artists; the last two sections look at the interventions of women in Fauvism and Cubism and how women exhibited and sold their work. Many contemporary documents are used to sustain the argument.

2301 PETERSEN, KAREN, and J. J. WILSON. *Women Artists: Recognition and Reappraisal from the Early Middle Ages to the Twentieth Century.* 2nd ed. London: Women's Press, 1979, 212pp., illus.

Another of the pionéering texts on women artists. This gives basic biographical information on a considerably larger number of women than Tufts and also Harris and Nochlin, although in less detail. It contains many illustrations and an extensive bibliography. Although superseded by much subsequent research, it has status as a historical document.

2302 PETHERBRIDGE, DEANNA. "Ten Decades: Ten Women Artists Born 1897–1906." *Women's Art Magazine* 46 (1992): 16–7.

Review of the exhibition of the same title of which the catalogue is by Katy Deepwell (q.v.)

2303 POLLOCK, GRISELDA. *Vision and Difference: Femininity, Feminism and the Histories of Art.* New York and London: Routledge, 1988, 239pp., illus.

An anthology of essays by Pollock previously published in journals. They examine critically issues concerning Elizabeth Siddal, Mary Cassatt (qq.v.), the exhibition *Difference: On Representation and Sexuality* (q.v.) and the problem of how and whether the discipline of art history can accommodate women artists.

2304 *Présences Polonaises.* Paris: Centre national d'art et de culture Georges Pompidou, 1983, 335pp., illus.

Text in French. Women artists feature in two of the three sections, those on Constructivism (Kobro, Nicz-Borowiak, Zarnower and Themerson) and Contemporaries (Stangret and Szapoczinikow).

2305 REFFLINGHAUS, CHRISTINE. "Dänische Künstlerinnen in Deutschland—unter Vesonderer Berüchsichtigung der Ausbildungs—möglichkeiten." *Konsthistorisk Tidskrift* 63, no. 3–4 (1994): 203–211.

Text in German with an English summary. Examines the small number of Danish women artists from the late nineteenth century who went to Germany rather than France for further training and the development of academies for women in Denmark.

2306 ROBERTS, DIANE, and PAM JOHNSTON (EDS.). *Out of Isolation.* Wrexham, Clwyd: Library Arts Centre, 1985, 39pp., illus.

Exhibition of a group of eight women who all belonged to the collective Artemesia (after the Renaissance painter Artemesia Gentileschi) which gave like-minded women an opportunity to meet and discuss key issues. After an introductory essay by Griselda Pollock, each artist has an outline biography and a list of exhibitions and makes a statement.

2307 ROSENFELD, ALLA, and NORTON DODGE. *Non-Conformist Art: The Soviet Experience 1956–1986.* London: Thames and Hudson in association with the Jane Voorhees Zimmerli Art Museum, State University of New Jersey, Rutgers, 1995, 360pp., illus.

Based on the Norton and Nancy Dodge Collection of art from the former Soviet Union, this contains an examination of an area of art still largely unknown in Western Europe. Introductory essays discuss the official policies on art from the Revolution to the late 1980s. A further twelve essays analyse styles other than Social Realism and countries other than Russia: Latvia, Luthuania, Estonia and Georgia. Women are mentioned in almost all the essays, although little biographical information is given on any of the artists.

2308 SARAJAS-KORTE, SALME. *Sieben Finnische Malerinnen.* Hamburg: Kunsthalle, 1983, 94pp., illus.

Text in German and Finnish. Each of the artists has a chronology and their work is contextualised in a short essay which is generously illustrated. The seven included are: Fanny Churberg, Maria Wiik, Helene Schjerfbeck, Ellen Thesleff, Beda Stjernschantz, Ester Helenius and Sigrid Schauman.

2309 SAUNDERS, GILL. *Picturing Plants: An Analytical History of Botanical Illustration.* London: Victoria and Albert Museum in association with Zwemmer, 1995, 152pp., illus.

Examines by type of function various themes within the history of botanical illustration such as Florilegia and pattern books, the dissemination of new discoveries, the taxonomy of plants required for botanical texts, horticultural illustration, floras and field guides. The examples are drawn from those in the collection of the Victoria and Albert Museum and are mainly from the eighteenth and nineteenth centuries. Women have often been associated with flower painting and this text includes a number who were specifically employed as botanical illustrators, a new phenomenon in the nineteenth century. Several

journals and serial publications depended on the work of such women. In the twentieth century women have dominated botanical illustration. Several women from the nineteenth and twentieth centuries are mentioned although the information on them is limited. Flower painters are not included.

2310 *Scandinavian Modernism: Painting in Denmark, Finland, Iceland, Norway and Sweden, 1910–1920.* Gothenberg: Goteborgs Museum, 1989, 262pp., illus.
 Only the Swedish section includes any women artists: Sigrid Hjerten and Siri Derkert, for whom biographical essays are also provided.

2311 SPARROW, WALTER SHAW. *Women Painters of the World*. London: Hodder & Stroughton, 1905.
 Contemporary with Clara Clement's book on women artists (q.v.), this is a useful source for nineteenth-century women artists. It is also interesting as a document of the attitudes of many late-nineteenth-century critics toward women artists.

2312 STERLING, SUSAN FISHER, ANNE WICHSTRØM, and TORIL SMIT. *At Century's End: Norwegian Artists and the Figurative Tradition, 1880–1990.* Høvikodden: Henie-Onstad Art Centre, 1995, 142pp., illus.
 Three critical essays analyse different aspects of the exhibition which considers the work only of women artists, three from the late nineteenth century and five contemporary: the feminist perspective which informed the exhibition, the women of the late nineteenth century and the contemporary imagery. Biographical outlines, lists of solo and group exhibitions and works in public collections are followed by individual bibliographies which give access to material in both Norwegian and English.

2313 *"Stiller Nachmittag": Aspekte Junger Schweizer Kunst.* Zurich: Kunsthaus, 1987, 213pp., illus.
 Text in German. Exhibition of twenty-four contemporary Swiss artists, of whom eight are women: Miriam Cahn, Olivia Etter, Barbara Hee, Carmen Perrin, Ilona Rügg, Klaudia Schifferle, Hannah Villiger and Anna Winteler. After two introductory essays, there is a short critical text on each artist, an outline biography, a list of their exhibitions and the literature on them.

2314 *Stroke, Line and Figure.* London: Gimpel Fils, 1983, n.p., illus.
 In this exhibition of works on paper by sixteen artists, only two are men. From Europe are Sonia Delaunay, Christine Fitzpatrick, Susan Hiller, Avis Newman, Winifred Nicholson, Freya Purdue, Marilyn Raban and Shelagh Wakely.

2315 STUTZER, BEAT (ED.). *Künstlergruppen in der Schweiz, 1910–1936.* Aarau: Aargauer Kunsthaus, 1981, 245pp., illus.
 Text in German. After chapters on the nature of the exhibition and an overview of artistic societies and organisations in Switzerland, there are

essays on eight groups of which only one, Das Neue Leben, included women. Its members included Alice Bailly, Sophie Täuber-Arp and Emmy Henning.

2316 SULTER, MAUD. *Echo: Works by Women Artists, 1850–1940.* Liverpool: Tate Gallery, 1991, 44pp., illus.

An exhibition selected from the permanent collection of the Tate Gallery organised around themes such as A Room of One's Own, Landscapes of Desire. There are short biographies on each of the artists whose works are in the exhibition and others are mentioned in the critical introductory essay.

2317 *Surrealismen i Danmark, 1930–1950.* Copenhagen: Statens Museum for Kunst, 1986, 111pp., illus.

Text in Danish. Consists of two essays, detailed notes on the exhibits and a chronological overview of Surrealism in Denmark. Three women are included: Franciska Clausen, Rita Kernn-Larsen and Sonja Ferlov Mancoba (qq.v.)

2318 SYDHOFF, BEATE. *Sweden Comes to New York: An Exhibition of Six Women Artists.* New York: A.I.R. Gallery, 1981, n.p., illus.

A brief statement only is provided on each of the exhibitors: Grete Billgren, Barbro Backstrom, Kristina Elander, Marie-Louise de Geer Bergenstrahle, Ann-Charlotte Johannsson and Lenke Rothman.

2319 ŠMAGRE, RITA. *Latviešu Pastelis. Latvian Pastel Painting.* Riga: Liesma, 1990, n.p., mainly illus.

Text in Latvian with summaries in Russian and English. Consists of a short historical background and a survey of the groups of Latvian artists from the beginning of the century who used pastel and are included in the book. Pastel was a popular medium Short biographical accounts are included. Eleven women are included.

2320 *The Last Romantics: The Romantic Tradition in British Art. Burne-Jones to Stanley Spencer.* London: Barbican Art Gallery, 1989.

Consists of several sections, arranged chronologically, under titles such as Burne-Jones and his followers, the Birmingham group, the early academic tradition, the Celtic dimension, Rome Scholars, muralists and others. Such an approach allows the inclusion of many artists hitherto omitted from the histories of art. Women are well represented, from the Pre-Raphaelite circles and their offshoots in the Midlands to the early Newlyn artists. A number are well known for their illustration work.

2321 *The McTaggarts and other Artist Families.* Edinburgh: Fine Art Society, 1989, 47pp., illus.

Looks at sixteen artist families most of which contain at least one woman artist. Other than a family tree with dates, there is no information on the artists

2322 *The Vigorous Imagination: New Scottish Art.* Edinburgh: Scottish National Gallery of Modern Art, 1987, 128pp., illus.

After several essays on aspects of recent Scottish art, including the resurgence of Glasgow, the work of seventeen artists is presented, of which four are women: Sam Ainsley, Gwen Hardie, June Redfern and Kate Whiteford. Outline biographies and select bibliographies are included for each.

2323 THOMAS, ALISON. *Portraits of Women: Gwen John and her Forgotten Contemporaries.* Cambridge: Polity Press, 1994, 259pp., illus.

Interweaves detailed biographical accounts, derived from primary sources, of Edna Clarke Hall, Gwen Salmond, Ida Nettleship and Gwen John. Ursula Tyrwhit also appears in the narrative. These women met as students at the Slade School of Art in London in the 1890s and continued their friendship for most of the rest of their lives.

2324 TICKNER, LISA. "Men's Work: Masculinity and Modernism." *Differences* 4, no. 3 (Autumn 1992): 1–37.

Analyses the notion of the modernist artist as automatically masculine in the context of early-twentieth-century British art. Gwen John, Jessica Dismorr and Helen Saunders are mentioned.

2325 TUFTS, ELEANOR. *Our Hidden Heritage: Five Centuries of Women Artists.* New York and London: Paddington Press Ltd., 1974, 256pp., illus.

One of the pionéering texts on women artists, almost all of whom are painters. Four are selected from each of the sixteenth to the nineteenth centuries and six from the twentieth century, with the majority from Europe. Detailed biographical accounts are given for each. Those active in Europe after 1800 are Angelika Kauffmann, Elizabeth Vigée-Lebrun, Rosa Bonheur, Suzanne Valadon, Käthe Kollwitz, Paula Modersohn-Becker, Gwen John, Natalian Goncharova and Germaine Richier.

2326 TYTLER, SARAH (pseudonym of HENRIETTA KEDDY). *Modern Painters and Their Paintings. For the Use of Schools and Learners in Art.* London: Strahan and Co., 1873, 362pp.

Includes several women artists from mainland Europe as well as contemporaries in Britain. Amongst the former, she discussses Bonheur, Lindegren, Jerichau and Henriette Brown while the latter include the Mutrie sisters, Boyce, Blackburn, Henrietta Ward and Carpenter (qq.v.)

2327 *Vedute romane: Myriam Laplante, Susanna Sartarelli, Sabina Mirri, Patrizia Cantalupo.* Vancouver: Charles H. Scott Gallery, Emily Carr College of Art and Design, 1989, 8pp., illus.

A brief introductory essay precedes biographies and illustrations of the work of the individual artists. All four artists work in Italy although Laplante was born in Canada. The exhibition arose from a specific wish to see the work of contemporary Italian women artists.

2328 VERDONE, MARIO. *Prosa e critica futurista.* Milan: Feltrinelli, 1973, 350pp.
Text in Italian. Concerned principally with the literature and criticism of Futurism. Two introductory essays are followed by an anthology of documents from the two phases of the movement. Most are short. Statements by three women—writer Maria Ginanni, artists Rosa Rosà and Benedetta—are included.

2329 VERGINE, LEA. *L'altra metà dell'avanguardia, 1910–40.* Milan: Mazzotta Editore 1980. French edition: *L'autre moitié de l'avant-garde, 1910–40.* Paris: Des Femmes, 1982, 313pp., illus.
Text in Italian. Includes over 100 women who were involved in the avant-garde groups in Europe. Organised around movements, it begins with the Blue Rider and ends with Surrealism. A large section on abstract art enables her to include those not directly connected to a movement.

2330 VON BONSDORF, BENGT. "Finnish painting from 1840–1940." *Apollo* (May 1982): 370–379.
A survey in which several of the better-known women are included.

2331 WARNER, MARINA, ET AL. *Women's Art at New Hall.* Cambridge: New Hall, 1992, 55pp., illus.
An exhibition of twentieth-century, and mostly post-1970, works donated by women artists to the permanent collection at New Hall, a women's college at Cambridge University. As Warner recounts in her introductory essay, Mary Kelly's *Extase,* a donation following her residency in Cambridge, was the catalyst for the formation of the collection. For practical reasons, all the works are two-dimensional so sculptors who are represented have usually submitted prints. Some artists from the earlier part of the century are also included.

2332 *Waves of Influence: cinco séculos do azulejjo português.* Staten Island, New York: Snug Harbor Cultural Center, 1995, 94pp., illus.
Text in Portuguese and English. After a survey of the history of the ceramic tile in Portugal, the exhibition focusses on the revival of the tradition in the twentieth century, partly through designers who have worked on projects for the Lisbon metro stations and partly through painters who have adapted their work to the format. About eight women are included.

2333 WEEKS, CHARLOTTE. "Women at Work: The Slade Girls." *Magazine of Art* 6 (1883): 324–329.
Discusses the educational opportunities and the activities of the women students at the Slade, which opened in 1871 and was one of the most progressive schools of art at which women could study.

2334 WEIMANN, JEANNE MADELEINE. *The Fair Women.* Chicago: Academy Press, 1981, 611pp., illus.

Examines the contribution of women to the World's Columbian Exposition of 1893. Several unique factors raised the profile of women's activity. There was a Women's Building where the artistic exhibits of women would be housed. For this building a competition was held among women architects. The organising committee consisted of several outstanding female organisers and fund-raisers. The interior of the building was decorated by women and included a mural by Mary Cassatt. The work of women from many countries was exhibited here and it is a useful reminder that international exhibiting was already established by this time.

2335 WICHSTRØM, ANNE. *Kvinner ved staffeliet. Kvinnelige malere I Norge før 1900.* Oslo: Universitetsforlaget, 1983, 176pp., illus.

Text in Norwegian. Seven chapters analyse the context and practice of women artists in Norway in the late nineteenth and early twentieth centuries. Topics covered include education, travel abroad particularly to Paris and Italy, the theme of self-portraits and subject matter more generally. At the end are biographical accounts of all the women artists encountered, in effect a biographical dictionary.

2336 WITZLING, MARA (ED.). *Voicing Our Visions: Writings by Women Artists.* New York: Universe Books, 1991 and London: Women's Press, 1992, 390pp., illus.

Consists of extracts from writings by twenty women artists, of whom nine are European or worked in Europe: Bonheur, Cassatt, Morisot, Bashikirtseff, Werefkin, Kollwitz, Modersohn-Becker, Hepworth and Leonora Carrington. Each extract is preceded by a lengthy biographical account which shows the development of her work and gives the context for the writings, which may be journals, autobiographies or letters. There is also a select bibliography for each.

2337 *Women's Images of Men.* London: Institute of Contemporary Art, 1980, n.p., illus.

An analytical essay by Lisa Tickner is followed by outline biographies, lists of exhibitions and, in some cases, a personal statement for each of the individuals. Produced by a collective, this exhibition aimed to reverse the gaze, although approaches were very varied.

2338 YABLONSKAYA, MIUDA. *Women Artists of Russia's New Age, 1900–1930.* London: Thames and Hudson, 1990, 248pp., illus. Trans. Anthony Parton.

Consists of a series of biographical accounts of women artists. In addition to the better-known figures of the revolutionary period there are informative sections on earlier and later figures. The author has chosen depth of treament rather than including a larger number of artists. There are useful individual bibliographies which include material in Russian.

INDIVIDUALS

2339 ABBEMA, LOUISE (1858–1927)
French painter of portraits, genre and allegory; companion of Sarah Bernhardt (q.v.).

Main Sources

Skinner, C. *Madame Sarah.* London: 1967.

Exhibitions

Sarah Bernhardt: 1844–1923. London: Ferrers Gallery, 1973, 40 pp., illus. Contains a biographical essay and notes on the works exhibited, which include some by Bernhardt's friends.

La Femme: peintre et sculpteur du XVIIe au XXe siècle. Paris: Grand Palais, 1975.

Fusco, Peter, and H. W. Janson. *The Romantics to Rodin: French Nineteenth Century Sculpture from N. American Collections.* Los Angeles: County Museum of Art in association with George Braziller Inc., 1980.

Beaulieu, Germaine, et al. *La femme artiste d'Elisabeth Vigée-Lebrun à Rosa Bonheur.* Lacoste: Musée Despiau-Wlerick et Dubalen Mont-de-Marsan, 1981. Includes a bibliography.

Other Sources

Cooper, Emmanuel. *The Sexual Perspective: Homosexuality and Art in the Last 100 Years in the West.* London: Routledge and Kegan Paul, 1986.

Dunford, Penny. *A Biographical Dictionary of Women Artists in Europe and America since 1850.* Hemel Hempstead: Harvester Wheatsheaf and Philadelphia: University of Pennsylvania Press, 1990. Contains a bibliography.

Edouard-Joseph, R. *Dictionnaire biographique des artistes contemporains, 1910–1930.* Paris: Art et Editions, 1930–1934.

Krichbaum, J., and R. Zondergeld. *Künstlerinnen: von der Antike bis zur Gegenwart.* Cologne: DuMont, 1979.

Martin, Jules. *Nos peintres et sculpteurs, graveurs et dessinateurs.* Paris: 1897.

2340 ACCARDI, CARLA (1924–)
Italian painter of abstract works.

Exhibitions

Italian Painting of Today. London: New Vision Art Centre, 1961.

Recent Italian Painting. New York: Jewish Museum, 1968.

Pasquali, Marilena. *Figure dallo sfondo.* Ferrara: Padiglione d'Arte Contemporanea and Grafis Editore, 1984.

Other Sources

Dunford, Penny. *A Biographical Dictionary of Women Artists in Europe and America since 1850.* Hemel Hempstead: Harvester Wheatsheaf and Philadelphia: University of Pennsylvania Press, 1990. Contains a bibliography.

Vergine, Lea. *L'altra metà dell'avanguardia.* Milan: Mazzotta Editore, 1980; *L'autre moitié de l'avant-garde, 1910–1940.* Paris: Des Femmes, 1982.

Weller, Simone. *Il Complesso di Michelangelo: ricerca sul contributo dato dalla donna all'arte italiana del novecento.* Pollenza-Macerata: La Nuova Foglio [*sic*] Editrice, 1976.

2341 ACHILLE-FOULD, GEORGES (Alt. FOULD) (1868–1951)
French painter of historical subjects, genre and portraits whose mother and sister were also artists.

Main Sources

Karageorgevich, Prince Bojidor. "Mlle. Achille-Fould." *Magazine of Art,* 1903, 341–345.

Other Sources

Clement, Clara. *Women in the Fine Arts.* Boston: Houghton Mifflin, 1904.

Dunford, Penny. *A Biographical Dictionary of Women Artists in Europe and America since 1850.* Hemel Hempstead: Harvester Wheatsheaf and Philadelphia: University of Pennsylvania Press, 1990. Contains a bibliography.

Edouard-Joseph, R. *Dictionnaire biographique des artistes contemporains, 1910–1930.* Paris: Art et Editions, 1930–1934.

Sparrow, Walter Shaw. *Women Painters of the World.* London: Hodder and Stoughton, 1905.

2342 ADSHEAD, MARY (1904–1995)
English mural painter, illustrator and graphic artist.

Publications

Adshead, Mary, and Stephen Bone. *Travelling with a Sketchbook: A Guide to Carry on a First Sketching Holiday.* London: Adam and Charles Black, 1966.
The Little Boy and his House. London, 1936.
The Silly Snail. London, 1942.
The Little Boys and their Boats. London, 1953.

Main Sources

Powers, Alan. "Mary Adshead: Art on a Grand Scale." *The Guardian,* 7 September 1995. Obituary.

Exhibitions

Deepwell, Katy. *Ten Decades: Careers of Ten Women Artists born 1897–1906.* Norwich: Norwich Gallery, Norfolk Institute of Art and Design, 1992.

Other Sources

Dunford, Penny. *A Biographical Dictionary of Women Artists in Europe and America since 1850.* Hemel Hempstead: Harvester Wheatsheaf and Philadelphia: University of Pennsylvania Press, 1990. Contains a bibliography.

2343 AGAR, EILEEN FORRESTER (1899–1991)
English Surrealist painter and mixed media artist.

Publications

A Look at my Life. London: Methuen, 1988, 244pp., illus. Autobiography, the writing of which was assisted by Andrew Lambirth.
"A movement of the spirit." *The Artists and Illustrators Magazine* 25 (October 1988): 14–17.

Main Sources

"Eileen Agar." *The Independent,* 19 November 1991, 18. Obituaries.
Ades, Dawn. "Notes on two women Surrealist painters." *Oxford Art Journal* 3 (April 1980).
Chadwick, Whitney. *Women Artists and the Surrealist Movement.* London: Thames and Hudson, 1985.
Grimes, Teresa, Judith Collins, and Oriana Baddeley. *Five Women Painters.* London: Channel Four in Association with the Arts Council of Great Britain and Lennard Publishing, 1989. Reprint 1991.Contains a perceptive analysis of Agar's work and a bibliography.

Exhibitions

Eileen Agar retrospective, London: Commonwealth Art Gallery, 1971 with introduction by Roland Penrose.
Dada and Surrealism reviewed. London: Hayward Gallery, 1978.
Salute to British Surrealism. Colchester: Minories Gallery, 1985.
Eileen Agar: A Retrospective. London: Birch and Conran Gallery, 1987, n.p., illus. Contains a biographical essay by Andrew Lambirth, who assisted with the autobiography.
Hedley, Gill. *Let Her Paint.* Southampton: City Art Gallery, 1988.
The Surrealist Spirit in Britain. London: Whitford and Hughes Gallery, 1988.
Eileen Agar. London: Birch and Conran, 1990.
Deepwell, Katy. *Ten Decades: Careers of Ten Women Artists Born 1897–1906.* Norwich: Norwich Gallery, Norfolk Institute of Art and Design, 1992.

Other Sources

Chadwick, Whitney. *Women Artists and the Surrealist Movement.* London: Thames & Hudson, 1985.

Dunford, Penny. *A Biographical Dictionary of Women Artists in Europe and America since 1850.* Hemel Hempstead: Harvester Wheatsheaf and Philadelphia: University of Pennsylvania Press, 1990. Contains a bibliography.

Vergine, Lea. *L'altra metà dell'avanguardia.* Milan: Mazzotta Editore, 1980; *L'autre moitie de l'avant-garde, 1910–1940.* Paris: Des Femmes, 1982.

2344 AIJA, ZARINA (1954–)
Latvian painter and graphic artist.

Main Sources

Aija. Riga: Jana Seta, 1989, 62pp., mainly illus. Text in Latvian.

2345 AIRY, ANNA (1882–1964)
English painter and etcher.

Publications

The Art of Pastel. London, 1930.
Making a Start in Art. London, 1951.

Other Sources

Bennett, Chloe. *Suffolk Artists, 1750–1930. Paintings from the Ipswich Borough Museum and Galleries Collections.* Woolpit, Suffolk: Images Publications, 1991.

Burbidge, R. Brinsley. *Dictionary of British Flower, Fruit and Still Life Painters.* Leigh-on-Sea: F. Lewis, 1974.

Dunford, Penny. *A Biographical Dictionary of Women Artists in Europe and America since 1850.* Hemel Hempstead: Harvester Wheatsheaf and Philadelphia: University of Pennsylvania Press, 1990. Contains a bibliography.

2346 AKHVLEDIANI, ELENA (1901–1979)
Georgian early modernist painter who studied for a time in Paris.

Other Sources

Rosenfeld, Alla, and Norton Dodge, eds. *Nonconformist Art: The Soviet Experience, 1956–1986. The Norton and Nancy Dodge Collection.* London: Thames and Hudson in association with the Jane Voorhees Zimmerli Art Museum, State University of New Jersey, Rutgers, 1995.

2347 ALEXEYEVA, OLGA VIKTOROVNA (1895–?)
Russian painter and graphic artist.

Exhibitions

Paris-Moscou 1900–1930. Paris: Centre national d'art et de culture Georges Pompidou, 1979.

Other Sources

Aguitatsionno-massovoe iskusstvo pervykh let Oktiabria [Art of the masses and propaganda art in the first years of October]. Moscow, 1971, pp. 88–124.

Milner, John. *A Dictionary of Russian and Soviet Artists, 1420–1970.* Woodbridge: Antique Collectors Club, 1993.

2348 ALLAR, MARGUÉRITE (1899–1974)
French painter of still life, genre and landscapes; founder of the Académie d'Art Moderne at Marseille.

Other Sources

Alauzon di Genova, André. *La Peinture en Provence.* Marseille: J. Lafitte, 1984.

2349 ALLINGHAM, HELEN (née PATERSON) (1848–1926)
English painter and graphic artist who specialised in depicting idealised rural life; niece of painter Laura Herford (q.v.)

Main Sources

Dyer, Laura. "Mrs Allingham." *The Art Journal,* 1888, 198–201.

Huish, Marcus. *The Happy England of Helen Allingham.* London: Adam and Charles Black, 1903. Reprint. London: Bracken Books, 1985, 204pp., 80 illus. by Allingham. A biographical account with some criticism in the late-Victorian manner.

Neve, C. "Mrs Allingham's Cottage Gardens." *Country Life* 155: 632–633.

Exhibitions

Casteras, Susan, and Linda H. Peterson. *A Struggle for Fame: Victorian Women Artists and Authors.* New Haven, Conn.: Yale Center for British Art, 1994.

Other Sources

Bachmann, D., and S. Piland. *Women Artists: A Historical, Contemporary and Feminist Bibliography.* Metuchen, N.J.: Scarecrow Press, 1978.

Cherry, Deborah. *Painting Women. Victorian Women Artists.* London: Routledge, 1993.

Clayton, Ellen. *English Female Artists.* London: Tinsley, 1876.

Clement, Clara. *Women in the Fine Arts.* Boston: Houghton Mifflin, 1904.

Dunford, Penny. *A Biographical Dictionary of Women Artists in Europe and America since 1850.* Hemel Hempstead: Harvester Wheatsheaf and Philadelphia:

University of Pennsylvania Press, 1990. Contains a bibliography.

Nunn, Pamela Gerrish. *Victorian Women Artists.* London: Women's Press, 1987.

Sparrow, Walter Shaw. *Women Painters of the World.* London: Hodder and Stoughton, 1905.

Wood, Christopher. *Dictionary of Victorian Painters.* Woodbridge: Antique Collectors Club, 1978.

2350 ALLI, AINO SOPHIA (née NEUMANN) (1879–?)
Finnish painter of portraits and miniatures.

Other Sources

Edouard-Joseph, R. *Dictionnaire biographique des artistes contemporains, 1910–1930.* Paris: Art et Editions, 1930–1934.

2351 ALMA-TADEMA, LAURA (née EPPS) (1852–1909)
English painter of portraits, genre, landscapes and flowers.

Main Sources

Clayton, Ellen. *English Female Artists.* London: Tinsley, 1876.

Meynell, Alice. "Laura Alma-Tadema." *The Art Journal,* 1883, 345–347. Recounts how she took up art and identifies her characteristics.

Other Sources

Bachmann, D., and S. Piland. *Women Artists: A Historical, Contemporary and Feminist Bibliography.* Metuchen, N.J.: Scarecrow Press, 1978.

Cherry, Deborah. *Painting Women. Victorian Women Artists.* London: Routledge, 1993.

Clement, Clara. *Women in the Fine Arts.* Boston: Houghton Mifflin, 1904.

Dunford, Penny. *A Biographical Dictionary of Women Artists in Europe and America since 1850.* Hemel Hempstead: Harvester Wheatsheaf and Philadelphia: University of Pennsylvania Press, 1990. Contains a bibliography.

Edouard-Joseph, R. *Dictionnaire biographique des artistes contemporains, 1910–1930.* Paris: Art et Editions, 1930–1934.

Greer, Germaine. *The Obstacle Race.* London: Secker and Warburg, 1979.

Lexikon der Frau. Zurich: Encyclios Verlag, 1953.

Sparrow, Walter Shaw. *Women Painters of the World.* London: Hodder and Stoughton, 1905.

Wood, Christopher. *Dictionary of Victorian Painters.* Woodbridge: Antique Collectors Club, 1978.

2352 ANCHER, ANNA KIRSTINE (née BRONDUM) (1859–1935)
Danish painter of interiors and figures, mostly from the small fishing community of Skagen where she spent her life.

Exhibitions

Dreams of a Summer Night. London: Hayward Gallery, 1985.
Nordisk Sekelskifte: The Light of the North. Stockholm: Nationalmuseum, 1995.

Other Sources

Clement, Clara. *Women in the Fine Arts.* Boston: Houghton Mifflin, 1904.
Dunford, Penny. *A Biographical Dictionary of Women Artists in Europe and America since 1850.* Hemel Hempstead: Harvester Wheatsheaf and Philadelphia: University of Pennsylvania Press, 1990. Contains a bibliography.
Edouard-Joseph, R. *Dictionnaire biographique des artistes contemporains, 1910–1930.* Paris: Art et Editions, 1930–1934.
Krichbaum, J., and R. Zondergeld. *Künstlerinnen: von der Antike bis zur Gegenwart.* Cologne: DuMont, 1979.

2353 ANDERSON, SOPHIE (née GENGEMBRE) (1823–c. 1898)
French-born painter of portraits and genre who worked mainly in England.

Main Sources

Clayton, Ellen. *English Female Artists.* London: Tinsley, 1876.

Exhibitions

Sellars, Jane. *Women's Work.* Liverpool: Walker Art Gallery, 1988.
Casteras, Susan, and Linda H. Peterson. *A Struggle for Fame: Victorian Women Artists and Authors.* New Haven, Conn.: Yale Center for British Art, 1994.

Other Sources

Bachmann, D., and S. Piland. *Women Artists: A Historical, Contemporary and Feminist Bibliography.* Metuchen, N.J.: Scarecrow Press, 1978.
Clement, Clara. *Women in the Fine Arts.* Boston: Houghton Mifflin, 1904.
Dunford, Penny. *A Biographical Dictionary of Women Artists in Europe and America since 1850.* Hemel Hempstead: Harvester Wheatsheaf and Philadelphia: University of Pennsylvania Press, 1990. Contains a bibliography.
Sparrow, Walter Shaw. *Women Painters of the World.* London: Hodder and Stoughton, 1905.
Wood, Christopher. *Dictionary of Victorian Painters.* Woodbridge: Antique Collectors Club, 1978.

2354 ANGELL, HELEN CORDELIA (née COLEMAN) (1847–1884)
English painter of flowers, fruit and birds.

Main Sources

Clayton, Ellen. *English Female Artists.* London: Tinsley, 1876.

Exhibitions

Women's Art Show, 1550–1970. Nottingham: Castle Museum, 1982. Contains a brief biography.

Other Sources

Cherry, Deborah. *Painting Women: Victorian Women Artists.* London: Routledge, 1993.

Mallalieu, Hugh. *Dictionary of British Watercolour Artists.* Woodbridge: Antique Collectors Club, 1976.

Sparrow, Walter Shaw. *Women Painters of the World.* London: Hodder and Stoughton, 1905.

2355 ANGELOTTI, SILVIA (1936–)
Italian abstract painter.

Other Sources

Weller, Simone. *Il Complesso di Michelangelo: ricerca sul contributo dato dalla donna all'arte italiana del novecento.* Pollenza-Macerata: La Nuova Foglio [*sic*] Editrice, 1976.

2356 ANGELUCCI, LEANDRA (c. 1895–after 1976)
Italian painter who was involved in the later stages of the Futurist movement.

Other Sources

Weller, Simone. *Il Complesso di Michelangelo: ricerca sul contributo dato dalla donna all'arte italiana del novecento.* Pollenza-Macerata: La Nuova Foglio [*sic*] Editrice, 1976.

2357 ANGUS, PEGGY (née MARGARET McGREGOR ANGUS) (1904–1993)
English painter, graphic artist and designer; also a teacher.

See Graphic Arts section.

2358 ANNA, MARGIT (1913–)
Hungarian painter who combines Surrealism and motifs from folk art.

Other Sources

Hárs, Éva, and Ferenc Romváry. *Modern Hungarian Gallery Pécs.* Budapest: Corvina Kiadó, 1981.

Németh, Lajos. *Modern Art in Hungary.* Budapest: Corvina Press, 1969.

2359 ANNOT (Pseudonym of ANNA OTTILIE KRIGAR-MENZEL; alt. JACOBI) (1894–1981)
German figurative painter who worked for pacifism.

Publications

"Die Frau als Malerin." In *Die Kultur der Frau,* ed. A. Schmidt-Weil. Berlin, 1931.

Exhibitions

Künstlerinnen International, 1877–1977. Berlin: Schloss Charlottenburg, 1977.
Das Verborgene Museum. Dokumentation der Kunst de Frauen in Berliner offentlichen Sammlungen. Berlin: Edition Hentrich, 1987.

Other Sources

Dunford, Penny. *A Biographical Dictionary of Women Artists in Europe and America since 1850.* Hemel Hempstead: Harvester Wheatsheaf and Philadelphia: University of Pennsylvania Press, 1990. Contains a bibliography.
Krichbaum, J., and R. Zondergeld. *Künstlerinnen: von der Antike bis zur Gegenwart.* Cologne: DuMont, 1979.

2360 ANSINGH, LIZZY (née MARIA ELIZABETH GEORGINA ANSINGH) (1875–1959)
Dutch painter of portraits and still lifes.

Main Sources

Venema, A. *Die Amsterdamse Joffers.* Baarn, 1977.

Other Sources

Dunford, Penny. *A Biographical Dictionary of Women Artists in Europe and America since 1850.* Hemel Hempstead: Harvester Wheatsheaf and Philadelphia: University of Pennsylvania Press, 1990. Contains a bibliography.
Krichbaum, J., and R. Zondergeld. *Künstlerinnen: von der Antike bis zur Gegenwart.* Cologne: DuMont, 1979.

2361 ANTALOVÁ, ELVÍRA (1924–)
Czech painter.

Exhibitions

Obraz 69. Brno: Moravská Galerie, 1969.

2362 ARENDRUP, EDITH (née COURTAULD) (1846–?)
English painter of landscapes and religious subjects.

Main Sources

Clayton, Ellen. *English Female Artists.* London: Tinsley, 1876.

Other Sources

Dunford, Penny. *A Biographical Dictionary of Women Artists in Europe and America since 1850.* Hemel Hempstead: Harvester Wheatsheaf and Philadelphia: University of Pennsylvania Press, 1990. Contains a bibliography.
Krichbaum, J., and R. Zondergeld. *Künstlerinnen: von der Antike bis zur Gegenwart.* Cologne: DuMont, 1979.
Lexikon der Frau. Zurich: Encyclios Verlag, 1953.
Wood, Christopher. *Dictionary of Victorian Painters.* Woodbridge: Antique Collectors Club, 1978.

2363 ARMOUR, MARY NICOL NEILL (née STEEL) (1902–)
Scottish painter of flowers and landscapes.

Exhibitions

Centenary Exhibition of the Society of Lady Artists. Glasgow: Society of Women Artists, 1982.
Billcliffe, Roger. *Mary Armour: A Retrospective Exhibition.* Edinburgh: Fine Art Society, 1986, n.p. Short biographical essay and a chronology.
Burkhauser, Jude. *Glasgow Girls: Women in Art and Design 1880–1920.* Edinburgh: Canongate, 1990.

Other Sources

Dunford, Penny. *A Biographical Dictionary of Women Artists in Europe and America since 1850.* Hemel Hempstead: Harvester Wheatsheaf and Philadelphia: University of Pennsylvania Press, 1990.

2364 ARNESEN, BORGHILD (1872–1950)
Norwegian painter of figures.

Other Sources

Dunford, Penny. *A Biographical Dictionary of Women Artists in Europe and America since 1850.* Hemel Hempstead: Harvester Wheatsheaf and Philadelphia: University of Pennsylvania Press, 1990. Contains a bibliography.

Krichbaum, J., and R. Zondergeld. *Künstlerinnen: von der Antike bis zur Gegenwart.* Cologne: DuMont, 1979.

2365 ARNIM, BETTINA (Alt. VON ARNIM) (1940–)
German painter of fantastic images, often including robots and machinery, who works in France.

Exhibitions

Das Verborgene Museum. Dokumentation der Kunst von Frauen in Berliner öffentlichen Sammlungen. Berlin: Edition Hentrich, 1987.

Other Sources

Dunford, Penny. *A Biographical Dictionary of Women Artists in Europe and America since 1850.* Hemel Hempstead: Harvester Wheatsheaf and Philadelphia: University of Pennsylvania Press, 1990.

Evers, Ulrike. *Deutsche Künstlerinnen des 20. Jahrhunderts. Malerei—Bildhauerei—Tapisserie.* Hamburg: Ludwig Schultheis Verlag, 1983.

Krichbaum, J., and R. Zondergeld. *Künstlerinnen: von der Antike bis zur Gegenwart.* Cologne: DuMont, 1979.

2366 AROSA, MARGARITA (1852–?)
Spanish painter who included female nudes among her subjects.

Other Sources

Diego, Estrella de. *La mujer y la pintura del XIX español: cuatrocientes olvidadas y algumas más.* Madrid: Cátedra, 1987.

2367 ASCHEHOUG, DINA (1861–1956)
Norwegian painter.

Other Sources

Wichstrøm, Anne. *Kvinner ved staffeliet: Kvinnelige malere i Norge før 1900.* Oslo: Universitetsforlaget, 1983.

2368 ASSE, GENEVIÈVE (1923–)
French graphic artist and painter.

See Graphic Art section.

2369 ATWOOD, CLARE (1866–1962)
English painter of still life, interiors, portraits and flowers.

Other Sources

Dunford, Penny. *A Biographical Dictionary of Women Artists in Europe and America since 1850.* Hemel Hempstead: Harvester Wheatsheaf and Philadelphia: University of Pennsylvania Press, 1990. Contains a bibliography.

Waters, Grant. *Dictionary of British Artists Working 1900–1940.* Eastbourne: Eastbourne Fine Art, 1975.

2370 AUTSEMA, BERNIE (1940–)
Dutch abstract painter.

Exhibitions

De Vrouw in de kunst. Leiden: Pand Caecilia, 1987.

2371 AUZA, LIDIJA (1914–)
Latvian painter of landscapes.

Other Sources

Rosenfeld, Alla, and Norton Dodge, eds. *Nonconformist Art: The Soviet Experience, 1956–1986.The Norton and Nancy Dodge Collection.* London: Thames and Hudson in association with the Jane Voorhees Zimmerli Art Museum, State University of New Jersey, Rutgers, 1995.

2372 AUZOU, PAULINE (née JEANNE-MARIE CATHERINE DEMAR-QUETS) (1775–1835)
French painter of genre and portraits who exhibited from 1793 to 1820 and taught for twenty years.

Main Sources

Cameron, Vivian. "Portrait of a Musician by Pauline Auzou." *Currier Gallery of Art Bulletin* 2 (1974): 1–17.

Exhibitions

Harris, Anne Sutherland, and Linda Nochlin. *Women Artists 1550–1950.* Los Angeles: County Museum of Art, 1976.

Beaulieu, Germaine, et al. *La femme artiste d'Elisabeth Vigée-Lebrun à Rosa Bonheur.* Lacoste: Musée Despiau-Wlerick et Dubalen Mont-de-Marsan, 1981. Includes a bibliography.

Other Sources

Clement, Clara. *Women in the Fine Arts.* Boston: Houghton Mifflin, 1904.

Gabet, Charles. *Dictionnaire des artistes de l'école française au XIXe siècle.* Paris: Verge, 1831.

2373 AYRES, GILLIAN (1930–)
English painter of highly coloured abstract works.

Exhibitions

British Painting in the 60s. London: Tate Gallery and Whitechapel Art Gallery, 1963.
British Painting 1952–1977. London: Royal Academy, 1977.
Rippon, P. *Gillian Ayres.* Cambridge: Kettle's Yard, 1978.
Hilton, Tim. *Gillian Ayres.* London: Serpentine Gallery, 1983, 40pp., mainly illus. Introduction by Tim Hilton. Contains a biographical outline.
Current Affairs. Oxford: Museum of Modern Art, 1987. Contains a bibliography.
Mellor, David. *The Sixties Art Scene in London.* London: Barbican Art Gallery in association with Phaidon Press, 1993.
Gillian Ayres. London: Royal Academy, 1997, 48pp., mainly illus.

Other Sources

Dunford, Penny. *A Biographical Dictionary of Women Artists in Europe and America since 1850.* Hemel Hempstead: Harvester Wheatsheaf and Philadelphia: University of Pennsylvania Press, 1990. Contains a bibliography.

2374 BACKER, HARRIET (1845–1932)
Norwegian painter of interiors, figure subjects and still lifes in which the play of light is the central feature.

Main Sources

Kielland, Else. *Harriet Backer.* Oslo: Aschehoug, 1958.
Vishny, M. "Harriet Backer: A Northern Light." *Arts Magazine* 59 (May 1983): 78–80.
Wichstrøm, Anne. *Kvinner ved staffeliet.* Oslo: Universtetsforlaget, 1983.

Exhibitions

Kvinnor som målat. Stockholm: Nationalmuseum, 1975.
Lange, Marit. *Harriet Backer 1845–1932: Kitty Kielland 1843–1914.* Blaafarvevaerk: Stifelsen modums, 1983, 68pp., illus. Text in Norwegian. After an introductory essay, there are detailed entries for each of the seventy-four exhibits and a chronology for each artist.
Dreams of a Summer Night. London: Hayward Gallery, 1985.
Wichstrøm, Anne. *Rooms with a View: Women's Art in Norway, 1880–1990.* Oslo: Ministry of Foreign Affairs, 1989.
Fisher, Susan Sterling, Anne Wichstrøm, and Toril Smit. *At Century's End: Norwegian Artists and the Figurative Tradition, 1880–1990.* Høvikodden: Henie-Onstad Art Centre, 1995. Includes a list of exhibitions and an individual bibliography.

Nordisk Sekelskifte: The Light of the North. Stockholm: Nationalmuseum, 1995.

Other Sources

Dunford, Penny. *A Biographical Dictionary of Women Artists in Europe and America since 1850.* Hemel Hempstead: Harvester Wheatsheaf and Philadelphia: University of Pennsylvania Press, 1990.

Krichbaum, J., and R. Zondergeld. *Künstlerinnen: von der Antike bis zur Gegenwart.* Cologne: DuMont, 1979.

2375 BACKHOUSE, MARGARET (née HOLDEN) (1818–after 1885)

English painter of figure subjects often set in Italy and Switzerland.

Main Sources

Clayton, Ellen. *English Female Artists.* London: Tinsley, 1876.

Other Sources

Dunford, Penny. *A Biographical Dictionary of Women Artists in Europe and America since 1850.* Hemel Hempstead: Harvester Wheatsheaf and Philadelphia: University of Pennsylvania Press, 1990.

Wood, Christopher. *The Dictionary of Victorian Painters.* Woodbridge: Antique Collectors Club, 1978.

2376 BADIALI, CARLA (1907–)

Italian painter of abstracts.

Exhibitions

Künstlerinnen International, 1877–1977. Berlin: Schloss Charlottenburg, 1977.

Anni trenta: Arte e cultura in Italia. Milan: Comune di Milano in association with Mazzotta Editore, 1982.

Vergine, Lea. *L'altra metà dell'avanguardia.* Milan: Mazzotta Editore, 1980.

L'autre moitié de l'avant-garde. Paris: Des Femmes, 1982.

Other Sources

Dunford, Penny. *A Biographical Dictionary of Women Artists in Europe and America since 1850.* Hemel Hempstead: Harvester Wheatsheaf and Philadelphia: University of Pennsylvania Press, 1990.

Weller, Simone. *Il Complesso di Michelangelo: ricerca sul contributo dato dalla donna all'arte italiana del novecento.* Pollenza-Macerata: La Nuova Foglio [*sic*] Editrice, 1976.

2377 BAGGE, EVA (1871–?)

Swedish painter of interiors, landscapes and portraits.

Main Sources

Boethius, Gerda. *Eva Bagges Konst. Ett urval Målningar inledning av Gerda Boethius*. Stockholm: Nordisk Rotogravyr, 1944, 38pp., illus. Text in Swedish. Contains a biographical essay on the development of her work.

Exhibitions

Kvinnor som målat. Stockholm: Nationalmuseum, 1975.

Other Sources

Ingelman, Ingrid. *Kvinuliga konstnarer i Sverige en undersokning av Elever vid konstakademin Inskriva 1864–1924*. Uppsala: Almquist & Wiksell, 1982.

2378 BAILLY, ALICE (1872–1938)
 Swiss figurative painter in a style which was a synthesis of Cubism, Fauvism and Futurism.

Main Sources

Butler, J. "Alice Bailly: Cubo-Futurist Pioneer." *Oxford Art Journal* 3 (April 1980): 52–55.
Vergine, Lea. *L'altra metà dell'avanguardia*. Milan: Mazzotta Editore, 1980. *L'autre moitié de l'avant-garde*. Paris: Des Femmes, 1982.

Exhibitions

Stutzer, Beat. *Künstlergruppen in der Schweiz, 1910–1936*. Aarau: Aargauer Kunsthaus, 1981.

Other Sources

Dunford, Penny. *A Biographical Dictionary of Women Artists in Europe and America since 1850*. Hemel Hempstead: Harvester Wheatsheaf and Philadelphia: University of Pennsylvania Press, 1990.
National Museum of Women in the Arts: Catalogue of the Permanent Collection. New York: Harry Abrams Inc., 1987.
Perry, Gill. *Women Artists and the Parisian Avant-Garde*. Manchester: Manchester University Press, 1995.

2379 BALODE, LAILA (1959–)
 Latvian painter.

Exhibitions

8. Baltijas Republiku Akvareļu Izstāde: Katalogs. Riga, 1989.

2380 BARBARIGO, IDA (1925–)
Italian figurative painter who works in France.

Main Sources

De Solier, René. *Chaise et voyeurs de Ida Barbarigo.* Venice: Alfieri, 1970.

Exhibitions

Barbarigo: peintures. Paris: Musée d'Art Moderne de la Ville de Paris, 1972.
Clair, Jean, and Ida Barbarigo. *Ida Barbarigo.* Munich: Bayerische
Staatsgemäldesammlungen, 1982.

Other Sources

Ceysson, B., et al. *25 ans d'art en France, 1960–1985.* Paris: Larousse, 1986.
Includes a select list of exhibitions for each artist.
Weller, Simone. *Il Complesso di Michelangelo: ricerca sul contributo dato
dalla donna all'arte italiana del novecento.* Pollenza-Macerata: La Nuova Foglio
[*sic*] Editrice, 1976.

2381 BARDEY, JEANNE (1872–1954)
French sculptor and painter of portraits and, more rarely, flowers.

See Sculpture section.

2382 BARDUA, CAROLINE (1781–1864)
German painter.

Exhibitions

*Das Verborgene Museum. Dokumentation der Kunst von Frauen in Berliner
öffentlichen Sammlungen.* Berlin: Edition Hentrich, 1987.

2383 BARFUSS, INA (1949–)
German painter.

Exhibitions

*Das Verborgene Museum. Dokumentation der Kunst von Frauen in Berliner
öffentlichen Sammlungen.* Berlin: Edition Hentrich, 1987.

2384 BARNS-GRAHAM, WILHEMINA (1912–)
Scottish painter of semi-abstract landscapes.

Exhibitions

Bowness, Alan. *Wilhemina Barns-Graham.* Edinburgh: Scottish Gallery,
1956.

Cornwall 1945–1955. London: New Art Centre, 1977.
Jackson, W. *Wilhemina Barns-Graham*. St. Andrews: Crawford Centre, 1982.
St. Ives 1939–64. London: Tate Gallery, 1985.

Other Sources

Dunford, Penny. *A Biographical Dictionary of Women Artists in Europe and America since 1850*. Hemel Hempstead: Harvester Wheatsheaf and Philadelphia: University of Pennsylvania Press, 1990.

2385 BARRY, MOYRA A. (1886–1960)
 Irish painter of still-life, landscapes, genre and portraits.

Exhibitions

Irish Women Artists from the Eighteenth Century to the Present Day. Dublin: National Gallery of Ireland, Douglas Hyde Gallery and Hugh Lane Gallery, 1987.

2386 BARTHOLOMEW, ANNE CHARLOTTE (née FAYERMANN; alt. TURN-
 BULL) (1800–1862)
 English painter of genre, allegory and still life.

Main Sources

Clayton, Ellen. *English Female Artists*. London: Tinsley, 1876.

Other Sources

Cherry, Deborah. *Painting Women: Victorian Women Artists*. London: Routledge, 1993.
Dunford, Penny. *A Biographical Dictionary of Women Artists in Europe and America since 1850*. Hemel Hempstead: Harvester Wheatsheaf and Philadelphia: University of Pennsylvania Press, 1990.
Mallalieu, Hugh. *Dictionary of British Watercolour Artists*. Woodbridge: Antique Collectors Club, 1976.
Nunn, Pamela Gerrish. *Victorian Women Artists*. London: Women's Press, 1987.
Wood, Christopher. *The Dictionary of Victorian Painters*. Woodbridge: Antique Collectors Club, 1978.

2387 BARTOLETTI-VISSÀ, ELISA (1832–c.1912)
 Italian painter.

Exhibitions

Baraldi Anna, and Francesca Mellone. *4a Biennale Donna—1990. Presenze femminili nella vita artistica a Ferrara tra Ottocento e Novecento*. Ferrara: Palazzo dei Diamanti, 1990.

2388 BARTON, ROSE MAYNARD (1856–1929)
Irish painter of landscapes and city scenes.

Publications

Familiar London. London, 1904.

Exhibitions

Irish Women Artists from the Eighteenth Century to the Present Day. Dublin:
National Gallery of Ireland, Douglas Hyde Gallery and Hugh Lane Gallery, 1987.

Other Sources

De Breffny, Brian, ed. *Ireland: A Cultural Encyclopaedia.* London: Thames
and Hudson, 1983.
Dunford, Penny. *A Biographical Dictionary of Women Artists in Europe and
America since 1850.* Hemel Hempstead: Harvester Wheatsheaf and Philadelphia:
University of Pennsylvania Press, 1990.
Mallalieu, Hugh. *Dictionary of British Watercolour Artists.* Woodbridge:
Antique Collectors Club, 1976.
Sparrow, Walter Shaw. *Women Painters of the World.* London: Hodder and
Stoughton, 1905.

2389 BASHKIRTSEFF, MARIE (1858–1884)
Russian-born painter of figure subjects who lived in Paris.

Publications

Theuriet, A., ed. *Le Journal de Marie Bashkirtseff.* 2 vols. Paris, 1887. There
are various English translations from 1890 but one of the most recent is Parker,
Roszika, and Griselda Pollock, eds. *The Journal of Marie Bashkirtseff.* Translated
by Mathilde Blind. London: Virago, 1985, 716pp. The new introduction allows a
feminist perspective to be applied to Bashkirtseff.

Main Sources

Blind, Mathilde. "A Study of Marie Bashkirtseff." in A. Theuriet, *Jules
Bastien-Lepage and his Art: A Memoir,* 149–190. London: 1892.
Breakell, M. L. "Marie Bashkirtseff: The Reminiscence of a Fellow Student."
Nineteenth Century and After 62 (1904): 110–125.
Cahuet, A. *Moussia: ou la vie et la mort de Marie Bashkirtseff.* Paris, 1926.
Garb, Tamar. "Unpicking the Seams of her Disguise: Self-Representation in
the Case of Marie Bashkirtseff." *Block* 13 (winter 1987–1988): 79–86.
Parker, Roszika. "Portrait of the Artist as a Young Woman." *Spare Rib* 30
(April 1975): 32–35.

Exhibitions

Harris, Anne Sutherland, and Linda Nochlin. *Women Artists 1550–1950.* Los Angeles: County Museum of Art, 1976.

Fehrer, Catherine. *The Julian Academy, Paris, 1868–1939.* New York: Shepherd Gallery, 1989.

Other Sources

Clement, Clara. *Women in the Fine Arts.* Boston: Houghton Mifflin, 1904.

Dunford, Penny. *A Biographical Dictionary of Women Artists in Europe and America since 1850.* Hemel Hempstead: Harvester Wheatsheaf and Philadelphia: University of Pennsylvania Press, 1990. Contains a bibliography.

Greer, Germaine. *The Obstacle Race.* London: Secker and Warburg, 1979.

Sparrow, Walter Shaw. *Women Painters of the World.* London: Hodder and Stoughton, 1905.

2390 BAUCK, JEANNA MARIA CHARLOTTA (1846–1925)
Swedish-born painter of landscapes and portraits who worked in Germany.

Main Sources

Hagen, Luise. "Lady Artists in Germany." *International Studio* 4 (1898): 91–99.

Exhibitions

Kvinnor som målat. Stockholm: Nationalmuseum, 1975.

Other Sources

Clement, Clara. *Women in the Fine Arts.* Boston: Houghton Mifflin, 1904.

Dunford, Penny. *A Biographical Dictionary of Women Artists in Europe and America since 1850.* Hemel Hempstead: Harvester Wheatsheaf and Philadelphia: University of Pennsylvania Press, 1990. Contains a bibliography.

Sparrow, Walter Shaw. *Women Painters of the World.* London: Hodder and Stoughton, 1905.

2391 BAUDRY DE BALZAC, CAROLINE CATHERINE (Alt. CERRÈS) (1798–1844)
French painter of flowers who was for a time the drawing teacher at the Légion d'Honneur School; niece of Thérèse Baudry de Balzac (q.v.).

Other Sources

Hardouin-Fugier, Elizabeth, and E. Grafe. *French Flower Painters of the Nineteenth Century: A Dictionary.* London: Philip Wilson, 1989.

2392 BAUDRY DE BALZAC, THÉRSE ANTOINETTE (1774–1831)
French painter of flowers who carried out ninety-nine botanical drawings on vellum for the Natural History Museum in Paris and taught drawing at the Légion d'Honneur School in Paris; aunt of Caroline (q.v.).

Other Sources

Hardouin-Fugier, Elizabeth, and E. Grafe. *French Flower Painters of the Nineteenth Century: A Dictionary.* London: Philip Wilson, 1989.

2393 BAUER-PEZELLAN, TINA (1897–)
German figurative painter whose work was declared degenerate by the Nazis.

Exhibitions

Meskimmon, Marsha. *Domesticity and Dissent: The Role of Women Artists in Germany 1918–1938. Haüsliches Leben und Dissens.* Leicester: Leicestershire Museums Publication no. 120, 1992.

2394 BAUER-STUMPF, JO (née STUMPF) (1873–1964)
Dutch painter of portraits and still lifes.

Main Sources

Venema, A. *Die Amsterdamse Joffers.* Baarn, 1977.

Other Sources

Dunford, Penny. *A Biographical Dictionary of Women Artists in Europe and America since 1850.* Hemel Hempstead: Harvester Wheatsheaf and Philadelphia: University of Pennsylvania Press, 1990. Contains a bibliography.
Krichbaum, J., and R. Zondergeld. *Künstlerinnen: von der Antike bis zur Gegenwart.* Cologne: DuMont, 1979.

2395 BEAURY-SAUREL, AMÉLIE (Alt. JULIAN) (1848–1924)
French painter of portraits, genre and literary subjects who ran the Académie Julian in Paris after the death of her husband.

Exhibitions

Fehrer, Catherine. *The Julian Academy, Paris, 1868–1939.* New York: Shepherd Gallery, 1989.

Other Sources

Clement, Clara. *Women in the Fine Arts.* Boston: Houghton Mifflin, 1904.
Dunford, Penny. *A Biographical Dictionary of Women Artists in Europe and*

America since 1850. Hemel Hempstead: Harvester Wheatsheaf and Philadelphia: University of Pennsylvania Press, 1990. Contains a bibliography.

Edouard-Joseph, R. *Dictionnaire biographique des artistes contemporains, 1910–1930.* Paris: Art et Editions, 1930–1934.

Martin, Jules. *Nos peintres et sculpteurs, graveurs et dessinateurs.* Paris, 1897.

Yeldham, Charlotte. *Women Artists in Nineteenth Century France and England.* London and New York: Garland, 1984.

2396 BEBUTOVA, ELENA MIKHAILOVNA (Alt. BEBUTOVA-KUZNETSO-VA) (1892–1970)
Russian painter and theatre designer.

Other Sources

Milner, John. *A Dictionary of Russian and Soviet Artists, 1420–1970.* Woodbridge: Antique Collectors Club, 1993.

2397 BEERNAERTS, EUPHROSINE (1831–1901)
Belgian painter of landscapes.

Other Sources

Clement, Clara. *Women in the Fine Arts.* Boston: Houghton Mifflin, 1904.

Dunford, Penny. *A Biographical Dictionary of Women Artists in Europe and America since 1850.* Hemel Hempstead: Harvester Wheatsheaf and Philadelphia: University of Pennsylvania Press, 1990. Contains a bibliography.

Krichbaum, J., and R. Zondergeld. *Künstlerinnen: von der Antike bis zur Gegenwart.* Cologne: DuMont, 1979.

Sparrow, Walter Shaw. *Women Painters of the World.* London: Hodder and Stoughton, 1905.

2398 BEGAS, LUISE (née PARMENTIER; alt. BEGAS-PARMENTIER) (1850–?)
Austrian painter of landscapes and interiors who was also an engraver.

Exhibitions

Das Verborgene Museum. Dokumentation der Kunst von Frauen in Berliner öffentlichen Sammlungen. Berlin: Edition Hentrich, 1987.

Other Sources

Clement, Clara. *Women in the Fine Arts.* Boston: Houghton Mifflin, 1904.

Dunford, Penny. *A Biographical Dictionary of Women Artists in Europe and America since 1850.* Hemel Hempstead: Harvester Wheatsheaf and Philadelphia: University of Pennsylvania Press, 1990. Contains a bibliography.

2399 BELCOVA-SUTA, ALEKSANDRA (1892–1981)
Latvian painter.

Other Sources

Šmagre, Rita. *Latviešu Pastelis. Latvian Pastel Painting.* Riga: Liesma, 1990. Includes a brief account of her career.

2400 BELLINGHAM-SMITH, ELINOR (1906–1988)
English painter of London scenes and Suffolk landscapes.

Main Sources

Shone, Richard. "Elinor Bellingham-Smith." *The Independent,* 9 November 1988. Obituary.

Exhibitions

Elinor Bellingham Smith. London: Leicester Gallery, 1967.
Elinor Bellingham Smith: A Tribute. London: Royal Academy Friends' Room, 1990, 1 folded sheet.

Other Sources

Dunford, Penny. *A Biographical Dictionary of Women Artists in Europe and America since 1850.* Hemel Hempstead: Harvester Wheatsheaf and Philadelphia: University of Pennsylvania Press, 1990. Contains a bibliography.
Waters, Grant. *Dictionary of British Artists working 1900–1940.* Eastbourne: Eastbourne Fine Art, 1975.

2401 BELLUŠOVÁ-RUSKOVÁ, ZUZKA
Czech painter.

Exhibitions

Obraz 69. Brno: Moravská Galerie, 1969.

2402 BELL, VANESSA (née STEPHEN) (1979–1961)
English painter of figures, interiors and still lifes who also designed furnishings and fabrics.

Publications

Marler, Regina, ed. *Selected Letters of Vanessa Bell.* London: Bloomsbury, 1993, 593pp., illus. Introduction by Quentin Bell. Contains extracts from over 600 of her surviving 3000 letters and a bibliography.

Main Sources

Bell, Quentin, and Angelica Garnett. *Vanessa Bell's Family Album*. London: Jill Norman & Hobhouse Ltd., 1981, 144pp., illus. Contains annotated photographs in chronological order, which were taken by Bell from the time when she acquired her first camera in 1900. Her son, Quentin, provides the introductory essay.

Caws, Mary Ann. *Women of Bloomsbury: Virginia, Vanessa and Carrington*. London and New York: Routledge, 1990, 218pp., illus. A personal view of these three women based around the thesis of the relation between work and its reward, or lack of it.

Dunn, Jane. "A House of One's Own." *The National Trust Magazine* 61 (Autumn 1990): 28–30.

————. *A Very Close Conspiracy: Vanessa Bell and Virginia Woolf*. London: Jonathan Cape, 1990

Elinor, Gillian. "Vanessa Bell and Dora Carrington." *Women's Art Journal* 5, no. 1 (spring–summer 1984): 28–34.

Elliott, Bridget, and Jo-Ann Wallace. *Women Artists and Writers: Modernist (Im)positionings,* London: Routledge, 1994, chapter 3.

Marsh, Jan. *Bloomsbury Women: Distinct Figures in Life and Art*. London: Pavilion, 1995, 160pp., illus. Chiefly concerns Bell and Virginia Woolf although Carrington (see vol. 1) is also included.

Spalding, Frances. *Vanessa Bell*. London: Weidenfeld & Nicolson, 1983 and San Diego: 1985.

Tickner. Lisa. "'The Left-Handed Marriage': Vanessa Bell and Duncan Grant." In *Significant Others: Creativity and Intimate Partnership,* ed. Whitney Chadwick and I. de Courtivron. London: Thames and Hudson, 1993.

Exhibitions

Pickvance, Ronald. *Vanessa Bell: A Memorial Exhibition of Paintings*. London: Arts Council, 1964.

Harris, Anne Sutherland, and Linda Nochlin. *Women Artists 1550–1950*. Los Angeles: County Museum of Art, 1976.

Künstlerinnen International, 1877–1977. Berlin: Schloss Charlottenburg, 1977.

Sulter, Maud. *Echo: Works by Women Artists, 1850–1940*. Liverpool: Tate Gallery, 1991.

Vanessa Bell and Virginia Woolf: "Disegnare la vita." Settima Biennale Donna. Ferrara: Padiglione dell'arte contemporanea, 1996, 202pp., illus. Text in Italian. Contains several critical essays and a bibliography of sources in English, Spanish and Italian.

Other Sources

Bachmann, Donna, and Sherry Piland. *Women Artists: A Historical, Contemporary and Feminist Bibliography*. Metuchen, N.J.: Scarecrow Press, 1978.

Dunford, Penny. *A Biographical Dictionary of Women Artists in Europe and*

America since 1850. Hemel Hempstead: Harvester Wheatsheaf and Philadelphia: University of Pennsylvania Press, 1990. Contains a bibliography.
 Vergine, Lea. *L'altra metà dell'avanguardia.* Milan: Mazzotta Editore, 1980. *L'autre moitié de l'avant-garde.* Paris: Des Femmes, 1982.
 Williams, Val. *The Other Observers: Women Photographers in Britain 1900 to the Present.* London: Virago, 1986.

2403 BENDALL, MILDRED (1891–1977)
 Anglo-French painter of brightly coloured interiors and still lifes.

Exhibitions

Mildred Bendall, 1891–1977. London: Whitford and Hughes, 1987, n.p., 40 illus. Contains a biography.

Other Sources

Dunford, Penny. *A Biographical Dictionary of Women Artists in Europe and America since 1850.* Hemel Hempstead: Harvester Wheatsheaf and Philadelphia: University of Pennsylvania Press, 1990. Contains a bibliography.

2404 BENEDETTA (Pseudonym of BENEDETTA CAPPA OR CAPA; alt. MARINETTI) (1897/9–1977).
 Italian Futurist painter and theatre designer.

Publications

Orestano, Francesco, ed. *Opera letteraria di Benedetta.* Rome: Edizioni Futuriste di Poesia, 1936, 26pp. A critical discussion of her writings which includes extracts from several works, most notably *Le Forze Umane* of 1924.
 "Le Futurisme." *Cahiers d'Art,* 1950.
 "Viaggio di Gargarà nel regno della materia dinamica." (1931) Extract reprinted in Enrico Crispolti, *Il mito della macchina e altri tema del futurismo,* 214–217. Trapani: Editore Celebes, 1969. There is a list of her publications on page 334.

Main Sources

Centonze, Nino. "La pittrice futurista Benedetta. " *Stile Futurista* 2, no. 10 (June 1935): 10–11.
 Katz, B. "The Women of Futurism." *Women's Art Journal* 7, no. 2 (fall 1986–winter 1987): 3–13.
 Marinetti, Filippo. "Benedetta." *L'Impero d'Italia,* 20 January 1931, 3.
 Marinetti, Filippo. "Benedetta e l'aeropittura geografica." *Stile Futurista* 1, no. 4 (October 1934): 26–30. Includes three pages of photographs of these rarely illustrated works.

Exhibitions

Künstlerinnen International, 1877–1977. Berlin: Schloss Charlottenburg, 1977.
Anni trenta: Arte e cultura in Italia. Milan: Comune di Milano in association with Mazzotta Editore, 1982.

Other Sources

Crispolti, Enrico. *La Ceramica futurista da Balla a Tullio d'Albisola.* Florence: Centro Di, 1982.
Dunford, Penny. *A Biographical Dictionary of Women Artists in Europe and America since 1850.* Hemel Hempstead: Harvester Wheatsheaf and Philadelphia: University of Pennsylvania Press, 1990. Contains a bibliography.
Vergine, Lea. *L'altra metà dell'avanguardia.* Milan: Mazzotta Editore, 1980. *L'autre moitié de l'avant-garde.* Paris: Des Femmes, 1982.
Weller, Simone. *Il Complesso di Michelangelo: ricerca sul contributo dato dalla donna all'arte italiana del novecento.* Pollenza-Macerata: La Nuova Foglio [*sic*] Editrice, 1976.

2405 BENEDINI AZZONI, GABRIELLA (Alt. BENEDINI) (1932–)
Italian sculptor and painter.

See Sculpture section.

2406 BENOIST, MARIE GUILLEMINE (COMTESSE) (née DELAVILLE LE-ROUX) (1768–1826)
French painter of portraits and figures who studied with Elisabeth Vigée-Lebrun (q.v.).

Main Sources

Ballot, Marie-Juliette. *Une élève de David, la Comtesse Benoit, l'Émilie de Demoustier, 1768–1826.* Paris: Librairie Plon, 1914, 294pp., illus. Based on a doctoral thesis, it constitutes a very detailed account of the training and work of Benoist.

Exhibitions

Harris, Anne Sutherland, and Linda Nochlin. *Women Artists 1550–1950.* Los Angeles: County Museum of Art, 1976.
Beaulieu, Germaine, et al. *La femme artiste d'Elisabeth Vigée-Lebrun à Rosa Bonheur.* Lacoste: Musée Despiau-Wlerick et Dubalen Mont-de-Marsan, 1981. Includes a bibliography.

Other Sources

Fine, Elsa Honig. *Women and Art.* New York and London: Allanfield and Schram/Prior, 1978.

Gabet, Charles. *Dictionnaire des artistes de l'école française au XIXe siècle.* Paris: Verge, 1831.

2407 BENOIS, NADIA (née NADEZHDA LEONTIEVNA BENOIS) (1896–1975)
Russian-born painter of landscape and flowers and stage designer who worked in England.

Main Sources

Ustinov, Peter. *Dear Me.* London: 1977. Ustinov is the son of Benois.

Exhibitions

Nadia Benois. London: Leicester Gallery, 1943.
Sulter, Maud. *Echo: Works by Women Artists, 1850–1940.* Liverpool: Tate Gallery, 1991.

Other Sources

Dunford, Penny. *A Biographical Dictionary of Women Artists in Europe and America since 1850.* Hemel Hempstead: Harvester Wheatsheaf and Philadelphia: University of Pennsylvania Press, 1990. Contains a bibliography.
Waters, Grant. *Dictionary of British Artists working 1900–1940.* Eastbourne: Eastbourne Fine Art, 1975.

2408 BENSON, MARY KATE (?–1921)
Irish painter of landscapes, figures and interiors in Ireland and in mainland Europe, notably Belgium; her sister Charlotte was also a painter and regular exhibitor.

Exhibitions

Irish Women Artists from the Eighteenth Century to the Present Day. Dublin: National Gallery of Ireland, Douglas Hyde Gallery and Hugh Lane Gallery, 1987.

2409 BEREND-CORINTH, CHARLOTTE (née BEREND) (1880–1967)
German painter.

Exhibitions

Gleisberg, D. *Deutsche Künstlerinnen des zwanzigsten Jahrhunderts.* Attenburg: Staatlichen Lindendau Museum, 1963.
Das Verborgene Museum. Dokumentation der Kunst von Frauen in Berliner öffentlichen Sammlungen. Berlin: Edition Hentrich, 1987.

Other Sources

Evers, Ulrike. *Deutsche Künstlerinnen des 20. Jahrhunderts. Malerei— Bildhauerei—Tapisserie.* Hamburg: Ludwig Schultheis Verlag, 1983.

2410 BERGMAN, ANNA-EVA (1909–1987)
Swedish abstract painter and engraver.

Exhibitions

Berg, Knut, and Jean Tardieu. *Anna-Eva Bergmann.* Paris. Musée d'Art Moderne de la Ville de Paris, 1977.

Other Sources

Ceysson, B., et al. *25 ans d'art en France, 1960–1985.* Paris: Larousse, 1986. Includes a select list of exhibitions for each artist.
Dunford, Penny. *A Biographical Dictionary of Women Artists in Europe and America since 1850.* Hemel Hempstead: Harvester Wheatsheaf and Philadelphia: University of Pennsylvania Press, 1990. Contains a bibliography.
Gran, H. and P. Anker, eds. *Illustrert Norsk Kunstner Leksikon.* Oslo: Broen Bokhandel, 1956.

2411 BERKI, VIOLA (1932–)
Hungarian figurative painter.

Other Sources

Németh, Lajos. *Modern Art in Hungary.* Budapest: Corvina Press, 1969.

2412 BERNHARDT, SARAH (Pseudonym of HENRIETTE ROSINE BERNARD) (1844–1923)
French sculptor and painter who is best known as an actress.

Publications

Memoirs: My Double Life. London: 1907. Reprinted 1969.

Main Sources

Meynell, Alice. "Madame Sarah Bernhardt." *Art Journal,* 1888, 134–139.
Richardson, J. *Sarah Bernhardt and her World.* New York: G. Putnam's Sons, 1977.
Rueff, S. *I knew Sarah Bernhardt.* London, 1951.

Exhibitions

Sarah Bernhardt: 1844–1923. London: Ferrers Gallery, 1973, 40 pp., illus. Contains a biographical essay and notes on the works exhibited which include some by Bernhardt's friends.
Fusco, Peter, and H. W. Janson. *The Romantics to Rodin: French Nineteenth Century Sculpture from N. American Collections.* Los Angeles: County Museum of Art in association with George Braziller Inc., 1980.
Beaulieu, Germaine, et al. *La femme artiste d'Elisabeth Vigée-Lebrun à Rosa*

Bonheur. Lacoste: Musée Despiau-Wlerick et Dubalen Mont-de-Marsan, 1981. Includes a bibliography.

Dufresne, Jean-Luc, and Olivier Messac, eds. *Femmes créatrices des années vingt.* Granville: Musée Richard Anacréon, 1988. Wide-ranging catalogue with a short biographical account on each woman included.

Other Sources

Clement, Clara. *Women in the Fine Arts.* Boston: Houghton Mifflin, 1904.

Dunford, Penny. *A Biographical Dictionary of Women Artists in Europe and America since 1850.* Hemel Hempstead: Harvester Wheatsheaf and Philadelphia: University of Pennsylvania Press, 1990. Contains a bibliography.

Kjellberg, Pierre. *Les bronzes du XIXe siècle: dictionnaire des sculpteurs.* Paris: Editions de l'Amateur, 1987.

Krichbaum, J., and R. Zondergeld. *Künstlerinnen: von der Antike bis zur Gegenwart.* Cologne: DuMont, 1979.

Martin, Jules. *Nos peintres et sculpteurs, graveurs et dessinateurs.* Paris, 1897.

2413 BERTOLETTI, PASQUAROSA MARCELLI (1896–1973)
Italian painter.

Exhibitions

Baraldi, Anna Maria, et al. *6 Biennale Donna.* Ferrara: Padiglione d'Arte Contemporanea, 1994.

2414 BEST, MARY ELLEN (Alt. SARG) (1809–1891)
English painter of very precise and detailed interiors, architectural town scenes and figures; unusually, she travelled extensively in northern Europe.

Main Sources

Davidson, Caroline. *The World of Mary Ellen Best.* London: Chatto and Windus, 1985, 160pp., 137 illus. An extremely detailed account of her life and work which shows how she was able to practise her art and travel despite the constratints on women at the time.

2415 BĒRENTE, INTA (1960–)
Latvian painter.

Exhibitions

8. Baltijas Republiku Akvareļu Izstāde: Katalogs. Riga, 1989.

2416 BIEDERBICK, CHRISTA (1940–)
German realist painter.

Other Sources

Evers, Ulrike. *Deutsche Künstlerinnen des 20. Jahrhunderts. Malerei—Bildhauerei—Tapisserie.* Hamburg: Ludwig Schultheis Verlag, 1983. Contains an individual bibliography.

2417 BIENFAIT, ALINE (1941–)
 Belgian-born painter and sculptor who works in France and Mexico.

Other Sources

Dunford, Penny. *A Biographical Dictionary of Women Artists in Europe and America since 1850.* Hemel Hempstead: Harvester Wheatsheaf and Philadelphia: University of Pennsylvania Press, 1990. Contains a bibliography.

2418 BIFFIN, SARAH (Alt. BEFFIN; WRIGHT) (1784–1850)
 English painter of miniatures despite being born without hands, arms or feet; she painted holding the brush in her mouth.

Other Sources

Foskett, Daphne. *Dictionary of British Miniature Painters.* London: Faber & Faber, 1972.
 Foskett, Daphne. *Miniatures: A Dictionary and Guide.* Woodbridge: Antique Collectors Club, 1987.

2419 BILDERS, VAN BOSSE, MARIA PHILIPPINA (1837–1900)
 Dutch painter.

Exhibitions

Oele, Anneke, Mirian van Rijsingen, and Hesther van den Donk. *Bloemen uit de kelder: negen kunstnaressen rond de eeuwwisseling.* Arnhem: Gemeentemuseum, 1989.

2420 BILINSKA-BOHDANOWICZ, ANNA (née BILINSKA) (1857–1893)
 Polish painter of portraits, still lifes, landscapes and sea scenes.

Main Sources

Jenson, J. C. *Polnische Malerei von 1830 bis 1914.* Cologne, 1978.

Exhibitions

Morawińska, Agnieszka. *Voices of Freedom: Polish Women Artists of the Avant-garde, 1880–1990.* Washington, D.C.: National Museum of Women in the Arts, 1991. Includes a list of her main exhibitions and a bibliography.

Other Sources

Clement, Clara. *Women in the Fine Arts*. Boston: Houghton Mifflin, 1904.
Dunford, Penny. *A Biographical Dictionary of Women Artists in Europe and America since 1850*. Hemel Hempstead: Harvester Wheatsheaf and Philadelphia: University of Pennsylvania Press, 1990. Contains a bibliography.
Krichbaum, J., and R. Zondergeld. *Künstlerinnen: von der Antike bis zur Gegenwart*. Cologne: DuMont, 1979.

2421 BISSCHOP-ROBERTSON, SUZE (née ROBERTSON) (1855/7–1922)
Dutch painter of figure subjects, landscapes and portraits.

Main Sources

Hammacher, A. *Suze Robertson*. Amsterdam 1943.
Wagner, A., and H. Henkels. *Suze Robertson*. Amsterdam, 1985.

Exhibitions

Tentoonstellung van schilderijn van Suze Bisschop-Robertson. The Hague: Kunsthandel J. Biesing, 1909.
Suze Robertson. Amsterdam: Stedelijk Museum, 1956.
Vrouwen op de Bres: drie kunstnaressen rond 1900. The Hague: Gemeentemuseumm 1980.
Kunst door vrouwen. Leiden: Stedelijk Museum, De Lakenhal, 1987.

Other Sources

Dunford, Penny. *A Biographical Dictionary of Women Artists in Europe and America since 1850*. Hemel Hempstead: Harvester Wheatsheaf and Philadelphia: University of Pennsylvania Press, 1990. Contains a bibliography.
Krichbaum, J., and R. Zondergeld. *Künstlerinnen: Von der Antike bis zur Gegenwart*. Cologne: DuMont, 1979.

2422 BISWAS, SUTAPA (1962–)
Indian-born painter of figurative works who works in England.

Main Sources

Di Bello, Patrizia. "Intimate Distance: Five Black Women Photographers." *Women's Art Magazine* 40 (1991): 24–25. Review of a touring exhibition which first opened at the Photographers' Gallery, London.
Robinson, Hilary, ed. *Visibly Female: Feminism and Art Today*. London, 1987.

Exhibitions

The Thin Black Line. London: Institute of Contemporary Art, 1985.

Other Sources

Dunford, Penny. *A Biographical Dictionary of Women Artists in Europe and America since 1850.* Hemel Hempstead: Harvester Wheatsheaf and Philadelphia: University of Pennsylvania Press, 1990. Contains a bibliography.

2423 BLACKADDER, ELIZABETH (1931–)
Scottish painter of landscapes, still lifes and interiors; the first woman to be elected Academician of both the Royal Academy in London and the Royal Scottish Academy.

Main Sources

Bumpus, Judith. *Elizabeth Blackadder.* Oxford: Phaidon, 1988, 96pp., illus.

Exhibitions

British Painting 1952–1977. London: Royal Academy, 1977.
Elizabeth Blackadder. Edinburgh: Scottish Arts Council, 1981, 64pp., illus. Contains a very brief text and a chronology.

Other Sources

Dunford, Penny. *A Biographical Dictionary of Women Artists in Europe and America since 1850.* Hemel Hempstead: Harvester Wheatsheaf and Philadelphia: University of Pennsylvania Press, 1990. Contains a bibliography.

2424 BLACKBURN, JEMIMA (née WEDDERBURN) (1823–1909)
Scottish painter of animals and birds.

Publications

See R. Fairley below.

Main Sources

Clayton, Ellen. *English Female Artists.* 2 vols. London: Tinsley, 1876.
Fairley, R., ed. *Jemima: The paintings and Memoirs of a Victorian Lady.* Edinburgh: Canongate and North Pomfret, Vt.: Trafalgar Square Publishing, 1988, 207pp., illus. A detailed biography is followed by extracts from Blackburn's memoirs.

Other Sources

Dunford, Penny. *A Biographical Dictionary of Women Artists in Europe and America since 1850.* Hemel Hempstead: Harvester Wheatsheaf and Philadelphia: University of Pennsylvania Press, 1990. Contains a bibliography.
Mallalieu, Hugh. *Dictionary of British Watercolour Artists.* Woodbridge: Antique Collectors Club, 1976.

Nunn, Pamela Gerrish. *Victorian Women Artists*. London: Women's Press, 1987.

2425 BLAGOVESHENKAYA-VASILIANOVA, NADEZDA SERGHEEVNA (1881–1943)
Russian painter best known for painting on porcelain.

Exhibitions

Avanguardia russa dalle collezioni private sovietiche origini e percorso 1904–1934. Milan: Palzzo Reale, 1989.

2426 BLANCHARD, MARIA (Alt. GUTIERREZ-BLANCHARD) (1881–1932)
Spanish painter of figures and still lifes in a Cubist style.

Exhibitions

Les femmes artistes modernes. Exposition de peintures, sculptures, 1937. Paris: Buffet & Leclerc, 1937. She was amongst the recently deceased members who were included.

Dufresne, Jean-Luc, and Olivier Messac, eds. *Femmes créatrices des années vingt*. Granville: Musée Richard Anacréon, 1988. Wide-ranging catalogue with a short biographical account on each woman included.

Other Sources

Bachmann, Donna, and Sherry Piland. *Women Artists: A Historical, Contemporary and Feminist Bibliography*. Metuchen, N.J.: Scarecrow Press, 1978.

Bunoust, Madeleine. *Quelques Femmes Peintres*. Paris: Librairie Stock, 1936.

Dunford, Penny. *A Biographical Dictionary of Women Artists in Europe and America since 1850*. Hemel Hempstead: Harvester Wheatsheaf and Philadelphia: University of Pennsylvania Press, 1990. Contains a bibliography.

Krichbaum, J., and R. Zondergeld. *Künstlerinnen: von der Antike bis zur Gegenwart*. Cologne: DuMont, 1979.

Perry, Gill. *Women Artists and the Parisian Avant-Garde*. Manchester: Manchester University Press, 1995.

2427 BLAND, BEATRICE (née EMILY BEATRICE BLAND) (1864/9–1951)
English painter of flowers and landscapes.

Exhibitions

Beatrice Bland. London: Leicester Gallery, 1934.

Other Sources

Burbidge, R. Brinsley. *Dictionary of British Flower, Fruit and Still Life Painters*. Leigh-on-Sea: F. Lewis, 1974.

Dunford, Penny. *A Biographical Dictionary of Women Artists in Europe and America since 1850.* Hemel Hempstead: Harvester Wheatsheaf and Philadelphia: University of Pennsylvania Press, 1990. Contains a bibliography.

Sellars, Jane. *Women's Work.* Liverpool: Walker Art Gallery, 1988.

2428 BLAU-LANG, TINA (née BLAU) (1845–1937)

Austrian painter of landscapes and still life.

Main Sources

Harriman, Helga. "Olga Wisinger-Florian and Tina Blau: Painters in fin-de-siècle Vienna." *Woman's Art Journal* 10, no. 2 (fall 1989–winter 1990): 23–28.

Other Sources

Krichbaum, J., and R. Zondergeld. *Künstlerinnen: von der Antike bis zur Gegenwart.* Cologne: DuMont, 1979.

Pavière, Sidney. *Dictionary of Flower, Fruit and Still-life Painters.* Leigh-on-Sea: F. Lewis, 1964, vol. 3, part 2.

Sparrow, Walter Shaw. *Women Painters of the World.* London: Hodder and Stoughton, 1905.

2429 BLOW, SANDRA (1925–)

English abstract painter and collagist. Member of the Royal Academy.

Main Sources

Garlake, Margaret. "Spaced Out." *Women's Art Magazine* 58 (1994): 20–21. Review of Blow's exhibition at the Royal Academy.

Exhibitions

British Painting in the 60s. London: Tate Gallery and Whitechapel Art Gallery, 1963.

British Painting 1952–1977. London: Royal Academy, 1977.

Hayward Annual '78. London: Hayward Gallery, 1978.

St. Ives 1939–1964. London: Tate Gallery, 1985.

Other Sources

Dunford, Penny. *A Biographical Dictionary of Women Artists in Europe and America since 1850.* Hemel Hempstead: Harvester Wheatsheaf and Philadelphia: University of Pennsylvania Press, 1990. Contains a bibliography.

Sellars, Jane. *Women's Work.* Liverpool: Walker Art Gallery, 1988.

2430 BLUNDEN, ANNA E. (Alt. MARTINO) (1829–1915)

English painter of landscapes and figures.

Main Sources

Clayton, Ellen. *English Female Artists.* 2 vols. London: Tinsley, 1876.
Surtees, V. *Sublime and Instructive: Letters from John Ruskin to Louisa, Marchioness of Waterford, Anna Blunden and Ellen Heaton.* London, 1972.

Exhibitions

Casteras, Susan, and Linda H. Peterson. *A Struggle for Fame: Victorian Women Artists and Authors.* New Haven: Yale Center for British Art, 1994.

Other Sources

Cherry, Deborah. *Painting Women: Victorian Women Artists.* London: Routledge, 1993.

2431 BOCH, ANNA
Belgian painter.

Main Sources

Colin, P. *Anna Boch.* Brussels, 1928.

Exhibitions

Brunhammer, Yvonne. *Art Nouveau: Belgium, France.* Chicago: Institute of the Arts, Rice University, and the Art Institute, 1976.

2432 BODICHON, BARBARA (née LEIGH-SMITH) (1827–1891)
English painter of landscapes and coastal scenes in watercolour who is best known as a campaigner for women's rights.

Publications

Reed, J. W., ed. *An American Diary, 1857–8.* London, 1972.

Main Sources

Many studies of Bodichon mention her artistic activities only briefly, if at all. Publications listed here deal with her art at greater length.
"Barbara Bodichon." *The Times,* 15 June 1891. Obituary.
Burton, H. *Barbara Bodichon, 1827–1891.* London, 1949.
Clayton, Ellen. *English Female Artists.* 2 vols. London: Tinsley, 1876.
Crabbe, J. "An Artist Divided." *Apollo,* May 1981, 311–314.
Hirsch, Pam. "Barbara Leigh-Smith Bodichon, Artist and Activist." In *Women in the Victorian Art World,* ed. Clarissa Campbell Orr. Manchester: Manchester University Press, 1995. There are many additional references to her in other essays in this collection.
Matthews, J. "Barbara Bodichon: Integrity in Diversity." In *Feminist Theorists,* ed. Dale Spender. London, 1983.

Exhibitions

Casteras, Susan, and Linda H. Peterson. *A Struggle for Fame: Victorian Women Artists and Authors.* New Haven, Conn.: Yale Center for British Art, 1994.

Other Sources

Cherry, Deborah. *Painting Women: Victorian Women Artists.* London: Routledge, 1993.

Dunford, Penny. *A Biographical Dictionary of Women Artists in Europe and America since 1850.* Hemel Hempstead: Harvester Wheatsheaf and Philadelphia: University of Pennsylvania Press, 1990. Contains a bibliography.

Fine, Elsa Honig. *Women and Art.* New York and London: Allanfield and Schram/Prior, 1978.

Nunn, Pamela Gerrish. *Victorian Women Artists.* London: Women's Press, 1987.

Spender, Dale. *Women of Ideas.* London, 1972, pp. 404–420.

2433 BODMAN, VIRGINIA (1954–)

English painter who often deals with the subject of women, in particular motherhood.

Exhibitions

Golding, John. *10 artisti britannici.* Rome: British School at Rome and Palazzo Barberini, 1983.

Barnicoat, John. *Rome Scholars' Retrospective 1980–1990.* London: British School at Rome, 1990.

Kingston, Angela. *Mothers.* Birmingham: Ikon Gallery, 1990.

Andrew, Patricia. *Durham Cathedral: Artists and Images.* Durham: Durham Art Gallery, 1993.

Camouflage. Long Beach: Dept. of Art, California State University, 1994.

Andrew, Patricia. *Durham Cathedral: Artists in residence 1983–1996.* Durham: Durham Art Gallery, 1996.

2434 BOERO, RENATA (1936–)

Italian abstract painter.

Exhibitions

Pasquali, Marilena. *Figure dallo sfondo.* Ferrara: Padiglione d'Arte Contemporanea and Grafis Editore, 1984. Includes a bibliography.

7 Biennale Donna. Vanessa Bell e Virginia Woolf: disegnare la Vita. Ferrara: Padiglione d'Arte Contemporanea, 1996.

Other Sources

Weller, Simone. *Il Complesso di Michelangelo: ricerca sul contributo dato dalla donna all'arte italiana del novecento.* Pollenza-Macerata: La Nuova Foglio [*sic*] Editrice, 1976.

2435 BONHEUR, JULIETTE (Alt. PEYROL OR PEYROL-BONHEUR) (1830–1891)
French painter of animals; sister of Rosa.

Main Sources

See also under Rosa Bonheur.
Clement, Clara, and L. Hutton. *Artists of the Nineteenth Century.* New York, 1879.

Exhibitions

La Femme: peintre et sculpteur du XVIIe au XXe siècle. Paris: Grand Palais, 1975.

Other Sources

Dunford, Penny. *A Biographical Dictionary of Women Artists in Europe and America since 1850.* Hemel Hempstead: Harvester Wheatsheaf and Philadelphia: University of Pennsylvania Press, 1990. Contains a bibliography.

2436 BONHEUR, ROSA (née MARIE ROSALIE BONHEUR) (1822–1899)
French animal painter and sculptor; sister of Juliette.

Publications

Bonheur, Rosa. "Fragments of my Autobiography." *Magazine of Art* 26 (1902): 531–536.

Main Sources

Bonnefon, Paul. *Artistes contemporains des pays de Guyenne, Saintonge et Languedoc. Rosa Bonheur.* Bordeaux: G. Gounouilhou, 1889, 95pp., illus.
Cantrel, Émile. "Mademoiselle Rosa Bonheur." *L'Artiste* 8 (new series) (1 September 1859): 5–8. One of a series called Galérie du XIX siècle. Contains a detailed account of her early life.
Demont-Breton, Virginie. "Rosa Bonheur." *Revue des Revues* du 15 juin 1899, 605–619. Obituary by another woman artist.
Digne, Danielle. *Rosa Bonheur ou l'insolence: histoire d'une vie, 1822–1899.* Collection Femme. Paris: Denoël/Gontier, 1980, 198pp., illus. A biographical account which attempts to retain Bonheur's strength of character.
Fould, Consuelo. "Rosa Bonheur (Souvenirs)." *Revue Illustrée,* 1 November 1899.
Hird, Frank. *Rosa Bonheur.* London: G. Bell & Sons, 1904, 89pp., illus.
Klumpke, Anna. *Rosa Bonheur: sa vie, son oeuvre.* Paris: Flammarion, 1908, 445pp., illus.
Mirecourt, Eugène de. *Les Contemporains. Rosa Bonheur.* Paris: G. Havard, 1856, 94pp., 1 photograph and 1 plate.

Stanton, Théodore. *Reminiscences of Rosa Bonheur.* London, 1910.

Exhibitions

Harris, Anne Sutherland, and Linda Nochlin. *Women Artists 1550–1950.* Los Angeles: County Museum of Art, 1976.

Beaulieu, Germaine, et al. *La femme artiste d'Elisabeth Vigée-Lebrun à Rosa Bonheur.* Lacoste: Musée Despiau-Wlerick et Dubalen Mont-de-Marsan, 1981. Includes a bibliography.

Das Verborgene Museum. Dokumentation der Kunst de Frauen in Berliner offentlichen Sammlungen. Berlin: Edition Hentrich, 1987.

Other Sources

Bachmann, Donna, and Sherry Piland. *Women Artists: A Historical, Contemporary and Feminist Bibliography.* Metuchen, N.J.: Scarecrow Press, 1978.

Clement, Clara. *Women in the Fine Arts.* Boston: Houghton Mifflin, 1904.

Dunford, Penny. *A Biographical Dictionary of Women Artists in Europe and America since 1850.* Hemel Hempstead: Harvester Wheatsheaf and Philadelphia: University of Pennsylvania Press, 1990. Contains a bibliography.

Horswell, Jane. *Bronze Sculpture of "Les Animaliers": A Reference and Price Guide.* Woodbridge: Antique Collectors Club, 1971, 340pp., illus. There are longer biographies on seven artists of whom Bonheur is the only woman.

Kjellberg, Pierre. *Les bronzes du XIXe siècle: dictionnaire des sculpteurs.* Paris: Editions de l'Amateur, 1987.

Sparrow, Walter Shaw. *Women Painters of the World.* London: Hodder and Stoughton, 1905.

Tufts, Eleanor. *Our Hidden Heritage: Five Centuries of Women Artists.* New York and London: Paddington Press, 1974.

Uglow, Jennifer. *The Macmillan Dictionary of Women's Biography.* London: Macmillan, 1982.

2437 BOREEL, WENDELA (Pseudonym of EDITH WANDELA) (1875–after 1974) Dutch-American painter and engraver of figures and architectural subjects who was born in France. She trained in England and until 1939 divided her time between France and England, settling in France in 1945.

Exhibitions

Baron, Wendy. *The Sickert Women and the Sickert Girls.* London: Parkin Gallery, 1974.

Other Sources

Dunford, Penny. *A Biographical Dictionary of Women Artists in Europe and America since 1850.* Hemel Hempstead: Harvester Wheatsheaf and Philadelphia: University of Pennsylvania Press, 1990. Contains a bibliography.

Greer, Germaine. *The Obstacle Race*. London: Secker and Warburg, 1979.
Waters, Grant. *Dictionary of British Artists Working 1900–1940*. Eastbourne: Eastbourne Fine Art, 1975.

2438 BORTOLAN, ROSA (1818–1892)
Italian painter of religious scenes and portraits.

Main Sources

Comanducci, A. *Dizionario illustrato dei pittori italiani moderni e contemporanei*. Milan, 1966.

Other Sources

Clement, Clara. *Women in the Fine Arts*. Boston: Houghton Mifflin, 1904.
Dunford, Penny. *A Biographical Dictionary of Women Artists in Europe and America since 1850*. Hemel Hempstead: Harvester Wheatsheaf and Philadelphia: University of Pennsylvania Press, 1990. Contains a bibliography.
Lexikon der Frau. Zurich: Encyclios Verlag, 1953.

2439 BOSSI, ERMA (Alt. ERMINIA or BARRERA BOSSI) (1882/5–1952/60)
Italian expressionist painter of figures, still lifes and landscapes who belonged to the Blue Rider Group.

Main Sources

Comanducci, A. *Dizionario illustrato dei pittori italiani moderni e contemporanei*. Milan, 1966.

Exhibitions

Vergine, Lea. *L'altra metà dell'avanguardia*. Milan: Mazzotta Editore, 1980.
L'autre moitié de l'avant-garde. Paris: Des Femmes, 1982.

Other Sources

Behr, Shulamith. *Women Expressionists*. Oxford: Phaidon, 1988. Dunford, Penny. *A Biographical Dictionary of Women Artists in Europe and America since 1850*. Hemel Hempstead: Harvester Wheatsheaf and Philadelphia: University of Pennsylvania Press, 1990. Contains a bibliography.
Evers, Ulrike. *Deutsche Künstlerinnen des 20. Jahrhunderts. Malerei—Bildhauerei—Tapisserie*. Hamburg: Ludwig Schultheis Verlag, 1983. Contains an individual bibliography.
Weller, Simone. *Il Complesso di Michelangelo: ricerca sul contributo dato dalla donna all'arte italiana del novecento*. Pollenza-Macerata: La Nuova Foglio [*sic*] Editrice, 1976.

2440 BOSWELL, JESSIE (1881–1956)
English-born painter who lived in Italy from 1913.

Exhibitions

Baraldi, Anna Maria, et al. *6 Biennale Donna.* Ferrara: Padiglione d'Arte Contemporanea, 1994.

2441 BOULIAR, MARIE GENEVIVE (1762–1825)
French painter of portraits.

Exhibitions

Harris, Anne Sutherland, and Linda Nochlin. *Women Artists 1550–1950.* Los Angeles: County Museum of Art, 1976.

2442 BOURILLON-TOURNAY, JEANNE (1867/70–1932)
French portrait painter.

Other Sources

Clement, Clara. *Women in the Fine Arts.* Boston: Houghton Mifflin, 1904.
Dunford, Penny. *A Biographical Dictionary of Women Artists in Europe and America since 1850.* Hemel Hempstead: Harvester Wheatsheaf and Philadelphia: University of Pennsylvania Press, 1990. Contains a bibliography.
Edouard-Joseph, R. *Dictionnaire biographique des artistes contemporains, 1910–1930.* Paris: Art et Editions, 1930–1934.

2443 BOWKETT, JANE MARIA (1837–1891)
English painter of domestic genre and seaside scenes.

Main Sources

Foley, John. "The World of Jane Maria Bowkett." *The Lady,* 18–25 December 1986.

Other Sources

Cherry, Deborah. *Painting Women: Victorian Women Artists.* London: Routledge, 1993.
Dunford, Penny. *A Biographical Dictionary of Women Artists in Europe and America since 1850.* Hemel Hempstead: Harvester Wheatsheaf and Philadelphia: University of Pennsylvania Press, 1990. Contains a bibliography.
Nunn, Pamela Gerrish. *Victorian Women Artists.* London: Women's Press, 1987.
Wood, Christopher. *The Dictionary of Victorian Painters.* Woodbridge: Antique Collectors Club, 1978.

2444 BOYCE, JOANNA MARY (Alt. WELLS) (1831–1861)
English painter of figure subjects, including historical and literary themes.

Main Sources

Cherry, Deborah. *Painting Women: Victorian Women Artists.* London: Routledge, 1993.

Nunn, Pamela Gerrish. *Victorian Women Artists.* London: Women's Press, 1987.

Exhibitions

Joanna Mary Wells. London: Tate Gallery, 1935.

Casteras, Susan, and Linda H. Peterson. *A Struggle for Fame: Victorian Women Artists and Authors.* New Haven, Conn.: Yale Center for British Art, 1994.

Other Sources

Dunford, Penny. *A Biographical Dictionary of Women Artists in Europe and America since 1850.* Hemel Hempstead: Harvester Wheatsheaf and Philadelphia: University of Pennsylvania Press, 1990. Contains a bibliography.

2445 BOYCE, SONIA (1962–)
 English figurative painter.

Exhibitions

The Thin Black Line. London: Institute of Contemporary Art, 1985.

Sonia Boyce. London: AIR Gallery, 1986, n.p., illus. Includes extracts from an interview with Boyce and a list of her exhibitions.

Along the Lines of Resistance: An Exhibition of Contemporary Feminist Art. Barnsley: Cooper Gallery, 1988.

Ascherson, Neil. *Shocks to the System: Social and Political Issues in Recent British Art from the Arts Council Collection.* London: Royal Festival Hall, 1991.

Other Sources

Dunford, Penny. *A Biographical Dictionary of Women Artists in Europe and America since 1850.* Hemel Hempstead: Harvester Wheatsheaf and Philadelphia: University of Pennsylvania Press, 1990. Contains a bibliography.

2446 BOZNAŃSKA, OLGA (1865–1940)
 Polish painter of figure subjects and still lifes.

Exhibitions

Morawińska, Agnieszka. *Voices of Freedom: Polish Women Artists of the Avant-garde, 1880–1990.* Washington, D.C.: National Museum of Women in the Arts, 1991. Includes a list of her main exhibitions and a bibliography.

Other Sources

Clement, Clara. *Women in the Fine Arts.* Boston: Houghton Mifflin, 1904.
Dunford, Penny. *A Biographical Dictionary of Women Artists in Europe and America since 1850.* Hemel Hempstead: Harvester Wheatsheaf and Philadelphia: University of Pennsylvania Press, 1990. Contains a bibliography.
Edouard-Joseph, R. *Dictionnaire biographique des artistes contemporains, 1910–1930.* Paris: Art et Editions, 1930–1934.
Krichbaum, J., and R. Zondergeld. *Künstlerinnen: von der Antike bis zur Gegenwart.* Cologne: DuMont, 1979.
Lexikon der Frau. Zurich: Encyclios Verlag, 1953.
Bunoust, Madeleine. *Quelques Femmes Peintres.* Paris: Librairie Stock, 1936.

2447 BØDTKER, MIRANDA
 Norwegian flower painter.

Other Sources

Blunt, Wilfrid. *The Art of Botanical Illustration.* New Naturalist Series. London: Collins, 1950.

2448 BØLLING, SIGRID (1853–1917)
 Norwegian painter.

Other Sources

Wichstrøm, Anne. *Kvinner ved staffeliet: Kvinnelige malere i Norge før 1900.* Oslo: Universitetsforlaget, 1983.

2449 BRACQUEMOND, MARIE (née QUIVERON) (1841–1916)
 French Impressionist painter.

Main Sources

Bouillon, J.-P., and E. Kane. "Marie Bracquemond." *Woman's Art Journal* 5, no. 2 (fall 1984–winter 1985): 21–27.
Garb, Tamar. *Women of Impressionism.* Oxford: Phaidon, 1986.

Other Sources

Dunford, Penny. *A Biographical Dictionary of Women Artists in Europe and America since 1850.* Hemel Hempstead: Harvester Wheatsheaf and Philadelphia: University of Pennsylvania Press, 1990. Contains a bibliography.

2450 BRANDT, MURIEL (1909–1981)
 Irish painter of landscapes and figures.

Other Sources

De Breffny, Brian, ed. *Ireland: A Cultural Encyclopaedia.* London: Thames and Hudson, 1983.

2451 BRASIER, JENNY
 English painter of flowers, often for botanical publications, and graphic artist.

Other Sources

Saunders, Gill. *Picturing Plants: An Analytical History of Botanical Illustration.* London: Victoria and Albert Museum in association with Zwemmer, 1995.

2452 BRASSE-FORSTMANN, ALICE (1903–)
 German figurative painter concerned with social and political issues.

Exhibitions

Gretel Haas-Gerber, Alice Brasse-Forstmann. Ausstellungkatalog. Berlin: Rathaus Wedding (Altbau), 1976, n.p., mainly illus. Includes a short essay discussing the life and work of both artists.

2453 BRECKTE, ILONA (1952–)
 Latvian painter.

Exhibitions

8. Baltijas Republiku Akvareļu Izstāde: Katalogs. Riga, 1989.

2454 BREITLING, GISELA A. (1939–)
 German figurative painter.

Publications

Breitling, Gisela. *Die Spuren des Schiffs in den Wellen.* Berlin: 1980.
Co-author of *Das Verborgene Museum. Dokumentation der Kunst von Frauen in Berliner öffentlichen Sammlungen.* Berlin: Edition Hentrich, 1987.

Exhibitions

Künstlerinnen International, 1877–1977. Berlin: Schloss Charlottenburg, 1977.

Other Sources

Dunford, Penny. *A Biographical Dictionary of Women Artists in Europe and America since 1850.* Hemel Hempstead: Harvester Wheatsheaf and Philadelphia: University of Pennsylvania Press, 1990. Contains a bibliography.

Painting

Evers, Ulrike. *Deutsche Künstlerinnen des 20. Jahrhunderts. Malerei—Bildhauerei—Tapisserie.* Hamburg: Ludwig Schultheis Verlag, 1983.
Krichbaum, J., and R. Zondergeld. *Künstlerinnen: von der Antike bis zur Gegenwart.* Cologne: DuMont, 1979.

2455 BRESLAU, LOUISE CATHERINE (Alt. LOUISA) (1856–1927)
German painter of portraits, children and genre.

Main Sources

Alexandre, A. *Louise Breslau.* Paris, 1928.
Bashkirtseff, Marie. *Journal.* Various editions such as that translated by Mathilde Blind with a new introduction by Roszika Parker and Griselda Pollock. London: Virago, 1985, 716pp.
Zillhardt, Madeleine. *Louise Catherine Breslau et ses amis.* Paris, 1937.

Other Sources

Bachmann, Donna, and Sherry Piland. *Women Artists: A Historical, Contemporary and Feminist Bibliography.* Metuchen, N.J.: Scarecrow Press, 1978.
Dunford, Penny. *A Biographical Dictionary of Women Artists in Europe and America since 1850.* Hemel Hempstead: Harvester Wheatsheaf and Philadelphia: University of Pennsylvania Press, 1990. Contains a bibliography.
Greer, Germaine. *The Obstacle Race.* London: Secker and Warburg, 1979.
Krichbaum, J., and R. Zondergeld. *Künstlerinnen: von der Antike bis zur Gegenwart.* Cologne: DuMont, 1979.
Yeldham, Charlotte. *Women Artists in Nineteenth Century France and England.* London and New York: Garland, 1984.

2456 BRETT, ROSA (Occasional pseudonym ROSARIUS BRETT) (1829–1882)
English painter of landscapes, topographical works and small animals in a Pre-Raphaelite style.

Main Sources

Nunn, Pamela. "Rosa Brett." *Burlington Magazine* 126 (October 1984): 630–634.
Nunn, Pamela Gerrish. *Victorian Women Artists.* London: Women's Press, 1987.

Other Sources

Dunford, Penny. *A Biographical Dictionary of Women Artists in Europe and America since 1850.* Hemel Hempstead: Harvester Wheatsheaf and Philadelphia: University of Pennsylvania Press, 1990. Contains a bibliography.
Wood, Christopher. *The Dictionary of Victorian Painters.* Woodbridge: Antique Collectors Club, 1978.

2457 BRET-CHARBONNIER, CLAUDIA JULIA (exhibited 1893–1950)
French painter of flowers who was not only a prolific artist but was also one of the most popular teachers of her time.

Other Sources

Hardouin-Fugier, Elizabeth, and Etienne Grafe. *The Lyon School of Flower Painting.* Leigh-on-Sea: F. Lewis, 1978, 88pp., illus.

2458 BREUSING, IMA (1886–1968)
German painter of still lifes, portraits and landscapes.

Exhibitions

Das Verborgene Museum. Dokumentation der Kunst von Frauen in Berliner öffentlichen Sammlungen. Berlin: Edition Hentrich, 1987.

2459 BRICKDALE, ELEANOR (née MARY ELEANOR FORTESCUE BRICK-DALE; alt. FORTESCUE-BRICKDALE) (1872–1945)
English painter of historical and literary scenes and a prolific graphic artist who illustrated books.

Publications

See Taylor, G., below

Main Sources

Sparrow, Walter. "On Some Watercolour Pictures by Miss Eleanor Fortescue Brickdale." *Studio* 23 (1901): 31–44.

Exhibitions

Taylor, G. *Centenary Exhibition of Eleanor Fortescue Brickdale, 1872–1945.* Oxford: Ashmolean Museum, 1972. Lists many of the publications containing her illustrations.
The Last Romantics. The Romantic Tradition in British Art: Burne-Jones to Stanley Spencer. London: Barbican Art Gallery, 1989.
Casteras, Susan, and Linda H. Peterson. *A Struggle for Fame: Victorian Women Artists and Authors.* New Haven, Conn.: Yale Center for British Art, 1994.

Other Sources

Dunford, Penny. *A Biographical Dictionary of Women Artists in Europe and America since 1850.* Hemel Hempstead: Harvester Wheatsheaf and Philadelphia: University of Pennsylvania Press, 1990. Contains a bibliography.
Mallalieu, Hugh. *Dictionary of British Watercolour Artists.* Woodbridge: Antique Collectors Club, 1976.
Sellars, Jane. *Women's Works.* Liverpool: Walker Art Gallery, 1988.

Sparrow, Walter Shaw. *Women Painters of the World.* London: Hodder and Stoughton, 1905.

Wood, Christopher. *The Dictionary of Victorian Painters.* Woodbridge: Antique Collectors Club, 1978.

2460 BRIDELL-FOX, ELIZA FLORANCE (née FOX) (c. 1825–1903)

English painter of Arab scenes and children in historical and genre scenes. She contributed to the improvement of women's art education.

Main Sources

Cherry, Deborah. *Painting Women: Victorian Women Artists.* London: Routledge, 1993.

Clayton, Ellen. *English Female Artists.* London: Tinsley, 1876.

Yeldham, Charlotte. *Women Artists in Nineteenth Century France and England.* London and New York: Garland, 1984. Includes her as a case study.

Other Sources

Dunford, Penny. *A Biographical Dictionary of Women Artists in Europe and America since 1850.* Hemel Hempstead: Harvester Wheatsheaf and Philadelphia: University of Pennsylvania Press, 1990. Contains a bibliography.

Nunn, Pamela Gerrish. *Victorian Women Artists.* London: Women's Press, 1987.

Orr, Clarissa Campbell, ed. *Women in the Victorian Art World.* Manchester: Manchester University Press, 1995.

2461 BRIDGWATER, EMMY (1902–)

English Surrealist painter.

Main Sources

Chadwick, Whitney. *Women Artists and the Surrealist Movement.* London: Thames and Hudson, 1985.

Deepwell, Katy, and Deborah Sugg. "Emmy Bridgwater." *Women's Art Magazine* 37 (1990): 14–16. A reassessment of her life and work which also includes a chronology and list of exhibitions.

Exhibitions

British Women Surrealists. London: Blond Fine Art, 1985.

Salute to British Surrealism. Colchester: Minories Gallery, 1985.

Deepwell, Katy. *Ten Decades: Careers of Ten Women Artists born 1897–1906.* Norwich: Norwich Gallery, Norfolk Institute of Art and Design, 1992.

Other Sources

Dunford, Penny. *A Biographical Dictionary of Women Artists in Europe and America since 1850.* Hemel Hempstead: Harvester Wheatsheaf and Philadelphia: University of Pennsylvania Press, 1990. Contains a bibliography.

2462 BROGLIO, EDITA (Alt. EDITA WALTEROWNA ZUR-MÜHLEN BROGLIO) (1886–1977)
 Latvian-born realist painter who worked for a short time in Germany before settling in Italy about 1912.

Main Sources

Appella, Giuseppe, Mario Quesada, and Anne-Marie Sauzeau Boetti. *Edita Walterowna Broglio*. Comune di Macerata: Palazzo Ricci in association with Leonardo-De Luca Editori, Rome, 1991, 250pp., illus. The only full-length study of this artist, this publication contains several scholarly esays about her life and the development of her work.

Exhibitions

Baraldi, Anna Maria, et al. *6 Biennale Donna*. Ferrara: Padiglione d'Arte Contemporanea, 1994.

Other Sources

Weller, Simone. *Il Complesso di Michelangelo: ricerca sul contributo dato dalla donna all'arte italiana del novecento*. Pollenza-Macerata: La Nuova Foglio [*sic*] Editrice, 1976.

2463 BROWNE, HENRIETTE (Pseudonym of SOPHIE DE SAUX OR DESAUX; née BOUTEILLER) (1829–1901)
 French painter of genre, religious themes and Eastern scenes. She was also an engraver.

Main Sources

Béraldi, H. *Les graveurs du 19e siècle*. Paris, 1885–1892.
Tytler, Sarah. *Modern Painters*. London: Strahan & Co.,1873.
Yeldham, Charlotte. *Women Artists in Nineteenth Century France and England*. London and New York: Garland, 1984. Includes Browne as a case study.

Other Sources

Clement, Clara. *Women in the Fine Arts*. Boston: Houghton Mifflin, 1904.
Dunford, Penny. *A Biographical Dictionary of Women Artists in Europe and America since 1850*. Hemel Hempstead: Harvester Wheatsheaf and Philadelphia: University of Pennsylvania Press, 1990. Contains a bibliography.
Krichbaum, J., and R. Zondergeld. *Künstlerinnen: von der Antike bis zur Gegenwart*. Cologne: DuMont, 1979.
Nunn, Pamela Gerrish. *Victorian Women Artists*. London: Women's Press, 1987.
Sellars, Jane. *Women's Works*. Liverpool: Walker Art Gallery, 1988.

2464 BROWNING, AMY KATHERINE (1882–1978)
English painter of figures, landscapes, still lifes and interiors.

Main Sources

Bury, Adrian. "Amy Katherine Browning—Painter of Happiness." *Apollo* 56 (August 1952): 56–58.
Mories, F. G. "Artists of Note: Amy Katherine Browning." *Artist* 23 (1942): 116–118.

Other Sources

Dunford, Penny. *A Biographical Dictionary of Women Artists in Europe and America since 1850.* Hemel Hempstead: Harvester Wheatsheaf and Philadelphia: University of Pennsylvania Press, 1990. Contains a bibliography.
Waters, Grant. *Dictionary of British Artists Working 1900–1940.* Eastbourne: Eastbourne Fine Art, 1975.

2465 BROWNLOW, EMMA (Alt. BROWNLOW-KING) (1832–1905)
English painter of genre scenes.

Main Sources

Nicholson, Benedict. *The Treasures of the Foundling Hospital.* Oxford: Oxford University Press, 1972.
Nunn, Pamela Gerrish. *Victorian Women Artists.* London: Women's Press, 1987.

Other Sources

Dunford, Penny. *A Biographical Dictionary of Women Artists in Europe and America since 1850.* Hemel Hempstead: Harvester Wheatsheaf and Philadelphia: University of Pennsylvania Press, 1990. Contains a bibliography.

2466 BRUYÈRE, ELISA (née LE BARBIER; alt. ELISE)
French painter of flowers, portraits and genre.

Other Sources

Hardouin-Fugier, Elizabeth, and E. Grafe. *French Flower Painters of the Nineteenth Century: A Dictionary.* London: Philip Wilson, 1989.

2467 BRÜCK, TRUDE (1902–)
German painter and graphic artist.

Exhibitions

Trude Brück: Gemälde—Graphiken. Düsseldorf: Stadtmuseum, 1982, n.p., illus. Text in German. Includes an autobiographical essay.

2468 BUCHHOLZ-STARCKJ, HELENA (1902–)
German painter of geometrical abstracts.

Exhibitions

Das Verborgene Museum. Dokumentation der Kunst von Frauen in Berliner öffentlichen Sammlungen. Berlin: Edition Hentrich, 1987.

2469 BUNCE, KATE ELIZABETH (1856–1927)
English figure painter who worked in Birmingham; sister of Myra.

Exhibitions

Crawford, Alan. *By Hammer and Hand: The Arts and Crafts Movement in Birmingham.* Birmingham: City Museum and Art Gallery, 1984.
The Last Romantics. The Romantic Tradition in British Art: Burne-Jones to Stanley Spencer. London: Barbican Art Gallery, 1989.

Other Sources

Cherry, Deborah. *Painting Women: Victorian Women Artists.* London: Routledge, 1993.
Marsh, Jan, and Pamela Gerrish Nunn. *Women Artists of the Pre-Raphaelite Movement.* London: Virago, 1989.

2470 BUNCE, MYRA LOUISA (1854–1919)
English painter of landscapes and designer of metalwork; sister of Kate.

See under Kate Bunce.

2471 BURY, MARIE PÉLAGIE EULALIE (née DE BRIDIEU) (?–1849)
French painter of still lifes which often included insects.

Other Sources

Hardouin-Fugier, Elizabeth. *The Pupils of Redouté.* Leigh-on-Sea: F. Lewis, 1981.

2472 BUTLER, ELIZABETH SOUTHERDEN (LADY) (née THOMPSON) (1846–1933)
English painter of military subjects.

Publications

Letters From the Holy Land. London: Adam & Charles Black, 1903.
From Sketch Book and Diary. London: Adam & Charles Black, 1909.
An Autobiography. London: Constable & Co. Ltd., 1922.

Main Sources

Lalumia, M. "Lady Elizabeth Thompson Butler in the 1870s." *Woman's Art Journal* 4, no. 1 (spring–summer 1983): 9–14.

Meynell, Wilfred. "The Life and Work of Lady Butler." *Art Annual,* 1898.

Usherwood, Paul. "Elizabeth Thompson Butler: The Consequences of Marriage." *Woman's Art Journal* 9, no. 1 (spring–summer 1988): 30–34.

Usherwood, Paul. "Elizabeth Thompson Butler: A Case of Tokenism." *Woman's Art Journal* 11, no. 2 (fall 1990–winter 1991): 14–18.

Exhibitions

Harris, Anne Sutherland, and Linda Nochlin. *Women Artists 1550–1950.* Los Angeles: County Museum of Art, 1976.

Usherwood, Paul, and Jenny Spencer-Smith. *Lady Butler: Battle artist, 1846–1933.* London: National Army Museum in association with Alan Sutton, 1987, 190pp., illus. The first major consideration of Butler's career, this contains a carefully researched series of critical essays together with detailed comments on individual exhibits. It sets Butler in her historical and social context and includes use of contemporary sources.

Casteras, Susan, and Linda H. Peterson. *A Struggle for Fame: Victorian Women Artists and Authors.* New Haven, Conn.: Yale Center for British Art, 1994.

Other Sources

Ash, Russell. "English painting of 1874." *Connoisseur* 185 (January 1974): 33–40. Discusses a selection of paintings exhibited in England in 1874 and commences with Butler's *The Roll Call.*

Bachmann, Donna, and Sherry Piland. *Women Artists: A Historical, Contemporary and Feminist Bibliography.* Metuchen, N.J.: Scarecrow Press, 1978.

Clayton, Ellen. *English Female Artists.* London: Tinsley, 1876.

Clement, Clara. *Women in the Fine Arts.* Boston: Houghton Mifflin, 1904.

Dunford, Penny. *A Biographical Dictionary of Women Artists in Europe and America since 1850.* Hemel Hempstead: Harvester Wheatsheaf and Philadelphia: University of Pennsylvania Press, 1990. Contains a bibliography.

Fine, Elsa Honig. *Women and Art.* New York and London: Allanfield and Schram/Prior, 1978.

Nunn, Pamela Gerrish. *Victorian Women Artists.* London: Women's Press, 1987.

Yeldham, Charlotte. *Women Artists in Nineteenth Century France and England.* London and New York: Garland, 1984.

2473 BUTLER, MILDRED ANNE (1858–1941)
 Irish painter of landscapes.

Exhibitions

Irish Women Artists from the Eighteenth Century to the Present Day. Dublin: National Gallery of Ireland, Douglas Hyde Gallery and Hugh Lane Gallery: 1987.

Casteras, Susan, and Linda H. Peterson. *A Struggle for Fame: Victorian Women Artists and Authors.* New Haven: Yale Center for British Art, 1994.

Other Sources

De Breffny, Brian, ed. *Ireland: A Cultural Encyclopaedia.* London: Thames and Hudson, 1983.

Dunford, Penny. *A Biographical Dictionary of Women Artists in Europe and America since 1850.* Hemel Hempstead: Harvester Wheatsheaf and Philadelphia: University of Pennsylvania Press, 1990. Contains a bibliography.

Mallalieu, Hugh. *Dictionary of British Watercolour Artists.* Woodbridge: Antique Collectors Club, 1976.

Wood, Christopher. *The Dictionary of Victorian Painters.* Woodbridge: Antique Collectors Club, 1978.

2474 BYRNE, LETITIA (1779–1849)
English graphic artist, who produced etchings and illustrations, and painter of landscapes and architectural scenes.

See Graphic Art section.

2475 CAHN, MARCELLE (1895–1981)
French painter of geometric and Cubist abstractions.

Exhibitions

Ceysson, B., et al. *Marcelle Cahn.* Paris: Centre National d'Art Contemporain, 1972.

Abadie, Daniel. *Marcelle Cahn.* Les Sables d'Olonne: Abbaye Sainte-Croix, 1977.

Vergine, Lea. *L'altra metà dell'avanguardia.* Milan: Mazzotta Editore, 1980. *L'autre moitié de l'avant-garde.* Paris: Des Femmes, 1982.

Dufresne, Jean-Luc, and Olivier Messac, eds. *Femmes créatrices des années vingt.* Granville: Musée Richard Anacréon, 1988. Wide-ranging catalogue with a short biographical account on each woman included.

Künstlerinnen des 20 Jahrhunderts. Wiesbaden: Museum Wiesbaden in association with Verlag Weber & Weidermeyer GmbH, Kassel, 1990.

Other Sources

Lucie-Smith, Edward. *Art Deco Painting.* Oxford: Phaidon. 1990.

2476 CAMERON, KATHERINE (née CATHERINE; alt. KAY) (1874–1965)
Scottish painter of flowers, especially roses.

Main Sources

Marillier, H. C. "The Romantic Watercolours of Miss Cameron." *Art Journal,* 1900, 149.

Exhibitions

The Last Romantics. The Romantic Tradition in British Art: Burne-Jones to Stanley Spencer. London: Barbican Art Gallery, 1989.
Burkhauser, Jude. *Glasgow Girls: Women in Art and Design 1880–1920.* Edinburgh: Canongate, 1990.

Other Sources

Burbidge, R. Brinsley. *Dictionary of British Flower, Fruit and Still Life Painters.* Leigh-on-Sea: F. Lewis, 1974.
Clement, Clara. *Women in the Fine Arts.* Boston: Houghton Mifflin, 1904.
Sparrow, Walter Shaw. *Women Painters of the World.* London: Hodder and Stoughton, 1905.

2477 CAMPAGNANO, MARCELLA (1941–)
Italian photographer who was a painter until the 1970s.

See Photography section.

2478 CANTALUPO, PATRIZIA (1952–)
Italian painter of symbolic landscapes and still lifes.

Main Sources

Bonfigli, R. "Basiliea: Patrizia Cantalupo." *Flash Art* (Italian Edition) 114 (June 1983): 72.
Meneghelli, L. "Mantova officine e ateliers 3: Casa del Mantegna." *Flash Art* (Italian Edition) 114 (June 1983): 68.

Exhibitions

Fox, Howard. *A New Romanticism: Sixteen Artists from Italy.* Washington, D.C.: Hirschhorn Museum and Sculpture Garden, 1986.
Vedute romane: Myriam Laplante, Susanna Sartarelli, Sabina Mirri, Patrizia Cantalupo. Vancouver: Charles H. Scott Gallery, Emily Carr College of Art and Design, 1989.

Other Sources

Dunford, Penny. *A Biographical Dictionary of Women Artists in Europe and America since 1850*. Hemel Hempstead: Harvester Wheatsheaf and Philadelphia: University of Pennsylvania Press, 1990. Contains a bibliography.

2479 CANZIANI, ESTELLA STARR (1887–1964)
 English painter of portraits, landscapes and figure subjects; also a graphic artist who illustrated books and a muralist. She was the daughter of the famous painter Louisa Starr (q.v.).

Publications

Costumes, Traditions and Songs of Savoy, Piedmont. Through the Apennines and Lands of the Abruzzi (exists in English, French and Italian Editions).
Round About Palace Green. London, 1939. Autobiography.

Main Sources

Nunn, Pamela Gerrish. *Canvassing*. London: Camden Press, 1986.

Other Sources

Dunford, Penny. *A Biographical Dictionary of Women Artists in Europe and America since 1850*. Hemel Hempstead: Harvester Wheatsheaf and Philadelphia: University of Pennsylvania Press, 1990. Contains a bibliography.

2480 CAPET, GABRIELLE (1761–1817)
 French painter of portraits.

Exhibitions

Harris, Anne Sutherland, and Linda Nochlin. *Women Artists 1550–1950*. Los Angeles: County Museum of Art, 1976.

2481 CARBONE, SARA (c. 1945–)
 Italian abstract painter.

Other Sources

Weller, Simone. *Il Complesso di Michelangelo: ricerca sul contributo dato dalla donna all'arte italiana del novecento*. Pollenza-Macerata: La Nuova Foglio [*sic*] Editrice, 1976.

2482 CARLISLE, FIONNA (1954–)
 Scottish painter of highly coloured figurative works who works in Greece.

Exhibitions

Fionna Carlisle Retrospective Exhibition. Edinburgh: 369 Gallery, 1989, n.p., illus. Contains a useful analytical essay and a list of her exhibitions.

2483 CARPENTER, MARGARET SARAH (née GEDDES) (1793–1872)
English painter of portraits, genre and miniatures; sister of Catherine Gray (q.v.).

Main Sources

Clayton, Ellen. *English Female Artists.* London: Tinsley, 1876.
Art Journal, January 1873, 6. Obituary.
Smith, Richard. "One Face to Remember." *Women's Art Magazine* 54 (1993): 26–27.

Other Sources

Clement, Clara. *Women in the Fine Arts.* Boston: Houghton Mifflin, 1904.
Dunford, Penny. *A Biographical Dictionary of Women Artists in Europe and America since 1850.* Hemel Hempstead: Harvester Wheatsheaf and Philadelphia: University of Pennsylvania Press, 1990. Contains a bibliography.
Fine, Elsa Honig. *Women and Art.* New York and London: Allanfield and Schram/Prior, 1978.
Nunn, Pamela Gerrish. *Victorian Women Artists.* London: Women's Press, 1987.
Sparrow, Walter Shaw. *Women Painters of the World.* London: Hodder and Stoughton, 1905.
Wood, Christopher. *The Dictionary of Victorian Painters.* Woodbridge: Antique Collectors Club, 1978.
Yeldham, Charlotte. *Women Artists in Nineteenth Century France and England.* London and New York: Garland, 1984.

2484 CARPENTIER, MADELEINE (1865–after 1939)
French painter of portraits and still lifes, usually in watercolour or pastel.

Other Sources

Clement, Clara. *Women in the Fine Arts.* Boston: Houghton Mifflin, 1904.
Dunford, Penny. *A Biographical Dictionary of Women Artists in Europe and America since 1850.* Hemel Hempstead: Harvester Wheatsheaf and Philadelphia: University of Pennsylvania Press, 1990. Contains a bibliography.
Edouard-Joseph, R. *Dictionnaire biographique des artistes contemporains, 1910–1930.* Paris: Art et Editions, 1930–1934.
Hardouin-Fugier, Elizabeth, and E. Grafe. *French Flower Painters of the Nineteenth Century: A Dictionary.* London: Philip Wilson, 1989.
Hirsch, A. *Die Bildenden Künstlerinnen der Neuzeit.* Stuttgart: 1905.
Sparrow, Walter Shaw. *Women Painters of the World.* London: Hodder and Stoughton, 1905.

2485 CARRINGTON (née DORA DE HOUGHTON CARRINGTON) (1893–1932)

English painter associated with the Bloomsbury group; illustrator and designer of graphics, ceramics and textiles.

See volume 1: Interior Design section.

2486 CARRINGTON, LEONORA (1917–)

English-born Surrealist painter and writer who lived in France, Mexico and, from 1988, the U.S.A.

Publications

See Chadwick (1985) below.

Conrad, Peter. "Leonora: The Last of the Surrealists." *The Observer,* 8 December 1991, 24–30. Interview with Carrington.

Main Sources

Caws, Mary Ann, Rudolf Kuenzli, and Gwen Raaberg, eds. *Surrealism and Women.* Cambridge, Mass.: MIT Press, 1991.

Chadwick, Whitney. *Women Artists and the Surrealist Movement.* London: Thames and Hudson, 1985. Contains a bibliography and list of Carrington's publications.

————. "Leonora Carrington: Evolution of a Feminist Consciousness." *Woman's Art Journal* 7, no. 1 (spring–summer 1986): 37–42.

Chadwick, Whitney and Marina Warner. "Leonora Carrington: Her Life and Work: A Symposium." *Women's Art Magazine* 45 (1992): 26–29. Edited version of two papers given at the symposium.

Craddock, Sarah. "Down to Earth with a Surrealist." *The Guardian,* 11 December 1991, 34. Review of the Serpentine Gallery exhibition.

Feaver, William. "Hyenas amid Viyella lagging." *The Observer,* 15 December 1991. Review of the Serpentine Gallery exhibition.

Graham-Dixon, Andrew. "The Rocking Horse Winner." *The Independent,* 17 December 1991, 14. Review of her exhibition at the Serpentine Gallery together with an extract from *The Debutante* by Carrington.

Hubert, Renée Riese. *Magnifying Mirrors: Women. Surrealism and Partnership,* 113–140. Lincoln and London: University of Nebraska Press, 1994. Discusses the nature of relationships within the Surrealist group and its effect on the productivity of both partners.

Exhibitions

Künstlerinnen International, 1877–1977. Berlin: Schloss Charlottenburg, 1977.

Paris 1937–Paris 1957: créations en France. Paris: Centre national d'art et de culture Georges Pompidou, 1981.

Vergine, Lea. *L'altra metà dell'avanguardia.* Milan: Mazzotta Editore, 1980. *L'autre moitié de l'avant-garde.* Paris: Des Femmes, 1982. *Leonora Carrington.* London: Serpentine Gallery, 1991.

Other Sources

Bachmann, Donna, and Sherry Piland. *Women Artists: A Historical, Contemporary and Feminist Bibliography.* Metuchen, N.J.: Scarecrow Press, 1978.
Dunford, Penny. *A Biographical Dictionary of Women Artists in Europe and America since 1850.* Hemel Hempstead: Harvester Wheatsheaf and Philadelphia: University of Pennsylvania Press, 1990. Contains a bibliography.
National Museum of Women in the Arts. New York: Abrams, 1987. Catalogue of the permanent collection.

2487 CARTERON, MARIE ZOÉ (née VALLERAY) (1813–?)
French painter of portraits, still lifes and, more rarely, flowers.

Other Sources

Hardouin-Fugier, Elizabeth, and E. Grafe. *French Flower Painters of the Nineteenth Century: A Dictionary.* London: Philip Wilson, 1989.

2488 CASORATI, DAPHNE MAUGHAM (1897–1982)
English-born painter who trained in Paris and settled in Italy in 1926.

Exhibitions

Baraldi, Anna Maria, et al. *6 Biennale Donna.* Ferrara: Padiglione d'Arte Contemporanea, 1994.

2489 CASPAR-FILSER, MARIA (1878–1968)
German painter.

Exhibitions

Gleisberg, D. *Deutsche Künstlerinnen des zwanzigsten Jahrhunderts.* Attenburg: Staatlichen Lindendau Museum, 1963.
Maria Caspar-Filser (1878–1968). Albstadt: Städtische Galerie, 1978, 101pp., illus. Centenary exhibition. Text in German.
Barron, Stephanie. *Degenerate Art: The Fate of the Avant-garde in Nazi Germany.* Los Angeles: County Museum of Art, 1991.

Other Sources

Wirth, Günther. *Verbotene Kunst: verfolgete Künstler im Deutschen Sudwesten 1933–1945.* Stuttgart: Hatje, 1987.

2490 CASSATT, MARY STEVENSON (1844–1926)
American Impressionist painter of figures and graphic artist who worked in Paris.

Publications

Mathews, Nancy Mowll, ed. *Cassatt and Her Circle: Selected Letters.* New York: Abbeville Press, 1984, 360pp., illus.

Main Sources

Breeskin, Adelyn. *Mary Cassatt: A Catalogue Raisonné of Oils, Pastels, Watercolors and Drawings.* Washington, D.C.: Smithsonian Institute Press, 1970, 322pp., illus.

Effeny, Alison. *Mary Cassatt (1844–1926).* Rev. ed. London: Studio Vista, 1993, 144pp., illus.

Faxon, Alicia. "Painter and Patron: Collaboration of Mary Cassatt and Louisine Havermeyer." *Woman's Art Journal* 3, no. 2 (fall 1982–winter 1983): 15–20.

Getlein, Frank. *Mary Cassatt: Paintings and Prints.* New York, London and Paris: Abbeville Press, 1980, 156pp., illus. Comments on a series of individual paintings.

Hale, Nancy. *Mary Cassatt.* New York: Doubleday, 1975, 333pp., illus.

Kysela, John. "Mary Cassatt's Mystery Mural and the World's Fair of 1893." *Art Quarterly* 29 (1966): 128–145.

Love, Richard. *Cassatt: The Independent.* Chicago: Milton H. Kreines, 1980, 270pp., illus.

Pollock, Griselda. *Mary Cassatt.* London: Jupiter Books, 1980.

———. "Modernity and the Spaces of Femininity." In *Vision and Difference,* 50–90. London: Routledge, 1988. Examines the depiction of the public and private spheres by Cassatt and Morisot in their sociocultural context and in comparison with their male contemporaries.

Exhibitions

Sargent, Whistler and Mary Cassatt. Chicago: Art Institute, 1954, 104pp., illus.

Mary Cassatt: peintre et graveur, 1844–1926. Paris: Centre Culturel Américain, 1959, n.p. illus.

Bullard, Edgar. *Mary Cassatt: Oils and Pastels.* Washington, D.C.: National Gallery of Modern Art in association with Watson-Guptill, New York, 1976, 87pp., illus.

Harris, Anne Sutherland, and Linda Nochlin. *Women Artists 1550–1950.* Los Angeles: County Museum of Art, 1976.

Breeskin, Adelyn. *Mary Cassatt: Graphic Art.* Washington, D.C.: Smithsonian Institution, 1981, 25pp., 49 illus.

———, ed. *The Art of Mary Cassatt, 1844–1926.* Tokyo: Isetan Museum of Art, 1981, 125pp., illus.

Mathews, Nancy, and N. L. Manson. *Mary Cassatt and Edward Degas.* San Jose, Calif.: Museum of Art, 1981. Examines their friendship and questions of male and female imagery.

Lindsay, Suzanne. *Mary Cassatt and Philadelphia.* Philadelphia: Museum of Art, 1985, 96pp., illus.

Das Verborgene Museum. Dokumentation der Kunst von Frauen in Berliner öffentlichen Sammlungen. Berlin: Edition Hentrich, 1987.

Mathews, Nancy Mowll, and Barbara Stern Schapiro. *Mary Cassatt: The Color Prints.* New York: Harry Abrams in association with Williams College Museum of Art, 1989, 207pp., illus.

Other Sources

Bachmann, Donna, and Sherry Piland. *Women Artists: A Historical, Contemporary and Feminist Bibliography.* Metuchen, N.J.: Scarecrow Press, 1978.

Bunoust, Madeleine. *Quelques Femmes Peintres.* Paris: Librairie Stock, 1936.

Clement, Clara. *Women in the Fine Arts.* Boston: Houghton Mifflin, 1904.

Dunford, Penny. *A Biographical Dictionary of Women Artists in Europe and America since 1850.* Hemel Hempstead: Harvester Wheatsheaf and Philadelphia: University of Pennsylvania Press, 1990. Contains a bibliography.

2491 CASTELLUCCI, CATERINA (1905–1985)
 Italian painter.

Exhibitions

Baraldi, Anna Maria, et al. *6 Biennale Donna.* Ferrara: Padiglione d'Arte Contemporanea, 1994.

2492 CAVE, MARIE-ELIZABETH (1809–after 1875) (Alt. Mme. CLEMENT BOULANGER)
 French painter in watercolours, engraver and illustrator.

Publications

La Beauté physique de la Femme. Paris, 1868.
La Vièrge Marie et la Femme. Paris, 1875.

Main Sources

Angrand, Pierre. *Marie-Elizabeth Cave: Disciple de Degas.* Paris: La Bibliothèque des Arts, 1960, 176pp., illus. A biographical account.

2493 CAZIN, MARIE (née GUILLET) (1844–1924)
 French sculptor of figures and painter of rural genre and landscapes.

See Sculpture section.

2494 CECCHI PIERACCINI, LEONETTA (1882–?)
Italian figurative painter.

Other Sources

Weller, Simone. *Il Complesso di Michelangelo: ricerca sul contributo dato dalla donna all'arte italiana del novecento.* Pollenza-Macerata: La Nuova Foglio [*sic*] Editrice, 1976.

2495 CHAILLY, MARIA (1861–1928)
Italian painter.

Exhibitions

Baraldi Anna, and Francesca Mellone. *4a Biennale Donna—1990. Presenze femminili nella vita artistica a Ferrara tra Ottocento e Novecento.* Ferrara: Palazzo dei Diamanti, 1990.

2496 CHALON, MARIA A. (Alt. MOSELEY) (c. 1800–1867)
English painter of portraits and miniatures.

Other Sources

Foskett, Daphne. *Miniatures: A Dictionary and Guide.* Woodbridge: Antique Collectors Club, 1987.

2497 CHAMBERLAIN, BRENDA (1912–1971)
Welsh painter of figures and the seashore; also a writer.

Main Sources

Piercy, J. "Brenda Chamberlain: An Island Artist." *Women Artists Slide Library Journal* 27 (February–March 1989): 22–24.

Exhibitions

Brenda Chamberlain: Island Artist. Llandudno: Mostyn Art Gallery, 1988.

Other Sources

Dunford, Penny. *A Biographical Dictionary of Women Artists in Europe and America since 1850.* Hemel Hempstead: Harvester Wheatsheaf and Philadelphia: University of Pennsylvania Press, 1990. Contains a bibliography.
Dunthorne, Katherine. *Artists Exhibited in Wales, 1945–1976.* Cardiff: Welsh Arts Council, 1976.

2498 CHAMPION-MÉTARDIER, ISABELLE (Alt. MÉTARDIER; MÉTADIER) (1947–)
French painter of semi-abstract expressionist works.

Main Sources

Boudaille, Georges. "Peindre le monde en rose." *Art Press,* 1982: 7.
Thomas, M. "Elle aime les étoiles et les soucoupes volantes: Isabelle Champion-Métardier." *Beaux-Arts Magazine* 15 (July–August 1984): 68–69.

Exhibitions

Künstlerinnen International, 1877–1977. Berlin: Schloss Charlottenburg, 1977.
Millet, C. *Peinture en Pluie.* Paris: Galérie Stevenson et Palluel, 1977.
Tronche, A. *Marseilles, art présent: catalogue de l'exposition de la Vieille Charité.* Marseilles, 1983.
Eiblmayr, Silvia, Valie Export, and Monika Prischl-Maier. *Kunst mit Eigen-Sinn. Aktuelle Kunst von Frauen: Texte und Dokumentation.* Vienna: Locker Verlag in association with the Museum Moderner Kunst and Museum des 20. Jahrhunderts, Munich, 1985.

2499 CHARMY, EMILIE (1878–1974)
French painter of landscapes, portraits, still lifes and figures.

Exhibitions

Les femmes artistes modernes. Exposition de peintures, sculptures, 1937. Paris: Buffet & Leclerc, 1937.

Other Sources

Bunoust, Madeleine. *Quelques Femmes Peintres.* Paris: Librairie Stock, 1936.
Edouard-Joseph, R. *Dictionnaire biographique des artistes contemporains, 1910–1930.* Paris: Art et Editions, 1930–1934.
Perry, Gill. *Women Artists and the Parisian Avant-Garde.* Manchester: Manchester University Press, 1995. Includes a biography and select bibliography.

2500 CHARPENTIER, CONSTANCE MARIE (née BLONDELU) (1767–1849)
French painter of figures and portraits.

Exhibitions

Harris, Anne Sutherland, and Linda Nochlin. *Women Artists 1550–1950.* Los Angeles: County Museum of Art, 1976.

Other Sources

Clement, Clara. *Women in the Fine Arts.* Boston: Houghton Mifflin, 1904.
Ellet, Elizabeth. *Women Artists in all Ages and Countries.* New York: Harper and Brothers Co., 1859, 377pp.
Fine, Elsa Honig. *Women and Art.* New York and London: Allanfield and Schram/Prior, 1978.

2501 CHARRETIE, ANNA MARIA (née KENWELL) (1819–1875)
English painter of flowers and miniatures in watercolour and, later, of figure subjects and portraits in oil.

Main Sources

"Mrs Charretie." *Art Journal,* 1876, 12. Obituary.
Clayton, Ellen. *English Female Artists.* London: Tinsley, 1876.

Other Sources

Clement, Clara. *Women in the Fine Arts.* Boston: Houghton Mifflin, 1904.
Dunford, Penny. *A Biographical Dictionary of Women Artists in Europe and America since 1850.* Hemel Hempstead: Harvester Wheatsheaf and Philadelphia: University of Pennsylvania Press, 1990. Contains a bibliography.
Foskett, Daphne. *Dictionary of British Miniature Painters.* London: Faber and Faber, 1972.
Nunn, Pamela Gerrish. *Victorian Women Artists.* London: Women's Press, 1987.

2502 CHASE, MARION EMMA (1844–1905)
English painter of landscapes and genre scenes.

Main Sources

Clayton, Ellen. *English Female Artists.* London: Tinsley, 1876.

Other Sources

Dunford, Penny. *A Biographical Dictionary of Women Artists in Europe and America since 1850.* Hemel Hempstead: Harvester Wheatsheaf and Philadelphia: University of Pennsylvania Press, 1990. Contains a bibliography.
Mallalieu, Hugh. *Dictionary of British Watercolour Artists.* Woodbridge: Antique Collectors Club, 1976.
Nunn, Pamela Gerrish. *Victorian Women Artists.* London: Women's Press, 1987.
Sparrow, Walter Shaw. *Women Painters of the World.* London: Hodder and Stoughton, 1905.

2503 CHAUDET, JEANNE (née GABIOU) (1767–1832)
French painter.

Exhibitions

Beaulieu, Germaine, et al. *La femme artiste d'Elisabeth Vigée-Lebrun à Rosa Bonheur.* Lacoste: Musée Despiau-Wlerick et Dubalen Mont-de-Marsan, 1981. Includes a bibliography.

2504 CHAVES, ALEXANDRINA (née MARIA ALEXANDRINA PIRES CHAVES BERGER) (1892–)
Portuguese painter.

Other Sources

Di Pamplona, Fernando. *Um seculo de pintura e escultura em Portugal, 1830–1930.* Porto: Livraria Tavares Martins, 1943.

2505 CHESTON, EVELYN (née DAVY) (1875–1929)
English painter who shared a painting prize with Augustus John at the Slade School of Art.

Main Sources

Cheston, Charles. *Evelyn Cheston: Member of the New English Art Club, 1908–1929.* London: Faber & Faber, 1931, 50pp. and 48 pp. of plates. A biographical account by her husband, who was also an artist. This publication coincided with a memorial exhibition.

2506 CHEVSKA, MARIA (1948–)
English figurative painter.

Main Sources

Bonshek, A. "Feminist Romantic Painting: A Re-constellation." *Artists' Newsletter,* May 1985: 24–27.
Fortnum, Rebecca. "Double Speak: Maria Chevska's Diptychs." *Women's Art Magazine* 38 (1991): 26. Exhibition review.

Exhibitions

Landscape, Memory and Desire. London: Serpentine Gallery, 1984.
Pandora's Box. Bristol: Arnolfini Gallery, 1984.

Other Sources

Dunford, Penny. *A Biographical Dictionary of Women Artists in Europe and America since 1850.* Hemel Hempstead: Harvester Wheatsheaf and Philadelphia: University of Pennsylvania Press, 1990. Contains a bibliography.

2507 CHILINSKAIA, NINA (1926–)
Russian painter.

Exhibitions

De la Révolution à la Péréstroika. Art Soviétique de la Collection Ludwig. St. Etienne: Musée d'Art Moderne, 1989.

2508 CHUHAN, JAGJIT (1955–)
Indian-born painter working in England who produces semi-abstract works.

Exhibitions

Secret Spaces: Paintings and Drawings by Jagjit Chuhan. Rochdale: Art Gallery, 1986, n.p., illus.

Other Sources

Dunford, Penny. *A Biographical Dictionary of Women Artists in Europe and America since 1850.* Hemel Hempstead: Harvester Wheatsheaf and Philadelphia: University of Pennsylvania Press, 1990. Contains a bibliography.

2509 CHURBERG, FANNY (1845–1892)
Finnish painter of landscapes and still lifes with a free, almost Expressionist technique.

Exhibitions

Sieben Finnische Malerinnen. Hamburg: Kunsthalle, 1983.
Nordisk Sekelskifte: The Light of the North. Stockholm: Nationalmuseum, 1995.

Other Sources

Dunford, Penny. *A Biographical Dictionary of Women Artists in Europe and America since 1850.* Hemel Hempstead: Harvester Wheatsheaf and Philadelphia: University of Pennsylvania Press, 1990. Contains a bibliography.

2510 CHURGULIA, NANA (1951–)
Georgian painter.

Other Sources

Rosenfeld, Alla, and Norton Dodge, eds. *Nonconformist Art: The Soviet Experience, 1956–1986. The Norton and Nancy Dodge Collection.* London: Thames and Hudson in association with the Jane Voorhees Zimmerli Art Museum, State University of New Jersey, Rutgers, 1995.

2511 CIARDI, EMMA (1879–1933)
Italian painter mainly of landscapes who exhibited widely in England.

Other Sources

Weller, Simone. *Il Complesso di Michelangelo: ricerca sul contributo dato dalla donna all'arte italiana del novecento.* Pollenza-Macerata: La Nuova Foglio [*sic*] Editrice, 1976.

2512 CLARKE-HALL, EDNA (LADY) (née WAUGH) (1879–1979)
English painter of figurative subjects and flowers.

Main Sources

Taylor, Hilary. "'If a Young Painter be not Fierce and Arrogant God Help Him': Some Women Art Students at the Slade, c. 1895–99. *" Art History* 9 (June 1986): 232–244.
Thomas, Alison. *Portraits of Women: Gwen John and Her Forgotten Contemporaries.* Cambridge: Polity Press, 1996.

Exhibitions

Thomas, Alison. *Edna Clarke-Hall, 1879–1979: Watercolours and Drawings.* Sheffield: Graves Art Gallery, 1985, 6pp., illus. Gives a detailed biography.

Other Sources

Dunford, Penny. *A Biographical Dictionary of Women Artists in Europe and America since 1850.* Hemel Hempstead: Harvester Wheatsheaf and Philadelphia: University of Pennsylvania Press, 1990. Contains a bibliography.
Greer, Germaine. *The Obstacle Race.* London: Secker and Warburg, 1979.
Wood, Christopher. *The Dictionary of Victorian Painters.* Woodbridge: Antique Collectors Club, 1978.

2513 CLARKE, MARGARET (née CRILLEY) (1888/9–1961)
Irish painter of landscapes, flowers and portraits.

Exhibitions

Irish Women Artists from the Eighteenth Century to the Present Day. Dublin: National Gallery of Ireland, Douglas Hyde Gallery and Hugh Lane Gallery, 1987.

Other Sources

De Breffny, Brian, ed. *Ireland: A Cultural Encyclopaedia.* London: Thames and Hudson, 1983.

2514 CLAUSEN, FRANCISKA (1899–)
Danish painter who also used collage to create abstract or semi-abstract works.

Exhibitions

Harris, Anne Sutherland, and Linda Nochlin. *Women Artists 1550–1950.* Los Angeles: County Museum of Art, 1976.
Vergine, Lea. *L'altra metà dell'avanguardia.* Milan: Mazzotta Editore, 1980. *L'autre moitié de l'avant-garde.* Paris: Des Femmes, 1982.

Surrealismen i Danmark 1930–1950. Copenhagen: Statens Museum for Kunst, 1986.

Other Sources

Dunford, Penny. *A Biographical Dictionary of Women Artists in Europe and America since 1850.* Hemel Hempstead: Harvester Wheatsheaf and Philadelphia: University of Pennsylvania Press, 1990. Contains a bibliography.

Edouard-Joseph, R. *Dictionnaire biographique des artistes contemporains, 1910–1930.* Paris: Art et Editions, 1930–1934.

2515 CLOUGH, PRUNELLA (1919–)
English painter of abstract works inspired by industrial landscapes.

Main Sources

Garlake, Margaret. "The Colour of the City." *Women's Art Magazine* 55 (1993): 21.

Key, Joan. "The Metamorphosis of Attrition." *Women's Art Magazine* 70 (1996): 5–7. Review of a retrospective of twenty-five years of Clough's paintings.

Exhibitions

British Painting 1952–1977. London: Royal Academy, 1977.

Prunella Clough: New Paintings 1979–1982. London: Warwick Arts Trust, 1982, n.p., illus. Includes an interview, outline biography and a list of exhibitions.

Women's Art Show, 1550–1970. Nottingham: Castle Museum, 1982. Contains a brief biography.

Other Sources

Dunford, Penny. *A Biographical Dictionary of Women Artists in Europe and America since 1850.* Hemel Hempstead: Harvester Wheatsheaf and Philadelphia: University of Pennsylvania Press, 1990. Contains a bibliography.

Krichbaum, J., and R. Zondergeld. *Künstlerinnen: von der Antike bis zur Gegenwart.* Cologne: DuMont, 1979.

Parry-Crooke, Charlotte. *Contemporary British Artists.* London: Bergstrom and Boyle, 1979.

2516 COKE, DOROTHY JOSEPHINE (1897–1979)
English painter and engraver of landscapes, town scenes, still lifes and portraits.

Exhibitions

Exhibition of Paintings and Drawings by Some Women War Artists. London: Imperial War Museum, 1958.

Other Sources

Dunford, Penny. *A Biographical Dictionary of Women Artists in Europe and America since 1850.* Hemel Hempstead: Harvester Wheatsheaf and Philadelphia: University of Pennsylvania Press, 1990. Contains a bibliography.

Waters, Grant. *Dictionary of British Artists Working 1900–1940.* Eastbourne: Eastbourne Fine Art, 1975.

2517 COLQUHOUN, ITHELL (née MARGARET ITHELL COLQUHOUN) (1906–1988)
English Surrealist painter and mixed-media artist.

Main Sources

Chadwick. Whitney. *Women Artists and the Surrealist Movement.* London: Thames and Hudson, 1985.

Exhibitions

Ithell Colquhoun: Paintings and Drawings, 1930–1940. London: Parkin Gallery, 1970.

Ithell Colquhoun: Surrealism. Newlyn, Cornwall: Orion Gallery, 1976.

Vergine, Lea. *L'altra metà dell'avanguardia.* Milan: Mazzotta Editore, 1980.

L'autre moitié de l'avant-garde. Paris: Des Femmes, 1982.

Women's Art Show 1550–1970. Nottingham: Castle Museum, 1982.

British Women Surrealists. London: Blond Fine Art, 1985.

Salute to British Surrealism, 1930–1950. Colchester: Minories Gallery, 1985.

Hedley, Gill. *Let Her Paint.* Southampton: City Art Gallery, 1988.

Surrealist Spirit in Britain. London: Whitford & Hughes, 1988.

Other Sources

Dunford, Penny. *A Biographical Dictionary of Women Artists in Europe and America since 1850.* Hemel Hempstead: Harvester Wheatsheaf and Philadelphia: University of Pennsylvania Press, 1990. Contains a bibliography.

2518 COOKESLEY, MARGARET MURRAY (c. 1860–1927)
English painter of historical and genre scenes, many set in the Middle East.

Exhibitions

Sellars, Jane. *Women's Works.* Liverpool: Walker Art Gallery, 1988.

Other Sources

Clement, Clara. *Women in the Fine Arts.* Boston: Houghton Mifflin, 1904.

Dunford, Penny. *A Biographical Dictionary of Women Artists in Europe and*

America since 1850. Hemel Hempstead: Harvester Wheatsheaf and Philadelphia: University of Pennsylvania Press, 1990. Contains a bibliography.

Waters, Grant. *Dictionary of British Artists Working 1900–1940.* Eastbourne: Eastbourne Fine Art, 1975.

Wood, Christopher. *The Dictionary of Victorian Painters.* Woodbridge: Antique Collectors Club, 1978.

2519 COOKE, JEAN (1927–)

English painter of figures and some still lifes; full member of the Royal Academy, London.

Exhibitions

Jean Cooke. London: Leicester Gallery, 1964.
British Painting 1952–1977. London: Royal Academy, 1977.

Other Sources

Burbidge, R. Brinsley. *Dictionary of British Flower, Fruit and Still Life Painters.* Leigh-on-Sea: F. Lewis, 1974.

Dunford, Penny. *A Biographical Dictionary of Women Artists in Europe and America since 1850.* Hemel Hempstead: Harvester Wheatsheaf and Philadelphia: University of Pennsylvania Press, 1990. Contains a bibliography.

Parry-Crooke, Charlotte. *Contemporary British Artists.* London: Bergstrom and Boyle, 1979.

2520 COOK, BERYL (1937–)

English painter best known for her stylised, plump figures engaged in everyday activities.

Exhibitions

Women's Art Show 1550–1970. Nottingham: Castle Museum, 1982.

Other Sources

Dunford, Penny. *A Biographical Dictionary of Women Artists in Europe and America since 1850.* Hemel Hempstead: Harvester Wheatsheaf and Philadelphia: University of Pennsylvania Press, 1990. Contains a bibliography.

2521 COOPER, EILEEN (1953–)

English figurative painter who deals with the female body and ideas of motherhood.

Main Sources

Deepwell, Katy. "Eileen Cooper at Blond." *Artscribe,* July–August 1985.

Greenan, Althea. "Single Female Currency." *Women's Art Magazine* 58 (1994): 23–24. Includes a review of her exhibition *Lifelines.*

Hill, A. "Flying: Eileen Cooper." *Artscribe* 41 (June 1983): 20–25.

Exhibitions

Women's Images of Men. London: Institute of Contemporary Art, 1980.
Ball, M., and T. Godfrey. *Figuring Out the 80s.* Newcastle-upon-Tyne: Laing Art Gallery, 1988.

Other Sources

Dunford, Penny. *A Biographical Dictionary of Women Artists in Europe and America since 1850.* Hemel Hempstead: Harvester Wheatsheaf and Philadelphia: University of Pennsylvania Press, 1990. Contains a bibliography.
Lucie-Smith, Edward, C. Cohen, and J. Higgins. *The New British Painting.* Oxford: Phaidon, 1988.

2522 COOPER, EMMA (née WREN) (1837–c.1912)
English painter of birds and flowers.

Publications

Plain Words on the Art and Practice of Illumination. London, 1868.

Main Sources

Clayton, Ellen. *English Female Artists.* London: Tinsley, 1876.

Other Sources

Dunford, Penny. *A Biographical Dictionary of Women Artists in Europe and America since 1850.* Hemel Hempstead: Harvester Wheatsheaf and Philadelphia: University of Pennsylvania Press, 1990. Contains a bibliography.
Mallalieu, Hugh. *Dictionary of British Watercolour Artists.* Woodbridge: Antique Collectors Club, 1976.
Wood, Christopher. *The Dictionary of Victorian Painters.* Woodbridge: Antique Collectors Club, 1978.

2523 CORBAUX, FANNY (née MARIA FRANÇOISE DOETTER CORBAUX; alt. DOETYER, DOETGER) (1812–1883)
English painter of portraits and miniatures in oil and watercolour. Sister of Louisa Corbaux (q.v.).

Main Sources

Athenaeum, 1883: 192. Obituary.
Clayton, Ellen. *English Female Artists.* London: Tinsley, 1876.

Other Sources

Dunford, Penny. *A Biographical Dictionary of Women Artists in Europe and America since 1850.* Hemel Hempstead: Harvester Wheatsheaf and Philadelphia: University of Pennsylvania Press, 1990. Contains a bibliography.

Foskett, Daphne. *Dictionary of British Miniature Painters.* London: Faber and Faber, 1972.

Mallalieu, Hugh. *Dictionary of British Watercolour Artists.* Woodbridge: Antique Collectors Club, 1976.

Nunn, Pamela Gerrish. *Victorian Women Artists.* London: Women's Press, 1987.

Wood, Christopher. *The Dictionary of Victorian Painters.* Woodbridge: Antique Collectors Club, 1978.

2524 CORBAUX, LOUISA (1808–after 1881)
English painter and lithographer who specialised in depicting children and pet animals. Sister of Fanny Corbaux.

Publications

Amateur's Painting Guide. London, 1852.

Main Sources

Clayton, Ellen. *English Female Artists.* London: Tinsley, 1876.

Other Sources

See Fanny Corbaux.

Yeldham, Charlotte. *Women Artists in Nineteenth Century France and England.* London and New York: Garland, 1984.

2525 CORREIA PERRIERA, LUISA (1945–)
Portuguese painter who has also designed work to be produced on ceramic tiles.

Exhibitions

Waves of Influence: cinco séculos do azulejo português. Staten Island, New York: Snug Harbour Cultural Center, 1995.

2526 COSWAY, MARIA LOUISA CATHERINE CECILIA (née HADFIELD) (1759–1838)
Miniature painter, born in Italy to Irish-Italian parents, who worked in London.

Main Sources

Barnett, Gerald. *Richard and Marie Cosway: A Biography.* Tiverton, Devon: Westcountry Books and Cambridge: Lutterworth Press, 1995, 288pp., 48pp. of plates. Contains an extensive bibliography.

Clarke, Roger. "Small Wonder." *Independent Magazine,* 27 May 1995, 40–41. Discusses Richard and Maria Cosway in the context of the recent film in which they appear, *Jefferson in Paris.*

Exhibitions

Das Verborgene Museum. Dokumentation der Kunst von Frauen in Berliner öffentlichen Sammlungen. Berlin: Edition Hentrich, 1987.
Richard and Maria Cosway: Regency Artists of Taste and Fashion. Edinburgh: Scottish National Portrait Gallery, 1995, 142pp., illus.

Other Sources

Ellet, Elizabeth. *Women Artists in all Ages and Countries.* New York: Harper and Brothers Co., 1859, 377pp.
Fine, Elsa Honig. *Women and Art.* New York and London: Allanfield and Schram/Prior, 1978.
Foskett, Daphne. *Miniatures: A Dictionary and Guide.* Woodbridge: Antique Collectors Club, 1987.
Foster, Joshua. *Dictionary of Painters of Miniatures.* London: Philip Allan & Co. Ltd., 1926.

2527 COURIARD, PELAGIA PETROVNA (née VOKHINA)
Russian landscape painter.

Other Sources

Dunford, Penny. *A Biographical Dictionary of Women Artists in Europe and America since 1850.* Hemel Hempstead: Harvester Wheatsheaf and Philadelphia: University of Pennsylvania Press, 1990. Contains a bibliography.
Krichbaum, J., and R. Zondergeld. *Künstlerinnen: von der Antike bis zur Gegenwart.* Cologne: DuMont, 1979.
Lexikon der Frau. Zurich: Encyclios Verlag, 1953.

2528 CRIDDLE, MARY ANN (née ALABASTER) (1805–1880)
English painter of literary and historical subjects and portraits.

Main Sources

Clayton, Ellen. *English Female Artists.* London: Tinsley, 1876.

Other Sources

Dunford, Penny. *A Biographical Dictionary of Women Artists in Europe and America since 1850.* Hemel Hempstead: Harvester Wheatsheaf and Philadelphia: University of Pennsylvania Press, 1990. Contains a bibliography.
Mallalieu, Hugh. *Dictionary of British Watercolour Artists.* Woodbridge: Antique Collectors Club, 1976.

Wood, Christopher. *The Dictionary of Victorian Painters.* Woodbridge: Antique Collectors Club, 1978.
Yeldham, Charlotte. *Women Artists in Nineteenth Century France and England.* London and New York: Garland, 1984.

2529 DABOWSKA-TARASIN, ZOFIA (1924–)
Polish graphic artist, painter and stage designer.

Other Sources

Jakimowicz, Irena. *Wspótczesna grafika polska.* Warsaw: Arkady, 1975.

2530 DACRE, SUSAN ISABEL (1844–1933)
English painter of figures, landscapes and portraits who worked in Manchester.

Other Sources

Cherry, Deborah. *Painting Women: Victorian Women Artists.* London: Routledge, 1993.
Orr, Clarissa Campbell, ed. *Women in the Victorian Art World.* Manchester: Manchester University Press, 1995.

2531 DAHL, CECILIE (1858–1943)
Norwegian painter, sister of Ingrid Dahl.

Other Sources

Wichstrøm, Anne. *Kvinner ved staffeliet: Kvinnelige malere i Norge før 1900.* Oslo: Universitetsforlaget, 1983.

2532 DAHL, INGRID (1861–1944)
Norwegian painter, sister of Cecilie Dahl.

Other Sources

Wichstrøm, Anne. *Kvinner ved staffeliet: Kvinnelige malere i Norge før 1900.* Oslo: Universitetsforlaget, 1983.

2533 DARBOVEN, HANNE (1940–)
German graphic artist and painter who divides her time between New York and Hamburg.

See Graphic Art section.

2534 DAVID, HERMINE (1886–1971)
French graphic artist, painter and book illustrator.

See Graphic Art section.

2535 DAVIN, CÉSARINE HENRIETTE FLORE MIRVAULT (1773–1844)
French painter of miniatures who ran a successful school of design and painting for young women.

Other Sources

Foster, Joshua. *Dictionary of Painters of Miniatures.* London: Philip Allan & Co. Ltd., 1926.

2536 DE BAÑUELOS, ANTONIA
Spanish painter of figures.

Other Sources

Diego, Estrella de. *La mujer y la pintura del XIX español: cuatrocientes olvidadas y algunas más.* Madrid: Cátedra, 1987.
Ossorio y Barnard, Manuel. *Galería biográfica de artieas españoles del siglo XIX.* Madrid: Moreno y Royas, 1883.

2537 DE CHANTEREINE, CAMILLE (?–1847)
French painter of flowers in watercolour.

Other Sources

Hardouin-Fugier, Elizabeth. *The Pupils of Redoute.* Leigh-on-Sea: F. Lewis, 1981.

2538 DE COOL, DELPHINE (née FORTIN; occasional pseudonym ARNOULD DE COOL) (1830–c.1911)
French painter, sculptor, lithographer and director of a women's art school.

Publications

Traité de peinture sur porcelaine. Paris, 1866.

Other Sources

Bunoust, Madeleine. *Quelques femmes peintres.* Paris: Librairie Stock, 1936.
Clement, Clara. *Women in the Fine Arts.* Boston: Houghton Mifflin, 1904.
Dunford, Penny. *A Biographical Dictionary of Women Artists in Europe and America since 1850.* Hemel Hempstead: Harvester Wheatsheaf and Philadelphia: University of Pennsylvania Press, 1990. Contains a bibliography.
Lechevallier-Chevignard, G. *La manufacture nationale de Sèvres.* 2 vols. Paris, 1908.
Lexikon der Frau. Zurich: Encyclios Verlag, 1953.

Sparrow, Walter Shaw. *Women Painters of the World.* London: Hodder and Stoughton, 1905.

Yeldham, Charlotte. *Women Artists in Nineteenth Century France and England.* London and New York: Garland, 1984.

2539 DE KARLOWSKA, STANISLAWA (Alt. BEVAN) (1876–1952)
Polish-born painter of urban scenes, landscapes and interiors who worked in England.

Exhibitions

Selected Paintings by Robert Bevan and Stanislawa de Karlowska, 1876–1952. London: Polish Library, 1968.

Hedley, Gill. *Let Her Paint.* Southampton: City Art Gallery, 1988.

Other Sources

Dunford, Penny. *A Biographical Dictionary of Women Artists in Europe and America since 1850.* Hemel Hempstead: Harvester Wheatsheaf and Philadelphia: University of Pennsylvania Press, 1990. Contains a bibliography.

Krichbaum, J., and R. Zondergeld. *Künstlerinnen: von der Antike bis zur Gegenwart.* Cologne: DuMont, 1979.

2540 DE LAFONTAINE, ROSALIE (c. 1786–?)
French history painter.

Other Sources

Gabet, Charles. *Dictionnaire des artistes de l'École française au XIXe siècle.* Paris: Verge, 1831.

2541 DE LEMPICKA, TAMARA (née GORSKA) (1898–1980)
Polish-born painter of portraits and figures in an elegant Art Deco style who worked mainly in France.

Main Sources

Bernard, Bruce. "Tamara's World." *Sunday Times Magazine,* 22 August 1976, 18–23.

Bojko, S. "Tamara de Lempicka." *Art and Artists* 15 (June 1980): 6–9.

De Lempicka-Foxall, Kizette, as told to C. Phillips. *Passion by Design: The Art and Times of Tamara de Lempicka.* Oxford: Phaidon, 1987.

Marmori, G. *Tamara de Lempicka.* London, 1978.

Néret, Gilles. *Tamara de Lempicka, 1898–1980.* 2nd ed. Cologne: Benedikt Taschen, 1992, 80pp., illus. Relies on accounts of Kizette de Lempicka-Foxall as basis for some of this anecdotal biography. Contains a chronology.

Exhibitions

Les femmes artistes modernes. Exposition de peintures, sculptures, 1937.
Paris: Buffet & Leclerc, 1937.

Dufresne, Jean-Luc and Olivier Messac, eds. *Femmes créatrices des années vingt.* Granville: Musée Richard Anacréon, 1988. Wide-ranging catalogue with a short biographical account on each woman included.

Morawińska, Agnieszka. *Voices of Freedom: Polish Women Artists of the Avant-garde, 1880–1990.* Washington, D.C.: National Museum of Women in the Arts, 1991. Includes a list of her main exhibitions and a bibliography.

Other Sources

Dunford, Penny. *A Biographical Dictionary of Women Artists in Europe and America since 1850.* Hemel Hempstead: Harvester Wheatsheaf and Philadelphia: University of Pennsylvania Press, 1990. Contains a bibliography.

Lucie-Smith, Edward. *Art Deco Painting.* Oxford: Phaidon. 1990.

2542 DE MELO E CASTRO, MARIA DE LOURDES
 Portuguese painter of portraits and landscapes.

Other Sources

Di Pamplona, Fernando. *Um seculo de pintura e escultura em Portugal, 1830–1930.* Porto: Livraria Tavares Martins, 1943.

2543 DE MIRBEL, MME (née LIZINSKA) (1776–1849)
 French painter of miniatures.

Main Sources

Jean, René. "Mme. de Mirbel." *Gazette des Beaux Arts* 35 (1906): 131–146. Gives an account of her life and work.

Other Sources

Foster, Joshua. *Dictionary of Painters of Miniatures.* London: Philip Allan & Co. Ltd., 1926.

2544 DE MORGAN, EVELYN MARY (née PICKERING) (1855–1919)
 English painter of mythological and allegorical scenes who was associated with the Pre-Raphaelites.

Main Sources

Marsh, Jan, and Pamela Gerrish Nunn. *Women Artists and the Pre-Raphaelite Movement,* 107–113. London: Virago, 1989. De Morgan appears under Pickering in the chapter on the second generation of women, active between 1865 and 1880.

Stirling, A. M. W. *William de Morgan and his Wife.* London: Cassell, 1922. Detailed and at times anecdotal account written by a niece.

Exhibitions

Women's Art Show, 1550–1970. Nottingham: Castle Museum, 1982. Contains a brief biography.

Sellars, Jane. *Women's Works.* Liverpool: Walker Art Gallery, 1988.

The Last Romantics: The Romantic Tradition in British Art; Burne-Jones to Stanley Spencer. London: Barbican Gallery, 1989.

Casteras, Susan, and Linda H. Peterson. *A Struggle for Fame: Victorian Women Artists and Authors.* New Haven, Conn.: Yale Center for British Art, 1994.

Other Sources

Cherry, Deborah. *Painting Women: Victorian Women Artists.* London: Routledge, 1993.

Clement, Clara. *Women in the Fine Arts.* Boston: Houghton Mifflin, 1904.

Dunford, Penny. *A Biographical Dictionary of Women Artists in Europe and America since 1850.* Hemel Hempstead: Harvester Wheatsheaf and Philadelphia: University of Pennsylvania Press, 1990. Contains a bibliography.

2545 DE PELICHY, GERTRUDE (1743–1825)
 Belgian painter of portraits.

Other Sources

Dictionnaire des Peintres Belges di XIVe siècle à nos jours. Brussels: La Renaissance du Livre, 1995.

2546 DE ROMANIS, MARIALUISA (c. 1930–)
 Italian abstract painter who earlier went through periods of Expressionism and Abstract Expressioniam.

Other Sources

Weller, Simone. *Il Complesso di Michelangelo: ricerca sul contributo dato dalla donna all'arte italiana del novecento.* Pollenza-Macerata: La Nuova Foglio [*sic*] Editrice, 1976.

2547 DE SOUZA, AURÉLIA (1866–1922)
 Portuguese painter.

Main Sources

Almeida-Matos, Lucia. "Aurélia de Souza: A Portuguese Artist of the Turn of the Century." *Woman's Art Journal* 4, no. 2 (fall 1983–winter 1984): 26–29.

Other Sources

Di Pamplona, Fernando. *Um seculo de pintura e escultura em Portugal, 1830–1930.* Porto: Livraria Tavares Martins, 1943.

2548 DEAN, STANSMORE (1866–1944)
Scottish painter.

Exhibitions

Burkhauser, Jude. *Glasgow Girls: Women in Art and Design 1880–1920.* Edinburgh: Canongate, 1990.

2549 DEBILLEMONT-CHARDON, GABRIELLE (née CHABILLEMONT) (1860–1947)
French painter mainly of portraits and miniatures.

Main Sources

Uzanne, Octave. "Madame Debillemont-Chardon's Miniatures." *Studio* 48 (1910): 210–216.

Exhibitions

Sellars, Jane. *Women's Works.* Liverpool: Walker Art Gallery, 1988.

Other Sources

Clement, Clara. *Women in the Fine Arts.* Boston: Houghton Mifflin, 1904.
Dunford, Penny. *A Biographical Dictionary of Women Artists in Europe and America since 1850.* Hemel Hempstead: Harvester Wheatsheaf and Philadelphia: University of Pennsylvania Press, 1990. Contains a bibliography.
Edouard-Joseph, R. *Dictionnaire biographique des artistes contemporains, 1910–1930.* Paris: Art et Editions, 1930–1934.

2550 DECAUX, IPHIGÉNIE (VICOMTESSE) (née MILET DE MUREAU) (1780–?)
French painter of flowers.

Other Sources

Hardouin-Fugier, Elizabeth, and E. Grafe. *French Flower Painters of the Nineteenth Century: A Dictionary.* London: Philip Wilson, 1989.

2551 DEHÉRAIN, HERMINIE (née LERMINIER) (1798/9–1839)
French painter of portraits, historical and religious subjects.

Main Sources

Batissier, Louis. "Mme. Dehérain." *L'Artiste* 3 (1839–40): 72–73. Obituary.

2552 DELACROIX, PAULINE (née GARNIER) (1863–1912)
French painter of genre and portraits.

Publications

Un cours d'aquarelle, en trois états, sans professeur.

Other Sources

Clement, Clara. *Women in the Fine Arts.* Boston: Houghton Mifflin, 1904.
Dunford, Penny. *A Biographical Dictionary of Women Artists in Europe and America since 1850.* Hemel Hempstead: Harvester Wheatsheaf and Philadelphia: University of Pennsylvania Press, 1990. Contains a bibliography.
Lexikon der Frau. Zurich: Encyclios Verlag, 1953.
Martin, Jules. *Nos peintres et sculpteurs, graveurs et dessinateurs.* Paris, 1897.

2553 DELAPORTE, ROSINE (née BESSIN) (1807–1876)
French painter of flowers who became the drawing teacher at the school of the Légion d'Honneur in Paris.

Other Sources

Hardouin-Fugier, Elizabeth. *The Pupils of Redouté.* Leigh-on-Sea: F. Lewis, 1981. Includes a bibliography.

2554 DELARUE, CLAIRE CORALIE (née LIREUX) (1821–1906)
French botanical painter.

Other Sources

Hardouin-Fugier, Elizabeth. *The Pupils of Redouté.* Leigh-on-Sea: F. Lewis, 1981.

2555 DELASALLE, ANGÈLE (née DE JAREY) (1867–after 1938)
French painter of many subjects, including scenes with wild animals, city views and biblical subjects.

Main Sources

Bunoust, Madeleine. *Quelques femmes peintres.* Paris, 1936.
Dufernez, B. "Angèle Delasalle." *Magazine of Art* 26 (1902): 349–354.
Escholier, Raymond. "Peintres-graveurs contemporains: Angèle Delasalle." *Gazette des Beaux-Arts* 2 (1912): 319–332. A useful discussion of her work, with several illustrations.

Exhibitions

Les femmes artistes modernes. Exposition de peintures, sculptures, 1937.
Paris: Buffet & Leclerc, 1937.

Other Sources

Clement, Clara. *Women in the Fine Arts.* Boston: Houghton Mifflin,
1904.
Dunford, Penny. *A Biographical Dictionary of Women Artists in Europe and America since 1850.* Hemel Hempstead: Harvester Wheatsheaf and Philadelphia: University of Pennsylvania Press, 1990. Contains a bibliography.
Edouard-Joseph, R. *Dictionnaire biographique des artistes contemporains, 1910–1930.* Paris: Art et Editions, 1930–1934.
Lexikon der Frau. Zurich: Encyclios Verlag, 1953.

2556 DELLA-VOS-KARDOVSKAYA, OLGA LYUDVIGOVNA (1875–1952)
Russian painter of portraits and a graphic artist.

Other Sources

Milner, John. *A Dictionary of Russian and Soviet Artists, 1420–1970.*
Woodbridge: Antique Collectors Club, 1993.

2557 DELLE, BIRUTA
Latvian painter.

Exhibitions

Biruta Delle: gleznas. Riga: Latvijas psr Mākslinieku Savienības, 1989, n.p.,
mainly illus. Text in Latvian, English and Russian gives a short description of the
ideas underlying her work.

Other Sources

Rosenfeld, Alla, and Norton Dodge, eds. *Nonconformist Art: The Soviet Experience, 1956–1986. The Norton and Nancy Dodge Collection.* London: Thames and Hudson in association with the Jane Voorhees Zimmerli Art Museum, State University of New Jersey, Rutgers, 1995.

2558 DELORME, MARGUÉRITE (1876–?)
French painter of flowers.

Other Sources

Hardouin-Fugier, Elizabeth, and E. Grafe. *French Flower Painters of the Nineteenth Century: A Dictionary.* London: Philip Wilson, 1989.

2559 DEMONT-BRETON, VIRGINIE ELODIE (née BRETON) (1859–1935)
French painter of rural life, especially that of a fishing community. Also a vigorous campaigner for women artists.

Publications

"Rosa Bonheur." *Revue des Revues du 15 juin 1899*, 605–619.
Les maisons que j'ai connues. Paris, 1926. An autobiography.

Exhibitions

Beaulieu, Germaine, et al. *La femme artiste d'Elisabeth Vigée-Lebrun à Rosa Bonheur.* Lacoste: Musée Despiau-Wlerick et Dubalen Mont-de-Marsan, 1981. Includes a bibliography.

Other Sources

Clement, Clara. *Women in the Fine Arts.* Boston: Houghton Mifflin, 1904.
Dunford, Penny. *A Biographical Dictionary of Women Artists in Europe and America since 1850.* Hemel Hempstead: Harvester Wheatsheaf and Philadelphia: University of Pennsylvania Press, 1990. Contains a bibliography.
Edouard-Joseph, R. *Dictionnaire biographique des artistes contemporains, 1910–1930.* Paris: Art et Editions, 1930–1934.
Garb, Tamar. "L'art féminin: The Formation of a Critical Category in Late Nineteeenth Century France." *Art History* 12, no. 1 (March 1989): 39–65.
Hirsch, A. *Die Bildenden Künstlerinnen der Neuzeit.* Stuttgart: 1905.
Krichbaum, J. and R. Zondergeld. *Künstlerinnen: von der Antike bis zur Gegenwart.* Cologne: DuMont, 1979.
Sparrow, Walter Shaw. *Women Painters of the World.* London: Hodder and Stoughton, 1905.
Yeldham, Charlotte. *Women Artists in Nineteenth Century France and England.* London and New York: Garland, 1984.

2560 DERKERT, SIRI (1888–1973)
Swedish painter.

Exhibitions

Kvinnor som målat. Stockholm: Nationalmuseum, 1975.
Scandinavian Modernism: Painting in Denmark, Finland, Iceland, Norway and Sweden, 1910–1920. Gothenberg: Gåtheborgs Konstmuseum, 1989.

2561 DETTMANN, EDITH (1898–1987)
German painter whose left-wing affiliations led her to choose working people as her subject matter.

Exhibitions

Meskimmon, Marsha. *Domesticity and Dissent: The Role of Women Artists in Germany 1918–1938. Haüsliches Leben und Dissens.* Leicester: Leicestershire Museums Publication no. 120, 1992.

2562 DÉNES, VALÉRIA (1877–1915)

Hungarian painter who with her husband, Galimberti, introduced Cubism to Hungary.

Main Sources

Mezei, O. "Les Galimberti, couple d'artistes hongrois des années 1910." *Acta Historia Art* 23 (1977): 329–355.

Zolnay, Lázló. "A Galimberti házapár múvészete" [The art of the Galimbertis]. *Múvészettörteneti Ertesító* 23, no. 4 (1974): 318–322.

Exhibitions

Galimberti Sandor és G.né Dénes Valéria. Kiállitásának Katalógusa. Budapest: Nemzeti Szalon 1914 febru·r, n.p. illus. Nearly eighty works by Dénes are listed with their prices. Some had previously been in the Salon des Indépendents at Paris.

L'Art en hongrie 1905–1930—art et révolution. St. Etienne: Musée d'Art et d'Industrie, 1980.

Willett, John, ed. *The Hungarian Avant-Garde.* London: Hayward Gallery, 1980.

Vergine, Lea. *L'altra metà dell'avanguardia.* Milan: Mazzotta Editore, 1980. *L'autre moitié de l'avant-garde.* Paris: Des Femmes, 1982.

Other Sources

Hárs, Éva and Ferenc Romváry. *Modern Hungarian Gallery Pécs.* Budapest: Corvina Kiadó, 1981.

Németh, Lajos. *Modern Art in Hungary.* Budapest: Corvina Press, 1969.

2563 DIAMANTINI, CHIARA

Italian conceptual painter.

Exhibitions

Vescovo, Marisa. *Il Gioco delle Parti. 4 Biennale Donna.* Ferrara: Padiglione d'Arte Contemporanea, Palazzo Massari, 1990.

2564 DICKER, FRIEDL (1898–1944)

German painter and collagist.

Exhibitions

Das Verborgene Museum. Dokumentation der Kunst von Frauen in Berliner öffentlichen Sammlungen. Berlin: Edition Hentrich, 1987.

2565 DICKSEE, MARGARET, ISABEL (1858–1903)
English painter of historical and domestic genre scenes.

Other Sources

Dunford, Penny. *A Biographical Dictionary of Women Artists in Europe and America since 1850.* Hemel Hempstead: Harvester Wheatsheaf and Philadelphia: University of Pennsylvania Press, 1990. Contains a bibliography.
 Fish, Arthur. *Henrietta Rae.* London: Cassell & Co., 1906.
 Lexikon der Frau. Zurich: Encyclios Verlag, 1953.
 Sparrow, Walter Shaw. *Women Painters of the World.* London: Hodder and Stoughton, 1905.

2565a DIEHN, KATE (née BITT; alt. DIEHN-BITT) (1900–)
German figurative artist who worked in an Expressionist style.

Exhibitions

Vergine, Lea. *L'altra metà dell'avanguardia.* Milan: Mazzotta Editore, 1980. *L'autre moitié de l'avant-garde.* Paris: Des Femmes, 1982.
 Meskimmon, Marsha. *Domesticity and Dissent: The Role of Women Artists in Germany 1918–1938. Haüsliches Leben und Dissens.* Leicester: Leicestershire Museums Publication no. 120, 1992.

Other Sources

Dunford, Penny. *A Biographical Dictionary of Women Artists in Europe and America since 1850.* Hemel Hempstead: Harvester Wheatsheaf and Philadelphia: University of Pennsylvania Press, 1990. Contains a bibliography.

2566 DIETRICHSON, MATHILDE (née JOHNNA MATHILDE BONNEVIE. Alt. BONNEIR) (1837–1921)
Norwegian painter of genre, portraits and landscapes.

Main Sources

Wichstrøm, Anne. *Kvinner ved staffeliet: Kvinnelige malere i Norge før 1900.* Oslo: Universitetsforlaget, 1983.

Other Sources

Clement, Clara. *Women in the Fine Arts.* Boston: Houghton Mifflin, 1904.
Dunford, Penny. *A Biographical Dictionary of Women Artists in Europe and America since 1850.* Hemel Hempstead: Harvester Wheatsheaf and Philadelphia: University of Pennsylvania Press, 1990. Contains a bibliography.

2567 DISMORR, JESSICA STEWART (1885–1939)

English painter of abstract works who was involved with the the Vorticist movement.

Main Sources

Beckett, Jane, and Deborah Cherry. "Women under the Banner of Vorticism." *Cahier* 8/9: 129–143.
Cork, Richard. *Theory and Design in the First Machine Age.* London & Bedford, 1975.

Exhibitions

Vergine, Lea. *L'altra metà dell'avanguardia.* Milan: Mazzotta Editore, 1980. *L'autre moitié de l'avant-garde.* Paris: Des Femmes, 1982.

Other Sources

Dunford, Penny. *A Biographical Dictionary of Women Artists in Europe and America since 1850.* Hemel Hempstead: Harvester Wheatsheaf and Philadelphia: University of Pennsylvania Press, 1990. Contains a bibliography.

2568 DONAGH, RITA (1939–)

English painter and graphic artist of Irish descent whose works are formal and restrained but also political.

See Graphic Art section.

2569 DONAS, MARTHE (Alt. TOUR-DONAS; TOUR D'ONASKY) (1885–1967)

Belgian painter of Cubist and, later, abstract works.

Exhibitions

Vergine, Lea. *L'altra metà dell'avanguardia.* Milan: Mazzotta Editore, 1980. *L'autre moitié de l'avant-garde.* Paris: Des Femmes, 1982.

Other Sources

Dunford, Penny. *A Biographical Dictionary of Women Artists in Europe and America since 1850.* Hemel Hempstead: Harvester Wheatsheaf and Philadelphia: University of Pennsylvania Press, 1990. Contains a bibliography.

Edouard-Joseph, R. *Dictionnaire biographique des artistes contemporains, 1910–1930.* Paris: Art et Editions, 1930–1934.

Krichbaum, J., and R. Zondergeld. *Künstlerinnen: von der Antike bis zur Gegenwart.* Cologne: DuMont, 1979.

2570 DUBOURG, VICTORIA (Alt. FANTIN-LATOUR) (1840–1926)
French painter of flowers.

Main Sources

Gibson, M. "The 'admirable' Fantin-Latour." *Art News* 82 (1983): 68–72.

Kane, Elizabeth. "Victoria Dubourg: The Other Fantin-Latour." *Woman's Art Journal* 9, no. 2 (fall 1988–winter 1989): 15–21.

Other Sources

Bachmann, Donna, and Sherry Piland. *Women Artists: A Historical, Contemporary and Feminist Bibliography.* Metuchen, N.J.: Scarecrow Press, 1978.

Clement, Clara. *Women in the Fine Arts.* Boston: Houghton Mifflin, 1904.

Dunford, Penny. *A Biographical Dictionary of Women Artists in Europe and America since 1850.* Hemel Hempstead: Harvester Wheatsheaf and Philadelphia: University of Pennsylvania Press, 1990. Contains a bibliography.

Edouard-Joseph, R. *Dictionnaire biographique des artistes contemporains, 1910–1930.* Paris: Art et Editions, 1930–1934.

Sparrow, Walter Shaw. *Women Painters of the World.* London: Hodder and Stoughton, 1905.

Wood, Christopher. *The Dictionary of Victorian Painters.* Woodbridge: Antique Collectors Club, 1978.

2571 DUCHAMP, SUZANNE (1889–1963)
French Dada mixed-media artist and abstract painter.

Main Sources

Ratel, Simonne. "Suzanne Duchamp et Jean Crotti: Apôtres de la 'peinture pure.'" *Comoedia,* 16 September 1926.

Exhibitions

Les femmes artistes modernes. Exposition de peintures, sculptures, 1937.
Paris: Buffet & Leclerc, 1937.
Vergine, Lea. *L'altra metà dell'avanguardia.* Milan: Mazzotta Editore, 1980.
L'autre moitié de l'avant-garde. Paris: Des Femmes, 1982.
Tabu Dada: Jean Crotti et Suzanne Duchamp. Paris: Centre national d'art et
de culture Georges Pompidou, 1983. Text in French, German and English. Contains
a bibliography.
Dufresne, Jean-Luc, and Olivier Messac, eds. *Femmes créatrices des années
vingt.* Granville: Musée Richard Anacréon, 1988. Wide-ranging catalogue with a
short biographical account on each woman included.

Other Sources

Dunford, Penny. *A Biographical Dictionary of Women Artists in Europe and
America since 1850.* Hemel Hempstead: Harvester Wheatsheaf and Philadelphia:
University of Pennsylvania Press, 1990. Contains a bibliography.
Edouard-Joseph, R. *Dictionnaire biographique des artistes contemporains,
1910–1930.* Paris: Art et Editions, 1930–1934.

2572 DUFAU, HÉLÈNE (née CLEMENTINE HÉLÈNE DUFAU) (1869–1937)
French painter of portraits, genre and mythological subjects.

Main Sources

Mauclair, Camille. "Mademoiselle Clémentine-Hélène Dufau." *Art et
Décoration* 1 (1905): 105–116. Detailed account of her life and discussion of her
works.

Exhibitions

Les femmes artistes modernes. Exposition de peintures, sculptures, 1937.
Paris: Buffet & Leclerc, 1937. She was amongst the recently deceased members
who were included.
Dufresne, Jean-Luc, and Olivier Messac, eds. *Femmes créatrices des années
vingt.* Granville: Musée Richard Anacréon, 1988. Wide-ranging catalogue with a
short biographical account on each woman included.

Other Sources

Clement, Clara. *Women in the Fine Arts.* Boston: Houghton Mifflin, 1904.
Dunford, Penny. *A Biographical Dictionary of Women Artists in Europe and*

America since 1850. Hemel Hempstead: Harvester Wheatsheaf and Philadelphia: University of Pennsylvania Press, 1990. Contains a bibliography.

Edouard-Joseph, R. *Dictionnaire biographique des artistes contemporains, 1910–1930.* Paris: Art et Editions, 1930–1934.

Le livre des peintres exposants en Paris. Paris, 1930.

Sparrow, Walter Shaw. *Women Painters of the World.* London: Hodder and Stoughton, 1905.

2573 DUFFIELD, MARY ELIZABETH (née ROSENBERG) (1819–1914)
English painter of flowers and still lifes in watercolour.

Publications

The Art of Flower Painting. London, 1856.

Main Sources

Clayton, Ellen. *English Female Artists.* London: Tinsley, 1876.

Other Sources

Blunt, Wilfrid. *The Art of Botanical Illustration.* New Naturalist Series. London: Collins, 1950.

Cherry, Deborah. *Painting Women: Victorian Women Artists.* London: Routledge, 1993.

Dunford, Penny. *A Biographical Dictionary of Women Artists in Europe and America since 1850.* Hemel Hempstead: Harvester Wheatsheaf and Philadelphia: University of Pennsylvania Press, 1990. Contains a bibliography.

Mallalieu, Hugh. *Dictionary of British Watercolour Artists.* Woodbridge: Antique Collectors Club, 1976.

Nunn, Pamela Gerrish. *Victorian Women Artists.* London: Women's Press, 1987.

Wood, Christopher. *The Dictionary of Victorian Painters.* Woodbridge: Antique Collectors Club, 1978.

2574 DUFFY, RITA (1959–)
Irish painter.

Exhibitions

Irish Women Artists from the Eighteenth Century to the Present Day. Dublin: National Gallery of Ireland, Douglas Hyde Gallery and Hugh Lane Gallery, 1987.

2575 DUMITRESCO, NATALIA (1915–)
Romanian-born abstract painter who worked in France.

Exhibitions

Paris 1937–1957: créations en France. Paris: Centre national d'art et de culture Georges Pompidou, 1981.

Natalia Dumitresco: oeuvres récentes, 1971–1984. Paris: Artcurial, 1985.

Other Sources

Ceysson, B., et al. *25 ans d'art en France, 1960–1985.* Paris: Larousse, 1986. Includes a select list of exhibitions for each artist.

2576 DUNBAR, EVELYN MARY (1906–1960)
English painter of figure subjects and landscapes who was appointed an official war artist in 1940.

Main Sources

Dunford, Penny. "Evelyn Dunbar, 1906–1960." *Women Artists' Slide Library Journal* 27 (February–March 1989): 20–21.

Exhibitions

Exhibition of Works by Some Women War Artists. London: Imperial War Museum, 1958.

Other Sources

Dunford, Penny. *A Biographical Dictionary of Women Artists in Europe and America since 1850.* Hemel Hempstead: Harvester Wheatsheaf and Philadelphia: University of Pennsylvania Press, 1990. Contains a bibliography.

Waters, Grant. *Dictionary of British Artists Working 1900–1940.* Eastbourne: Eastbourne Fine Art, 1975.

2577 DUNCAN, MARY (1885–1960)
Irish graphic artist who specialised in etching; also a painter.

Exhibitions

Irish Women Artists from the Eighteenth Century to the Present Day. Dublin: National Gallery of Ireland, Douglas Hyde Gallery and Hugh Lane Gallery, 1987.

2578 DURAT-LASSALLE, LOUISE.
French painter of flowers who exhibited in the Exposition Universelle of 1855.

Other Sources

Hardouin-Fugier, Elizabeth, and E. Grafe. *French Flower Painters of the Nineteenth Century: A Dictionary.* London: Philip Wilson, 1989.

2579 DURRANT, JENNIFER (1942–)
English abstract painter.

Main Sources

Maclean, J. "Aspects of Contemporary British Painting: A Painter's View." *Arts Magazine* 13, no. 56 (November 1981–January 1982): 28–31.
Titterington, C. "Jennifer Durrant at Nicola Jacobs." *Artscribe* 39 (February 1983): 56–58.

Exhibitions

British Painting 1952–1977. London: Royal Academy, 1977.
Hayward Annual, 1979. London: Hayward Gallery, 1979.
The New Generation: A Curator's Choice. New York: André Emmerich Gallery, 1980.

Other Sources

Dunford, Penny. *A Biographical Dictionary of Women Artists in Europe and America since 1850.* Hemel Hempstead: Harvester Wheatsheaf and Philadelphia: University of Pennsylvania Press, 1990. Contains a bibliography.
Parry-Crooke, Charlotte. *Contemporary British Artists.* London: Bergstrom and Boyle, 1979.

2580 DURRUTHY-LAYRLE, ZÉLIE (1872–?)
French painter of genre and, occasionally, flowers.

Other Sources

Hardouin-Fugier, Elizabeth, and E. Grafe. *French Flower Painters of the Nineteenth Century: A Dictionary.* London: Philip Wilson, 1989.

2581 DURY-VASSELON, HORTENSE (Exhibited from 1889)
French painter of flowers.

Other Sources

Hardouin-Fugier, Elizabeth, and E. Grafe. *French Flower Painters of the Nineteenth Century: A Dictionary.* London: Philip Wilson, 1989.

2582 DUUIEUX, LOUISE STÉPHANIE (Alt. DUSSIEUX-KELLER)
French painter of flowers.

Other Sources

Hardouin-Fugier, Elizabeth, and E. Grafe. *French Flower Painters of the Nineteenth Century: A Dictionary.* London: Philip Wilson, 1989.

2583 DYMSHITS-TOLSTAYA, SOFIA ISAAKOVNA (Alt. PESSATI) (1889–1963)
Russian painter and graphic artist.

Other Sources

Milner, John. *A Dictionary of Russian and Soviet Artists, 1420–1970.* Woodbridge: Antique Collectors Club, 1993.

2584 EARDLEY, JOAN (1921–1963)
Scottish painter of land- and, especially, seascapes in an expressionst, semi-abstract style.

Main Sources

Buchanan, W. *Joan Eardley.* Edinburgh, 1976.

Jacobs, M., and Marina Warner. *Phaidon Companion to Art and Artists in the British Isles.* Oxford: Phaidon, 1976. Organised as a gazetteer, Eardley is featured under Glasgow and Catterline.

McEwan, John. "Suffering for Art." *Independent Magazine,* 30 June 1990, 44–47.

Oliver, Cordelia. "Joan Eardley and Glasgow." *Scottish Art Review* 14, no. 3 (1974): 16–19, 31.

Oliver, Cordelia. *Joan Eardley, R.S.A.* Edinburgh: Mainstream Publishing, 1988, 120pp., illus. A detailed and analytical biography with careful examination of the paintings. Contains a list of collections in which her works are found.

Exhibitions

Hall, D. *Joan Eardley.* Stirling: University Art Gallery, 1969.

British Painting 1952–1977. London: Royal Academy, 1977.

Women's Art Show, 1550–1970. Nottingham: Castle Museum, 1982. Contains a brief biography.

Oliver, Cordelia. *Joan Eardley: A Retrospective.* Edinburgh: Talbot Rice Centre, 1988.

2585 EDGCUMBE, URSULA (1900–1984)
English sculptor and, later, painter.

See Sculpture section.

2586 EDWARDS, MARY ELLEN (Alt. FREER; STAPLES) (1839–1908)
English painter and illustrator of children and genre subjects.

Main Sources

Clayton, Ellen. *English Female Artists.* 2 vols. London: Tinsley, 1876.

Exhibitions

Casteras, Susan, and Linda H. Peterson. *A Struggle for Fame: Victorian Women Artists and Authors.* New Haven: Yale Center for British Art, 1994.

Other Sources

Clement, Clara. *Women in the Fine Arts.* Boston: Houghton Mifflin, 1904.
Dunford, Penny. *A Biographical Dictionary of Women Artists in Europe and America since 1850.* Hemel Hempstead: Harvester Wheatsheaf and Philadelphia: University of Pennsylvania Press, 1990. Contains a bibliography.
Lexikon der Frau. Zurich: Encyclios Verlag, 1953.
Mallalieu, Hugh. *Dictionary of British Watercolour Artists.* Woodbridge: Antique Collectors Club, 1976.
Nunn, Pamela Gerrish. *Victorian Women Artists.* London: Women's Press, 1987.
Sketchley, R. *English Book Illustrators of Today.* London: 1903.
Sparrow, Walter Shaw. *Women Painters of the World.* London: Hodder and Stoughton, 1905.
Wood, Christopher. *The Dictionary of Victorian Painters.* Woodbridge: Antique Collectors Club, 1978 (Under Staples)

2587 EGORSHCHINA, NATALIA
Russian painter.

Other Sources

Rosenfeld, Alla, and Norton Dodge, eds. *Nonconformist Art: The Soviet Experience, 1956–1986. The Norton and Nancy Dodge Collection.* London: Thames and Hudson in association with the Jane Voorhees Zimmerli Art Museum, State University of New Jersey, Rutgers, 1995.

2588 EKWALL, EMMA (1835–1925)
Swedish painter.

Painting

Exhibitions

Kvinnor som målat. Stockholm: Nationalmuseum, 1975.

Other Sources

Ingelman, Ingrid. *Kvinuliga konstnarer i Sverige en undersokning av Elever vid konstakademin Inskriva 1864–1924.* Uppsala: Almquist & Wiksell, 1982.

2589 ELLENRIEDER, MARIA (Alt. ANNA-MARIA) (1791–1863)
German history painter and etcher.

Exhibitions

Das Verborgene Museum. Dokumentation der Kunst von Frauen in Berliner öffentlichen Sammlungen. Berlin: Edition Hentrich, 1987.

Other Sources

Ellet, Elizabeth. *Women Artists in all Ages and Countries.* New York: Harper and Brothers Co., 1859.

2590 ELSKAIA, NADEZHDA
Russian painter.

Other Sources

Rosenfeld, Alla, and Norton Dodge, eds. *Nonconformist Art: The Soviet Experience, 1956–1986. The Norton and Nancy Dodge Collection.* London: Thames and Hudson in association with the Jane Voorhees Zimmerli Art Museum, State University of New Jersey, Rutgers, 1995.

2591 ELVERY, BEATRICE (Alt. LADY GLENAVY) (1883–1968)
Irish sculptor and, later, painter.

See Sculpture section.

2592 ENDER, MARIYA VLADIMIROVNA (1897–1942)
Russian painter, sister of Xenia.

Other Sources

Milner, John. *A Dictionary of Russian and Soviet Artists, 1420–1970.* Woodbridge: Antique Collectors Club, 1993.

2593 ENDER, XENIA VLADIMIROVNA (1895–1955)
Russian abstract painter, sister of Mariya.

Exhibitions

De la Révolution à la Pérréstroika. Art Soviétique de la Collection Ludwig. St. Etienne: Musée d'Art Moderne, 1989.

Other Sources

Milner, John. *A Dictionary of Russian and Soviet Artists, 1420–1970.* Woodbridge: Antique Collectors Club, 1993.

2594 ENGELBACH, FLORENCE (née NEUMEGEN) (1872–1951)
English painter of landscapes, flowers, figure subjects and portraits.

Exhibitions

Florence Engelbach. London: Leicester Gallery, 1939.
Sellars, Jane. *Women's Works.* Liverpool: Walker Art Gallery, 1988.
Sulter, Maud. *Echo: Works by Women Artists, 1850–1940.* Liverpool: Tate Gallery, 1991.

Other Sources

Burbidge, R. Brinsley. *Dictionary of British Flower, Fruit and Still Life Painters.* Leigh-on-Sea: F. Lewis, 1974.
Dunford, Penny. *A Biographical Dictionary of Women Artists in Europe and America since 1850.* Hemel Hempstead: Harvester Wheatsheaf and Philadelphia: University of Pennsylvania Press, 1990. Contains a bibliography.

2595 ERMOLAYEVA, VERA MIKHAILOVNA (1893–1938)
Russian Suprematist painter and illustrator.

Exhibitions

Paris-Moscou, 1900–1939. Paris: Centre national d'art et de culture Georges Pompidou, 1979.
Russian Women Artists of the Avant-garde; Künstlerinnen der Russichen avantgarde, 1910–1930. Cologne: Galerie Gmurzynska, 1979.
Vergine, Lea. *L'altra metà dell'avanguardia.* Milan: Mazzotta Editore, 1980.
L'autre moitié de l'avant-garde. Paris: Des Femmes, 1982.
L'avant-garde au féminin 1907–1930. Paris: Artcurial, 1983.

Other Sources

Dunford, Penny. *A Biographical Dictionary of Women Artists in Europe and America since 1850.* Hemel Hempstead: Harvester Wheatsheaf and Philadelphia: University of Pennsylvania Press, 1990. Contains a bibliography.

Elliott, David, and V. Dudakov. *100 Years of Russian Art.* Lund Humphries, 1989.

Milner, John. *A Dictionary of Russian and Soviet Artists, 1420–1970.* Woodbridge: Antique Collectors Club, 1993.

2596 ESCALLIER, MARIE CAROLINE ELÉONORE (1827–1888)
French painter of flowers; also a china painter.

Other Sources

Hardouin-Fugier, Elizabeth, and E. Grafe. *French Flower Painters of the Nineteenth Century: A Dictionary.* London: Philip Wilson, 1989.

2597 EXTER, ALEXANDRA ALEXANDROVNA (née GRIGOROVICH) (1882–1949)
Russian Constructivist painter and stage designer.

Main Sources

Bowlt, John. "Alexandra Exter: A Veritable Amazon of the Russian Avant-garde." *Artnews* 73, no. 7 (1974): 41, 43.

Cohen. Ronny. "Alexandra Exter's Designs for the Theater." *Artforum* 19, no. 10 (1981): 46–49.

Compton, Susan. "Alexandra Exter and the Dynamic Stage." *Art in America* 62, no. 5 (1970): 100–102.

Marcade, Jean-Claude. "Femmes d'avant-garde sur fond russe." *L'Oeil* 334 (May 1983): 38–45.

Strausberg, A. "Renaissance Women in the Age of Technology." *Spare Rib* 19 (1973): 38–40.

Yablonskaya, Miuda. *Women Artists of Russia's New Age, 1900–1935.* Ed. and trans. Anthony Parton. New York: Rizzoli & London: Thames and Hudson, 1990. Contains a chapter on each artist while notes and an individual bibliography provide access to material in Russian.

Exhibitions

Harris, Anne Sutherland, and Linda Nochlin. *Women Artists 1550–1950.* Los Angeles: County Museum of Art, 1976.

Künstlerinnen International, 1877–1977. Berlin: Schloss Charlottenburg, 1977.

Paris-Moscou, 1900–1939. Paris: Centre national d'art et de culture Georges Pompidou, 1979.

Russian Women Artists of the Avant-garde; Künstlerinnen der Russischen avantgarde, 1910–1930. Cologne: Galerie Gmurzynska, 1979.

Vergine, Lea. *L'altra metà dell'avanguardia.* Milan: Mazzotta Editore, 1980.
L'autre moitié de l'avant-garde. Paris: Des Femmes, 1982.
L'avant-garde au féminin, 1907–1930. Paris: Artcurial, 1983.
Das Verborgene Museum. Dokumentation der Kunst von Frauen in Berliner öffentlichen Sammlungen. Berlin: Edition Hentrich, 1987.
De la Révolution à la Pérréstroika. Art Soviétique de la Collection Ludwig. St. Etienne: Musée d'Art Moderne, 1989.
Avanguardia russa dalle collezioni private sovietiche origini e percorso 1904–1934. Milan: Palazzo Reale, 1989.

Other Sources

Bachmann, Donna, and Sherry Piland. *Women Artists: A Historical, Contemporary and Feminist Bibliography.* Metuchen, N.J.: Scarecrow Press, 1978.
Dabrowski, M. *Contrasts of Form: Geometric Abstract Art, 1910–1980.* New York: Museum of Modern Art, 1985.
Dunford, Penny. *A Biographical Dictionary of Women Artists in Europe and America since 1850.* Hemel Hempstead: Harvester Wheatsheaf and Philadelphia: University of Pennsylvania Press, 1990. Contains a bibliography.
Elliott, David and V. Dudakov. *100 Years of Russian Art.* Lund Humphries, 1989.
Fine, Elsa. *Women and Art: A History of Women Painters and Sculptors from the Renaissance to the Twentieth Century.* Montclair and London: Allenheld & Schram, 1978.
Milner, John. *A Dictionary of Russian and Soviet Artists, 1420–1970.* Woodbridge: Antique Collectors Club, 1993.
National Museum of Women in the Arts. [Catalogue of permanent collection.] Washington, D.C.: Abrams, 1987.
Uglow, Jenny. *The Macmillan Dictionary of Women's Biography.* London: Macmillan, 1982.

2598 FARRER, ANN
English botanical painter and graphic artist.

Other Sources

Saunders, Gill. *Picturing Plants: An Analytical History of Botanical Illustration.* London: Victoria and Albert Museum in association with Zwemmer, 1995.

2599 FAULKNER, AMANDA (1953–)
English painter of women who has forged a radical imagery in order to question women's roles.

Main Sources

Beaumont, M. "Judith Cowan, Amanda Faulkner." *Arts Review,* September 1987, 630–631.

Januszcek, Waldemar. "Sister of Mercy." *Studio International,* January 1985, 12–13.

Exhibitions

Amanda Faulkner. London: Angela Flowers Gallery, 1986, 4pp., illus.

Other Sources

Dunford, Penny. *A Biographical Dictionary of Women Artists in Europe and America since 1850.* Hemel Hempstead: Harvester Wheatsheaf and Philadelphia: University of Pennsylvania Press, 1990. Contains a bibliography.

Lucie-Smith, Edward, C. Cohen, and J. Higgins. *The New British Painting.* Oxford: Phaidon, 1988.

2600 FAUX-FROIDURE, EUGÉNIE JULIETTE (1876–1971)
French painter especially of flowers and fruit.

Other Sources

Clement, Clara. *Women in the Fine Arts.* Boston: Houghton Mifflin, 1904.

Dunford, Penny. *A Biographical Dictionary of Women Artists in Europe and America since 1850.* Hemel Hempstead: Harvester Wheatsheaf and Philadelphia: University of Pennsylvania Press, 1990. Contains a bibliography.

Edouard-Joseph, R. *Dictionnaire biographique des artistes contemporains, 1910–1930.* Paris: Art et Editions, 1930–1934.

Hardouin-Fugier, Elizabeth, and E. Grafe. *French Flower Painters of the Nineteenth Century: A Dictionary.* London: Philip Wilson, 1989.

2601 FEARON, HILDA (1878–1917)
English painter of figure subjects and landscapes.

Main Sources

Marriott, C. "The Paintings of Miss Hilda Fearon." *Studio* 63 (October 1914): 27–34.

Other Sources

Dunford, Penny. *A Biographical Dictionary of Women Artists in Europe and America since 1850*. Hemel Hempstead: Harvester Wheatsheaf and Philadelphia: University of Pennsylvania Press, 1990. Contains a bibliography.

Edouard-Joseph, R. *Dictionnaire biographique des artistes contemporains, 1910–1930*. Paris: Art et Editions, 1930–1934.

2602 FEDOROVITCH, SOPHIE (1893–1953)
Russian-born painter and designer of stage and ballet sets who worked in England.

Exhibitions

Sophie Fedorovitch, 1893–1953: A Memorial Exhibition. London: Victoria and Albert Museum, 1955.

Other Sources

Dunford, Penny. *A Biographical Dictionary of Women Artists in Europe and America since 1850*. Hemel Hempstead: Harvester Wheatsheaf and Philadelphia: University of Pennsylvania Press, 1990. Contains a bibliography.

2603 FELICYTA (Pseudonym of ELIZIEBETA FELICYTA ZASTAWNY CHACHAJ) (1945–)
Polish figurative painter.

Exhibitions

Morawińska, Agnieszka. *Voices of Freedom: Polish Women Artists of the Avant-garde, 1880–1990*. Washington, D.C.: National Museum of Women in the Arts, 1991. Includes a list of her main exhibitions and a bibliography.

2604 FELL, SHEILA (1931–1979)
English painter of landscapes.

Main Sources

Feaver, William, "Lady of the Land." *The Observer,* 21 October 1990, 66–67.

Exhibitions

British Painting in the 60s. London: Tate Gallery and Whitechapel Art Gallery, 1963.

British Painting 1952–1977. London: Royal Academy, 1977.
Women's Art Show, 1550–1970. Nottingham: Castle Museum, 1982. Contains a brief biography.
Sellars, Jane. *Women's Work.* Liverpool: Walker Art Gallery, 1988.
Sheila Fell. London: Hayward Gallery, 1990, 48pp., illus. Contains a biographical essay and some analysis of her work.

Other Sources

Dunford, Penny. *A Biographical Dictionary of Women Artists in Europe and America since 1850.* Hemel Hempstead: Harvester Wheatsheaf and Philadelphia: University of Pennsylvania Press, 1990. Contains a bibliography.
Parry-Crooke, Charlotte. *Contemporary British Artists.* London: Bergstrom and Boyle, 1979.

2605 FIGURINA, ELENA (1955–)
Russian Expressionist painter of figures.

Other Sources

Rosenfeld, Alla, and Norton Dodge, eds. *Nonconformist Art: The Soviet Experience, 1956–1986. The Norton and Nancy Dodge Collection.* London: Thames and Hudson in association with the Jane Voorhees Zimmerli Art Museum, State University of New Jersey, Rutgers, 1995.

2606 FINI, LEONOR (1908/18–)
Hispano-Italian painter and illustrator who lived in France.

Main Sources

Chadwick, Whitney. *Women Artists and the Surrealist Movement.* London: Thames and Hudson, 1985.
Gaggi, S. "Leonor Fini: A Mythology of the Feminine." *Art International* 23 (September 1979): 34–39.
Lauter, Estella. "Leonor Fini: Preparing to Meet the Strangers of the New World." *Woman's Art Journal* 1, no. 1 (spring–summer 1980): 44–49.

Exhibitions

Harris, Anne Sutherland, and Linda Nochlin. *Women Artists 1550–1950.* Los Angeles: County Museum of Art, 1976.
Leonor Fini. Bologna: Galleria Civica d'Arte, 1983.

Other Sources

Bachmann, Donna, and Sherry Piland. *Women Artists: A Historical, Contemporary and Feminist Bibliography.* Metuchen, N.J.: Scarecrow Press, 1978.

Dunford, Penny. *A Biographical Dictionary of Women Artists in Europe and America since 1850*. Hemel Hempstead: Harvester Wheatsheaf and Philadelphia: University of Pennsylvania Press, 1990. Contains a bibliography.

Uglow, Jennifer. *Macmillan Dictionary of Women's Biography*. London: Macmillan, 1982.

Weller, Simone. *Il Complesso di Michelangelo: ricerca sul contributo dato dalla donna all'arte italiana del novecento*. Pollenza-Macerata: La Nuova Foglio [*sic*] Editrice, 1976.

2607 FIORONI, GIOSETTA (1933–)
Italian painter and conceptual mixed media artist.

Exhibitions

Pasquali, Marilena. *Figure dallo sfondo*. Ferrara: Padiglione d'Arte Contemporanea and Grafis Editore, 1984. Includes a bibliography.

Other Sources

Weller, Simone. *Il Complesso di Michelangelo: ricerca sul contributo dato dalla donna all'arte italiana del novecento*. Pollenza-Macerata: La Nuova Foglio [*sic*] Editrice, 1976.

2608 FISHER, BETH (1944–)
American-born painter and graphic artist working in Scotland whose works deals with the figure.

Exhibitions

Beth Fisher: The Canopy Series. Glasgow: Third Eye Centre, 1987, 23pp., illus. Includes a biographical outline and list of exhibitions.

Kingston, Angela. *Mothers*. Birmingham: Ikon Gallery, 1990.

2609 FITZ-JAMES, ANNA MARIA (Alt. FITZJAMES) (Active 1852–1886)
English painter of still life.

Main Sources

Clayton, Ellen. *English Female Artists*. 2 vols. London: Tinsley, 1876.

Other Sources

Dunford, Penny. *A Biographical Dictionary of Women Artists in Europe and America since 1850*. Hemel Hempstead: Harvester Wheatsheaf and Philadelphia: University of Pennsylvania Press, 1990. Contains a bibliography.

Wood, Christopher. *Dictionary of Victorian Painters.* Woodbridge: Antique Collectors Club, 1978.

2610 FLIN, STEFANIE DRETLER (1909–)
Polish graphic artist, painter and designer of ceramics.

See Graphic Art section.

2611 FLORENCE, MARY SARGANT (née SARGANT) (1857–1954)
English painter of figure subjects and landscapes in oil and murals in tempera; also active in the suffrage and peace movements.

Publications

Florence, M. S., C. K. Ogden, and M. S. Marshall. *Militarism versus Feminism.* London: 1915. 2nd ed. London: Virago, 1987.
Editor of *Papers of the Society of Painters in Tempera,* 1925–1935. Vol. 3. London, 1935–1936.
Colour Co-ordination. London, 1940.

Main Sources

Spence, Keith. "A Country Refuge From Bloomsbury." *Country Life,* 15 November 1973, 1579, 1582, 1584. Examines Lors's Wood, Marlow, the house which Sargant Florence had built and decorated.

Exhibitions

The Last Romantics. The Romantic Tradition in British Art: Burne-Jones to Stanley Spencer. London: Barbican Art Gallery, 1989.

Other Sources

Dunford, Penny. *A Biographical Dictionary of Women Artists in Europe and America since 1850.* Hemel Hempstead: Harvester Wheatsheaf and Philadelphia: University of Pennsylvania Press, 1990. Contains a bibliography.
Wood, Christopher. *Dictionary of Victorian Painters.* Woodbridge: Antique Collectors Club, 1978.

2612 FOLLESTAD, DOROTHEA (1855–1921)
Norwegian painter.

Other Sources

Wichstrøm, Anne. *Kvinner ved staffeliet: Kvinnelige malere i Norge før 1900.* Oslo: Universitetsforlaget, 1983.

2613 FORBES, ELIZABETH ADELA (née ARMSTRONG; alt. ELIZABETH
STANHOPE FORBES) (1859–1912)
Canadian-born painter of rural genre who depicted many scenes from the
fishing community in Newlyn, Cornwall; also a graphic artist.

Publications

"On the Slope of a Southern Hill." *Studio* 18 (1900): 25–34.

Main Sources

Birch, Mrs. Lionel. *Stanhope Forbes and Elizabeth Stanhope Forbes.*
London: 1906.
Crozier, Gladys B. "Elizabeth Stanhope Forbes." *Art Journal,* 1904, 382–384.

Exhibitions

Fox, Caroline, and Francis Greenacre. *Artists of the Newlyn School.* Newlyn:
Newlyn Art Gallery, 1979.
———. *Painting in Newlyn, 1880–1930.* London: Barbican Art Gallery,
1985.
*The Last Romantics. The Romantic Tradition in British Art: Burne-Jones to
Stanley Spencer.* London: Barbican Art Gallery, 1989.

Other Sources

Cherry, Deborah. *Painting Women: Victorian Women Artists.* London:
Routledge, 1993.
Dunford, Penny. *A Biographical Dictionary of Women Artists in Europe and
America since 1850.* Hemel Hempstead: Harvester Wheatsheaf and Philadelphia:
University of Pennsylvania Press, 1990. Contains a bibliography.
Wedmore, F. *Etching in England.* London: 1985.
Wood, Christopher. *Dictionary of Victorian Painters.* Woodbridge: Antique
Collectors Club, 1978.

2614 FREDERIKS, JOLANDA (1955–1)
Dutch figurative painter.

Exhibitions

De Vrouw in de kunst. Leiden: Pand Caecilia, 1987.

2615 FREMIET, SOPHIE (Alt. RUDE) (1797–1867)
French painter, one of David's pupils.

Main Sources

De La Chavignerie, Emile Bellier. "Nécrologie." *Chronique des Arts,* 15 December 1867, 301. Obituary.

2616 FRESE, VARVARA PETROVNA (Alt. FREZE) (1883–1968)
Russian painter, graphic artist and painter on porcelain.

Exhibitions

Avanguardia russa dalle collezioni private sovietiche origini e percorso 1904–1934. Milan: Palazzo Reale, 1989.

Other Sources

Milner, John. *A Dictionary of Russian and Soviet Artists, 1420–1970.* Woodbridge: Antique Collectors Club, 1993.

2617 FRIEDLÄNDER, LISELOTTE (1898–1973)
German painter.

Exhibitions

Das Verborgene Museum. Dokumentation der Kunst von Frauen in Berliner öffentlichen Sammlungen. Berlin: Edition Hentrich, 1987.

2618 GABAIN, ETHEL LEONTINE (Alt. COPLEY) (1883–1950)
English graphic artist and painter of portraits, especially of women; also an official war artist.

Exhibitions

Paintings and Drawings by Some Women War Artists. London: Imperial War Museum, 1958.

Other Sources

Dunford, Penny. *A Biographical Dictionary of Women Artists in Europe and America since 1850.* Hemel Hempstead: Harvester Wheatsheaf and Philadelphia: University of Pennsylvania Press, 1990. Contains a bibliography.
Harries, M., and S. *The War Artists.* London: 1983.
Waters, Grant. *Dictionary of British Artists Working 1900–1940.* Eastbourne: Eastbourne Fine Art, 1975.

2619 GAMEIRO, HELENA ROQUE
Portuguese painter.

Other Sources

Di Pamplona, Fernando. *Um seculo de pintura e escultura em Portugal, 1830–1930.* Porto: Livraria Tavares Martins, 1943.

2620 GANDOLFI, PAOLA (1949–)
Italian painter of figures some of which are inspired by Titian's work.

Exhibitions

Fox, Howard. *A New Romanticism: Sixteen Artists from Italy.* Washington, D.C.: Hirschhorn Museum and Sculpture Garden, 1986. Contains a bibliography.

2621 GARDNER, ELIZABETH JANE (Alt. BOUGUEREAU) (1837–1922)
American-born painter of religious, allegorical and genre subjects who worked in France.

Main Sources

Fidell-Beaufort, M. "Elizabeth Jane Gardner Bouguereau: A Parisian Artist from New Hampshire." *Archives of American Art Journal* 24, no. 2 (1984): 1–7.

Exhibitions

The Genius of the Fair Muse: Painting and Sculpture Celebrating American Women Artists, 1875–1910. New York: Grand Central Galleries, 1987.

Other Sources

Clement, Clara. *Women in the Fine Arts.* Boston: Houghton Mifflin, 1904.
Dunford, Penny. *A Biographical Dictionary of Women Artists in Europe and America since 1850.* Hemel Hempstead: Harvester Wheatsheaf and Philadelphia: University of Pennsylvania Press, 1990. Contains a bibliography.
Rubinstein, Charlotte. *American Women Artists from Early Indian Times to the Present Day.* Boston: G.K. Hall, 1982.

2622 GARMAIN, LOUISE (1874–1939)
French painter of animals.

Other Sources

Alauzon di Genova, André. *La Peinture en Provence.* Marseille: J. Lafitte, 1984.

2623 GAUDRIOT, MICHELE (1955–)
 French abstract painter.

Other Sources

Dunford, Penny. *A Biographical Dictionary of Women Artists in Europe and America since 1850.* Hemel Hempstead: Harvester Wheatsheaf and Philadelphia: University of Pennsylvania Press, 1990. Contains a bibliography.

2624 GAZETOPOULOU, JULIA (1935–)
 Greek abstract painter.

Exhibitions

Iliopoulou-Rogan, Dora. *Three Generations of Greek Women Artists: Figures, Forms and Personal Myths.* Washington, D.C.: National Museum of Women in the Arts, 1989.

2625 GEISTAUTE, ERNA (1911–1975)
 Latvian painter of landscapes and figures who began to work in pastel in the late 1930s.

Other Sources

Šmagre, Rita. *Latviešu Pastelis. Latvian Pastel Painting.* Riga: Liesma, 1990. Includes a brief account of her career.

2626 GERHARDI, IDA (1864–1927)
 German Impressionist painter.

Other Sources

Evers, Ulrike. *Deutsche Künstlerinnen des 20. Jahrhunderts. Malerei— Bildhauerei—Tapisserie.* Hamburg: Ludwig Schultheis Verlag, 1983. Contains an individual bibliography.

2627 GÉRARD, MARGUÉRITE (1761–1837)
 French figure painter and graphic artist who was a pupil of her brother-in-law, Fragonard.

Main Sources

Doin, Jeanne. "Marguérite Gérard." *Gazette des Beaux-Arts* 109 (1912): 429–452. Detailed account of her life and work.

Exhibitions

Harris, Anne Sutherland, and Linda Nochlin. *Women Artists 1550–1950.* Los Angeles: County Museum of Art, 1976.

Beaulieu, Germaine, et al. *La femme artiste d'Elisabeth Vigée-Lebrun à Rosa Bonheur.* Lacoste: Musée Despiau-Wlerick et Dubalen Mont-de-Marsan, 1981. Includes a bibliography.

Das Verborgene Museum. Dokumentation der Kunst von Frauen in Berliner öffentlichen Sammlungen. Berlin: Edition Hentrich, 1987.

Other Sources

Alauzon di Genova, André. *La Peinture en Provence.* Marseille: J. Lafitte, 1984.

Fine, Elsa Honig. *Women and Art.* New York and London: Allanfield and Schram/Prior, 1978.

Ray, Gordon. *The Art of the French Illustrated Book, 1700–1914.* 2nd ed. New York: Pierpont Library in Association with Dover Publications, 1986, 557pp., illus. Gérard is the only women included.

2628 GIBBS, EVELYN (1905–1991)
English painter of figurative works who was involved with a number of artists' organisations including the Women's International Art Club; she was a founder of the Midland Group in 1943.

Main Sources

Lucas, Pauline. "Second Time Around." *Women's Art Magazine* 57 (1994): 23. Review of an exhibition.

Exhibitions

Deepwell, Katy. *Ten Decades: Careers of Ten Women Artists born 1897–1906.* Norwich: Norwich Gallery, Norfolk Institute of Art and Design, 1992.

2629 GILLIES, MARGARET (1803–1887)
Scottish painter of literary and domestic genre scenes, portraits and miniatures.

Main Sources

"Miss Margaret Gillies." *The Times,* 26 July 1887. Obituary.
Clayton, Ellen. *English Female Artists.* 2 vols. London: Tinsley, 1876.

Exhibitions

Cherry, Deborah. *Painting Women: Victorian Women Artists.* Rochdale: Art Gallery, 1987.

Other Sources

Cherry, Deborah. *Painting Women: Victorian Women Artists.* London: Routledge, 1993.

Dunford, Penny. *A Biographical Dictionary of Women Artists in Europe and America since 1850.* Hemel Hempstead: Harvester Wheatsheaf and Philadelphia: University of Pennsylvania Press, 1990. Contains a bibliography.

Foskett, Daphne. *Miniatures: A Dictionary and Guide.* Woodbridge: Antique Collectors Club, 1987.

Howitt, Mary. *An Autobiography.* London: 1889.

Nunn, Pamela Gerrish. *Victorian Women Artists.* London: Women's Press, 1987.

Orr, Clarissa Campbell, ed. *Women in the Victorian Art World.* Manchester: Manchester University Press, 1995.

Yeldham, Charlotte. *Women Artists in Nineteenth Century France, and England.* London and New York, 1984.

2630 GINESI, EDNA (1902–)

English painter of landscapes and still lifes.

Exhibitions

Edna Ginesi. Bradford: City Art Gallery, 1956.

Other Sources

Dunford, Penny. *A Biographical Dictionary of Women Artists in Europe and America since 1850.* Hemel Hempstead: Harvester Wheatsheaf and Philadelphia: University of Pennsylvania Press, 1990. Contains a bibliography.

Waters, Grant. *Dictionary of British Artists Working 1900–1940.* Eastbourne: Eastbourne Fine Art, 1975.

2631 GINÉS Y ORTIZ, ADELA (1847–?)

Spanish painter of still lifes and landscapes; also a teacher.

Other Sources

Diego, Estrella de. *La mujer y la pintura del XIX español: cuatrocientes olvidadas y algunas más.* Madrid: Cátedra, 1987.

Ossorio y Barnard, Manuel. *Galería biográfica de artieas españoles del siglo XIX.* Madrid: Moreno y Royas, 1883.

2632 GIRARDIN, PAULINE (née JOANIS) (1818–?)

French painter of flowers, usually in watercolour, who exhibited at the Paris Salon from 1838 to 1875.

Other Sources

Hardouin-Fugier, Elizabeth. *The Pupils of Redouté*. Leigh-on-Sea: F. Lewis, 1981.

2633 GLEICHEN, HELENA (LADY) (1873–1947)
English-born painter of landscapes and animals, especially horses; sister of Feodora Gleichen (q.v. in Sculpture section).

Publications

Contacts and Contrasts. London, 1939.

Exhibitions

Paintings and Drawings by Some Women War Artists. London: Imperial War Museum, 1958.

Other Sources

Dunford, Penny. *A Biographical Dictionary of Women Artists in Europe and America since 1850*. Hemel Hempstead: Harvester Wheatsheaf and Philadelphia: University of Pennsylvania Press, 1990. Contains a bibliography.
Waters, Grant. *Dictionary of British Artists Working 1900–1940*. Eastbourne: Eastbourne Fine Art, 1975.

2634 GLOAG, ISABEL LILIANE (1865–1917)
Scottish painter of literary, mythological and genre subjects.

Main Sources

Grieg, J. "Isabel Gloag and her Work." *Magazine of Art* 26 (1902): 289–293.

Other Sources

Clement, Clara. *Women in the Fine Arts*. Boston: Houghton Mifflin, 1904.
Dunford, Penny. *A Biographical Dictionary of Women Artists in Europe and America since 1850*. Hemel Hempstead: Harvester Wheatsheaf and Philadelphia: University of Pennsylvania Press, 1990. Contains a bibliography.
Waters, Grant. *Dictionary of British Artists Working 1900–1940*. Eastbourne: Eastbourne Fine Art, 1975.
Wood, Christopher. *Dictionary of Victorian Painters*. Woodbridge: Antique Collectors Club, 1978.

2635 GLUCK (née HANNAH GLUCKSTEIN) (1895–1978)
Anglo-American painter of a wide range of figurative subjects and still lifes.

Main Sources

Souhami, Diana. *Gluck: Her Biography.* London: Pandora, 1988, 333pp., illus. The only detailed biography of Gluck. Includes a select bibliography but most of the sources are primary. Some extracts from letters are in the text.

Exhibitions

Gluck, 1895–1978: Memorial Exhibition. London: Fine Art Society, 1980, n.p., illus. Includes an essay on her life and work.

Other Sources

Dunford, Penny. *A Biographical Dictionary of Women Artists in Europe and America since 1850.* Hemel Hempstead: Harvester Wheatsheaf and Philadelphia: University of Pennsylvania Press, 1990. Contains a bibliography.

Lucie-Smith, Edward. *Art Deco Painting.* Oxford: Phaidon. 1990.

2636 GODEFROID, MARIE ÉLÉONORE (Alt. GODEFROY) (1778–1849)

French painter of portraits, especially of women and children.

Publications

De l'Éducation, suivi de conseils aux jeunes filles. 2 vols. Paris, 1824.

Main Sources

Arbaud, Léon. "Mademoiselle Godefroid." *Gazette des Beaux-Arts* 40 (1869): 38–52, 512–522. An account of her life and work.

Exhibitions

La Femme: peintre et sculpteur du XVIIe au XXe siècle. Paris: Grand Palais, 1975.

Harris, Anne Sutherland, and Linda Nochlin. *Women Artists 1550–1950.* Los Angeles: County Museum of Art, 1976.

Beaulieu, Germaine, et al. *La femme artiste d'Elisabeth Vigée-Lebrun à Rosa Bonheur.* Lacoste: Musée Despiau-Wlerick et Dubalen Mont-de-Marsan, 1981. Includes a bibliography.

Das Verborgene Museum. Dokumentation der Kunst von Frauen in Berliner öffentlichen Sammlungen. Berlin: Edition Hentrich, 1987.

Other Sources

Ellet, Elizabeth. *Women Artists in all Ages and Countries.* New York: Harper and Brothers Co., 1859, 377pp.

Sparrow, Walter Shaw. *Women Painters of the World.* London: Hodder and Stoughton, 1905.

2637 GODFREY-ISAACS, LAURA

English painter whose work is informed by feminism and whose abstract works contain elements of relief.

Publications

"Laura Godfrey-Isaacs: MOMART Fellowship." *Women's Art Magazine* 37 (1990): 17. Recounts her residency at the Tate Gallery Liverpool, comparing it to an earlier one in New York.

"First date." *Women's Art Magazine* 64 (May–June 1995): 17–21. Interview with Godfrey-Isaacs and Abigail Frost.

Main Sources

Kharibian, Leah. "The Politics of Paint: Laura Godfrey-Isaacs." *Women's Art Magazine* 40 (1991): 14–15. Exhibition review.

Exhibitions

Pink: Laura Godfrey-Isaacs. Liverpool: Tate Gallery, 1990.

Other Sources

Betterton, Rosemary. *Intimate Distance: Women, Artists and the Body.* London: Routledge, 1996.

2638 GONCHAROVA, NATALIA SERGEEVNA (1881–1962)

Russian-born painter of Cubo-Futurist and abstract works; also designer of sets and costumes for the theatre and ballet.

Main Sources

Chamot, Mary. *Natalia Goncharova.* Collection Art Moderne. Paris: Bibliothèque des Arts, 1972, 160pp., illus.

————. *Goncharova: Stage Designs and Paintings.* London: Oresko Books Ltd., 1979, 104pp., mainly illus. Contains an introductory essay followed by annotated plates.

Loguine, Tatiana. *Goncharova et Larionov: cinquante ans à St-Germain-des-Près. Témoinages et documents.* Paris: Klincksieck, 1971, 240pp., illus. Contains a year-by-year chronology made up from recollections, documents and including unpublished letters. Includes particular detail about her early activities in Russia. Also contains an essay on her work for the theatre. The final chapters deal with her last year, her spirituality and teaching.

Tsvetaeva, Maria. *Natalia Goncharova: sa vie, son oeuvre.* Translated by Véronique Lossky. Paris: C. Hiver, 1990, 208pp., illus. The author, a poet, knew Goncharova in Russia and they met again in Paris in 1928. Although based on personal acquaintance, this book avoids the anecdotal conversational style in favour of something more objective.

Yablonskaya, Miuda. *Women Artists of Russia's New Age, 1900–1935.* Ed. and trans. Anthony Parton. New York: Rizzoli & London: Thames and Hudson, 1990. Contains a chapter on each artist while notes and an individual bibliography provide access to material in Russian.

Exhibitions

Harris, Anne Sutherland, and Linda Nochlin. *Women Artists 1550–1950.* Los Angeles: County Museum of Art, 1976.

Künstlerinnen International, 1877–1977. Berlin: Schloss Charlottenburg, 1977.

Vergine, Lea. *L'altra metà dell'avanguardia.* Milan: Mazzotta Editore, 1980; *L'autre moitié de l'avant-garde, 1910–1940.* Paris: Des Femmes, 1982.

Das Verborgene Museum. Dokumentation der Kunst von Frauen in Berliner öffentlichen Sammlungen. Berlin: Edition Hentrich, 1987.

De la Révolution à la Pérréstroika. Art Soviétique de la Collection Ludwig. St. Etienne: Musée d'Art Moderne, 1989.

Avanguardia russa dalle collezioni private sovietiche origini e percorso 1904–1934. Milan: Palazzo Reale, 1989.

Sulter, Maud. *Echo: Works by Women Artists, 1850–1940.* Liverpool: Tate Gallery, 1991.

Other Sources

Bachmann, Donna, and Sherry Piland. *Women Artists: A Historical, Contemporary and Feminist Bibliography.* Metuchen, N.J.: Scarecrow Press, 1978.

Dunford, Penny. *A Biographical Dictionary of Women Artists in Europe and America since 1850.* Hemel Hempstead: Harvester Wheatsheaf and Philadelphia: University of Pennsylvania Press, 1990. Contains a bibliography.

Gray, Camilla. *The Russian Experiment in Art, 1863–1922.* London and New York, 1962.

Milner, John. *A Dictionary of Russian and Soviet Artists, 1420–1970.* Woodbridge: Antique Collectors Club, 1993.

Tufts, Eleanor. *Our Hidden Heritage: Five Centuries of Women Artists.* New York, 1974.

Uglow, Jennifer. *The Macmillan Dictionary of Women's Biography.* London: Macmillan, 1982.

2639 GONZALES, EVA (Alt. GUÉRARD) (1849–1883)
French Impressionist painter.

Main Sources

Bayle, Paule. "Eva Gonzales." *La Renaissance,* June 1932, 110–115. Gives an account of her background, upbringing and her work. Several works which are relatively unfamiliar today are illustrated.

Boime, Albert. "Maria Deraismes and Eva Gonzales." *Woman's Art Journal* 15, no. 2 (fall 1994–winter 1995): 31–37.

Exhibitions

Harris, Anne Sutherland, and Linda Nochlin. *Women Artists 1550–1950.* Los Angeles: County Museum of Art, 1976.

Other Sources

Bachmann, Donna, and Sherry Piland. *Women Artists: A Historical, Contemporary and Feminist Bibliography.* Metuchen, N.J.: Scarecrow Press, 1978.

Dunford, Penny. *A Biographical Dictionary of Women Artists in Europe and America since 1850.* Hemel Hempstead: Harvester Wheatsheaf and Philadelphia: University of Pennsylvania Press, 1990. Contains a bibliography.

Garb, Tamar. *Women of Impressionism.* Oxford: Phaidon, 1986.

2640 GOODMAN, JULIA (née SALAMAN) (1812–1906)
English portrait painter.

Main Sources

"Mrs Goodman." *Art Journal,* 1907, 64. Obituary.
"Mrs Goodman." *Jewish Chronicle,* 4 January 1907. Obituary.

Other Sources

Dunford, Penny. *A Biographical Dictionary of Women Artists in Europe and America since 1850.* Hemel Hempstead: Harvester Wheatsheaf and Philadelphia: University of Pennsylvania Press, 1990. Contains a bibliography.

Lexikon der Frau. Zurich: Encyclios Verlag, 1953.

Wood, Christopher. *Dictionary of Victorian Painters.* Woodbridge: Antique Collectors Club, 1978.

2641 GORDON-BELL, OPHELIA (née JOAN OPHELIA GORDON-BELL) (1915–1975)
English sculptor and painter.

See Sculpture section.

2642 GOSSE, NELLIE (née ELLEN EPPS) (1850–?)
English painter of landscapes; sister of Laura Alma-Tadema (q.v.) and mother of Sylvia Gosse (q.v.).

Main Sources

Clayton, Ellen. *English Female Artists.* 2 vols. London: Tinsley, 1876.
Fisher, Katherine. *Conversations with Sylvia.* London, 1975.

Other Sources

Cherry, Deborah. *Painting Women: Victorian Women Artists.* London: Routledge, 1993.
Dunford, Penny. *A Biographical Dictionary of Women Artists in Europe and America since 1850.* Hemel Hempstead: Harvester Wheatsheaf and Philadelphia: University of Pennsylvania Press, 1990. Contains a bibliography.
Thwaite, Ann. *Edmund Gosse: A Literary Landscape, 1849–1928.* London: Secker & Warburg, 1984, 567pp., illus. A biography in which Nellie Epps and her daughter Sylvia Gosse (q.v.) both feature.
Wood, Christopher. *Dictionary of Victorian Painters.* Woodbridge: Antique Collectors Club, 1978.

2643 GOSSE, SYLVIA (née LAURA SYLVIA GOSSE) (1881–1968)
English graphic artist and painter of figures and still lifes; daughter of Nellie Gosse (q.v.) and niece of Laura Alma-Tadema (q.v.).

See Graphic Art section.

2644 GRAVEROL. JEANNE.
Belgian Surrealist painter.

Main Sources

Orenstein, Gloria. "Women of Surrealism." *Feminist Art Journal,* Spring 1973.

Other Sources

Dunford, Penny. *A Biographical Dictionary of Women Artists in Europe and America since 1850.* Hemel Hempstead: Harvester Wheatsheaf and Philadelphia: University of Pennsylvania Press, 1990. Contains a bibliography.
Krichbaum, J., and R. Zondergeld. *Künstlerinnen: von der Antike bis zur Gegenwart.* Cologne: DuMont, 1979.

2645 GRAY, CATHERINE ESTHER (née GEDDES) (1796–1882)
English painter of portraits in watercolour and miniatures; sister of Margaret Carpenter (q.v.).

Other Sources

Foskett, Daphne. *Miniatures: A Dictionary and Guide.* Woodbridge: Antique Collectors Club, 1987.

2646 GRAY, NORAH NEILSON (1882–1931)
Scottish painter who exhibited regularly in Paris.

Exhibitions

Burkhauser, Jude. *Glasgow Girls: Women in Art and Design 1880–1920.* Edinburgh: Canongate, 1990.

2647 GRÁBER, MARGIT (1895–)
Hungarian plein-air painter.

Other Sources

Németh, Lajos. *Modern Art in Hungary.* Budapest: Corvina Press, 1969.

2648 GREENAWAY, KATE (née CATHERINE GREENAWAY) (1846–1901)
English painter, illustrator and writer, especially of books for children.

See Graphic Design section.

2649 GRIERSON, MARY
English botanical painter and graphic artist.

Other Sources

Saunders, Gill. *Picturing Plants: An Analytical History of Botanical Illustration.* London: Victoria and Albert Museum in association with Zwemmer, 1995.

2650 GRIMSGAARD, CLARA (1851–1935)
Norwegian painter.

Other Sources

Wichstrøm, Anne. *Kvinner ved staffeliet: Kvinnelige malere i Norge før 1900.* Oslo: Universitetsforlaget, 1983.

2651 GRISI, LAURA (1939–)
Greek conceptual painter and mixed media artist who works in New York and Rome.

Main Sources

Celant, Germano. *Laura Grisi.* New York: Rizzoli, 1990, 274pp., illus. Illustrates a selection of works with notes by Grisi. Includes an interview with Grisi and a critical essay.

Other Sources

Weller, Simone. *Il Complesso di Michelangelo: ricerca sul contributo dato dalla donna all'arte italiana del novecento.* Pollenza-Macerata: La Nuova Foglio [*sic*] Editrice, 1976.

2652 GRITSENKO, ELENA
Russian painter.

Other Sources

Rosenfeld, Alla, and Norton Dodge, eds. *Nonconformist Art: The Soviet Experience, 1956–1986. The Norton and Nancy Dodge Collection.* London: Thames and Hudson in association with the Jane Voorhees Zimmerli Art Museum, State University of New Jersey, Rutgers, 1995.

2653 GUÉRIN, THÉRÈSE (1861–1933)
French painter of flowers who was best known for her paintings of roses; she was also a teacher.

Other Sources

Hardouin-Fugier, Elizabeth, and Etienne Grafe. *The Lyon School of Flower Painting.* Leigh-on-Sea: F. Lewis, 1978, 88pp., illus.
————. *French Flower Painters of the Nineteenth Century: A Dictionary.* London: Philip Wilson, 1989.

2654 GUINNESS, MAY (1863–1955)
Irish abstract painter.

Exhibitions

Irish Women Artists from the Eighteenth Century to the Present Day. Dublin: National Gallery of Ireland, Douglas Hyde Gallery and Hugh Lane Gallery, 1987.

Other Sources

De Breffny, Brian, ed. *Ireland: A Cultural Encyclopaedia.* London: Thames and Hudson, 1983.

2655 GUSTOWSKA, IZABELLA (1948–)
Polish painter and graphic artist.

Exhibitions

Morawińska, Agnieszka. *Voices of Freedom: Polish Women Artists of the Avant-garde, 1880–1990.* Washington, D.C.: National Museum of Women in the Arts, 1991. Includes a list of her main exhibitions and a bibliography.

2656 GUYON, MAXIMILIENNE (Alt. GOEPP) (1868–1903)

French painter of figure subjects and portraits.

Other Sources

Clement, Clara. *Women in the Fine Arts*. Boston: Houghton Mifflin, 1904.
Dunford, Penny. *A Biographical Dictionary of Women Artists in Europe and America since 1850*. Hemel Hempstead: Harvester Wheatsheaf and Philadelphia: University of Pennsylvania Press, 1990. Contains a bibliography.
Martin, Jules. *Nos peintres et sculpteurs, graveurs et dessinateurs*. Paris, 1897.

2657 HAARBURGER, ALICE (1881–1942)

German painter of figures and town scenes.

Main Sources

"Künstlerin zwischen der Kriegen: Alice Haarburger—einer vergessene Stuttgarter Malerin." *Amtsblatt der Landeshauptstadt Stuttgart* 13 (16 March 1987): 8. This review of an exhibition concentrates on Haarburger.

Other Sources

Wirth, Günther. *Verbotene Kunst: verfolgete Künstler im Deutschen Sudwesten 1933–1945*. Stuttgart: Hatje, 1987.

2658 HAAS-GERBER, GRETEL (1903–)

German figurative painter concerned with social and political issues.

Publications

"'Spanierin putzt die Treppe' 1977: Selbstbiografie der Künstlerin." *Das offene Tor* 7–8 (1985): 22–23.

Exhibitions

Gretel Haas-Gerber, Alice Brasse-Forstmann. Ausstellungkatalog. Berlin: Rathaus Wedding (Altbau), 1976, n.p. Mainly illus. Includes a short essay discussing the life and work of both artists.

Other Sources

Evers, Ulrike. *Deutsche Künstlerinnen des 20. Jahrhunderts. Malerei—Bildhauerei—Tapisserie*. Hamburg: Ludwig Schultheis Verlag, 1983. Contains an individual bibliography.
Wirth, Günther. *Verbotene Kunst: verfolgete Künstler im Deutschen Sudwesten 1933–1945*. Stuttgart: Hatje, 1987.

2659 HAGEN-SCHWARZ, JULIE WILHELMINE EMILIE (1824–1902)

Estonian painter of figures and landscapes who has been called the only distinguished Estonian woman painter of the nineteenth century.

Exhibitions

Julia Hagen-Schwarz, 1824–1902. Lunebourg: Museum für das Fürstentum, 1990.

2660 HALICKA, ALICE (1889/95–1975)
Polish painter, collagist and, later, also a set designer for ballet.

Exhibitions

Les femmes artistes modernes. Exposition de peintures, sculptures, 1937. Paris: Buffet & Leclerc, 1937.
Vergine, Lea. *L'altra metà dell'avanguardia.* Milan: Mazzotta Editore, 1980. *L'autre moitié de l'avant-garde.* Paris: Des Femmes, 1982.
Dufresne, Jean-Luc, and Olivier Messac, eds. *Femmes créatrices des années vingt.* Granville: Musée Richard Anacréon, 1988. Wide-ranging catalogue with a short biographical account on each woman included.

Other Sources

Dunford, Penny. *A Biographical Dictionary of Women Artists in Europe and America since 1850.* Hemel Hempstead: Harvester Wheatsheaf and Philadelphia: University of Pennsylvania Press, 1990. Contains a bibliography.
Perry, Gill. *Women Artists and the Parisian Avant-Garde.* Manchester: Manchester University Press, 1995. Includes a biography and select bibliography.

2661 HAMBLING, MAGGI (née MARGARET HAMBLING) (1945–)
English painter of figures and landscapes.

Main Sources

Billen, Andrew. "Gallery's Rogue." *The Observer,* 7 October 1990, 28–29.
Feinstein, E. "Maggi Hambling." *Modern Painters* 1, no. 2 (summer 1988): 27–28.
Loppert, Susan. "The Colour of Laughter." *The Independent,* 20 November 1993, 42–44, 47.

Exhibitions

Maggi Hambling. London: Serpentine Gallery, 1987.

Other Sources

Dunford, Penny. *A Biographical Dictionary of Women Artists in Europe and America since 1850.* Hemel Hempstead: Harvester Wheatsheaf and Philadelphia: University of Pennsylvania Press, 1990. Contains a bibliography.

Parry-Crooke, Charlotte. *Contemporary British Artists.* London: Bergstrom and Boyle, 1979.

2662 HAMILTON, CAROLINE (1771–1861)
Irish painter.

Exhibitions

Irish Women Artists from the Eighteenth Century to the Present Day. Dublin: National Gallery of Ireland, Douglas Hyde Gallery and Hugh Lane Gallery, 1987.

2663 HAMILTON, LETITIA (1878–1964)
Irish painter of landscapes; her sister Eva was also a painter.

Exhibitions

Irish Women Artists from the Eighteenth Century to the Present Day. Dublin: National Gallery of Ireland, Douglas Hyde Gallery and Hugh Lane Gallery, 1987.

Other Sources

De Breffny, Brian, ed. *Ireland: A Cultural Encyclopaedia.* London: Thames and Hudson, 1983.

2664 HAMNETT, NINA (1890–1956)
English painter of figures, landscapes, interiors and portraits.

Publications

Laughing Torso. London: Constable, 1932. Reprint. London: Virago, 1984, 322pp., illus. Autobiography up to 1926.
Is she a lady? A problem in autobiography. London: Allan Wingate, 1955, 161pp., illus. Autobiography from 1926 to circa 1950.

Main Sources

Elliott, Bridget, and Jo-Ann Wallace. *Women Artists and Writers: Modernist (Im)positionings.* London: Routledge, 1994, ch. 5.
Grimes, Teresa, Judith Collins, and Oriana Baddeley. *Five Women Painters.* London: Channel Four in Association with the Arts Council of Great Britain and Lennard Publishing, 1989. Reprint 1991. Contains a perceptive analysis of Hamnett's work and a bibliography.
Hooker, Denise. *Nina Hamnett: Queen of Bohemia.* London: Constable, 1986. The first serious study of Hamnett.

Exhibitions

Hooker, Denise. *Nina Hamnett and her circle.* London: Parkin Gallery, 1986, n.p., illus.

Other Sources

Dunford, Penny. *A Biographical Dictionary of Women Artists in Europe and America since 1850.* Hemel Hempstead: Harvester Wheatsheaf and Philadelphia: University of Pennsylvania Press, 1990. Contains a bibliography.

2665 HANSEN-KRONE, JOHANNE MARIE (1952–)
Norwegian painter and graphic artist who exhibits many drawings.

See Graphic Art section.

2666 HANSTEEN, AASTA (Alt. ASTA) (1824–1908)
Norwegian painter.

Other Sources

Wichstrøm, Anne. *Kvinner ved staffeliet: Kvinnelige malere i Norge før 1900.* Oslo: Universitetsforlaget, 1983.

2667 HARDIE, GWEN (1962–)
Scottish painter of figures and portraits who searches for radical images of the female body.

Exhibitions

Allthorpe-Guyton, Marjorie. *Gwen Hardie: Paintings and Drawings.* Edinburgh: Fruitmarket Gallery, 1987.
The Vigorous Imagination. Edinburgh: Scottish National Gallery of Modern Art, 1987.

Other Sources

Dunford, Penny. *A Biographical Dictionary of Women Artists in Europe and America since 1850.* Hemel Hempstead: Harvester Wheatsheaf and Philadelphia: University of Pennsylvania Press, 1990. Contains a bibliography.

2668 HARDIN, FÉLICIE ANNE ELISABETH (1799–?)
French painter of flowers and miniature portraits; also a teacher of art.

Other Sources

Gabet, Charles. *Dictionnaire des artistes de l'école française au XIXe siècle.* Paris: Verge, 1831.

2669 HARMAR, FAIRLIE (Alt. LADY HARBERTON) (1876–1945)
English painter of landscapes, figure scenes and still lifes.

Other Sources

Dunford, Penny. *A Biographical Dictionary of Women Artists in Europe and America since 1850.* Hemel Hempstead: Harvester Wheatsheaf and Philadelphia: University of Pennsylvania Press, 1990. Contains a bibliography.

Waters, Grant. *Dictionary of British Artists Working 1900–1940.* Eastbourne: Eastbourne Fine Art, 1975.

2670 HARPER, ALISON (1964–)
Scottish painter of figures, especially women, who uses themes of myth and spirituality.

Exhibitions

Art in Exile. Glasgow: School of Art, 1987.
Glasgow Girls. Glasgow: Boundary Gallery, 1987.

Other Sources

Dunford, Penny. *A Biographical Dictionary of Women Artists in Europe and America since 1850.* Hemel Hempstead: Harvester Wheatsheaf and Philadelphia: University of Pennsylvania Press, 1990. Contains a bibliography.

2671 HARRISON, MARIA (c. 1823–1904).
English painter of flowers; daughter of Mary Harrison (q.v.).

Main Sources

Clayton, Ellen. *English Female Artists.* London: Tinsley, 1876.

Exhibitions

Sellars, Jane. *Women's Works.* Liverpool: Walker Art Gallery, 1988.

Other Sources

Dunford, Penny. *A Biographical Dictionary of Women Artists in Europe and America since 1850.* Hemel Hempstead: Harvester Wheatsheaf and Philadelphia: University of Pennsylvania Press, 1990. Contains a bibliography.

Mallalieu, Hugh. *Dictionary of British Watercolour Artists.* Woodbridge: Antique Collectors Club, 1976.

Nunn, Pamela Gerrish. *Victorian Women Artists.* London: Women's Press, 1987.

Wood, Christopher. *Dictionary of Victorian Painters.* Woodbridge: Antique Collectors Club, 1978.

2672 HARRISON, MARY (née ROSSITER) (1788–1875)
English painter of flowers, in particular wild flowers with birds' nests and grasses; a founder member of the New Watercolour Society and mother of Maria Harrison (q.v.).

Main Sources

Clayton, Ellen. *English Female Artists*. London: Tinsley, 1876.

Exhibitions

Sellars, Jane. *Women's Works*. Liverpool: Walker Art Gallery, 1988.

Other Sources

Dunford, Penny. *A Biographical Dictionary of Women Artists in Europe and America since 1850*. Hemel Hempstead: Harvester Wheatsheaf and Philadelphia: University of Pennsylvania Press, 1990. Contains a bibliography.

Mallalieu, Hugh. *Dictionary of British Watercolour Artists*. Woodbridge: Antique Collectors Club, 1976.

Nunn, Pamela Gerrish. *Victorian Women Artists*. London: Women's Press, 1987.

Wood, Christopher. *The Dictionary of Victorian Painters*. Woodbridge: Antique Collectors Club, 1978.

2673 HARRISON, SARAH CECILIA (1863–1941)
Irish painter of genre, figures and miniatures who was also influential in the founding of the Modern Art Gallery in Dublin.

Exhibitions

Irish Women Artists from the Eighteenth Century to the Present Day. Dublin: National Gallery of Ireland, Douglas Hyde Gallery and Hugh Lane Gallery, 1987.

Other Sources

De Breffny, Brian, ed. *Ireland: A Cultural Encyclopaedia*. London: Thames and Hudson, 1983.

2674 HAUDEBOURT-LESCOT, ANTOINETTE (née LESCOT) (1784–1845)
French painter.

Main Sources

Vallabrègue, Antony. "Les femmes artistes du XIXe siècle: Madame Haudebourt-Lescot." *Les Lettres et les Arts,* 1887, 102–109.

Exhibitions

La Femme: peintre et sculpteur du XVIIe au XXe siècle. Paris: Grand Palais, 1975.

Harris, Anne Sutherland, and Linda Nochlin. *Women Artists 1550–1950*. Los Angeles: County Museum of Art, 1976.

Beaulieu, Germaine, et al. *La femme artiste d'Elisabeth Vigée-Lebrun à Rosa Bonheur*. Lacoste: Musée Despiau-Wlerick et Dubalen Mont-de-Marsan, 1981. Includes a bibliography.

Other Sources

Fine, Elsa Honig. *Women and Art*. New York and London: Allanfield and Schram/Prior, 1978.
Sparrow, Walter Shaw. *Women Painters of the World*. London: Hodder and Stoughton, 1905.

2675 HAVERS, ALICE MARY (Alt. MORGAN) (1850–1890)
English painter of genre and figure subjects in landscapes.

Main Sources

Furniss, Harry. *Some Victorian Women: Good, Bad and Indifferent*. London: 1923.

Exhibitions

Cherry, Deborah. *Painting Women: Victorian Women Artists*. Rochdale: Art Gallery, 1987.
Sellars, Jane. *Women's Works*. Liverpool: Walker Art Gallery, 1988.

Other Sources

Cherry, Deborah. *Painting Women: Victorian Women Artists*. London: Routledge, 1993.
Dunford, Penny. *A Biographical Dictionary of Women Artists in Europe and America since 1850*. Hemel Hempstead: Harvester Wheatsheaf and Philadelphia: University of Pennsylvania Press, 1990. Contains a bibliography.
Mallalieu, Hugh. *Dictionary of British Watercolour Artists*. Woodbridge: Antique Collectors Club, 1976.
Nunn, Pamela Gerrish. *Victorian Women Artists*. London: Women's Press, 1987.
Sparrow, Walter Shaw. *Women Painters of the World*. London: Hodder and Stoughton, 1905.
Wood, Christopher. *Dictionary of Victorian Painters*. Woodbridge: Antique Collectors Club, 1978.

2676 HAYLLAR, EDITH (1860–1948)
English painter of middle-class genre scenes; sister of Jessica (q.v.), Kate and Mary, who were all painters.

Main Sources

Wood, Christopher. "The Artistic Family Hayllar." *Connoisseur* 186 (1974), part 1: (April) 266–273; part 2: (May): 2–10.

Exhibitions

Harris, Anne Sutherland, and Linda Nochlin. *Women Artists 1550–1950.* Los Angeles: County Museum of Art, 1976.

Cherry, Deborah. *Painting Women: Victorian Women Artists.* Rochdale: Art Gallery, 1987.

Casteras, Susan, and Linda H. Peterson. *A Struggle for Fame: Victorian Women Artists and Authors.* New Haven: Yale Center for British Art, 1994. Includes work by all four sisters.

Other Sources

Bachmann, Donna, and Sherry Piland. *Women Artists: A Historical, Contemporary and Feminist Bibliography.* Metuchen, N.J.: Scarecrow Press, 1978.

Cherry, Deborah. *Painting Women: Victorian Women Artists.* London: Routledge, 1993.

Dunford, Penny. *A Biographical Dictionary of Women Artists in Europe and America since 1850.* Hemel Hempstead: Harvester Wheatsheaf and Philadelphia: University of Pennsylvania Press, 1990. Contains a bibliography.

Nunn, Pamela Gerrish. *Victorian Women Artists.* London: Women's Press, 1987.

Wood, Christopher. *The Dictionary of Victorian Painters.* Woodbridge: Antique Collectors Club, 1978.

2677 HAYLLAR, JESSICA (1858–1940) Also KATE and MARY HAYLLAR
English painters of genre, interiors and flowers; sisters of Edith Hayllar (q.v.).

Main Sources

See under Edith Hayllar.

2678 HEAPHY, MARY ANNE (Alt. MUSGRAVE) (active 1821–1847)
English minature painter and sister of Elizabeth Heaphy Murray (q.v.).

Other Sources

Foskett, Daphne. *Miniatures: A Dictionary and Guide.* Woodbridge: Antique Collectors Club, 1987.

2679 HEGEMANN, MARTA (1894–1970)
German painter of Magic Realist still lifes who was also influenced by Dada.

Other Sources

Evers, Ulrike. *Deutsche Künstlerinnen des 20. Jahrhunderts. Malerei— Bildhauerei—Tapisserie.* Hamburg: Ludwig Schultheis Verlag, 1983. Contains an individual bibliography.

2680 HELENIUS, ESTER (1875–1955)
Finnish painter of interiors, still lifes, portraits and landscapes in bright colours and a freely handled style.

Exhibitions

Sieben Finnische Malerinnen. Hamburg: Kunsthalle, 1983.

Other Sources

Dunford, Penny. *A Biographical Dictionary of Women Artists in Europe and America since 1850.* Hemel Hempstead: Harvester Wheatsheaf and Philadelphia: University of Pennsylvania Press, 1990. Contains a bibliography.

2681 HENRY, GRACE (née EMILY GRACE MITCHELL) (1868–1953)
Irish painter of town scenes and landscapes in Ireland and in mainland Europe, where she travelled regularly.

Exhibitions

Irish Women Artists from the Eighteenth Century to the Present Day. Dublin: National Gallery of Ireland, Douglas Hyde Gallery and Hugh Lane Gallery, 1987.

2682 HENRY, LOUISE (1798–1839)
German painter of portraits and figures.

Exhibitions

Das Verborgene Museum. Dokumentation der Kunst von Frauen in Berliner öffentlichen Sammlungen. Berlin: Edition Hentrich, 1987.

2683 HERBELIN, JEANNE MATHILDE (née HABERT) (1820–1904)
French painter of miniatures.

Other Sources

Clement, Clara. *Women in the Fine Arts.* Boston: Houghton Mifflin, 1904.
Dunford, Penny. *A Biographical Dictionary of Women Artists in Europe and*

America since 1850. Hemel Hempstead: Harvester Wheatsheaf and Philadelphia: University of Pennsylvania Press, 1990. Contains a bibliography.

Ellet, Elizabeth. *Women Artists in all Ages and Countries.* New York: Harper and Brothers Co., 1859, 377pp.

2684 HERFORD, LAURA (née ANNE LAURA HERFORD. Alt. HEREFORD) (1831–1870)

English genre painter and the first woman to be admitted as a student at the Royal Academy Schools; aunt of the painter Helen Allingham (q.v.).

Main Sources

Clayton, Ellen. *English Female Artists.* London: Tinsley, 1876.

Exhibitions

Cherry, Deborah. *Painting Women: Victorian Women Artists.* Rochdale: Art Gallery, 1987.

Other Sources

Cherry, Deborah. *Painting Women: Victorian Women Artists.* London: Routledge, 1993.

Clement, Clara. *Women in the Fine Arts.* Boston: Houghton Mifflin, 1904.

Dunford, Penny. *A Biographical Dictionary of Women Artists in Europe and America since 1850.* Hemel Hempstead: Harvester Wheatsheaf and Philadelphia: University of Pennsylvania Press, 1990. Contains a bibliography.

Huish, Marcus. *The Happy England of Helen Allingham.* London: Adam & Charles Black, 1903; reprint London: Bracken Books, 1985. Includes an account of Herford's admission to the Royal Academy schools.

Nunn, Pamela Gerrish. *Victorian Women Artists.* London: Women's Press, 1987.

Sparrow, Walter Shaw. *Women Painters of the World.* London: Hodder and Stoughton, 1905.

2685 HERTZER, ELSE (1884–1978)

German painter.

Exhibitions

Das Verborgene Museum. Dokumentation der Kunst von Frauen in Berliner öffentlichen Sammlungen. Berlin: Edition Hentrich, 1987.

2686 HERVIEU, LOUISE (1878–1954)

French painter, graphic artist and writer.

Exhibitions

La Femme: peintre et sculpteur du XVIIe au XXe siècle. Paris: Grand Palais, 1975.

Dufresne, Jean-Luc, and Olivier Messac, eds. *Femmes créatrices des années vingt.* Granville: Musée Richard Anacréon, 1988. Wide-ranging catalogue with a short biographical account on each woman included.

Other Sources

Perry, Gill. *Women Artists and the Parisian Avant-Garde.* Manchester: Manchester University Press, 1995. Includes a biography and select bibliography.

2687 HIMID, LUBAINA (1954–)
Tanzanian-born painter who works in England.

Exhibitions

The Thin Black Line. London: Institute of Contemporary Art, 1985.
Along the Lines of Resistance: An Exhibition of Contemporary Feminist Art. Barnsley: Cooper Gallery, 1988.

Other Sources

Dunford, Penny. *A Biographical Dictionary of Women Artists in Europe and America since 1850.* Hemel Hempstead: Harvester Wheatsheaf and Philadelphia: University of Pennsylvania Press, 1990. Contains a bibliography.
Nairne, Sandy. *State of the Art.* London: 1987.

2688 HISZPAŃSKA-NEUMANN, MARIA (1917–)
Polish graphic artist, engaged in engraving, printmaking and book illustration; also a painter.

See Graphic Art section.

2689 HJERTEN, SIGRID (Alt. HERTJEN-GRÜNEWALD) (1885–1948)
Swedish Expressionist painter.

Exhibitions

Derkert, Carlo. *Sigrid Hjerten Minnesutställning.* Vandringsutställning no. 67. Stockholm: Riksförbundet för Bildande Konst, 1949, 13pp., illus. Text in Swedish.
Derkert, Carlo, ed. *Sigrid Hjerten, 1885–1948. En retrospectiv utställning av målningar.* Catalogue no. 38. Stockholm: Museum of Modern Art, 1964, n.p., illus. Text in Swedish. Consists of a chronology, a short biographical essay and a list of her works.
Kvinnor som målat. Stockholm: Nationalmuseum, 1975.
Scandinavian Modernism: Painting in Denmark, Finland, Iceland, Norway and Sweden, 1910–1920. Gothenberg: Götheborgs Konstmuseum, 1989.

Other Sources

Behr, Shulamith. *Women Expressionists*. Oxford: Phaidon, 1988.

Ingelman, Ingrid. *Kvinuliga konstnarer i Sverige en undersokning av Elever vid konstakademin Inskriva 1864–1924*. Uppsala: Almquist & Wiksell, 1982.

2690 HODGKINS, FRANCES (1869–1947)

New Zealand–born painter of freely handled landscapes, portraits, still lifes and figure subjects who worked in England.

Main Sources

Evans, Myfanwy. *Frances Hodgkins*. Harmondsworth: Penguin Books, 1948. 20pp., illus. A critical biographical account which establishes Hodgkins in a positive way as a woman artist. Analyses her work, her contacts with her contemporaries and the problems of the British art world.

Howell, A. R. *Frances Hodgkins: Four Vital Years*. London: 1951.

McCormick, E. *Portrait of Frances Hodgkins*. New York, 1981.

McCormick, E. H. "Woman and Child: A Note on a Motif in the Paintings of Frances Hodgkins." *Art New Zealand* 27 (1983): 18–19.

Nunn, Pamela Gerrish. "Frances Hodgkins: A Question of Identity." *Woman's Art Journal* 15, no. 2 (fall 1994–winter 1995): 9–13.

Rendall, Clare. "Frances Hodgkins." *Women Artists Slide Library Journal* (February–March 1988): 25.

Exhibitions

Sulter, Maud. *Echo: Works by Women Artists, 1850–1940*. Liverpool: Tate Gallery, 1991.

Other Sources

Burbidge, R. Brinsley. *Dictionary of British Flower, Fruit and Still Life Painters*. Leigh-on-Sea: F. Lewis, 1974.

Deepwell, Katy. "Women in the 7 & 5 Society." *Women Artists Slide Library Journal* (April–May 1988): 10–12.

Dunford, Penny. *A Biographical Dictionary of Women Artists in Europe and America since 1850*. Hemel Hempstead: Harvester Wheatsheaf and Philadelphia: University of Pennsylvania Press, 1990. Contains a bibliography.

2691 HOLGATE, JEANNE (Alt. COVINGTON) (1920–)

American-born botanical painter who worked in England and became the official artist to the Orchid Committee of the Royal Horticultural Society, London.

Other Sources

Burbidge, R. Brinsley. *Dictionary of British Flower, Fruit and Still Life Painters*. Leigh-on-Sea: F. Lewis, 1974.

2692 HOLM-MØLLER, OLIVA (1875–1970)
Danish painter of figures in nature, mythological and religious subjects.

Main Sources

Christensen, I. "Early Twentieth-Century Danish Women Artists in the Light of De Beavoir's 'The Second Sex.'" *Woman's Art Journal* 9, no. 1 (spring–summer 1988): 10–15.

Exhibitions

Friis, Eva. *Kunst under Krigen.* Copenhagen: Statens Museum for Kunst, 1995.

Other Sources

Dunford, Penny. *A Biographical Dictionary of Women Artists in Europe and America since 1850.* Hemel Hempstead: Harvester Wheatsheaf and Philadelphia: University of Pennsylvania Press, 1990. Contains a bibliography.

2693 HONE, EVIE (née EVA SIDNEY HONE) (1894–1955)
Irish painter of abstract works, landscapes and religious subjects; also a designer of stained glass.

Exhibitions

Abstraction-Création, 1931–1936. Paris: Centre national d'art et de culture Georges Pompidou, 1978.
Evie Hone. Dublin: Trinity College Gallery, 1958.
Irish Women Artists from the Eighteenth Century to the Present Day. Dublin: National Gallery of Ireland, Douglas Hyde Gallery and Hugh Lane Gallery: 1987.
Pyle, H. *Irish Art, 1900–1950.* Crawford: Municipal Art Gallery, 1975.

Other Sources

De Breffny, Brian, ed. *Ireland: A Cultural Encyclopaedia.* London: Thames and Hudson, 1983.
Dunford, Penny. *A Biographical Dictionary of Women Artists in Europe and America since 1850.* Hemel Hempstead: Harvester Wheatsheaf and Philadelphia: University of Pennsylvania Press, 1990. Contains a bibliography.

2694 HOOKER, HARRIET ANN (Alt. LADY THISSELTON-DYER) (1854–1946)
English botanical painter.

Other Sources

Blunt, Wilfrid. *The Art of Botanical Illustration.* New Naturalist Series. London: Collins, 1950.

2695 HORTENSE, QUEEN OF HOLLAND (née DE BEAUHARNAIS) (1783–1837)
French painter, wife of Louis Bonaparte, who practised art until the end of her life.

Exhibitions

La reine Hortense: une femme artiste. Malmaison: Musée Nationale des Chateaux de Malmaison et de Bois Préau, 1993, 112pp., illus. Discusses her upbringing and all aspects of her artistic activities: as a practitioner, her artistic circle and her collection of paintings.

Other Sources

Hardouin-Fugier, Elisabeth. *The Pupils of Redouté.* Leigh-on-Sea: F. Lewis, 1981.

2696 HOUGHTON, GEORGIANA (1818–1884)
English painter who produced abstract works in the 1860s by the use of spiritualism.

Publications

Evenings at Home in Spiritual Séance. 2 vols. London: vol. 1, 1881; vol. 2, 1882.
Chronicles of the Photographs of Spiritual Beings. London, 1882.

Main Sources

Gibbons, T. "British Abstract Paintings of the 1860s: The Spirit Drawings of Georgiana Houghton." *Modern Painters* 1, no. 2 (summer 1988): 33–37.

Other Sources

Dunford, Penny. *A Biographical Dictionary of Women Artists in Europe and America since 1850.* Hemel Hempstead: Harvester Wheatsheaf and Philadelphia: University of Pennsylvania Press, 1990. Contains a bibliography.

2697 HOW, BEATRICE (née JULIA BEATRICE HOW) (1867–1932)
Scottish painter, best known for her depictions of babies, who often worked in France.

Exhibitions

Les femmes artistes modernes. Exposition de peintures, sculptures, 1937. Paris: Buffet & Leclerc, 1937. She was amongst the recently deceased members who were included.
Beatrice How, 1867–1932: A Scottish painter in Paris. Edinburgh: Fine Art Society, 1979, n.p. Mainly illus. Contains a short account of her life and work.
Sulter, Maud. *Echo: Works by Women Artists, 1850–1940.* Liverpool: Tate Gallery, 1991.

Other Sources

Dunford, Penny. *A Biographical Dictionary of Women Artists in Europe and America since 1850.* Hemel Hempstead: Harvester Wheatsheaf and Philadelphia: University of Pennsylvania Press, 1990. Contains a bibliography.

Edouard-Joseph, R. *Dictionnaire biographique des artistes contemporains, 1910–1930.* Paris: Art et Editions, 1930–1934.

Sparrow, Walter Shaw. *Women Painters of the World.* London: Hodder and Stoughton, 1905.

2698 HOWARD-JONES, RAY (1903–1996)
Welsh painter of rocky coastal scenes.

Publications

"Philip Wilson Steer." *Burlington Magazine,* 1942.
Poems and Stories, 1968.

Main Sources

Anson, Elizabeth. "Off Target." *Women's Art Magazine* 52 (1993): 27. Review of a retrospective exhibition.

Blunson-Hall, E. "The Art of Ray Howard-Jones." *Anglo-Welsh Review,* summer 1968.

Exhibitions

Vincentelli, Moira. *Ray Howard-Jones.* Haverfordwest: Castle Museum, 1983, n.p., illus. After dealing first with her early work, the catalogue is divided into sections by subject matter. For each there is a useful, if brief, analysis. Contains a bibliography.

Other Sources

Dunford, Penny. *A Biographical Dictionary of Women Artists in Europe and America since 1850.* Hemel Hempstead: Harvester Wheatsheaf and Philadelphia: University of Pennsylvania Press, 1990. Contains a bibliography.

Dunthorne, Katherine. *Artists Exhibited in Wales, 1945–1976.* Cardiff: Welsh Arts Council, 1976.

2699 HOWITT, ANNA MARY (Alt. WATTS) (1824–1884)
English painter of figures and a writer.

Publications

An Art Student in Munich. 2 vols. London, 1853. Reprinted 1880.

Main Sources

Howitt, Mary. *An Autobiography.* Edited by Margaret Howitt. London, William Ibister Ltd., 1889, vol. 1: 326pp.; vol. 2: 370pp., illus. Written by Anna Mary's mother, it was edited by the artist's sister.

Exhibitions

Johnson, Diana. *Fantastic Illustration and Design in Britain, 1850–1930.* New York: Cooper Hewitt Museum and Museum of Art, Rhode Island School of Design,1979.

Casteras, Susan, and Linda H. Peterson. *A Struggle for Fame: Victorian Women Artists and Authors.* New Haven, Conn.: Yale Center for British Art, 1994.

Other Sources

Cherry, Deborah. *Painting Women: Victorian Women Artists.* London: Routledge, 1993.

Nunn, Pamela Gerrish. *Victorian Women Artists.* London: Women's Press, 1987.

Orr, Clarissa Campbell, ed. *Women in the Victorian Art World.* Manchester: Manchester University Press, 1995.

2700 HÖRLE, ANGELIKA (Alt. FICK-HÖRLE) (1899–1923)
German painter.

Exhibitions

Barron, Stephanie, et al. *German Expressionism, 1915–1925: The Second Generation.* Los Angeles: County Museum of Art, 1988.

Other Sources

Evers, Ulrike. *Deutsche Künstlerinnen des 20. Jahrhunderts. Malerei— Bildhauerei—Tapisserie.* Hamburg: Ludwig Schultheis Verlag, 1983. Contains an individual bibliography.

Meskimmon, Marsha, and Shearer West. *Visions of the 'Neue Frau': Women and the Visual Arts in Weimar Germany.* London: Scolar Press, 1995.

2701 HUBLIER, CHARLOTTE (née MAST; alt. JACOB) (1817–?)
French painter of flowers and fruit; illustrator of botanical books.

Other Sources

Hardouin-Fugier, Elizabeth, and E. Grafe. *French Flower Painters of the Nineteenth Century: A Dictionary.* London: Philip Wilson, 1989.

2702 HUDSON, NAN (née ANNE HOPE HUDSON) (1868–1957)
American painter, mainly of French rural and city life, who worked in England and France with the painter Ethel Sands (q.v.).

Main Sources

Baron, Wendy. *Miss Ethel Sands and her Circle.* London: Peter Owen, 1977, 300pp., illus.

Other Sources

Dunford, Penny. *A Biographical Dictionary of Women Artists in Europe and America since 1850.* Hemel Hempstead: Harvester Wheatsheaf and Philadelphia: University of Pennsylvania Press, 1990. Contains a bibliography.

2703 HUEFFER, CATHERINE (née BROWN) (1850–1927)
English painter of portraits, landscapes and genre scenes.

Main Sources

Cherry, Deborah. *Painting Women: Victorian Women Artists.* London: Routledge, 1993.
Clayton, Ellen. *English Female Artists.* London: Tinsley, 1876.

Other Sources

Dunford, Penny. *A Biographical Dictionary of Women Artists in Europe and America since 1850.* Hemel Hempstead: Harvester Wheatsheaf and Philadelphia: University of Pennsylvania Press, 1990. Contains a bibliography.
Mallalieu, Hugh. *Dictionary of British Watercolour Artists.* Woodbridge: Antique Collectors Club, 1976.
Nunn, Pamela Gerrish. *Victorian Women Artists.* London: Women's Press, 1987.
Wood, Christopher. *Dictionary of Victorian Painters.* Woodbridge: Antique Collectors Club, 1978.

2704 HULBERT, THELMA (1913–1995)
English painter who worked close to the Euston Road School.

Main Sources

Thelma Hulbert: Retrospective Exhibition. Paintings and Drawings 1937–1962. London: Whitechapel Art Gallery, 1962, 21pp., illus. Contains an essay by another member of the Euston Road School, Colin MacInnes.
Robertson, Bryan. "Thelma Hulbert: A Life of Paint and Pleasure." *The Guardian,* 28 February 1995, 17. Obituary.

2705 HUMBERT-VIGNOT, LÉONIE (1878–1960)
French painter of portraits, figures and, occasionally, flowers.

Other Sources

Hardouin-Fugier, Elizabeth, and E. Grafe. *French Flower Painters of the Nineteenth Century: A Dictionary.* London: Philip Wilson, 1989.

2706 HUNJAN, BHAJAN (1956–)
Kenyan-born painter working in England.

Exhibitions

Numaish Exhibition of Asian Women Artists' Work. London: The People's Gallery, 1987.

Other Sources

Dunford, Penny. *A Biographical Dictionary of Women Artists in Europe and America since 1850.* Hemel Hempstead: Harvester Wheatsheaf and Philadelphia: University of Pennsylvania Press, 1990. Contains a bibliography.

2707 HUNTER, ALEXIS (1948–)
New Zealand–born painter and photographer, working in England, who often deals with ways of establishing positive role models for women.

Publications

Campbell, Meg. "Alexis Hunter: 'Personal Archetypes.'" *Women's Art Magazine* 36 (1990): 18–19. Interview.

Exhibitions

Hayward Annual 1978. London: Hayward Gallery, 1978.
Lippard, Lucy. *Issue.* London: Institute of Contemporary Art, 1980.
Lippard, Lucy, and Margaret Richardson. *Alexis Hunter: Photographic Narrative Sequences.* London: Edward Totah Gallery, 1981, n.p., illus. Contains critical essays.
Sense and Sensibility in Feminist Art Practice. Nottingham: Midland Group, 1982.

Other Sources

Dunford, Penny. *A Biographical Dictionary of Women Artists in Europe and America since 1850.* Hemel Hempstead: Harvester Wheatsheaf and Philadelphia: University of Pennsylvania Press, 1990. Contains a bibliography.
Nairne, Sandy. *State of the Art.* London: 1987.
Parker, Roszika, and Griselda Pollock. *Framing Feminism.* London: Pandora, 1987.

2708 HUNTER, MARGARET (1948–)
Scottish Expressionist painter of figures, especially women, who has worked mainly in Germany since 1985.

Exhibitions

Art in Exile. Glasgow: School of Art, 1987.
Margaret Hunter: Recent Paintings and Drawings. London: Vanessa Devereux Gallery, 1990. Short introduction in German and English. Includes outline biography and list of exhibitions.

Margaret Hunter: Changing Places. Strathclyde: Collins Gallery, University of Strathclyde, 1992, 35pp., illus. Text in German and English. Contains two critical essays.

Other Sources

Dunford, Penny. *A Biographical Dictionary of Women Artists in Europe and America since 1850.* Hemel Hempstead: Harvester Wheatsheaf and Philadelphia: University of Pennsylvania Press, 1990. Contains a bibliography.

2709 HUSEN, FLORENCE (1952–)
Dutch painter of figures.

Exhibitions

De Vrouw in de kunst. Leiden: Pand Caecilia, 1987.

2710 ISERBYT, GEORGINA (1915–)
Belgian painter of figure and marine subjects.

Main Sources

Rey, S. "Georgina Iserbyt: les ivresses de l'imagination." *La libre Belgique,* 11 March 1988.

Exhibitions

Georgina Iserbyt. Brussels: Galérie Kintz, 1978.

Other Sources

Dunford, Penny. *A Biographical Dictionary of Women Artists in Europe and America since 1850.* Hemel Hempstead: Harvester Wheatsheaf and Philadelphia: University of Pennsylvania Press, 1990. Contains a bibliography.

2711 JACQUEMART, NÉLIE BARBE HYACINTHE (Alt. JACQUEMART-ANDRÉ) (1841–1912)
French painter, best known for her portraits; also a sculptor and collector of art whose house is now a museum in Paris.

Other Sources

Clement, Clara. *Women in the Fine Arts.* Boston: Mifflin, 1904.
Clement, Clara, and L. Hutton. *Artists of the Nineteenth Century.* New York, 1879.
Dunford, Penny. *A Biographical Dictionary of Women Artists in Europe and America since 1850.* Hemel Hempstead: Harvester Wheatsheaf and Philadelphia: University of Pennsylvania Press, 1990. Contains a bibliography.
Lexikon der Frau. Zurich: Encyclios Verlag, 1953.

2712 JAMNÍKOVÁ-GABRIELOVÁ, LUDMILA (1926–)
Czech painter.

Exhibitions

Obraz 69. Brno: Moravská Galerie, 1969.

2713 JARAY, TESS (1937–)
English abstract painter whose use of geometrical forms has also led to an involvement with murals and decorative paving schemes.

Main Sources

Baro, Gene. "Tess Jaray's mural for Expo '67." *Studio International,* March 1967.
Kudielka, T. "Tess Jaray: New Paintings." *Art International,* summer 1969.

Exhibitions

Hayward Annual 1978. London: Hayward Gallery, 1978.
Mellor, David. *The Sixties Art Scene in London.* London: Barbican Art Gallery in association with Phaidon Press, 1993.

Other Sources

Dunford, Penny. *A Biographical Dictionary of Women Artists in Europe and America since 1850.* Hemel Hempstead: Harvester Wheatsheaf and Philadelphia: University of Pennsylvania Press, 1990. Contains a bibliography.
Parry-Crooke, Charlotte. *Contemporary British Artists.* London: Bergstrom and Boyle, 1979.

2714 JAREMA, MARIA (1908–1958)
Polish abstract painter, sculptor, stage designer and graphic artist.

Publications

[Untitled statement.] *Glos plastykow,* 1937, 43–44.

Exhibitions

Zwei polnische Malerinnen: Maria Jarema, Maria Hiszpańska-Neumann. Bern: Kunstmuseum, 1963. Contains a biographical account and some critical discussion of the work.
Morawińska, Agnieszka. *Voices of Freedom: Polish Women Artists of the Avant-garde, 1880–1990.* Washington, D.C.: National Museum of Women in the Arts, 1991. Includes a list of her main exhibitions and a bibliography.

Other Sources

Dunford, Penny. *A Biographical Dictionary of Women Artists in Europe and America since 1850.* Hemel Hempstead: Harvester Wheatsheaf and Philadelphia: University of Pennsylvania Press, 1990. Contains a bibliography.

2715 JELLETT, MAINIE (née MARY HARRIET JELLETT) (1897–1944)
 Irish painter of Cubist-influenced abstracts early in her career; later she painted landscapes, seascapes and figure subjects.

Exhibitions

Mainie Jellett: A Retrospective Exhibition of Paintings and Drawings. Dublin: Hugh Lane Municipal Gallery, 1962.
 Pyle, H. *Irish art, 1900–1950.* Crawford: Municipal Art Gallery, 1975.
 Abstraction-Création, 1931–1936. Paris: Musée d'Art Moderne de la Ville de Paris, 1978.
 Irish Women Artists from the Eighteenth Century to the Present Day. Dublin: National Gallery of Ireland, Douglas Hyde Gallery and Hugh Lane Gallery: 1987.

Other Sources

De Breffny, Brian, ed. *Ireland: A Cultural Encyclopaedia.* London: Thames and Hudson, 1983.
 Dunford, Penny. *A Biographical Dictionary of Women Artists in Europe and America since 1850.* Hemel Hempstead: Harvester Wheatsheaf and Philadelphia: University of Pennsylvania Press, 1990. Contains a bibliography.

2716 JENKINS, EVELINE (1893–)
 Welsh painter of botanical subjects.

Other Sources

Burbidge, R. Brinsley. *Dictionary of British Flower, Fruit and Still Life Painters.* Leigh-on-Sea: F. Lewis, 1974.

2717 JERICHAU, ELIZABETH MARIA ANNA (née BAUMANN) (1819–1881)
 German-born painter of portraits, especially of royalty, religious and genre subjects who worked in Denmark.

Publications

Jugenderinnerungen, 1874.
Pictures of Travel. n.d. (between 1874 and 1881).

Main Sources

"The Works of M. and Madame Jerichau." *Art Journal,* 1863, 152.
"The Works of Madame Jerichau." *Art Journal,* 1871, 165.
Clayton, Ellen. *English Female Artists.* London: Tinsley, 1876.

Other Sources

Clement, Clara. *Women in the Fine Arts.* Boston: Houghton Mifflin, 1904.
Dunford, Penny. *A Biographical Dictionary of Women Artists in Europe and America since 1850.* Hemel Hempstead: Harvester Wheatsheaf and Philadelphia: University of Pennsylvania Press, 1990. Contains a bibliography.
Krichbaum, J., and R. Zondergeld. *Künstlerinnen: von der Antike bis zur Gegenwart.* Cologne: DuMont, 1979.
Lexikon der Frau. Zurich: Encyclios Verlag, 1953.
Nunn, Pamela Gerrish. *Victorian Women Artists.* London: Women's Press, 1987.
Yeldham, Charlotte. *Women Artists in Nineteeenth Century France and England.* London and New York: Garland, 1984.

2718 JEWELS, MARY (née TREGURTHA) (1886–1977)
English naïve painter of scenes based on her Cornish background.

Main Sources

Bowness, Alan. "Mary Jewels and Naïve Painting." *Painter and Sculptor* 1, no. 3 (autumn 1958).

Exhibitions

St Ives, 1939–1964. London: Tate Gallery, 1985.

Other Sources

Dunford, Penny. *A Biographical Dictionary of Women Artists in Europe and America since 1850.* Hemel Hempstead: Harvester Wheatsheaf and Philadelphia: University of Pennsylvania Press, 1990. Contains a bibliography.

2719 JĒRITA, HELGA (1925–)
Estonian painter.

Exhibitions

8. Baltijas Republiku Akvareļu Izstāde: Katalogs. Riga, 1989.

2720 JOHNOVÁ-ŠIMOTOVÁ, ADRIENA (1926–)
Czech painter.

Exhibitions

Obraz 69. Brno: Moravská Galerie, 1969.

2721 JOHN, GWEN (née GWENDOLINE MARY JOHN) (1876–1939)
Welsh painter of female figures, interiors and cats.

Main Sources

Chitty, Susan. *Gwen John.* London: 1981.

Foster, Alicia. "She Shopped at The Bon Marché." *Women's Art Magazine* 65 (July–August 1995): 10–14.

John, Augustus. "Gwendolen John." *Burlington Magazine* 81 (1942): 236–237.

Langdale, Cecily. *Gwen John.* New Haven and London: Yale University Press, 1987.

Lloyd-Morgan, Ceridwen. *Gwen John: Papers at the National Library of Wales.* Aberystwyth: National Library of Wales, 1988, 52pp., illus. Gives an account of the various collections of John's papers, of which this is one of the three main ones, and a biographical account which allows the papers in Wales to be set in context.

Taubmann, Mary. *Gwen John.* Ithaca, 1985 and London, 1986.

Taylor, Hilary. "'If a Young Painter be not Fierce and Arrogant God Help Him': Some Women Art Students at the Slade, c. 1895–99." *Art History* 9 (June 1986): 232–244.

Thomas, Alison. *Portraits of Women: Gwen John and Her Forgotten Contemporaries.* Cambridge: Polity Press, 1996.

Exhibitions

Harris, Anne Sutherland, and Linda Nochlin. *Women Artists 1550–1950.* Los Angeles: County Museum of Art, 1976.

Künstlerinnen International, 1877–1977. Berlin: Schloss Charlottenburg, 1977.

Langdale, Cecily, and David Jenkins. *Gwen John: An Interior Life.* London: Barbican Art Gallery in association with Phaidon Press, 1985, 94pp., illus. An essay analyses her work and her patron. Contains a summary biography, select bibliography and list of exhibitions.

Sulter, Maud. *Echo: Works by Women Artists, 1850–1940.* Liverpool: Tate Gallery, 1991.

Other Sources

Bachmann, Donna, and Sherry Piland. *Women Artists: A Historical, Contemporary and Feminist Bibliography.* Metuchen, N.J.: Scarecrow Press, 1978.

Dunford, Penny. *A Biographical Dictionary of Women Artists in Europe and America since 1850.* Hemel Hempstead: Harvester Wheatsheaf and Philadelphia: University of Pennsylvania Press, 1990. Contains a bibliography.

Tufts, Eleanor. *Our Hidden Heritage: Five Centuries of Women Artists.* New York and London: Paddington Press, 1974.

2722 JOKISALO, ULLA (1955–)
Finnish painter.

Exhibitions

Ulla Jokisalo: Animalis. Helsinki: Museet for Nutidikonst, 1992, 10pp., illus. After a short essay on the artist and her work, there is an outline biography and a list of exhibitions.

2723 JONES, LOUIE JOHNSON (1856–after 1923)
 Welsh painter of animals, especially horses.

Other Sources

Dunford, Penny. *A Biographical Dictionary of Women Artists in Europe and America since 1850.* Hemel Hempstead: Harvester Wheatsheaf and Philadelphia: University of Pennsylvania Press, 1990. Contains a bibliography.
 Lexikon der Frau. Zurich: Encyclios Verlag, 1953.
 Wood, Christopher. *Dictionary of Victorian Painters.* Woodbridge: Antique Collectors Club, 1978.

2724 JOPLING, LOUISE (née GOODE; alt. ROMER; JOPLING-ROWE) (1843–1933)
 English painter of figure subjects and portraits.

Publications

Hints to Amateurs. London, 1891; reprint London, 1911.
Twenty Years of My Life. London, 1925. Autobiography.

Main Sources

Clayton, Ellen. *English Female Artists.* London: Tinsley, 1876.
Nunn, Pamela Gerrish. *Canvassing.* London: Camden Press, 1986. Contains extracts from Jopling's autobiography.

Exhibitions

Cherry, Deborah. *Painting Women: Victorian Women Artists.* Rochdale: Art Gallery, 1987.

Other Sources

Ash, Russell. "English painting of 1874." *Connoisseur* 185 (January 1974): 33–40. Discusses a selection of paintings exhibited in England in 1874. A work by Jopling is included at the end of the article.
 Clement, Clara. *Women in the Fine Arts.* Boston: Houghton Mifflin, 1904.
 Cherry, Deborah. *Painting Women: Victorian Women Artists.* London: Routledge, 1993.
 Dunford, Penny. *A Biographical Dictionary of Women Artists in Europe and America since 1850.* Hemel Hempstead: Harvester Wheatsheaf and Philadelphia: University of Pennsylvania Press, 1990. Contains a bibliography.

Nunn, Pamela Gerrish. *Victorian Women Artists*. London: Women's Press, 1987.

Orr, Clarissa Campbell, ed. *Women in the Victorian Art World*. Manchester: Manchester University Press, 1995.

Sparrow, Walter Shaw. *Women Painters of the World*. London: Hodder and Stoughton, 1905.

Wood, Christopher. *The Dictionary of Victorian Painters*. Woodbridge: Antique Collectors Club, 1978.

2725 JORDAN, EITHNE (1954–)
Irish painter.

Exhibitions

Irish Women Artists from the Eighteenth Century to the Present Day. Dublin: National Gallery of Ireland, Douglas Hyde Gallery and Hugh Lane Gallery: 1987.

Other Sources

Dunford, Penny. *A Biographical Dictionary of Women Artists in Europe and America since 1850*. Hemel Hempstead: Harvester Wheatsheaf and Philadelphia: University of Pennsylvania Press, 1990. Contains a bibliography.

2726 JORIS, AGNESE (sometimes used the pseudonym ALTISSIMI) (1850–1922)
Italian painter and graphic artist.

Other Sources

Clement, Clara. *Women in the Fine Arts*. Boston: Houghton Mifflin, 1904.

Dunford, Penny. *A Biographical Dictionary of Women Artists in Europe and America since 1850*. Hemel Hempstead: Harvester Wheatsheaf and Philadelphia: University of Pennsylvania Press, 1990. Contains a bibliography.

Commanducci, A. *Dizionario illustrato dei pittori italiani moderni e contemporanei*. Milan, 1966.

2727 JOSEPH, LILY (née SOLOMON; alt. DELISSA JOSEPH) (1864–1940)
English painter of portraits, landscapes and interiors.

Other Sources

Dunford, Penny. *A Biographical Dictionary of Women Artists in Europe and America since 1850*. Hemel Hempstead: Harvester Wheatsheaf and Philadelphia: University of Pennsylvania Press, 1990. Contains a bibliography.

Edouard-Joseph, R. *Dictionnaire biographique des artistes contemporains, 1910–1930*. Paris: Art et Editions, 1930–1934.

Wood, Christopher. *The Dictionary of Victorian Painters*. Woodbridge: Antique Collectors Club, 1978.

2728 JUNG, EDITH (1953–)
German painter and graphic artist.

Other Sources

Evers, Ulrike. *Deutsche Künstlerinnen des 20. Jahrhunderts. Malerei—Bildhauerei—Tapisserie.* Hamburg: Ludwig Schultheis Verlag, 1983. Contains an individual bibliography.

2729 JÜRGENS, GRETHE (1899–1981)
German painter of figures and urban scenes in the style of Neue Sachlichkeit.

Exhibitions

Vergine, Lea. *L'altra metà dell'avanguardia.* Milan: Mazzotta Editore, 1980. *L'autre moitié de l'avant-garde.* Paris: Des Femmes, 1982.
Meskimmon, Marsha. *Domesticity and Dissent: The Role of Women Artists in Germany 1918–1938. Haüsliches Leben und Dissens.* Leicester: Leicestershire Museums Publication no. 120, 1992.

Other Sources

Dunford, Penny. *A Biographical Dictionary of Women Artists in Europe and America since 1850.* Hemel Hempstead: Harvester Wheatsheaf and Philadelphia: University of Pennsylvania Press, 1990. Contains a bibliography.
Evers, Ulrike. *Deutsche Künstlerinnen des 20. Jahrhunderts. Malerei—Bildhauerei—Tapisserie.* Hamburg: Ludwig Schultheis Verlag, 1983. Contains an individual bibliography.
Meskimmon, Marsha, and Shearer West. *Visions of the 'Neue Frau': Women and the Visual Arts in Weimar Germany.* London: Scolar Press, 1995.

2730 KAGAN, ANNA ALEXANDROVNA (1902–1974)
Russian painter, graphic artist and decorator of ceramics.

Exhibitions

Avanguardia russa dalle collezioni private sovietiche origini e percorso 1904–1934. Milan: Palazzo Reale, 1989.

Other Sources

Elliott, David, and V. Dudakov. *100 Years of Russian Art.* London: Lund Humphries, 1989.
Milner, John. *A Dictionary of Russian and Soviet Artists, 1420–1970.* Woodbridge: Antique Collectors Club, 1993.

2731 KALKREUTH, MARIA (COUNTESS) (Alt. MARIE KALKREUTH) (1857–1897)
German painter of religious and genre scenes.

Other Sources

Clement, Clara. *Women in the Fine Arts.* Boston: Houghton Mifflin, 1904.
Dunford, Penny. *A Biographical Dictionary of Women Artists in Europe and America since 1850.* Hemel Hempstead: Harvester Wheatsheaf and Philadelphia: University of Pennsylvania Press, 1990. Contains a bibliography.

2732 KAMRADZIUSA, INGŪNA (1956–)
Latvian painter.

Exhibitions

8. Baltijas Republiku Akvareļu Izstāde: Katalogs. Riga, 1989.

2733 KAPANADZE, KETI (1962–)
Georgian conceptual painter who was one of the first in that country to address feminist issues.

Other Sources

Rosenfeld, Alla, and Norton Dodge, eds. *Nonconformist Art: The Soviet Experience, 1956–1986. The Norton and Nancy Dodge Collection.* London: Thames and Hudson in association with the Jane Voorhees Zimmerli Art Museum, State University of New Jersey, Rutgers, 1995.

2734 KARLINSKY, ELIZABETH (Alt. KARLINSKY-SCHERFIG) (1904–)
Austrian-born painter who worked in Denmark.

Exhibitions

Gamey, S. *Movement and the City: Vienna and New York in the 1920s.* New York: Rachel Adler Gallery, 1987.

Other Sources

Dunford, Penny. *A Biographical Dictionary of Women Artists in Europe and America since 1850.* Hemel Hempstead: Harvester Wheatsheaf and Philadelphia: University of Pennsylvania Press, 1990. Contains a bibliography.

2735 KARSKAYA, IDA (née BENDER) (1905–)
Ukrainian painter who worked in France.

Exhibitions

Bonnefoi, Geneviève. *Rétrospective Karskaya: vingt-cinq années d'inventions.* Abbaye de Beaulieu: Centre d'Art Contemporain, 1972.

Künstlerinnen International, 1877–1977. Berlin: Schloss Charlottenburg, 1977.

Anthonicz, B., et al. *Karskaya.* Paris: Fondation Nationale des Arts Graphiques et Plastiques, 1980.

2736 KAUFFMAN, ANGELICA (Alt. ZUCCHI) (1741–1807)
Swiss Neo-Classical painter who trained in Italy and worked in England from 1766–1781.

Main Sources

Langdon, Helen. "Pretty Good." *The Independent Magazine,* 12 December 1992, 42–45.

Rosenthal, Angela. "Angelica Kauffman Ma(s)king Claims." *Art History* 15, no. 1 (1992): 38–59. Argues that Kauffman was commenting on the dominant ideologies of sexual diference in two of her best known paintings.

Exhibitions

Harris, Anne Sutherland, and Linda Nochlin. *Women Artists 1550–1950.* Los Angeles: County Museum of Art, 1976.

Das Verborgene Museum. Dokumentation der Kunst von Frauen in Berliner öffentlichen Sammlungen. Berlin: Edition Hentrich, 1987.

Roworth, Wendy Wassyng. *Angelica Kauffman: A Continental Artist in Georgian England.* Brighton: Royal Pavilion in association with Reaktion Books, 1992, 216pp., illus. Scholarly essays consider Kauffman's portraits, her decorative work, her relation to the print market and her effect on English painting. There is a full bibliography.

Other Sources

Fine, Elsa Honig. *Women and Art.* New York and London: Allanfield and Schram/Prior, 1978.

Orr, Clarissa Campbell, ed. *Women in the Victorian Art World.* Manchester: Manchester University Press, 1995.

Tufts, Eleanor. *Our Hidden Heritage: Five Centuries of Women Artists.* New York and London: Paddington Press, 1974.

2737 KEEGAN, RITA (1949–)
American painter and mixed-media artist who works in England.

Publications

"Rita Keegan." *Women Live,* spring 1988, 19–21.

"An Update on Black Women and WASL." *Feminist Art News* 2, no. 8 (autumn 1988): 29. Describes black women artists being included in the archives of the Women Artists' Slide Library in London.

"Distilling the Essence." *Ten-8* 2, no. 3 (spring 1992): 148–149.

Main Sources

Denning, Laura. "Photomontage now." *Women's Art Magazine* 42 (1991): 18–19. Review of the exhibition of two artists, Keegan and Cath Tate.

Rendall, Clare. "Actual Lives of Women Artists: Rita Keegan." *Women Artists' Slide Library Journal* (October–November 1987): 10–11.

Other Sources

Dunford, Penny. *A Biographical Dictionary of Women Artists in Europe and America since 1850.* Hemel Hempstead: Harvester Wheatsheaf and Philadelphia: University of Pennsylvania Press, 1990. Contains a bibliography.

2738 KEMP-WELCH, LUCY ELIZABETH (1869–1958)
English painter of horses and country occupations.

Publications

In the Open Country: Studies and Sketches by Lucy Kemp-Welch. London, 1905.

Main Sources

Messum, David. *The Life and Work of Lucy Kemp-Welch.* London, 1976.

Exhibitions

Paintings and Drawings by Some Women War Artists. London: Imperial War Museum, 1958.

Sellars, Jane. *Women's Works.* Liverpool: Walker Art Gallery, 1988.

Other Sources

Clement, Clara. *Women in the Fine Arts.* Boston: Houghton Mifflin, 1904.

Dunford, Penny. *A Biographical Dictionary of Women Artists in Europe and America since 1850.* Hemel Hempstead: Harvester Wheatsheaf and Philadelphia: University of Pennsylvania Press, 1990. Contains a bibliography.

Sparrow, Walter Shaw. *Women Painters of the World.* London: Hodder and Stoughton, 1905.

Wood, Christopher. *The Dictionary of Victorian Painters.* Woodbridge: Antique Collectors Club, 1978.

2739 KERKOVIUS, IDA (1879–1970)
Latvian-born painter who worked in Germany.

Main Sources

Kurt, Leonhard. *Ida Kerkovius: Leben und Werk.* Cologne: Verlag M. DuMont Schauberg, 1967, 104pp., illus. A study of her life and work.

Exhibitions

Ida Kerkovius, 1879–1970: Gesichter. Bilder und Zeichnungen aus sieben Jahrzehtnten. Stuttgart: Galerie der Stadt, 1979, 66pp., mainly illus. Introduction by Kurt Leonhard. Apart from the illustrations, the short introduction is supplemented only by a biographical outline, a list of exhibitions and a bibliography.

Vergine, Lea. *L'altra metà dell'avanguardia.* Milan: Mazzotta Editore, 1980. *L'autre moitié de l'avant-garde.* Paris: Des Femmes, 1982.

La Tessitura del Bauhaus, 1919–33 nelle collezioni della Repubblica Democratica Tedesca. Venice: Palazzo Ducale and Cataloghi Marsilio, 1985.

Gunta Stölzl: Weberei am Bauhaus und aus eigener Werkstatt. Berlin: Bauhaus Archiv in association with Kupfergraben Verlag, 1987.

Das Verborgene Museum. Dokumentation der Kunst von Frauen in Berliner öffentlichen Sammlungen. Berlin: Edition Hentrich, 1987.

Other Sources

Dunford, Penny. *A Biographical Dictionary of Women Artists in Europe and America since 1850.* Hemel Hempstead: Harvester Wheatsheaf and Philadelphia: University of Pennsylvania Press, 1990. Contains a bibliography.

Evers, Ulrike. *Deutsche Künstlerinnen des 20. Jahrhunderts. Malerei— Bildhauerei—Tapisserie.* Hamburg: Ludwig Schultheis Verlag, 1983. Contains an individual bibliography.

Jarry, Madeleine. *La tapisserie: Art du XXème siècle.* Fribourg: Office du Livre, 1974.

Krichbaum, J., and R. Zondergeld. *Künstlerinnen: von der Antike bis zur Gegenwart.* Cologne: DuMont, 1979.

Weltge, Sigrid Wortmann. *Bauhaus Textiles: Women Artists and the Weaving Workshop.* London: Thames and Hudson, 1993.

2740 KERNN-LARSEN, RITA (1904–)

Danish painter who exhibited with the Surrealists in the 1930s.

Main Sources

Chadwick, Whitney. *Women Artists and the Surrealist Movement.* London: Thames and Hudson, 1985.

Exhibitions

Surrealismen i Danmark 1930–1950. Copenhagen: Statens Museum for Kunst, 1986.

Other Sources

Dunford, Penny. *A Biographical Dictionary of Women Artists in Europe and America since 1850.* Hemel Hempstead: Harvester Wheatsheaf and Philadelphia: University of Pennsylvania Press, 1990. Contains a bibliography.

2741 KESERÜ, ILONA (1933–)
Hungarian painter, graphic artist and theatre designer.

Main Sources

Beke, L. "The Painter and the Tombstones." *New Hungarian Quarterly* 12 (1971): 43.
Frank, J. "Ilona Keserü's Lyrical Objectivity." *New Hungarian Quarterly* 25 (1984): 95.

Exhibitions

Contemporary Visual Art in Hungary. Glasgow: Third Eye Centre, 1985.

Other Sources

Hárs, Éva, and Ferenc Romváry. *Modern Hungarian Gallery Pécs.* Budapest: Corvina Kiadó, 1981.
Dunford, Penny. *A Biographical Dictionary of Women Artists in Europe and America since 1850.* Hemel Hempstead: Harvester Wheatsheaf and Philadelphia: University of Pennsylvania Press, 1990. Contains a bibliography.
Németh, Lajos. *Modern Art in Hungary.* Budapest: Corvina Press, 1969.

2742 KESSELL, MARY (1914–)
English painter of landscapes and figure subjects, graphic artist and designer of jewellery; also an official war artist.

Exhibitions

Paintings and Drawings by Some Women War Artists. London: Imperial War Museum, 1958.
Mary Kessell. London: Leicester Gallery, 1964.

Other Sources

Dunford, Penny. *A Biographical Dictionary of Women Artists in Europe and America since 1850.* Hemel Hempstead: Harvester Wheatsheaf and Philadelphia: University of Pennsylvania Press, 1990. Contains a bibliography.
Waters, Grant. *Dictionary of British Artists Working 1900–1940.* Eastbourne: Eastbourne Fine Art, 1975.

2743 KEYSER, RAGNHILD (1889–1943)
Norwegian cubist painter.

Exhibitions

Wichstrøm, Anne. *Rooms with a View: Women's Art in Norway, 1880–1990.* Oslo: Ministry of Foreign Affairs, 1989.

2744 KHLEBNIKOVA, VERA VLADIMIROVNA (Alt. MITURICH-KHLEB-
NIKOVA)
Russian painter and graphic artist who produced some work commenting
on women's role in Soviet society.

Main Sources

Elliott, David, and V. Dudakov. *100 Years of Russian Art.* London: Lund
Humphries, 1989.

Other Sources

Enfeld, Alla, and Norton Dodge, eds. *Nonconformist Art: The Soviet
Experience, 1956–1986. The Norton and Nancy Dodge Collection.* London: Thames
and Hudson in association with the Jane Voorhees Zimmerli Art Museum, State
University of New Jersey, Rutgers, 1995.

2745 KIELLAND, ELSE CHRISTIE (1903–)
Norwegian painter of landscapes.

Publications

"Kitty L. Kielland." *Urd,* 1943, 376–378.

Exhibitions

Nordisk Sekelskifte: The Light of the North. Stockholm: Nationalmuseum,
1995.

Other Sources

Dunford, Penny. *A Biographical Dictionary of Women Artists in Europe and
America since 1850.* Hemel Hempstead: Harvester Wheatsheaf and Philadelphia:
University of Pennsylvania Press, 1990. Contains a bibliography.
Gran, H., and P. Anker, eds. *Illustrert Norsk Kunstner Leksikon.* Oslo: Broen
Bokhandel, 1956.

2746 KIELLAND, KITTY (née CHRISTIANE LANGE KIELLAND) (1843–
1914)
Norwegian painter of landscapes.

Main Sources

Kielland, Else. "Kitty L. Kielland." *Urd,* 1943, 376–378.
Lange, Marit. "Fra den hellige lund til Fleskum. Kitty Lange Kielland og den
nordiske somernatt." *Kunst og Kultur* 60 (1975): 69–92.

Exhibitions

Lange, Marit. *Harriet Backer 1845–1932; Kitty Kielland 1843–1914*. Åmot: Stifelsen modums Blaafarvevaerk, 1983, 68pp., illus. Text in Norwegian. After an introductory essay, there are detailed entries for each of the seventy-four exhibits and a chronology for each artist.

Dreams of a Summer Night. London: Hayward Gallery, 1986.

Fisher, Susan Sterling, Anne Wichstrøm, and Toril Smit. *At Century's End: Norwegian Artists and the Figurative Tradition, 1880–1990*. Høvikodden: Henie-Onstad Art Centre, 1995. Includes a list of exhibitions and an individual bibliography.

Wichstrøm, Anne. "Blant likemenn. Søkelys på Harriet Backers og Kitty Lange Kiellands karrierer." In *Den skjulte tradition,* ed. K. Vogt, 172–191. Bergen, 1982.

Other Sources

Dunford, Penny. *A Biographical Dictionary of Women Artists in Europe and America since 1850*. Hemel Hempstead: Harvester Wheatsheaf and Philadelphia: University of Pennsylvania Press, 1990. Contains a bibliography.

Gran, H., and P. Anker, eds. *Illustrert Norsk Kunstner Leksikon*. Oslo: Broen Bokhandel, 1956.

Wichstrøm, Anne. *Kvinner ved staffeliet*. Oslo: Universtetsforlaget, 1983.

2747 KIERS-HAANEN, ELISABETH ALIDA (née HAANEN) (1809–1845)
Dutch painter.

Exhibitions

Kunst door vrouwen. Leiden: Stedelijk Museum, De Lakenhal, 1987.

2748 KIKI DE MONPARNASSE (Pseudonym of ALICE PRIN) (1901–?)
French artists' model, singer and painter.

Main Sources

Benstock, Shari. *Women of the Left Bank: Paris 1900–1940*. University of Texas Press, 1986 and London: Virago, 1987. A brief mention of Kiki in a discussion of Janet Flanner's writings.

Other Sources

Dunford, Penny. *A Biographical Dictionary of Women Artists in Europe and America since 1850*. Hemel Hempstead: Harvester Wheatsheaf and Philadelphia: University of Pennsylvania Press, 1990. Contains a bibliography.

2749 KINTSURASHVILI, SOPHIE (1948–)
Georgian painter.

Other Sources

Enfeld, Alla, and Norton Dodge, eds. *Nonconformist Art: The Soviet Experience, 1956–1986. The Norton and Nancy Dodge Collection.* London: Thames and Hudson in association with the Jane Voorhees Zimmerli Art Museum, State University of New Jersey, Rutgers, 1995.

2750 KIRKWOOD, HARRIET (1880–1953)
Irish painter.

Exhibitions

Irish Women Artists from the Eighteenth Century to the Present Day. Dublin: National Gallery of Ireland, Douglas Hyde Gallery and Hugh Lane Gallery, 1987.

2751 KIRSCHNER, MARIE LUISE (1852–1931)
Austrian painter of still life and landscapes.

Other Sources

Clayton, Ellen. *English Female Artists.* London: Tinsley, 1873.
Clement, Clara. *Women in the Fine Arts.* Boston: Houghton Mifflin, 1904.
Krichbaum, J., and R. Zondergeld. *Künstlerinnen: von der Antike bis zur Gegenwart.* Cologne: DuMont, 1979.
Lexikon der Frau. Zurich: Encyclios Verlag, 1953.

2752 KITSMEGI, LINDA (1916–)
Estonian painter.

Exhibitions

8. Baltijas Republiku Akvareļu Izstāde: Katalogs. Riga, 1989.

2753 KLEIN, ERIKA GIOVANNA (1900–1957)
Austrian painter concerned with depicting an analysis of movement who worked in New York from 1929.

Exhibitions

Vergine, Lea. *L'altra metà dell'avanguardia.* Milan: Mazzotta Editore, 1980.
L'autre moitié de l'avant-garde. Paris: Des Femmes, 1982.
Gamey, S. *Movement and the City: Vienna and New York in the 1920s.* New York: Rachel Adler Gallery, 1987.

Other Sources

Dunford, Penny. *A Biographical Dictionary of Women Artists in Europe and America since 1850.* Hemel Hempstead: Harvester Wheatsheaf and Philadelphia: University of Pennsylvania Press, 1990. Contains a bibliography.

2754 KLIMOVÁ, TAMARA (1922–)
Czech painter.

Exhibitions

Obraz 69. Brno: Moravská Galerie, 1969.

2755 KLINGHOFFER, CLARA (1900–1970)
Austrian-born painter and graphic artist who worked in England and America.

Exhibitions

Clara Klinghoffer and Mark Gertler. London: Leicester Gallery, 1932. Contains only a list of exhibits.

Other Sources

Dunford, Penny. *A Biographical Dictionary of Women Artists in Europe and America since 1850.* Hemel Hempstead: Harvester Wheatsheaf and Philadelphia: University of Pennsylvania Press, 1990. Contains a bibliography.
Waters, Grant. *Dictionary of British Artists Working 1900–1940.* Eastbourne: Eastbourne Fine Art, 1975.

2756 KLINT, HILMA AF (1862–1944)
Swedish painter of Symbolist and abstract canvases which derived from her experiences with Spiritualism.

Exhibitions

Fant, A. "The Case of the Artist Hilma af Klint." In *The Spiritual in Art: Abstract Painting 1890–1985.* Los Angeles: County Museum of Art, 1986.

Other Sources

Dunford, Penny. *A Biographical Dictionary of Women Artists in Europe and America since 1850.* Hemel Hempstead: Harvester Wheatsheaf and Philadelphia: University of Pennsylvania Press, 1990. Contains a bibliography.

2757 KMIEĻAUSKAITE-IDZELIENE, RAMUNE (1960–)
Lithuanian painter.

Exhibitions

8. Baltijas Republiku Akvareļu Izstāde: Katalogs. Riga, 1989.

2758 KNIGHT, LAURA (née JOHNSON) (1887–1970)
English figure painter especially of beach, ballet and circus themes.

Publications

Oil paint and grease paint. London: Ivor Nicholson and Watson, 1936; Harmondsworth: Penguin, 1941. Autobiography.
Magic of a line. London: William Kimber, 1965. Autobiography.

Main Sources

Laura Knight: A book of drawings. Foreword by Charles Merriot. London: Bodley Head, 1923 (limited edition).
Masters of modern etching: Laura Knight CBE, ARA. Introduction by Michael Saloman. London: *The Studio,* 1932.
 Bolling, G., Frederic, and Valerie Withington. *The Graphic Work of Laura Knight Including a Catalogue Raisonné of her Prints.* London: Scolar Press, 1993, 154pp., mainly illus.
 Cole, Margaret. *Women of Today.* Essay Index Reprint Series. Freeport, N.Y.: Books for Libraries Press Inc., 1968, pp. 161–190. Reprint of 1938 edition. Accessible biographical account which uses material from the autobiographies.
 Dunbar, Janet. *Laura Knight.* London: William Collins Sons and Co. Ltd., 1975.
 Fox, Caroline. *Dame Laura Knight.* Oxford: Phaidon Press, 1988.
 Grimes, Teresa, Judith Collins, and Oriana Baddeley. *Five Women Painters.* London: Channel Four in Association with the Arts Council of Great Britain and Lennard Publishing, 1989. Reprint 1991. Contains a perceptive analysis of Knight's work and a bibliography.

Exhibitions

On with the show: Drawings by Dame Laura Knight. Introduction by Laura Wortley and catalogue notes by Caroline Fox. Marlow: The Studio Fine Art Publications in association with David Messum Gallery, London, n.d., n.p. Consists mainly of illustrations and catalogue notes.
The Women's Art Show 1550–1970. Nottingham: Castle Museum, 1982.
 Fox, Caroline, and Francis Greenacre. *Painting in Newlyn, 1880–1930.* London: Barbican Art Gallery, 1985. Contains a useful introductory essay, biographical account and detailed notes on the paintings exhibited.
 Sellars, Jane. *Women's Works.* Liverpool: Walker Art Gallery, 1988.

Other Sources

Dunford, Penny. *A Biographical Dictionary of Women Artists in Europe and America since 1850.* Hemel Hempstead: Harvester Wheatsheaf and Philadelphia: University of Pennsylvania Press, 1990. Contains a bibliography.
 Harries, M., and S. *The War Artists.* London: 1983.
 Waters, Grant. *Dictionary of British Artists Working 1900–1940.* Eastbourne: Eastbourne Fine Art, 1975.

2759 KNIGHTS, WINIFRED MARGARET (Alt. MONNINGTON) (1899–1947)
English painter of landscapes and religious subjects.

Exhibitions

The Last Romantics. The Romantic Tradition in British Art: Burne-Jones to Stanley Spencer. London: Barbican Art Gallery, 1989.
Sulter, Maud. *Echo: Works by Women Artists, 1850–1940.* Liverpool: Tate Gallery, 1991.

Other Sources

Day, Michael. *Modern Art in Church: A Gazeteer.* London, 1982.
Dunford, Penny. *A Biographical Dictionary of Women Artists in Europe and America since 1850.* Hemel Hempstead: Harvester Wheatsheaf and Philadelphia: University of Pennsylvania Press, 1990. Contains a bibliography.
Waters, Grant. *Dictionary of British Artists Working 1900–1940.* Eastbourne: Eastbourne Fine Art, 1975.

2760 KNUTSON, GRETA (1899–1983)
Swedish painter who contributed to Parisian Surrealism before developing her own style of abstraction.

Exhibitions

Vergine, Lea. *L'altra metà dell'avanguardia.* Milan: Mazzotta Editore, 1980. *L'autre moitié de l'avant-garde.* Paris: Des Femmes, 1982.

Other Sources

Dunford, Penny. *A Biographical Dictionary of Women Artists in Europe and America since 1850.* Hemel Hempstead: Harvester Wheatsheaf and Philadelphia: University of Pennsylvania Press, 1990. Contains a bibliography.

2761 KOCAN, IRMA
Swiss painter.

Exhibitions

Stutzer, Beat. *Künstlergruppen in der Schweiz, 1910–1936.* Aarau: Aargauer Kunsthaus, 1981.

2762 KOCK, ANNEKE (1944–)
Dutch graphic artist and painter.

See Graphic Art section.

2763 KODASSEVICH, VALENTINA MICHAILOVNA (1894–1970)
Russian painter, graphic artist and stage designer.

Main Sources

Paris-Moscou, 1900–1930. Paris: Centre national d'art et de culture Georges Pompidou, 1979.

Elliott, David, and V. Dudakov. *100 Years of Russian Art.* London: Lund Humphries, 1989.

Exhibitions

Avanguardia russa dalle collezioni private sovietiche origini e percorso 1904–1934. Milan: Palazzo Reale, 1989.

Other Sources

Milner, John. *A Dictionary of Russian and Soviet Artists, 1420–1970.* Woodbridge: Antique Collectors Club, 1993.

2764 KOGAN, NINA OSIPOVNA (Alt. NANA IOSIFOVNA) (1887–1942?)
 Russian Suprematist painter.

Exhibitions

Russian Women Artists of the Avant-garde; Künstlerinnen der Russischen avantgarde, 1910–1930. Cologne: Galerie Gmurzynska, 1979.

Vergine, Lea. *L'altra metà dell'avanguardia.* Milan: Mazzotta Editore, 1980. *L'autre moitié de l'avant-garde.* Paris: Des Femmes, 1982.

De la Révolution à la Pérréstroika. Art Soviétique de la Collection Ludwig. St Etienne: Musée d'Art Moderne, 1989.

L'avant-garde au féminin 1907–1930. Paris: Artcurial, 1983.

Other Sources

Bowlt, John. "Malevich and His Students." *Soviet Union* 5, no. 2 (1978): 256–286.

Dunford, Penny. *A Biographical Dictionary of Women Artists in Europe and America since 1850.* Hemel Hempstead: Harvester Wheatsheaf and Philadelphia: University of Pennsylvania Press, 1990. Contains a bibliography.

Milner, John. *A Dictionary of Russian and Soviet Artists, 1420–1970.* Woodbridge: Antique Collectors Club, 1993.

2765 KOKAMEGI, EPA-MARIJA (1959–)
 Estonian painter.

Exhibitions

8. Baltijas Republiku Akvareļu Izstāde: Katalogs. Riga, 1989.

2766 KOPISTIANSKAIA, SVETLANA (1950–)
 Ukrainian-born painter who works in Russia.

Exhibitions

De la Révolution à la Pérréstroika. Art Soviétique de la Collection Ludwig.
St. Etienne: Musée d'Art Moderne, 1989.

Other Sources

Enfeld, Alla, and Norton Dodge, eds. *Nonconformist Art: The Soviet Experience, 1956–1986. The Norton and Nancy Dodge Collection.* London: Thames and Hudson in association with the Jane Voorhees Zimmerli Art Museum, State University of New Jersey, Rutgers, 1995.

2767 KRAFFT, BARBARA (née STEINER) (1764–1825)
German painter of life-size genre works and portraits.

Other Sources

Ellet, Elizabeth. *Women Artists in all Ages and Countries.* New York: Harper and Brothers Co., 1859.

2768 KRAIKOVÁ, VIERA (1920–)
Czech painter.

Exhibitions

Obraz 69. Brno: Moravská Galerie, 1969.

2769 KREITUSE, ANITA (1954–)
Latvian painter.

Other Sources

Šmagre, Rita. *Latviešu Pastelis. Latvian Pastel Painting.* Riga: Liesma, 1990. Includes a brief account of her career.

2770 KROHG, ODA (née OTTILIA LASSON; alt ENGELHARDT) (1860–1935)
Norwegian painter of figures, portraits and landscapes.

Main Sources

Wichstrøm, Anne. "Oda Krohg: A Turn-of the Century Nordic Artist." *Woman's Art Journal* 12, no. 2 (fall 1991–winter 1992): 3–8.

Other Sources

Dunford, Penny. *A Biographical Dictionary of Women Artists in Europe and America since 1850.* Hemel Hempstead: Harvester Wheatsheaf and Philadelphia: University of Pennsylvania Press, 1990. Contains a bibliography.

Wichstrøm, Anne. *Kvinner ved staffeliet.* Oslo: Universitetsforlaget, 1983.

2771 KROPIVNITSKAYA, VALENTINA (1924–)
Russian painter and graphic artist.

Other Sources

Enfeld, Alla, and Norton Dodge, eds. *Nonconformist Art: The Soviet Experience, 1956–1986. The Norton and Nancy Dodge Collection.* London: Thames and Hudson in association with the Jane Voorhees Zimmerli Art Museum, State University of New Jersey, Rutgers, 1995.

2772 KRUGLIKOVA, ELIZAVETA SERGEEVNA (Alt. KROUGLIKOVA) (1865–1941)
Russian graphic artist, specialising in etching, and painter.

See Graphic Art section.

2773 KUBICKA, MARGARETHE (née STANISLOVA) (1891–?)
German painter and graphic artist who often addressed social and political themes.

Exhibitions

Das Verborgene Museum. Dokumentation der Kunst von Frauen in Berliner öffentlichen Sammlungen. Berlin: Edition Hentrich, 1987.

Other Sources

Dunford, Penny. *A Biographical Dictionary of Women Artists in Europe and America since 1850.* Hemel Hempstead: Harvester Wheatsheaf and Philadelphia: University of Pennsylvania Press, 1990. Contains a bibliography.

2774 KUDISĪMA, INGE (1950–)
Estonian painter.

Exhibitions

8. Baltijas Republiku Akvareļu Izstāde: Katalogs. Riga, 1989.

2775 KURISMAA, MARI (1956–)
Estonian abstract painter who depicts geometrical forms.

Other Sources

Enfeld, Alla, and Norton Dodge, eds. *Nonconformist Art: The Soviet Experience, 1956–1986. The Norton and Nancy Dodge Collection.* London: Thames and Hudson in association with the Jane Voorhees Zimmerli Art Museum, State University of New Jersey, Rutgers, 1995.

2776 KURYLUK, EWA (1946–)
Polish painter and graphic artist who has lived in America since 1988.

Exhibitions

Morawińska, Agnieszka. *Voices of Freedom: Polish Women Artists of the Avant-garde, 1880–1990.* Washington, D.C.: National Museum of Women in the Arts, 1991. Includes a list of her main exhibitions and a bibliography.

2777 LAMBA, JACQUELINE (1919–)
French Surrealist painter who also wrote poetry.

Main Sources

Chadwick, Whitney. *Women Artists and the Surrealist Movement.* London: Thames and Hudson, 1985.

Exhibitions

Paris 1937–Paris 1957: créations en France. Paris: Centre national d'art et de culture Georges Pompidou, 1981.
Vergine, Lea. *L'altra metà dell'avanguardia.* Milan: Mazzotta Editore, 1980. *L'autre moitié de l'avant-garde.* Paris: Des Femmes, 1982.

Other Sources

Dunford, Penny. *A Biographical Dictionary of Women Artists in Europe and America since 1850.* Hemel Hempstead: Harvester Wheatsheaf and Philadelphia: University of Pennsylvania Press, 1990. Contains a bibliography.

2778 LAMBERT, ISABEL (Alt. DELMER; RAWSTHORNE) (1912–1992)
English figurative painter who from the later 1940s specialised in ballet subjects and designed sets for the Royal Ballet.

Main Sources

"Isabel Rawsthorne." *The Independent,* 29 January 1992, 27. Obituary.
"Isabel Rawsthorne." *The Independent,* 4 February 1992, 11. Obituary.

Exhibitions

Isabel Lambert: Recent Paintings. London: Hanover Gallery, 1959.

Other Sources

Dunford, Penny. *A Biographical Dictionary of Women Artists in Europe and America since 1850.* Hemel Hempstead: Harvester Wheatsheaf and Philadelphia: University of Pennsylvania Press, 1990. Contains a bibliography.

2779 LANDSEER, JESSICA (1807–1880)
 English painter, graphic artist and miniaturist.

Main Sources

Lennie, Campbell. *Edwin Landseer.* London, 1976.

Other Sources

Dunford, Penny. *A Biographical Dictionary of Women Artists in Europe and America since 1850.* Hemel Hempstead: Harvester Wheatsheaf and Philadelphia: University of Pennsylvania Press, 1990. Contains a bibliography.
 Lexikon der Frau. Zurich: Encyclios Verlag, 1953.
 Nunn, Pamela Gerrish. *Victorian Women Artists.* London: Women's Press, 1987.
 Wood, Christopher. *The Dictionary of Victorian Painters.* Woodbridge: Antique Collectors Club, 1978.

2780 LAPA, MARIA EDUARDA (1897–)
 Portuguese painter of flowers and still life.

Other Sources

Di Pamplona, Fernando. *Um seculo de pintura e escultura em Portugal, 1830–1930.* Porto: Livraria Tavares Martins, 1943.

2781 LASERSTEIN LOTTE (1898–1993)
 German-born figurative painter who worked in Sweden.

Main Sources

Auty, G. "Overdue Tribute." *The Spectator,* 31 October 1987, 45.
 Smyth, Caroline. "Lotte Laserstein." *The Independent,* 26 February 1993, 27. Obituary.
 Stroude, C., and A. "Lotte Laserstein and the German Naturalist Tradition." *Woman's Art Journal* 9, no. 1 (spring–summer 1988): 35–39.

Exhibitions

Meskimmon, Marsha. *Domesticity and Dissent: The Role of Women Artists in Germany 1918–1938. Haüsliches Leben und Dissens.* Leicester: Leicestershire Museums Publication no. 120, 1992.

Other Sources

Dunford, Penny. *A Biographical Dictionary of Women Artists in Europe and America since 1850.* Hemel Hempstead: Harvester Wheatsheaf and Philadelphia: University of Pennsylvania Press, 1990. Contains a bibliography.

2782 LASKER-SCHÜLER, ELSE (1869–1945)
German painter.

Exhibitions

Das Verborgene Museum. Dokumentation der Kunst von Frauen in Berliner öffentlichen Sammlungen. Berlin: Edition Hentrich, 1987.

2783 LASSEN, KÄTHE (1880–1956)
German painter of landscapes and figures, often based on Danish farming communities.

Exhibitions

Käthe Lassen. Flensburg: Stadtisches Museum, 1980.
Das Verborgene Museum. Dokumentation der Kunst von Frauen in Berliner öffentlichen Sammlungen. Berlin: Edition Hentrich, 1987.

Other Sources

Dunford, Penny. *A Biographical Dictionary of Women Artists in Europe and America since 1850.* Hemel Hempstead: Harvester Wheatsheaf and Philadelphia: University of Pennsylvania Press, 1990. Contains a bibliography.

Evers, Ulrike. *Deutsche Künstlerinnen des 20. Jahrhunderts. Malerei—Bildhauerei—Tapisserie.* Hamburg: Ludwig Schultheis Verlag, 1983. Contains an individual bibliography.

2784 LAUCKNER-THUM, ELFRIEDE (1885/6–1952)
German painter.

Exhibitions

Das Verborgene Museum. Dokumentation der Kunst von Frauen in Berliner öffentlichen Sammlungen. Berlin: Edition Hentrich, 1987.

2785 LAUENSTEIN, PAULA (1898–1980)
German painter and graphic artist who was based in Dresden and whose work often dealt with social outcasts.

Exhibitions

Meskimmon, Marsha. *Domesticity and Dissent: The Role of Women Artists in Germany 1918–1938. Haüsliches Leben und Dissens.* Leicester: Leicestershire Museums Publication no. 120, 1992.

2786 LAURENCIN, MARIE (1883–1956)
French painter who initially worked with the Cubists and who later turned to painting women and designed sets for ballet.

Main Sources

Day, George. *Marie Laurencin*. Paris: Editions du Dauphin, 1947, 57pp., illus.

Elliott, Bridget, and Jo-Ann Wallace. *Women Artists and Writers: Modernist (Im)positionings*. London: Routledge, 1994, ch. 4.

Fagan-King, J. "United on the Threshold of the Twentieth Century Mystical Ideal: Marie-Laurencin's Involvement with Apollinaire and the Inmates of the Bateau Lavoir." *Art History* 11, no. 1 (March 1988): 88–114.

Fosca, François. "Marie Laurencin." *Art et Décoration* 47 (1925): 119–122. Speaks of her art as "charming and monotonous" but mentions other contemporary writings on Laurencin.

Gere, C. *Marie Laurencin*. Paris: Flammarion, 1977, 95pp., illus.

José, Pierre. *Marie Laurencin*. Paris: Les Grands Maîtres de Notre Temps, 1988, 144pp., illus.

Marchessau, Daniel. *Marie Laurencin*. Paris: F. Hazan, 1981, 189pp., illus.

Marchessau, Daniel, and Tatsuyi Ohmori. *Marie Laurencin: Catalogue raisonné de l'oeuvre gravé*. Tokyo: Kyuryudo, 1981, 181pp., illus.

Marchessau, Daniel. *Marie Laurencin, 1883–1956. Catalogue raisonné de l'oeuvre peint*. Tokyo: Nagano-Ken Museum, 554pp., illus. Text in French. Beginning with the portraits on plates after Raphael of 1901–1902, 1334 paintings are all annotated and illustrated in this, the most complete catalogue of her work. Works which are datable are in chronological order, while others, mainly from the period 1940–1956, are arranged by subject. A list of all her solo shows and a bibliography are included.

Sandell, René. "Marie Laurencin: Cubist Muse or More?" *Woman's Art Journal* 1, no. 1 (1980): 23–27.

Verlaine, Paul-Marie. *Fêtes galantes illustrées: Marie Laurencin*. Paris: Les Peintres du Livre, 1971, 104pp., illus.

Von Wedderkop, H. *Marie Laurencin*. Leipzig: Klinkhardt und Biermann, 1921, 13pp., illus.

Exhibitions

Les femmes artistes modernes. Exposition de peintures, sculptures, 1937. Paris: Buffet & Leclerc, 1937.

Harris, Anne Sutherland, and Linda Nochlin. *Women Artists 1550–1950*. Los Angeles: County Museum of Art, 1976.

Das Verborgene Museum. Dokumentation der Kunst von Frauen in Berliner öffentlichen Sammlungen. Berlin: Edition Hentrich, 1987.

Max Jacob et les artistes de son temps. De Picasso à Dubuffet. Orléans: Musée des Beaux-Arts, 1989, 240pp., illus. This exhibitions examines Max Jacob's circle of artistic friends. Laurencin and Marevna are the only women artists included. There are detailed notes on the exhibits.

Hyland, Douglas, and Heather McPherson. *Marie Laurencin: Artist and Muse*. Birmingham, Ala.: Museum of Art in association with the University of Washington Press, 1989. Susan Maby and William Hansell Hulsey established

Birmingham as a centre for the work of Laurencin. They assembled the largest collection of her works of which they published a catalogue in 1964.

Sulter, Maud. *Echo: Works by Women Artists, 1850–1940.* Liverpool: Tate Gallery, 1991.

Other Sources

Bachmann, Donna, and Sherry Piland. *Women Artists: A Historical, Contemporary and Feminist Bibliography.* Metuchen, N.J.: Scarecrow Press, 1978.

Dunford, Penny. *A Biographical Dictionary of Women Artists in Europe and America since 1850.* Hemel Hempstead: Harvester Wheatsheaf and Philadelphia: University of Pennsylvania Press, 1990. Contains a bibliography.

Perry, Gill. *Women Artists and the Parisian Avant-Garde.* Manchester: Manchester University Press, 1995. Includes a biography and select bibliography.

2787 LA VILLETTE, ELODIE (née JACQUIER; alt. LAVILLETTE) (1843/8–after 1914)

French painter of seascapes and landscapes who exhibited extensively throughout Europe and in America.

Other Sources

Clement, Clara. *Women in the Fine Arts.* Boston: Houghton Mifflin, 1904.

Dunford, Penny. *A Biographical Dictionary of Women Artists in Europe and America since 1850.* Hemel Hempstead: Harvester Wheatsheaf and Philadelphia: University of Pennsylvania Press, 1990. Contains a bibliography.

Martin, Jules. *Nos peintres et sculpteurs, graveurs et dessinateurs.* Paris: 1897.

2788 LAZDIŅA, IRĪDA (1949–)

Latvian abstract painter.

Exhibitions

8. Baltijas Republiku Akvareļu Izstāde: Katalogs. Riga, 1989.

2789 LAZZARI, BICE (1900–1981)

Italian abstract painter.

Main Sources

G.D. "Le testimonianze di Bice Lazzari." *Domus,* September 1961, 45. Review of an exhibition at the Galleria Pater, Milan.

Exhibitions

Künstlerinnen international, 1877–1977. Berlin: Schloss Charlottenburg, 1977.

Bice Lazzari: retrospettiva. Bassano del Grappa: Palazzo Sturm, 1970.

Anni trenta: Arte e cultura in Italia. Milan: Comune di Milano in association with Mazzotta Editore, 1982.

Vergine, Lea. *L'altra metà dell'avanguardia.* Milan: Mazzotta Editore, 1980. *L'autre moitié de l'avant-garde.* Paris: Des Femmes, 1982.

Bice Lazzari: Figure dallo sfondo. Ferrara: Padiglione d'Arte Contemporanea, 1988, n.p., mainly illus. Text in Italian. The introduction examines the ideas behind her work and then includes extracts from her writings from 1929 to 1974.

Baraldi, Anna Maria, et al. *6 Biennale Donna.* Ferrara: Padiglione d'Arte Contemporanea, 1994. Includes an essay by Monica Naldi, "Bice Lazzari: dal merletto veneziano all'arte astratta."

Other Sources

Dunford, Penny. *A Biographical Dictionary of Women Artists in Europe and America since 1850.* Hemel Hempstead: Harvester Wheatsheaf and Philadelphia: University of Pennsylvania Press, 1990. Contains a bibliography.

Weller, Simone. *Il Complesso di Michelangelo: ricerca sul contributo dato dalla donna all'arte italiana del novecento.* Pollenza-Macerata: La Nuova Foglio [*sic*] Editrice, 1976.

2790 LEAPMAN, EDWINA (1934–)
English abstract painter.

Main Sources

Kent, Sarah. "Edwina Leapman at the New Art Centre." *Studio International,* March 1974, 12.

————. "Edwina Leapman." *Art Monthly,* December 1976/January 1977, 25.

Exhibitions

Hayward Annual '78. London: Hayward Gallery, 1978.

Other Sources

Dunford, Penny. *A Biographical Dictionary of Women Artists in Europe and America since 1850.* Hemel Hempstead: Harvester Wheatsheaf and Philadelphia: University of Pennsylvania Press, 1990. Contains a bibliography.

Parry-Crooke, Charlotte. *Contemporary British Artists.* London: Bergstrom and Boyle, 1979.

2791 LEBEDĪTE, RAMUNE (1940–)
Lithuanian painter.

Exhibitions

8. Baltijas Republiku Akvareļu Izstāde: Katalogs. Riga, 1989.

2792 LEHOTSKÁ, EUGENIA (1943–)
Czech painter.

Exhibitions

Obraz 69. Brno: Moravská Galerie, 1969.

2793 LEIGHTON, CLARE (née VERONICA HOPE CLARE LEIGHTON)
(1898–1989)
English graphic artist and painter who specialised in wood engraving and
illustration.

See Graphic Art section.

2794 LEIS, MALLE (1940–)
Estonian painter of figures, plants, flowers and vegetables with occasion-
al landscapes; also a graphic artist.

Main Sources

Malle Leis. Soviet Artists series. Moscow: Mezhdunarodnaya Kniga, n.d.,
8pp., illus. Consisting mainly of illustrations, this brochure contains a short text
about her work, a biographical outline and a select list of exhibitions.
Pihlak, Evi. *Malle Leis. Maal, serigrafia, akvarell: Painting, Serigraph,
Watercolour.* Tallinn: Kirjastus Kunst, 1988, 96pp., illus. Text in Estonian with
summaries in Russian and English. Discusses the subjects and techniques of the
artist. Contains a short bibliography.

Exhibitions

Bernstein, Boris. *Malle Leis: A Contemporary Estonian Artist.* Sewickley,
Penn.: International Images Ltd., 1989, 28pp., illus. Contains two useful essays, a
list of solo and group exhibitions, museum collections and a bibliography.
8. Baltijas Republiku Akvareļu Izstāde: Katalogs. Riga, 1989.

Other Sources

Enfeld, Alla, and Norton Dodge, eds. *Nonconformist Art: The Soviet
Experience, 1956–1986. The Norton and Nancy Dodge Collection.* London:
Thames and Hudson in association with the Jane Voorhees Zimmerli Art Museum,
State University of New Jersey, Rutgers, 1995.

2795 LEMAIRE, MADELEINE JEANNE (née COLLE; alt. COLL) (1845/6–
1928)
French painter of landscapes, portraits, genre and flowers; also an illus-
trator. Her daughter Suzanne (q.v.) was also a painter.

Exhibitions

La Femme: peintre et sculpteur du XVIIe au Xxe siècle. Paris: Grand Palais, 1975.

Other Sources

Clement, Clara. *Women in the Fine Arts.* Boston: Houghton Mifflin, 1904.

Dunford, Penny. *A Biographical Dictionary of Women Artists in Europe and America since 1850.* Hemel Hempstead: Harvester Wheatsheaf and Philadelphia: University of Pennsylvania Press, 1990. Contains a bibliography.

Edouard-Joseph, R. *Dictionnaire biographique des artistes contemporains, 1910–1930.* Paris: Art et Editions, 1930–1934.

Hardouin-Fugier, Elizabeth, and E. Grafe. *French Flower Painters of the Nineteenth Century: A Dictionary.* London: Philip Wilson, 1989.

Martin, Jules. *Nos peintres et sculpteurs, graveurs et dessinateurs.* Paris: 1897.

Yeldham, Charlotte. *Women Artists in Nineteenth Century France and England.* London and New York: Garland, 1984.

2796 LEMAIRE, SUZANNE (Exhibited from 1890)
French painter of flowers; daughter of Madeleine Lemaire (q.v.).

Other Sources

Hardouin-Fugier, Elizabeth, and E. Grafe. *French Flower Painters of the Nineteenth Century: A Dictionary.* London: Philip Wilson, 1989.

2797 LEMAITRE, CLAIRE (Exhibited from 1888)
French flower painter.

Other Sources

Hardouin-Fugier, Elizabeth, and E. Grafe. *French Flower Painters of the Nineteenth Century: A Dictionary.* London: Philip Wilson, 1989.

2798 LEMAÎTRE, LOUISE (Exhibited from 1878)
French flower painter.

Other Sources

Hardouin-Fugier, Elizabeth, and E. Grafe. *French Flower Painters of the Nineteenth Century: A Dictionary.* London: Philip Wilson, 1989.

2799 LEMARCHAND, ANNE (née BÉNARD) (Exhibited at the Paris Salon 1855–1877)
French painter of flowers.

Other Sources

Hardouin-Fugier, Elizabeth, and E. Grafe. *French Flower Painters of the Nineteenth Century: A Dictionary.* London: Philip Wilson, 1989.

2800 LEMBERE-BOGATKINA, VALLI (1921–)
Estonian painter.

Exhibitions

8. Baltijas Republiku Akvareļu Izstāde: Katalogs. Riga, 1989.

2801 LEPSIUS, SABINE (1864–1942)
German painter.

Exhibitions

Das Verborgene Museum. Dokumentation der Kunst von Frauen in Berliner öffentlichen Sammlungen. Berlin: Edition Hentrich, 1987.

2802 LERMONTOVA, NADEZHDA VLADIMIROVNA (1885–1921)
Russian painter and graphic artist.

Exhibitions

Avanguardia russa dalle collezioni private sovietiche origini e percorso 1904–1934. Milan: Palazzo Reale, 1989.

Other Sources

Milner, John. *A Dictionary of Russian and Soviet Artists, 1420–1970.* Woodbridge: Antique Collectors Club, 1993.

2803 LESSORE, THÉRÈSE (1884–1945)
English painter of city and rural scenes together with some theatre subjects.

Exhibitions

Thérèse Lessore Memorial Exhibition. London: Leicester Gallery, 1946. Contains a list of exhibits and a short biography.
Baron, Wendy. *The Sickert Women and the Sickert Girls.* London: Parkin Gallery, 1974.
Sellars, Jane. *Women's Works.* Liverpool: Walker Art Gallery, 1988.

Other Sources

Blunt, Wilfrid. *The Art of Botanical Illustration.* New Naturalist Series. London: Collins, 1950.

Dunford, Penny. *A Biographical Dictionary of Women Artists in Europe and America since 1850*. Hemel Hempstead: Harvester Wheatsheaf and Philadelphia: University of Pennsylvania Press, 1990. Contains a bibliography.

2804 LESZCZYNSKA-KLUZA, DANUTA (1926–)
Polish graphic artist and painter.

See Graphic Art section.

2805 LESZNAI, ANNA (1885–1966)
Hungarian painter, graphic artist and designer of embroidery who exhibited with the Eight, an avant-garde group.

Main Sources

Berény, Róbert. "Lesznai Anna." *Forum: Zeitschrift für Kunst, Bau und Einrichtung/Művészeti, építészet és építőipari folyórat* 2 (1932): 262. Text in Hungarian.
Lesznai képeskönyv. Lesznai Anna írásai, képei és hímzései. Budapest: Corvia Kiadó, n.d., 97pp., illus. Text in Hungarian. Contains a bibliography.

Exhibitions

L'Art en hongrie 1905–1930—art et révolution. St. Etienne: Musée d'Art et d'Industrie, 1980.
Willett, John, ed. *The Hungarian Avant-Garde.* London: Hayward Gallery, 1980.

Other Sources

Hárs, Éva, and Ferenc Romváry. *Modern Hungarian Gallery Pécs.* Budapest: Corvina Kiadó, 1981.
Németh, Lajos. *Modern Art in Hungary.* Budapest: Corvina Press, 1969.

2806 LEVI MONTALCINI, PAOLA (1909–)
Italian conceptual artist and abstract painter.

Exhibitions

Pasquali, Marilena. *Figure dallo sfondo.* Ferrara: Padiglione d'Arte Contemporanea and Grafis Editore, 1984.
Vescovo, Marisa. *Il Gioco delle Parti. 4 Biennale Donna.* Ferrara: Padiglione d'Arte Contemporanea, Palazzo Massari, 1990.
Baraldi, Anna Maria, et al. *6 Biennale Donna.* Ferrara: Padiglione d'Arte Contemporanea, 1994.

Other Sources

Weller, Simone. *Il Complesso di Michelangelo: ricerca sul contributo dato dalla donna all'arte italiana del novecento.* Pollenza-Macerata: La Nuova Foglio [*sic*] Editrice, 1976.

2807 LICATA-FACCIOLI, ORSOLA (Alt. FACCIOLI LICATA) (1826–?)
Italian painter of landscapes.

Other Sources

Clement, Clara. *Women in the Fine Arts.* Boston: Houghton Mifflin, 1904.
Comanducci, A. *Dizionario illustrato.* 3rd ed. Milan: 1966.
Dunford, Penny. *A Biographical Dictionary of Women Artists in Europe and America since 1850.* Hemel Hempstead: Harvester Wheatsheaf and Philadelphia: University of Pennsylvania Press, 1990. Contains a bibliography.

2808 LIEPIŅA-GRĪVA, GUNTA (1942–)
Latvian painter.

Exhibitions

8. Baltijas Republiku Akvareļu Izstāde: Katalogs. Riga, 1989.

2809 LINDBERG, HILDA
Swedish painter.

Exhibitions

Kvinnor som målat. Stockholm: Nationalmuseum, 1975.

Other Sources

Ingelman, Ingrid. *Kvinuliga konstnarer i Sverige en undersokning av Elever vid konstakademin Inskriva 1864–1924.* Uppsala: Almquist & Wiksell, 1982.

2810 LINDEGREN, AMALIA EUPHROSYNE (1814–1891)
Swedish painter of portraits and genre.

Main Sources

Bengtsson, Eva-Lena. "Amalia Lindegren: Aspects of a 19th Century Artist." *Woman's Art Journal* 5, no. 2 (fall 1984–winter 1985): 16–20.
Ingelman, Ingrid. "Women Artists in Sweden." *Woman's Art Journal* 5, no. 1 (spring–summer 1984): 1–7.

Exhibitions

Kvinnor som målat. Stockholm: Nationalmuseum, 1975.

Other Sources

Clement, Clara. *Women in the Fine Arts.* Boston: Houghton Mifflin, 1904.

Dunford, Penny. *A Biographical Dictionary of Women Artists in Europe and America since 1850.* Hemel Hempstead: Harvester Wheatsheaf and Philadelphia: University of Pennsylvania Press, 1990. Contains a bibliography.

Krichbaum, J., and R. Zondergeld. *Künstlerinnen: von der Antike bis zur Gegenwart.* Cologne: Dumont, 1979.

Lexikon der Frau. Zurich: Encyclios Verlag, 1953.

2811 LION, FLORA (1876–1958)

English painter of figures, portraits, landscapes and still life.

Exhibitions

Paintings and Drawings by Some Women War Artists. London: Imperial War Museum, 1958.

Other Sources

Dunford, Penny. *A Biographical Dictionary of Women Artists in Europe and America since 1850.* Hemel Hempstead: Harvester Wheatsheaf and Philadelphia: University of Pennsylvania Press, 1990. Contains a bibliography

Waters, Grant. *Dictionary of British Artists Working 1900–1940.* Eastbourne: Eastbourne Fine Art, 1975.

Wood, Christopher. *Dictionary of Victorian Painters.* Woodbridge: Antique Collectors Club, 1978.

2812 LITHIBY, BEATRICE ETHEL (1889–?)

English painter of landscapes and figure subjects.

Exhibitions

Paintings and Drawings by Some Women War Artists. London: Imperial War Museum, 1958.

Other Sources

Dunford, Penny. *A Biographical Dictionary of Women Artists in Europe and America since 1850.* Hemel Hempstead: Harvester Wheatsheaf and Philadelphia: University of Pennsylvania Press, 1990. Contains a bibliography.

Waters, Grant. *Dictionary of British Artists Working 1900–1940.* Eastbourne: Eastbourne Fine Art, 1975.

2813 LLOYD-JONES, MARY (1934–)

Welsh painter who works with fabric and paint.

Exhibitions

Out of Isolation. Wrexham: Library Arts Centre, 1985.

Other Sources

Dunford, Penny. *A Biographical Dictionary of Women Artists in Europe and America since 1850.* Hemel Hempstead: Harvester Wheatsheaf and Philadelphia: University of Pennsylvania Press, 1990. Contains a bibliography.

Dunthorne, Katherine. *Artists Exhibited in Wales, 1945–1974.* Cardiff: Welsh Arts Council, 1976.

2814 LOEBER, LOU (1894–1983)
Dutch painter of abstract, geometric works.

Exhibitions

Tout droit—droit au but: neuf femmes constructivistes. Paris: Institut néerlandais, 1976.

Künstlerinnen international, 1877–1977. Berlin: Schloss Charlottenburg, 1977.

Das Verborgene Museum. Dokumentation der Kunst von Frauen in Berliner öffentlichen Sammlungen. Berlin: Edition Hentrich, 1987.

Other Sources

Dunford, Penny. *A Biographical Dictionary of Women Artists in Europe and America since 1850.* Hemel Hempstead: Harvester Wheatsheaf and Philadelphia: University of Pennsylvania Press, 1990. Contains a bibliography.

2815 LOGINA, ZENTA (1908–1980)
Latvian painter and sculptor who used geometrical abstractions to convey cosmological themes.

Other Sources

Enfeld, Alla, and Norton Dodge, eds. *Nonconformist Art: The Soviet Experience, 1956–1986. The Norton and Nancy Dodge Collection.* London: Thames and Hudson in association with the Jane Voorhees Zimmerli Art Museum, State University of New Jersey, Rutgers, 1995.

2816 LOHMANN, JULIA (1951–)
German painter and graphic artist who studied with Josef Beuys.

Other Sources

Evers, Ulrike. *Deutsche Künstlerinnen des 20. Jahrhunderts. Malerei—Bildhauerei—Tapisserie.* Hamburg: Ludwig Schultheis Verlag, 1983. Contains an individual bibliography.

2817 LORENTZEN, IDA (1951–)
Norwegian hyper-realist painter.

Exhibitions

Wichstrøm, Anne. *Rooms with a View: Women's Art in Norway, 1880–1990.*
Oslo: Ministry of Foreign Affairs, 1989.
Fisher, Susan Sterling, Anne Wichstrøm, and Toril Smit. *At Century's End:*
Norwegian Artists and the Figurative Tradition, 1880–1990. Høvikodden: Henie-
Onstad Art Centre, 1995. Includes a list of exhibitions and an individual bibliog-
raphy.

2818 LOUISE CAROLINE ALBERTA (PRINCESS) (Alt. DUCHESS OF
ARGYLL) (1848–1939)
English sculptor and watercolour painter.

See Sculpture section.

2819 LOUISE, QUEEN OF THE BELGIANS (née LOUISE THÉRÈSE CARO-
LINE ELISABETH D'ORLEANS) (1812–1850)
French painter of flowers who persisted at drawing lessons and achieved
a professional standard.

Other Sources

Hardouin-Fugier, Elizabeth. *The Pupils of Redouté.* Leigh-on-Sea: F. Lewis,
1981.

2820 LOWENSBURG, VERENA (1912–)
Swiss painter of abstract, geometrical works.

Exhibitions

Vergine, Lea. *L'altra metà dell'avanguardia.* Milan: Mazzotta Editore, 1980.
L'autre moitié de l'avant-garde. Paris: Des Femmes, 1982.
Künstlerinnen des 20. Jahrhunderts. Wiesbaden: Museum Wiesbaden in asso-
ciation with Verlag Weber & Weidermeyer GmbH, Kassel, 1990.

Other Sources

Dunford, Penny. *A Biographical Dictionary of Women Artists in Europe and*
America since 1850. Hemel Hempstead: Harvester Wheatsheaf and Philadelphia:
University of Pennsylvania Press, 1990. Contains a bibliography.

2821 LOW, BET (1924–)
Scottish painter of semi-abstract landscapes in which concerns with trans-
parency, reflection and the qualities of light and water are investigated.

Exhibitions

Oliver, Cordelia. *Bet Low: Paintings and Drawings 1945–1985.* Glasgow: Third Eye Centre, 1985, 28pp., illus. Contains a list of her group and solo exhibitions from 1946 and an essay on Low and Scottish landscape.

Other Sources

Dunford, Penny. *A Biographical Dictionary of Women Artists in Europe and America since 1850.* Hemel Hempstead: Harvester Wheatsheaf and Philadelphia: University of Pennsylvania Press, 1990. Contains a bibliography.

2822 LUCANDER, ANITRA MARIA INGEBORG (1918–)
Finnish painter and graphic artist of atmospheric abstractions.

Other Sources

Boulton-Smith, J. *Modern Finnish Painting.* London: 1970.
Dunford, Penny. *A Biographical Dictionary of Women Artists in Europe and America since 1850.* Hemel Hempstead: Harvester Wheatsheaf and Philadelphia: University of Pennsylvania Press, 1990. Contains a bibliography.

2823 LUISE, PRINCESS OF PRUSSIA (1799–1882)
German painter.

Exhibitions

Das Verborgene Museum. Dokumentation der Kunst von Frauen in Berliner öffentlichen Sammlungen. Berlin: Edition Hentrich, 1987.

2824 LUKSCH-MAKOWSKAIA, ELENA (Alt. MAKOWSKY) (1878–1967)
Russian sculptor and painter who worked in Austria after her marriage in 1900 and later in Germany.

See Sculpture section.

2825 LUMB, EDNA (1931–)
English painter of industrial scenes.

Main Sources

Ince, Martin. "Sweat and Tears in a Bijou Residence." *Times Higher Education Supplement,* 31 January 1992. Review of the the retrospective exhibition of this distinguished industrial artist.

2826 LUNDGREN, TYRA (1897–1979)
Swedish painter, sculptor and designer of ceramics.

See Sculpture section.

2827 LUOSTARINEN, LEENA (1949–)
Finnish painter.

Exhibitions

Akt 83: suomalaista nykytaidetta. Helsinki: Ateneum, 1983.

2828 LŪSE, IRĒNA (1948–)
Latvian painter.

Other Sources

Šmagre, Rita. *Latviešu Pastelis. Latvian Pastel Painting.* Riga: Liesma, 1990. Includes a brief account of her career.

2829 LYDIS, MARIETTA (née RONSPERGER) (1894–?)
Austrian-born painter and graphic artist who worked in France.

Exhibitions

Marietta Lydis. London: Leicester Gallery, 1935. Contains a list of exhibits and a brief biography.

Other Sources

Dunford, Penny. *A Biographical Dictionary of Women Artists in Europe and America since 1850.* Hemel Hempstead: Harvester Wheatsheaf and Philadelphia: University of Pennsylvania Press, 1990. Contains a bibliography.
Edouard-Joseph, R. *Dictionnaire biographique des artistes contemporains, 1910–1930.* Paris: Art et Editions, 1930–1934.
Lucie-Smith, Edward. *Art Deco Painting.* Oxford: Phaidon. 1990.

2830 MacGREGOR, JESSIE (1846/7–1919)
English painter of historical and genre scnes.

Exhibitions

Sellars, Jane. *Women's Works.* Liverpool: Walker Art Gallery, 1988.

Other Sources

Clement, Clara. *Women in the Fine Arts.* Boston: Houghton Mifflin, 1904.
Dunford, Penny. *A Biographical Dictionary of Women Artists in Europe and America since 1850.* Hemel Hempstead: Harvester Wheatsheaf and Philadelphia: University of Pennsylvania Press, 1990. Contains a bibliography.
Nunn, Pamela Gerrish. *Victorian Women Artists.* London: Women's Press, 1987.
Waters, Grant. *Dictionary of British Artists Working 1900–1940.* Eastbourne: Eastbourne Fine Art, 1975.

Yeldham, Charlotte. *Women Artists in Nineteenth Century France and England.* London and New York: Garland, 1984.

2831 MacIAN, FANNY (née FRANCES MATHILDA WHITAKER) (1814–1897)

English painter of historical, literary and genre scenes who ran the Female School of Art in London.

Main Sources

"The Female School of Design in the Capital of the World." *Household Words* 51 (15 March 1851): 577–581. Describes a visit made by the author to the School, on which Fanny MacIan conducted him. Despite a sceptical attitude on his arrival, he was impressed with MacIan and the work which he saw by the students. Callen, Anthea. *The Angel in the Studio.* London: Architectural Press, 1979.

Exhibitions

Women's Art Show, 1550–1970. Nottingham: Castle Museum, 1982. Contains a brief biography.

Cherry, Deborah. *Painting Women: Victorian Women Artists.* Rochdale: Art Gallery, 1987.

Other Sources

Dunford, Penny. *A Biographical Dictionary of Women Artists in Europe and America since 1850.* Hemel Hempstead: Harvester Wheatsheaf and Philadelphia: University of Pennsylvania Press, 1990. Contains a bibliography.

Nunn, Pamela Gerrish. *Victorian Women Artists.* London: Women's Press, 1987.

Wood, Christopher. *The Dictionary of Victorian Painters.* Woodbridge: Antique Collectors Club, 1978.

Yeldham, Charlotte. *Women Artists in Nineteenth Century France and England.* London and New York: Garland, 1984.

2832 MacNICOL, BESSIE (1869–1908)

Scottish painter of figures.

Exhibitions

Burkhauser, Jude. *Glasgow Girls: Women in Art and Design 1880–1920.* Edinburgh: Canongate, 1990.

2833 MADDEN, ANNE (Alt. LE BROCQUY) (1932–)

English-born painter, sculptor and graphic artist who moved to Ireland as a child.

See Sculpture section.

2834 MAMMEN, JEANNE (1890–1976)
German painter and graphic artist who depicted Berlin society in the 1920s.

Main Sources

Sykora, Katharina. "Jeanne Mammen." *Woman's Art Journal* 9, no. 2 (fall 1988–winter 1989): 28–31.

Exhibitions

Künstlerinnen international, 1877–1977. Berlin: Schloss Charlottenburg, 1977.
Vergine, Lea. *L'altra metà dell'avanguardia.* Milan: Mazzotta Editore, 1980. *L'autre moitié de l'avant-garde.* Paris: Des Femmes, 1982.
Das Verborgene Museum. Dokumentation der Kunst von Frauen in Berliner öffentlichen Sammlungen. Berlin: Edition Hentrich, 1987.
Meskimmon, Marsha. *Domesticity and Dissent: The Role of Women Artists in Germany 1918–1938. Haüsliches Leben und Dissens.* Leicester: Leicestershire Museums Publication no. 120, 1992.

Other Sources

Dunford, Penny. *A Biographical Dictionary of Women Artists in Europe and America since 1850.* Hemel Hempstead: Harvester Wheatsheaf and Philadelphia: University of Pennsylvania Press, 1990. Contains a bibliography.

2835 MANCUSO, MARIA (1891–1977)
Italian painter who became one of the most significant artists in Rome in the 1920s.

Exhibitions

Baraldi, Anna Maria, et al. *6 Biennale Donna.* Ferrara: Padiglione d'Arte Contemporanea, 1994.

Other Sources

Weller, Simone. *Il Complesso di Michelangelo: ricerca sul contributo dato dalla donna all'arte italiana del novecento.* Pollenza-Macerata: La Nuova Foglio [*sic*] Editrice, 1976.

2836 MANDELBAUM, GERTRUD (1935–)
Dutch abstract painter.

Exhibitions

De Vrouw in de kunst. Leiden: Pand Caecilia, 1987.

2837 MANGILLANI, ADA (1863–?)
Italian painter of mythological, religious and historical subjects.

Other Sources

Clement, Clara. *Women in the Fine Arts.* Boston: Houghton Mifflin, 1904.
Comanducci, A. *Dizionario illustrato dei pittori italiani moderni e contemporanei.* 3rd ed. Milan: Patuzzi, 1966.
Dunford, Penny. *A Biographical Dictionary of Women Artists in Europe and America since 1850.* Hemel Hempstead: Harvester Wheatsheaf and Philadelphia: University of Pennsylvania Press, 1990. Contains a bibliography.

2838 MANNER, MARIANA (1943–)
Swedish graphic artist, painter and sculptor.

See Graphic Art section.

2839 MARCHESINI, NELLA (1901–1953)
Italian painter.

Exhibitions

Baraldi, Anna Maria, et al. *6 Biennale Donna.* Ferrara: Padiglione d'Arte Contemporanea, 1994.

2840 MARC, MARIA (née FRANCK) (1877–1955)
German painter and designer of textiles.

Main Sources

Behr, Shulamith. "Comparative Issues of Marginality." *Women's Art Magazine* 69 (1996): 18–20.

2841 MAREVNA (Alt. MAREA MAREVNA; pseudonym of MARIA VOROBI-EFF) (1892–1983/4)
Russian-born figurative painter whose style was influenced by Cubism and who worked in France.

Publications

Life with the Painters of La Ruche. London: Constable, 1972. Autobiography of her years in Paris.

Main Sources

Irving, Anne. "Marevna." *Women's Art Magazine* 39 (1991): 9.

Exhibitions

Marevna. Geneva: Petit Palais, 1971, n.p., illus. Contains a short essay which describes her life and work.

Vergine, Lea. *L'altra metà dell'avanguardia*. Milan: Mazzotta Editore, 1980. *L'autre moitié de l'avant-garde*. Paris: Des Femmes, 1982.

Dufresne, Jean-Luc, and Olivier Messac, eds. *Femmes créatrices des années vingt*. Granville: Musée Richard Anacréon, 1988. Wide-ranging catalogue with a short biographical account on each woman included.

Marevna: Paintings and Works on Paper, 1915–1975. London: England and Co., 1989, 8pp., illus. Includes a chronology.

Max Jacob et les artistes de son temps. De Picasso à Dubuffet. Orléans: Musée des Beaux-Arts, 1989, 240pp., illus. This exhibitions examines Max Jacob's circle of artistic friends. Laurencin and Marevna are the only women artists included. There are detailed notes on the exhibits.

Other Sources

Dunford, Penny. *A Biographical Dictionary of Women Artists in Europe and America since 1850*. Hemel Hempstead: Harvester Wheatsheaf and Philadelphia: University of Pennsylvania Press, 1990. Contains a bibliography.

Perry, Gill. *Women Artists and the Parisian Avant-Garde*. Manchester: Manchester University Press, 1995. Includes a biography and select bibliography.

2842 MARGITSON, MARIA (1832–1896)

English painter of flowers and still lifes who lived in Norfolk.

Other sources

Day, Harold. *East Anglian Painters,* 2:234. Eastbourne: Sumfield and Day Ltd., 1968.

2843 MARLEF, CLAUDE (Pseudonym of MARTHE LEFEBVRE; née ANDREA JOSÉPHINE BOYER) (1864–after 1922)

French painter of portraits and mythological subjects.

Other Sources

Clement, Clara. *Women in the Fine Arts*. Boston: Houghton Mifflin, 1904.

Dunford, Penny. *A Biographical Dictionary of Women Artists in Europe and America since 1850*. Hemel Hempstead: Harvester Wheatsheaf and Philadelphia: University of Pennsylvania Press, 1990. Contains a bibliography.

Edouard-Joseph, R. *Dictionnaire biographique des artistes contemporains, 1910–1930*. Paris: Art et Editions, 1930–1934.

2844 MARRABLE, MADELINE [*sic*] FRANCES (née COCKBURN) (1833/4–1916)

Anglo-Scottish painter of landscapes, figures and portraits; first president of the Society of Women Artists in London.

Main Sources

Clayton, Ellen. *English Female Artists*. London: Tinsley, 1876.

Other Sources

Dunford, Penny. *A Biographical Dictionary of Women Artists in Europe and America since 1850*. Hemel Hempstead: Harvester Wheatsheaf and Philadelphia: University of Pennsylvania Press, 1990. Contains a bibliography.

Mallalieu, Hugh. *Dictionary of British Watercolour Artists*. Woodbridge: Antique Collectors Club, 1976.

2845 MARSEEN, ULRIKE (1912–)
Danish sculptor, painter and critic.

See Sculpture section.

2846 MARVAL, JACQUELINE (Pseudonym of MARIE JOSÉPHINE VALLET) (1866–1932)
French painter of figures, especially female, in a freely handled style with bright colouring.

Exhibitions

Jacqueline Marval: A Retrospective Exhibition. London: Crane Gallery, 1989, 32pp., illus. Short introductory essay with a chronology. Illustrations include works from different periods of her life and photographs.

Dufresne, Jean-Luc, and Olivier Messac, eds. *Femmes créatrices des années vingt*. Granville: Musée Richard Anacréon, 1988. Wide-ranging catalogue with a short biographical account on each woman included.

Other Sources

Dunford, Penny. *A Biographical Dictionary of Women Artists in Europe and America since 1850*. Hemel Hempstead: Harvester Wheatsheaf and Philadelphia: University of Pennsylvania Press, 1990. Contains a bibliography.

Edouard-Joseph, R. *Dictionnaire biographique des artistes contemporains, 1910–1930*. Paris: Art et Editions, 1930–1934.

Perry, Gill. *Women Artists and the Parisian Avant-Garde*. Manchester: Manchester University Press, 1995. Includes a biography and select bibliography.

2847 MASELLI, TITINA (1924–)
Italian painter.

Exhibitions

Pasquali, Marilena. *Figure dallo sfondo*. Ferrara: Padiglione d'Arte Contemporanea and Grafis Editore, 1984.

Vescovo, Marisa. *Il Gioco delle Parti. 4 Biennale Donna.* Ferrara: Padiglione d'Arte Contemporanea, Palazzo Massari, 1990.

Other Sources

Weller, Simone. *Il Complesso di Michelangelo: ricerca sul contributo dato dalla donna all'arte italiana del novecento.* Pollenza-Macerata: La Nuova Foglio [*sic*] Editrice, 1976.

2848 MASTERKOVA, LYDIA (1929–)
Russian painter.

Other Sources

Enfeld, Alla, and Norton Dodge, eds. *Nonconformist Art: The Soviet Experience, 1956–1986. The Norton and Nancy Dodge Collection.* London: Thames and Hudson in association with the Jane Voorhees Zimmerli Art Museum, State University of New Jersey, Rutgers, 1995.

2849 MATTON, IDA (1863–1940)
Swedish sculptor, medallist, landscape painter and graphic artist.

See Sculpture section.

2850 MAURER, DÓRA (1937–)
Hungarian abstract painter.

Other Sources

Hárs, Éva, and Ferenc Romváry. *Modern Hungarian Gallery Pécs.* Budapest: Corvina Kiadó, 1981.

2851 MAYER, CONSTANCE (née MARIE FRANÇOISE M. LA MARTINIÈRE MAYER) (1775/8–1821)
French painter of genre, portraits, allegorical subjects and miniatures.

Main Sources

Doin, Jeanne. "Constance Mayer, 1775–1821." *La Revue de l'Art* 29 (1911): 49–60. Offers a reassessment of her work, believing her to have been underestimated.
Gueullette, Charles. "Mademoiselle Constance Mayer et Prud'hon." *Gazette des Beaux-Arts,* 1879, 476–490.

Exhibitions

Harris, Anne Sutherland, and Linda Nochlin. *Women Artists 1550–1950.* Los Angeles: County Museum of Art, 1976.

693

Beaulieu, Germaine, et al. *La femme artiste d'Elisabeth Vigée-Lebrun à Rosa Bonheur*. Lacoste: Musée Despiau-Wlerick et Dubalen Mont-de-Marsan, 1981. Includes a bibliography.

Other Sources

Bachmann, Donna, and Sherry Piland. *Women Artists: A Historical, Contemporary and Feminist Bibliography*. Metuchen, N.J.: Scarecrow Press, 1978.

Clement, Clara. *Women in the Fine Arts*. Boston: Houghton Mifflin, 1904.

Sparrow, Walter Shaw. *Women Painters of the World*. London: Hodder and Stoughton, 1905.

2852 McEVOY, MARY SPENCER (née EDWARDS) (1870–1941)
English painter of portraits, still lifes and interiors.

Exhibitions

Sulter, Maud. *Echo: Works by Women Artists, 1850–1940*. Liverpool: Tate Gallery, 1991.

Other Sources

Dunford, Penny. *A Biographical Dictionary of Women Artists in Europe and America since 1850*. Hemel Hempstead: Harvester Wheatsheaf and Philadelphia: University of Pennsylvania Press, 1990. Contains a bibliography.

Waters, Grant. *Dictionary of British Artists Working 1900–1940*. Eastbourne: Eastbourne Fine Art, 1975.

Wood, Christopher. *The Dictionary of Victorian Painters*. Woodbridge: Antique Collectors Club, 1978.

2853 McGUINNESS, NORAH (1903–1980)
Irish painter of Cubist landscapes and figures and promoter of modernist art in Ireland.

Exhibitions

Irish Women Artists from the Eighteenth Century to the Present Day. Dublin: National Gallery of Ireland, Douglas Hyde Gallery and Hugh Lane Gallery, 1987.

Other Sources

De Breffny, Brian, ed. *Ireland: A Cultural Encyclopaedia*. London: Thames and Hudson, 1983.

Dunford, Penny. *A Biographical Dictionary of Women Artists in Europe and America since 1850*. Hemel Hempstead: Harvester Wheatsheaf and Philadelphia: University of Pennsylvania Press, 1990. Contains a bibliography.

2854 MEDVECKÁ, MÁRIA
Czechoslovakian painter.

Other Sources

Lamač, Miroslav. *Contemporary Art in Czechoslovakia.* Prague: Orbis, 1958.

2855 MEE, ANNE (née FOLDSTONE) (c. 1770/5–1851)
English painter of miniatures who received royal patronage in the 1790s and who continued to work and exhibit despite having six children.

Other Sources

Foskett, Daphne. *Miniatures: A Dictionary and Guide.* Woodbridge: Antique Collectors Club, 1987.

2856 MEE, MARGARET
English botanical painter.

Publications

Morrison, Tony, ed. *Margaret Mee: In Search of Flowers of the Amazon Forests.* Woodbridge: Nonesuch expeditions, 1988, 302pp., illus. Extracts from Mee's diaries taken from over thirty years of expeditions to the Amazon rainforests.

2857 MELLAND, SYLVIA (1906–)
English painter who was active in the Artists' International Assocation and had links with the Euston Road School.

Exhibitions

Deepwell, Katy. *Ten Decades: Careers of Ten Women Artists born 1897–1906.* Norwich: Norwich Gallery, Norfolk Institute of Art and Design, 1992.

2858 MELLIS, MARGARET (1914–)
Scottish painter and, later, sculptor of reliefs.

Exhibitions

Cornwall 1945–1955. London: New Art Centre, 1977.
Women's Art Show, 1550–1970. Nottingham: Castle Museum, 1982. Contains a brief biography.
Margaret Mellis: A Retrospective Exhibition, 1940–1987. Constructions in Wood and Paintings. London: Redfern Gallery, 1987. Contains a short introduction, lists of her solo and some group exhibitions and an outline biography.

Other Sources

Dunford, Penny. *A Biographical Dictionary of Women Artists in Europe and America since 1850.* Hemel Hempstead: Harvester Wheatsheaf and Philadelphia: University of Pennsylvania Press, 1990. Contains a bibliography.

2859 MENASSADE, EMILIA
Spanish painter of still lifes.

Other Sources

Diego, Estrella de. *La mujer y la pintura del XIX español: cuatrocientes olvidadas y algunas más.* Madrid: Cátedra, 1987.
Ossorio y Barnard, Manuel. *Galería biográfica de arteas españoles del siglo XIX.* Madrid: Moreno y Royas, 1883.

2860 MENEZ (Pseudonym of MARIA INEZ RIBEIRO DA FONSECA) (1926–)
Portuguese painter in whose work is integrated the native tile tradition.

Exhibitions

Art portugais contemporain. Paris: Musée d'Art Moderne de la Ville de Paris, 1976.
Waves of Influence: cinco séculos do azulejo português. Staten Island, N.Y.: Snug Harbour Cultural Center, 1995.

2861 MERRITT, ANNA (née LEA) (1844–1930)
American painter of allegorical, literary and genre figure subjects who worked in England.

Publications

"A Letter to Artists, Especially Women Artists." *Lippincott's Monthly Magazine* 65 (1900): 466.

Exhibitions

Cherry, Deborah. *Painting Women: Victorian Women Artists.* Rochdale: Art Gallery, 1987
Sulter, Maud. *Echo: Works by Women Artists, 1850–1940.* Liverpool: Tate Gallery, 1991.
Casteras, Susan, and Linda H. Peterson. *A Struggle for Fame: Victorian Women Artists and Authors.* New Haven: Yale Center for British Art, 1994.

Other Sources

Cherry, Deborah. *Painting Women: Victorian Women Artists.* London: Routledge, 1993.
Dunford, Penny. *A Biographical Dictionary of Women Artists in Europe and*

America since 1850. Hemel Hempstead: Harvester Wheatsheaf and Philadelphia: University of Pennsylvania Press, 1990. Contains a bibliography.

Nunn, Pamela Gerrish. *Canvassing.* London: Camden Press, 1986.

Nunn, Pamela Gerrish. *Victorian Women Artists.* London: Women's Press, 1987.

Rubinstein, Charlotte Streifer. *American Women Artists from Early Indian Times to the Present Day.* Boston: G.K. Hall, 1982.

Sparrow, Walter Shaw. *Women Painters of the World.* London: Hodder and Stoughton, 1905.

Wood, Christopher. *The Dictionary of Victorian Painters.* Woodbridge: Antique Collectors Club, 1978.

2862 MESDAG-VAN HOUTEN, SIENTJE (1834–1909)
Dutch painter.

Exhibitions

Oele, Anneke, Mirian van Rijsingen, and Hesther van den Donk. *Bloemen uit de kelder: negen kunstnaressen rond de eeuwwisseling.* Arnhem: Gemeentemuseum, 1989.

2863 MEYER, HILDE (1910–1973)
German painter of portraits, self-portraits and figures who worked in a Neue Sachlichkeit style in the late 1920s.

Other Sources

Evers, Ulrike. *Deutsche Künstlerinnen des 20. Jahrhunderts. Malerei—Bildhauerei—Tapisserie.* Hamburg: Ludwig Schultheis Verlag, 1983. Contains an individual bibliography.

2864 MEZEROVÁ, JULIE W. (1893–?)
Czech painter of flowers and figure subjects.

Other Sources

Dunford, Penny. *A Biographical Dictionary of Women Artists in Europe and America since 1850.* Hemel Hempstead: Harvester Wheatsheaf and Philadelphia: University of Pennsylvania Press, 1990. Contains a bibliography.

Edouard-Joseph, R. *Dictionnaire biographique des artistes contemporains, 1910–1930.* Paris: Art et Editions, 1930–1934.

2865 MILDAŽĪTE-KULIKAUSKIENE, MILDA (1937–)
Lithuanian painter.

Exhibitions

8. Baltijas Republiku Akvareļu Izstāde: Katalogs. Riga, 1989.

2866 MILROY, LISA (1959–)
Canadian-born painter of sets of everyday objects who works in England.

Main Sources

Mottram, Judith. "Where Are You Going My Lovely?" *Women's Art Magazine* 66 (September–October 1995): 26. Exhibition review.

Exhibitions

Current Affairs: British Painting and Sculpture in the 1980s. Oxford: Museum of Modern Art, 1987.

British Art Now: A Subjective View. Setagaya, Japan: Setagaya Art Museum in association with the British Council, 1990. Includes a list of group and solo exhibitions together with a select bibliography.

Other Sources

Dunford, Penny. *A Biographical Dictionary of Women Artists in Europe and America since 1850.* Hemel Hempstead: Harvester Wheatsheaf and Philadelphia: University of Pennsylvania Press, 1990. Contains a bibliography.

2867 MIRET Y GONZALES, ENRIQUETA
Spanish painter of flowers who exhibited from 1876.

Other Sources

Diego, Estrella de. *La mujer y la pintura del XIX español: cuatrocientes olvidadas y algunas más.* Madrid: Cátedra, 1987.

Ossorio y Barnard, Manuel. *Galería biográfica de artieas españoles del siglo XIX.* Madrid: Moreno y Royas, 1883.

2868 MIRRI, SABINA (1957–)
Italian painter of earthy landscapes with disquieting atmospheres.

Exhibitions

Eiblmayr, Silvia, Valie Export, and Monika Prischl-Maier. *Kunst mit Eigen-Sinn. Aktuelle Kunst von Frauen: Texte und Dokumentation.* Vienna: Locker Verlag in association with the Museum of Modern Art and Museum of 20th Century Art, 1985.

Fox, Howard. *A New Romanticism: Sixteen Artists from Italy.* Washington, D.C.: Hirschhorn Museum and Sculpture Garden, 1986. Contains a bibliography.

Vedute romane: Myriam Laplante, Susanna Sartarelli, Sabina Mirri, Patrizia Cantalupo. Vancouver: Charles H. Scott Gallery, Emily Carr College of Art and Design, 1989.

2869 MODERSOHN-BECKER, PAULA (née BECKER) (1876–1907)
German Expressionist painter of figures, especially women, in rural settings.

Main Sources

Jahn, Beata. *Paula Modersohn-Becker: Briefe und Aufzeichnungen.* Leipzig and Weimar: Gustav Kiepenheuer Verlag, 1982, 405pp., illus. The artist's letters and notes are organised into chronological groups. There are also accounts and memoirs of Becker written by those who knew her, including Clara Westhoff. An initial essay sets Becker's writings in context.

Oppler, E. "Paula Modersohn-Becker: Some Facts and Legends." *Art Journal* 35 (summer 1976): 346–369.

Perry, Gillian. *Paula Modersohn-Becker.* London: Women's Press, 1979, 149pp., illus. Offering more than a biographical account, this book analyses her work by subject matter within the social and political context of the time. Contains a selective bibliography which includes material in German.

Exhibitions

Harris, Anne Sutherland, and Linda Nochlin. *Women Artists 1550–1950.* Los Angeles: County Museum of Art, 1976.

Künstlerinnen international, 1877–1977. Berlin: Schloss Charlottenburg, 1977 (as Becker-Modersohn).

Das Verborgene Museum. Dokumentation der Kunst von Frauen in Berliner öffentlichen Sammlungen. Berlin: Edition Hentrich, 1987.

Other Sources

Bachmann, Donna, and Sherry Piland. *Women Artists: A Historical, Contemporary and Feminist Bibliography.* Metuchen, N.J.: Scarecrow Press, 1978.

Behr, Shulamith. *Women Expressionists.* Oxford: Phaidon, 1988.

Betterton, Rosemary. *Intimate Distance: Women, Artists and the Body.* London: Routledge, 1996.

Dunford, Penny. *A Biographical Dictionary of Women Artists in Europe and America since 1850.* Hemel Hempstead: Harvester Wheatsheaf and Philadelphia: University of Pennsylvania Press, 1990. Contains a bibliography.

Evers, Ulrike. *Deutsche Künstlerinnen des 20. Jahrhunderts. Malerei—Bildhauerei—Tapisserie.* Hamburg: Ludwig Schultheis Verlag, 1983. Contains an extensive individual bibliography.

Radycki, D. "The Life of Lady Art Students: Changing Art Education at the Turn of the Century." *Art Journal* 42 (spring 1982): 9–13.

Tufts, Eleanor. *Our Hidden Heritage: Five Centuries of Women Artists.* New York and London: Paddington Press, 1974.

2870 MODOK, MÁRIA (1896–)
Hungarian painter.

Other Sources

Németh, Lajos. *Modern Art in Hungary.* Budapest: Corvina Press, 1969.

2871 MOLL, MARG (née MARGARETHE HAEFFNER) (1884–1977)
German painter and sculptor.

See Sculpture section.

2872 MONGEZ, ANGÉLIQUE (née MARIE JOSÉPHINE A. LEVOL)
(1775–1855)
French history painter.

Main Sources

Doy, Gen. "What Do You Say When You're Looking? Women as Makers and Viewers in Early Modern France." *Women's Art Magazine* 70 (1996): 10–15. Considerable attention is given to Mongez in this article.

Exhibitions

Beaulieu, Germaine, et al. *La femme artiste d'Elisabeth Vigée-Lebrun à Rosa Bonheur.* Lacoste: Musée Despiau-Wlerick et Dubalen Mont-de-Marsan, 1981. Includes a bibliography.

2873 MONTALBA, CLARA (1840/2–1929)
English painter of landscapes, particularly in watercolour, often with a slightly melancholy air; sister of Ellen, Henrietta and Hilda Montalba (qq.v.).

Main Sources

"Clara Montalba." *Connoisseur* 84 (1929): 263. Obituary.
Clayton, Ellen. *English Female Artists.* London: Tinsley, 1876.
Leroi, Paul. "Silhouettes d'Artistes Contemporains: xvii Miss Clara Montalba." *L'Art* 30 (1882): 207–213.

Exhibitions

Women's Art Show, 1550–1970. Nottingham: Castle Museum, 1982. Contains a brief biography.

Other Sources

Clement, Clara. *Women in the Fine Arts.* Boston: Houghton Mifflin, 1904.
Dunford, Penny. *A Biographical Dictionary of Women Artists in Europe and America since 1850.* Hemel Hempstead: Harvester Wheatsheaf and Philadelphia: University of Pennsylvania Press, 1990. Contains a bibliography.
Lexikon der Frau. Zurich: Encyclios Verlag, 1953.
Nunn, Pamela Gerrish. *Victorian Women Artists.* London: Women's Press, 1987.

Wood, Christopher. *The Dictionary of Victorian Painters.* Woodbridge: Antique Collectors Club, 1978.

2874 MONTALBA, ELLEN (c. 1846–after 1902)
English painter of landscapes, genre and portraits; sister of Clara, Henrietta and Hilda.

Main Sources

See under Clara Montalba.

2875 MONTALBA, HENRIETTA SKERRET (1856–1893)
English sculptor and painter of portraits and genre; sister of Clara, Ellen and Hilda Montalba.

See Sculpture section.

2876 MONTALBA, HILDA (1844/54–1919)
English painter of landscapes and genre; sister of Clara, Ellen and Henrietta Montalba.

Main Sources

See under Clara Montalba.

2877 MONTESSORI, ELISA (1931–)
Italian painter.

Exhibitions

Pasquali, Marilena. *Figure dallo sfondo.* Ferrara: Padiglione d'Arte Contemporanea and Grafis Editore, 1984.
Vescovo, Marisa. *Il Gioco delle Parti. 4 Biennale Donna.* Ferrara: Padiglione d'Arte Contemporanea, Palazzo Massari, 1990.

Other Sources

Weller, Simone. *Il Complesso di Michelangelo: ricerca sul contributo dato dalla donna all'arte italiana del novecento.* Pollenza-Macerata: La Nuova Foglio [*sic*] Editrice, 1976.

2878 MONTIGNY, JENNY (1875–1937)
Belgian luminist painter of landscapes, portraits and still life.

Exhibitions

Polden, Sarah. *A Clear View: The Belgian Luminist Tradition.* London: Whitford and Hughes Gallery, 1987.

Other Sources

Dictionnaire des Peintres Belges du XIVe siècle à nos jours. Brussels: La Renaissance du Livre, 1995.

Dunford, Penny. *A Biographical Dictionary of Women Artists in Europe and America since 1850.* Hemel Hempstead: Harvester Wheatsheaf and Philadelphia: University of Pennsylvania Press, 1990. Contains a bibliography.

Sparrow, Walter Shaw. *Women Painters of the World.* London: Hodder and Stoughton, 1905.

2879 MOORE, ELEANOR ALLEN (1885–1955)
Scottish painter.

Exhibitions

Burkhauser, Jude. *Glasgow Girls: Women in Art and Design 1880–1920.* Edinburgh: Canongate, 1990.

2880 MORAIS, GRAÇA (1948–)
Portuguese painter who also designed tiles.

Exhibitions

Waves of Influence: cinco séculos do azulejo português. Staten Island, N.Y.: Snug Harbour Cultural Center, 1995.

2881 MOREL, HENRIETTE (1884–1956)
French painter of portraits, nudes, a few landscapes and flowers.

Other Sources

Hardouin-Fugier, Elizabeth, and Etienne Grafe. *The Lyon School of Flower Painting.* Leigh-on-Sea: F. Lewis, 1978, 88pp., illus.

2882 MORENO, MARIA (1933–)
Spanish realist painter.

Other Sources

Dunford, Penny. *A Biographical Dictionary of Women Artists in Europe and America since 1850.* Hemel Hempstead: Harvester Wheatsheaf and Philadelphia: University of Pennsylvania Press, 1990. Contains a bibliography.

Krichbaum, J., and R. Zondergeld. *Künstlerinnen: von der Antike bis zur Gegenwart.* Cologne: DuMont, 1979.

2883 MORISOT, BERTHE (1841–1895)
French Impressionist painter.

Publications

Adler, Kathleen, and Tamar Garb. *The Correspondence of Berthe Morisot.* London: Camden Press, 1986. Rev. ed. of 1957. Trans. Denis Rouart.

Main Sources

Adler, Kathleen, and Tamar Garb. *Berthe Morisot.* Oxford: Phaidon, 1987, 161pp., 40 pl. Rigorous analysis of Morisot's art practice in her sociocultural context.

Adler, Kathleen, et al. *Perspectives on Berthe Morisot.* New York: Hudson Hills Press & Mount Holyoke College Art Museum, 1990, 120pp., illus. Based on papers given at a symposium.

Angoulvent, Monique. *Berthe Morisot.* Paris: A. Morancé, [1933?], 161pp., illus.

Fourreau, Armand. *Berthe Morisot.* Maîtres d'Art Moderne. Paris: F. Rieder, 1925, 63pp., 40 pl.

Garb, Tamar. *Women of Impressionism.* Oxford: Phaidon, 1986.

Higonnet, Anne. *Berthe Morisot: une biographie.* Paris: Adam Biro, 1989, 236pp., illus.

———. *Berthe Morisot's Images of Women.* Cambridge, Mass. and London: Harvard University Press, 1992, 311pp., 111 illus. This examines Morisot's practice as a women painter, showing how she negotiated contradictory circumstances operating in the visual culture at the time. The author argues that the second part of her career was experimental both stylistically and intellectually. The portraits of herself and her daughter allow her to deal with issues surounding the representation of women.

Kessler, Marni Reva. "Reconstructing Relationships: Berthe Morisot's Edma Series." *Woman's Art Journal* 12, no. 1 (spring–summer 1991): 24–28.

Nochlin, Linda. "Morisot's Wet Nurse: The Construction of Work and Leisure in Impressionist Painting." In *Women, Art and Power and Other Essays.* New York, 1988.

Pollock, Griselda. "Modernity and the Spaces of Femininity." In *Vision and Difference,* pp. 50–90. London: Routledge, 1988. Examines the depiction of the public and private spheres by Cassatt and Morisot in their sociocultural context and in comparison with their male contemporaries.

Shannon, Margaret. *Berthe Morisot: The First Lady of Impressionism.* Stroud: Alan Sutton, 1996.

Exhibitions

Berthe Morisot: Mme. Eugène Manet: 1841–1895. Paris: Galérie Durand-Ruel, 1896, 44pp., illus. Preface by Stéphane Mallarmé. Catalogue of memorial retrospective exhibition.

Berthe Morisot 1841–1895: malerier, akvareller og tegninger: udstilling. Carlsberg: Glyptotek, 1949, 25pp., illus.

Gauthier, Serge, and Denis Rouart. *Hommage à Berthe Morisot et à Paul-August Renoir.* Limoges: Musée Municipal, 1952, 47pp., illus.

Künstlerinnen international, 1877–1977. Berlin: Schloss Charlottenburg, 1977.

Stuckey, C., and W. Scott. *Berthe Morisot: Impressionist.* Washington, D.C.: National Gallery of Art in association the Hudon Hills Press, New York, 1987, 228pp., illus.

Other Sources

Bachmann, Donna, and Sherry Piland. *Women Artists: A Historical, Contemporary and Feminist Bibliography.* Metuchen, N.J.: Scarecrow Press, 1978.

Bunoust, Madeleine. *Quelques Femmes Peintres.* Paris: Librairie Stock, 1936.

Dunford, Penny. *A Biographical Dictionary of Women Artists in Europe and America since 1850.* Hemel Hempstead: Harvester Wheatsheaf and Philadelphia: University of Pennsylvania Press, 1990. Contains a bibliography.

Yeldham, Charlotte. *Women Artists in Nineteenth Century France and England.* London and New York: Garland, 1984.

2884 MORI, MARISA (1900–1985)
Italian painter, for a time associated with the Futurists.

Main Sources

Katz, B. "The Women of Futurism." *Woman's Art Journal* 7, no. 2 (fall 1986–winter 1987): 3–13.

Exhibitions

Vergine, Lea. *L'altra metà dell'avanguardia.* Milan: Mazzotta Editore, 1980. *L'autre moitié de l'avant-garde.* Paris: Des Femmes, 1982.

Baraldi, Anna Maria, et al. *6 Biennale Donna.* Ferrara: Padiglione d'Arte Contemporanea, 1994.

Other Sources

Dunford, Penny. *A Biographical Dictionary of Women Artists in Europe and America since 1850.* Hemel Hempstead: Harvester Wheatsheaf and Philadelphia: University of Pennsylvania Press, 1990. Contains a bibliography.

Weller, Simone. *Il Complesso di Michelangelo: ricerca sul contributo dato dalla donna all'arte italiana del novecento.* Pollenza-Macerata: La Nuova Foglio [*sic*] Editrice, 1976.

2885 MORREAU, JACQUELINE (1929–)
American-born figurative painter working in England; she examines the representation of women from a feminist viewpoint and often re-examines ancient mythological figures.

Publications

"Gaining Ground." In *Pandora's Box,* ed. Gill Calvert, Jill Morgan and Mouse Katz, 19–23. Bristol: Arnolfini Gallery, 1984.
Kent, Sarah, and Jacqueline Morreau, eds. *Women's Images of Men.* London: Writers and Readers Publishing, 1985.

Main Sources

Jacqueline Morreau: Drawings and Graphics. Metuchen, N.J., and London: Scarecrow Press, 1986. Introduction by Sarah Kent.

Exhibitions

Women's Images of Men. London: Institute of Contemporary Art, 1980.
Kent, Sarah. *Paradise Lost: An Exploration of Greek Myth.* Birmingham: Ikon Gallery, 1983.
Calvert, Gill, Jill Morgan, and Mouse Katz, eds. *Pandora's Box.* Bristol: Arnolfini Gallery, 1984.

Other Sources

Dunford, Penny. *A Biographical Dictionary of Women Artists in Europe and America since 1850.* Hemel Hempstead: Harvester Wheatsheaf and Philadelphia: University of Pennsylvania Press, 1990. Contains a bibliography.

2886 MOSS, MARLOW (Pseudonym of MARJORIE JEWELL MOSS) (1890–1958)
 English painter of geometric abstract canvases and a few reliefs in a style influenced by De Stijl.

Exhibitions

Harris, Anne Sutherland, and Linda Nochlin. *Women Artists 1550–1950.* Los Angeles: County Museum of Art, 1976.
Abstraction-Création, 1931–1936. Paris: Musée d'Art Moderne de la Ville de Paris, 1978.
Vergine, Lea. *L'altra metà dell'avanguardia.* Milan: Mazzotta Editore, 1980. *L'autre moitié de l'avant-garde.* Paris: Des Femmes, 1982.
Women's Art Show, 1550–1970. Nottingham: Castle Museum, 1982. Contains a brief biography.

Other Sources

Dunford, Penny. *A Biographical Dictionary of Women Artists in Europe and America since 1850.* Hemel Hempstead: Harvester Wheatsheaf and Philadelphia: University of Pennsylvania Press, 1990. Contains a bibliography.
Greer, Germaine. *The Obstacle Race.* London: Secker and Warburg, 1979.

2887 MOSTOVA, ZOYA YAKOVLEVNA (Alt. MOSTOVA-MATVEEVA; MATVEEVA-MOSTOVA) (1884–1972)
Russian painter.

Other Sources

Milner, John. *A Dictionary of Russian and Soviet Artists, 1420–1970.* Woodbridge: Antique Collectors Club, 1993.

2888 MUIŽULE, MALDA (1937–)
Latvian painter and graphic artist.

Exhibitions

8. Baltijas Republiku Akvareļu Izstāde: Katalogs. Riga, 1989.

Other Sources

Enfeld, Alla, and Norton Dodge, eds. *Nonconformist Art: The Soviet Experience, 1956–1986. The Norton and Nancy Dodge Collection.* London: Thames and Hudson in association with the Jane Voorhees Zimmerli Art Museum, State University of New Jersey, Rutgers, 1995.

2889 MUNSKY, MAINA MIRIAM (1943–)
German hyper-realist painter who uses her work to make social comments.

Exhibitions

Das Verborgene Museum. Dokumentation der Kunst von Frauen in Berliner öffentlichen Sammlungen. Berlin: Edition Hentrich, 1987.

Other Sources

Dunford, Penny. *A Biographical Dictionary of Women Artists in Europe and America since 1850.* Hemel Hempstead: Harvester Wheatsheaf and Philadelphia: University of Pennsylvania Press, 1990. Contains a bibliography.

Evers, Ulrike. *Deutsche Künstlerinnen des 20. Jahrhunderts. Malerei— Bildhauerei—Tapisserie.* Hamburg: Ludwig Schultheis Verlag, 1983. Contains an individual bibliography.

Krichbaum, J., and R. Zondergeld. *Künstlerinnen: von der Antike bis zur Gegenwart.* Cologne: DuMont, 1979.

2890 MUNTHE-NORSTEDT, ANNA KATARINA FREDERIKA (1845–1936)
Swedish painter of still life.

Other Sources

Pavière, Sidney. *Dictionary of Flower, Fruit and Still-life Painters.* Vol. 3: *The 19th Century*, part 2. Leigh-on-Sea: Frank Lewis, 1964.

2891 MURRAY, ELIZABETH (née HEAPHY) (1815–1882)
English painter of figure scenes based on her wide travels; with her diplomat husband she spent twelve years in America. Sister of Mary Anne Heaphy (q.v.).

Publications

Sixteen Years of an Artist's Life. London, 1859.

Main Sources

Clayton, Ellen. *English Female Artists.* London: Tinsley, 1876.

Exhibitions

Women Pioneers in Maine Art. Portland, Maine: Joan Whitney Payson Gallery, Westbrook College, 1981.

Other Sources

Clement, Clara. *Women in the Fine Arts.* Boston: Houghton Mifflin, 1904.
Dunford, Penny. *A Biographical Dictionary of Women Artists in Europe and America since 1850.* Hemel Hempstead: Harvester Wheatsheaf and Philadelphia: University of Pennsylvania Press, 1990. Contains a bibliography.
Mallalieu, Hugh. *Dictionary of British Watercolour Artists.* Woodbridge: Antique Collectors Club, 1976.
Nunn, Pamela Gerrish. *Victorian Women Artists.* London: Women's Press, 1987.
Wood, Christopher. *The Dictionary of Victorian Painters.* Woodbridge: Antique Collectors Club, 1978.

2892 MUTER, MELA (Pseudonym of MARIA MELANIA MUTERMILCH) (1876–1967)
Polish-born painter who lived in Paris from 1901.

Exhibitions

Morawińska, Agnieszka. *Voices of Freedom: Polish Women Artists of the Avant-garde, 1880–1990.* Washington, D.C.: National Museum of Women in the Arts, 1991. Includes a list of her main exhibitions and a bibliography.

Other Sources

Bunoust, Madeleine. *Quelques Femmes Peintres.* Paris: Librairie Stock, 1936.
Perry, Gill. *Women Artists and the Parisian Avant-Garde.* Manchester: Manchester University Press, 1995. Includes a biography and select bibliography.

2893 MUTRIE, ANNA FERAY (1826–1893)
English painter of flowers and fruit; sister of Martha (q.v.).

Main Sources

Clayton, Ellen. *English Female Artists.* London: Tinsley, 1876.

Exhibitions

Women's Art Show, 1550–1970. Nottingham: Castle Museum, 1982. Contains a brief biography.

Other Sources

Cherry, Deborah. *Painting Women: Victorian Women Artists.* London: Routledge, 1993.

Dunford, Penny. *A Biographical Dictionary of Women Artists in Europe and America since 1850.* Hemel Hempstead: Harvester Wheatsheaf and Philadelphia: University of Pennsylvania Press, 1990. Contains a bibliography.

Nunn, Pamela Gerrish. "Ruskin's Patronage of Women Artists." *Woman's Art Journal* 2, no. 2 (fall 1981–winter 1982): 8–13.

Nunn, Pamela Gerrish. *Victorian Women Artists.* London: Women's Press, 1987.

Tytler, Sarah. *Modern Painters and their Paintings.* London: Strahan & Co., 1873.

Wood, Christopher. *The Dictionary of Victorian Painters.* Woodbridge: Antique Collectors Club, 1978.

2894 MUTRIE, MARTHA DARLEY (1824–1885)
English painter of flowers and fruit; sister of Annie.

Main Sources

See under Anna Mutrie.

2895 MÜNTER, GABRIELE (1877–1962)
German Expressionist painter of landscapes, figures and interiors.

Main Sources

Bachrach, Susan. "A Comparison of the Early Landscapes of Münter and Kandinsky." *Woman's Art Journal* 2, no. 1 (spring–summer 1981).

Behr, Shulamith. *Women Expressionists.* Oxford: Phaidon, 1988.

Comini, Alexandra. "State of the Field 1980: The Women Artists of German Expressionism." *Arts Magazine* 55 (November 1980): 147–153.

Exhibitions

Gabriele Münter. First American Exhibition with 7 Additional major Paintings by Kandinsky. Los Angeles: Dalzell Hatfireld Gallery, 1960, 20pp., illus.

Gleisberg, D. *Deutsche Künstlerinnen des zwanzigsten Jahrhunderts.* Attenburg: Staatlichen Lindendau Museum, 1963.

Harris, Anne Sutherland, and Linda Nochlin. *Women Artists 1550–1950.* Los Angeles: County Museum of Art, 1976.

Künstlerinnen international, 1877–1977. Berlin: Schloss Charlottenburg, 1977.

Vergine, Lea. *L'altra metà dell'avanguardia.* Milan: Mazzotta Editore, 1980.

L'autre moitié de l'avant-garde. Paris: Des Femmes, 1982.

Das Verborgene Museum. Dokumentation der Kunst von Frauen in Berliner öffentlichen Sammlungen. Berlin: Edition Hentrich, 1987.

Hoberg, Annegret, and Helmut Friedel, eds. *Gabriele Münter, 1877–1962: Retrospektive.* Munich: Städtischen Galerie im Lenbachhaus in association with Prestel, 1992, 300pp., illus. Text in German. Consists of several scholarly essays on Münter, followed by detailed catalogue entries on the 250 works exhibited. Contains a list of her exhibitions since 1908 and a full bibliography. The most detailed publication on Münter to date.

Other Sources

Bachmann, Donna, and Sherry Piland. *Women Artists: A Historical, Contemporary and Feminist Bibliography.* Metuchen, N.J.: Scarecrow Press, 1978.

Behr, Shulamith. *Women Expressionists.* Oxford: Phaidon, 1988.

Dunford, Penny. *A Biographical Dictionary of Women Artists in Europe and America since 1850.* Hemel Hempstead: Harvester Wheatsheaf and Philadelphia: University of Pennsylvania Press, 1990. Contains a bibliography.

Evers, Ulrike. *Deutsche Künstlerinnen des 20. Jahrhunderts. Malerei— Bildhauerei—Tapisserie.* Hamburg: Ludwig Schultheis Verlag, 1983. Contains an individual bibliography.

2896 NAKHOVA, IRINA (1955–)
 Russian painter, some of whose work commented on women's role in Soviet society.

Other Sources

Enfeld, Alla, and Norton Dodge, eds. *Nonconformist Art: The Soviet Experience, 1956–1986. The Norton and Nancy Dodge Collection.* London: Thames and Hudson in association with the Jane Voorhees Zimmerli Art Museum, State University of New Jersey, Rutgers, 1995.

2897 NAZARENKO, TATIANA (1944–)
 Russian painter.

Exhibitions

De la Révolution à la Pérréstroika. Art Soviétique de la Collection Ludwig. St. Etienne: Musée d'Art Moderne, 1989.

2898 NELEDVA, GALINA (1938–)
Russian painter.

Exhibitions

De la Révolution à la Pérréstroika. Art Soviétique de la Collection Ludwig. St. Etienne: Musée d'Art Moderne, 1989.

2899 NEMOURS, AURÉLIE (1910–)
French abstract painter who trained with Léger.

Exhibitions

Paris 1937–1957: création en France. Paris: Centre national d'art et de culture Georges Pompidou, 1981.

Other Sources

Ceysson, B., et al. *25 ans d'art en France, 1960–1985.* Paris: Larousse, 1986. Includes a select list of exhibitions for each artist.

2900 NESTEROVA, NATALIA (1944–)
Russian painter.

Exhibitions

De la Révolution à la Pérréstroika. Art Soviétique de la Collection Ludwig. St. Etienne: Musée d'Art Moderne, 1989.

Other Sources

Enfeld, Alla, and Norton Dodge, eds. *Nonconformist Art: The Soviet Experience, 1956–1986. The Norton and Nancy Dodge Collection.* London: Thames and Hudson in association with the Jane Voorhees Zimmerli Art Museum, State University of New Jersey, Rutgers, 1995.

2901 NEWCOMB, MARY (1922–)
English painter of poetic rural scenes.

Exhibitions

Mary Newcomb. London: Crane Kalman Gallery, 1982.
Mary Newcomb. London: Crane Kalman Gallery, 1986.

Other Sources

Dunford, Penny. *A Biographical Dictionary of Women Artists in Europe and America since 1850.* Hemel Hempstead: Harvester Wheatsheaf and Philadelphia: University of Pennsylvania Press, 1990. Contains a bibliography.

2902 NIATI, HOURIA (1948–)
Algerian-born painter of semi-abstract images who works in England.

Main Sources

Drake, C. "Houria Niati—Paintings and Pastels." *Women Artists' Slide Library Journal,* June–July 1988, 22.

Exhibitions

1984–1988, Paintings and Pastels by Houria Niati. London: The Open Space, 1988.

Other Sources

Dunford, Penny. *A Biographical Dictionary of Women Artists in Europe and America since 1850.* Hemel Hempstead: Harvester Wheatsheaf and Philadelphia: University of Pennsylvania Press, 1990. Contains a bibliography.

2903 NICHOLSON, WINIFRED (née ROSE WINIFRED ROBERTS; alt. DACRE) (1893–1981)
English painter who explored light and colour through flower studies and landscapes.

Publications

Flower Tales. Brampton, Cumbria: LYC Publications (limited edition), 1976.
Unknown Colour: Paintings, letters, writings. An anthology compiled by Andrew Nicholson. London: Faber and Faber, 1987.
See Judith Collins below.

Main Sources

Lane, John. *The living tree: Art and the sacred.* Bideford, Devon: Green Books, 1988. Chapter on Nicholson.
Grimes, Teresa, Judith Collins, and Oriana Baddeley. *Five Women Painters.* London: Channel Four in Association with the Arts Council of Great Britain and Lennard Publishing, 1989. Reprint 1991. Contains a perceptive analysis of her work and a bibliography.

Exhibitions

Abstraction-Création 1931–1936. Paris: Musée d'Art Moderne de la Ville de Paris, 1976.
Winifred Nicholson: Paintings, 1900–1978. Glasgow: Third Eye Centre, 1979.
Women's Art Show, 1550–1970. Nottingham: Castle Museum, 1982. Contains a brief biography.
Collins, Judith. *Winifred Nicholson.* London: Tate Gallery, 1987, 117pp., illus. A useful analysis of the development of her work is accompanied by a detailed chronology. Contains a full bibliography and list of her publications.

Sulter, Maud. *Echo: Works by Women Artists, 1850–1940.* Liverpool: Tate Gallery, 1991.

Other Sources

Dunford, Penny. *A Biographical Dictionary of Women Artists in Europe and America since 1850.* Hemel Hempstead: Harvester Wheatsheaf and Philadelphia: University of Pennsylvania Press, 1990. Contains a bibliography.

Spalding, Frances. *British Art Since 1900.* London, 1986.

2904 NICZ-BOROWIAK, MARIA (1896–1944)
Polish painter influenced by Cubism.

Main Sources

Turowski, Andrzej. "Twórczošč Marii Nicz-Borowiakowej (1896–1944)." *Studia Muzealne* 5 (1966): 125–146. Text in Polish with a brief summary in French. Following the discovery of several works by this artist, notably at the National Museum in Poznan, sufficient was known to attempt the first critical assessment of her work.

Exhibitions

Constructivism in Poland, 1923–1936: Blok—Praesans—ar. Essen: Museum Folkwang, 1973. Text in German. Based around works and articles published in these Polish journals of the artistic avant-garde.

Gresty, Hilary, and Jeremy Lewison. *Constructivism in Poland 1923–1936.* Cambridge: Kettle's Yard Gallery in association with the Muzeum Stuki, Łodz, 1984. Includes a biographical essay.

Vergine, Lea. *L'altra metà dell'avanguardia.* Milan: Mazzotta Editore, 1980. *L'autre moitié de l'avant-garde.* Paris: Des Femmes, 1982.

Présences Polonaises. L'Art vivant autour du Musee Łodz. Paris: Centre national d'art et de culture Georges Pompidou, 1983.

Other Sources

Dunford, Penny. *A Biographical Dictionary of Women Artists in Europe and America since 1850.* Hemel Hempstead: Harvester Wheatsheaf and Philadelphia: University of Pennsylvania Press, 1990. Contains a bibliography.

2905 NIELSEN, SOEREN HJORTH (1901–1983)
Danish painter.

Exhibitions

Friis, Eva. *Kunst under Krigen.* Copenhagen: Statens Museum for Kunst, 1995.

2906 NIELSON, HELGE (1893–1980)
Danish painter.

Exhibitions

Friis, Eva. *Kunst under Krigen.* Copenhagen: Statens Museum for Kunst, 1995.

2907 NIKITINA, LENINA (1931–)
Russian painter much of whose work concerns the seige of Leningrad which she lived through.

Other Sources

Enfeld, Alla, and Norton Dodge, eds. *Nonconformist Art: The Soviet Experience, 1956–1986. The Norton and Nancy Dodge Collection.* London: Thames and Hudson in association with the Jane Voorhees Zimmerli Art Museum, State University of New Jersey, Rutgers, 1995.

2908 NILSSON, VERA (1888–1978)
Swedish Expressionist painter.

Main Sources

Ingelman, Ingrid. "Women Artists in Sweden." *Woman's Art Journal* 5, no. 1 (spring–summer 1984): 1–7.

Exhibitions

Kvinnor som målat. Stockholm: Nationalmuseum, 1975.

Other Sources

Behr, Shulamith. *Women Expressionists.* Oxford: Phaidon, 1988.
Dunford, Penny. *A Biographical Dictionary of Women Artists in Europe and America since 1850.* Hemel Hempstead: Harvester Wheatsheaf and Philadelphia: University of Pennsylvania Press, 1990. Contains a bibliography.

2909 NISBET, NOEL LAURA (1887–1956)
Scottish painter and graphic artist who illustrates legendary, mythological and imaginary scenes.

See Graphic Art section.

2910 NOACK, ASTRID (1888–1954)
Danish painter.

Exhibitions

Friis, Eva. *Kunst under Krigen.* Copenhagen: Statens Museum for Kunst, 1995.

2911 NORDGREN, ANNA (1847–1916)
Swedish painter of interiors, often in simple rural homes, genre and portraits.

Exhibitions

Kvinnor som målat. Stockholm: Nationalmuseum, 1975.

Other Sources

Dunford, Penny. *A Biographical Dictionary of Women Artists in Europe and America since 1850.* Hemel Hempstead: Harvester Wheatsheaf and Philadelphia: University of Pennsylvania Press, 1990. Contains a bibliography.

Ingelman, Ingrid. *Kvinuliga konstnarer i Sverige en undersokning av Elever vid konstakademin Inskriva 1864–1924.* Uppsala: Almquist & Wiksell, 1982.

2912 NORKUTE, VIDA (1949–)
Lithuanian painter.

Exhibitions

8. Baltijas Republiku Akvareļu Izstāde: Katalogs. Riga, 1989.

2913 NORTH, MARIANNE (1830–1890)
English painter who travelled the world to paint flowers in their natural habitat.

Publications

Addington Symonds, (Mrs.) John, ed. *Recollections of a Happy Life, being the Autobiography of Marianne North.* London, 1892. This publication was edited by her sister.

————. *Some Further Recollections of a Happy Life, Selected from the Journals of Marianne North Chiefly Between the Years 1859–1869.* London, 1893.

A Vision of Eden: The Life and Work of Marianne North. Exeter: Webb and Bower, 1980 in collaboration with the Royal Botanic Gardens, Kew, 239pp., illus. Consists of selections from her journals together with a biographical chapter by Brenda Moon.

Main Sources

"Miss Marianne North." *Art Journal,* 1890, 230. Obituary.
Birkett, Dea. *Spinsters Abroad: Victorian Lady Explorers.* Oxford:

Blackwell, 1989, 300pp., illus. An analysis of the motives and achievements of a number of nineteenth-century women explorers of which North is one.

Middleton, Dorothy. *Victorian Lady Travellers*. London, 1965.

Moon, Brenda. "Marianne North's Recollections of a Happy Life: How they Came to be Written and Published." *Journal of the Society for the Bibliography of Natural History* 8, no. 4 (1978): 497–505.

Other Sources

Dunford, Penny. *A Biographical Dictionary of Women Artists in Europe and America since 1850*. Hemel Hempstead: Harvester Wheatsheaf and Philadelphia: University of Pennsylvania Press, 1990. Contains a bibliography.

Saunders, Gill. *Picturing Plants: An Analytical History of Botanical Illustration*. London: Victoria and Albert Museum in association with Zwemmer, 1995.

2914 NOURSE, ELIZABETH (1859–1938)
American painter of European. especially Breton, peasant life, figures and landscapes who worked in France.

Exhibitions

Burke, Mary Alice Heekin, and Lois Marie Fink. *Elizabeth Nourse, 1859–1938: A Salon Career*. Washington, D.C.: Smithsonian Institution Press for the National Museum of American Art, 1983, 279pp., illus. A very detailed study of the life and works of Nourse with a catalogue raisonné organised by subject. Contains a full bibliography.

Other Sources

Dunford, Penny. *A Biographical Dictionary of Women Artists in Europe and America since 1850*. Hemel Hempstead: Harvester Wheatsheaf and Philadelphia: University of Pennsylvania Press, 1990. Contains a bibliography.

Rubinstein, Charlotte. *American Women Artists from Early Indian Times to the Present Day*. Boston: G.K. Hall, 1982.

2915 NØRREGAARD, ASTA ELISA JAKOBINE (1853–1933)
Norwegian painter of female figures in interiors, religious subjects and portraits.

Exhibitions

Fisher, Susan Sterling, Anne Wichstrøm, and Toril Smit. *At Century's End: Norwegian Artists and the Figurative Tradition, 1880–1990*. Høvikodden: Henie-Onstad Art Centre, 1995. Includes a list of exhibitions and an individual bibliography.

Other Sources

Dunford, Penny. *A Biographical Dictionary of Women Artists in Europe and America since 1850.* Hemel Hempstead: Harvester Wheatsheaf and Philadelphia: University of Pennsylvania Press, 1990. Contains a bibliography.

Wichstrøm, Anne. *Kvinner ved staffeliet.* Oslo: Universitetsforlaget: 1983.

2916 O'BRIEN, KITTY WILMER (1910–1982)
Irish painter of landscapes.

Other Sources

De Breffny, Brian, ed. *Ireland: A Cultural Encyclopaedia.* London: Thames and Hudson, 1983.

2917 O'CONNELL, ÉMILIE (née FRÉDÉRIC ÉMILIE AUGUSTE MIETHE; alt. O'CONNEL) (1823–1885)
German-born painter and graphic artist who lived in Belgium and, from 1853, Paris, where she opened an atelier and had many pupils.

Main Sources

Burty, Philippe. "L'Atelier de Madame O'Connell." *Gazette des Beaux-Arts,* 1860, 349–355.

Exhibitions

La Femme: peintre et sculpteur du XVIIe au XXe siècle. Paris: Grand Palais, 1975.

Other Sources

Clement, Clara. *Women in the Fine Arts.* Boston: Houghton Mifflin, 1904.
Clement, Clara, and L. Hutton. *Artists of the Nineteenth Century.* New York, 1879.
Lexikon der Frau. Zurich: Encyclios Verlag, 1953.

2918 OELMACHER, ANNA (1908–)
Hungarian painter who belonged to the Group of Socialist Artists.

Other Sources

Németh, Lajos. *Modern Art in Hungary.* Budapest: Corvina Press, 1969.

2919 OLBRI, KAI-MAI (1943–)
Estonian painter.

Exhibitions

8. Baltijas Republiku Akvareļu Izstāde: Katalogs. Riga, 1989.

2920 OLIVEIRA, ANA MARIA SOARES PACHECO VIEIRA NERYDE
(1940–)
Portuguese painter, mixed media artist and graphic artist.

Exhibitions

Art portugais contemporain. Paris: Musée d'Art Moderne de la Ville de Paris, 1976.

Other Sources

Tannock, Michael. *Portuguese Artists of the Twentieth Century: A Biographical Dictionary.* Chichester: Phillimore & Co. Ltd., 1988.

2921 OROVIDA (Pseudonym of OROVIDA CAMILLE PISSARRO) (1893–1968)
English painter and graphic artist who specialised in animal subjects.

See Graphic Art section.

2922 ORPEN, BEA (1913–1980)
Irish painter who with her husband, Chalmers Trench, founded the Municipal Art Collection at Drogheda.

Exhibitions

Irish Women Artists from the Eighteenth Century to the Present Day. Dublin: National Gallery of Ireland, Douglas Hyde Gallery and Hugh Lane Gallery, 1987.

Other Sources

Trench, Chalmers. *Drogheda Municipal Art Collection Catalogue.* Drogheda: Corporation of Drogheda, n.d., 20pp.

2923 ORSZÁG, LILI (1926–1978)
Hungarian painter of mainly abstract works.

Other Sources

Hárs, Éva, and Ferenc Romváry. *Modern Hungarian Gallery Pécs.* Budapest: Corvina Kiadó, 1981.
Németh, Lajos. *Modern Art in Hungary.* Budapest: Corvina Press, 1969.

2924 OSBORN, EMILY MARY (1834–after 1913)
English painter of figure subjects, genre scenes and portraits.

Main Sources

Dafforne, J. "British Artists—Their Style and Character, no. LXXV: Emily Mary Osborne." *Art Journal* 26 (1864): 261–263.

Nochlin, Linda. "Some Women Realists." In *Women, Art and Power, and Other Essays.* New York, 1988.
Cherry, Deborah. *Painting Women: Victorian Women Artists.* London: Routledge, 1993.

Exhibitions

Harris, Anne Sutherland, and Linda Nochlin. *Women Artists 1550–1950.* Los Angeles: County Museum of Art, 1976.
Women's Art Show, 1550–1970. Nottingham: Castle Museum, 1982. Contains a brief biography.
Cherry, Deborah. *Painting Women: Victorian Women Artists.* Rochdale: Art Gallery, 1987.
Casteras, Susan, and Linda H. Peterson. *A Struggle for Fame: Victorian Women Artists and Authors.* New Haven, Conn.: Yale Center for British Art, 1994.

Other Sources

Bachmann, Donna, and Sherry Piland. *Women Artists: A Historical, Contemporary and Feminist Bibliography.* Metuchen, N.J.: Scarecrow Press, 1978.
Cherry, Deborah. *Painting Women: Victorian Women Artists.* London: Routledge, 1993.
Dunford, Penny. *A Biographical Dictionary of Women Artists in Europe and America since 1850.* Hemel Hempstead: Harvester Wheatsheaf and Philadelphia: University of Pennsylvania Press, 1990. Contains a bibliography
Nunn, Pamela Gerrish. *Victorian Women Artists.* London: Women's Press, 1987.
Yeldham, Charlotte. *Women Artists in Nineteenth Century France and England.* London and New York: Garland, 1984.

2925 OSTROUMOVA-LEBEDEVA, ANNA PETROVNA (1871–1955)
Russian graphic artist and watercolour painter who specialised in town scenes.

See Graphic Art section.

2926 OTTOLINI, GUIDA GAMEIRO
Portuguese painter; daughter of Raquel Roque Gameiro Ottolini.

Other Sources

Di Pamplona, Fernando. *Um seculo de pintura e escultura em Portugal, 1830–1930.* Porto: Livraria Tavares Martins, 1943. In appendix for artists active in the 1930s.

2927 OTTOLINI, RAQUEL ROQUE GAMEIRO (1889–1970)
Portuguese painter of genre and fishing scenes; mother of painter Guida Gameiro Ottolini.

Other Sources

Di Pamplona, Fernando. *Um seculo de pintura e escultura em Portugal, 1830–1930.* Porto: Livraria Tavares Martins, 1943.

Tannock, Michael. *Portuguese Artists of the Twentieth Century: A Biographical Dictionary.* Chichester: Phillimore & Co. Ltd., 198.

2928 OULTON, THÉRÈSE (1953–)
English painter of thickly textured, almost abstract works.

Main Sources

Kinmouth, P. "Thérèse Oulton: Painting." *Vogue,* July 1984, 100–101.

Lucie-Smith, Edward, C. Cohen, and J. Higgins. *The New British Painting.* Oxford: Phaidon, 1988.

Exhibitions

Fool's Gold. London: Gimpel Fils, 1984, n.p., illus. Scholarly essay by Catherine Lampert examines Oulton's imagery and textures.

Landscape, Memory and Desire. London: Serpentine Gallery, 1984.

Other Sources

Dunford, Penny. *A Biographical Dictionary of Women Artists in Europe and America since 1850.* Hemel Hempstead: Harvester Wheatsheaf and Philadelphia: University of Pennsylvania Press, 1990. Contains a bibliography.

2929 OVERBECK, GERTA (Alt. OVERBECK-SCHENK) (1898–1979)
German painter of industrial scenes and portraits in the style of the New Objectivity.

Exhibitions

Künstlerinnen international, 1877–1977. Berlin: Schloss Charlottenburg, 1977.

Schmied, W. *Neue Sachlichkeit und Magischer Realismus, 1918–1933.* London: Hayward Gallery, 1979.

Vergine, Lea. *L'altra metà dell'avanguardia.* Milan: Mazzotta Editore, 1980. *L'autre moitié de l'avant-garde.* Paris: Des Femmes, 1982.

Meskimmon, Marsha. *Domesticity and Dissent: The Role of Women Artists in Germany 1918–1938. Haüsliches Leben und Dissens.* Leicester: Leicestershire Museums Publication no. 120, 1992.

Other Sources

Dunford, Penny. *A Biographical Dictionary of Women Artists in Europe and America since 1850.* Hemel Hempstead: Harvester Wheatsheaf and Philadelphia: University of Pennsylvania Press, 1990. Contains a bibliography.

Evers, Ulrike. *Deutsche Künstlerinnen des 20. Jahrhunderts. Malerei—Bildhauerei—Tapisserie.* Hamburg: Ludwig Schultheis Verlag, 1983. Contains an individual bibliography.

Meskimmon, Marsha, and Shearer West. *Visions of the 'Neue Frau': Women and the Visual Arts in Weimar Germany.* London: Scolar Press, 1995.

2930 PACZKA-WAGNER, CORNELIA (née WAGNER) (1864–1895)
German painter of figures.

Exhibitions

Das Verborgene Museum. Dokumentation der Kunst von Frauen in Berliner öffentlichen Sammlungen. Berlin: Edition Hentrich, 1987.

2931 PAGOWSKA, TERESA (1929–)
Polish painter.

Exhibitions

Morawińska, Agnieszka. *Voices of Freedom: Polish Women Artists of the Avant-garde, 1880–1990.* Washington, D.C.: National Museum of Women in the Arts, 1991. Includes a list of her main exhibitions and a bibliography.

2932 PAHL, ANNE (née FRANK) (1896–1979)
German painter.

Exhibitions

Die Malerin Anne Pahl im Pahl-Museum im Mainhardt-Gailsbach. Stuttgart: Pahl Museum, 1984, n.p., mainly illus. Written by her husband, this exhibition follows a memorial one held in 1980. There is a biographical account at the beginning of the catalogue.

2933 PAILTHORPE, GRACE W. (1883–1971)
English Surrealist painter who first trained as a doctor.

Main Sources

Chadwick, Whitney. *Women Artists and the Surrealist Movement.* London: Thames and Hudson, 1985.

Exhibitions

British Women Surrealists. London: Blond Fine Art, 1985.
Salute to British Surrealism. Colchester: Minories Gallery, 1985.
The Surrealist Spirit in Britain. London: Whitford and Hughes, 1988.

Other Sources

Dunford, Penny. *A Biographical Dictionary of Women Artists in Europe and America since 1850.* Hemel Hempstead: Harvester Wheatsheaf and Philadelphia: University of Pennsylvania Press, 1990. Contains a bibliography.

2934 PANKHURST, SYLVIA (née ESTELLE SYLVIA PANKHURST) (1882–1960)
 English painter and graphic artist whose artistic practice was integrated with her political activities until c. 1914, when she gave up art to devote herself to social and political campaigns, notably the vote for women.

Publications

The Suffragette: The History of the Women's Militant Suffrage Movement. London: 1911

Main Sources

Pankhurst, Richard. *Sylvia Pankhurst: Artist and Crusader.* New York and London: 1979.
 Romero, P. *Sylvia Pankhurst:* New Haven, Conn. and London: Yale University Press, 1986.
 Tickner, Lisa. *Spectacle of Women: Imagery of the Suffrage Campaign, 1907–1914.* London: Chatto & Windus, 1987.

Other Sources

Betterton, Rosemary. *Intimate Distance: Women, Artists and the Body.* London: Routledge, 1996.
 Dunford, Penny. *A Biographical Dictionary of Women Artists in Europe and America since 1850.* Hemel Hempstead: Harvester Wheatsheaf and Philadelphia: University of Pennsylvania Press, 1990. Contains a bibliography.

2935 PANNO, LAURA
 Italian painter and graphic artist.

Exhibitions

Vescovo, Marisa. *Il Gioco delle Parti. 4 Biennale Donna.* Ferrara: Padiglione d'Arte Contemporanea, Palazzo Massari, 1990.

2936 PARISA, MALLE (1954–)
 Estonian painter.

Exhibitions

8. Baltijas Republiku Akvareļu Izstāde: Katalogs. Riga, 1989.

2937 PARKER, AGNES MILLER (1895–)
Scottish graphic artist and painter.

See Graphic Art section.

2938 PATERSON, EMILY MURRAY (1855–1934)
Scottish painter of landscapes, coastal and river scenes who was associated with the Glasgow School.

Exhibitions

Paintings and Drawings by Some Women War Artists. London: Imperial War Museum, 1958.

Other Sources

Dunford, Penny. *A Biographical Dictionary of Women Artists in Europe and America since 1850.* Hemel Hempstead: Harvester Wheatsheaf and Philadelphia: University of Pennsylvania Press, 1990. Contains a bibliography.
Mallalieu, Hugh. *Dictionary of British Watercolour Artists.* Woodbridge: Antique Collectors Club, 1976.
Waters, Grant. *Dictionary of British Artists Working 1900–1940.* Eastbourne: Eastbourne Fine Art, 1975.

2939 PAULI, HANNA (née HIRSCH) (1864–1940)
Swedish painter of figures subjects, landscapes and portraits.

Main Sources

Ingelmann, Ingrid. " Women Artists in Sweden: A Two-Front Struggle." *Woman's Art Journal* 5, no. 1 (spring–summer 1984): 1–7.

Exhibitions

Kvinnor som målat. Stockholm: Nationalmuseum, 1975.
Nordisk Sekelskifte: The Light of the North. Stockholm: Nationalmuseum, 1995.

Other Sources

Clement, Clara. *Women in the Fine Arts.* Boston: Houghton Mifflin, 1904.
Dunford, Penny. *A Biographical Dictionary of Women Artists in Europe and America since 1850.* Hemel Hempstead: Harvester Wheatsheaf and Philadelphia: University of Pennsylvania Press, 1990. Contains a bibliography.
Ingelman, Ingrid. *Kvinuliga konstnarer i Sverige en undersokning av Elever vid konstakademin Inskriva 1864–1924.* Uppsala: Almquist & Wiksell, 1982.
Krichbaum, J., and R. Zondergeld. *Künstlerinnen: von der Antike bis zur Gegenwart.* Cologne: DuMont, 1979.

2940 PAULUKA, FELICITA (1925–)
Latvian painter and graphic artist.

Other Sources

Šmagre, Rita. *Latviešu Pastelis. Latvian Pastel Painting.* Riga: Liesma, 1990.
Includes a brief account of her career.

2941 PAURA, ELGA (1952–)
Latvian painter.

Exhibitions

8. Baltijas Republiku Akvareļu Izstāde: Katalogs. Riga, 1989.

2942 PAUVERT, ODETTE MARIE (Alt. TISSIER) (1903–)
French painter and miniaturist who, in 1925, was the first woman to win
the Grand Prix de Rome for painting.

Exhibitions

Dufresne, Jean-Luc, and Olivier Messac, eds. *Femmes créatrices des années
vingt.* Granville: Musée Richard Anacréon, 1988. Wide-ranging catalogue with a
short biographical account on each woman included.

2943 PÊCHEUR, ANNE-MARIE (1950–)
French painter.

Exhibitions

Anne Pêcheur. Bordeaux: C.A.P.C., 1978.

Other Sources

Ceysson, B., et al. *25 ans d'art en France, 1960–1985.* Paris: Larousse, 1986.
Includes a select list of exhibitions for each artist.

2944 PERUGINI, KATE (née CATHERINE ELIZABETH MACREADY
DICKENS) (1838–1929)
English painter of genre and portraits; the daughter of Charles Dickens.

"Mrs Perugini." *Connoisseur* 84 (1929): 60. Obituary.
Storey, G. *Dickens and Daughter.* London: 1939. Reprinted New York, 1971.

Other Sources

Clement, Clara. *Women in the Fine Arts.* Boston: Houghton Mifflin, 1904.
Dunford, Penny. *A Biographical Dictionary of Women Artists in Europe and*

America since 1850. Hemel Hempstead: Harvester Wheatsheaf and Philadelphia: University of Pennsylvania Press, 1990. Contains a bibliography.

Nunn, Pamela Gerrish. *Victorian Women Artists.* London: Women's Press, 1987.

Wood, Christopher. *The Dictionary of Victorian Painters.* Woodbridge: Antique Collectors Club, 1978.

2945 PESTEL, VERA EFIMOVNA (1886/7–1952)
Russian abstract painter.

Exhibitions

Vergine, Lea. *L'altra metà dell'avanguardia.* Milan: Mazzotta Editore, 1980. *L'autre moitié de l'avant-garde.* Paris: Des Femmes, 1982.

L'avant-garde au féminin, 1907–1930. Paris: Artcurial, 1983.

Avanguardia russa dalle collezioni private sovietiche origini e percorso 1904–1934. Milan: Palazzo Reale, 1989.

Other Sources

Dunford, Penny. *A Biographical Dictionary of Women Artists in Europe and America since 1850.* Hemel Hempstead: Harvester Wheatsheaf and Philadelphia: University of Pennsylvania Press, 1990. Contains a bibliography.

Milner, John. *A Dictionary of Russian and Soviet Artists, 1420–1970.* Woodbridge: Antique Collectors Club, 1993.

2946 PETHERBRIDGE, DEANNA (1939–)
South African-born painter working in England who specialises in architecturally based drawings in indian ink; also a critic.

Exhibitions

Hayward Annual '78. London: Hayward Gallery, 1978.

Deanna Petherbridge: Drawings 1968–1982. Manchester: City Art Gallery, 1982, 44pp., illus. Includes an interview with Petherbridge.

Temples and Tenements: The Indian drawings of Deanna Petherbridge. London: Seagull Books in association with Fischer Fine Art, 1987, 88pp., illus. Designed to coincide with a British Council touring exhibition to India entitled *Architectural Rites,* this catalogue contains two critical essays which analyse both the architectural and Indian aspects of this body of work. It also includes a full list of her own writings together with a select bibliography on her work.

Other Sources

Dunford, Penny. *A Biographical Dictionary of Women Artists in Europe and America since 1850.* Hemel Hempstead: Harvester Wheatsheaf and Philadelphia: University of Pennsylvania Press, 1990. Contains a bibliography.

2947 PETROVA-TROTZKAIA, EKATERINA MICHAILOVNA (1900/1–1932)
Russian painter and graphic artist.

Exhibitions

Avanguardia russa dalle collezioni private sovietiche origini e percorso 1904–1934. Milan: Palazzo Reale, 1989.

2948 PEUGNIEZ, PAULINE (Alt. MME HEBERT-STEVENS) (1890–)
French painter of figure subjects, landscapes, interiors and murals; designer of tapestries and stained glass.

Other Sources

Bunoust, Madeleine. *Quelques Femmes Peintres.* Paris: Librairie Stock, 1936.
Edouard-Joseph, R. *Dictionnaire biographique des artistes contemporains, 1910–1930.* Paris: Art et Editions, 1930–1934.

2949 PICARD, JULIE-ANGE (née WASSET) (1802–1842)
French painter of flowers.

Other Sources

Hardouin-Fugier, Elizabeth. *The Pupils of Redouté.* Leigh-on-Sea: F. Lewis, 1981.

2950 PIKKA, ENE (1925–)
Estonian painter.

Exhibitions

8. Baltijas Republiku Akvareļu Izstāde: Katalogs. Riga, 1989.

2951 PILIPAITIENE, EUGENIA (1934–)
Lithuanian painter.

Exhibitions

8. Baltijas Republiku Akvareļu Izstāde: Katalogs. Riga, 1989.

2952 PINCHERLE, ADRIANA (c. 1908–)
Italian figurative painter.

Other Sources

Weller, Simone. *Il Complesso di Michelangelo: ricerca sul contributo dato dalla donna all'arte italiana del novecento.* Pollenza-Macerata: La Nuova Foglio [*sic*] Editrice, 1976.

2953 PIROT, FRANÇOISE (1946–)
French painter.

Other Sources

Alauzon di Genova, André. *La Peinture en Provence.* Marseille: J. Lafitte, 1984.

2954 PLUNKET, KATHERINE (1820–1932)
Irish painter of flowers and landscapes; a botanical artist.

Exhibitions

Irish Women Artists from the Eighteenth Century to the Present Day. Dublin: National Gallery of Ireland, Douglas Hyde Gallery and Hugh Lane Gallery, 1987.

Other Sources

De Breffny, Brian, ed. *Ireland: A Cultural Encyclopaedia.* London: Thames and Hudson, 1983.

2955 POINSOT, JULIE
French flower painter.

Other Sources

Blunt, Wilfrid. *The Art of Botanical Illustration.* New Naturalist Series. London: Collins, 1950.

2956 POLLI, HEITI (1951–)
Estonian painter who deals with the anonymous nature of modern city life and also produces portraits.

Other Sources

Enfeld, Alla, and Norton Dodge, eds. *Nonconformist Art: The Soviet Experience, 1956–1986. The Norton and Nancy Dodge Collection.* London: Thames and Hudson in association with the Jane Voorhees Zimmerli Art Museum, State University of New Jersey, Rutgers, 1995.

2957 POLUNIN, ELIZABETH V. (née HART) (1887–?)
English painter of figures, portraits and stage designs.

Exhibitions

Paintings and Drawings by Some Women War Artists. London: Imperial War Museum, 1958.

Other Sources

Dunford, Penny. *A Biographical Dictionary of Women Artists in Europe and America since 1850.* Hemel Hempstead: Harvester Wheatsheaf and Philadelphia: University of Pennsylvania Press, 1990. Contains a bibliography.

Waters, Grant. *Dictionary of British Artists Working 1900–1940.* Eastbourne: Eastbourne Fine Art, 1975.

2958 POPE, CLARA MARIA (née LEIGH; alt. WHEATLEY) (c. 1750–1838)
English painter of flowers; both of her husbands were painters.

Other Sources

Blunt, Wilfrid. *The Art of Botanical Illustration.* New Naturalist Series. London: Collins, 1950.

Burbidge, R. Brinsley. *Dictionary of British Flower, Fruit and Still Life Painters.* Leigh-on-Sea: F. Lewis, 1974.

2959 POPOVA, LIUBOV SERGEEVNA (1889–1924)
Russian geometrical abstract painter and textile designer.

Main Sources

Adaskina, Natalie, and Dmitri Sarabianov. *Lioubov Popova.* Paris: Philippe Sers, c. 1989, 394pp., 433 illus. Text in French. The first section examines the development of her painting while the second section includes consideration of her theory, her teaching and all her designs, including those for the theatre, graphic art and textiles. Some of her writings are reprinted.

Yablonskaya, Miuda. *Women Artists of Russia's New Age, 1900–1935.* Ed. and trans. Anthony Parton. New York: Rizzoli & London: Thames and Hudson, 1990. Contains a chapter on each artist while notes and an individual bibliography provide access to material in Russian.

Exhibitions

Harris, Anne Sutherland, and Linda Nochlin. *Women Artists 1550–1950.* Los Angeles: County Museum of Art, 1976.

Künstlerinnen international, 1877–1977. Berlin: Schloss Charlottenburg, 1977.

Russian Women Artists of the Avant-garde, 1910–1930. Cologne: Galerie Gmurzynska, 1979.

Barron, Stephanie, and M. Tuchman. *The avant-garde in Russia, 1910–1930.* Los Angeles: County Museum of Art, 1980.

Vergine, Lea. *L'altra metà dell'avanguardia.* Milan: Mazzotta Editore, 1980. *L'autre moitié de l'avant-garde.* Paris: Des Femmes, 1982.

Liubov Popova: Spatial Force Constructions, 1921–22. New York: Rachel Adler Gallery, 1985, n.p., mainly illus. A short analysis of the works exhibited is followed by a chronology.

De la Révolution à la Pérréstroika. Art Soviétique de la Collection Ludwig. St Etienne: Musée d'Art Moderne, 1989.
Avanguardia russa dalle collezioni private sovietiche origini e percorso 1904–1934. Milan: Palazzo Reale, 1989.
Künstlerinnen des 20. Jahrhunderts. Wiesbaden: Museum Wiesbaden in association with Verlag Weber & Weidermeyer GmbH, Kassel, 1990.

Other Sources

Byars, Mel. *The Design Encyclopedia.* London: Lawrence King, 1994.
Dunford, Penny. *A Biographical Dictionary of Women Artists in Europe and America since 1850.* Hemel Hempstead: Harvester Wheatsheaf and Philadelphia: University of Pennsylvania Press, 1990. Contains a bibliography.
Milner, John. *A Dictionary of Russian and Soviet Artists, 1420–1970.* Woodbridge: Antique Collectors Club, 1993. Includes a bibliography.
Uglow, Jennifer. *The Macmillan Dictionary of Women's Biography.* London: Macmillan, 1982.
Yasinskaya, I. *Soviet Textile Design of the Revolutionary Period.* London: Thames and Hudson, 1983.

2960 POTTER, BEATRIX (1866–1943)
English painter, graphic artist and writer best known for the children's stories about animals which she wrote and illustrated.

Main Sources

Golden, Catherine. "Beatrix Potter: Naturalist Artist." *Woman's Art Journal* 11, no.1 (spring–summer 1990): 16–20.
McEwen, John. "Book Illustration: Tales From the Dark Side." *Art In America* 76 (June 1988): 44–45.
Peck, Robert. "Beatrix Potter, Scientific Illustrator." *The Magazine Antiques* 149 (June 1996): 868–877.
Smithson, Alison. "Beatrix Potter's Places." *Studio International* 201 (April 1988): 28–33. Republished version of an article in *Architectural Design,* December 1967, with an addendum concerning postboxes. Examines Potter's depiction of interiors.
Stemp, Robin. "The Seeing Eye." *The Artist* 105 (March 1990): 38–40.
Townsend, Juliet. "The Tale of Beatrix Potter." *Connoisseur* 218 (June 1988): 138–141.
Wilsher, Ann. "The Potters and Photography." *History of Photography* 9 (July/September 1985): 223–235.

Exhibitions

Casteras, Susan, and Linda H. Peterson. *A Struggle for Fame: Victorian Women Artists and Authors.* New Haven, Conn.: Yale Center for British Art, 1994.

2961 POTTER, MARY (née ATTENBOROUGH) (1900–1981)
English painter of still lifes, interiors, beach scenes and landscapes.

Main Sources

Spalding, Frances. "Mary Potter." *Studio International,* no. 3 (1977): 183.

Exhibitions

Piper, M. *Mary Potter: Paintings, 1938–1964.* London: Whitechapel Gallery, 1964.
British Painting 1952–1977. London: Royal Academy, 1977.
Mary Potter: Paintings, 1922–1980. London: Serpentine Gallery, 1981, n.p., mainly illus. Short biographical account is followed by a list of her exhibitions.
Women's Art Show, 1550–1970. Nottingham: Castle Museum, 1982. Contains a brief biography.

Other Sources

Dunford, Penny. *A Biographical Dictionary of Women Artists in Europe and America since 1850.* Hemel Hempstead: Harvester Wheatsheaf and Philadelphia: University of Pennsylvania Press, 1990. Contains a bibliography.

2962 POVORINA, ALEXANDRA (Alt. AHLERS-HESTERMANN) (1883/5–1963)
Russian-born painter who studied and worked in Germany from c. 1903 and who produced abstract works from c. 1934.

Exhibitions

Abstraction-Création 1931–1936. Paris: Musée d'Art Moderne de la Ville de Paris, 1976.
Das Verborgene Museum. Dokumentation der Kunst von Frauen in Berliner öffentlichen Sammlungen. Berlin: Edition Hentrich, 1987.

2963 PRAEGER, ROSAMUND (née SOPHIA ROSAMUND) (1867–1954)
Irish botanical painter and sculptor who became president of the Royal Ulster Academy.

Exhibitions

Irish Women Artists from the Eighteenth Century to the Present Day. Dublin: National Gallery of Ireland, Douglas Hyde Gallery and Hugh Lane Gallery, 1987.

Other Sources

De Breffny, Brian, ed. *Ireland: A Cultural Encyclopaedia.* London: Thames and Hudson, 1983.

2964 PREECE, PATRICIA
English painter of figures subjects and portraits.

Exhibitions

Paintings and Drawings by Some Women War Artists. London: Imperial War Museum, 1958.

Other Sources

Dunford, Penny. *A Biographical Dictionary of Women Artists in Europe and America since 1850.* Hemel Hempstead: Harvester Wheatsheaf and Philadelphia: University of Pennsylvania Press, 1990. Contains a bibliography.
Waters, Grant. *Dictionary of British Artists Working 1900–1940.* Eastbourne: Eastbourne Fine Art, 1975.

2965 PROCTER, DOD (née DORIS M.SHAW) (1892–1972)
English painter chiefly of figures who worked in Cornwall and who was the third woman to be elected a full member of the Royal Academy.

Main Sources

Bertram, Anthony. "Contemporary British Painting: Dod Procter." *Studio,* January 1929, 92–97.
Welch, N. "Dod Procter: A Memoir." *The Cornish Review* 22 (winter 1972): 37–42.

Exhibitions

Dod Procter. London: Leicester Gallery, 1945. Consists of a brief biography and a list of exhibits.
Fox, Caroline, and Francis Greenacre. *Painting in Newlyn, 1880–1930.* London: Barbican Art Gallery, 1985.
Silver Bells and Cockle Shells. London: Whitford and Hughes, 1986.
Dod Procter R.A., 1892–1972. Liverpool: Walker Art Gallery, 1990, 52pp., illus. A biographical essay includes an analysis of her figure paintings. There are detailed notes on the exhibits.
Sulter, Maud. *Echo: Works by Women Artists, 1850–1940.* Liverpool: Tate Gallery, 1991.

Other Sources

Dunford, Penny. *A Biographical Dictionary of Women Artists in Europe and America since 1850.* Hemel Hempstead: Harvester Wheatsheaf and Philadelphia: University of Pennsylvania Press, 1990. Contains a bibliography.
Lucie-Smith, Edward. *Art Deco Painting.* Oxford: Phaidon. 1990.

2966 PROUT, MARGARET MILLICENT (née FISHER) (1875–1963)
English painter of landscapes, figures and flowers; daughter of the painter Mark Fisher.

Main Sources

Lines, V. *Mark Fisher and Margaret Fisher Prout: Father and Daughter.* London, 1966.

Other Sources

Dunford, Penny. *A Biographical Dictionary of Women Artists in Europe and America since 1850.* Hemel Hempstead: Harvester Wheatsheaf and Philadelphia: University of Pennsylvania Press, 1990. Contains a bibliography.

Waters, Grant. *Dictionary of British Artists Working 1900–1940.* Eastbourne: Eastbourne Fine Art, 1975.

2967 PURMALE, LĪGA (1948–)
Latvian painter.

Other Sources

Enfeld, Alla, and Norton Dodge, eds. *Nonconformist Art: The Soviet Experience, 1956–1986. The Norton and Nancy Dodge Collection.* London: Thames and Hudson in association with the Jane Voorhees Zimmerli Art Museum, State University of New Jersey, Rutgers, 1995.

2968 PURSER, SARAH HENRIETTA (1848–1943)
Irish painter, collector and promoter of Irish art.

Exhibitions

Pyle, H. *Irish Art, 1900–1950.* Crawford: Municipal School of Art, 1975.

Campbell, J. *The Irish Impressionists: Irish Artists in France and Belgium, 1850–1914.* Dublin: National Gallery of Art, 1984.

Irish Women Artists from the Eighteenth Century to the Present Day. Dublin: National Gallery of Ireland, Douglas Hyde Gallery and Hugh Lane Gallery, 1987.

Other Sources

De Breffny, Brian, ed. *Ireland: A Cultural Encyclopaedia.* London: Thames and Hudson, 1983.

Dunford, Penny. *A Biographical Dictionary of Women Artists in Europe and America since 1850.* Hemel Hempstead: Harvester Wheatsheaf and Philadelphia: University of Pennsylvania Press, 1990. Contains a bibliography.

White, J., and M. Wynne. *Irish Stained Glass.* Dublin, 1963.

2969 PUUSTAK, KAISA (1945–)
Estonian painter who often depicts the machinery of city life.

Other Sources

Enfeld, Alla, and Norton Dodge, eds. *Nonconformist Art: The Soviet Experience, 1956–1986. The Norton and Nancy Dodge Collection.* London: Thames and Hudson in association with the Jane Voorhees Zimmerli Art Museum, State University of New Jersey, Rutgers, 1995.

2970 PUYROCHE-WAGNER, ELISA (née WAGNER) (1828–1895)
German painter of flowers who came to Lyon with her sister Adelaide, in order to study painting and who exhibited for almost fifty years, including at the Exposition Universelle of 1855.

Other Sources

Hardouin-Fugier, Elizabeth, and Etienne Grafe. *The Lyon School of Flower Painting.* Leigh-on-Sea: F. Lewis, 1978, 88pp., illus.

2971 QUINTANILLA, ISABEL (1938–)
Spanish realist painter of still lifes and interiors.

Exhibitions

Das Verborgene Museum. Dokumentation der Kunst von Frauen in Berliner öffentlichen Sammlungen. Berlin: Edition Hentrich, 1987.

Other Sources

Dunford, Penny. *A Biographical Dictionary of Women Artists in Europe and America since 1850.* Hemel Hempstead: Harvester Wheatsheaf and Philadelphia: University of Pennsylvania Press, 1990. Contains a bibliography.
Krichbaum, J., and R. Zondergeld. *Künstlerinnen: von der Antike bis zur Gegenwart.* Cologne: DuMont, 1979.

2972 RAE, HENRIETTA (Alt. NORMAND) (1859–1928)
English painter of classical and allegorical subjects which often included female nudes.

Main Sources

Fish, Arthur. *Henrietta Rae (Mrs Ernest Normand).* London: Cassell & Company, 1906, 120pp., 40 illus. A detailed biographical account up to 1905, which shows how Rae was brought up expecting to earn her own living.
Rinder, Fr. "'Henrietta Rae'—Mrs Ernest Normand." *Art Journal,* 1901, 303–307.

Exhibitions

Women's Art Show, 1550–1970. Nottingham: Castle Museum, 1982. Contains a brief biography.

Cherry, Deborah. *Painting Women: Victorian Women Artists.* Rochdale: Art Gallery, 1987.

Sellars, Jane. *Women's Works.* Liverpool: Walker Art Gallery, 1988.

Other Sources

Clement, Clara. *Women in the Fine Arts.* Boston: Houghton Mifflin, 1904.

Dunford, Penny. *A Biographical Dictionary of Women Artists in Europe and America since 1850.* Hemel Hempstead: Harvester Wheatsheaf and Philadelphia: University of Pennsylvania Press, 1990. Contains a bibliography.

Smith, Alison. *The Victorian Nude: Sexuality, Morality and Art.* Manchester: Manchester University Press, 1996.

Wood, Christopher. *The Dictionary of Victorian Painters.* Woodbridge: Antique Collectors Club, 1978.

2973 RAMA, OLGA CAROL (Alt. CAROLRAMA) (1918–)
Italian painter of familiar objects in fantastic, quasi-surreal settings.

Exhibitions

Vergine, Lea. *L'altra metà dell'avanguardia.* Milan: Mazzotta Editore, 1980. *L'autre moitié de l'avant-garde.* Paris: Des Femmes, 1982.

Pasquali, Marilena. *Figure dallo sfondo.* Ferrara: Padiglione d'Arte Contemporanea and Grafis Editore, 1984.

Vergine, Lea. "Carol Rama: Heroic, Exotic, Heretic." In *Inside the Visible: An Elliptical View of 20th Century Art—In, Of and From the Feminine,* ed. Catherine De Zegher. Ghent: The Kanaal Foundation, 1996.

Other Sources

Dunford, Penny. *A Biographical Dictionary of Women Artists in Europe and America since 1850.* Hemel Hempstead: Harvester Wheatsheaf and Philadelphia: University of Pennsylvania Press, 1990. Contains a bibliography.

Weller, Simone. *Il Complesso di Michelangelo: ricerca sul contributo dato dalla donna all'arte italiana del novecento.* Pollenza-Macerata: La Nuova Foglio [*sic*] Editrice, 1976 (as Carolrama).

2974 RANTANEN, ULLA (c. 1940–)
Finnish painter and graphic artist.

Main Sources

Pallasmaa, U. "Beauty is Irrelevant, Disturbing." *Look at Finland* 4 (1985): 6–11.

Exhibitions

Akt 83: suomalaista nykytaidetta. Helsinki: Ateneum, 1983.

Other Sources

Dunford, Penny. *A Biographical Dictionary of Women Artists in Europe and America since 1850.* Hemel Hempstead: Harvester Wheatsheaf and Philadelphia: University of Pennsylvania Press, 1990. Contains a bibliography.

2975 RAPHAEL, ANTONIETTA (Alt. RAPHAEL MAFAI) (1895/1900–1975)
Lithuanian-born painter and sculptor who studied in England and worked in Italy from c. 1925.

Exhibitions

Künstlerinnen international, 1877–1977. Berlin: Schloss Charlottenburg, 1977.
Anni trenta: Arte e cultura in Italia. Milan: Comune di Milano in association with Mazzotta Editore, 1982.
Vergine, Lea. *L'altra metà dell'avanguardia.* Milan: Mazzotta Editore, 1980. *L'autre moitié de l'avant-garde.* Paris: Des Femmes, 1982.
Baraldi, Anna Maria, et al. *6 Biennale Donna.* Ferrara: Padiglione d'Arte Contemporanea, 1994.

Other Sources

Dunford, Penny. *A Biographical Dictionary of Women Artists in Europe and America since 1850.* Hemel Hempstead: Harvester Wheatsheaf and Philadelphia: University of Pennsylvania Press, 1990. Contains a bibliography.
Weller, Simone. *Il Complesso di Michelangelo: ricerca sul contributo dato dalla donna all'arte italiana del novecento.* Pollenza-Macerata: La Nuova Foglio [*sic*] Editrice, 1976.

2976 RAPIN, AIMÉE (c. 1860–?)
Swiss painter of portraits and sculptor of bas-reliefs who worked with her feet.

Other Sources

Clement, Clara. *Women in the Fine Arts.* Boston: Houghton Mifflin, 1904.
Dunford, Penny. *A Biographical Dictionary of Women Artists in Europe and America since 1850.* Hemel Hempstead: Harvester Wheatsheaf and Philadelphia: University of Pennsylvania Press, 1990. Contains a bibliography.

2977 RATHSMAN, SIRI (1895–1974)
Swedish graphic artist and painter who worked mainly in France.

Other Sources

Carey, Frances. *Modern Scandinavian Prints*. London: British Museum Press, 1997.

2978 RAYNER, FRANCES (Alt. COPPINGER)

English painter; one of five artist sisters, daughters of the watercolour painter, Samuel Rayner. She appears to have ceased painting on her marriage.

Main Sources

See under Louise Rayner.

2979 RAYNER, LOUISE (1832–1924)

English painter of architectural subjects, views of towns and landscapes; one of five artist sisters, daughters of the watercolour painter, Samuel Rayner.

Main Sources

Clayton, Ellen. *English Female Artists*. London: Tinsley, 1876.

Exhibitions

Cherry, Deborah. *Painting Women: Victorian Women Artists*. Rochdale: Art Gallery, 1987.

Other Sources

Dunford, Penny. *A Biographical Dictionary of Women Artists in Europe and America since 1850*. Hemel Hempstead: Harvester Wheatsheaf and Philadelphia: University of Pennsylvania Press, 1990. Contains a bibliography.

Mallalieu, Hugh. *Dictionary of British Watercolour Artists*. Woodbridge: Antique Collectors Club, 1976.

Nunn, Pamela Gerrish. *Victorian Women Artists*. London: Women's Press, 1987.

Wood, Christopher. *The Dictionary of Victorian Painters*. Woodbridge: Antique Collectors Club, 1978.

2980 RAYNER, MARGARET

English painter particularly of architectural views and interiors of old churches; one of five artist sisters, daughters of the watercolour painter, Samuel Rayner.

Main Sources

See under Louise Rayner.

2981 RAYNER, NANCY (1827–1855)
English painter of rustic figures and interiors; one of five artist sisters, daughters of the watercolour painter, Samuel Rayner.

Main Sources

See under Louise Rayner.

2982 RAYNER, ROSA
English painter of figure subjects and teacher of art; one of five artist sisters, daughters of the watercolour painter, Samuel Rayner.

Main Sources

See under Louise Rayner.

2983 REBAY, HILLA (Alt. HILDEGARD ANNA AUGUSTA ELIZABETH REBAY VON EHRENWEISEN (BARONESS) (1890–1967)
German abstract painter who worked in America from 1927.

Main Sources

Lukach, Joan. *Hilla Rebay: In Search of the Spiritual in Art.* New York: 1983. Contains a full bibliography.

Other Sources

Dunford, Penny. *A Biographical Dictionary of Women Artists in Europe and America since 1850.* Hemel Hempstead: Harvester Wheatsheaf and Philadelphia: University of Pennsylvania Press, 1990. Contains a bibliography.
Rubinstein, Charlotte. *American Women Artists from Early Indian Times to the Present Day.* Boston: G.K. Hall, 1982.

2984 REDFERN, JUNE (1951–)
Scottish painter of monumental figures, often women, in a broadly handled style.

Main Sources

Anson, Elizabeth. "The Vibrancy of June Redfern." *Women's Art Magazine* 39 (1991): 16.

Exhibitions

June Redfern: To the River. Glasgow: Third Eye Centre, 1985, 23pp., illus. Contains a short analysis of her work at that time and a list of her main exhibitions.
Smith, A. *June Redfern: New Work.* Bradford: Cartwright Hall, 1987, 6pp., illus. Includes a useful bibliography.
The Vigorous Imagination. Edinburgh: Scottish National Gallery of Modern Art, 1987.

Other Sources

Dunford, Penny. *A Biographical Dictionary of Women Artists in Europe and America since 1850.* Hemel Hempstead: Harvester Wheatsheaf and Philadelphia: University of Pennsylvania Press, 1990. Contains a bibliography.

2985 REDPATH, ANNE (1895–1965)
Scottish painter of landscapes, still lifes and church interiors.

Exhibitions

Anne Redpath Memorial Exhibition. Edinburgh: Scottish Arts Council, 1965.
Anne Redpath, 1895–1965. Edinburgh: City Art Centre, 1972.
British Painting 1952–1977. London: Royal Academy, 1977.
Women's Art Show, 1550–1970. Nottingham: Castle Museum, 1982. Contains a brief biography.
Anne Redpath, 1895–1965. London: Mercury Gallery, 1986.

Other Sources

Dunford, Penny. *A Biographical Dictionary of Women Artists in Europe and America since 1850.* Hemel Hempstead: Harvester Wheatsheaf and Philadelphia: University of Pennsylvania Press, 1990. Contains a bibliography.

2986 REGO, PAULA (1935–)
Portuguese-born painter who has worked in England since 1952.

Publications

Fortnum, Rebecca. "Paula Rego: Tales from the National Gallery." *Women's Art Magazine* 40 (1991): 12–13. Interview with Rego.

Main Sources

Craddock, Sacha. "Bottoms Up." *Women's Art Magazine* 62 (January–February 1995): 26–27. Exhibition review.
Joliffe, Jill. "Shades of Youth." *The Guardian,* 20 May 1988, 33. Review of a retrospective held in Lisbon.
McEwen, John. "Rhymes of Innocence and Experience." *The Independent,* 18 November 1989, n.p.
———. *Paula Rego.* London: Phaidon, 1992, 239pp., illus. The principal monograph to date. Contains a bibliography.

Exhibitions

Art portugais contemporain. Paris: Musée d'Art Moderne de la Ville de Paris, 1976.
Willing, V. *Paula Rego: Paintings.* London: Edward Totah Gallery, 1985. Catalogue introduced by her husband.

Current Affairs: British Painting and Sculpture in the 1980s. Oxford: Museum of Modern Art, 1987.

Paula Rego. London: Serpentine Gallery, 1988.

Paula Rego: Nursery Rhymes. London: South Bank Centre, 1990, 47pp., mainly illus.

British Art Now: A Subjective View. Setagaya, Japan: Setagaya Art Museum in association with the British Council, 1990. Includes a list of group and solo exhibitions together with a select bibliography.

Waves of Influence: cinco séculos do azulejo português. Staten Island, N.Y.: Snug Harbour Cultural Center, 1995.

Paula Rego. Liverpool: Tate Gallery, 1995, 154pp., illus. Contains four scholarly essays analysing Rego's work.

Other Sources

Dunford, Penny. *A Biographical Dictionary of Women Artists in Europe and America since 1850.* Hemel Hempstead: Harvester Wheatsheaf and Philadelphia: University of Pennsylvania Press, 1990. Contains a bibliography.

2987 REIDMETA, ILME (1954–)
 Estonian painter.

Exhibitions

8. Baltijas Republiku Akvareļu Izstāde: Katalogs. Riga, 1989.

2988 REID, NANO (1905–1981)
 Irish painter of landscapes and figure subjects; with Norah McGuinness, she was a promoter of contemporary Irish art.

Exhibitions

Irish Women Artists from the Eighteenth Century to the Present Day. Dublin: National Gallery of Ireland, Douglas Hyde Gallery and Hugh Lane Gallery, 1987.

Other Sources

Dunford, Penny. *A Biographical Dictionary of Women Artists in Europe and America since 1850.* Hemel Hempstead: Harvester Wheatsheaf and Philadelphia: University of Pennsylvania Press, 1990. Contains a bibliography.

2989 REIS, MARIA LUIZA (1902–)
 Portuguese painter.

Other Sources

Di Pamplona, Fernando. *Um seculo de pintura e escultura em Portugal, 1830–1930.* Porto: Livraria Tavares Martins, 1943.

2990 RICHARDS, FRANCES (née CLAYTON) (1901–1985)
 English graphic artist, painter and collagist in textiles who also wrote
 poetry; wife of the painter Ceri Richards.

Exhibitions

Frances Richards. London: Leicester Gallery, 1964. Contains a brief biography and list of exhibits.

Other Sources

Dunford, Penny. *A Biographical Dictionary of Women Artists in Europe and America since 1850.* Hemel Hempstead: Harvester Wheatsheaf and Philadelphia: University of Pennsylvania Press, 1990. Contains a bibliography.
 Dunthorne, Katherine. *Artists Exhibited in Wales, 1945–1974.* Cardiff: Welsh Arts Council, 1976.

2991 RICHÉ, ADÈLE (1791–1887)
 French painter of flowers.

Other Sources

Hardouin-Fugier, Elizabeth. *The Pupils of Redouté.* Leigh-on-Sea: F. Lewis, 1981.
 Hardouin-Fugier, Elizabeth, and E. Grafe. *French Flower Painters of the Nineteenth Century: A Dictionary.* London: Philip Wilson, 1989.

2992 RIJKS, NAAN (1940–)
 Dutch painter.

Exhibitions

De Vrouw in de kunst. Leiden: Pand Caecilia, 1987.

2993 RILEY, BRIDGET (1931–)
 English abstract painter who explores optical effects in black and white and colour.

Publications

"The Hermaphrodite." In *Art and Sexual Politics,* ed. Thomas Hess and Elizabeth Baker. New York, 1973.

Main Sources

Lee, Rosa. "Oblique Glances." *Women's Art Magazine* 49 (1992): 7–9.

Exhibitions

British Painting 1952–1977. London: Royal Academy, 1977.
Künstlerinnen international, 1877–1977. Berlin: Schloss Charlottenburg, 1977.
Women's Art Show, 1550–1970. Nottingham: Castle Museum, 1982.
Contains a brief biography.
Sellars, Jane. *Women's Works.* Liverpool: Walker Art Gallery, 1988.
Künstlerinnen des 20. Jahrhunderts. Wiesbaden: Museum Wiesbaden in association with Verlag Weber & Weidermeyer GmbH, Kassel, 1990.
Koudielka, Robert. *Bridget Riley: Paintings 1982–1992.* London: Hayward Gallery, 1992, 62pp., 23 illus.
Mellor, David. *The Sixties Art Scene in London.* London: Barbican Art Gallery in association with Phaidon Press, 1993.

Other Sources

Dunford, Penny. *A Biographical Dictionary of Women Artists in Europe and America since 1850.* Hemel Hempstead: Harvester Wheatsheaf and Philadelphia: University of Pennsylvania Press, 1990. Contains a bibliography.
Parry-Crooke, Charlotte. *Contemporary British Artists.* London: Bergstrom and Boyle, 1979.

2994 RIMMINGTON, EDITH (1902–1986)
 English Surrealist painter and, from 1967, photographer.

Main Sources

Chadwick, Whitney. *Women Artists and the Surrealist Movement.* London: Thames and Hudson, 1985.

Exhibitions

British Women Surrealists. London: Blond Fine Art, 1985.
Salute to British Surrealism. Colchester: Minories Gallery, 1985.
The Surrealist Spirit in Britain. London: Whitford and Hughes, 1988.

Other Sources

Dunford, Penny. *A Biographical Dictionary of Women Artists in Europe and America since 1850.* Hemel Hempstead: Harvester Wheatsheaf and Philadelphia: University of Pennsylvania Press, 1990. Contains a bibliography.

2995 RISSA (1938–)
 German painter and graphic artist.

Other Sources

Evers, Ulrike. *Deutsche Künstlerinnen des 20. Jahrhunderts. Malerei— Bildhauerei—Tapisserie.* Hamburg: Ludwig Schultheis Verlag, 1983. Contains an individual bibliography.

2996 RITSEMA, COBA (née JACOBA JOHANNA RITSEMA) (1876–1961)
Dutch painter of still lifes, figures and portraits.

Exhibitions

Kunst door vrouwen. Leiden: Stedelijk Museum De Lakenhal, 1987.

Other Sources

Dunford, Penny. *A Biographical Dictionary of Women Artists in Europe and America since 1850.* Hemel Hempstead: Harvester Wheatsheaf and Philadelphia: University of Pennsylvania Press, 1990. Contains a bibliography.

Krichbaum, J., and R. Zondergeld. *Künstlerinnen: von der Antike bis zur Gegenwart.* Cologne: DuMont, 1979.

Venema, A. *De Amsterdamse Joffers.* Baarn, 1977.

2997 ROBERTSON, CHRISTINA (née SAUNDERS) (1796–1854)
Scottish portrait painter patronised by the British and Russian aristocracy and later by the Tsar's family in St. Petersburg.

Exhibitions

Christina Robertson: A Scottish Portraitist at the Russian Court. Edinburgh: City Art Gallery, 1996, 52pp., illus. Separate essays describe the activities of Robertson in Britain and Russia and there are detailed notes on the exhibits.

2998 ROBERTSON, CLEMENTINA (Alt. SIREE) (1795–c. 1853/8)
Irish painter of miniatures.

Other Sources

Foskett, Daphne. *Miniatures: A Dictionary and Guide.* Woodbridge: Antique Collectors Club, 1987.

2999 ROCHE, JULIETTE (1884–after 1980)
French painter who worked with the Nabis and later participated in Dada activities.

Publications

Demi-cercle. Paris, 1920. A collection of poems.
Souvenirs. Paris, 1980. Autobiography.

Exhibitions

Vergine, Lea. *L'altra metà dell'avanguardia.* Milan: Mazzotta Editore, 1980. *L'autre moitié de l'avant-garde.* Paris: Des Femmes, 1982.

Other Sources

Dunford, Penny. *A Biographical Dictionary of Women Artists in Europe and America since 1850.* Hemel Hempstead: Harvester Wheatsheaf and Philadelphia: University of Pennsylvania Press, 1990. Contains a bibliography.

3000 ROEDERSTEIN, OTTILIE W. (1859–1937)
Swiss painter of portraits, genre, still life and landscapes.

Other Sources

Dunford, Penny. *A Biographical Dictionary of Women Artists in Europe and America since 1850.* Hemel Hempstead: Harvester Wheatsheaf and Philadelphia: University of Pennsylvania Press, 1990. Contains a bibliography.
Hirsch, A. *Die bildenden Künstlerinnen der Neuzeit.* Stuttgart, 1905.
Krichbaum, J., and R. Zondergeld. *Künstlerinnen: von der Antike bis zur Gegenwart.* Cologne: DuMont, 1979.
Lexikon der Frau. Zurich: Encyclios Verlag, 1953.
Sparrow, Walter Shaw. *Women Painters of the World.* London: Hodder and Stoughton, 1905.

3001 ROMANELLI, LILLI (c. 1936–)
Italian abstract painter.

Other Sources

Weller, Simone. *Il Complesso di Michelangelo: ricerca sul contributo dato dalla donna all'arte italiana del novecento.* Pollenza-Macerata: La Nuova Foglio [*sic*] Editrice, 1976.

3002 ROMANI, JUANA H. C. (1869–1924)
Italian painter of historical and allegorical figures, including images of femmes fatales, together with portraits; she worked in France.

Main Sources

"Juana Romani." *Studio* 53 (May 1913): 325–327.

Other Sources

Clement, Clara. *Women in the Fine Arts.* Boston: Houghton Mifflin, 1904.
Dunford, Penny. *A Biographical Dictionary of Women Artists in Europe and America since 1850.* Hemel Hempstead: Harvester Wheatsheaf and Philadelphia: University of Pennsylvania Press, 1990. Contains a bibliography.
Edouard-Joseph, R. *Dictionnaire biographique des artistes contemporains, 1910–1930.* Paris: Art et Editions, 1930–1934.
Hirsch, A. *Die bildenden Künstlerinnen der Neuzeit.* Stuttgart, 1905.
Krichbaum, J., and R. Zondergeld. *Künstlerinnen: von der Antike bis zur Gegenwart.* Cologne: DuMont, 1979.

Martin, Jules. *Nos peintres et sculpteurs, graveurs et dessinateurs.* Paris, 1897.

Sparrow, Walter Shaw. *Women Painters of the World.* London: Hodder and Stoughton, 1905.

3003 RONNER, HENRIETTE (née KNIP) (1821–1909)
Dutch painter of dogs and, particularly, cats, who worked in Belgium.

Main Sources

Spielmann, Marion Harry. *Henriette Ronner: The Painter of Cat Life and Cat Character.* London: Cassell & Co., 1891, 47pp., chiefly illus.

Other Sources

Clement, Clara. *Women in the Fine Arts.* Boston: Houghton Mifflin, 1904.

Dunford, Penny. *A Biographical Dictionary of Women Artists in Europe and America since 1850.* Hemel Hempstead: Harvester Wheatsheaf and Philadelphia: University of Pennsylvania Press, 1990. Contains a bibliography.

3004 ROOSENBOOM, MARGARETHA (1843–1896)
Dutch painter.

Exhibitions

Oele, Anneke, Mirian van Rijsingen, and Hesther van den Donk. *Bloemen uit de kelder: negen kunstnaressen rond de eeuwwisseling.* Arnhem: Gemeente-museum, 1989.

Other Sources

Pavière, Sidney. *Dictionary of Flower, Fruit and Still-life Painters.* Vol. 3: *The 19th Century*, part 2. Leigh-on-Sea: Frank Lewis, 1964.

3005 ROSA, ROSÀ (Pseudonym of EDITH VON HAYNAU; alt. ARNALDI) (1884–after 1980)
Austrian painter, graphic artist, sculptor, designer of ceramics and poet who worked in Italy.

Publications

"Romanticismo sonnambulo" (1917). Reprinted in Enrico Crispolti, *Il mito della macchina e altri temi del futurismo,* 152–155. Trapani: Editore Celebes, 1969. See Lea Vergine below.

Main Sources

Katz, M. B. "The Women of Futurism." *Woman's Art Journal* 7, no. 2 (fall 1986–winter 1987): 4–5.

Exhibitions

Vergine, Lea. *L'altra metà dell'avanguardia.* Milan: Mazzotta Editore, 1980. *L'autre moitié de l'avant-garde.* Paris: Des Femmes, 1982.

Other Sources

Dunford, Penny. *A Biographical Dictionary of Women Artists in Europe and America since 1850.* Hemel Hempstead: Harvester Wheatsheaf and Philadelphia: University of Pennsylvania Press, 1990. Contains a bibliography.

Weller, Simone. *Il Complesso di Michelangelo: ricerca sul contributo dato dalla donna all'arte italiana del novecento.* Pollenza-Macerata: La Nuova Foglio [*sic*] Editrice, 1976.

3006 ROSSETTI, LUCY (née BROWN) (1843–1894)
English painter of literary and atmospheric pictures, often with unusual lighting effects; the daughter of the Pre-Raphaelite painter Ford Madox Brown.

Main Sources

Clayton, Ellen. *English Female Artists.* London: Tinsley, 1876.

Other Sources

Cherry, Deborah. *Painting Women: Victorian Women Artists.* London: Routledge, 1993.

Dunford, Penny. *A Biographical Dictionary of Women Artists in Europe and America since 1850.* Hemel Hempstead: Harvester Wheatsheaf and Philadelphia: University of Pennsylvania Press, 1990. Contains a bibliography.

Fredeman, W. *Pre-Raphaelitism: A Biblio-critical Study.* Cambridge, Mass., 1965. To be consulted for bibliographical references.

3007 ROSS-CRAIG, STELLA (1906–)
English botanical painter.

Other Sources

Blunt, Wilfrid. *The Art of Botanical Illustration.* New Naturalist Series. London: Collins, 1950.

Saunders, Gill. *Picturing Plants: An Analytical History of Botanical Illustration.* London: Victoria and Albert Museum in association with Zwemmer, 1995.

3008 ROZANOVA, OLGA VLADIMIROVNA (Alt. ROSANOVA) (1886–1918)
Russian abstract painter, graphic artist and collagist.

Main Sources

Yablonskaya, Miuda. *Women Artists of Russia's New Age, 1900–1935.* Ed. and trans. Anthony Parton. N.Y.: Rizzoli & London: Thames and Hudson, 1990. Contains a chapter on each artist while notes and an individual bibliography provide access to material in Russian.

Exhibitions

Harris, Anne Sutherland, and Linda Nochlin. *Women Artists 1550–1950.* Los Angeles: County Museum of Art, 1976.

Künstlerinnen international, 1877–1977. Berlin: Schloss Charlottenburg, 1977.

Russian Women Artists of the Avant-garde, 1910–1930. Cologne, Galerie Gmurzynska, 1979.

Barron, S., and M. Tuchman. *The Avant-garde in Russia, 1910–1930: New Perspectives.* Los Angeles: County Museum of Art, 1980.

Vergine, Lea. *L'altra metà dell'avanguardia.* Milan: Mazzotta Editore, 1980. *L'autre moitié de l'avant-garde.* Paris: Des Femmes, 1982.

Dabrowski, M. *Contrasts of Form.* New York: Museum of Modern Art, 1980.

De la Révolution à la Pérréstroika. Art Soviétique de la Collection Ludwig. St. Etienne: Musée d'Art Moderne, 1989.

Avanguardia russa dalle collezioni private sovietiche origini e percorso 1904–1934. Milan: Palazzo Reale, 1989.

Other Sources

Dunford, Penny. *A Biographical Dictionary of Women Artists in Europe and America since 1850.* Hemel Hempstead: Harvester Wheatsheaf and Philadelphia: University of Pennsylvania Press, 1990. Contains a bibliography.

Milner, John. *A Dictionary of Russian and Soviet Artists, 1420–1970.* Woodbridge: Antique Collectors Club, 1993.

3009 ROZENDORF, ELIZAVETA BERNGARDOVNA (1898–after 1932)
Russian painter, graphic artist and designer of ceramics.

Exhibitions

Paris-Moscou 1900–1939. Paris: Centre national d'art et de culture Georges Pompidou, 1979.

Other Sources

Milner, John. *A Dictionary of Russian and Soviet Artists, 1420–1970.* Woodbridge: Antique Collectors Club, 1993.

3010 ROZENGOLTS-LEVINA, EVA (1898–1975)
Russian painter of figures and landscapes.

Main Sources

Yablonskaya, Miuda. *Women Artists of Russia's New Age, 1900–1935.* Ed. and trans. Anthony Parton. New York: Rizzoli & London: Thames and Hudson, 1990. Contains a chapter on each artist while notes and an individual bibliography provide access to material in Russian.

Other Sources

Milner, John. *A Dictionary of Russian and Soviet Artists, 1420–1970.* Woodbridge: Antique Collectors Club, 1993.

3011 ROŽÁTOVÁ, ELIŠKA (1940–)
Czech painter.

Exhibitions

Obraz 69. Brno: Moravská Galerie, 1969.

3012 RØGEBERG, HANNELINE (1963–)
Norwegian painter of monumental nude female figures.

Exhibitions

Fisher, Susan Sterling, Anne Wichstrøm, and Toril Smit. *At Century's End: Norwegian Artists and the Figurative Tradition, 1880–1990.* Høvikodden: Henie-Onstad Art Centre, 1995. Includes a list of exhibitions and an individual bibliography.

3013 RÖSLER, LOUISE (1907–)
German painter and graphic artist.

Exhibitions

Das Verborgene Museum. Dokumentation der Kunst von Frauen in Berliner öffentlichen Sammlungen. Berlin: Edition Hentrich, 1987.

Other Sources

Evers, Ulrike. *Deutsche Künstlerinnen des 20. Jahrhunderts. Malerei— Bildhauerei—Tapisserie.* Hamburg: Ludwig Schultheis Verlag, 1983. Contains an individual bibliography.

3014 RUNGE, SIRI (1950–)
Estonian abstract painter.

Other Sources

Rosenfeld, Alla, and Norton Dodge, eds. *Nonconformist Art: The Soviet Experience, 1956–1986. The Norton and Nancy Dodge Collection.* London: Thames and Hudson in association with the Jane Voorhees Zimmerli Art Museum, State University of New Jersey, Rutgers, 1995.

3015 RYANGINA, SERAFIMA VASILIEVNA (Alt. RIANGINA) (1891–1955)
 Russian painter of genre in the Socialist Realist style.

Other Sources

Milner, John. *A Dictionary of Russian and Soviet Artists, 1420–1970.* Woodbridge: Antique Collectors Club, 1993.

3016 SALGADO, MARIA DA CONCEIÇAO RAVARA ALVES VELOSO (1929–)
 Portuguese painter.

Other Sources

Tannock, Michael. *Portuguese Artists of the Twentieth Century: A Biographical Dictionary.* Chichester: Phillimore & Co. Ltd., 1988.

3017 SALOMON, CHARLOTTE (1917–1943)
 German painter who depicted her sufferings under Nazi rule.

Main Sources

Felstiner, Mary Lowenthal. *To Paint Her Life: Charlotte Salomon in the Nazi Era.* New York: Harper Collins, 1994, 290pp., illus. A thorough and carefully researched investigation into her life and work. Contains a detailed bibliography.

Schmetterling, Astrid. "Life? or Theatre?" *Women's Art Magazine* 68 (1996): 32–33. Review of exhibition at the Kunstverein Braunschweig in 1995.

Exhibitions

Van Alphen, Ernst. "Charlotte Salomon: Autobiography as Resistance to History." In *Inside the Visible: An Elliptical View of 20th Century Art—In, Of and From the Feminine,* ed. Catherine De Zegher. Ghent: The Kanaal Foundation, 1996.

3018 SAMPERI, ELENA (1951–)
 Italian-born figurative painter who has worked in England since 1975.

Exhibitions

Women's Images of Men. London: Institute of Contemporary Art, 1980.

3019 SANDS, ETHEL (1873–1962)
American-born painter of interiors, figures and still lifes, associated at one time with the Camden Town Group, who worked in England and France.

Main Sources

Baron, Wendy. *Miss Ethel Sands and her Circle.* London: Peter Owen, 1977, 300pp., illus. A scholarly critical biography using primary sources and contacts with people who knew Sands.

Other Sources

Dunford, Penny. *A Biographical Dictionary of Women Artists in Europe and America since 1850.* Hemel Hempstead: Harvester Wheatsheaf and Philadelphia: University of Pennsylvania Press, 1990. Contains a bibliography.
Waters, Grant. *Dictionary of British Artists Working 1900–1940.* Eastbourne: Eastbourne Fine Art, 1975.

3020 SANTOS, ALDA MACHADO (1892–after 1943)
Portuguese painter of interiors and still life.

Other Sources

Di Pamplona, Fernando. *Um seculo de pintura e escultura em Portugal, 1830–1930.* Porto: Livraria Tavares Martins, 1943.

3021 SAUNDERS, HELEN (1885–1963)
English Vorticist painter and poet.

Main Sources

Beckett, Jane, and Deborah Cherry. "Women under the Banner of Vorticism." *Cahier* 8/9, 129–143.

Exhibitions

Vergine, Lea. *L'altra metà dell'avanguardia.* Milan: Mazzotta Editore, 1980. *L'autre moitié de l'avant-garde.* Paris: Des Femmes, 1982.
Peppin, Bridgid. *Helen Saunders.* Oxford: Asmolean Museum, 1996, 57pp.

Other Sources

Cork, Richard. *Vorticism and Abstract Art in the First Machine Age.* 2 vols. London, 1976.
Dunford, Penny. *A Biographical Dictionary of Women Artists in Europe and America since 1850.* Hemel Hempstead: Harvester Wheatsheaf and Philadelphia: University of Pennsylvania Press, 1990. Contains a bibliography.
Krichbaum, J., and R. Zondergeld. *Künstlerinnen: von der Antike bis zur Gegenwart.* Cologne: DuMont, 1979.

3022 SCHAUMANN, SIGRID MARIA (1877–1979)
Finnish painter of landscapes and figures.

Exhibitions

Sieben Finnische Malerinnen. Hamburg: Kunsthalle, 1983. Contains a short but focussed bibliography.

Other Sources

Boulton-Smith, J. *Modern Finnish Painting.* London, 1970.
Dunford, Penny. *A Biographical Dictionary of Women Artists in Europe and America since 1850.* Hemel Hempstead: Harvester Wheatsheaf and Philadelphia: University of Pennsylvania Press, 1990. Contains a bibliography.

3023 SCHEEL, SIGNE (1860–1942)
Norwegian painter of portraits and *intimiste* figures and interiors.

Other Sources

Dunford, Penny. *A Biographical Dictionary of Women Artists in Europe and America since 1850.* Hemel Hempstead: Harvester Wheatsheaf and Philadelphia: University of Pennsylvania Press, 1990. Contains a bibliography.
Wichstrøm, Anne. *Kvinner ved staffeliet.* Oslo: Universitetsforlaget, 1983.

3024 SCHEIN, FRANÇOISE (1953–)
Belgian painter who has contributed designs for the Lisbon Metro stations.

Exhibitions

Waves of Influence: cinco séculos do azulejo português. Staten Island, N.Y.: Snug Harbour Cultural Center, 1995.

3025 SCHJELDERUP, LEIS (1856–1933)
Norwegian painter.

Other Sources

Wichstrøm, Anne. *Kvinner ved staffeliet: Kvinnelige malere i Norge før 1900.* Oslo: Universitetsforlaget, 1983.

3026 SCHJERFBECK, HÉLNE SOFIA (1862–1946)
Finnish painter of interiors, figures, still lifes and self-portraits.

Main Sources

Facos, Michelle. "Hélène Schjerfbeck's Self-Portraits: Revelation and Dissimulation." *Woman's Art Journal* 16, no. 1 (spring–summer 1995): 12–17.

Holger, L. "The Convalescent motif and the Free Replicas: Hélène Schjerfbeck's Painting of a Young Girl." *Museojulkonisu (publication of the Ateneumin Taidemuseuo)* 23 (1980): 40–45.

Exhibitions

Sieben Finnische Malerinnen. Hamburg: Kunsthalle, 1983. Contains a short but focussed bibliography.

Dreams of a Summer Night. London: Hayward Gallery, 1985.

Levanto, Marjatta. *Hélène Schjerfbeck: Toipilaat Konvalescenter; Convalescents.* Helsinki: Ateneum Taidemuseuo, 1988, 60pp., illus. Text in Finnish and English. Held on the centenary of the first version of Scherfbeck's *The Convalescent.* The other versions were all commissioned by art dealer Gösler Stenman who was born in that same year. There is a detailed essay on the theme and the commissions.

Nordisk Sekelskifte: The Light of the North. Stockholm: Nationalmuseum, 1995.

Other Sources

Dunford, Penny. *A Biographical Dictionary of Women Artists in Europe and America since 1850.* Hemel Hempstead: Harvester Wheatsheaf and Philadelphia: University of Pennsylvania Press, 1990. Contains a bibliography.

3027 SCHRAG, MARTHA (1870–1957)

German graphic artist and painter of industrial landscapes and the local working people.

Exhibitions

Gleisberg, D. *Deutsche Künstlerinnen des zwanzigsten Jahrhunderts.* Attenburg: Staatlichen Lindendau Museum, 1963.

Meskimmon, Marsha. *Domesticity and Dissent: The Role of Women Artists in Germany 1918–1938. Haüsliches Leben und Dissens.* Leicester: Leicestershire Museums Publication no. 120, 1992.

3028 SCHULZE-KNABE, EVA (née KNABE) (1906–1976)

German painter.

Exhibitions

Gleisberg, D. *Deutsche Künstlerinnen des zwanzigsten Jahrhunderts.* Attenburg: Staatlichen Lindendau Museum, 1963.

Meskimmon, Marsha. *Domesticity and Dissent: The Role of Women Artists in Germany 1918–1938. Haüsliches Leben und Dissens.* Leicester: Leicestershire Museums Publication no. 120, 1992.

3029 SCHWARTZE, THÉRÈSE (1851–1918)

Dutch painter of portraits, with some genre and still lifes.

Exhibitions

Oele, Anneke, Mirian van Rijsingen, and Hesther van den Donk. *Bloemen uit de kelder: negen kunstnaressen rond de eeuwwisseling.* Arnhem: Gemeentemuseum, 1989.

Other Sources

Clement, Clara. *Women in the Fine Arts.* Boston: Houghton Mifflin, 1904.
Dunford, Penny. *A Biographical Dictionary of Women Artists in Europe and America since 1850.* Hemel Hempstead: Harvester Wheatsheaf and Philadelphia: University of Pennsylvania Press, 1990. Contains a bibliography.
Krichbaum, J., and R. Zondergeld. *Künstlerinnen: von der Antike bis zur Gegenwart.* Cologne: DuMont, 1979.
Venema, A. *Die Amsterdamse Joffers.* Baarn, 1977.

3030 SCOTT-MOORE, ELIZABETH (née BRIER) (1902–1993)
English painter.

Main Sources

Sheppard, Maurice. "Elizabeth Scott-Moore." *Independent,* 23 August 1993. Obituary.
———. "Elizabeth Scott-Moore." *Guardian,* 24 August 1993. Obituary.

3031 SELLARS, PANDORA
English botanical painter and graphic artist.

Other Sources

Saunders, Gill. *Picturing Plants: An Analytical History of Botanical Illustration.* London: Victoria and Albert Museum in association with Zwemmer, 1995.

3032 SERRANO Y BARTOLOME, JOAQUINA (active late nineteenth century)
Spanish painter of portraits, flowers, still life and genre.

Other Sources

Clement, Clara. *Women in the Fine Arts.* Boston: Houghton Mifflin, 1904.
Dunford, Penny. *A Biographical Dictionary of Women Artists in Europe and America since 1850.* Hemel Hempstead: Harvester Wheatsheaf and Philadelphia: University of Pennsylvania Press, 1990. Contains a bibliography.

3033 SERRUYS, YVONNE (1873/4–1953)
French sculptor and painter; also designer of glass.

Other Sources

Dictionnaire des Peintres Belges du XIVe siècle à nos jours. Brussels: La Renaissance du Livre, 1995.

Arwas, Victor. *Glass: Art Nouveau to Art Déco.* London: Academy Editions, 1977.

Hilschenz, Helga. *Das Glas von Jugendstils: Katalog der Sammlung Hentrich im Kunstmuseum Düsseldorf.* Munich: Prestel, 1973.

Hammel, Maurice. "Les Salons de 1914: la sculpture." *Les Arts* 150 (1914): 9–13. Illustrates a work of a girl dancing with a scarf; there is a brief mention of the artist.

Maignan, M. "Cours de décoration: cinquième leçon: des concours." *L'Art Décoratif* 27 (1912): 69–76. Serruys is mentioned favourably on pp. 74–75.

3034 SETCHELL, SARAH (1803–1894)
English painter of scenes of humble life.

Main Sources

"Sarah Setchell." *The Times,* 17 January 1894. Obituary.
Clayton, Ellen. *English Female Artists.* London: Tinsley, 1876.

Exhibitions

Women's Art Show, 1550–1970. Nottingham: Castle Museum, 1982. Contains a brief biography.

Other Sources

Dunford, Penny. *A Biographical Dictionary of Women Artists in Europe and America since 1850.* Hemel Hempstead: Harvester Wheatsheaf and Philadelphia: University of Pennsylvania Press, 1990. Contains a bibliography.

Mallalieu, Hugh. *Dictionary of British Watercolour Artists.* Woodbridge: Antique Collectors Club, 1976.

Yeldham, Charlotte. *Women Artists in Nineteenth Century France and England.* London and New York: Garland, 1984.

3035 SEVERN, ANN MARY (Alt. LADY NEWTON) (1832–1866)
English painter of portraits, figures and topographical landscapes executed during her travels abroad.

Main Sources

"Lady Newton." *Art Journal,* 1866, 100.
Clayton, Ellen. *English Female Artists.* London: Tinsley, 1876.

Exhibitions

Cherry, Deborah. *Painting Women: Victorian Women Artists.* Rochdale: Art Gallery, 1987.

Other Sources

Clement, Clara. *Women in the Fine Arts.* Boston: Houghton Mifflin, 1904.
Cherry, Deborah. *Painting Women: Victorian Women Artists.* London: Routledge, 1993.
Dunford, Penny. *A Biographical Dictionary of Women Artists in Europe and America since 1850.* Hemel Hempstead: Harvester Wheatsheaf and Philadelphia: University of Pennsylvania Press, 1990. Contains a bibliography.
Mallalieu, Hugh. *Dictionary of British Watercolour Artists.* Woodbridge: Antique Collectors Club, 1976.
Nunn, Pamela Gerrish. *Victorian Women Artists.* London: Women's Press, 1987.
Wood, Christopher. *The Dictionary of Victorian Painters.* Woodbridge: Antique Collectors Club, 1978. She is listed under both Newton and Severn.

3036 SHACKLETON, LYDIA (1828–1914)
Irish botanical painter who specialised in exotic orchids and by whom over 1500 paintings are known.

Exhibitions

Irish Women Artists from the Eighteenth Century to the Present Day. Dublin: National Gallery of Ireland, Douglas Hyde Gallery and Hugh Lane Gallery, 1987.

Other Sources

De Breffny, Brian, ed. *Ireland: A Cultural Encyclopaedia.* London: Thames and Hudson, 1983.

3037 SHAKESPEAR, DOROTHY (Alt. POUND) (1886–1973)
English Vorticist painter.

Main Sources

Beckett, Jane, and Deborah Cherry. "Women under the Banner of Vorticism." *Cahier* 8/9, 129–143.
Merchant, M., ed. *A Notebook with Drawings and Watercolours by Dorothy Shakespear Pound.* Exeter: Rougemeont Press, 1971.

Exhibitions

Vergine, Lea. *L'altra metà dell'avanguardia.* Milan: Mazzotta Editore, 1980. *L'autre moitié de l'avant-garde.* Paris: Des Femmes, 1982.

Other Sources

Cork, Richard. *Vorticism and Abstract Art in the First Machine Age.* 2 vols. London: 1976.
Dunford, Penny. *A Biographical Dictionary of Women Artists in Europe and*

America since 1850. Hemel Hempstead: Harvester Wheatsheaf and Philadelphia: University of Pennsylvania Press, 1990. Contains a bibliography.

3038 SHARPLES, ELLEN (née WALLACE) (1769–1849)
English painter mainly of portraits and miniatures; third wife of the portraitist James and mother of Rolinda (q.v.).

Main Sources

Knox, Katharine McCook. *The Sharples: Their Portraits of George Washington and His Contemporaries. A Diary and an Account of the Life and Work of James Sharples and His Family in England and America.* New York: Kennedy Graphics Inc. & Da Capo Press Inc., 1930; reprinted 1972 by Yale University Press, New Haven. A very thorough biographical account using large extracts of primary sources.
Metz, Kathryn. "Ellen and Rolinda Sharples: Mother and Daughter Painters." *Woman's Art Journal* 16, no. 1 (spring–summer 1995): 3–11.

Other Sources

Foskett, Daphne. *Dictionary of British Miniature Painters.* London: Faber & Faber, 1972.
————. *Miniatures: A Dictionary and Guide.* Woodbridge: Antique Collectors Club, 1987.
Rubinstein, Charlotte Streifer. *American Women Artists from Early Indian Times to the Present Day.* Boston: G.K. Hall, 1984.

3039 SHARPLES, ROLINDA (1793–1838)
English painter of portraits, genre and historical subjects who died of breast cancer; daughter of Ellen (q.v.).

Main Sources

Knox, Katharine McCook. *The Sharples: Their Portraits of George Washington and His Contemporaries. A Diary and an Account of the Life and Work of James Sharples and His Family in England and America.* New York: Kennedy Graphics Inc. & Da Capo Press Inc., 1930; reprinted 1972 by Yale University Press, New Haven. A very thorough biographical account using large extracts of primary sources.
Metz, Kathryn. "Ellen and Rolinda Sharples: Mother and Daughter Painters." *Woman's Art Journal* 16, no. 1 (spring–summer 1995): 3–11.

Other Sources

Foskett, Daphne. *Miniatures: A Dictionary and Guide.* Woodbridge: Antique Collectors Club, 1987.
Rubinstein, Charlotte Streifer. *American Women Artists from Early Indian Times to the Present Day.* Boston: G.K. Hall, 1984.

3040 SHARP, DOROTHEA (1874–1955)

English painter, in an Impressionist style, of children both indoors and outside.

Main Sources

"Dorothea Sharp." *The Artist,* April 1935, 55–57.

Exhibitions

Silver Bells and Cockle Shells. London: Whitford and Hughes, 1986.

Other Sources

Dunford, Penny. *A Biographical Dictionary of Women Artists in Europe and America since 1850.* Hemel Hempstead: Harvester Wheatsheaf and Philadelphia: University of Pennsylvania Press, 1990. Contains a bibliography.

Waters, Grant. *Dictionary of British Artists Working 1900–1940.* Eastbourne: Eastbourne Fine Art, 1975.

3041 SHIRIKOVA, TATIANA (1952–)

Russian painter who uses a hyperrealist technique for fantastic images.

Other Sources

Rosenfeld, Alla, and Norton Dodge, eds. *Nonconformist Art: The Soviet Experience, 1956–1986. The Norton and Nancy Dodge Collection.* London: Thames and Hudson in association with the Jane Voorhees Zimmerli Art Museum, State University of New Jersey, Rutgers, 1995.

3042 SIDDAL, ELIZABETH ELEANOR (Alt. SIDDALL; ROSSETTI) (1829–1862)

English painter of medieval and literary scenes in a Pre-Raphaelite style; also a poet.

Publications

Allnutt, Gillian. *Lizzie Siddal: Her Journal 1862.* Warwick: Greville Press, 1985.

Main Sources

Cherry, Deborah, and Griselda Pollock. "Woman as Sign in Pre-Raphaelite Literature: A Study of the Representation of Elizabeth Siddal." *Art History* 7, no. 2 (1984): 206–227.

Marsh, Jan. *Pre-Raphaelite Sisterhood.* London: Quartet Books, 1985. Reprinted 1992. 408pp., illus. Analyses the reality of life for a group of women in this intellectual circle, amongst whom is Siddal.

———. *The Legend of Elizabeth Siddal.* London: Quartet Books, 1989,

244pp., illus. The most detailed attempt to identify Siddal's training and activities as an artist and to separate this from the representations of her by the Pre-Raphaelites and others.

————. "Elizabeth Siddal: Pre-Raphaelite Artist." *Women's Art Magazine* 38 (1991): 17.

Marsh, Jan, and Pamela Gerrish Nunn. *Women Artists and the Pre-Raphaelite Movement.* London: Virago, 1989.

Shefer, E. "Elizabeth Siddal's Lady of Shalott." *Woman's Art Journal* 9, no. 1 (spring–summer 1988): 21–29.

Exhibitions

Casteras, Susan, and Linda H. Peterson. *A Struggle for Fame: Victorian Women Artists and Authors.* New Haven, Conn.: Yale Center for British Art, 1994.

Harris, Anne Sutherland, and Linda Nochlin. *Women Artists 1550–1950.* Los Angeles: County Museum of Art, 1976.

Marsh, Jan. *Elizabeth Siddal: Pre-Raphaelite Artist, 1829–1862.* Sheffield: Ruskin Gallery, 1991, 82pp., illus. Contains a bibliography.

Sulter, Maud. *Echo: Works by Women Artists, 1850–1940.* Liverpool: Tate Gallery, 1991.

Other Sources

Bachmann, Donna, and Sherry Piland. *Women Artists: A Historical, Contemporary and Feminist Bibliography.* Metuchen, N.J.: Scarecrow Press, 1978.

Dunford, Penny. *A Biographical Dictionary of Women Artists in Europe and America since 1850.* Hemel Hempstead: Harvester Wheatsheaf and Philadelphia: University of Pennsylvania Press, 1990. Contains a bibliography.

Fredeman, W. *Pre-Raphaelitism: A Biblio-critical Study.* Cambridge, Mass., 1965. To be consulted for bibliographical references.

3043 SIDVALL, AMANDA (1844–1892)
 Swedish painter.

Exhibitions

Kvinnor som målat. Stockholm: Nationalmuseum, 1975.

Other Sources

Ingelman, Ingrid. *Kvinuliga konstnarer i Sverige en undersokning av Elever vid konstakademin Inskriva 1864–1924.* Uppsala: Almquist & Wiksell, 1982.

3044 SIEWERT, CLARA (1862–1944)
 German painter.

Exhibitions

Das Verborgene Museum. Dokumentation der Kunst von Frauen in Berliner öffentlichen Sammlungen. Berlin: Edition Hentrich, 1987.

3045 SILINA, INESE (1952–)
Latvian painter.

Exhibitions

8. Baltijas Republiku Akvareļu Izstāde: Katalogs. Riga, 1989.

3046 SIMONOVICH-EFIMOVA, NINA (1877–1948)
Russian painter and graphic artist.

Main Sources

Yablonskaya, Miuda. *Women Artists of Russia's New Age, 1900–1935.* Ed. and trans. Anthony Parton. New York: Rizzoli & London: Thames and Hudson, 1990. Contains a chapter on each artist while notes and an individual bibliography provide access to material in Russian.

Other Sources

Milner, John. *A Dictionary of Russian and Soviet Artists, 1420–1970.* Woodbridge: Antique Collectors Club, 1993.

3047 SITTER, INGER (1929–)
Norwegian painter and graphic artist.

Exhibitions

Wichstrøm, Anne. *Rooms with a View: Women's Art in Norway, 1880–1990.* Oslo: Ministry of Foreign Affairs, 1989.

Other Sources

Carey, Frances. *Modern Scandinavian Prints.* London: British Museum Press, 1997.
Dunford, Penny. *A Biographical Dictionary of Women Artists in Europe and America since 1850.* Hemel Hempstead: Harvester Wheatsheaf and Philadelphia: University of Pennsylvania Press, 1990. Contains a bibliography.
Gran, H., and P. Anker, eds. *Illustrert Norsk Kunstner Leksikon.* Oslo: Broen Bokhandel, 1956.

3048 SJOO, MONICA (1938–)
Swedish-born spiritual feminist painter, graphic artist and writer who lives in Wales.

Main Sources

Vincentelli, Moira. "Interview with Monica Sjoo." *Link: Newsheet of the Association of Artists and Designers of Wales,* July–August 1985, n.p.

Other Sources

Dunford, Penny. *A Biographical Dictionary of Women Artists in Europe and America since 1850.* Hemel Hempstead: Harvester Wheatsheaf and Philadelphia: University of Pennsylvania Press, 1990. Contains a bibliography.

Parker, Roszika, and Griselda Pollock. *Framing Feminism.* London: Pandora, 1987.

3049 SKAIDRĪTE, ELKSNĪTE (1929–)
Latvian painter.

Other Sources

Šmagre, Rita. *Latviešu Pastelis. Latvian Pastel Painting.* Riga: Liesma, 1990. Includes a brief account of her career.

3050 SKULME, DŽEMMA (1925–)
Latvian painter.

Main Sources

Stille, Alexander. "Comrade Artist." *Art News* 86 (January 1987): 10–12. Concerns Skulme as head of the Latvian Artists League and Secretary of the USSR Union of Artists.

Other Sources

Rosenfeld, Alla, and Norton Dodge, eds. *Nonconformist Art: The Soviet Experience, 1956–1986. The Norton and Nancy Dodge Collection.* London: Thames and Hudson in association with the Jane Voorhees Zimmerli Art Museum, State University of New Jersey, Rutgers, 1995.

3051 SLAVONA, MARIA (Pseudonym of MARIA DORETTE CAROLINE SCHORER) (1865–1931)
German Impressionist painter of portraits, landscapes and still lifes.

Main Sources

Stonge, Carmen. "Ida Gerhardt, Milly Steger and Maria Slavona." *Woman's Art Journal* 15, no. 1 (spring–summer 1994): 3–10.

Exhibitions

Das Verborgene Museum. Dokumentation der Kunst von Frauen in Berliner öffentlichen Sammlungen. Berlin: Edition Hentrich, 1987.

Other Sources

Dunford, Penny. *A Biographical Dictionary of Women Artists in Europe and America since 1850.* Hemel Hempstead: Harvester Wheatsheaf and Philadelphia: University of Pennsylvania Press, 1990. Contains a bibliography.

Krichbaum, J., and R. Zondergeld. *Künstlerinnen: von der Antike bis zur Gegenwart.* Cologne: DuMont, 1979.

Lexikon der Frau. Zurich: Encyclios Verlag, 1953.

3052 SNELLING, LILIAN (1878–?)
English botanical painter.

Other Sources

Blunt, Wilfrid. *The Art of Botanical Illustration.* New Naturalist Series. London: Collins, 1950.

Saunders, Gill. *Picturing Plants: An Analytical History of Botanical Illustration.* London: Victoria and Albert Museum in association with Zwemmer, 1995.

3053 SNITKOVSKAIA, ZHANNA (1934–)
Ukrainian painter.

Other Sources

Rosenfeld, Alla, and Norton Dodge, eds. *Nonconformist Art: The Soviet Experience, 1956–1986. The Norton and Nancy Dodge Collection.* London: Thames and Hudson in association with the Jane Voorhees Zimmerli Art Museum, State University of New Jersey, Rutgers, 1995.

3054 SOFRONOVA, ANTONINA FYODOROVNA (1892–1966)
Russian painter who in the 1920s and 1930s also took up graphic art.

Main Sources

Elliott, David, and V. Dudakov. *100 Years of Russian Art.* London: Lund Humphries, 1989.

Yablonskaya, Miuda. *Women Artists of Russia's New Age, 1900–1935.* Ed. and trans. Anthony Parton. New York: Rizzoli & London: Thames and Hudson, 1990. Contains a chapter on each artist while notes and an individual bibliography provide access to material in Russian.

Other Sources

Milner, John. *A Dictionary of Russian and Soviet Artists, 1420–1970.* Woodbridge: Antique Collectors Club, 1993.

3055 SOLOMONS, ESTELLA FRANCES (1882–1968)
Irish painter.

Exhibitions

Irish Women Artists from the Eighteenth Century to the Present Day. Dublin: National Gallery of Ireland, Douglas Hyde Gallery and Hugh Lane Gallery, 1987.

3056 SOLOMON, REBECCA (1832–1886)
English painter of literary and other figure subjects.

Main Sources

Clayton, Ellen. *English Female Artists.* London: Tinsley, 1876.
Nunn, Pamela Gerrish. "Rebecca Solomon: Painting and Drama." *Theatrephile* 8 (1985).
Nunn, Pamela Gerrish. "Rebecca Solomon's A Young Teacher." *Burlington Magazine,* October 1988, 769–770.

Exhibitions

Women's Art Show, 1550–1970. Nottingham: Castle Museum, 1982. Contains a brief biography.
Solomon: A Family of Painters. London: Geffrye Museum, 1985, 87pp., illus. Contains a critical essay on Rebecca Solomon by Nunn, detailed notes on the eleven works exhibited and a bibliography.
Casteras, Susan, and Linda H. Peterson. *A Struggle for Fame: Victorian Women Artists and Authors.* New Haven, Conn.: Yale Center for British Art, 1994.

Other Sources

Dunford, Penny. *A Biographical Dictionary of Women Artists in Europe and America since 1850.* Hemel Hempstead: Harvester Wheatsheaf and Philadelphia: University of Pennsylvania Press, 1990. Contains a bibliography.

3057 SONREL, ELIZABETH (1874–1953)
French painter of literary and figure subjects, which often have a mystical atmosphere.

Exhibitions

Symbolist Painting. London: Hayward Gallery, 1972.
Fehrer, Catherine. *The Julian Academy, Paris, 1868–1939.* New York: Shepherd Gallery, 1989.

Other Sources

Dunford, Penny. *A Biographical Dictionary of Women Artists in Europe and America since 1850.* Hemel Hempstead: Harvester Wheatsheaf and Philadelphia: University of Pennsylvania Press, 1990. Contains a bibliography.

Edouard-Joseph, R. *Dictionnaire biographique des artistes contemporains, 1910–1930.* Paris: Art et Editions, 1930–1934.

Krichbaum, J., and R. Zondergeld. *Künstlerinnen: von der Antike bis zur Gegenwart.* Cologne: DuMont, 1979.

Sparrow, Walter Shaw. *Women Painters of the World.* London: Hodder and Stoughton, 1905.

Yeldham, Charlotte. *Women Artists in Nineteenth Century France and England.* London and New York: Garland, 1984.

3058 SOUTER, CAMILLE (née BETTY PAMELA HOLMES)
English painter of abstracts and semi-abstract landscapes and still lifes who lives in Ireland.

Exhibitions

Irish Women Artists from the Eighteenth Century to the Present Day. Dublin: National Gallery of Ireland, Douglas Hyde Gallery and Hugh Lane Gallery, 1987.

Other Sources

De Breffny, Brian, ed. *Ireland: A Cultural Encyclopaedia.* London: Thames and Hudson, 1983.

Dunford, Penny. *A Biographical Dictionary of Women Artists in Europe and America since 1850.* Hemel Hempstead: Harvester Wheatsheaf and Philadelphia: University of Pennsylvania Press, 1990. Contains a bibliography.

3059 SPALVINA, IEVA (1948–)
Latvian painter.

Exhibitions

8. Baltijas Republiku Akvareļu Izstāde: Katalogs. Riga, 1989.

3060 SPARTALI, MARIA (Alt. STILLMAN; SPARTALI-STILLMAN) (1844–1927)
Greek painter of classical, Italian and medieval subjects who worked in England with the Pre-Raphaelite circle.

Main Sources

Christian, J. "Marie Stillman."*Antique Collector,* 1984, no. 3, 42–47.

Clayton, Ellen. *English Female Artists.* London: Tinsley, 1876.

Marsh, Jan, and Pamela Gerrish Nunn. *Women Artists and the Pre-Raphaelite Movement.* London: Virago, 1989.

Exhibitions

Cherry, Deborah. *Painting Women: Victorian Women Artists.* Rochdale: Art Gallery, 1987.

Sellars, Jane. *Women's Works*. Liverpool: Walker Art Gallery, 1988.
The Last Romantics. The Romantic Tradition in British Art: Burne-Jones to Stanley Spencer. London: Barbican Art Gallery, 1989.
Casteras, Susan, and Linda H. Peterson. *A Struggle for Fame: Victorian Women Artists and Authors*. New Haven, Conn.: Yale Center for British Art, 1994.

Other Sources

Dunford, Penny. *A Biographical Dictionary of Women Artists in Europe and America since 1850*. Hemel Hempstead: Harvester Wheatsheaf and Philadelphia: University of Pennsylvania Press, 1990. Contains a bibliography.
Fredeman, W. *Pre-Raphaelitism: A Biblio-critical Study*. Cambridge, Mass., 1965. To be consulted for bibliographical references.
Marsh, Jan. *Pre-Raphaelite Sisterhood*. London: Quartet Books, 1989.
Yeldham, Charlotte. *Women Artists in Nineteenth Century France and England*. London and New York: Garland, 1984.

3061 STANNARD, ELOISE HARRIET (1828–1915)
English painter of fruit and flowers who belonged to the Norwich School.

Main Sources

Clayton, Ellen. *English Female Artists*. London: Tinsley, 1876.

Exhibitions

Women's Art Show, 1550–1970. Nottingham: Castle Museum, 1982. Contains a brief biography.
Cherry, Deborah. *Painting Women: Victorian Women Artists*. Rochdale: Art Gallery, 1987.

Other Sources

Cherry, Deborah. *Painting Women: Victorian Women Artists*. London: Routledge, 1993.
Day, Harold. *East Anglian Painters*. Eastbourne: Sumfield and Day, 1968, vol. 3. Contains an annotated chronology, a discussion of her work and lists of works exhibited in London and various Norfolk venues.
Dilkes, W. F. *The Norwich School of Painting*, 3:207–221. London, 1969.
Dunford, Penny. *A Biographical Dictionary of Women Artists in Europe and America since 1850*. Hemel Hempstead: Harvester Wheatsheaf and Philadelphia: University of Pennsylvania Press, 1990. Contains a bibliography.
Nunn, Pamela Gerrish. *Victorian Women Artists*. London: Women's Press, 1987.

3062 STANNARD, EMILY (née COPPIN) (1803–1885)
English painter of fruit and flowers; her mother was a still life painter. She belonged to the Norwich school.

Main Sources

Clayton, Ellen. *English Female Artists.* London: Tinsley, 1876.
Cherry, Deborah. *Painting Women: Victorian Women Artists.* London: Routledge, 1993.

Exhibitions

Women's Art Show, 1550–1970. Nottingham: Castle Museum, 1982. Contains a brief biography.

Other Sources

Day, Harold. *East Anglian Painters,* vol. 3. Eastbourne: Sumfield and Day, 1968. Contains an annotated chronology, a discussion of her work and lists of works exhibited in London and various Norfolk venues.
Dunford, Penny. *A Biographical Dictionary of Women Artists in Europe and America since 1850.* Hemel Hempstead: Harvester Wheatsheaf and Philadelphia: University of Pennsylvania Press, 1990. Contains a bibliography.
Wood, Christopher. *The Dictionary of Victorian Painters.* Woodbridge: Antique Collectors Club, 1978.

3063 STARR, LOUISA (Alt. CANZIANI) (1845–1909)
English painter of historical, literary and genre scenes, one of the earliest and—at 16, one of the youngest—women to gain admission to the Royal Academy Schools; mother of the painter Estella Canziani (q.v.).

Main Sources

Canziani, Estella. *Round About Three Palace Green.* London, 1939. Biography of Starr by her daughter.
Clayton, Ellen. *English Female Artists.* London: Tinsley, 1876.
Nunn, Pamela Gerrish. *Canvassing.* London: Camden Press, 1986. Contains extracts from Canziani's biography and an assessment by Nunn of Starr's achievements.

Exhibitions

Sellars, Jane. *Women's Works.* Liverpool: Walker Art Gallery, 1988.

Other Sources

Dunford, Penny. *A Biographical Dictionary of Women Artists in Europe and America since 1850.* Hemel Hempstead: Harvester Wheatsheaf and Philadelphia: University of Pennsylvania Press, 1990. Contains a bibliography.
Nunn, Pamela Gerrish. *Victorian Women Artists.* London: Women's Press, 1987.
Sparrow, Walter Shaw. *Women Painters of the World.* London: Hodder and Stoughton, 1905.

Yeldham, Charlotte. *Women Artists in Nineteenth Century France and England.* London and New York: Garland, 1984.

3064 STEINEGER, AGNES (1863–1965)
Norwegian painter.

Other Sources

Wichstrøm, Anne. *Kvinner ved staffeliet: Kvinnelige malere i Norge før 1900.* Oslo: Universitetsforlaget, 1983.

3065 STEPANOVA, VARVARA FEODOROVNA (1894–1958)
Russian painter and designer.

Main Sources

Lavrentiev, A. *Varvara Stepanova: A Constructivist Life.* London: 1988.

Yablonskaya, Miuda. *Women Artists of Russia's New Age, 1900–1935.* Ed. and trans. Anthony Parton. New York: Rizzoli & London: Thames and Hudson, 1990. Contains a chapter on each artist while notes and an individual bibliography provide access to material in Russian.

Exhibitions

Künstlerinnen international, 1877–1977. Berlin: Schloss Charlottenburg, 1977.

Russian Women Artists of the Avant-garde, 1910–1930. Cologne: Galerie Gmurzynska, 1979.

Barron, Stephanie, and M. Tuchman. *The avant-garde in Russia, 1910–1930.* Los Angeles: County Museum of Art, 1980.

Vergine, Lea. *L'altra metà dell'avanguardia.* Milan: Mazzotta Editore, 1980. *L'autre moitié de l'avant-garde.* Paris: Des Femmes, 1982.

L'avant-garde au féminin. Paris: Artcurial, 1983.

Dabrowski, M. *Contrasts of Form.* New York: Museum of Modern Art, 1985.

De la Révolution à la Pérréstroika. Art Soviétique de la Collection Ludwig. St. Etienne: Musée d'Art Moderne, 1989.

Avanguardia russa dalle collezioni private sovietiche origini e percorso 1904–1934. Milan: Palazzo Reale, 1989.

Künstlerinnen des 20. Jahrhunderts. Wiesbaden: Museum Wiesbaden in association with Verlag Weber & Weidermeyer GmbH, Kassel, 1990.

Rodchenko-Stepanova: The Future is our Only Goal. Munich: Prestel in association with the Österreichische Museum für angewandte Kunst, Vienna, 1991, 260pp., illus. Two critical essays examine the full range of their output in art and design. There are also biographies, lists of exhibitions and a bibliography in Russian and other language texts.

Other Sources

Dunford, Penny. *A Biographical Dictionary of Women Artists in Europe and America since 1850.* Hemel Hempstead: Harvester Wheatsheaf and Philadelphia: University of Pennsylvania Press, 1990. Contains a bibliography.

Milner, John. *A Dictionary of Russian and Soviet Artists, 1420–1970.* Woodbridge: Antique Collectors Club, 1993.

Strausberg, A. "Renaissance Women in the Age of Technology." *Spare Rib* 19 (1973): 38–40.

3066 STJERNSCHANTZ, BEDA MARIA (1867–1910)

Finnish painter of figure subjects, often melancholy and often with musical themes.

Exhibitions

Sieben Finnische Malerinnen. Hamburg: Kusthalle, 1985. Contains a short but focussed bibliography.

Other Sources

Dunford, Penny. *A Biographical Dictionary of Women Artists in Europe and America since 1850.* Hemel Hempstead: Harvester Wheatsheaf and Philadelphia: University of Pennsylvania Press, 1990. Contains a bibliography.

3067 STOKES, MARGARET (1832–1900)

Irish painter of landscapes.

Exhibitions

Irish Women Artists from the Eighteenth Century to the Present Day. Dublin: National Gallery of Ireland, Douglas Hyde Gallery and Hugh Lane Gallery, 1987.

3068 STOKES, MARIANNE (née PREINDELSBERGER) (1855–1927)

Austrian-born painter of literary, biblical and genre scenes, especially of children; she studied in Munich and worked in England.

Main Sources

"Marianne Stokes." *Connoisseur* 79 (1927): 127. Obituary.

Ford, Harriet. "The Work of Mrs Adrian Stokes." *International Studio* 10 (May 1900): 148–156. After talking to Stokes, the author describes her training, the difficulties for her as a woman, and the development of her work.

Meynell, Wilfrid. "Mr. and Mrs. Adrian Stokes." *Art Journal,* 1900, 193–198.

Exhibitions

Cherry, Deborah. *Painting Women: Victorian Women Artists.* Rochdale: Art Gallery, 1987.

The Last Romantics. The Romantic Tradition in British Art: Burne-Jones to Stanley Spencer. London: Barbican Art Gallery, 1989.

Other Sources

Clement, Clara. *Women in the Fine Arts.* Boston: Houghton Mifflin, 1904.

Dunford, Penny. *A Biographical Dictionary of Women Artists in Europe and America since 1850.* Hemel Hempstead: Harvester Wheatsheaf and Philadelphia: University of Pennsylvania Press, 1990. Contains a bibliography.

Lexikon der Frau. Zurich: Encyclios Verlag, 1953.

Nunn, Pamela Gerrish. *Victorian Women Artists.* London: Women's Press, 1987.

Sparrow, Walter Shaw. *Women Painters of the World.* London: Hodder and Stoughton, 1905.

3069 STONGRET, MARIA (Alt. STANGRET-KANTOR) (1929–)
Polish abstract painter.

Exhibitions

Présences Polonaises. L'Art vivant autour du Musée Łodz. Paris: Centre national d'art et de culture Georges Pompidou, 1983.

3070 STRYJEŃSKA, ZOFIA (1894–1976)
Polish painter and designer who became well known for her series of six panels executed for the Polish Pavilion at the 1925 International Exposition of Decorative Arts.

Exhibitions

Morawińska, Agnieszka. *Voices of Freedom: Polish Women Artists of the Avant-garde, 1880–1990.* Washington, D.C.: National Museum of Women in the Arts, 1991. Includes a list of her main exhibitions and a bibliography.

3071 STUCKY, SILVIA (1959–)
Italian abstract painter and installation artist.

Exhibitions

Vescovo, Marisa. *Il Gioco delle Parti. 4 Biennale Donna.* Ferrara: Padiglione d'Arte Contemporanea, Palazzo Massari, 1990.

3072 SULTER, MAUD
Painter and writer who works in England.

Publications

Passion: Discourses on Blackwomen's Creativity. Preston, 1990.

Echo: Works by Women Artists, 1850–1940. Liverpool: Tate Gallery, 1991.

Exhibitions

The Thin Black Line. London: Institute of Contemporary Art, 1985.
Zabat: Narratives. Preston, 1989.
Hysteria. Preston, 1991.
Ascherson, Neil. *Shocks to the System: Social and Political Issues in Recent British Art from the Arts Council Collection.* London: Royal Festival Hall, 1991.

3073 SWANWICK, BETTY (1915–1989)
English painter of landscapes and figurative subjects.

Exhibitions

British Painting 1952–1977. London: Royal Academy, 1977.

Other Sources

Dunford, Penny. *A Biographical Dictionary of Women Artists in Europe and America since 1850.* Hemel Hempstead: Harvester Wheatsheaf and Philadelphia: University of Pennsylvania Press, 1990. Contains a bibliography.

3074 SWANZY, MARY (1882–1978)
Irish modernist painter of landscapes and figures subjects, some of which have religious or allegorical overtones.

Exhibitions

Mary Swanzy: Retrospective Exhibition. Dublin: Hugh Lane Municipal Gallery, 1968.
Campbell, Julian. *The Irish Impressionists: Irish Artists in France and Belgium, 1850–1914.* Dublin: National Gallery, 1984.
———. *Mary Swanzy HRHA (1882–1968).* London: Pyms Gallery, 1986, 92pp., illus. Includes a useful analysis of her life and work and detailed notes on some of the exhibits.
Irish Women Artists from the Eighteenth Century to the Present Day. Dublin: National Gallery of Ireland, Douglas Hyde Gallery and Hugh Lane Gallery, 1987.
Mary Swanzy H.R.H.A (1882–1978). London: Pyms Gallery, 1989.

Other Sources

De Breffny, Brian, ed. *Ireland: A Cultural Encyclopaedia.* London: Thames and Hudson, 1983.
Dunford, Penny. *A Biographical Dictionary of Women Artists in Europe and America since 1850.* Hemel Hempstead: Harvester Wheatsheaf and Philadelphia: University of Pennsylvania Press, 1990. Contains a bibliography.

3075 SWYNNERTON, ANNIE LOUISA (née ROBINSON) (1844–1933)

English painter of allegorical and mythogical figure scenes, children and portraits; she was the first woman to be elected an Associate of the Royal Academy.

Exhibitions

Women's Art Show, 1550–1970. Nottingham: Castle Museum, 1982. Contains a brief biography.

Sellars, Jane. *Women's Works.* Liverpool: Walker Art Gallery, 1988.

Other Sources

Cherry, Deborah. *Painting Women: Victorian Women Artists.* London: Routledge, 1993.

Dunford, Penny. *A Biographical Dictionary of Women Artists in Europe and America since 1850.* Hemel Hempstead: Harvester Wheatsheaf and Philadelphia: University of Pennsylvania Press, 1990. Contains a bibliography.

Knight, Laura (q.v.). *Oil Paint and Grease Paint.* London; Ivor Nicholson & Watson, 1936; Harmondsworth: Penguin, 1941.

Nunn, Pamela Gerrish. *Victorian Women Artists.* London: Women's Press, 1987.

Sparrow, Walter Shaw. *Women Painters of the World.* London: Hodder and Stoughton, 1905.

Storey, G. *Dickens and Daughter,* pp. 201–204. London, 1931 (see under Perugini).

Waters, Grant. *Dictionary of British Artists Working 1900–1940.* Eastbourne: Eastbourne Fine Art, 1975.

Wood, Christopher. *The Dictionary of Victorian Painters.* Woodbridge: Antique Collectors Club, 1978.

3076 SZÁNTÓ, PIROSKA (1913–)

Hungarian painter whose approach is similar to Surrealism.

Other Sources

Hárs, Éva, and Ferenc Romváry. *Modern Hungarian Gallery Pécs.* Budapest: Corvina Kiadó, 1981.

Németh, Lajos. *Modern Art in Hungary.* Budapest: Corvina Press, 1969.

3077 ŠUVINSKA, EWA (1909–)

Polish graphic artist and painter.

See Graphic Art section.

3078 TABAKA, MAIJA (1939–)

Latvian painter.

Other Sources

Rosenfeld, Alla, and Norton Dodge, eds. *Nonconformist Art: The Soviet Experience, 1956–1986. The Norton and Nancy Dodge Collection.* London: Thames and Hudson in association with the Jane Voorhees Zimmerli Art Museum, State University of New Jersey, Rutgers, 1995.

3079 TAMEGÁO, MARJARIDA YOLANDA BOTELHO DE MACEDO (1901–)
Portuguese painter and graphic artist.

Other Sources

Tannock, Michael. *Portuguese Artists of the Twentieth Century: A Biographical Dictionary.* Chichester: Phillimore & Co. Ltd., 1988.

3080 TANG, RAILI (1956–)
Finnish painter.

Exhibitions

Akt 83: suomalaista nykytaidetta. Helsinki: Ateneum, 1983.
Kuusi näkö kulmaa: sex synvinklar, six aspects. Helsinki: Ateneum, 1988, 48pp., illus. Tang is the only woman in this exhibition.

3081 TANNAES, MARIE KATHERINE HÉLÈNE (1854–1939)
Norwegian painter of landscapes.

Other Sources

Dunford, Penny. *A Biographical Dictionary of Women Artists in Europe and America since 1850.* Hemel Hempstead: Harvester Wheatsheaf and Philadelphia: University of Pennsylvania Press, 1990. Contains a bibliography.
Wichstrøm, Anne. *Kvinner ved staffeliet.* Oslo: Universitetsforlaget, 1983.

3082 TEIŠERSKYTE-STOŠĶIENE, JOLANTA (1947–)
Lithuanian painter.

Exhibitions

8. Baltijas Republiku Akvareļu Izstāde: Katalogs. Riga, 1989.

3083 TENNANT, DOROTHY (Alt. LADY STANLEY) (1855–1926)
English painter of genre, especially London street children, and portraits.

Publications

London Street Arabs. London, 1890.

Exhibitions

Sellars, Jane. *Women's Works*. Liverpool: Walker Art Gallery, 1988.

Other Sources

Clement, Clara. *Women in the Fine Arts*. Boston: Houghton Mifflin, 1904.

Dunford, Penny. *A Biographical Dictionary of Women Artists in Europe and America since 1850*. Hemel Hempstead: Harvester Wheatsheaf and Philadelphia: University of Pennsylvania Press, 1990. Contains a bibliography.

Waters, Grant. *Dictionary of British Artists Working 1900–1940*. Eastbourne: Eastbourne Fine Art, 1975.

Wood, Christopher. *The Dictionary of Victorian Painters*. Woodbridge: Antique Collectors Club, 1978.

3084 THEMERSON, FRANCISKA
Polish painter.

Exhibitions

Présences Polonaises. L'Art vivant autour du Musée Łodz. Paris: Centre national d'art et de culture Georges Pompidou, 1983.

Gresty, Hilary, and Jeremy Lewison. *Constructivism in Poland 1923–1936*. Cambridge: Kettle's Yard Gallery in association with the Muzeum Stuki, Łodz, 1984. Includes a biographical essay.

3085 THESLEFF, ELLEN (1869–1954)
Finnish painter of landscapes, figures and portraits in an atmospheric, expressionist style.

Publications

Dikteer och tankar. Helsingfors, 1954.

Exhibitions

Northern Light: Realism and Symbolism in Scandinavian Painting, 1880–1910. New York: Brooklyn Museum, 1982.

Sieben Finnische Malerinnen. Hamburg: Kunsthalle, 1983. Contains a short individual bibliography.

Dreams of a Summer Night. London: Hayward Gallery, 1986.

Nordisk Sekelskifte: The Light of the North. Stockholm: Nationalmuseum, 1995.

Other Sources

Boulton-Smith, J. *Modern Finnish Painting*. London: 1970.

———. *The Golden Age of Finnish Art: Art Nouveau and the National Spirit*. Helsinki: 1976. Rev. ed. 1986.

Dunford, Penny. *A Biographical Dictionary of Women Artists in Europe and America since 1850.* Hemel Hempstead: Harvester Wheatsheaf and Philadelphia: University of Pennsylvania Press, 1990. Contains a bibliography.

Sparrow, Walter Shaw. *Women Painters of the World.* London: Hodder and Stoughton, 1905.

3086 THIL, JEANNE (1887–after 1938)
 French painter of landscapes and figure subjects, often oriental in setting; her works were sometimes on large panels for the decoration of public buildings.

Other Sources

Dunford, Penny. *A Biographical Dictionary of Women Artists in Europe and America since 1850.* Hemel Hempstead: Harvester Wheatsheaf and Philadelphia: University of Pennsylvania Press, 1990. Contains a bibliography.

Edouard-Joseph, R. *Dictionnaire biographique des artistes contemporains, 1910–1930.* Paris: Art et Editions, 1930–1934.

3087 THIOLLIER, ELIANE (1926–)
 French painter of landscapes, still life and marine scenes.

Other Sources

Dunford, Penny. *A Biographical Dictionary of Women Artists in Europe and America since 1850.* Hemel Hempstead: Harvester Wheatsheaf and Philadelphia: University of Pennsylvania Press, 1990. Contains a bibliography.

3088 THORELL, HILDEGARD (1850–1939)
 Swedish painter.

Exhibitions

Kvinnor som målat. Stockholm: Nationalmuseum, 1975.

Other Sources

Ingelman, Ingrid. *Kvinuliga konstnarer i Sverige en undersokning av Elever vid konstakademin Inskriva 1864–1924.* Uppsala: Almquist & Wiksell, 1982.

3089 THORNYCROFT, ALYCE MARY (née ALICE) (1844–1906)
 English painter and sculptor of figurative, often literary subjects; daughter of Mary and sister of Helen and Theresa (qq.v.).

Main Sources

See under Mary Thornycroft (Sculpture section).

3090 THORNYCROFT, HELEN (1848–1937)
English painter of Biblical subjects, landscapes and flowers; daughter of Mary and sister of Alyce and Theresa (qq.v.).

Main Sources

See under Mary Thornycroft (Sculpture section).

Other Sources

Mallalieu, Hugh. *Dictionary of British Watercolour Artists.* Woodbridge: Antique Collectors Club, 1976.

3091 THORNYCROFT, THERESA GEORGIANA (1853–1947)
English painter of Biblical and literary subjects.

Main Sources

See under Mary Thornycroft (Sculpture section).

3092 THRANE, RAGNILD (1856–1913)
Norwegian painter.

Other Sources

Wichstrøm, Anne. *Kvinner ved staffeliet: Kvinnelige malere i Norge før 1900.* Oslo: Universitetsforlaget, 1983.

3093 TOORUP, CHARLEY (née ANNIE CAROLINE PONTIFEX TOORUP) (1891–1955)
Dutch realist painter of figures. especially portraits.

Other Sources

Dunford, Penny. *A Biographical Dictionary of Women Artists in Europe and America since 1850.* Hemel Hempstead: Harvester Wheatsheaf and Philadelphia: University of Pennsylvania Press, 1990. Contains a bibliography.
Krichbaum, J., and R. Zondergeld. *Künstlerinnen: von der Antike bis zur Gegenwart.* Cologne: DuMont, 1979.

3094 TOYEN (Pseudonym of MARIE CHERMINOVA) (1902–1980)
Czech Surrealist painter.

Main Sources

Chadwick, Whitney. *Women Artists and the Surrealist Movement.* London: Thames and Hudson, 1985.
Hubert, Renée Riese. *Magnifying Mirrors: Women, Surrealism and Partnership.* Lincoln and London: University of Nebraska Press, 1994, pp.

309–344. Discusses the nature of relationships within the Surrealist group and its effect on the productivity of both partners.

Exhibitions

Künstlerinnen international, 1877–1977. Berlin: Schloss Charlottenburg, 1977.

Paris 1937–Paris 1957: créations en France. Paris: Centre national d'art et de culture Georges Pompidou, 1981.

Vergine, Lea. *L'altra metà dell'avanguardia.* Milan: Mazzotta Editore, 1980. *L'autre moitié de l'avant-garde.* Paris: Des Femmes, 1982.

Other Sources

Dunford, Penny. *A Biographical Dictionary of Women Artists in Europe and America since 1850.* Hemel Hempstead: Harvester Wheatsheaf and Philadelphia: University of Pennsylvania Press, 1990. Contains a bibliography.

Krichbaum, J., and R. Zondergeld. *Künstlerinnen: von der Antike bis zur Gegenwart.* Cologne: DuMont, 1979.

3095 TRÉBUCHET, LOUISE-MARIE (née HOUSEL) (Exhibited from 1875)
French flower painter and teacher.

Other Sources

Hardouin-Fugier, Elizabeth, and E. Grafe. *French Flower Painters of the Nineteenth Century: A Dictionary.* London: Philip Wilson, 1989.

3096 TURY, MÁRIA (1930–)
Hungarian painter.

Other Sources

Németh, Lajos. *Modern Art in Hungary.* Budapest: Corvina Press, 1969.

3097 TYRWHITT, URSULA (1872/8–1966)
English painter.

Main Sources

Taylor, Hilary. "'If a Young Painter Be Not Fierce and Arrogant God Help Him': Some Women Art Students at the Slade, c. 1895–99." *Art History* 9 (June 1986): 232–244.

Other Sources

Thomas, Alison. *Portraits of Women: Gwen John and Her Forgotten Contemporaries.* Cambridge: Polity Press, 1996.

Waters, Grant. *Dictionary of British Artists Working 1900–1940.* Eastbourne: Eastbourne Fine Art, 1975.

3098 UDALTSOVA, NADIEJDA ANDREYEVNA (1886–1961)
Russian Cubist and geometrical abstract painter.

Main Sources

Yablonskaya, Miuda. *Women Artists of Russia's New Age, 1900–1935.* Ed. and trans. Anthony Parton. New York: Rizzoli & London: Thames and Hudson, 1990. Contains a chapter on each artist, while notes and an individual bibliography provide access to material in Russian.

Exhibitions

Harris, Anne Sutherland, and Linda Nochlin. *Women Artists 1550–1950.* Los Angeles: County Museum of Art, 1976.
Russian Women Artists of the Avant-garde, 1910–1930. Cologne: Galerie Gmurzynska, 1979.
Barron, Stephanie, and M. Tuchman. *The avant-garde in Russia, 1910–1930.* Los Angeles: County Museum of Art, 1980.
Vergine, Lea. *L'altra metà dell'avanguardia.* Milan: Mazzotta Editore, 1980. *L'autre moitié de l'avant-garde.* Paris: Des Femmes, 1982.
De la Révolution à la Pérréstroika. Art Soviétique de la Collection Ludwig. St Etienne: Musée d'Art Moderne, 1989.
Avanguardia russa dalle collezioni private sovietiche origini e percorso 1904–1934. Milan: Palazzo Reale, 1989.
L'avant-garde au féminin. Paris: Artcurial, 1983.

Other Sources

Dunford, Penny. *A Biographical Dictionary of Women Artists in Europe and America since 1850.* Hemel Hempstead: Harvester Wheatsheaf and Philadelphia: University of Pennsylvania Press, 1990. Contains a bibliography.
Krichbaum, J., and R. Zondergeld. *Künstlerinnen: von der Antike bis zur Gegenwart.* Cologne: DuMont, 1979.
Milner, John. *A Dictionary of Russian and Soviet Artists, 1420–1970.* Woodbridge: Antique Collectors Club, 1993.

3099 UIGA, SIGRIDA (1922–)
Estonian painter.

Exhibitions

8. Baltijas Republiku Akvareļu Izstāde: Katalogs. Riga, 1989.

3100 URSULA (Pseudonym of URSULA SCHULTZE-BLUHM) (1921–)
German painter, sculptor and mixed-media artist.

Other Sources

Evers, Ulrike. *Deutsche Künstlerinnen des 20. Jahrhunderts. Malerei—Bildhauerei—Tapisserie.* Hamburg: Ludwig Schultheis Verlag, 1983. Contains an extensive individual bibliography.

3101 ÜKSINE, MARJE (1945–)
Estonian painter and graphic artist.

Other Sources

Rosenfeld, Alla, and Norton Dodge, eds. *Nonconformist Art: The Soviet Experience, 1956–1986. The Norton and Nancy Dodge Collection.* London: Thames and Hudson in association with the Jane Voorhees Zimmerli Art Museum, State University of New Jersey, Rutgers, 1995.

3102 VAJDA, JÚLIA (1913–)
Hungarian painter in a Surrealist idiom.

Other Sources

Németh, Lajos. *Modern Art in Hungary.* Budapest: Corvina Press, 1969.

3103 VALADON, SUZANNE (née MARIE-CLÉMENTINE VALADON) (1865–1938)
French painter of figures, especially female nudes, in strong colours.

Main Sources

Betterton, Rosemary. "How do Women Look? The Female Nude in the Work of Suzanne Valadon." *Feminist Review* 19 (March 1985): 1–23.
Warnod, J. *Suzanne Valadon.* New York, 1981.
Champion, Jeanne. *Suzanne Valadon ou la recherche de la verité.* Paris: Presses de la Renaissance, 1983, 383pp., illus. Takes an anecdotal conversational approach which is dramatised in places.
Guilleminault, Gilbert, et al. *Les maudits de Cézanne à Utrillo.* Paris: Denoël, 1959, 319pp., illus.
Petrides, Paul. *L'oeuvre complet de Suzanne Valadon.* Paris: Compagnie française des arts graphiques, 1971, 371pp., illus.

Exhibitions

Suzanne Valadon. Paris: Galérie Georges Petit, 1932, 32pp., illus.
Les femmes artistes modernes. Exposition de peintures, sculptures, 1937. Paris: Buffet & Leclerc, 1937.
Exposition d'oeuvres anciennes et récentes de Suzanne Valadon choisies dans les collections de M. et Mme Utrillo et de M. et MMe. O. Pétrides. Paris: Galérie O. Pétrides, 1938, n.p., illus.

Hommage à Suzanne Valadon. Paris: Musée d'Art Moderne, 1948, 103pp., illus.

Baudson, Françoise. *Exposition organisée par la ville de Bourg-en-Bresse en hommage à Utrillo—Valadon—Utter.* Bourg-en Bresse: Imprimérie Berthod, 1965, 76pp., illus.

Suzanne Valadon. Paris: Centre national d'art et de culture Georges Pompidou in association with the Réunion des Musées Nationaux, 1967, 102pp., illus.

Harris, Anne Sutherland, and Linda Nochlin. *Women Artists 1550–1950.* Los Angeles: County Museum of Art, 1976.

Künstlerinnen international, 1877–1977. Berlin: Schloss Charlottenburg, 1977.

Other Sources

Bachmann, Donna, and Sherry Piland. *Women Artists: A Historical, Contemporary and Feminist Bibliography.* Metuchen, N.J.: Scarecrow Press, 1978.

Bunoust, Madeleine. *Quelques Femmes Peintres.* Paris: Librairie Stock, 1936.

Dunford, Penny. *A Biographical Dictionary of Women Artists in Europe and America since 1850.* Hemel Hempstead: Harvester Wheatsheaf and Philadelphia: University of Pennsylvania Press, 1990. Contains a bibliography.

Perry, Gill. *Women Artists and the Parisian Avant-Garde.* Manchester: Manchester University Press, 1995. Includes a biography and select bibliography.

Tufts, Eleanor. *Our Hidden Heritage: Five Centuries of Women Artists.* New York and London: Paddington Press, 1974.

3104 VALLAYER-COSTER, ANNE (1744–1818)
 French painter of still lifes and portraits.

Exhibitions

Harris, Anne Sutherland, and Linda Nochlin. *Women Artists 1550–1950.* Los Angeles: County Museum of Art, 1976.

Das Verborgene Museum. Dokumentation der Kunst von Frauen in Berliner öffentlichen Sammlungen. Berlin: Edition Hentrich, 1987.

Other Sources

Fine, Elsa Honig. *Women and Art.* New York and London: Allanfield and Schram/Prior, 1978.

Foster, Joshua. *Dictionary of Painters of Miniatures.* London: Philip Allan & Co. Ltd., 1926.

3105 VALNERE, RITA (1929–)
 Latvian painter.

Other Sources

Šmagre, Rita. *Latviešu Pastelis. Latvian Pastel Painting.* Riga: Liesma, 1990. Includes a brief account of her career.

3106 VAN DE PAVORD SMITS, HELENA CHRISTINA (1867–1941)
Dutch painter of still lifes and portraits.

Exhibitions

Kunst door vrouwen. Leiden: Stedelijk Museum, De Lakenhal, 1987.

3107 VAN HEEMSKERCK, JACOBA BERENDINA VAN BEEST (1876–1923)
Dutch painter of Expressionist landscapes and portraits; also a graphic artist and designer of mosaics and stained glass.

Exhibitions

Hussen, A., Jr., and Herbert Henkels. *Jacopa Berendina van Heemskerck (1876–1923): Kunstnares van het Expressionisme.* The Hague: Haags Gemeentemuseum, 1982.

Barron, Stephanie. *Degenerate Art: The Fate of the Avant-Garde in Nazi Germany.* Los Angeles: County Museum of Art in association with H. Abrams, New York, 1991.

Das Verborgene Museum. Dokumentation der Kunst von Frauen in Berliner öffentlichen Sammlungen. Berlin: Edition Hentrich, 1987.

Other Sources

Behr, Shulamith. *Women Expressionists.* Oxford: Phaidon, 1988.

Dunford, Penny. *A Biographical Dictionary of Women Artists in Europe and America since 1850.* Hemel Hempstead: Harvester Wheatsheaf and Philadelphia: University of Pennsylvania Press, 1990. Contains a bibliography.

Krichbaum, J., and R. Zondergeld. *Künstlerinnen: von der Antike bis zur Gegenwart.* Cologne: DuMont, 1979.

3108 VAN MARCKE, JULIE-PALMYRE (1801–1875)
French painter of flowers.

Other Sources

Hardouin-Fugier, Elizabeth, and E. Grafe. *French Flower Painters of the Nineteenth Century: A Dictionary.* London: Philip Wilson, 1989.

3109 VAN REGTEREN, MARIA ENGELINA (née ALTENA) (1868–1958)
Dutch painter amd graphic artist who produced still lifes and town scenes.

Other Sources

Dunford, Penny. *A Biographical Dictionary of Women Artists in Europe and America since 1850.* Hemel Hempstead: Harvester Wheatsheaf and Philadelphia: University of Pennsylvania Press, 1990. Contains a bibliography.
Venema, A. *Die Amsterdamse Joffers.* Baarn, 1977.

3110 VANDENBERG, DIANA (Pseudonym of ANGELE THÉRÈSE BLOMJOUS) (1923–)
Dutch hyper-realist painter.

Other Sources

Dunford, Penny. *A Biographical Dictionary of Women Artists in Europe and America since 1850.* Hemel Hempstead: Harvester Wheatsheaf and Philadelphia: University of Pennsylvania Press, 1990. Contains a bibliography.
Krichbaum, J., and R. Zondergeld. *Künstlerinnen: von der Antike bis zur Gegenwart.* Cologne: DuMont, 1979.

3111 VANSTON, DIARINE (Alt. DOREEN) (1903–)
Irish painter of figures and landscapes in a style which was among the most avant-garde in the 1940s.

Exhibitions

Irish Women Artists from the Eighteenth Century to the Present Day. Dublin: National Gallery of Ireland, Douglas Hyde Gallery and Hugh Lane Gallery, 1987.

Other Sources

Dunford, Penny. *A Biographical Dictionary of Women Artists in Europe and America since 1850.* Hemel Hempstead: Harvester Wheatsheaf and Philadelphia: University of Pennsylvania Press, 1990. Contains a bibliography.

3112 VARO, REMEDIOS (1913–1963)
Spanish Surrealist painter who lived in Mexico from 1940.

Main Sources

Chadwick, Whitney. *Women Artists and the Surrealist Movement.* London: Thames and Hudson, 1985.
Haynes, Deborah. "The Art of Remedios Varo: Issues of Gender Ambiguity and Religious Meaning." *Woman's Art Journal* 16, no. 1 (spring–summer 1995): 26–32.
Hubert, Renée Riese. *Magnifying Mirrors: Women, Surrealism and Partnership.* Lincoln and London: University of Nebraska Press, 1994, pp. 255–276. Discusses the nature of relationships within the Surrealist group and its effect on the productivity of both partners.

Kaplan, Janet. "Remedios Varo: Voyages and Visions." *Woman's Art Journal* 1, no. 2 (fall 1980–winter 1981): 13–18.

Kaplan, Janet. *Unexpected Journeys: The Life and Work of Remedios Varo.* New York: Abbeville Press and London: 1988. The fundamental and essential study of Varo.

Exhibitions

Vergine, Lea. *L'altra metà dell'avanguardia.* Milan: Mazzotta Editore, 1980. *L'autre moitié de l'avant-garde.* Paris: Des Femmes, 1982.

Remedios Varo. Madrid: Fondación Banco Exterior, 1988. Text in Spanish. Contains several critical essays.

Other Sources

Dunford, Penny. *A Biographical Dictionary of Women Artists in Europe and America since 1850.* Hemel Hempstead: Harvester Wheatsheaf and Philadelphia: University of Pennsylvania Press, 1990. Contains a bibliography.

Krichbaum, J., and R. Zondergeld. *Künstlerinnen: von der Antike bis zur Gegenwart.* Cologne: DuMont, 1979.

3113 VASSILIEFF, MARIA (Alt. VASSILIEV) (1884–1957)
Russian painter and designer of theatre sets and costumes who worked in France.

Main Sources

Prim-Goguel, Solange. "Marie Vassilieff: de l'avant-garde aux modes, 1907–1937." *L'Ecrit-Voir* 3 (1983): 35–42. Includes a bibliography.

Exhibitions

Marie Vassilieff. Paris: Galérie Hupel, 1971.

Paris-Moscou, 1900–1939. Paris: Centre national d'art et de culture Georges Pompidou, 1979.

Vergine, Lea. *L'altra metà dell'avanguardia.* Milan: Mazzotta Editore, 1980. *L'autre moitié de l'avant-garde.* Paris: Des Femmes, 1982.

Modernism and Tradition. London: Whitford and Hughes, 1987.

Dufresne, Jean-Luc, and Olivier Messac, eds. *Femmes créatrices des années vingt.* Granville: Musée Richard Anacréon, 1988. Wide-ranging catalogue with a short biographical account on each woman included.

Other Sources

Byars, Mel. *The Design Encyclopedia.* London: Lawrence King, 1994.

Dunford, Penny. *A Biographical Dictionary of Women Artists in Europe and America since 1850.* Hemel Hempstead: Harvester Wheatsheaf and Philadelphia: University of Pennsylvania Press, 1990. Contains a bibliography.

Milner, John. *A Dictionary of Russian and Soviet Artists, 1420–1970.* Woodbridge: Antique Collectors Club, 1993.

Perry, Gill. *Women Artists and the Parisian Avant-Garde.* Manchester: Manchester University Press, 1995. Includes a biography and select bibliography.

3114 VEGERE, BAIBA (1948–)
Latvian painter.

Other Sources

Šmagre, Rita. *Latviešu Pastelis. Latvian Pastel Painting.* Riga: Liesma, 1990. Includes a brief account of her career.

3115 VELBA, MARIAN (1930–)
Czech painter.

Exhibitions

Obraz 69. Brno: Moravská Galerie, 1969.

3116 VELLACOTT, ELIZABETH (1905–)
English painter of figure subjects and landscapes who began her career as a stage designer.

Exhibitions

Robertson, Brian. *Elizabeth Vellacott: Paintings and Drawings 1942–1981.* Cambridge: Kettles Yard, 1981, n.p., illus. Consists of a detailed chronology constructed from the author's interviews with the artist, followed by a short analytical essay on her work.

Other Sources

Dunford, Penny. *A Biographical Dictionary of Women Artists in Europe and America since 1850.* Hemel Hempstead: Harvester Wheatsheaf and Philadelphia: University of Pennsylvania Press, 1990. Contains a bibliography.

3117 VEMREN, HILDE (1953–)
Norwegian painter who first trained in ceramics.

Exhibitions

Wichstrøm, Anne. *Rooms with a View: Women's Art in Norway, 1880–1990.* Oslo: Ministry of Foreign Affairs, 1989.

3118 VERSTEEG, INA (1945–)
Dutch graphic artist and painter whose subjects are taken from nature.

Exhibitions

De Vrouw in de kunst. Leiden: Pand Caecilia, 1987.

3119 VEZELAY, PAULE (Pseudonym of MARGARET WATSON-WILLIAMS) (1892–?)
English abstract painter and sculptor who constructed boxes containing linear wire elements.

Publications

Listed in R. Alley below.

Main Sources

Greenan, Althea. "Have You Called Any Art 'Sweet' Lately?" *Women's Art Magazine* 66 (September–October 1995): 30. Review of an exhibition at the Henry Moore Institute, Leeds, which documents her freindship with Jean Arp.
Rembert, Virginia Pitts. "Paule Vezelay's Lines in Space and Other Works." *Arts Magazine* 58 (November 1980): 98–103.
Spencer, Charles. "Profile of Paule Vezelay." *Arts Review* 20 (1968): 683.

Exhibitions

Abstraction-Création, 1931–1936. Paris: Musée d'Art Moderne de la Ville de Paris, 1978.
Alley, Ronald. *Paule Vezelay.* London: Tate Gallery, 1983, 47pp., illus. Contains an account of the development of her work, a chronology, a list of her solo exhibitions, her publications and a bibliography.

Other Sources

Carandente, Giovanni, ed. *Knaurs Lexikon der moderne Plastik.* Munich & Zurich: Droemersche Verlagsanstalt Th. Knaur Nachf., 1961. Includes an account of the development of her work.
Dunford, Penny. *A Biographical Dictionary of Women Artists in Europe and America since 1850.* Hemel Hempstead: Harvester Wheatsheaf and Philadelphia: University of Pennsylvania Press, 1990. Contains a bibliography.

3120 VIEIRA DA SILVA, MARIA HELENA (1908–1992)
Portuguese painter who worked in France for much of her career.

Main Sources

Butor, Michel. *Vieira da Silva: Peintures.* Paris: L'Autre Musée, 1983, 79pp., illus.
Lassaigne, Jacques, and Guy Wheelan. *Vieira da Silva.* Paris: Editions Cercle d'Art, 1987, 366pp., illus. Contains an extensive bibliography.

Vallier, Dora. *Vieira da Silva: chemins d'approche.* Paris: Galilee, 1982, 158pp., illus.

Exhibitions

Oeuvres graphiques de Maria Helena Vieira da Silva. Rouen: Musée des Beaux-Arts, 1972, n.p., mainly illus. Contains a chronology and a list of exhibitions.

Dufresne, Jean-Luc, and Olivier Messac, eds. *Femmes créatrices des années vingt.* Granville: Musée Richard Anacréon, 1988. Wide-ranging catalogue with a short biographical account on each woman included.

Künstlerinnen des 20. Jahrhunderts. Wiesbaden: Museum Wiesbaden in association with Verlag Weber & Weidermeyer GmbH, Kassel, 1990.

Vieira da Silva dans les Collections Portugais. Brussels: Musées Royaux des Beaux-Arts de Belgique, Musée d'Art Moderne, 1991, 222pp., illus.

Waves of Influence: cinco séculos do azulejo português. Staten Island, N.Y.: Snug Harbour Cultural Center, 1995.

Guilbaut, Serge. "The Taming of the Saccadic Eye: The Work of Vieira da Silva in Paris." In *Inside the Visible: An Elliptical View of 20th Century Art—In, Of and From the Feminine,* ed. Catherine De Zegher. Ghent: The Kanaal Foundation, 1996.

Other Sources

Carandente, Giovanni, ed. *Knaurs Lexikon der moderne Plastik.* Munich & Zurich: Droemersche Verlagsanstalt Th. Knaur Nachf., 1961. Includes account of the development of her work.

Dunford, Penny. *A Biographical Dictionary of Women Artists in Europe and America since 1850.* Hemel Hempstead: Harvester Wheatsheaf and Philadelphia: University of Pennsylvania Press, 1990. Contains a bibliography.

Krichbaum, J., and R. Zondergeld. *Künstlerinnen: von der Antike bis zur Gegenwart.* Cologne: DuMont, 1979.

3121 VIGÉE-LEBRUN, ELISABETH (née MARIE LOUISE ELISABETH VIGÉE) (1755–1842)
French painter of portraits who fled from France during the Revolution.

Publications

The Memoirs of Elisabeth Vigée-Lebrun. Translated by Sian Evans. London: Camden Press, 1989, 368pp., illus. Diaries of the artist and letters to friends which recount episodes in her life, together with a list of all her portraits painted before leaving France in 1789.

Exhibitions

Harris, Anne Sutherland, and Linda Nochlin. *Women Artists 1550–1950.* Los Angeles: County Museum of Art, 1976.

Beaulieu, Germaine, et al. *La femme artiste d'Elisabeth Vigée-Lebrun à Rosa Bonheur.* Lacoste: Musée Despiau-Wlerick et Dubalen Mont-de-Marsan, 1981. Includes a bibliography.

Das Verborgene Museum. Dokumentation der Kunst von Frauen in Berliner öffentlichen Sammlungen. Berlin: Edition Hentrich, 1987.

Other Sources

Clement, Clara. *Women in the Fine Arts.* Boston: Houghton Mifflin, 1904.

Ellet, Elizabeth. *Women Artists in all Ages and Countries.* New York: Harper and Brothers Co., 1859, 377pp.

Fine, Elsa Honig. *Women and Art.* New York and London: Allanfield and Schram/Prior, 1978.

Sparrow, Walter Shaw. *Women Painters of the World.* London: Hodder and Stoughton, 1905.

Tufts, Eleanor. *Our Hidden Heritage: Five Centuries of Women Artists,* New York and London: Paddington Press, 1974.

3122 VILLANUEVA, SIMONE (née KAUTZMANN) (1932–)
French painter who carries out much work under glass, a strong tradition in her native Alsace.

Other Sources

Kiefer, L. *La peinture sous verre contemporain.* Cahiers du Musée de Pfaffenhoffen no. 6. Pfaffenhoffen: Musée de Pfaffenhoffen, 1978.

Lotz, François. *Femmes peintres sous verre.* Pfaffenhoffen: Musée de l'Imagérie Peinte et Populaire Alsacienne, 1984.

———. *L'imagérie populaire d'Alsace peinte à la main.* Strasbourg: Der Nouvelle Alsace, 1979.

3123 VILLIERS, MARIE DENISE (née LEMOINE) (1772–1821)
French painter.

Exhibitions

Beaulieu, Germaine, et al. *La femme artiste d'Elisabeth Vigée-Lebrun à Rosa Bonheur.* Lacoste: Musée Despiau-Wlerick et Dubalen Mont-de-Marsan, 1981. Includes a bibliography.

3124 VINCENT, HENRIETTE ANTOINETTE (née RIDEAU DU SAL) (1775–1840)
French painter and lithographer whose subjects were mainly flowers.

Other Sources

Hardouin-Fugier, Elizabeth. *The Pupils of Redouté.* Leigh-on-Sea: F. Lewis, 1981.

3125 VINCENT, SONJA (1928–)
Dutch painter, graphic artist and designer of tapestries who lives in France.

Exhibitions

Tout droit—droit au but: neuf femmes constructivistes. Paris: Institut néerlandais, 1976.

3126 VINTA, MÁRA (1955–)
Estonian painter.

Exhibitions

8. Baltijas Republiku Akvareļu Izstāde: Katalogs. Riga, 1989.

3127 VIVANTI, CHRISTINE (1937–)
French painter.

Other Sources

Alauzon di Genova, André. *La Peinture en Provence.* Marseille: J. Lafitte, 1984.

3128 VĪKA, HILDA (1897–1963)
Latvian painter who depicted psychomythical fantasy images.

Other Sources

Rosenfeld, Alla, and Norton Dodge, eds. *Nonconformist Art: The Soviet Experience, 1956–1986. The Norton and Nancy Dodge Collection.* London: Thames and Hudson in association with the Jane Voorhees Zimmerli Art Museum, State University of New Jersey, Rutgers, 1995.

3129 VOLKOVA, NINA (1946)
Ukrainian painter.

Other Sources

Rosenfeld, Alla, and Norton Dodge, eds. *Nonconformist Art: The Soviet Experience, 1956–1986. The Norton and Nancy Dodge Collection.* London: Thames and Hudson in association with the Jane Voorhees Zimmerli Art Museum, State University of New Jersey, Rutgers, 1995.

3130 VON HEIDER-SCHWEINITZ, MARIA (1894–1974)
German painter in an Expressionist style.

Exhibitions

Das Verborgene Museum. Dokumentation der Kunst von Frauen in Berliner öffentlichen Sammlungen. Berlin: Edition Hentrich, 1987.

3131 VON WEREFKIN, MARIANNE VLADIMIROVNA (1860–1938)
Russian Expressionist painter of figures, landscapes and still lifes who exhibited with the Blue Rider School in Germany before 1914. There is a foundation named after her in Ascona, Italy, where she lived after World War I.

Publications

Weiler, C., ed. *Marianne von Werefkin: Briefe und einen Unbekannten, 1901–5.* Cologne: DuMont, 1960, 92pp., illus.

Main Sources

Brogmann, Nicole. *Marianne von Werefkin: oeuvres peintes, 1907–1936.* Paris: Bibliothèque des Arts, 1996.

Exhibitions

Künstlerinnen international, 1877–1977. Berlin: Schloss Charlottenburg, 1977.
Vergine, Lea. *L'altra metà dell'avanguardia.* Milan: Mazzotta Editore, 1980. *L'autre moitié de l'avant-garde.* Paris: Des Femmes, 1982.
Das Verborgene Museum. Dokumentation der Kunst von Frauen in Berliner öffentlichen Sammlungen. Berlin: Edition Hentrich, 1987.

Other Sources

Behr, Shulamith. *Women Expressionists.* Oxford: Phaidon, 1988.
Dunford, Penny. *A Biographical Dictionary of Women Artists in Europe and America since 1850.* Hemel Hempstead: Harvester Wheatsheaf and Philadelphia: University of Pennsylvania Press, 1990. Contains a bibliography.
Evers, Ulrike. *Deutsche Künstlerinnen des 20. Jahrhunderts. Malerei—Bildhauerei—Tapisserie.* Hamburg: Ludwig Schultheis Verlag, 1983. Contains an individual bibliography.
Krichbaum, J., and R. Zondergeld. *Künstlerinnen: von der Antike bis zur Gegenwart.* Cologne: DuMont, 1979.
Milner, John. *A Dictionary of Russian and Soviet Artists, 1420–1970.* Woodbridge: Antique Collectors Club, 1993.

3132 VON ZITZEWITZ, AUGUSTA (1880–1960)
German painter of portraits, interiors, still life and landscapes in a vigorous modernist style; also a wood engraver.

Exhibitions

Das Verborgene Museum. Dokumentation der Kunst von Frauen in Berliner öffentlichen Sammlungen. Berlin: Edition Hentrich, 1987.

Other Sources

Dunford, Penny. *A Biographical Dictionary of Women Artists in Europe and America since 1850.* Hemel Hempstead: Harvester Wheatsheaf and Philadelphia: University of Pennsylvania Press, 1990. Contains a bibliography.

Meskimmon, Marsha, and Shearer West. *Visions of the 'Neue Frau': Women and the Visual Arts in Weimar Germany.* London: Scolar Press, 1995.

3133 VON ZUMBUSCH, NORA EXNER (1879–1915)
Austrian painter, sculptor and graphic artist.

See Graphic Art section.

3134 VOS, MARIA (1824–1926)
Dutch painter.

Exhibitions

Oele, Anneke, Mirian van Rijsingen, and Hesther van den Donk. *Bloemen uit de kelder: negen kunstnaressen rond de eeuwwisseling.* Arnhem: Gemeentemuseum, 1989.

3135 WALKER, ELIZABETH (née REYNOLDS) (1800–1876)
English painter, including miniatures, and graphic artist who was taught by her father.

Other Sources

Foskett, Daphne. *Miniatures: A Dictionary and Guide.* Woodbridge: Antique Collectors Club, 1987.

Foster, Joshua. *Dictionary of Painters of Miniatures.* London: Philip Allan & Co. Ltd., 1926.

3136 WALKER, (DAME) ETHEL (1861–1951)
Scottish painter of landscapes, marine views, women and still lifes in a style which evolved from Impressionism.

Exhibitions

Ethel Walker. London: Leicester Gallery, 1929. Contains a list of works and an outline biography.

Ethel Walker, Gwen John and Frances Hodgkins. London: Tate Gallery, 1952.

Women's Art Show, 1550–1970. Nottingham: Castle Museum, 1982. Contains a brief biography.

786

Sellars, Jane. *Women's Works.* Liverpool: Walker Art Gallery, 1988.
Sulter, Maud. *Echo: Works by Women Artists, 1850–1940.* Liverpool: Tate Gallery, 1991.

Other Sources

Dunford, Penny. *A Biographical Dictionary of Women Artists in Europe and America since 1850.* Hemel Hempstead: Harvester Wheatsheaf and Philadelphia: University of Pennsylvania Press, 1990. Contains a bibliography.
Waters, Grant. *Dictionary of British Artists Working 1900–1940.* Eastbourne: Eastbourne Fine Art, 1975.

3137 WALTON, CECILE (1891–1956)
Scottish painter, sculptor and illustrator of figurative subjects.

Main Sources

Stephens, J. "Cecile Walton and Dorothy Johnstone." *Studio* 94 (1924): 80–84.

Exhibitions

Sellars, Jane. *Women's Works.* Liverpool: Walker Art Gallery, 1988.
The Last Romantics: The Romantic Tradition in British Art. Burne-Jones to Stanley Spencer. London: Barbican Gallery, 1989.

Other Sources

Dunford, Penny. *A Biographical Dictionary of Women Artists in Europe and America since 1850.* Hemel Hempstead: Harvester Wheatsheaf and Philadelphia: University of Pennsylvania Press, 1990. Contains a bibliography.
Waters, Grant. *Dictionary of British Artists Working 1900–1940.* Eastbourne: Eastbourne Fine Art, 1975.

3138 WANKEL, CHARLOTTE (1888–after 1956)
Norwegian painter.

Other Sources

Dunford, Penny. *A Biographical Dictionary of Women Artists in Europe and America since 1850.* Hemel Hempstead: Harvester Wheatsheaf and Philadelphia: University of Pennsylvania Press, 1990. Contains a bibliography.
Gran, H., and P. Anker, eds. *Illustrert Norsk Kunstner Leksikon.* Oslo: Broen Bokhandel, 1956.

3139 WARD, HENRIETTA MARY ADA (née WARD) (1832–1924)
English painter, mainly of scenes from history and contemporary life, who was the best-known woman painter in the mid-nineteenth century.

Publications

Reminiscences. London, 1911.
Memories of Ninety Years. London, 1924. Autobiography.

Main Sources

Clayton, Ellen. *English Female Artists.* London: Tinsley, 1876.
Nunn, Pamela Gerrish. "The Case History of a Woman Artist: Henrietta Ward." *Art History* 1, no. 3 (1978): 293–308.

Exhibitions

Women's Art Show, 1550–1970. Nottingham: Castle Museum, 1982. Contains a brief biography.
Cherry, Deborah. *Painting Women: Victorian Women Artists.* Rochdale: Art Gallery, 1987.
Sellars, Jane. *Women's Works.* Liverpool: Walker Art Gallery, 1988.
Casteras, Susan, and Linda H. Peterson. *A Struggle for Fame: Victorian Women Artists and Authors.* New Haven, Conn.: Yale Center for British Art, 1994.

Other Sources

Cherry, Deborah. *Painting Women: Victorian Women Artists.* London: Routledge, 1993.
Dunford, Penny. *A Biographical Dictionary of Women Artists in Europe and America since 1850.* Hemel Hempstead: Harvester Wheatsheaf and Philadelphia: University of Pennsylvania Press, 1990. Contains a bibliography.
Nunn, Pamela Gerrish. *Canvassing.* London: Camden Press, 1986. Contains extracts from Ward's autobiography.
Nunn, Pamela Gerrish. *Victorian Women Artists.* London: Women's Press, 1987.

3140 WATERFORD, LOUISA ANN, MARCHIONESS OF (née THE HONOURABLE MISS STUART) (1818–1891)
English painter of Biblical, allegorical and other figurative subjects in a style related to the Pre-Raphaelites.

Main Sources

Clayton, Ellen. *English Female Artists.* London: Tinsley, 1876.
Hare, Augustus. *Two Noble Lives.* London: 1893.
Stuart, C. *Short Sketch of the Life of Louisa, Marchioness of Waterford.* London, 1892.
Surtees, V. *Sublime and Instructive: Letters from John Ruskin to Louisa, Marchioness of Waterford, Anna Blunden and Ellen Heaton.* London, 1972.

Exhibitions

Women's Art Show, 1550–1970. Nottingham: Castle Museum, 1982. Contains a brief biography.
Lady Waterford Centenary Exhibition. Ford, Northumberland: Lady Waterford Hall, 1983, 32pp., illus. Contains an essay by Pamela Gerrish Nunn on Waterford's work, a biographical account and details of the 108 exhibits which were exhibited in the hall which she had decorated with murals.
Irish Women Artists from the Eighteenth Century to the Present Day. Dublin: National Gallery of Ireland, Douglas Hyde Gallery and Hugh Lane Gallery, 1987.
Casteras, Susan, and Linda H. Peterson. *A Struggle for Fame: Victorian Women Artists and Authors.* New Haven, Conn.: Yale Center for British Art, 1994.

Other Sources

Dunford, Penny. *A Biographical Dictionary of Women Artists in Europe and America since 1850.* Hemel Hempstead: Harvester Wheatsheaf and Philadelphia: University of Pennsylvania Press, 1990. Contains a bibliography.
Nunn, Pamela Gerrish. *Victorian Women Artists.* London: Women's Press, 1987.
Yeldham, Charlotte. *Women Artists in Nineteenth Century France and England.* London and New York: Garland, 1984.

3141 WATT, ALISON (1965–)
Scottish realist painter of figures, portraits, and still lifes.

Main Sources

Hilliard, E. "John Player Portrait Award." *Arts Review,* 19 June 1987.
Norman, Geraldine. "High Prices for Idiosyncracy." *The Independent,* 29 March 1993, 6. Review of Watt's exhibition at the Flowers East Gallery, London.
Sadler, R. "Alison Watt." *Modern Painters* 3, no. 1 (1990): 71–73.

Other Sources

Dunford, Penny. *A Biographical Dictionary of Women Artists in Europe and America since 1850.* Hemel Hempstead: Harvester Wheatsheaf and Philadelphia: University of Pennsylvania Press, 1990. Contains a bibliography.
Picardie, J. "Here Come the Glasgow Girls." *The Independent,* 22 June 1987.

3142 WAY, FANNY (née FRANCES ELIZABETH WAY; alt. THACKER) (1871–1961)
English painter who carried out many miniatures.

Other Sources

Foskett, Daphne. *Miniatures: A Dictionary and Guide.* Woodbridge: Antique Collectors Club, 1987.

3143 WEGMANN, BERTHA
Swiss painter of figures who worked in Germany.

Main Sources

Hagen, Luise. "Lady Artists in Germany." *International Studio* 4, 1898, 91–99. Examines the work of Wegmann and Jeanna Bauck (q.v.).

3144 WEJCHERT, ALEXANDRA (1920–)
Polish-born painter, architect and sculptor of abstract works who lives in Ireland.

Exhibitions

Irish Women Artists from the Eighteenth Century to the Present Day. Dublin: National Gallery of Ireland, Douglas Hyde Gallery and Hugh Lane Gallery, 1987.

Other Sources

Dunford, Penny. *A Biographical Dictionary of Women Artists in Europe and America since 1850.* Hemel Hempstead: Harvester Wheatsheaf and Philadelphia: University of Pennsylvania Press, 1990. Contains a bibliography.

3145 WELLER, SIMONE (1940–)
Italian scripto-visual painter.

Publications

Weller, Simone. *Il Complesso di Michelangelo: ricerca sul contributo dato dalla donna all'arte italiana del novecento.* Pollenza-Macerata: La Nuova Foglio [*sic*] Editrice, 1976.

Exhibitions

Künstlerinnen international, 1877–1977. Berlin: Schloss Charlottenburg, 1977.
Pasquali, Marilena. *Figure dallo sfondo.* Ferrara: Padiglione d'Arte Contemporanea and Grafis Editore, 1984.

Other Sources

Weller, Simone. *Il Complesso di Michelangelo: ricerca sul contributo dato dalla donna all'arte italiana del novecento.* Pollenza-Macerata: La Nuova Foglio [*sic*] Editrice, 1976. She includes herself in the dictionary of Italian women artists which forms part of this book.

3146 WEREFKIN, MARIA VON
See above under Von Werefkin.

3147 WETZEL, INES (1878–1940)
 German painter of figures who died in Dachau.

Exhibitions

Das Verborgene Museum. Dokumentation der Kunst von Frauen in Berliner öffentlichen Sammlungen. Berlin: Edition Hentrich, 1987.

3148 WHEELER-CUFFE, LADY (1867–1967)
 Irish botanical painter who recorded the plants of India and Burma.

Other Sources

De Breffny, Brian, ed. *Ireland: A Cultural Encyclopaedia.* London: Thames and Hudson, 1983.

3149 WHITEFORD, KATE (1952–)
 Scottish painter of semi-abstract works with rich surfaces and installation artist who is inspired by ancient cultures.

Main Sources

Kate Whiteford: Sitelines. Edinburgh: Graham Murray, 1992, 66pp., many illus. Contains an essay by Martin Kemp which analyses the links with older civilisations and how she uses them in her work. Includes lists of her exhibitions, artist's books, commissions, exhibitions and a bibliography.

Exhibitions

Kemp, Martin. *Votives and Libations in Summons of the Oracle.* St. Andrews: Crawford Centre for the Arts, University of St Andrews, 1983.
Kate Whiteford: Rites of Passage. Glasgow: Third Eye Centre, 1984, 19pp., illus. Essay by Cordelia Oliver.
The Vigorous Imagination: New Scottish Art. Edinburgh: Scottish National Gallery of Modern Art, 1987.
British Art Now: A Subjective View. Setagaya, Japan: Setagaya Art Museum in association with the British Council, 1990. Includes a list of group and solo exhibitions together with a select bibliography.

Other Sources

Dunford, Penny. *A Biographical Dictionary of Women Artists in Europe and America since 1850.* Hemel Hempstead: Harvester Wheatsheaf and Philadelphia: University of Pennsylvania Press, 1990. Contains a bibliography.

3150 WIGLEY, JANE NINA (c. 1821–after 1855)
 English photographer and painter who worked in Newcastle-upon-Tyne and then in London, opening a studio there in 1847.

See Photography section.

3151 WIIK, MARIA KATARINA (1853–1928)
Finnish painter of interiors, figures and portraits.

Exhibitions

Sieben Finnische Malerinnen. Hamburg: Kunsthalle, 1983. Contains a short bibliography.
Nordisk Sekelskifte: The Light of the North. Stockholm: Nationalmuseum, 1995.

Other Sources

Dunford, Penny. *A Biographical Dictionary of Women Artists in Europe and America since 1850.* Hemel Hempstead: Harvester Wheatsheaf and Philadelphia: University of Pennsylvania Press, 1990. Contains a bibliography.
Krichbaum, J., and R. Zondergeld. *Künstlerinnen: von der Antike bis zur Gegenwart.* Cologne: DuMont, 1979.
Lexikon der Frau. Zurich: Encyclios Verlag, 1953.
Sparrow, Walter Shaw. *Women Painters of the World.* London: Hodder and Stoughton, 1905.

3152 WITHERS, AUGUSTA (active 1827–1865)
English botanical painter who was at one time Flower Painter in Ordinary to Queen Adelaide.

Other Sources

Blunt, Wilfrid. *The Art of Botanical Illustration.* New Naturalist Series. London: Collins, 1950.
Pavière, Sidney. *Dictionary of Flower, Fruit and Still-life Painters.* Vol. 3: *The 19th Century*, part 1. Leigh-on-Sea: Frank Lewis, 1964.

3153 WOLFTHORN, JULIE (née WOLF) (1868–1944)
German painter of figures (usually women landscapes and portraits) who was also a graphic artist; she died in the concentration camp at Theresienstadt.

Exhibitions

Das Verborgene Museum. Dokumentation der Kunst von Frauen in Berliner öffentlichen Sammlungen. Berlin: Edition Hentrich, 1987.

Other Sources

Wende der Buchkunst, Literarisch-kunstlerische Zeitschriften aus den Jahren 1895 bis 1900. Stuttgart: Hoheren Fachschule fur das Graphische Gewerbe, 1962, 84pp., many illus.
Dunford, Penny. *A Biographical Dictionary of Women Artists in Europe and*

America since 1850. Hemel Hempstead: Harvester Wheatsheaf and Philadelphia: University of Pennsylvania Press, 1990. Contains a bibliography.

Sparrow, Walter Shaw. *Women Painters of the World.* London: Hodder and Stoughton, 1905.

3154 WYTSMAN, JULIETTE (Alt. WYTSMAN-TRULLEMANS) (1866–1923)
Belgian painter especially of garden scenes.

Other Sources

Dictionnaire des Peintres Belges di XIVe siècle à nos jours. Brussels: La Renaissance du Livre, 1995.

3155 XENOU, VANA (1949–)
Greek painter of semi-abstract figures.

Exhibitions

Iliopoulou-Rogan, Dora. *Three Generations of Greek Women Artists: Figures, Forms and Personal Myths.* Washington, D.C.: National Museum of Women in the Arts, 1989.

3156 YABLONSK'A, TETIANA NILIVNA (Alt. TATIANA NILOVNA YABLONSKAIA) (1917–)
Ukrainian figurative painter who became one of the leading artists in the former USSR; she painted rural genre in a Socialist Realist style.

Other Sources

Dunford, Penny. *A Biographical Dictionary of Women Artists in Europe and America since 1850.* Hemel Hempstead: Harvester Wheatsheaf and Philadelphia: University of Pennsylvania Press, 1990. Contains a bibliography.

Mandel, W. *Soviet Women.* New York: Anchor Books, 1975.

Rosenfeld, Alla, and Norton Dodge, eds. *Nonconformist Art: The Soviet Experience, 1956–1986. The Norton and Nancy Dodge Collection.* London: Thames and Hudson in association with the Jane Voorhees Zimmerli Art Museum, State University of New Jersey, Rutgers, 1995.

3157 YAKUNCHINOVA-WEBER, MARIA VASILIEVNA (1870–1902)
Russian painter and graphic artist who, under the influence of Elena Polenova, became interested in Russian heritage and also worked in several design specialisms, notably embroidery.

Main Sources

Yablonskaya, Miuda. *Women Artists of Russia's New Age, 1900–1935.* Ed. and trans. Anthony Parton. New York: Rizzoli & London: Thames and Hudson, 1990. Contains a chapter on each artist, while notes and an individual bibliography provide access to material in Russian.

Other Sources

Milner, John. A *Dictionary of Russian and Soviet Artists, 1420–1970.* Woodbridge: Antique Collectors Club, 1993.

3158 YASTREB, LIUDMYLA (1945–1980)
Ukrainian painter who concentrated on depicting women.

Other Sources

Rosenfeld, Alla, and Norton Dodge, eds. *Nonconformist Art: The Soviet Experience, 1956–1986. The Norton and Nancy Dodge Collection.* London: Thames and Hudson in association with the Jane Voorhees Zimmerli Art Museum, State University of New Jersey, Rutgers, 1995.

3159 YHAP, LAETITIA (1941–)
English painter of figurative works, many depicting fishing scenes on Hastings beach, on irregularly shaped canvases.

Exhibitions

Laetitia Yhap. Hastings: Museum and Art Gallery, 1979.
Laetitia Yhap. London: Serpentine Gallery, 1979.
Laetitia Yhap: Paintings since 1979. London: AIR Gallery, 1984.
Hyman, T. *Laetitia Yhap: The Business of the Beach. Paintings and Drawings, 1976–1988.* Newcastle-upon-Tyne: Laing Art Gallery, 1988.

Other Sources

Dunford, Penny. *A Biographical Dictionary of Women Artists in Europe and America since 1850.* Hemel Hempstead: Harvester Wheatsheaf and Philadelphia: University of Pennsylvania Press, 1990. Contains a bibliography.

3160 YOUNGMAN, NAN (1906–)
English painter of landscapes, town scenes and still lifes.

Exhibitions

Deepwell, Katy. *Ten Decades: Careers of Ten Women Artists born 1897–1906.* Norwich: Norwich Gallery, Norfolk Institute of Art and Design, 1992.

Other Sources

Dunford, Penny. *A Biographical Dictionary of Women Artists in Europe and America since 1850.* Hemel Hempstead: Harvester Wheatsheaf and Philadelphia: University of Pennsylvania Press, 1990. Contains a bibliography.
Dunthorne, Katherine. *Artists Exhibited in Wales, 1945–1974.* Cardiff: Welsh Arts Council, 1976.
Waters, Grant. *Dictionary of British Artists Working 1900–1940.* Eastbourne: Eastbourne Fine Art, 1975.

3161 ZAČESTE, MAIJA (1952–)
Latvian painter.

Exhibitions

8. Baltijas Republiku Akvareļu Izstāde: Katalogs. Riga, 1989.

3162 ZAMBACO, MARIA TERPITHEA (née CASSAVETTI) (1843–1914)
Greek artist who worked in England in the Pre-Raphaelite circle as a painter and later as a sculptor, particularly of medallions.

See Sculpture section.

3163 ZANARDELLI, ITALIA (née FOCCA) (1872/4–1944)
Italian painter and sculptor.

Other Sources

Clement, Clara. *Women in the Fine Arts.* Boston: Houghton Mifflin, 1904.

Dunford, Penny. *A Biographical Dictionary of Women Artists in Europe and America since 1850.* Hemel Hempstead: Harvester Wheatsheaf and Philadelphia: University of Pennsylvania Press, 1990. Contains a bibliography.

Krichbaum, J., and R. Zondergeld. *Künstlerinnen: von der Antike bis zur Gegenwart.* Cologne: DuMont, 1979.

3164 ZARNOWER, THERESA
Polish painter and graphic artist.

Exhibitions

Constructivism in Poland, 1923–1936: Blok—Praesans—ar. Essen: Museum Folkwang, 1973. Text in German. Based around works and articles published in these Polish journals of the artistic avant-garde.

Présences Polonaises. L'Art vivant autour du Musée Łodz. Paris: Centre national d'art et de culture Georges Pompidou, 1983.

Gresty, Hilary, and Jeremy Lewison. *Constructivism in Poland 1923–1936.* Cambridge: Kettle's Yard Gallery in association with the Muzeum Stuki, Łodz, 1984. Includes a biographical essay.

3165 ZATKOVÁ, ROUGENA (1885–1923)
Czech painter and designer who was at one time a member of the Italian Futurist Group.

Exhibitions

Künstlerinnen international, 1877–1977. Berlin: Schloss Charlottenburg, 1977.

Vergine, Lea. *L'altra metà dell'avanguardia.* Milan: Mazzotta Editore, 1980. *L'autre moitié de l'avant-garde.* Paris: Des Femmes, 1982.

Other Sources

Dunford, Penny. *A Biographical Dictionary of Women Artists in Europe and America since 1850.* Hemel Hempstead: Harvester Wheatsheaf and Philadelphia: University of Pennsylvania Press, 1990. Contains a bibliography.

Weller, Simone. *Il Complesso di Michelangelo: ricerca sul contributo dato dalla donna all'arte italiana del novecento.* Pollenza-Macerata: La Nuova Foglio [*sic*] Editrice, 1976.

3166 ZEMPLÉNYI, MAGDA (1899–)
Hungarian abstract painter.

Other Sources

Hárs, Éva, and Ferenc Romváry. *Modern Hungarian Gallery Pécs.* Budapest: Corvina Kiadó, 1981.

3167 ZERNOVA, EKATERINA SERGEEVNA (1900–after 1976)
Russian painter of monumental decorative works; also a graphic artist.

Exhibitions

Paris-Moscou, 1900–1939. Paris: Centre national d'art et de culture Georges Pompidou, 1979.

Other Sources

Milner, John. *A Dictionary of Russian and Soviet Artists, 1420–1970.* Woodbridge: Antique Collectors Club, 1993.

3168 ZHILINA, NATALIA
Russian painter of semi-abstract Expressionist works.

Other Sources

Rosenfeld, Alla, and Norton Dodge, eds. *Nonconformist Art: The Soviet Experience, 1956–1986. The Norton and Nancy Dodge Collection.* London: Thames and Hudson in association with the Jane Voorhees Zimmerli Art Museum, State University of New Jersey, Rutgers, 1995.

3169 ZILVINSKA, JADVIGA (1918–)
Latvian painter.

Other Sources

Šmagre, Rita. *Latviešu Pastelis. Latvian Pastel Painting.* Riga: Liesma, 1990. Includes a brief account of her career.

3170 ZINKEISEN, ANNA KATARINA (1902–1976)

Scottish painter of figure scenes and portraits, stage designer and mural painter; sister of Doris Zinkeisen (q.v.).

Main Sources

Walpole, J., ed. *Anna: A Tribute to Anna Zinkeisen.* London: 1978.

Exhibitions

Paintings and Drawings by some Women War Artists. London: Imperial War Museum, 1958.

Other Sources

Dunford, Penny. *A Biographical Dictionary of Women Artists in Europe and America since 1850.* Hemel Hempstead: Harvester Wheatsheaf and Philadelphia: University of Pennsylvania Press, 1990. Contains a bibliography.

Waters, Grant. *Dictionary of British Artists Working 1900–1940.* Eastbourne: Eastbourne Fine Art, 1975.

3171 ZINKEISEN, DORIS CLARE (1898–1991)

Scottish painter and theatrical designer; sister of Anna Zinkeisen (q.v.) and mother of twin daughters who both became illustrators of children's books.

Main Sources

Hassall, Geoff. "Doris Zinkeisen." *The Independent,* 5 January 1991. Obituary.

See under Anna Zinkeisen.

3172 ZŁOTNICKA, EULALIA (1946–) .

Polish graphic artist and painter.

See Graphic Art section.

3173 ZUYDERHOUDT, ANS (1938–)

Dutch figurative painter.

Exhibitions

De Vrouw in de kunst. Leiden: Pand Caecilia, 1987.

3174 ZVIRBULE, ALISE (1906–)

Latvian painter.

Exhibitions

8. Baltijas Republiku Akvareļu Izstāde: Katalogs. Riga, 1989.

Other Sources

Šmagre, Rita. *Latviešu Pastelis. Latvian Pastel Painting.* Riga: Liesma, 1990. Includes a brief account of her career.

3175 ZWOLLO, MARIANNE (1940–)
 Dutch painter.

Exhibitions

De Vrouw in de kunst. Leiden: Pand Caecilia, 1987.

Performance and Video Art, Mixed Media and Installations

PUBLICATIONS

3176 *About Time: Video, Performance and Installation by 21 Women Artists.*
London: Institute of Contemporary Art, 1980, n.p., illus.
 Two critical essays set the context for this season of performance art and examine the history of performance, suggesting reasons why it is such a rich area for women artists. Outline biographies are provided, together with further art work for each individual.

3177 ALLTHORPE-GUYTON, MARJORIE (ED.). *Edge 88.* Newcastle-upon-Tyne: Various venues, 1988, 70pp., illus.
 Catalogue for a season of performance art which forms one issue of the journal *Performance Art.* There are three critical essays, one of which deals with the female concept of self-representation. For each of the artists there is a summary of her work and, sometimes, a statement. Eight women based in Europe are included.

3178 BARBER, FIONNA, and R. L. WITHERS. "TSWA Four Cities Project: Derry, Plymouth, Newcastle and Glasgow." *Women's Art Magazine* 37 (1990): 8–10.
 Discusses this major project to create installations in four distinct regions— and three countries—of the UK. The Derry work—by local artist Moira McIver, Briton Melanie Counsell and American Nancy Spero—is analysed in most detail; Jetelova was the only woman to exhibit at Plymouth; Mona Hatoum and Jana Sterback were at Newcastle while Rosemarie Trockel, American Judith Barry and the partnership of Janette Emery and Kevin Rowbotham were at Glasgow.

3179 BETTERTON, ROSEMARY (ED.). *Looking On: Images of Femininity in the Visual Arts and Media.* London and New York: Pandora, 1987, 293pp., illus.

An anthology in four sections each of which is introduced by a short analytical essay on the issue concerned. After the introduction, entitled "Feminism, Femininity and Representations," the first two sections look at representations of women, the third at pornography and the politics of representation, while the fourth, in which the activities of women artists are discussed, examines the attempts of women to find a new iconography of the body. One essay is devoted to Suzanne Valadon.

3180 *British Art Now: A Subjective View.* Setagaya, Japan in association with the British Council: Setagaya Art Museum, 1990, 152pp., illus.

Text in English and Japanese. Catalogue of an exhibition which toured Japan in 1990–1991. It includes several essays by critics from both countries, with detailed chronologies and exhibition listings for each artist. Of the sixteen artists, four are women. No women were included in the sculpture section but Lisa Milroy and Paula Rego are among the five painters and Helen Chadwick and Kate Whiteford among the four mixed media artists.

3181 CADWALLADER, HELEN. "New Work, Newcastle, Edge 88." *Women Artists' Slide Library Journal* 26 (December 1988–January 1989): 17.

Discusses the contributions of nine women performance artists to this festival of performance art.

3182 CALVERT, GILL, JILL MORGAN, and MOUSE KATZ (EDS.). *Pandora's Box.* Bristol: Arnolfini Gallery, 1984, 120pp., illus.

This exhibition arose out of an earlier exhibition, *Women's Images of Men* (1980), and shares some of its organisers. Women artists were invited to submit works on the theme of Pandora's Box and offer varied reworkings of this myth. Each of the thirty-two women has written a statement about her reactions to the myth and the generation of the work exhibited. No biographical information is given.

3183 CHADWICK, WHITNEY. *Women Artists and the Surrealist Movement.* London: Thames and Hudson, 1895, 256pp., illus.

An analysis of the interventions of women across Europe in the various manifestations of the Surrealist movement. It looks at their participation in the formal activities, groups and networks and at their imagery. Short biographies are given at the end with a bibliography.

3184 CHOON, ANGELA. "Rebels of the Realm." *Art and Antiques* 17 (1994): 56–63.

Discussion about the work of several women artists, most of whom work in mixed media and installations: Anya Gallaccio, Rachel Evans, Sarah

Lucas, Angela Bulloch and the twins Jane and Louise Wilson. Sculptor Rachel Whiteread is also included.

3185 COTTELL, FRAN, and MARIAN SCHOETTLE. *Conceptual Clothing.* Birmingham: Ikon Gallery, 1986, 44pp., illus.
Two critical essays precede entries on thirty-two artists who have used clothing as subject matter. The majority are women and the techniques and materials are very varied. For each there is an outline biography, a list of exhibitions and a short statement.

3186 COTTELL, FRAN. "A Year in Performance." *Women Artists' Slide Library Journal* 26 (December 1988–January 1989): 18–19.
Discusses the author's three months spent on a placement and the subsequent work produced with fine art students, together with other work in which she was involved.

3187 DALLIER, ALINE. *Combative Acts, Profiles and Voices: An Exhibition of Women Artists from Paris.* New York: A.I.R. Gallery, 1976, n.p., illus.
An exhibition of works by Bernadette Bour, Maglione, Hessie and Francoise Janicot who all work in Paris although two of them are not French. A useful essay discusses their work.

3188 *De vrouw in de kunst.* Leiden: Pand Caecilia, 1987, 27pp., illus.
Text in Dutch. Twelve Dutch women are included in this exhibition. A chronology and a brief statement are given about each.

3189 DOUGLAS, ANNA. "Gracie Fields Live Art Commissions." *Women's Art Magazine* 37 (1990): 6–7.
Reviews the performance works by women seen live or on video at Rochdale Art Gallery. Works by Alison Marchant, Mary Duffy and Anne Tallentire are discussed in more detail, while the work of four others is briefly mentioned.

3190 FEMINIST ART COLLECTIVE. *Absent Bodies/Present Lives.* Leeds: City Art Gallery, 1993, n.p., illus.
Ten women artists collaborated on this project which—through installations, video and mixed media work—examines the problems of women representing women as people with real lives. No work is individually attributed.

3191 *Figures.* Cambridge: Cambridge Darkroom, 1987, n.p., illus.
An exhibition of photography and performance around the theme of the human figure but as part of a social, cultural and political milieu. Mona Hatoum produced a performance while Sue Arrowsmith, Helen Chadwick and Roberta Graham all provided photographic work (qq.v.).

3192 GLAISTER, DAN. "A Woman's Place—in the Gallery." *The Guardian,* 18 June 1997, 3.
 Examines the work of the four women selected for the shortlist for the Turner prize. All work in alternative media: Angela Bulloch, Christine Borland, Cornelia Parker and Gillian Wearing.

3193 *Hayward Annual '78.* London: Hayward Gallery, 1978, 107pp., illus.
 Curated by five women, this exhibition included sixteen women artists out of twenty-three. It resulted in part from the very minor appearances of women artists in previous major shows of British art and from a campaign to alter this. This background affected the critical reception of the exhibition and Griselda Pollock analysed the reviews in "Femininity, feminism and the Hayward Annual," reprinted in her anthology *Framing Feminism* (q.v.).

3194 *Het Zelfbeeld: Images of the Self.* Leiden: Stichting Burcht and Galerie Fotomania, 1987, 27pp., illus.
 Text in Dutch and English. An essay discusses the ideas of body art and self-portraiture through photography and video which emerge from the selected artists who come from several European countries. Over half the exhibitors are women.

3195 HIGGINS, JUDITH. "Art From the Edge." *Art in America* 83 (December 1995): 37–41.
 Examines recent developments in Irish art and discusses the work of several women artists.

3196 KULTERMANN, UDO. "Zehntausend Jahre habe ich geschlafen." *Du,* 12 December 1990: 49–55.
 Discusses the work of several women artists in Germany who work in the areas of performance and who deal in different ways with the theme of sleep.

3197 LINKER, KATE (ED.). *Difference: On Representation and Sexuality.* New York: New Museum of Contemporary Art, 1984, 48pp., illus.
 Contains several scholarly and critical analyses of the works of twenty artists. Lisa Tickner analyses the works of five British artists of whom three are women engaged in scripto-visual work: Kelly, Lomax and Yates. More European women are represented in the section on feature films. This is one of the few catalogues where the essays address key issues of gender and identity.

3198 LIPPARD, LUCY. *Issue: Social Strategies by Women Artists.* London: Institute of Contemporary Art, 1980, n.p., illus.
 Examines the work of about twenty British and American artists who use their work to address political and social issues in a direct manner. The media and forms of art which they use are varied.

3199 McDONALD, CLARE. "Live and Kicking." *Women's Art Magazine* 61 (1994): 12–17.
Examines the development of performance art by women in Britain and its relationship to other specialisms such as dance, theatre and narrative photography. She looks at the theme of archiving the performer's own history, which she identifies in several artists.

3200 MILLARD, JOHN, and TONY KNIPE. *2D/3D: Art and Craft Made and Designed for the Twentieth Century.* Sunderland: Northern Centre for Contemporary Art, 1987, 72pp., illus.
A wide-ranging set of short essays about objects on the boundary of art and craft as well as some performance art by women dealing with the domestic environment. A considerable number of women were included in the exhibition, not all of whom are discussed in the essays.

3201 *Mothers.* Birmingham: Ikon Gallery, 1990, 38pp., illus.
Organised around the experience of motherhood, as mother or daughter, for fifteen artists. A theoretical context is set in an essay by Hilary Robinson while two of the artists—Jo Spence and Cate Elwes—also provde written commentaries. Each artist includes a statement about her work.

3202 PARKER, ROSZIKA, and GRISELDA POLLOCK. *Old Mistresses: Women, Art and Ideology.* London: Routledge & Kegan Paul, 1981, 184pp., illus.
One of the seminal books in debates about women's participation in the art world. Consists of chapters on the language of art and art criticism, on the hierarchy of the arts, on women artists and their reception up to the nineteenth century and on representations of women with an analysis of the ways in which feminist artists dealt with the problems of representation which they inherited.

3203 PASQUALI, MARILENA. *Figure dallo sfondo.* Ferrara and Grafis Editore: Padiglione d'Arte Contemporanea, 1984, 154pp., illus.
Text in Italian. The first of a series of biennial exhibitions of women artists, this has no particular theme but includes thirty-two Italian women artists. For each there is a short biography, an analysis of their work and a bibliography.

3204 PEAK, LAURIE. "Seven Obsessions." *Women's Art Magazine* 37 (1990): 12.
Reviews the work of the three women participants among the seven in the exhibition title. Melanie Counsell and Angela Bulloch produced installations while the third, Sophie Calle, showed large-scale photographs entitled *The Graves.*

3205 POLLOCK, GRISELDA. *Vision and Difference: Femininity, Feminism and the Histories of Art.* New York and London: Routledge, 1988, 239pp., illus.
An anthology of essays by Pollock previously published in journals. They examine critically issues concerning Elizabeth Siddal, Mary Cassatt (qq.v.)

and the problem of how and whether the discipline of art history can accommodate women artists. The final chapter examines the exhibition *Difference: on Representation and Sexuality* (q.v. above under LINKER) and analyses the work of artists working in video, mixed media and installations.

3206 *Sense and Sensibility in Feminist Art Practice.* Nottingham: Midland Group, 1982, n.p., illus.

An essay by Griselda Pollock analyses this innovative work and its context. Ten of the twelve women artists work in Britain and explore issues around feminism through various media. Included are Mary Kelly, Anne Newmarch, Susan Hiller, Roberta Graham, Alexis Hunter, Margaret Harrison, Aimee Rankin, Marie Yates, Yves Lomax and Sarah McCarthy.

3207 PROPHET, JANE. "Cyber Chicks." *Women's Art Magazine* 69 (April–May 1996): 10–11.

Discusses on-line galleries and, in particular, two works of art which evolve on the Internet: *A Hypertext Journal* and *Egg of the Internet.*

3208 READ, SHIRLEY. "Glass Ceiling in Cyberspace? Thoughts on Gender and New Technology." *Women's Art Magazine* 68 (January–February 1996): 10–11.

Discusses her concern that new technology could marginalise women, since it is often presented as masculine technology. She believes that it has potential for women and that educational programmes are the key to ensuring that women participate fully.

3209 UGWU, CATHERINE. "Keep on Running: The Politics of Black British Performance Art." *P-Form* 38 (winter 1995–1996): 6–14.

Discusses the use made by artists (including several women) from ethnic minorities of performance art. The author believes it emerges from the role of the carnival and can be used to draw attention to the problems of black communities. She also comments on the lack of documentation of black performance art.

3210 WARNER, MARINA, ET AL. *Women's Art at New Hall.* Cambridge: New Hall, 1992, 55pp., illus.

An exhibition of twentieth-century, and mostly post-1970, works donated by women artist to the permanent collection at New Hall, a women's college at Cambridge University. As Warner recounts in her introductory essay, Mary Kelly's *Extase,* a donation following her residency in Cambridge, was the catalyst for the formation of the collection. For practical reasons all the works are two-dimensional so sculptors who are represented have usually submitted prints. Some artists from the earlier part of the century are also included.

INDIVIDUALS

3211 ABRAMOVIČ, MARINA (1946–)
Serbian performance and video artist who works in the Netherlands and other European countries.

Publications

"Art is About Energy." *Art & Design* 8, no. 7–8 (1993): 32–37. She discusses the uses of technology which she has made in her work since the 1970s.

Marina Abramovic: Cleaning the House. Art and Design Monograph Series. London: Academy Editions, 1995, 120pp., many illus. Contains images taken and made by the artist on her travels around the world, together with notes on these. The format imitates a personal journal but is more disciplined.

Juler, Caroline. "Marina Abramovic." *Untitled* 8 (summer 1995): 3. Interview.

Kuijken, Ilse. "Marina Abramovic: Here and Now—Art is to Serve." *Artefactum* 47 no. 10 (1993): 28–31. Interview in which Abramovic discusses her performance biography which contains autobiographical elements interwoven with mythological symbols, including live snakes.

Pejič, Bojana. "Marina Abramovič: der Raum 'Dawischen' (Marina Abramovic: The space 'in between.')" *Neue Bildende Kunst* 4–5 (1995): 70–71, illus. Interview.

See Iles, Chrissie below.

Main Sources

Brandauer, Aline. "Marina Abramovic: double bind." *Sculpture* 14, no. 4 (1995): 23–27. Discusses her installation and performance work over the past twenty years.

Martin, Tim. "Marina Abramovic." *Third Text* 33 (winter 1995–1996): 85–92. Discusses her work with reference to the exhibition at the Museum of Modern Art in Oxford (see Isles, Chrissie below).

Warr, Tracey. "To Rupture Is to Find." *Women's Art Magazine* 64 (May–June 1995): 11–13. Review of the 1995 exhibition, and a consideration of Abramovic's earlier work.

See Iles, Chrissie below.

Exhibitions

Künstlerinnen international, 1877–1977. Berlin: Schloss Charlottenburg, 1977.

Eiblmayr, Silvia, Valie Export, and Monika Prischl-Maier. *Kunst mit Eigen-Sinn. Aktuelle Kunst von Frauen: Texte und Dokumentation.* Vienna: Locker Verlag in association with the Museum of Modern Art and Museum of 20th Century Art, 1985.

Het Zelfbeeld: Images of the Self. Leiden: Stichting Burcht and Galerie Fotomania, 1987.

Künstlerinnen des 20. Jahrhunderts. Wiesbaden: Museum Wiesbaden in association with Verlag Weber & Weidermeyer GmbH, Kassel, 1990.

Pejič, Bojana, and Doris von Srathen. *Marina Abramovič.* Berlin: Neue Nationalgalerie, 1993, 312pp., illus. Text in German and English. Catalogue of exhibition of body art, performances and installations over the period from 1973. Organised into three chronological sections; the second includes her collaborative work with Ulay from 1976 to 1988. There are two scholarly essays.

Iles Chrissie, ed. *Marina Abramovic: Objects, Performance, Video, Sound.* Oxford: Museum of Modern Art in association with Edition Hansjörg Mayer, 1995, 144pp., illus. Contains a list of publications, a complete list of exhibitions and performances and a bibliography. There are four critical essay, which usefully analyse the work.

3212 AGAR, EILEEN FORRESTER (1899–1991)
English Surrealist painter and mixed media artist.

See Painting section.

3213 AMERICA, LOUS (1954–)
Dutch video artist.

Exhibitions

Het Zelfbeeld: Images of the Self. Leiden: Stichting Burcht and Galerie Fotomania, 1987.

3214 BAKER, BOBBY (1950–)
English performance artist whose work is often concerned with food and consumption.

Main Sources

Brown, Georgina. "Right Off Her Trolley." *Guardian,* 9 June 1993, 18.
Lister, David. "Artist tells her tale in yoghurt and roast beef." *The Independent,* 3 April 1990. Review of her performance *Drawing on a Mother's Experience.*

Exhibitions

Hayward Annual 1979. London: Hayward Gallery, 1979.
About Time. London: Institute of Contemporary Art, 1980.
Kingston, Angela. *Mothers.* Birmingham: Ikon Gallery, 1990.

3215 BENTIVOGLIO, MIRELLA (née BERTARELLI) (1922–)
Italian sculptor, performance artist, poet and critic.

See Sculpture section.

3216 BLANK, IRMA (1934–)

German-born scripto-visual mixed media artist who works in Italy.

Exhibitions

Pasquali, Marilena. *Figure dallo sfondo.* Ferrara: Padiglione d'Arte Contemporanea and Grafis Editore, 1984. Includes a bibliography.

Other Sources

Weller, Simone. *Il Complesso di Michelangelo: ricerca sul contributo dato dalla donna all'arte italiana del novecento.* Pollenza-Macerata: La Nuova Foglio [*sic*] Editrice, 1976.

3217 BURMAN, CHILA KUMARI

English mixed media artist and photographer.

Main Sources

Cheddie, Janice. "Bodyrites." *Women's Art Magazine* 49 (1992): 19.
Fernando, Sonali, ed. *Chila Kumari Burman: Beyond Two Cultures.* London: Kala Press, 1995.
Sebestyen, Amanda. "Evidence to the Point." *Women's Art Magazine* 67 (November–December 1995): 26–27. Reviews a retrospective exhibition.

Exhibitions

The Thin Black Line. London: Institute of Contemporary Art, 1985.
Along the Lines of Resistance. An Exhibition Of Contemporary Feminist Art. Barnsley: Cooper Gallery, 1988.

Other Sources

Wells, Liz. "The Eyes of Europe." *Women's Art Magazine* 59 (1994): 29–32.

3218 CAHN, MIRIAM (1949–)

Swiss mixed-media artist who lives in Germany.

Exhibitions

Miriam Kahn: Arbeiten 1979–1983. Basle: Kunsthalle, 1983.
Eiblmayr, Silvia, Valie Export, and Monika Prischl-Maier. *Kunst mit Eigen-Sinn. Aktuelle Kunst von Frauen: Texte und Dokumentation.* Vienna: Locker Verlag in association with the Museum Moderner Kunst and Museum des 20. Jahrhunderts, Munich, 1985.
Das Verborgene Museum. Dokumentation der Kunst von Frauen in Berliner öffentlichen Sammlungen. Berlin: Edition Hentrich, 1987.
"Stiller Nachmittag": Aspekte Junger Schweizer Kunst. Zurich: Kunsthaus, 1987.

Künstlerinnen des 20. Jahrhunderts. Wiesbaden: Museum Wiesbaden in association with Verlag Weber & Weidermeyer GmbH, Kassel, 1990.

Other Sources

Dunford, Penny. *A Biographical Dictionary of Women Artists in Europe and America since 1850.* Hemel Hempstead: Harvester Wheatsheaf and Philadelphia: University of Pennsylvania Press, 1990. Contains a bibliography.

3219 CAMERON, SHIRLEY (1944–)
English sculptor and performance artist who since 1982 has worked with Evelyn Silver.

Publications

"Knitting Performances." In Gillian Elinor et al., *Women and Craft.* London: Women's Press, 1987.
"Silver Mood and Golden Sun Goddesses." *Women's Art Magazine* 44 (1992): 21.

Exhibitions

Scale for Sculpture. London: Serpentine Gallery, 1978.
Triple Interpretations. Rochdale: Rochdale Art Gallery, 1985.

Other Sources

Dunford, Penny. *A Biographical Dictionary of Women Artists in Europe and America since 1850.* Hemel Hempstead: Harvester Wheatsheaf and Philadelphia: University of Pennsylvania Press, 1990. Contains a bibliography.
Dunthorne, Katherine. *Artists Exhibited in Wales, 1945–1976.* Cardiff: Welsh Arts Council, 1976.
Parry-Crooke, Charlotte. *Contemporary British Artists.* London: Bergstrom and Boyle, 1979.

3220 CHADWICK, HELEN (1953–1996)
English artist who used performance and installations with mixed media.

Main Sources

"Helen Chadwick: At the Edge of Mystery and Taboo." *The Guardian,* 18 March 1996, 12. Obituaries.
Allthorpe-Guyton, Marjorie. "Helen Chadwick." *Art Monthly* 100 (October 1986): 18–19.
Billen, Andrew. "Work of the Body as a Work of Art." *The Observer,* 21 March 1993, 57. Discussion of her *Piss Flowers* then on show at the Angel Row Gallery, Nottingham.

Cuddihy, Mikey. "Helen Chadwick." *Women's Art Magazine* 70 (1996): 34. Obituary.

Greenan, Althea. "Thank You, Oprah Winfrey." *Women's Art Magazine* 60 (1994): 24–25. Includes a review of Chadwick's exhibition *Effluvia*.

Exhibitions

Bayer, Jonathan, and Alex Noble. *Image and Exploration: Some Directions in British Photography, 1980–85*. London: Photographers' Gallery, 1985.

Eiblmayr, Silvia, Valie Export, and Monika Prischl-Maier. *Kunst mit Eigen-Sinn. Aktuelle Kunst von Frauen: Texte und Dokumentation*. Vienna: Locker Verlag in association with the Museum Moderner Kunst and Museum des 20. Jahrhunderts, Munich, 1985.

Of Mutability: Helen Chadwick. London: Institute of Contemporary Art, 1986, n.p., illus. Contains useful analytical essays by Marina Warner and Richard Cork.

Figures. Cambridge: Cambridge Darkroom, 1987, n.p., illus.

Allthorpe-Guyton, Marjorie. *Edge 88. Performance Magazine* 55, 1988, whole issue. This issue of the journal is the catalogue of the first of what is intended to be a Biennale of Experimental Art.

British Art Now: A Subjective View. Setagaya, Japan: Setagaya Art Museum in association with the British Council, 1990. Includes a list of group and solo exhibitions together with a select bibliography.

Other Sources

Betterton, Rosemary. *Intimate Distance: Women, Artists and the Body*. London: Routledge, 1996.

Butler, Susan. "Between Frames." *Aperture* 113 (winter 1988): 30–39.

Dunford, Penny. *A Biographical Dictionary of Women Artists in Europe and America since 1850*. Hemel Hempstead: Harvester Wheatsheaf and Philadelphia: University of Pennsylvania Press, 1990. Contains a bibliography.

3221 COLQUHOUN, ITHELL (née MARGARET ITHELL COLQUHOUN) (1906–1988)
English Surrealist painter and mixed media artist.

See Painting section.

3222 COSIN, CATHARINA (1940–)
German performance, installation and mixed media artist who also produces paintings.

Other Sources

Evers, Ulrike. *Deutsche Künstlerinnen des 20. Jahrhunderts. Malerei—Bildhauerei—Tapisserie*. Hamburg: Ludwig Schultheis Verlag, 1983. Contains an individual bibliography.

3223 CUMMINS, PAULINE (1949–)
Irish mixed media artist.

Exhibitions

Eye to Eye. London: Women Artists' Slide Library, 1986.
Irish Women Artists from the Eighteenth Century to the Present Day. Dublin:
National Gallery of Ireland, Douglas Hyde Gallery and Hugh Lane Gallery, 1987.

3224 DADAMAINO (1935–)
Italian conceptual mixed media artist who belonged to the New
Tendency Group.

Exhibitions

Vescovo, Marisa. *Il Gioco delle Parti. 4 Biennale Donna.* Ferrara: Padiglione
d'Arte Contemporanea, Palazzo Massari, 1990.

Other Sources

Weller, Simone. *Il Complesso di Michelangelo: ricerca sul contributo dato
dalla donna all'arte italiana del novecento.* Pollenza-Macerata: La Nuova Foglio
[*sic*] Editrice, 1976.

3225 DAVOU, BIA (1932–)
Greek mixed media artist.

Exhibitions

Iliopoulou-Rogan, Dora. *Three Generations of Greek Women Artists:
Figures, Forms and Personal Myths.* Washington, D.C.: National Museum of
Women in the Arts, 1989.

3226 DUCHAMP, SUZANNE (1889–1963)
French Dada mixed media artist and abstract painter.

See Painting section.

3227 DUJOURIE, LILI (1941–)
Belgian video artist and sculptor.

Exhibitions

Brouwer, Marianne. "Homage to the Pensive Images of Lili Dujourie." In
*Inside the Visible: An Elliptical View of 20th Century Art—In, Of and From the
Feminine,* edited by Catherine De Zegher. Ghent: The Kanaal Foundation, 1996.

3228 ELWES, CATHERINE (1952–)

English performance and video artist who was active in the women's movement.

Main Sources

Kent, Sarah, and Jacqueline Morreau, eds. *Women's Images of Men.* London: Camden Press, 1985.

Exhibitions

About Time. London: Institute of Contemporary Art, 1980.
Het Zelfbeeld: Images of the Self. Leiden: Stichting Burcht and Galerie Fotomania, 1987.
Kingston, Angela. *Mothers.* Birmingham: Ikon Gallery, 1990.

Other Sources

Dunford, Penny. *A Biographical Dictionary of Women Artists in Europe and America since 1850.* Hemel Hempstead: Harvester Wheatsheaf and Philadelphia: University of Pennsylvania Press, 1990. Contains a bibliography.
Parker, Roszika, and Griselda Pollock. *Framing Feminism.* London: Pandora, 1987.

3229 EXPORT, VALIE (1940–)

Austrian performance and installation artist.

Publications

Eiblmayr, Silvia, Valie Export, and Monika Prischl-Maier. *Kunst mit Eigen-Sinn. Aktuelle Kunst von Frauen: Texte und Dokumentation.* Vienna: Locker Verlag in association with the Museum of Modern Art and Museum of 20th Century Art, 1985.

Exhibitions

Künstlerinnen international, 1877–1977. Berlin: Schloss Charlottenburg, 1977.
Allthorpe-Guyton, Marjorie. *Edge 88. Performance Magazine* 55, 1988, whole issue. This issue of the journal is the catalogue of the first of what is intended to be a Biennale of Experimental Art. Includes select references to her performances and publications.
Künstlerinnen des 20. Jahrhunderts. Wiesbaden: Museum Wiesbaden in association with Verlag Weber & Weidermeyer GmbH, Kassel, 1990.

3230 FINN-KELCEY, ROSE

British performance artist.

Exhibitions

Künstlerinnen international, 1877–1977. Berlin: Schloss Charlottenburg, 1977.
About Time. London: Institute of Contemporary Art, 1980.
Eiblmayr, Silvia, Valie Export, and Monika Prischl-Maier. *Kunst mit Eigen-Sinn. Aktuelle Kunst von Frauen: Texte und Dokumentation.* Vienna: Locker Verlag in association with the Museum of Modern Art and Museum of 20th Century Art, 1985.

3231 FIORONI, GIOSETTA (1933–)
Italian painter and conceptual mixed media artist.

Exhibitions

Pasquali, Marilena. *Figure dallo sfondo.* Ferrara: Padiglione d'Arte Contemporanea and Grafis Editore, 1984. Includes a bibliography.

Other Sources

Weller, Simone. *Il Complesso di Michelangelo: ricerca sul contributo dato dalla donna all'arte italiana del novecento.* Pollenza-Macerata: La Nuova Foglio [*sic*] Editrice, 1976.

3232 FLOR, ELLINOR (1948–)
Norwegian mixed-media artist who makes wearable art, particularly hats.

Exhibitions

Wichstrøm, Anne. *Rooms with a View: Women's Art in Norway, 1880–1990.* Oslo: Ministry of Foreign Affairs, 1989.

3233 FRENZEL, HANNA (1957–)
German performance artist.

Other Sources

Evers, Ulrike. *Deutsche Künstlerinnen des 20. Jahrhunderts. Malerei—Bildhauerei—Tapisserie.* Hamburg: Ludwig Schultheis Verlag, 1983. Contains an individual bibliography.

3234 GARRARD, ROSE (1946–)
English feminist performance and video artist who also produces painting and sculpture which relate to the performances.

Publications

Archiving My Own History: Documentation of Works 1969–1994, Manchester: Cornerhouse, 1994, 83pp., illus. Invaluable text which includes the

artist's notes and later evaluations of her works, together with extracts from reviews. Includes a full list of exhibitions and television programmes on her work, and a selection of publications in which her work is discussed.

"Performance Art: The Tune of the Fiddler." *Art and Design,* September–October 1994, 68–73. Reviews the development of performance art from an insider's position. Mentions some other women artists.

Main Sources

Cullis, Ann. "Rejecting the Rules of the Game." *Women's Art Magazine* 58 (1994): 19–20. Review of *Archiving My Own History* (see above).

Exhibitions

About Time. London: Institute of Contemporary Art, 1980.

Rose Garrard: Between Ourselves. Birmingham: Ikon Gallery, 1984, 32pp., illus. Includes an analytical essay and a conversation between Garrard and Sue Arrowsmith (q.v.).

Eiblmayr, Silvia, Valie Export, and Monika Prischl-Meier. *Kunst mit Eigen-Sinn: Aktuelle Kunst von Frauen: Texte und Dokumentation.* Vienna: Locker Verlag in association with the Museum moderner Kunst & Museum des 20. Jahrhunderts, Munich, 1985.

Conceptual Clothing. Birmingham: Ikon Gallery, 1987.

Allthorpe-Guyton, Marjorie. *Edge 88. Performance Magazine* 55, 1988, whole issue. This issue of the journal is the catalogue of the first of what is intended to be a Biennale of Experimental Art.

Other Sources

Dunford, Penny. *A Biographical Dictionary of Women Artists in Europe and America since 1850.* Hemel Hempstead: Harvester Wheatsheaf and Philadelphia: University of Pennsylvania Press, 1990. Contains a bibliography.

3235 GERLOVINA, RIMMA (1951–)
Russian mixed media and performance artist.

Other Sources

Rosenfeld, Alla, and Norton Dodge, eds. *Nonconformist Art: The Soviet Experience, 1956–1986. The Norton and Nancy Dodge Collection.* London: Thames and Hudson in association with the Jane Voorhees Zimmerli Art Museum, State University of New Jersey, Rutgers, 1995.

3236 GRAHAM, ROBERTA (1954–)
Northern Irish performance artist.

Exhibitions

About Time. London: Institute of Contemporary Art, 1980.
Figures. Cambridge: Cambridge Darkroom, 1987, n.p., illus.

Other Sources

Butler, Susan. "Between Frames." *Aperture* 113 (winter 1988): 30–39.

3237 GRISI, LAURA (1939–)
Greek conceptual painter and mixed media artist who works in New York and Rome.

Main Sources

Celant, Germano. *Laura Grisi.* New York: Rizzoli, 1990, 274pp., illus. Illustrates a selection of works with notes by Grisi. Includes an interview with Grisi and a critical essay.

Other Sources

Weller, Simone. *Il Complesso di Michelangelo: ricerca sul contributo dato dalla donna all'arte italiana del novecento.* Pollenza-Macerata: La Nuova Foglio [*sic*] Editrice, 1976.

3238 HATHERLY ANA (1929–)
Portuguese mixed media artist, film-maker, designer and writer.

Main Sources

"Extrase e Leança." *Loreto 13. Rivista Literária da Associação Portuguesa de Escritores* 2 (April 1978): n.p.

Other Sources

Tannock, Michael. *Portuguese Artists of the Twentieth Century: A Biographical Dictionary.* Chichester: Phillimore & Co. Ltd., 1988.

3239 HATOUM, MONA (1952–)
Palestinian video and performance artist who has worked in England since 1975.

Main Sources

"Mona Hatoum: Body and Text." *Third Text,* autumn 1987, 26–33.
Di Bello, Patrizia. "Intimate Distance: Five Black Women Photographers." *Women's Art Magazine* 40 (1991): 24–25. Review of a touring exhibition which first opened at the Photographers' Gallery, London.
Smith, Caroline. "Lights Out." *Women's Art Magazine* 53 (1993): 28. Review of two installations.

Exhibitions

Eiblmayr, Silvia, Valie Export, and Monika Prischl-Maier. *Kunst mit Eigen-Sinn. Aktuelle Kunst von Frauen: Texte und Dokumentation.* Vienna: Locker Verlag in association with the Museum of Modern Art and Museum of 20th Century Art, 1985.

Contemporary Clothing, Birmingham: Ikon Gallery, 1987.

Figures. Cambridge: Cambridge Darkroom, 1987, n.p., illus.

Along the Lines of Resistance: An Exhibition of Contemporary Feminist Art. Barnsley: Cooper Gallery, 1988.

Allthorpe-Guyton, Marjorie. *Edge 88. Performance Magazine* 55, 1988, whole issue. This issue of the journal is the catalogue of the first of what is intended to be a Biennale of Experimental Art.

Ascherson, Neil. *Shocks to the System: Social and Political Issues in Recent British Art from the Arts Council Collection.* London: Royal Festival Hall, 1991.

Philippi, Desa. "Mona Hatoum: Some Any No Every Body." In *Inside the Visible: An Elliptical View of 20th Century Art—In, Of and From the Feminine,* edited by Catherine De Zegher. Ghent: The Kanaal Foundation, 1996.

Other Sources

Betterton, Rosemary. *Intimate Distance: Women, Artists and the Body.* London: Routledge, 1996.

Dunford, Penny. *A Biographical Dictionary of Women Artists in Europe and America since 1850.* Hemel Hempstead: Harvester Wheatsheaf and Philadelphia: University of Pennsylvania Press, 1990. Contains a bibliography.

Lajer-Burcharth, Ewa. "Real Bodies: Video in the 1990s." *Art History* 20, no. 2 (1997): 185–213, illus.

3240 HEIBACH, ASTRID (1954–)
German video artist.

Exhibitions

Het Zelfbeeld: Images of the Self. Leiden: Stichting Burcht and Galerie Fotomania, 1987.

3241 HENNINGS, EMMY (Alt. BALL-HENNINGS) (1885–?)
German artist who worked in several media, including performance, and who was involved in the Dada movement in Zurich.

Publications

Das Fluchtige Spiel. Einsiedeln, 1942.

Ruf und Echo: mein Leben mit Hugo Ball. Einsiedeln, 1953. An autobiography.

Main Sources

Ball, Hugo. *Flight Out of Time: A Dada Diary.* New York, 1973.
Rugh, T. "Emmy Hennings and the Emergence of New York Dada."
Woman's Art Journal 2, no. 1 (Spring–summer 1981): 1–6.

Exhibitions

Bollinger, Hans, Guido Magnaguagno, and Raymond Meyer. *Dada in Zurich.* Zurich: Kunsthaus, 1985.

Other Sources

Dunford, Penny. *A Biographical Dictionary of Women Artists in Europe and America since 1850.* Hemel Hempstead: Harvester Wheatsheaf and Philadelphia: University of Pennsylvania Press, 1990. Contains a bibliography.

3242 HESKE, MARIANNE (1946–)
Norwegian sculptor, video and installation artist, graphic artist and photographer.

See Sculpture section.

3243 HILLER, SUSAN (1942–)
American-born mixed media and video artist who has worked in England since 1967.

Publications

Einzig, Barbara. *Thinking About Art: Conversations with Susan Hiller.* Manchester: Manchester University Press, 1996, 240pp., illus. Documents Hiller's lectures, conversations and exhibitions over the past twenty years.
See Brett and Lacey below.

Main Sources

Brett, Guy, et al. *Susan Hiller 1973–83: The Muse, my Sister.* Londonderry: The Orchard Gallery, 1984, 48pp., illus. A collection of analytical essays published on the occasion of three simultaneous exhibitions in Londonderry, at the Third Eye Centre, Glasgow and at Gimpel Fils, London. Includes a bibliography and list of Hiller's publications.
Gresty, Hilary. "Susan Hiller: An Entertainment." *Women's Art Magazine* 41 (1991): 15. Review of a time-based work of that title presented at the Third Eye Centre, Glasgow.
Kubicki, Kathy. "Punches in the Dark." *Women's Art Magazine* 66 (September–October 1995): 28. Review of the exhibition *Night Lights* at Gimpel Fils, London.
Lacey, Catherine. *Susan Hiller: "Belshazzar's Feast."* Tate New Art. The

Artist's View. London: Tate Gallery, 1985, 16pp., illus. Contains a bibliography. An interview published on the acquisition of the work by Hiller.

Exhibitions

Künstlerinnen international, 1877–1977. Berlin: Schloss Charlottenburg, 1977.
Hayward Annual 1978. London: Hayward Gallery , 1978.
Susan Hiller: Recent Works. Cambridge: Kettle's Yard, 1978 35pp., illus. Contains, inter alia, three essays by Hiller about her work.
About Time. London: Institute of Contemporary Art, 1980.
Monument. Birmingham: Ikon Gallery, 1981. Text in French and English. Published for the exhibition in Birmingham and Toronto. Includes an essay by Hiller.
Eiblmayr, Silvia, Valie Export, and Monika Prischl-Maier. *Kunst mit Eigen-Sinn. Aktuelle Kunst von Frauen: Texte und Dokumentation.* Vienna: Locker Verlag in association with the Museum of Modern Art and Museum of 20th Century Art, 1985.
Fisher, Jean. *Susan Hiller: The Revenants of Time.* London: Matt's Gallery, 1990, n.p., illus. Also seen at the Mappin Gallery, Sheffield and the Third Eye Centre, Glasgow. Consists of a series of essays on Hiller's work.
Ascherson, Neil. *Shocks to the System: Social and Political Issues in Recent British Art from the Arts Council Collection.* London: Royal Festival Hall, 1991.
Fisher, Jean. "Susan Hiller: *Élan* and Other Evocations." In *Inside the Visible: An Elliptical View of 20th Century Art—In, Of and From the Feminine,* edited by Catherine De Zegher. Ghent: The Kanaal Foundation, 1996.

Other Sources

Butler, Susan. "Between Frames." *Aperture* 113 (winter 1988): 30–39.
Dunford, Penny. *A Biographical Dictionary of Women Artists in Europe and America since 1850.* Hemel Hempstead: Harvester Wheatsheaf and Philadelphia: University of Pennsylvania Press, 1990. Contains a bibliography.
Kent, Sarah, and Jacqueline Morreau. *Women's Images of Men.* London: Writers and Readers Publishing, 1985.
Williams, Val. *Women Photographers: The Other Observers, 1900 to the Present.* London: Virago, 1986.

3244 HÖCH, HANNAH (née JOHANNE HÖCH) (1889–1978)
German collage and mixed media artist who in her early career contributed to the Dada movement.

Main Sources

Dech, Julia. *Hannah Höch: Fotomontagen, Gemälde, Aquarelle.* Cologne: DuMont, 1980, 238pp., illus.
Hubert, Renée Riese. *Magnifying Mirrors: Women, Surrealism and Partnership.* Lincoln and London: University of Nebraska Press, 1994, pp.

207–308. Discusses the nature of relationships within the Surrealist group and its effect on the productivity of both partners.

Exhibitions

Hannah Höch. Paris. Musée d'Art Moderne de la Ville de Paris, 1976.
Harris, Anne Sutherland, and Linda Nochlin. *Women Artists 1550–1950.* Los Angeles: County Museum of Art, 1976.
Künstlerinnen international, 1877–1977. Berlin: Schloss Charlottenburg, 1977.
Beckett, Jane. *The Twenties in Berlin.* London: Annely Juda Gallery, 1978.
Hannah Höch, 1889–1978: Collages. Exhibition organised by the Institute for Foreign Cultural Relations, Stuttgart, 1985. London: Goethe Institute, 1986, 134pp., illus. Contains a detailed biography and three scholarly essays on aspects of Höch's work, including one from a feminist perspective.
Das Verborgene Museum. Dokumentation der Kunst von Frauen in Berliner öffentlichen Sammlungen. Berlin: Edition Hentrich, 1987.
Hannah Höch, 1889–1978. Ihr Werk, Ihr Leben, Ihre Freunde. Berlin: Berlinische Galerie für Modern Kunst, Photographie und Architektur of the Martin-Gropius Bau, 1989, 223pp., illus. Held on the centenary of her birth.
Künstlerinnen des 20. Jahrhunderts. Wiesbaden: Museum Wiesbaden in association with Verlag Weber & Weidermeyer GmbH, Kassel, 1990.
Makela, Marie, and Peter Boswell. *The Photomontages of Hannah Höch.* New York: Museum of Modern Art in association with the Walker Art Gallery, Minneapolis, 1996, 224pp., illus.
Lavin, Maud. "The Mess of History or the Unclean Hannah Höch." In *Inside the Visible: An Elliptical View of 20th Century Art—In, Of and From the Feminine,* edited by Catherine De Zegher. Ghent: The Kanaal Foundation, 1996.

Other Sources

Bachmann, Donna, and Sherry Piland. *Women Artists: A Historical, Contemporary and Feminist Bibliography.* Metuchen, N.J.: Scarecrow Press, 1978.
Dunford, Penny. *A Biographical Dictionary of Women Artists in Europe and America since 1850.* Hemel Hempstead: Harvester Wheatsheaf and Philadelphia: University of Pennsylvania Press, 1990. Contains a bibliography.
Evers, Ulrike. *Deutsche Künstlerinnen des 20. Jahrhunderts. Malerei—Bildhauerei—Tapisserie.* Hamburg: Ludwig Schultheis Verlag, 1983. Contains an individual bibliography.

3245 HOOVER, NAN (1931–)
American-born performance artist who has lived in the Netherlands since 1969.

Exhibitions

Eiblmayr, Silvia, Valie Export, and Monika Prischl-Maier. *Kunst mit Eigen-Sinn. Aktuelle Kunst von Frauen: Texte und Dokumentation.* Vienna: Locker Verlag in association with the Museum of Modern Art and Museum of 20th Century Art, 1985.

Het Zelfbeeld: Images of the Self. Leiden: Stichting Burcht and Galerie Fotomania, 1987.

3246 HOOYKAAS, MADELON (1942–)
Dutch video artist.

Exhibitions

Het Zelfbeeld: Images of the Self. Leiden: Stichting Burcht and Galerie Fotomania, 1987.

3247 HORKÝ-HEUEL, ULLA (1950–)
German performance artist.

Other Sources

Evers, Ulrike. *Deutsche Künstlerinnen des 20. Jahrhunderts. Malerei—Bildhauerei—Tapisserie.* Hamburg: Ludwig Schultheis Verlag, 1983. Contains an individual bibliography.

3248 HORN, REBECCA (1944–)
German performance and video artist, sculptor and film-maker.

Publications

See Guggenheim Museum catalogue below.

Main Sources

See Guggenheim Museum catalogue below.
"Rebecca Horn: Interview with Anne de Charmant. *Tate: The Art Magazine* 4 (winter 1994): 32–37.
Brink, Renate. "Don't Stop the Carnival." *Women's Art Magazine* 60 (1994): 18–20.
Debbaut, January "L'Empire des sens selon Rebecca Horn." *Art Press* 104 (June 1986): 24–27.

Exhibitions

Rebecca Horn. London: Serpentine Gallery, 1984.
Falls the Shadow: Recent British and European Art. London: Hayward Gallery, 1986.
Contemporary Clothing. Birmingham: Ikon Gallery, 1987.

Rebecca Horn: Missing Full Moon. Bath: Artsite Gallery, 1989, 80pp., mainly illus. Contains an analytical essay by Lynne Cook.
Rebecca Horn. New York: Guggenheim Museum, 1993, 344pp., illus. The most substantial work on the artist, this catalogue contains critical essays by four writers, two interviews with Horn and texts by the artist. It includes a full bibliography and lists of exhibitions, films and performances.
Rebecca Horn. London: Serpentine Gallery, 1995.

Other Sources

Dunford, Penny. *A Biographical Dictionary of Women Artists in Europe and America since 1850.* Hemel Hempstead: Harvester Wheatsheaf and Philadelphia: University of Pennsylvania Press, 1990. Contains a bibliography.
Evers, Ulrike. *Deutsche Künstlerinnen des 20. Jahrhunderts. Malerei—Bildhauerei—Tapisserie.* Hamburg: Ludwig Schultheis Verlag, 1983. Contains an individual bibliography.

3249 HUWS, BETHAN (c. 1964–)
Welsh installation artist who uses mixed media.

Exhibitions

Loock, Ulrich. *Bethan Huws: Works 1987–1991.* Bern: Kunsthalle, 1991, 71pp., illus. Text in German and English. The exhibition was also seen in London at the Institute of Contemporary Art. The critical essay discusses her previous work as well as that in the exhibition.

3250 IKAM, CATHERINE (1942–)
French installation, video artist and photographer.

Exhibitions

Eiblmayr, Silvia, Valie Export, and Monika Prischl-Maier. *Kunst mit Eigen-Sinn. Aktuelle Kunst von Frauen: Texte und Dokumentation.* Vienna: Locker Verlag in association with the Museum of Modern Art and Museum of 20th Century Art, 1985.

3251 JEREZ, CONCHA (1941–)
Spanish installation artist.

Exhibitions

Künstlerinnen des 20. Jahrhunderts. Wiesbaden: Museum Wiesbaden in association with Verlag Weber & Weidermeyer GmbH, Kassel, 1990.

3252 KANAGINI, NIKI (1933–)
Greek mixed media artist.

Exhibitions

Iliopoulou-Rogan, Dora. *Three Generations of Greek Women Artists: Figures, Forms and Personal Myths.* Washington, D.C.: National Museum of Women in the Arts, 1989.

3253 KAZOVSZKIJ, EL (1948–)
Russian-born installation artist and designer of theatre sets who has lived in Hungary since the 1960s.

Main Sources

Frank, J. "Naïve, Avant-garde, Pop." *New Hungarian Quarterly* 14 (1976): 60.

Exhibitions

Contemporary Visual Art in Hungary. Glasgow: Third Eye Centre, 1985.

Other Sources

Dunford, Penny. *A Biographical Dictionary of Women Artists in Europe and America since 1850.* Hemel Hempstead: Harvester Wheatsheaf and Philadelphia: University of Pennsylvania Press, 1990. Contains a bibliography.

3254 KEANE, TINA (c. 1948–)
English performance and video artist.

Exhibitions

About Time. London: Institute of Contemporary Art, 1980.
Eiblmayr, Silvia, Valie Export, and Monika Prischl-Maier. *Kunst mit Eigen-Sinn. Aktuelle Kunst von Frauen: Texte und Dokumentation.* Vienna: Locker Verlag in association with the Museum of Modern Art and Museum of 20th Century Art, 1985.
Allthorpe-Guyton, Marjorie. *Edge 88. Performance Magazine* 55, 1988, whole issue. This issue of the journal is the catalogue of the first of what is intended to be a Biennale of Experimental Art.

Other Sources

Dunford, Penny. *A Biographical Dictionary of Women Artists in Europe and America since 1850.* Hemel Hempstead: Harvester Wheatsheaf and Philadelphia: University of Pennsylvania Press, 1990. Contains a bibliography.

3255 KEEGAN, RITA (1949–)
American mixed-media artist and painter who works in England.

Publications

"Rita Keegan." *Women Live,* spring 1988, 19–21.
"An Update on Black Women and WASL [Women Artists' Slide Library]." *Feminist Art News* 2, no. 8 (autumn 1988): 29. Describes black women artists being included in the archives of the Women Artists' Slide Library in London.
"Distilling the Essence." *Ten-8* 2, no. 3 (spring 1992): 148–149.

Main Sources

Denning, Laura. "Photomontage now." *Women's Art Magazine* 42 (1991): 18–19. Review of the exhibition of two artists, Keegan and Cath Tate.
Rendall, Clare. "Actual Lives of Women Artists: Rita Keegan." *Women Artists' Slide Library Journal* (1987): 10–11.

Other Sources

Dunford, Penny. *A Biographical Dictionary of Women Artists in Europe and America since 1850.* Hemel Hempstead: Harvester Wheatsheaf and Philadelphia: University of Pennsylvania Press, 1990. Contains a bibliography.

3256 KELLY, MARY (1941–)
American-born feminist installation artist working in England who employs texts and objects to question society's notion of women's roles.

Publications

"The State of British Art." *Studio International* (1978): 80–82. The text of an introduction to a debate on "The Crisis in Professionalism" held at the Institute of Contemporary Art, London.
"Sexual Politics in Art." Paper given at a conference on art and politics in 1977 and published in Taylor, Brandon, *Art and Politics.* Winchester: Winchester School of Art, 1980, pp. 66–75. Reprinted in Parker and Pollock (1987) below.
"Re-Viewing Modernist Criticism." *Screen* 22, no. 3 (1981): 45–57.
Post-Partum Document. London: Routledge, Kegan Paul, 1983, 212pp., illus. Contains illustrations of every part of this installation by Kelly together with critical essays by several writers.
"Beyond the Purloined Image." *Block* 9 (1983): 68–72. Reprinted in Parker and Pollock (1987) below.

Exhibitions

Hayward Annual '78. London: Hayward Gallery, 1978.
Lippard, Lucy. *Issue: Social Strategies by Women Artists.* London: Institute of Contemporary Art, 1980.
Linker, Kate. *Difference: On Representation and Sexuality.* New York: New Museum of Contemporary Art, 1984.
Ascherson, Neil. *Shocks to the System: Social and Political Issues in*

Recent British Art from the Arts Council Collection. London: Royal Festival Hall, 1991.

Other Sources

Dunford, Penny. *A Biographical Dictionary of Women Artists in Europe and America since 1850.* Hemel Hempstead: Harvester Wheatsheaf and Philadelphia: University of Pennsylvania Press, 1990. Contains a bibliography.

Parker, Roszika, and Griselda Pollock. *Old Mistresses: Women, Art and Ideology.* London: Routledge and Kegan Paul, 1982. The final chapter deals with Kelly's *Post-Partum Document.*

————. *Framing Feminism.* London: Pandora, 1987. Reprints two articles by Kelly and Laura Mulvey's review of the *Post-Partum Document.*

3257 LAFONTAINE, MARIE-JO (1950–)

Belgian video artist and photographer who has also produced monochrome paintings, sculpture and weavings.

Exhibitions

Eiblmayr, Silvia, Valie Export, and Monika Prischl-Maier. *Kunst mit Eigen-Sinn. Aktuelle Kunst von Frauen: Texte und Dokumentation.* Vienna: Locker Verlag in association with the Museum of Modern Art and Museum of 20th Century Art, 1985.

Marie-Jo Lafontaine: Works 1976–1989. Edinburgh: Fruitmarket Gallery, 1989, 86pp., illus. Includes essays which analyse the themes and ideas which link her disparate output. Also includes a select list of exhibitions.

Künstlerinnen des 20. Jahrhunderts. Wiesbaden: Museum Wiesbaden in association with Verlag Weber & Weidermeyer GmbH, Kassel, 1990.

Other Sources

Schlagheck, Irma. "Parade der neuen Künste (Parade of the New Arts)." *ART: das Kunstmagazin* 2 (1993): 30–39. Examines the use made by several artists of new technology.

3258 LEESON, LORRAINE (1951–)

English mixed-media and installation artist who often works on community-based projects.

Exhibitions

Lippard, Lucy. *Issue: Social Strategies by Women Artists.* London: Institute of Contemporary Art, 1980.

Eiblmayr, Silvia, Valie Export, and Monika Prischl-Maier. *Kunst mit Eigen-Sinn. Aktuelle Kunst von Frauen: Texte und Dokumentation.* Vienna: Locker Verlag in association with the Museum of Modern Art and Museum of 20th Century Art, 1985.

Other Sources

Dunford, Penny. *A Biographical Dictionary of Women Artists in Europe and America since 1850.* Hemel Hempstead: Harvester Wheatsheaf and Philadelphia: University of Pennsylvania Press, 1990. Contains a bibliography.

3259 LEVENTON, ROSIE (1949–)
 English sculptor who uses mixed media to create environments and installations.

Main Sources

Clarke, M. "The Forest: Arnatt, Godwin, Rothenstein, Leventon." *Art Monthly,* October 1986, 20–21.
Winsby, I. "Rosie Leventon." *Arts Review,* August 1985, 455.

Other Sources

Dunford, Penny. *A Biographical Dictionary of Women Artists in Europe and America since 1850.* Hemel Hempstead: Harvester Wheatsheaf; Philadelphia: University of Pennsylvania Press, 1990. Contains a bibliography.

3260 LUSTIG, CHRISTA (1944–)
 German mixed-media artist.

Exhibitions

Das Verborgene Museum. Dokumentation der Kunst von Frauen in Berliner öffentlichen Sammlungen. Berlin: Edition Hentrich, 1987.

3261 MANETTI, ANDREA (1964–)
 Italian installation artist.

Exhibitions

Andrea Manetti. St. Etienne: Académie des Beaux-Arts, 1992, 11pp., illus. Text in French, Italian and Greek.

3262 MESSAGER, ANNETTE (1943–)
 French mixed media artist.

Publications

Annette Messager: 'collectioneuse.' Paris: Musée d'Art Moderne de la Ville de Paris, 1974.
Annette Messager: Les pièges à chimères. Paris: Musée d'Art Moderne de la Ville de Paris, 1984. A booklet containing a conversation between the artist and Suzanne Pagé.
 See Conkelton and Eliel below.

Main Sources

Wells, Liz. "Shades of Uncertainty." *Women's Art Magazine* 45 (1992): 10–12.

Exhibitions

Christian Boltanski & Annette Messager: Modelbilder: das Glück, die Schönheit und die Träume. Bonn: Rheinisches Landesmuseum in association with Rhainland-Verlag GmbH, Cologne, 1973, 119pp., illus. Text in German. Two essays precede the catalogue. There is also a biography and bibliography for each artist.

Künstlerinnen international, 1877–1977. Berlin: Schloss Charlottenburg, 1977.

Conkelton, Sheryl, and Carol Eliel. *Annette Messager.* Los Angeles: County Museum of Art in assocation with Abrams, New York, 96pp., illus. Two scholarly and analytical essays form the main part of this catalogue. They are supplemented by lists of Messager's publications, her solo and group exhibitions and a fairly detailed bibliography of critical writings about Messager.

Other Sources

Naggar, C. *Dictionnaire des photographes.* Paris: Editions du Seuil, 1982.

3263 NYBORG, HEGE (1961–)
 Norwegian scripto-visual and mixed-media artist.

Exhibitions

Fisher, Susan Sterling, Anne Wichstrøm, and Toril Smit. *At Century's End: Norwegian Artists and the Figurative Tradition, 1880–1990.* Høvikodden: Henie-Onstad Art Centre, 1995. Includes a list of exhibitions and an individual bibliography.

3264 O'SULLIVAN, ANNA (1958–)
 Irish performance artist.

Exhibitions

Irish Women Artists from the Eighteenth Century to the Present Day. Dublin: National Gallery of Ireland, Douglas Hyde Gallery and Hugh Lane Gallery, 1987.

3265 OLESEN, MURIEL
 Swiss installation and performance artist.

Exhibitions

Eiblmayr, Silvia, Valie Export, and Monika Prischl-Maier. *Kunst mit Eigen-Sinn. Aktuelle Kunst von Frauen: Texte und Dokumentation.* Vienna: Locker Verlag

in association with the Museum of Modern Art and Museum of 20th Century Art, 1985.

3266 OLIVEIRA, ANA MARIA SOARES PACHECO VIEIRA NERYDE (1940–)
Portuguese painter and mixed media and graphic artist.

Exhibitions

Art portugais contemporain. Paris: Musée d'Art Moderne de la Ville de Paris, 1976.

Other Sources

Tannock, Michael. *Portuguese Artists of the Twentieth Century: A Biographical Dictionary.* Chichester: Phillimore & Co. Ltd., 1988.

3267 OPPENHEIM, MERET (1913–1985)
Swiss Surrealist sculptor and installation artist.

See Sculpture section.

3268 ORGERET, VALÉRIE (c. 1966–)
French mixed-media artist and photographer.

See Photography section.

3269 ORLAN (1947–)
French video and performance artist who undergoes surgical operations to her face in order to question social pressures on women's appearance.

Publications

"I Do Not Want to Look Like." *Women's Art Magazine* 64 (May–June 1995): 5–10.

Main Sources

Armstrong, Rachel. "Woman With Head." *Women's Art Magazine* 70 (1996): 17.
Yakir, Nedira. "Speaking With." *Women's Art Magazine* 70 (1996): 16. Discussion of a lecture given by Orlan, together with a catalogue and exhibition of her most recent operation.

Exhibitions

Eiblmayr, Silvia, Valie Export, and Monika Prischl-Maier. *Kunst mit Eigen-Sinn. Aktuelle Kunst von Frauen: Texte und Dokumentation.* Vienna: Locker

Verlag in association with the Museum of Modern Art and Museum of 20th Century Art, 1985.

3270 PANE, GINA (1939–)
Performance artist of Italian-Austrian parents whose works focus on the body through pain and wounds; she was born and works in France.

Exhibitions

Vergine, Lea. *Gina Pane: Partitions. Opere Multimedia, 1984–5*. Milan: Padiglione dell'Arte Contemporanea, 1985. Text in Italian, French and English. Discusses the nature of body-art and the notion of pain, martyrdom and wounding. Contains an interview with Pane and a bibliography.
Vescovo, Marisa. *Il Gioco delle Parti. 4 Biennale Donna*. Ferrara: Padiglione d'Arte Contemporanea, Palazzo Massari, 1990.

Other Sources

Barry, Judith, and Sandy Flitterman. "Textual Strategies: The Politics of Art Making." *Screen* 21, no. 2 (1980).
Ceysson, B., et al. *25 ans d'art en France, 1960–1985*. Paris: Larousse, 1986. Includes a select list of exhibitions for each artist.
Dunford, Penny. *A Biographical Dictionary of Women Artists in Europe and America since 1850*. Hemel Hempstead: Harvester Wheatsheaf and Philadelphia: University of Pennsylvania Press, 1990. Contains a bibliography.

3271 PARKER, CORNELIA (1956–)
English installation artist and sculptor.

Main Sources

Adams, Tessa. "Cornelia Parker: The Enactment of Destruction and Restitution." *Issues in Architecture, Art and Design* 4, no. 1 (1995): 30–50. Analyses the psychological effects in several works of the tension between destruction and restoration.
Rudolph, Karen. "Die Energie des Sichtbaren (The Energy of the Visible)." *Neue Bildende Kunst* 3, no. 3 (1993): 60–62.

Exhibitions

New British Sculpture. London: Air Gallery, 1986. Contains an outline biography, a list of exhibitions and awards and a short statement from the artist.
Cornelia Parker. London: Serpentine Gallery, 1995.

Other Sources

"Absolutely Still." *Creative Camera* 335 (1995): 50. Interview with Tilda Swinton the actress, who was the sleeping figure in Parker's installation *The Maybe*.
Glaister, Dan. "A Woman's Place—in the Gallery." *The Guardian*, 18 June

1997, 3. Discusses the four women contenders for the 1997 Turner prize, of which Parker was one.

Hyman, Timothy. "Giving and Witholding." *Modern Painters* 8, no. 4 (winter 1995): 44–47. Comments on the use of alternative media used by several women artists.

3272 PEZOLD, FRIEDERIKE (1945–)
Austrian installation artist and photographer.

Exhibitions

Eiblmayr, Silvia, Valie Export, and Monika Prischl-Maier. *Kunst mit Eigen-Sinn. Aktuelle Kunst von Frauen: Texte und Dokumentation.* Vienna: Locker Verlag in association with the Museum of Modern Art and Museum of 20th Century Art, 1985.

3273 PONCHELET, MARIE (1940–)
French sculptor and performance and installation artist.

Exhibitions

Eiblmayr, Silvia, Valie Export, and Monika Prischl-Maier. *Kunst mit Eigen-Sinn. Aktuelle Kunst von Frauen: Texte und Dokumentation.* Vienna: Locker Verlag in association with the Museum of Modern Art and Museum of 20th Century Art, 1985.

Other Sources

Ceysson, B., et al. *25 ans d'art en France, 1960–1985.* Paris: Larousse, 1986. Includes a select list of exhibitions for each artist.

3274 PRINA, LIEVE (1948–)
Dutch video artist.

Exhibitions

Het Zelfbeeld: Images of the Self. Leiden: Stichting Burcht and Galerie Fotomania, 1987.

3275 ROSENBACH, ULRIKE NOLDEN (1943–)
German performance artist chiefly concerned with the representation of women.

Exhibitions

Künstlerinnen International, 1877–1977. Berlin: Schloss Charlottenburg, 1977.
Eiblmayr, Silvia, Valie Export, and Monika Prischl-Maier. *Kunst mit Eigen-*

Sinn. Aktuelle Kunst von Frauen: Texte und Dokumentation. Vienna: Locker Verlag in association with the Museum of Modern Art and Museum of 20th Century Art, 1985.

Allthorpe-Guyton, Marjorie. *Edge 88. Performance Magazine* 55, 1988, whole issue. This issue of the journal is the catalogue of the first of what is intended to be a Biennale of Experimental Art.

Het Zelfbeeld: Images of the Self. Leiden: Stichting Burcht and Galerie Fotomania, 1987.

Künstlerinnen des 20. Jahrhunderts. Wiesbaden: Museum Wiesbaden in association with Verlag Weber & Weidermeyer GmbH, Kassel, 1990.

Other Sources

Dunford, Penny. *A Biographical Dictionary of Women Artists in Europe and America since 1850.* Hemel Hempstead: Harvester Wheatsheaf and Philadelphia: University of Pennsylvania Press, 1990. Contains a bibliography.

Evers, Ulrike. *Deutsche Künstlerinnen des 20. Jahrhunderts. Malerei— Bildhauerei—Tapisserie.* Hamburg: Ludwig Schultheis Verlag, 1983. Contains an individual bibliography.

Krichbaum, J., and R. Zondergeld. *Künstlerinnen: von der Antike bis zur Gegenwart.* Cologne: DuMont, 1979.

Lippard, Lucy. *From the Center.* New York: Dutton, 1976.

3276 ROSS, MONICA (c. 1950–)
English performance artist.

Exhibitions

Lippard, Lucy. *Issue: Social Strategies by Women Artists.* London: Institute of Contemporary Art, 1980.

Triple Transformations. Rochdale: Art Gallery, 1985.

Along the Lines of Resistance: An Exhibition of Contemporary Feminist Art. Barnsley: Cooper Gallery, 1986.

Other Sources

Dunford, Penny. *A Biographical Dictionary of Women Artists in Europe and America since 1850.* Hemel Hempstead: Harvester Wheatsheaf and Philadelphia: University of Pennsylvania Press, 1990. Contains a bibliography.

3277 SCHEFFKNECHT, ROMANA (1952–)
Austrian installation and video artist.

Exhibitions

Eiblmayr, Silvia, Valie Export, and Monika Prischl-Maier. *Kunst mit Eigen-Sinn. Aktuelle Kunst von Frauen: Texte und Dokumentation.* Vienna: Locker Verlag in association with the Museum of Modern Art and Museum of 20th Century Art, 1985.

3278 SCHOUTEN, LYDIA (1948–)
Dutch video, performance and installation artist.

Main Sources

Van Kerkoff, Sonja. "Lydia Schouten." *Women's Art Magazine* 37 (1990): 24–25. Review of installation at the Wanda Reiff Gallery, Maastricht.

Exhibitions

Eiblmayr, Silvia, Valie Export, and Monika Prischl-Maier. *Kunst mit Eigen-Sinn. Aktuelle Kunst von Frauen: Texte und Dokumentation.* Vienna: Locker Verlag in association with the Museum of Modern Art and Museum of 20th Century Art, 1985.
Het Zelfbeeld: Images of the Self. Leiden: Stichting Burcht and Galerie Fotomania, 1987.

3279 SHEVLIDZE, LIA (1959–)
Georgian mixed media artist.

Other Sources

Rosenfeld, Alla, and Norton Dodge, eds. *Nonconformist Art: The Soviet Experience, 1956–1986. The Norton and Nancy Dodge Collection.* London: Thames and Hudson in association with the Jane Voorhees Zimmerli Art Museum, State University of New Jersey, Rutgers, 1995.

3280 SORIATO, LUCIANA (1965–)
Italian installation artist.

Exhibitions

Vescovo, Marisa. *Il Gioco delle Parti. 4 Biennale Donna.* Ferrara: Padiglione d'Arte Contemporanea, Palazzo Massari, 1990.

3281 STASSINOPOULOU, ASPA (1935–)
Greek mixed-media and installation artist.

Exhibitions

Iliopoulou-Rogan, Dora. *Three Generations of Greek Women Artists: Figures, Forms and Personal Myths.* Washington, D.C.: National Museum of Women in the Arts, 1989.

3282 STUCKY, SILVIA (1959–)
Italian abstract painter and installation artist.

Exhibitions

Vescovo, Marisa. *Il Gioco delle Parti. 4 Biennale Donna.* Ferrara: Padiglione d'Arte Contemporanea, Palazzo Massari, 1990.

3283 TEIPELKE, ILSE (1946–)

German performance and mixed media artist whose work is influenced by the women's movement.

Other Sources

Evers, Ulrike. *Deutsche Künstlerinnen des 20. Jahrhunderts. Malerei—Bildhauerei—Tapisserie.* Hamburg: Ludwig Schultheis Verlag, 1983. Contains an individual bibliography.

3284 TROCKEL, ROSEMARIE (1952–)

German artist who works in mixed media and installations.

Main Sources

Johnson, K. "Tales from the dark side." *Art in America,* December 1988, 140–144.

Koether, J. "The Resistant art of Rosemarie Trockel." *Artscribe* 62 (March–April 1987): 54–55.

Koether, J. "Interview with Rosemarie Trockel." *Flash Art* 134 (May 1987): 40–42.

Ottmann, K. "Rosemarie Trockel." *Flash Art* 134 (May 1987): 38–39.

Rein, I. "Knitting, stretching and drawing out: Rosemarie Trockel." *Artforum* 25/10 (summer 1987): 110.

Stich, Sidra (Ed.). *Rosemarie Trockel.* Munich: Prestel, 1991, 144pp., illus. Published in conjunction with an exhibition. Two critical essays are followed by commentaries of a further twelve writers. Contains a detailed bibliography.

Exhibitions

Eiblmayr, Silvia, Valie Export, and Monika Prischl-Maier. *Kunst mit Eigen-Sinn. Aktuelle Kunst von Frauen: Texte und Dokumentation.* Vienna: Locker Verlag in association with the Museum of Modern Art and Museum of 20th Century Art, 1985.

Rosemarie Trockel. Basle: Kunsthalle and London: Institute of Contemporary Art, 1988, 71pp., illus. Text in German and English. An essay analyses her knitted items in the context of a consumer society.

Künstlerinnen des 20. Jahrhunderts. Wiesbaden: Museum Wiesbaden in association with Verlag Weber & Weidermeyer GmbH, Kassel, 1990.

Other Sources

Dunford, Penny. *A Biographical Dictionary of Women Artists in Europe and America since 1850.* Hemel Hempstead: Harvester Wheatsheaf and Philadelphia: University of Pennsylvania Press, 1990. Contains a bibliography.

3285 TSEKHIMSKAIA, NATALIA
Russian photographer and mixed media artist.

See Photography section.

3286 TSETSKHLADZE, MAIA (1965–)
Georgian mixed media artist.

Other Sources

Rosenfeld, Alla, and Norton Dodge, eds. *Nonconformist Art: The Soviet Experience, 1956–1986. The Norton and Nancy Dodge Collection.* London: Thames and Hudson in association with the Jane Voorhees Zimmerli Art Museum, State University of New Jersey, Rutgers, 1995.

3287 TUERLINCKX, JOELLE (1958–)
Belgian mixed-media and installation artist.

Exhibitions

Vende Veire, Frank. "Something About How a Tuerlinckx Machine Traverses the Exhibition Machine." In *Inside the Visible: An Elliptical View of 20th Century Art—In, Of and From the Feminine,* edited by Catherine De Zegher. Ghent: The Kanaal Foundation, 1996.

3288 URSULA (Pseudonym of URSULA SCHULTZE-BLUHM) (1921–)
German painter, sculptor and mixed media artist.

Other Sources

Evers, Ulrike. *Deutsche Künstlerinnen des 20. Jahrhunderts. Malerei—Bildhauerei—Tapisserie.* Hamburg: Ludwig Schultheis Verlag, 1983. Contains an extensive individual bibliography.

3289 VAN BEMMEL, MARCELLE
Dutch performance artist.

Exhibitions

Allthorpe-Guyton, Marjorie. *Edge 88. Performance Magazine* 55, 1988, whole issue. This issue of the journal is the catalogue of the first of what is intended to be a Biennale of Experimental Art.

3290 VAN DER PUTTEN, HENDRI (1940–)
Dutch mixed media and installation artist.

Exhibitions

Künstlerinnen des 20. Jahrhunderts. Wiesbaden: Museum Wiesbaden in association with Verlag Weber & Weidermeyer GmbH, Kassel, 1990.

3291 VANES, PAULA (1946–)
Dutch video artist.

Exhibitions

Het Zelfbeeld: Images of the Self. Leiden: Stichting Burcht and Galerie Fotomania, 1987.

3292 VIGO, NANDA (1935–)
Italian conceptual artist producing mixed-media installations.

Exhibitions

Künstlerinnen International, 1877–1977. Berlin: Schloss Charlottenburg, 1977.
Pasquali, Marilena. *Figure dallo sfondo.* Ferrara: Padiglione d'Arte Contemporanea and Grafis Editore, 1984.

Other Sources

Weller, Simone. *Il Complesso di Michelangelo: ricerca sul contributo dato dalla donna all'arte italiana del novecento.* Pollenza-Macerata: La Nuova Foglio [*sic*] Editrice, 1976.

3293 WAELGAARD, LINA (1959–)
Norwegian mixed media artist who manipulates images from art history, myth and symbolism to examine gender roles.

Exhibitions

Fisher, Susan Sterling, Anne Wichstrøm, and Toril Smit. *At Century's End: Norwegian Artists and the Figurative Tradition, 1880–1990.* Høvikodden: Henie-Onstad Art Centre, 1995. Includes a list of exhibitions and an individual bibliography.

3294 WALKER, KATE (1942–)
English feminist performance and mixed media artist.

Publications

"Fenix Documents." In Parker, Roszika, and Griselda Pollock, *Framing Feminism.* London: Pandora, 1987.

Women's Work: Two Years in the Life of a Women's Group. London: privately printed, 1986.

Exhibitions

Künstlerinnen International, 1877–1977. Berlin: Schloss Charlottenburg, 1977.

Lippard, Lucy. *Issue: Social Strategies by Women Artists.* London: Institute of Contemporary Art, 1980.

Other Sources

Dunford, Penny. *A Biographical Dictionary of Women Artists in Europe and America since 1850.* Hemel Hempstead: Harvester Wheatsheaf and Philadelphia: University of Pennsylvania Press, 1990. Contains a bibliography.

Parker, Roszika, and Griselda Pollock. *Framing Feminism.* London: Pandora, 1987.

3295 WAWRIN, ISOLDE (1949–)
German installation and mixed media artist.

Other Sources

Evers, Ulrike. *Deutsche Künstlerinnen des 20. Jahrhunderts. Malerei— Bildhauerei—Tapisserie.* Hamburg: Ludwig Schultheis Verlag, 1983. Contains an individual bibliography.

3296 WINTELER, ANNA (1954–)
Swiss performance and installation artist.

Exhibitions

Eiblmayr, Silvia, Valie Export, and Monika Prischl-Maier. *Kunst mit Eigen-Sinn. Aktuelle Kunst von Frauen: Texte und Dokumentation.* Vienna: Locker Verlag in association with the Museum of Modern Art and Museum of 20th Century Art, 1985.

"Stiller Nachmittag": Aspekte Junger Schweizer Kunst. Zurich: Kunsthaus, 1987.

Künstlerinnen des 20. Jahrhunderts. Wiesbaden: Museum Wiesbaden in association with Verlag Weber & Weidermeyer GmbH, Kassel, 1990.

3297 YTREBERG, KRISTIN (1945–)
Norwegian sculptor and installation artist who was born in Canada but trained and works in Norway.

Exhibitions

Fisher, Susan Sterling, Anne Wichstrøm, and Toril Smit. *At Century's End: Norwegian Artists and the Figurative Tradition, 1880–1990.* Høvikodden: Henie-Onstad Art Centre, 1995. Includes a list of exhibitions and an individual bibliography.

3298 ZIRANEK, SYLVIA
 English performance artist.

Exhibitions

About Time. London: Institute of Contemporary Art, 1980.

Allthorpe-Guyton, Marjorie. *Edge 88. Performance Magazine* 55, 1988, whole issue. This issue of the journal is the catalogue of the first of what is intended to be a Biennale of Experimental Art.

Photography

3299 BONGE, SUSANNE. *Eldre norske fotografer: fotografer og amator fotografer i Norge frem til 1920.* Bergen: Universitetsbiblioteket, 1980, 533pp., illus.

Text in Norwegian. A biographical dictionary of Norwegian photographers active until about 1920. There are indices by area, by the main period of activity and a bibliography. A surprising number of women are included from this early period.

3300 BROWNE, TURNER, and ELAINE PARTNOW. *Macmillan Biographical Encyclopedia of Photographic Artists and Innovators.* New York and London: Macmillan, 1983, 722pp., illus.

Includes not only photographers but also curators, teachers, lawyers, chemists and others. Photographers from the nineteenth and twentieth centuries are given an outline biography, a brief description of their work and lists of publications, collections in which their work is found and their dealers. There is a slight bias toward America rather than Europe but the book is a useful source for women.

3301 *Catalogo nazionale Bolaffi della fotografia no. 2.* Turin: Giulio Bolaffi, 1977.

Text in Italian. An alphabetical listing of Italian photographers selected by a consultative committee. Each entry contains the person's place and date of birth, address, current employment, bibliography, exhibitions and prizes. There are twelve women.

3302 EVANS, MARTIN MARIX. *Contemporary Photographers. 3rd edition. Contemporary Arts Series.* New York and London: St. James Press, 1995, 1234pp., illus.

Considering the size of this publication, European women photographers are poorly represented with only twenty-five included. The entries are useful and relatively detailed with an outline biography, lists of exhibitions and publications and a bibliography.

3303 HIRN, SVEN. *Kameran edesta ja takaa, valokuvaajat suomessa 1839–1870.* Helsinki: Suomen Valukuvataiteen Museon Säätio, 1972, 128pp., illus.

Text in Finnish with English and Swedish summaries. Biographical dictionary of photographers active in Finland in the mid-nineteenth century, among whom there are several women. Several practised with their husbands or family, others used it as a means of earning a living when widowed, while yet others were only photographers until their marriage.

3304 LAMBRECHTS, ERIC, and LUC SALU. *Photography and literature: An international bibliography of monographs.* London: Mansell, 1992, 296pp.

Lists 3900 titles in twenty languages of publications which in various ways link photography and literature. The items are individually numbered and listed alphabetically by the author or photographer. It gives access to some of the material on well-known and unfamiliar women photographers but should not be treated as a bibliography on photography.

3305 NAGGAR, C. *Dictionnaire des photographes.* Paris: Editions du Seuil, 1982, 445pp., illus.

Text in French. Four hundred twenty photographers from twenty-eight countries are listed in alphabetical sequence. Of these, thirty are European women. Each entry contains a short biography, a list of exhibitions and a bibliography. The listing includes those involved in news and fashion photography and advertising in addition to fine art photography, a bibliography which includes references in news and photography magazines as well as academic journals. It also includes institutions, galleries, technical terms and agencies. It is a useful source for the women included.

3306 ROOSENS, LAURENT, and LUC SALU. *A History of Photography: A Bibliography of Books.* London: Mansell, 1989, 446pp.

Over 11,000 items are arranged under more than 3000 headings or subheadings covering different aspects of photography. Arranged in alphabetical order of topic—individuals, groups, techniques, institutions, countries—this provides a thorough and wide-ranging introduction to books on photography. One of the selection criteria used was to include only photographers born before 1914 as subject headings and it therefore provides a useful number of the earlier women photographers in Europe. Others will occur in publications under different headings. Publications on and by women can be readily identified.

PUBLICATIONS

3307 *A Fotográfia hónapja: 12 kiállitás a Magyar fotográfia 150 éves történetéból. A fénykép varázsa 1839–1989. A month of Photography. 12 Exhibitions of Hungarian photography. The Magic of Photography 1839–1989.* Budapest: Association of Hungarian photographers and Szabad Tér Publishing Co., 1989, 415pp., illus.

Text in Hungarian and English. Catalogues of twelve exhibitions held at different venues in Budapest, all covering photographic activity in Hungary from 1839. About twelve women are included. Most appear in either the exhibition of socialist photographers or among the contemporary practitioners, and little information is given on them.

3308 *Another Objectivity.* London: Institute of Contemporary Art, 1988, n.p., illus.

An exhibition of works which the curators claim resists creating a fiction or another world by making obvious the existence of the picture. Of the eleven photographers, three are women: Hilla Becher, Hannah Collins and Suzanne Lafont.

3309 ASH, SUSAN. "Five Women Photographers." *Women Artists' Slide Library Journal* 25 (October–November 1988): 8–14.

Discusses the author's discovery of women photographers and the making of a subsequent documentary series screened on British television in 1986. The photographers in the series were Ursula Powys Lybbe, Helen Muspratt, Barbara Ker Seymer, Margaret Monck and Grace Robertson.

3310 *Az Év Fotói. Pictures of the Year. 1992.* Budapest: Pelikán Könyvek and Magyar Fotóriporterek, 1993, 320pp., illus.

About eighty contemporary photographers are included in this annual review. Arranged in alphabetical order, most are given two pages with usually three to five works reproduced and a biographical outline in English and Hungarian. Some individuals are allocated up to eight pages. Some fifteen women are included.

3311 *Az Év Fotói. Pictures of the Year. 1993.* Budapest: Pelikán Könyvek and Magyar Fotóriporterek, 1994, 295pp., illus.

Follows the same format as the previous entry. The overall number of individuals has increased and the longer entries reduced. Many of the same women from the 1992 volume are included again with some new names, making a total of sixteen.

3312 BARBER, FIONNA. "Irish Art in Liverpool." *Women's Art Magazine* 40 (1991): 4–5.

From a season of exhibitions of Irish art, including photography, the author discusses two: *Strongholds,* which specifically addressed the issue of

gender, and *Parable Island* in which few women are featured and, then, as isolated individuals.

3313 *Bauhaus photographie.* Paris: Musée d'Art Moderne de la Ville de Paris, 1984, 86pp., illus.
Text in French. Three scholarly essays examine the context and content of photography at the Bauhaus. Outline biographies of the artists are provided together with a bibliography of photography at the Bauhaus and its contemporary work in France. Seven women are included: Marianne Brandt, Lucia Moholy, Lotte Gerson, Gyula Pap, Irene Bayer, Florence Henri and Lotte Beese.

3314 BAYER, JONATHAN, and ALEX NOBLE. *Image and Exploration: Some Directions in British Photography 1980–1985.* London: Photographers' Gallery, 1985, 108pp., illus.
An exhibition of seventy young photographers of whom less than ten are women. The short introductory essay gives an overview rather than commenting on any individuals. Those included are Helen Chadwick, Mary Cooper, Christine Duyt, Joyce Edwards, Helen Harris, Joy Miles, Sarah Morley, Sue Packer and Maureen Paley.

3315 BENTELER, PETRA (ED.). *Fotografie von 1945 bis 1985. Bilderheft des Museums für Kunst und Gewerbe 19.* Hamburg: Museum für Kunst under Gewerbe, 1987, 96pp., mainly illus.
Text in German. International in focus but with an emphasis on Germany, some eleven women photographers, all German, are featured. Short biographies are included.

3316 BENTELER, PETRA. *Deutsche fotografie nach 1945.* Kassel: Fotoforum, Universität Kassel, 1979, 228pp., illus.
Text in German and English. After a number of short essays, the artists are dealt with individually. Eight women are included: Marta Höpffner, Dagmar Houler Hamaan, Hilla Becher, Charlotte March, Regine Relong, Liselotte Strelow, Rosemarie Clausen and Karin Szekessy Wunderlich.

3317 BOFFIN, TESSA, and JEAN FRASER. *Stolen Glances: Lesbians Take Photographs.* London: Pandora, 1991, 282pp., illus.
A series of varied essays (some of which are phtgraphic essays, while others are academic and critical), artists' statements and debates on specific issues. There is a useful bibliography.

3318 BUSH, KATE. "Silent Health." *Women's Art Magazine* 38 (1991): 10–11.
Written by the exhibition organiser, the article discusses the genesis of the exhibition *Silent Health* and the photographic work which it included. The four photographers—Janice Howard, Clare Collison, Melanie Friend and Kate Musselwhite—are concerned with different aspects of the theme.

3319 BUTLER, SUSAN. *Shifting Focus: An International Exhibition of Contemporary Women's Photography.* Bristol: Arnolfini Gallery, 1989, 47pp., illus.
A critical text analyses the sociopolitical underpinnings to the works exhibited and the devices used by the photographers to deal with their subject matter. Of the seventeen women exhibited, ten are based in Europe: Sophie Calle, Hannah Collins, Candida Hofer, Astrid Klein, Yve Lomax, Ingrid Orfali, Katherina Sieverding, Mitra Tabrizian, Anne Testut and Susan Trangmar.

3320 CALVERT, GILL, JILL MORGAN, and MOUSE KATZ (EDS.). *Pandora's Box.* Bristol: Arnolfini Gallery, 1984, 120pp., illus.
This exhibition arose out of an earlier exhibition, *Women's Images of Men* (1980), and shares some of its organisers. Women artists were invited to submit works on the theme of Pandora's Box and offer varied reworkings of this myth. Each of the thirty-two women has written a statement about her reactions to the myth and the generation of the work exhibited. No biographical information is given.

3321 *Československá fotografie 1968–70.* Brno: Moravská Galerie, 1971, n.p., illus.
Text in Czech, English, French, German and Russian. A very brief introduction precedes a list of the participants amongst which are ten women born between 1924 and 1949.

3322 *Československá fotografie 1971–72 [Czechoslovakian photography from the collection of the Gallery].* Brno: Moravská Galerie, 1973, 68pp., illus.
Text in Czech with summaries in English, French, German and Russian. Third biennale exhibition based on the eleven-year-old photography collection at the gallery. A total of 440 works by 124 artists were exhibited. There is an emphasis on younger artists, with seventy-three being born after 1938. Overall, sixteen women were included.

3323 DALLIER, ALINE. *Combative Acts, Profiles and Voices. An Exhibition of Women Artists from Paris.* New York: A.I.R. Gallery, 1976, n.p., illus.
An exhibition of works by Bernadette Bour, Maglione, Hessie and Francoise Janicot, who all work in Paris although two of them are not French. Their work is discussed in a useful essay.

3324 DEEPWELL, KATY. "Beyond the Eye." *Women's Art Magazine* 52 (1993): 10–12.
Examines the ways in which women artists have deconstructed the landscape as a category of art using examples from the work of photographers Karen Knorr and Ingrid Pollard.

3325 DOUGLAS, ANNA. "Faceless Full Frontals." *Women's Art Magazine* 55 (1993): 8–9.

Review of the exhibition *What She Wants* in York in which contemporary women photographers show erotic work, some with considerable humour.

3326 *Figures.* Cambridge: Cambridge Darkroom, 1987, n.p., illus.

An exhibition of photography and performance art around the theme of the human figure but as part of a social, cultural and political milieu. Mona Hatoum produced a performance while Sue Arrowsmith, Helen Chadwick and Roberta Graham all provided photographic work (qq.v.).

3327 HEATHCOTE, BERNARD V., and PAULINE F. HEATHCOTE. "The Feminine Influence: Aspects of the Role of Women in the Evolution of Photography in the British Isles." *History of Photography* 12, no. 3 (July–September 1988): 259–273.

Examines the reasons why women in the nineteenth century took up aspects of photography. Discovers women previously unknown who practised professionally in London and provincial towns as well as looking briefly at the aristocratic amateurs such as Julia Margaret Cameron and Viscountess Hawarden. Anne Cooke, Matilda Hamilton and Jane Wigley are just three new pioneers introduced here.

3328 *Het Zelfbeeld: Images of the Self.* Leiden: Stichting Burcht and Galerie Fotomania, 1987, 27pp., illus.

Text in Dutch and English. An essay discusses the ideas of body art and self-portraiture through photography and video which emerge from the selected artists who come from several European countries. Over half the exhibitors are women.

3329 HIMID, LUBAINA. *The Thin Black Line.* London: Institute of Contemporary Art, 1985, n.p. [8pp.], illus.

An exhibition of eleven women artists of colour, working in a different media; one of them was the curator. The information on each varies but there is usually a chronology and a statement by the artist.

3330 *Hungarian Connection: The Roots of Photojournalism.* Bradford: National Museum of Film, Photography and Television, 1987, 40pp., illus.

Seven women are mentioned in the introductory essay although not all were featured in the exhibition itself. Two, Olga Máté and Ilke Révai, were early portraitists from the late nineteenth century. Four others gained their opportunities through left-wing political activity in the 1920s and 1930s. Dóra Maurer is identified as a fine art photographer.

3331 IHNATOWICZOWA, JADWIGA (ED.). *Fotografia Polska do 1914r* [Polish Photography before 1914]. 2 vols. Warsaw: Biblioteka Naradowe, 1981, vol. 1: 147pp.; vol. 2: n.p., all illus.

Text in Polish. Consists of a list of 872 photographs followed by brief biographies of the photographers amongst whom, even at this early date, there were several women: Helena Butkiewicz, Irena Brodecka, Wanda Chicinska, Jadwiga Golcz, Zofia Hoszowska, Emma Mirska and Jadwiga Bajokowska. There are also several female names which are clearly psuedonyms but the identity of the individual is not known.

3332 *Ils se disent peintres, ils se disent photographes*. Paris: Musée d'Art Moderne de la Ville de Paris, 1980.

Text in French. Considers the work of thirty-five artists who work in fine art photography. An introductory essay is followed by entries on the artists. Only one European woman working as an individual, Annette Messager, is included although three others feature as half of photographer couples: Hilla Becher, Silvie Defraoui and Barbara Leisgen.

3333 KENT, SARAH, and JACQUELINE MORREAU (EDS). *Women's Images of Men*. London: Writers and Readers Publishing, 1985, 199pp., illus.

A collection of thirteen essays by artists and critics on the issues which arose out of the series of three exhibitions held at the Institute of Contemporary Art in 1980. The first of those, entitled *Women's Images of Men*, aroused considerable debate and involved the work of a number of the contributors to this book.

3334 *L'art dans les années 30 en France*. Saint Etienne: Musée d'Art et d'Industrie, 1979, 141pp., 233 illus.

Gives a chronology of events in the decade. A chapter of the social context for art in the 1930s is followed by others on realism and figuration, surrealism, abstraction, photography, furniture and architecture in Saint Etienne. The 469 exhibits include works by a limited number of women who were active in France during the 1930s: Marcelle Cahn, Sonia Delaunay, Yolande Fieure, Laure Garcin, Hannah Kosnick-Kloss, Marie Laurencin, Tamara de Lempicka, Chana Orloff, Suzanne Roger, Sophie Taeuber-Arp, Suzanne Valadon and Maria Elena Vieira da Silva, with the photographers Gisèle Freund, Florence Henri and Germaine Krull.

3335 LINKER, KATE (ED.). *Difference: On Representation and Sexuality*. New York: New Museum of Contemporary Art, 1984, 48pp., illus.

Contains several scholarly and critical analyses of the works of twenty artists. Lisa Tickner analyses the works of five British artists of whom three are women engaged in scripto-visual work: Kelly, Lomax and Yates. More European women are represented in the section on feature films. This is one of the few catalogues where the essays address key issues of gender and identity.

3336 McDONALD, CLARE. "Live and Kicking." *Women's Art Magazine* 61 (1994): 12–17.
Examines the development of performance art by women in Britain, its relationship to other specialisms such as dance, theatre and narrative photography. She looks at the theme of archiving the performer's own history, which she identifies in several artists.

3337 MELLOR, DAVID (ED.). *Germany: The New Photography, 1927–1933. Documents and Essays.* London: Arts Council of Great Britain, 1978, 136pp., illus.
The first part of the book contains key documents on photography from this period, some not previously available in English. The second part contains five essays by modern scholars. Women do not occupy a large part of this book. Aenne Biermann, Lucia Moholy and Barbara Ker-Seymer are those mentioned most frequently while several others are mentioned in passing. There is little substantive material on any of them.

3338 MELLOR, DAVID. *Modern British Photography, 1919–1939.* Oxford: Museum of Modern Art in association with the Arts Council of Great Britain, 1980, 47pp., illus.
An introductory essay analyses the twenty years of photography in Britain before World War II, which mark the transition from pictorial photography to a professional structure. Photography is integrated into its social and economic context and the ways in which the women featured here were able to access the profession are indicated. Six of the twenty-nine photographers included here are women: Helen McGregor, Barbara Ker-Seymer, Rosalind Maingot, Edith Tudor-Hart, Dorothy Wildman and Madame Yevonde.

3339 MESKIMMON, MARSHA, and SHEARER WEST. *Visions of the 'Neue Frau': Women and the Visual Arts in Weimar Germany.* London: Scolar Press, 1995, 187pp., illus.
An anthology of essays which grew out of the exhibition *Domesticity and Dissent: The Role of Women Artists in Germany, 1918–1938,* curated by Meskimmon (q.v.). They analyse the sociopolitical context for women artists and chapters examine the notion of the artist couple, women sculptors, women photographers, dancers, dealers and women in the film industry. All these are rigorously examined in the context of Weimar Germany.

3340 *Mothers.* Birmingham: Ikon Gallery, 1990, 38pp., illus.
Organised around the experience of motherhood, as mother or daughter, for fifteen artists. A theoretical context is set in an essay by Hilary Robinson while two of the artists—Jo Spence and Cate Elwes—also provide written commentaries. Each artist includes a statement about her work.

3341 MURPHY, PAT, and MEIL McCAFFERTY. *Women in Focus:* *Contemporary Irish Women's Lives.* Dublin: Attic, 1987, 131pp., mainly illus.
Consists of photographs by some seventeen women photographers who are themselves Irish or are based in Ireland. They all seek to document the reality of women's lives rather than sustain a mythology.

3342 *Objetivo Italia: fotografía contemporánea italiana. Serie iconograficas 2.* Puebla: Universidad Autonoma, 1991, 130pp., mainly illus.
Text in Spanish. Two introductory essays discuss contemporary photography in Italy and the work of the exhibitors. Twenty-three women are included but biographical information is sparse.

3343 OLSCHEWSKI, PETRA. *Frauenbilder: Frauen gesehen von Frauen.* Schaffhausen: Edition Stemmle, 1987, 159pp., illus.
Text in German. Discusses seventeen women photographers who use the female body as their principal image. Two preliminary essays deal with the representation of women by women and, by Julia Dech, with women behind and in front of the camera. There are a few paragraphs and biographies on each of the artists.

3344 PETERS, URSULA. *Stilgeschichte der Fotografie in Deutschland,* *1939–1900.* Cologne: Dumont, 1979, 424pp., 410 illus.
Text in German. This survey of nineteenth-century photography in Germany is organised around subject categories. Short biographies of the photographers are included inside the fold-out covers at either end of the book; four women are included: Emilie Bieber, Franciska Möllinger, Nicola Perschied (who is the best documented) and Bertha Wehnert (who worked with her husband Eduard). There is an extensive bibliography.

3345 POLLOCK, GRISELDA. *Vision and Difference: Femininity, Feminism and the Histories of Art.* New York and London: Routledge, 1988, 239pp., illus.
An anthology of essays by Pollock previously published in journals. They examine critically issues concerning Elizabeth Siddal, Mary Cassatt (qq.v.), the exhibition *Difference: On Representation and Sexuality* (q.v.) and the problem of how and whether the discipline of art history can accommodate women artists.

3346 PROPHET, JANE. "Cyber Chicks." *Women Artists' Slide Library Journal* 69 (April–May 1996): 10–11.
Discusses on-line galleries and, in particular, two works of art which evolve on the Internet: *A Hypertext Journal* and *Egg of the Internet.*

3347 READ, SHIRLEY. "Glass Ceiling in Cyberspace? Thoughts on Gender and New Technology." *Women Artists' Slide Library Journal* 68 (January–February 1996): 10–11.
Discusses her concern that new technology could marginalise women, since it is often presented as masculine technology. She believes that it has

potential for women and that educational programmes are the key to ensuring that women participate fully.

3348 REICHARDT, JASIA (ED.). *Zeit, Worte under die Kamera/Time, Words and the Camera. Fotoarbeiten englisher Künstler/Photoworks by English Artists.* Graz: Künstlerhaus, 1976, 140pp., illus.
Text in German and English. The exhibition is organised into three sections, each exemplified by four artists: observation, recording of experience and recording of imaginary events, and imaginary solutions. Three women are included in the first two sections: Phillippa Ecobichon, Marie Yates and Sarah McCarthy.

3349 RUMPF, HARALD (ED.). *52 junge deutsche Fotografen: eine Anthologie zeitgenössischer junger Fotografen.* Munich: Verlag H. Rumpf, 1981, 97pp., mainly illus.
Text in German. Essentially a book of illustrations. The work of ten women is included in the survey of young German photographers. All were born after 1939.

3350 *Sense and Sensibility in Feminist Art Practice.* Nottingham: Midland Group, 1982, n.p., illus.
An essay by Griselda Pollock analyses this innovative work and its context. Ten of the twelve women artists work in Britain and explore issues around feminism through various media. Included are Mary Kelly, Anne Newmarch, Susan Hiller, Roberta Graham, Alexis Hunter, Margaret Harrison, Aimee Rankin, Marie Yates, Yves Lomax and Sarah McCarthy.

3351 STEVENSON, SARA, and A. D. MORRISON-LOW. *Scottish Photography. A Bibliography: 1839–1989.* Edinburgh: Salvia Books, 1990, 47pp., illus.
Consists mainly of books and articles by and about Scottish photographers. Several women are included: Jemima Blackburn, Angela Catlin, Lady Henrietta Gilmour, Fay Godwin, Lady Clementina Hawarden, Patricia Macdonald and Jessie Ann Matthew.

3352 SULLIVAN, CONSTANCE. *Women photographers.* London: Virago, 1990, 263pp., 200 illus.
The majority of photographers are American. Of the Europeans included, Germans predominate. The relatively small proportion of text (27pp.) means that there is little information on each individual.

3353 SZILÁGYI, GÁBOR, and SÁNDOR KARDOS. *Leletek: A Magyar fotográfia történetéből.* Budapest: Képzómúvészeti Kiadó, 1983, 473pp., 433pl.
Text in Hungarian. A short essay precedes the plates. There are short biographical accounts for each of the artists included, among whom are a small

number of women: Kata Kálmán, Éva Keleti, Klára Langer, Olga Máté, Edi Molnár and Zsuzsa Sándor.

3354 TAUSK, PETER. *Photography in the 20th Century.* London: Focal Press 1980, 344pp., 271 illus. Adapted by the author and translated from the German *Geschichte der Fotografie im 20. Jahrhunderts.* Cologne: Dumon Verlag, 1980.

Consists of three main sections: the precursors of modern photography active 1900–1918, the rise of modern photography between 1918 and 1945 the development of photography since 1945. Includes biographical section which lists the figures in the text, gives a short account of their professiona activities and lists published books of their photographs.

3355 TAYLOR, JOHN. *A Dream of England: Landscape, Photography and the Tourist's Imagination. Photography: Critical Views.* Manchester Manchester University Press, 1994, 300pp., illus.

Examines a variety of motives for landscape photography including nos talgia, heritage, documentation, national identity, gender and colour. The work of five women is discussed: Karen Knorr, Fay Godwin, Susar Trangmar, Ingrid Pollard and Jo Spence.

3356 WEAVER, MIKE. *The Photographic Art: Pictorial Traditions in Britain and America.* London: Herbert Press, 1986, 144pp., illus.

Based on an exhibition of the same title, the book is organised aroun themes occurring in pictorial photography in the nineteenth and twentieth centuries. Each is introduced by a critical essay. The British women includ ed are Julia Margaret Cameron, Fay Godwin and Eveleen Tennant Myers.

3357 WELLS, LIZ. "Mr Andrew's Place." *Women's Art Magazine* 52 (1993): 15–16 Examines the problems of the category of landscape for women and examines the approaches of several contemporary women photographers in Britain: Ingrid Pollard, Helen Harris, Fay Godwin and Elizabeth Williams.

3358 WELLS, LIZ. "The Eyes of Europe." *Women's Art Magazine* 59 (1994) 29–32.

Examines some themes and subjects which occur across Europe in the field of contemporary photography by women: national identity (or its lack) references to the Holocaust, representation of the body, the family album and the combination of image and text. Some festivals are also mentioned.

3359 WELLS, LIZ. *Viewfindings: Women Photographers: "Landscape" and Environment.* Tiverton, Devon: Available Light, 1994, 112pp., illus.

Part of the Signals Festival of women in photography held in 1994, this book is divided into three sections: Margins, Territories and Image Metaphor and Myth. It analyses the differing approaches to landscape in three critical essays and deals with the work of fifteen women photographers

3360 WILLIAMS, VAL, ET AL. *Who's Looking at the Family?* Barbican Art Gallery: London, 1994, 127pp., illus.

An international exhibition of photography of the family from the mid-1980s. A series of thematic critical essays analyse different approaches to the subject. Eleven European-based women are included: Jananne Al-Ani, Tina Barney, Anna Blume, Astrid Boorman, Florence Chevallier, Ouke Lele (Barbara Allende), Katrina Lithgow, Mari Mahr, Corinne Noordenbos, Liz Rideal and Margriet Smithers.

3361 WILLIAMS, VAL. *The Other Observers: Women Photographers in Britain 1900 to the Present.* London: Virago, 1986. Reprint 1994. 192pp., illus.

The fullest existing scholarly account of the activities of women photographers in Britain. Many unfamiliar names are introduced and the work is analysed in its sociocultural context. Includes a useful bibliography.

3362 WILLIAMS, VAL. *Warworks: Women, Photography and the Iconography of War.* London: Virago Press, 1994, 96pp., illus.

A series of critical essays which examine the contribution of women photographers to the photography of war from World War I to the 1990s.

3363 WILLIAMS, VAL. "Where Women Dare to Tread?" *Women's Art Magazine* 59 (1994): 7–9.

Examines some examples of women photographers who photograph men for a variety of reasons. Some explore masculinity in contemporary society, some take an erotic approach but overall a new agenda is being set.

3364 WILLIAMS, VAL, PETER E. PALMQUIST, and AMY RULE. "Women in Photography: Archives and Resources." *History of Photography* 18, no. 3 (Autumn 1994): 242–255.

Three sections deal with English archives in National Museums, resources for women photographers of World War II and American women photographers. Each also includes lists of individuals covered by the archives.

3365 *Women's Images of Men.* London: Institute of Contemporary Art, 1980, n.p., illus.

An analytical essay by Lisa Tickner is followed by outline biographies, lists of exhibitions and, in some cases, a personal statement for each of the individuals. Produced by a collective, this exhibition aimed to reverse the gaze, although the approaches were very varied.

3366 *Women of Photography: An Historical Survey.* San Francisco: Museum of Art, 1975, 128pp., 50 illus.

A lengthy introductory essay sets the context for the subsequent exhibits. Ten European women are included: Cameron and Filmer from the nineteenth century and Jacobi, Modotti, Henri, Model, Freund, Gerdes, Gueniot and

Luskacová from the later period. There is a short biographical account for each and details of their exhibits.

INDIVIDUALS

3367 ABEL, LOUISE DORIS SOPHIE PAULINE (née KLEFFEL) (1841–1907)
Norwegian photographer who was trained by her father and whose husband was also a photographer; she won several prizes and helped to train other women.

Other Sources

Bonge, S. *Eldre norske fotografer: fotografer og amator fotografer i Norge frem til 1920.* Bergen: Universitetsbiblioteket, 1980.

3368 AGEE, JOYCE (c. 1955–)
American-born photographer who has worked in England since 1977; her work is concerned with, and presented in the context of, community arts and health issues and is informed by the women's movement.

Publications

"In Chinatown: Feminism and Photography." In Sarah Kent and Jacqueline Morreau, *Women's Images of Men,* 154–163. London: Writers and Readers Publishing, 1985.

Exhibitions

Women's Images of Men. London: Institute of Contemporary Art, 1980.

3369 ALBIN-GUILLOT, LAURE (1938–)
French photographer.

Exhibitions

Paris 1937—Paris 1957: créations en France. Paris: Centre national d'art et de culture Georges Pompidou, 1981.
Dufresne, Jean-Luc, and Olivier Messac, eds. *Femmes créatrices des années vingt.* Granville: Musée Richard Anacréon, 1988. Wide-ranging catalogue with a short biographical account on each woman included.

3370 ALMEIDA, HELENA
Portuguese photographer.

Exhibitions

Eiblmayr, Silvia, Valie Export, and Monika Prischl-Maier. *Kunst mit Eigen-Sinn. Aktuelle Kunst von Frauen: Texte und Dokumentation.* Vienna: Locker

Verlag in association with the Museum of Modern Art and Museum of 20th Century Art, 1985.

3371 ANDERSEN, EMILIE (1867–?)
Norwegian photographer mainly active between 1900–1917.

Other Sources

Bonge, S. *Eldre norske fotografer: fotografer og amator fotografer i Norge frem til 1920.* Bergen: Universitetsbiblioteket, 1980.

3372 ANGINOT, DOMINIQUE (1949–)
French photographer.

Other Sources

Naggar, C. *Dictionnaire des Photographes.* Paris: Editions du Seuil, 1982.

3373 ANTONIOLI, RITA (1961–)
Italian photographer of theatre and dance.

Exhibitions

Objetivo Italia: fotografía contemporánea italiana. Puebla: Universidad Autonoma, 1991.

3374 ARGAGLIA, ADRIANA (1954–)
Italian photographer.

Exhibitions

Objetivo Italia: fotografía contemporánea italiana. Puebla: Universidad Autonoma, 1991.

3375 ARNDT, TRUDE (1903–)
German photographer who studied at the Bauhaus.

Other Sources

Meskimmon, Marsha, and Shearer West. *Visions of the 'Neue Frau': Women and the Visual Arts in Weimar Germany.* London: Scolar Press, 1995.

3376 ARNOLD, EVE (1913–)
American-born photographer of Russian parentage who has worked in England since 1961.

Publications

The Unretouched Woman. London: Jonathan Cape, 1976, 198pp., mainly illus. Includes an autobiographical account of how Arnold took up photography.

Main Sources

Williams, Val. "Carefully Crafted Picture." *Women's Art Magazine* 44 (1992): 14–15.

Exhibitions

Eve Arnold: In Britain. London: National Portrait Gallery, 1991.
Eve Arnold: In Retrospect. London: Barbican Art Gallery, 1996.

Other Sources

Evans, Martin Marix. *Contemporary Photographers.* 3rd ed. New York & London: St. James Press, 1995.

3377 ARROWSMITH, SUE (1950–)
English photographer who uses innovative techniques to explore concerns of form and content; she sometimes investigates gender issues.

Exhibitions

Gresty, Hilary. *Qualities of Silence: Sue Arrowsmith, Artist Fellow, Kettle's Yard and Wolfson College, 1986–7.* Cambridge: Kettle's Yard Gallery, 1987, n.p., illus. Essay by Robert Radford analysing the form and content of the work. Includes list of exhibitions.
Figures. Cambridge: Cambridge Darkroom, 1987, n.p., illus.
Ascherson, Neil. *Shocks to the System: Social and Political Issues in Recent British Art from the Arts Council Collection.* London: Royal Festival Hall, 1991.

Other Sources

Butler, Susan. "Between Frames." *Aperture* 113 (winter 1988): 30–39.

3378 ARZAMOVA, TATYANA (1955–)
Russian photographer who works in group of three called the AE group.

Other Sources

Tolnay, Alexander, ed. *Contemporary Photographic Art from Moscow. Zeitgenössische Fotokunst aus Moskau.* Munich and New York: Prestel, 1995.

3379 ATKINS, ANNA (née CHILDREN) (Active from 1843)
English photographer who produced cyanotype images of a collection of algae using the process of Sir John Herschel.

Main Sources

Heathcote, Bernard V., and Pauline F. "The Feminine Influence: Aspects of the Role of Women in the Evolution of Photography in the British Isles." *History of*

Photography 12, no. 3 (July–September 1988): 259–273. Short biographical account.

Other Sources

Adamson, Keith. "Women in Photography." *Photographic Journal* 125 (1985): 156–161.

Williams, Val. *The Other Observers: Women Photographers in Britain 1900 to the Present.* London: Virago, 1986.

3380 BARICZ, KATALIN (1948–)
Hungarian photographer who takes pictures of women from a male voyeur's viewpoint.

Other Sources

Az Év Fotói. Pictures of the Year. 1992. Budapest: Pelikán Könyvek, 1993.

3381 BARICZ, KATALIN (1948–)
Hungarian documentary photographer.

Exhibitions

A fotográfia hónapja: 12 kiállitás a Magyar fotográfia 150 éves történetéból. Month of Photography: 12 Exhibitions on 150 years of Hungarian photography. Budapest: Association of Hungarian photographers, and Szabad Tér Publishing Co., 1989.

3382 BARRAT, MARTINE (1937–)
French photographer.

Other Sources

Naggar, C. *Dictionnaire des Photographes.* Paris: Editions du Seuil, 1982.

3383 BARTON, EMMA BOAZ (née RAYSON; alt. Mrs. G. A. BARTON) (1872–1938)
English photographer.

Main Sources

Williams, Val. "Re-Emergence." *Women's Art Magazine* 65 (July–August 1995): 33. Review of the exhibition *Sunlight and Shadow* (see below).

Exhibitions

James, Peter, Tessa Sidey, and John Taylor, eds. *Sunlight and Shadow: The Photographs of Emma Barton, 1872–1938.* Birmingham: Museum and Art Gallery,

1995, 101 pp., illus. The definitive work on Barton to date. Contains several critical essays, newly researched material and a full bibliography.

Other Sources

Williams, Val. *The Other Observers: Women Photographers in Britain 1900 to the Present.* London: Virago, 1986.

3384 BECHER, HILLA (1934–)
German photographer who works with her husband Bernd in photographing monuments of industrial architecture in a formalist style.

Exhibitions

Bernd und Hilla Becher: Fördtürme; Chevalements [Mineheads]. Essen: Museum Folkwang, 1985, 224pp., illus. Text in German, French and English. Exhibition of photography taken in several European countries and America. Lists their exhibitions from 1963.
Another Objectivity. London: Institute of Contemporary Art, 1988.

Other Sources

Benteler, Petra. *Deutsche fotografie nach 1945.* Kassel: Fotoforum, Universität Kassel, 1979.
————, ed. *Fotografie von 1945 bis 1985.* Hamburg: Museum für Kunst und Gewerbe, 1987.
Evans, Martin Marix. *Contemporary Photographers.* 3rd ed. New York & London: St. James Press, 1995.
Tausk, Peter. *Photography in the Twentieth Century.* London: Focal Press, 1980. Includes an outline biography and published books of photographs.

3385 BECKER, CAROLINE CHARLOTTA AUGUSTA (née ELFSTRÖM) (?–1881)
Finnish photographer, who took up photography when widowed and was one of the first in Finland to make this her profession.

Other Sources

Hirn, Sven. *Kameran edesta ja takaa, valokuvaajat suomessa 1839–1870.* Helsinki: Suomen Valukuvataiteen Museon Säätio, 1972.

3386 BEESE, LOTTE (née CHARLOTTE) (1903–)
German photographer.

Exhibitions

Bauhaus photographie. Paris: Musée d'Art Moderne de la Ville de Paris, 1984.

3387 BEGE, NÓRA (1966–)
Hungarian Photographer.

Other Sources

Az Év Fotói. Pictures of the Year. 1992. Budapest: Pelikán Könyvek, 1993.
Az Év Fotói. Pictures of the Year. 1993. Budapest: Pelikán Könyvek, 1994.

3388 BERGMANN, TERÉZ
Hungarian photographer who dealt with social and political subjects.

Exhibitions

The Hungarian Connection: The Roots of Photojournalism. Bradford:
National Museum of Film, Photography and Television, 1987. Mentioned in text.
*A fotográfia hónapja: 12 kiállitás a Magyar fotográfia 150 éves történetéból.
Month of Photography: 12 Exhibitions on 150 years of Hungarian photography.*
Budapest: Association of Hungarian photographers, and Szabad Tér Publishing Co.,
1989.

3389 BESENYÖ, EVA (née ÉVA BESENYÖ) (1910–1986)
Hungarian documentary photographer who worked in Holland from
1932.

Publications

Van Soest, Margo. *Vijf jaar Dolle Mina.* The Hague: Stichting Uitgevereij
Dolle Mina, 1975, 166pp., illus. Besenyö's work is used to illustrate this account of
the early years of the women's movement.

Exhibitions

*A fotográfia hónapja: 12 kiállitás a Magyar fotográfia 150 éves történetéból.
Month of Photography: 12 Exhibitions on 150 years of Hungarian photography.*
Budapest: Association of Hungarian photographers, and Szabad Tér Publishing Co.,
1989.

3390 BÉHALOVÁ, MARTA (Alt. JEDLIČKOVÁ) (1945–)
Czech photographer.

Exhibitions

Československá fotografie 1968–1970. Brno: Moravská Galerie, 1971.
Československá fotografie 1971–1972. Brno: Moravská Galerie, 1973.

3391 BHIMJE, ZARINA (1963–)
Ugandan-born photographer who has lived in England since 1974.

Main Sources

Bradley, Jyll. "An Audience unto Herself." *Women's Art Magazine* 51 (1993): 23–24.

Di Bello, Patrizia. "Intimate Distance: Five Black Women Photographers." *Women's Art Magazine* 40 (1991): 24–25. Review of a touring exhibitions which first opened at the Photographers' Gallery, London.

Exhibitions

Ascherson, Neil. *Shocks to the System: Social and Political Issues in Recent British Art from the Arts Council Collection.* London: Royal Festival Hall, 1991.

Other Sources

Evans, Martin Marix. *Contemporary Photographers.* 3rd ed. New York & London: St. James Press, 1995.

Jones, Kellie. "Re-Creation." *Ten-8* 2, no. 3 (spring 1992): 96–105.

Tawadros, Gilane. "Other Britains, Other Britons." *Aperture* 113 (winter 1988): 40–46.

Wells, Liz. "The Eyes of Europe." *Women's Art Magazine* 59 (1994): 29–32.

3392 BIEBER, EMILIE (1810–1884)
German photographer who opened an atelier in Hamburg in 1852.

Other Sources

Peters, Ursula. *Stilgeschichte der Fotografie in Deutschland, 1839–1900.* Cologne: DuMont, 1979.

3393 BIERMANN, AENNE (née ANNA SIBILLA STERNFELD) (1898–1933)
German photographer.

Publications

60 Fotos. Berlin: Klinkhardt and Biermann, 1930, 11pp., chiefly illus. Text in French, German and English.

Exhibitions

Künstlerinnen international, 1877–1977. Berlin: Schloss Charlottenburg, 1977.

Eskilden, Ute. *Aenne Biermann.* Berlin: Nishen, 1987; English translation by Iain Boyd White, London: Nishen, 1988, 140pp., illus.

Meskimmon, Marsha. *Domesticity and Dissent: The Role of Women Artists in Germany 1918–1938. Haüsliches Leben und Dissens.* Leicester: Leicestershire Museums Publication no. 120, 1992.

Other Sources

Mellor, David, ed. *Germany: The New Photography, 1927–1933*. London: Arts Council of Great Britain, 1978.

Meskimmon, Marsha, and Shearer West. *Visions of the 'Neue Frau': Women and the Visual Arts in Weimar Germany*. London: Scolar Press, 1995.

3394 BING, ILSE (1899–)
German-born photographer who worked in France from 1930.

Publications

Numbers in Images: Illuminations of Numerical Meanings. New York: Ikon Press, 1970, n.p. illus. A collection of her prints and sketches on different numbers, measuring and numerical transactions, some accompanied by verse.

Words as Visions: Logograms by Ilse Bing. New York: Ikon Press, 1974, n.p., illus. Similar format to the previous publication but based on single words in German, French and English and illustrated by images, often calligraphic in style, which include the word.

Femmes de l'enfance à la vieillesse, 1929–1955. Paris: Des Femmes, 1982, n.p., mainly illus. Introduction by Gisèle Freund. Publication to accompany exhibition at the Galérie Des Femmes. Lists her exhibitions from 1931.

Exhibitions

Barrett, Nancy. *Ilse Bing: Three Decades of Photography*. New Orleans: Museum of Art, 1985, 99pp., illus.

Reynaud, Françoise, and Nancy Barrett. *Ilse Bing: Paris, 1931–1952*. Paris: Musée Carnavalet, 1987. Text in French. Two critical essays examine Bing's attitudes to Paris and place her life and work in context. Lists her exhibitions from 1931 and contains a full bibliography.

Other Sources

Evans, Martin Marix. *Contemporary Photographers*. 3rd ed. New York & London: St. James Press, 1995.

3395 BLEYOVÁ, OLGA (1930–)
Czech photographer.

Exhibitions

Československá fotografie 1968–1970. Brno: Moravská Galerie, 1971.
Československá fotografie 1971–1972. Brno: Moravská Galerie, 1973.

3396 BLOK, DIANA (1952–)
South-American born photographer who works in the Netherlands.

Exhibitions

Het Zelfbeeld: Images of the Self. Leiden: Stichting Burcht and Galerie Fotomania, 1987.

3397 BLÜHOVÁ, IRENA (1904–)
Czech photographer.

Main Sources

Mrázkowá, Daniela, and Vladimir Remeš. *Tschechoslowakische Fotografen 1900–1940.* Leipzig: Veb Fotokinoverlag, 1983, 196pp., 185 illus. Text in German. Blühová is the only women included in this survey of sixteen photographers.

Exhibitions

A fotográfia hónapja: 12 kiállitás a Magyar fotográfia 150 éves történetéból. Month of Photography: 12 Exhibitions on 150 years of Hungarian photography. Budapest: Association of Hungarian photographers, and Szabad Tér Publishing Co., 1989.

Other Sources

Tausk, Peter. *Photography in the Twentieth Century.* London: Focal Press, 1980. Includes an outline biography and published books of photographs.

3398 BOHM, CHRISTIANE (1950–)
German photographer.

Other Sources

Rumpf, Harald. *52 junge deutsche Fotografen.* Munich: Verlag H. Rumpf, 1981.

3399 BOHM, DOROTHY
English documentary photographer who travelled widely; one of the founders of the Photographers' Gallery in London.

Publications

Egypt. London: Thames and Hudson, 1989, 112pp., 71 colour illus. Text by Ian Jeffrey.

3400 BOT, MARRIE (1946–)
Dutch photographer.

Other Sources

Naggar, C. *Dictionnaire des Photographes.* Paris: Editions du Seuil, 1982.

3401 BRESLAUER, MARIANNE
 German photographer.

Other Sources

Meskimmon, Marsha, and Shearer West. *Visions of the 'Neue Frau': Women and the Visual Arts in Weimar Germany.* London: Scolar Press, 1995.

3402 BROOM, CHRISTINA (née LIVINGSTON) (1863–1939)
 English documentary photographer who specialised in military subjects which she made into postcards.

Main Sources

Fraser, John. "Postcard Pioneer." *British Journal of Photography* part 1: 136 (2 February 1989): 8–9; part 2: 136 (9 February 1989): 16–18. Biographical account based on primary sources and her daughter's recollections of this documentary photographer who single-handedly supported her family. She was so successful with army subjects, which were deemed good for morale, that she was granted special access to the royal family and military establishments.

Williams, Val. *The Other Observers: Women Photographers in Britain 1900 to the Present.* London: Virago, 1986.

Other Sources

Flukinger, Roy. *The Formative Decades: Photography in Great Britain, 1839–1920.* Austin, Tex.: University of Texas Press, 1985.

Stanley, Jo. "Marketable Maidens." *Women's Art Magazine* 59 (1994): 45–46.

3403 BRUZAK, NOÉMIE (1970–)
 Hungarian photographer.

Other Sources

Az Év Fotói. Pictures of the Year. 1993. Budapest: Pelikán Könyvek, 1994.

3404 BURMAN, CHILA KUMARI
 English mixed media artist and photographer.

See Performance and Video Art, Mixed Media and Installations section.

3405 BUTKIEWICZ, HELENA (active 1865–1878)
 Polish photographer.

Other Sources

Ihnatowiczowa, Jadwiga, ed. *Fotografia Polska do 1914r.* Warsaw: Biblioteka Naradowe, 1981.

3406 CAHUN, CLAUDE (Pseudonym of LUCY SCHWOB) (1893–1954)
French photographer, artist and writer.

Main Sources

Deepwell, Kay. "Uncanny Resemblances." *Women's Art Magazine* 62 (January–February 1995): 17–19.

Exhibitions

Monahan, Laurie. "Radical Transformations: Claude Cahun and the Masquerade of Womanliness." In *Inside the Visible: An Elliptical View of 20th Century Art—In, Of and From the Feminine,* ed. Catherine De Zegher. Ghent: The Kanaal Foundation, 1996.

3407 CALLE, SOPHIE (1953–)
French photographer.

Publications

Suite vénitienne. Paris: Editions de l'Etoile–Cahiers du Cinéma, 1983. American edition Seattle: Bay Press, 1988, 87pp., mainly illus. This contains a translation of Calle's text together with an essay, "Please follow me," by Jean Baudrillard.

Main Sources

Robinson, Hilary. "She Looks at Her Looking for Him." *Women's Art Magazine* 69 (1996): 5–9. A critical analysis of *Suite vénitienne.*

Exhibitions

Eiblmayr, Silvia, Valie Export, and Monika Prischl-Maier. *Kunst mit Eigen-Sinn. Aktuelle Kunst von Frauen: Texte und Dokumentation.* Vienna: Locker Verlag in association with the Museum of Modern Art and Museum of 20th Century Art, 1985.
Butler, Susan. *Shifting focus.* Bristol: Arnolfini Gallery, 1989.

Other Sources

Wells, Liz. "The Eyes of Europe." *Women's Art Magazine* 59 (1994): 29–32.

3408 CAMERON, JULIA MARGARET (1815–1879)
English photographer who began to practice in 1863; she specialised in portraits and allegorical compositions with girls and women.

Main Sources

Hopkinson, Amanda. *Julia Margaret Cameron*. Virago Pioneers series. London: Virago, 1986, 180pp., 52 illus. Consists of three sections: a demonstration of the unusual pattern of her photographic practice, a biographical account and a critical examination of her work, and her techniques and comparisons with her contemporaries.

Ford, Colin. *The Cameron Collection: An Album of Photographs by Julia Margaret Cameron Presented to Sir John Herschel*. New York: Van Nostrand Reinhold in association with the National Portrait Gallery, London, 1975, 144pp., illus. The text is primarily an examination of her life and work. Notes on the plates are included.

Ovenden, Graham. *A Victorian Album: Julia Margaret Cameron and her Circle*. London: Secker and Warburg, 1975, 252pp., mainly illus.

Powell, Tristram. *Victorian Photographs: Famous Men and Fair Women by Julia Margaret Cameron, with Introductions by Virginia Woolf and Roger Fry*. Expanded and revised edition of the 1926 publication. London: Hogarth Press, 1973, 32pp., 44 illus.

Exhibitions

Women of Photography: A Historical Survey. San Francisco: Museum of Art, 1975. Includes a short biographical account for each artist.

The Herschel Album: An Album of Photographs by Julia Margaret Cameron Presented to Sir John Herschel. London: National Portrait Gallery, 1975, n.p., illus. The album was presented to Sir John, an astronomer and a friend of Cameron and godfather to her eldest child, in 1864. It consisted of ninety-four pictures. This catalogue includes 5 pp. of memoirs of Cameron by those who knew her and 21 pp. of plates.

Künstlerinnen international, 1877–1977. Berlin: Schloss Charlottenburg, 1977.

Hommage de Julia Margaret Cameron à Victor Hugo. Paris: Maison de Victor Hugo, 1980, n.p., 28 illus. Text in French. Exhibition of the photographs which Cameron sent to Hugo while he was in exile on the island of Guernsey.

Whisper of the Muse: The Overstone Album and Other Photographs by Julia Margaret Cameron. Malibu: Getty Museum, 1986, 110pp., illus. Includes an essay by Mike Weaver, texts of some recently acquired Cameron documents and a checklist of the 111 images in the Overstone album given to Lord Overstone in 1865.

Howard, Jeremy, ed. *Whisper of the Muse: The World of Julia Margaret Cameron. A loan Exhibition of Photographs, Paintings and Engravings in Collaboration with the Royal Photographic Society*. London: Colnaghi, 1990, 128pp., illus. Contains essays by Pam Roberts and Jeremy Howard. The paintings included are by the Pre-Raphaelites.

Other Sources

Cherry, Deborah. *Painting Women: Victorian Women Artists*. London: Routledge, 1993.

Heathcote, Bernard V., and Pauline F. "The Feminine Influence: Aspects of the Role of Women in the Evolution of Photography in the British Isles." *History of Photography* 12, no.3 (July–September 1988): 259–273.

Flukinger, Roy. *The Formative Decades: Photography in Great Britain, 1839–1920.* Austin, Tex.: University of Texas Press, 1985.

Naggar, C. *Dictionnaire des Photographes.* Paris: Editions du Seuil, 1982.

Weaver, Mike. "Julia Margaret Cameron: The Stamp of Divinity." In Mike Weaver, *British Photography in the Nineteenth Century: The Fine Art Tradition,* 151–162. Cambridge: Cambridge University Press, 1989.

Williams, Val. *The Other Observers: Women Photographers in Britain 1900 to the Present.* London: Virago, 1986.

3409 CAMPAGNANO, MARCELLA (1941–)
 Italian photographer who was a painter until the 1970s.

Exhibitions

Objetivo Italia: fotografía contemporánea italiana. Puebla: Universidad Autonoma, 1991.

3410 CASSON, WINIFRED (c. 1900–1970)
 English Surrealist photographer who was active for some five years in the 1930s.

Main Sources

Williams, Val. *The Other Observers: Women Photographers in Britain 1900 to the Present.* London: Virago, 1986.

3411 CHARLES, LALLIE
 English photographer of studio portraits, who specialised in soft-focus works of Edwardian society women.

Other Sources

Williams, Val. *The Other Observers: Women Photographers in Britain 1900 to the Present.* London: Virago, 1986.

3412 CHERNYSHEVA, OLGA (1962–)
 Russian photographer.

Other Sources

Tolnay, Alexander, ed. *Contemporary Photographic Art from Moscow. Zeitgenössische Fotokunst aus Moskau.* Munich and New York: Prestel, 1995.

3413 CHICINSKA, WANDA (active 1870s)
 Polish photographer.

Other Sources

Ihnatowiczowa, Jadwiga, ed. *Fotografia Polska do 1914r.* Warsaw: Biblioteka Naradowe, 1981.

3414 CHIEWITZ, EUPHROSYNE (née AMALIA CLEMENTINE EUPHROSYNE CHIEWITZ: Alt. MAGNUSSON) (1819–1899)
Swedish photographer who worked in Finland from 1860.

Other Sources

Hirn, Sven. *Kameran edesta ja takaa, valokuvaajat suomessa 1839–1870.* Helsinki: Suomen Valukuvataiteen Museon Säätio, 1972.

3415 CHISHOLM, MAIRI (1896–)
English documentary photographer who recorded her experiences as a nurse in Belgium during World War I; colleague of photographer Elsie Knocker (q.v.).

Other Sources

Williams, Val. *The Other Observers: Women Photographers in Britain 1900 to the Present.* London: Virago, 1986.

3416 CIOCE, ANGELA (1954–)
Italian photographer.

Exhibitions

Objetivo Italia: fotografía contemporánea italiana. Puebla: Universidad Autonoma, 1991.

3417 CLAUSEN, ROSEMARIE (1907–)
German photographer.

Exhibitions

Rosemarie Clausen, Ingeborg Sello: zwei Hamburger Photographinnen. Hamburg: Photosammlungen, Museum für Kunst under Gewerbe, 1988, 96pp., illus.

Other Sources

Benteler, Petra. *Deutsche fotografie nach 1945.* Kassel: Fotoforum, Universität Kassel, 1979.

3418 COLLINS, HANNAH (1956–)
English photographer.

Main Sources

Brett, Guy. "Hannah Collins: An Introduction." *Creative Camera* 242 (February 1985): 19–23. Discusses her work *Evidence in the Streets*, which was originally an installation in the Interim Gallery, London.

Wyman, Jessica. "Inside the Urbane." *Women's Art Magazine* 65 (May–June 1995): 27. Review of exhibition *The Hunter's Space*.

Exhibitions

Another Objectivity. London: Institute of Contemporary Art, 1988.

Hannah Collins: Legends. London: Matt's Gallery in association with the Institute of Contemporary Art, London and the Orchard Gallery, Londonderry, 1988, 36pp., illus.

Butler, Susan. *Shifting focus*. Bristol: Arnolfini Gallery, 1989.

Hannah Collins. Barcelona: Galeria Jan Prats, 1992, 24pp., illus. Text in Spanish and English.

Hannah Collins: Signs of Life. London: British Council for the Third International Istanbul Biennale, 1992, 16pp.

Other Sources

Butler, Susan. "Between Frames." *Aperture* 113 (winter 1988): 30–39.

Williams, Val. *Warworks: Women, Photography and the Iconography of War*. London: Virago, 1994.

3419 COOKE, ANN (née HOLMES) (1796–after 1859)

English portrait photographer who entered this career on the death of her husband in 1843 and worked in Lincoln and Hull; she opened her own studio in Hull in 1844, the first English woman to do so.

Main Sources

Heathcote, Bernard V., and Pauline F. "The Feminine Influence: Aspects of the Role of Women in the Evolution of Photography in the British Isles." *History of Photography* 12, no. 3 (July–September 1988): 259–273. Short biographical account of this pioneer photographer gleaned from primary sources.

Other Sources

Adamson, Keith. "Women in Photography." *Photographic Journal* 125 (1985): 156–161.

3420 COOPER, MARY (1955–)

English photographer.

Exhibitions

Bayer, Jonathan, and Alex Noble. *Image and Exploration: Some Directions in British Photography, 1980–85*. London: Photographers' Gallery, 1985.

3421 CORPER, GISELA (1954–)
German photographer.

Other Sources

Rumpf, Harald. *52 junge deutsche Fotografen.* Munich: Verlag H. Rumpf, 1981.

3422 CSEKE, CSILLA (1968–)
Hungarian photographer.

Other Sources

Az Év Fotói. Pictures of the Year. 1992. Budapest: Pelikán Könyvek, 1993.
Az Év Fotói. Pictures of the Year. 1993. Budapest: Pelikán Könyvek, 1994.

3423 D'ORA (Pseudonym of DORA PHILIPPINE KALLMUS) (1880/1–)
Austrian photographer best known for her portraits of artists and actors and also as a fashion photographer.

Main Sources

Faber, Monika. *Madame D'Ora: Wien, Paris. Portraits aus Kunst und Gesellschaft, 1905–1957.* Vienna: Christian Brandstätter, 1983, 206pp., 258 illus. A detailed biographical account and a list of exhibitions. Contains a bibliography.

Exhibitions

Appel-Hayne, Odette, and Fritz Kempe. *Dokumente der Photographie: Nicola Perscheid, Arthur Benda, Madame D'Ora.* Hamburg: Museum für Kunst und Gewerbe, 1980, 186pp., illus. After introductory essays on each artist there are catalogue entries to accompany the reproductions.

Other Sources

Meskimmon, Marsha, and Shearer West. *Visions of the 'Neue Frau': Women and the Visual Arts in Weimar Germany.* London: Scolar Press, 1995.
Tausk, Peter. *Photography in the Twentieth Century.* London: Focal Press, 1980. Includes an outline biography and published books of photographs.

3424 DA PORTO, LOREDANA (?–1905)
Italian photographer who attracted the attention of Steiglitz with her classic scenes of family life and portraits of family and friends taken from 1855.

Other Sources

La fotografia pittorica, 1889–1911. Venice: Ala Napoleonica in association with Electa, Milan, 1979. Da Porto is the only woman included in this exhibition.

3425 DARIKOVICH, ELENA (1951–)
Russian photographer.

Main Sources

Mrázková, Daniela, and Vladimir Remeš. *Another Russia: Through the Eyes of the New Soviet Photographers.* London: Thames and Hudson, 1986.

3426 DE GRUITER, JOYCE (1959–)
Dutch photographer.

Exhibitions

Het Zelfbeeld: Images of the Self. Leiden: Stichting Burcht and Galerie Fotomania, 1987.

3427 DE VASSON, JENNY (1872–1920)
French photographer who left 5000 plates and negatives, which represented only 25 to 30 percent of her total output.

Main Sources

Caujolle, Christian, et al. *Jenny de Vasson: une femme photographe au début du siècle.* Paris: Herscher, 1980, 95pp., mainly plates.

3428 DECHER, MARIE-LAURE (1947–)
French photographer.

Other Sources

Naggar, C. *Dictionnaire des Photographes.* Paris: Editions du Seuil, 1982.

3429 DELLA PORTA, PATRIZIA (1954–)
Italian photographer.

Exhibitions

Objetivo Italia: fotografía contemporánea italiana. Puebla: Universidad Autonoma, 1991.

3430 DEUTSCH, GERTI
Austrian documentary photographer who came to England during the 1930s.

Other Sources

Williams, Val. *The Other Observers: Women Photographers in Britain 1900 to the Present.* London: Virago, 1986.

3431 DIEZ-DÜHRKOOP, MINYA (1873–1929)
German photographer who trained with her father.

Exhibitions

Secesja Europejska/European Art Nouveau/Europaischer Jugendstil aus dem Museum für Kunst und Gewerbe, Hamburg. Krakow: National Museum, 1991, 255pp., illus. Text in German, English and Polish. She is the only women featured in this catalogue.

3432 DUYT, CHRISTINE (1957–)
English photographer.

Other Sources

Bayer, Jonathan, and Alex Noble. *Image and Exploration: Some Directions in British Photography, 1980–85.* London: Photographers' Gallery, 1985.

3433 EDELSTEEN, CHARLOTTE REBEKKA (née VAN DER FEHR) (1868–1940)
Norwegian photographer who, with her sister Anna, was trained by her father.

Other Sources

Bonge, S. *Eldre norske fotografer: fotografer og amator fotografer i Norge frem til 1920.* Bergen Universitetsbiblioteket, 1980.

3434 EDIS, OLIVE (1876–1955)
English documentary photographer who was the only woman photographer to be commissioned to make documentary records of World War I.

Main Sources

Stanley, Jo. "The X-ray of the Soul." *Women's Art Magazine* 51 (1993): 23–24.

Other Sources

Stanley, Jo. "Marketable Maidens." *Women's Art Magazine* 59 (1994): 45–46.
Williams, Val. *The Other Observers: Women Photographers in Britain 1900 to the Present.* London: Virago, 1986.

3435 EPERJESI, ÁGNES
Hungarian photographer.

Exhibitions

A fotográfia hónapja: 12 kiállitás a Magyar fotográfia 150 éves történetéból.
Month of Photography: 12 Exhibitions on 150 years of Hungarian photography.
Budapest: Association of Hungarian photographers, and Szabad Tér Publishing
Co., 1989.

3436 ERRELL, LOTTE (née ROSENBERG; alt. LEVY) (1903–)
 German documentary photographer who during her career travelled to
 Ghana, China, Iran, Iraq and Kurdistan.

Other Sources

Meskimmon, Marsha, and Shearer West. *Visions of the 'Neue Frau': Women
and the Visual Arts in Weimar Germany.* London: Scolar Press, 1995.

3437 FARMBOROUGH, FLORENCE (1882–1978)
 English documentary photographer who photographed the involvement
 of Russia, where she went in 1908, during World War I.

Other Sources

Williams, Val. *The Other Observers: Women Photographers in Britain 1900
to the Present.* London: Virago, 1986.

3438 FÁBIÁN, GABRIELLA (1964–)
 Hungarian photographer.

Other Sources

Az Év Fotói. Pictures of the Year. 1993. Budapest: Pelikán Könyvek,
1994.

3439 FEHR, GERTRUDE (1895–)
 German portrait photographer who lived in France from 1933 to 1939
 where she encountered experimental photographers; she lived in Switzerland
 from 1939.

Exhibitions

Meskimmon, Marsha. *Domesticity and Dissent: The Role of Women Artists in
Germany 1918–1938. Haüsliches Leben und Dissens.* Leicester: Leicestershire
Museums Publication no. 120, 1992.

3440 FILMER, LADY MARY GEORGIANA CAROLINE (née CECIL)
 (c. 1840–1903)
 English photographer.

Exhibitions

Women of Photography: A Historical Survey. San Francisco: Museum of Art, 1975. Includes a short biographical account for each artist.

3441 FOX, ANNA (1961–)
 English photographer.

Publications

Wells, Liz, ed. *Viewfindings: Women Photographers: Landscape and Environment.* Tiverton: Available Light, 1994. As a contributor to this book, brief biographical details are included.

Main Sources

Robertson, Grace. "Home Truths." *Women's Art Magazine* 57 (1994): 21. Review of a solo exhibition entitled *The Village.*

Other Sources

Mellor, David. "Romances of Decay: Elegies for the Future." *Aperture* 113 (winter 1988): 52–67. A survey of tendencies in British photography in the 1980s. Fox is the only women included.

Williams, Val. *Warworks: Women, Photography and the Iconography of War.* London:Virago, 1994.

3442 FRANCK, MARTINE (1938–)
 French photographer.

Other Sources

Naggar, C. *Dictionnaire des Photographes.* Paris: Editions du Seuil, 1982.

3443 FRANKL, ALIÓNA (1954–)
 Hungarian photographer.

Other Sources

Az Év Fotói. Pictures of the Year. 1992. Budapest: Pelikán Könyvek, 1993.
Az Év Fotói. Pictures of the Year. 1993. Budapest: Pelikán Könyvek, 1994.

3444 FREUND, GISELE (1908/12–)
 German-born documentary photographer who fled to France in 1933 and settled in Paris.

Publications

Freund, Gisèle, and V. B. Carleton. *James Joyce in Paris: His Final Years.* London: Cassell, 1966, 117pp., illus. An essay by Freund describes her first meeting with Joyce and the photographic session two years later which resulted in over 100 pictures of the writer. There are also photographs of Paris, Adrienne Monnier, Amy Beach and her Paris bookshop together with a text describing Joyce's final years and personalities in the Paris literary world.

Le monde et ma caméra. Paris:Denoël/Gonthier, 1970, 258pp., illus. American edition: New York: Dial Press, 1974. Emerges as a version of an autobiography.

Mémoires de l'oeil: Gisèle Freund. Paris: Editions du Seuil, 1977, 141pp., illus. Freund describes how she took up photography; there follow sections of text and photographs on Frankfurt, Paris and England. German Edition: Frankfurt-am Main: S. Fischer Verlag GmbH, 1977.

Photography and Society. London and Bedford: Gordon Fraser Gallery, 1980, 231pp., illus. Translation of *Photographie et Société.* Paris: Editions du Seuil, 1974. A history of photography from 1839 written to show how artistic expression and social forms continually influence and reshape each other.

Trois jours avec Joyce: photographes de Gisèle Freund. Paris: Editions Denoël, 1982, 70pp., mainly illus. Freund first met Joyce in 1936. This series of photographs dates from 1938 and was done at her request. American edition New York: Persea Books, 1985.

Gisèle Freund: Itinéraires. Paris: Albin Michel, 1985, 223pp., mainly illus. English translation *Gisèle Freund: Photographer.* New York: Harry Abrams, 1985, 223pp., 205 illus. Freund discusses the nature of documentary photography and gives an autobiographical account.

Gisèle Freund: portraits d'écrivains et d'artistes avec une texte de Gisèle Freund. Bibliothèque visuelle 14. Munich & Paris: Schirmer/Mosel GmbH., 1989, 95pp., Includes anecdotes of sessions with her subjects.

Gisèle Freund: Portrait. Paris: Des Femmes, 1991, 139pp., illus. Freund's autobiographical reminiscences expressed through an interview with Rauda Jamis.

Main Sources

Makowski, Wanda. "Gisèle Freund: mémoires de l'oeil." *Art Press* 14 (January 1978): 26–27.

Martins, Kirsten. "Face to Face with Fame." *Women's Art Magazine* 59 (1994): 43–44. Interview with Freund.

Oberli, Fritz. "Gisèle Freund." *Camera* 11 (November 1978): 4–13, 33.

Perrine, B. "Les itinéraraires de Gisèle Freund." *Le Photographe* 1040 (December 1991): 24–28.

Exhibitions

Au pays des visages, 1938–1968: trente ans d'art et de litérature à travers la camera de Gisèle Freund. Paris: Musée d'Art Moderne de la Ville de Paris, 1968, 55pp., illus.

Women of Photography: A Historical Survey. San Francisco: Museum of Art, 1975. Includes a short biographical account for each artist.

Künstlerinnen international, 1877–1977. Berlin: Schloss Charlottenburg, 1977.

Gisèle Freund. Toulouse: Galérie Municipale du Chateau d'Eau, 1981, 24pp., illus.

Paris 1937-Paris 1957: créations en France. Paris: Centre national d'art et de culture Georges Pompidou, 1981.

Gisèle Freund. Berlin: Museum der Altagskultur des 20. in association with Argon, 1988, 80pp., illus. Contains a biography, bibliography and list of exhibitions.

Gisèle Freund/Olivier Bätz. Berlin: Werkbundarchiv, 1988, 64pp., illus.

Neyer, Hans. *Gisèle Freund.* Berlin: Akademie der Kunst, 1990, 90pp., illus. Contains four analytical essays on Freund's work

Other Sources

Tausk, Peter. *Photography in the Twentieth Century.* London: Focal Press, 1980. Includes an outline biography and published books of photographs.

3445 GALAMBOS, ANITA (1968–)
Hungarian photographer.

Other Sources

Az Év Fotói. Pictures of the Year. 1992. Budapest: Pelikán Könyvek, 1993.
Az Év Fotói. Pictures of the Year. 1993. Budapest: Pelikán Könyvek, 1994.

3446 GALLI, LUCIANA (1942–)
Italian photographer.

Exhibitions

Objetivo Italia: fotografía contemporánea italiana. Puebla: Universidad Autonoma, 1991.

3447 GARDNER, ALICE MAUDE (1884–c.1974)
Anglo-American photographer who lived in Italy and was active mainly before 1914.

Exhibitions

Gramigna, G., et al. *Mon rêve: fondo fotografico di Alice Maude Gardner, 1860–1920.* Prato: Palazzo Novellucci, 1981, in association with Vallecchi, Florence. Consists of three essays, a biographical summary and illustrations. Mon Rêve was the house in Palermo where her parents had settled and where Gardner was born. In 1920 it was sold as a result of financial difficulties and Gardner settled in Rapallo. Four albums of photographs survive.

3448 GASS, BARBARA (1939–)
German photographer.

Other Sources

Rumpf, Harald. *52 junge deutsche Fotografen.* Munich: Verlag H. Rumpf, 1981.

3449 GERSON, LOTTE (1905–)
German photographer.

Exhibitions

Bauhaus photographie. Paris: Musée d'Art Moderne de la Ville de Paris, 1984.

3450 GIROUX, MADAME
French photographer who was one of the earliest women photographers, her activities being recorded from 1839.

Other Sources

Adamson, Keith. "Women in Photography." *Photographic Journal* 125 (1985): 156–161.

3451 GLADYS (1950–)
French photographer.

Other Sources

Naggar, C. *Dictionnaire des Photographes.* Paris: Editions du Seuil, 1982.

3452 GODWIN, FAY (1931–)
English photographer of the landscape.

Publications

For a fuller list see *Fay Godwin: Landscape Photographs,* below.
The Oldest Road: An Exploration of the Ridgeway. Text by J. R. L Anderson. Wildwood House, 1975, 140 illus.
Remains of Elmet: A Pennine Sequence. London: Faber & Faber, 1979, 65 illus. Text consists of poems by Ted Hughes.

Exhibitions

Fay Godwin: Landscape Photographs. London: British Council, 1984 Includes selective list of exhibitions and books of her photographs.

Other Sources

Evans, Martin Marix. *Contemporary Photographers.* 3rd ed. New York & London: St. James Press, 1995.

Taylor, John. *A Dream of England: Landscape, Photography and the Tourist's Imagination.* Manchester: Manchester University Press.

3453 GOLCZ, JADWIGA (1866–1933)
Polish photographer.

Other Sources

Ihnatowiczowa, Jadwiga, ed. *Fotografia Polska do 1914r.* Warsaw: Biblioteka Naradowe, 1981.

3454 GROBET, ANNE-MARIE (1943–)
Swiss photographer.

Other Sources

Naggar, C. *Dictionnaire des Photographes.* Paris: Editions du Seuil, 1982.

3455 GUÉNIOT, CLAUDINE
French photographer specialising in landscapes.

Exhibitions

Women of Photography: A Historical Survey. San Francisco: Museum of Art, 1975. Includes a short biographical account for each artist.

3456 GYULYÁS, KATALIN
Hungarian photographer.

Exhibitions

A fotográfia hónapja: 12 kiállitás a Magyar fotográfia 150 éves történetéból. Month of Photography: 12 Exhibitions on 150 years of Hungarian photography. Budapest: Association of Hungarian photographers, and Szabad Tér Publishing Co., 1989.

3457 HALLENSLEBEN, RUTH
German photographer who trained with Elizabeth Gropp.

Main Sources

Peters, Ursula, ed. *Ruth Hallensleben: Frauenarbeit in der Industrie. Fotografen aus dem Jahren 1938–1967.* Das Foto-Taschenbuch 2. Berlin: Dirk Nishen, 1985, 157pp., mainly illus.

Other Sources

Benteler, Petra, ed. *Fotografie von 1945 bis 1985*. Hamburg: Museum für Kunst und Gewerbe, 1987.

3458 HAMILTON, MATILDA (c. 1820–?)
English photographer.

Main Sources

Heathcote, Bernard V., and Pauline F. "The Feminine Influence: Aspects of the Role of Women in the Evolution of Photography in the British Isles." *History of Photography* 12, no. 3 (July–September 1988): 259–273. Short biographical account of this pioneer photographer from London.

Other Sources

Adamson, Keith. "Women in Photography." *Photographic Journal* 125 (1985): 156–161.

3459 HAWARDEN, VISCOUNTESS CLEMENTINA (1822–1865)
English photographer.

Main Sources

Dodier, Virginia. "Clementina, Viscountess Hawarden: Studies from Life." In *British Photography in the Nineteenth Century: The Fine Art Tradition*, pp. 141–150. Mike Weaver, ed. Cambridge: Cambridge University Press, 1989.
Dodier, Virginia. "From the Interior: Photographs by Clementina, Viscountess Hawarden." *Antiques* 139 (January 1991): 194–207, mainly illus.
Ovenden, Graham. *Clementina, Lady Hawarden*. London: Academy Editions; New York: St. Martins Press, 1974, 112pp., mainly illus.

Exhibitions

Künstlerinnen international, 1877–1977. Berlin: Schloss Charlottenburg, 1977.
Women in White: Photographs by Lady Harwarden. Edinburgh: Scottish National Portrait Gallery, 1997.

Other Sources

Adamson, Keith. "Women in Photography." *Photographic Journal* 125 (1985): 156–161.
Heathcote, Bernard V., and Pauline F. "The Feminine Influence: Aspects of the Role of Women in the Evolution of Photography in the British Isles." *History of Photography* 12, no. 3 (July–September 1988): 259–273.
Williams, Val. *The Other Observers: Women Photographers in Britain 1900 to the Present*. London: Virago, 1986.

3460 HÁY, ÁGNES
Hungarian photographer.

Exhibitions

A fotográfia hónapja: 12 kiállitás a Magyar fotográfia 150 éves történetéból.
Month of Photography: 12 Exhibitions on 150 years of Hungarian photography.
Budapest: Association of Hungarian photographers, and Szabad Tér Publishing Co.,
1989.

3461 HENRIKSEN, IDA (née ADELAIDE HENRIKSEN) (1860–?)
Norwegian photographer who ran a studio in Kristiansand with her sister
Maria.

Other Sources

Bonge, S. *Eldre norske fotografer: fotografer og amator fotografer i Norge*
frem til 1920. Bergen Universitetsbiblioteket, 1980.

3462 HENRI, FLORENCE (1893–1982)
French photographer.

Main Sources

Armstrong, Carol. "Florence Henri: A Photographic Series of 1928." *History*
of Photography 18, no. 3 (autumn 1994): 205–210.

Exhibitions

Women of Photography: A Historical Survey. San Francisco: Museum of Art,
1975. Includes a short biographical account and select bibliography.
Abstraction-Création 1931–1936. Paris: Musée d'Art Moderne de la Ville de
Paris, 1976.
Künstlerinnen international, 1877–1977. Berlin: Schloss Charlottenburg, 1977.
Pagé, Suzanne, and Catherine Thieck. *Florence Henri: Photographes*
1927–1938. Paris: Musée d'Art Moderne de la Ville de Paris, 1978, n.p. An essay
discusses the images of this period.
Marcenaro, Giuseppe. *Aspetti di un percorso.* Genoa: Banco di Chiavari e
della Riviera Ligure in association with Sagep Editrice, 1979, 112pp., 279 illus. An
essay on Henri analyses her work up to 1940. Contains a chronology, a list of exhi-
bitions and a catalogue of the exhibits.
Bauhaus photographie. Paris: Musée d'Art Moderne de la Ville de Paris, 1984.
Dufresne, Jean-Luc, and Olivier Messac, eds. *Femmes créatrices des années*
vingt. Granville: Musée Richard Anacréon, 1988. Wide-ranging catalogue with a
short biographical account on each woman included.
Künstlerinnen des 20. Jahrhunderts. Wiesbaden: Museum Wiesbaden in asso-
ciation with Verlag Weber & Weidermeyer GmbH, Kassel, 1990.
Franciolli, Marco, ed. *Florence Henri: Fotografie 1927–1938.* Lugano:
Museo Cantonale, 1991, 141pp., illus.

Other Sources

Fiedler, Jeannine. *Photography at the Bauhaus.* London: Dirk Nishen, 1990, 362pp., illus. Henri is one of two women awarded a chapter in this book.

Naggar, C. *Dictionnaire des Photographes.* Paris: Editions du Seuil, 1982.

3463 HERVIEUX, NATHALIE (1966–)
French photographer.

Exhibitions

Domino, Christopher. "Inter-Image: Preliminary Observations of the Work of Nathalie Hervieux." In *Inside the Visible: An Elliptical View of 20th Century Art— In, Of and From the Feminine,* ed Catherine De Zegher. Ghent: The Kanaal Foundation, 1996.

3464 HESKE, MARIANNE (1946–)
Norwegian sculptor, video and installation artist, graphic artist and photographer.

See Performance and Video Art, Mixed Media and Installations section.

3465 HIGGINS, ELIZABETH (c. 1828–1891)
English photographer of portraits and rural scenes.

Main Sources

Heathcote, Bernard V., and Pauline F. "The Feminine Influence: Aspects of the Role of Women in the Evolution of Photography in the British Isles." *History of Photography* 12, no. 3 (July–September 1988): 259–273. Short biographical account of this pioneer photographer.

3466 HOCHOVÁ, DAGMAR (1926–)
Czech photographer who specialises in the subject of children who has had a considerable influence on Czech photography.

Main Sources

Blazek, Bohuslav. *Dagmar Hochová.* Prague: Odeon, 1984, 38pp., 91 illus. Text in Czech with summaries in English and Russian. Chapters analyse her themes, techniques and social factors in her photographs. The influence of film, notably of Fellini, is examined.

Exhibitions

Československá fotografie 1968–1970. Brno: Moravská Galerie, 1971.

3467 HOEPFFNER, MARTA (1912–)
German photographer who experimented with various techniques and whose styles moved from Surrealism in the 1930s to geometrical abstraction in later years.

Other Sources

Benteler, Petra. *Deutsche fotografie nach 1945.* Kassel: Fotoforum, Universität Kassel, 1979.

————, ed. *Fotografie von 1945 bis 1985.* Hamburg: Museum für Kunst und Gewerbe, 1987.

Evers, Ulrike. *Deutsche Künstlerinnen des 20. Jahrhunderts. Malerei— Bildhauerei—Tapisserie.* Hamburg: Ludwig Schultheis Verlag, 1983. Contains an individual bibliography.

3468 HORNÍČKOVÁ, DANIELA (1944–)
Czech photographer.

Exhibitions

Československá fotografie 1968–1970. Brno: Moravská Galerie, 1971.
Československá fotografie 1971–1972. Brno: Moravská Galerie, 1973.

3469 HORVÁTH, JUDIT (1952–)
Hungarian photographer.

Other Sources

Az Év Fotói. Pictures of the Year. 1992. Budapest: Pelikán Könyvek, 1993.
Az Év Fotói. Pictures of the Year. 1993. Budapest: Pelikán Könyvek, 1994.

3470 HORVÁTH, KATALIN (1973–)
Hungarian photographer.

Other Sources

Az Év Fotói. Pictures of the Year. 1993. Budapest: Pelikán Könyvek, 1994.

3471 HORVÁT, ÉVA (1954–)
Hungarian photographer.

Other Sources

Az Év Fotói. Pictures of the Year. 1992. Budapest: Pelikán Könyvek, 1993.

3472 HUGHES, ALICE (1857–1939)
English portrait photographer.

Other Sources

Stanley, Jo. "Marketable Maidens." *Women's Art Magazine* 59 (1994): 45–46.

Williams, Val. *The Other Observers: Women Photographers in Britain 1900 to the Present.* London: Virago, 1986.

3473 HUNTER, ALEXIS (1948–)
New Zealand-born painter and photographer, working in England, who often deals with ways of establishing positive role models for women.

See Painting section.

3474 IGNATOVICH, OLGA (1901–)
Russian photographer whose favourite subject was the group portrait.

Other Sources

Shudakov, Grigory, Olga Suslova, and Lilya Ukhtomskaya. *Pioneers of Soviet Photography.* London: Thames and Hudson, 1983. Gives a short biographical account and illustrates seven of her works. She is the only woman included.

3475 IKAM, CATHERINE (1942–)
French installation, video artist and photographer.

See Performance and Video Art, Mixed Media and Installations section.

3476 IONESCO, IRINA
Romanian-born photographer who works in France.

Publications

Femmes sans tain. Poèmes de Renée Vivien. Paris: Bernard Letu et Secle, 1975, n.p., many illus. The poems are interspersed with full-page photographs of women, most of whom wear heavy make-up and overly decorative jewellery.

Main Sources

Irina Ionescu. Geneva: Bernard Letu Editeur, 1979, 77pp., mainly illus. Text in French and English. Contains two short texts, a biography and bibliography.

3477 ISZÓ, SZILVIA (1967–)
Hungarian photographer.

Other Sources

Az Év Fotói. Pictures of the Year. 1992. Budapest: Pelikán Könyvek, 1993.

3478 JACOBI, LOTTE (1896–1990)
German photographer who worked in America from 1935.

Publications

"Photogenics: Lotte Jacobi." *Aperture* 10, no. 1 (1962): 4–16. Examples of her abstract photographs.
Berlin-New York: Scriftseller in den 30er Jahren, fotografiert von Lotte Jacobi. Marbacher Schriften no. 21. Marbach am Neckar: Deutschen Literaturarchiv, 1982, 98pp., mainly illus. Apart from a five-page introductory essay by Ludwig Greve, the book consists of photographs of German writers by Jacobi.

Main Sources

Lotte Jacobi: Theatre and Dance Photographs. Woodstock, Vt.: Countryman Press, 1982, 48pp., illus.
Wise, Kelly, ed. *Lotte Jacobi.* Danbury, N.H.: Addison House, 1978, 187pp., illus.

Exhibitions

Women of Photography: A Historical Survey. San Francisco: Museum of Art, 1975. Includes a short biographical account for each artist.
Künstlerinnen international, 1877–1977. Berlin: Schloss Charlottenburg, 1977.
Dufresne, Jean-Luc, and Olivier Messac, eds. *Femmes créatrices des années vingt.* Granville: Musée Richard Anacréon, 1988. Wide-ranging catalogue with a short biographical account on each woman included.
Eskilden, Ute, and Sally Stein. *Lotte Jacobi, 1896–1990.* Essen: Folkwang Museum, 1991.
Meskimmon, Marsha. *Domesticity and Dissent: The Role of Women Artists in Germany 1918–1938. Haüsliches Leben und Dissens.* Leicester: Leicestershire Museums Publication no. 120, 1992.

Other Sources

Meskimmon, Marsha, and Shearer West. *Visions of the 'Neue Frau': Women and the Visual Arts in Weimar Germany.* London: Scolar Press, 1995.
Naggar, C. *Dictionnaire des Photographes.* Paris: Editions du Seuil, 1982.

3479 JACOT, MONIQUE (1934–)
Swiss photographer.

Other Sources

Naggar, C. *Dictionnaire des Photographes*. Paris: Editions du Seuil, 1982.

3480 KÁLMÁN, KATA (1909–1978)
Hungarian photographer.

Exhibitions

A fotográfia hónapja: 12 kiállitás a Magyar fotográfia 150 éves történetéból. Month of Photography: 12 Exhibitions on 150 years of Hungarian photography. Budapest: Association of Hungarian photographers, and Szabad Tér Publishing Co., 1989.

Other Sources

The Hungarian Connection: The Roots of Photojournalism. Bradford: National Museum of Film, Photography and Television, 1987. Mentioned in text.

Gábor, Szilágyi, and Sándor Kardos. *Leletek: A magyar fotográfia történetéból*. Budapest: Képzómúvészeti Kiadó, 1983.

3481 KALOUSSI, OLGA (1944–)
Greek photographer who works in Germany.

Other Sources

Naggar, C. *Dictionnaire des Photographes*. Paris: Editions du Seuil, 1982.

3482 KAR, IDA (née IDA KARAMIAN) (1908–1974)
Russian-born portrait photographer who travelled widely, living in Egypt from 1921 and in Paris from 1928, and who settled in England in 1945.

Main Sources

Williams, Val. *Ida Kar, Photographer: 1908–1974*. London: Virago, 1979, 159pp., illus. Discusses how Kar took the genre of portrait photography away from the whimsy of the 1920s and 1930s and recorded the intellectuals of Bohemia in a documentary fashion. The only detailed account of Kar's life and work.

Exhibitions

Ida Kar. London: Whitechapel Art Gallery, 1960.

3483 KELETI, ÉVA (1931–)
Hungarian photographer specialising in photojournalism.

Other Sources

Gábor, Szilágyi, and Sándor Kardos. *Leletek: A magyar fotográfia történetéból*. Budapest: Képzómúvészeti Kiadó, 1983.

3484 KEMPADOO, ROSHINI (1959–)
English-born photographer whose work is informed by feminism.

Publications

Wells, Liz, ed. *Viewfindings: Women Photographers: Landscape and Environment.* Tiverton: Available Light, 1994. As a contributor to this book, brief biographical details are included.

Exhibitions

Roshini Kempadoo—Culture and Identity. Rotterdam: Perspectief, 1991.

Other Sources

Jones, Kellie. "Re-Creation." *Ten-8* 2, no. 3 (spring 1992): 96–105.
Williams, Val. *The Other Observers: Women Photographers in Britain 1900 to the Present.* London: Virago, 1986.

3485 KER-SEYMER, BARBARA (1905–)
English photographer of portraits, mostly of high society.

Exhibitions

Mellor, David. *Modern British Photography, 1919–1939.* Oxford: Museum of Modern Art, 1978.

Other Sources

Mellor, David, ed. *Germany: The New Photography, 1927–1933.* London: Arts Council of Great Britain, 1978.
Williams, Val. *The Other Observers: Women Photographers in Britain 1900 to the Present.* London: Virago, 1986.

3486 KLEIN, ASTRID (1951–)
German photographer.

Exhibitions

Eiblmayr, Silvia, Valie Export, and Monika Prischl-Maier. *Kunst mit Eigen-Sinn. Aktuelle Kunst von Frauen: Texte und Dokumentation.* Vienna: Locker Verlag in association with the Museum of Modern Art and Museum of 20th Century Art, 1985.
Astrid Klein:Photoworks 1984–1987. London: Gimpel Fils, 1987, 9pp., unbound.
Astrid Klein: Photoworks 1984–1989. London: Institute of Contemporary

Art, 1989, 62 pp., illus. First published in German by Kestner-Gesellscheaft, Hannover, 1989. Contains two essays analysing her work, a list of exhibitions and a bibliography.
Butler, Susan. *Shifting Focus*. Bristol: Arnolfini Gallery, 1989.

3487 KNOCKER, ELSIE
English photographer who recorded her experiences as a nurse in Belgium in World War I; colleague of photographer Mairi Chisholm (q.v.).

Other Sources

Williams, Val. *The Other Observers: Women Photographers in Britain 1900 to the Present*. London: Virago, 1986.

3488 KNORR, KAREN
German-born photographer who works in England.

Exhibitions

Ascherson, Neil. *Shocks to the System: Social and Political Issues in Recent British Art from the Arts Council Collection*. London: Royal Festival Hall, 1991.

Other Sources

Taylor, John. *A Dream of England: Landscape, Photography and the Tourist's Imagination*. Manchester: Manchester University Press.
Wells, Liz. "The Eyes of Europe." *Women's Art Magazine* 59 (1994): 29–32.

3489 KONCS, ZSUZSA (1941–)
Hungarian photographer.

Other Sources

Az Év Fotói. Pictures of the Year. 1992. Budapest: Pelikán Könyvek, 1993.
Az Év Fotói. Pictures of the Year. 1993. Budapest: Pelikán Könyvek, 1994.

3490 KRETSCHMER, ANNELIESE (1903–)
German photographer.

Exhibitions

Eskilden, Ute. *Anneliese Kretschmer Fotografen*. Essen: Folkwang Museum, 1982, 42pp., illus.

Other Sources

Meskimmon, Marsha, and Shearer West. *Visions of the 'Neue Frau': Women and the Visual Arts in Weimar Germany*. London: Scolar Press, 1995.

3491 KRULL, GERMAINE (1897–1985)
 German-born documentary photographer who worked in Paris from 1924; after 1945 she travelled widely as a photojournalist.

Publications

La route de Paris à Biarritz. Text by C. Farrère. Paris: Editions Jacques Haumont, 95pp., mainly photos by Krull. A photo-essay of a journey through France.
 La route de Paris à la Mediterranée. Text by Paul Morand. Paris: Firmin-Didit et Cie., 1931, 96pp., mainly photos by Krull. Follows the pattern of the previous publications.
 With Georges Simenon. *La folle d'Itteville.* Paris: Editions Jacques Haumont, 1931, n.p. [c. 123pp.], many illus. A phototext of a type of detective story. The photographs allude to rather than document events, although some are primarily narrative.
 Marseille. Text by André Suarès. Editions d'Histoire et d'Art. Paris: Librairie Plon, 1935, n.p., mainly illus.
 La bataille d'Alsace (nov.–déc. 1944). Text by R. Vailland. Paris: Jacques Haumont, 1945, n.p., mainly illus. Krull was an accredited war photographer. Gives a detailed account of the battle, complete with maps.

Main Sources

 Orlan, Pierre Mac. *Germaine Krull: ses photographes nouveaux.* Paris: Librairie Gallimard, 1931, 63pp., mostly illus. Limited edition of 115 copies. Contains an introductory essay, a biographical outline and quotations from Krull and from press reviews of her work. Lists her publications.

Exhibitions

Germain Krull: photographie 1924–1936. Arles: Musée Réattu, 1988, 155pp., 87 illus. Contains three essays, a biography and bibliography.
 Dufresne, Jean-Luc, and Olivier Messac, eds. *Femmes créatrices des années vingt.* Granville: Musée Richard Anacréon, 1988. Wide-ranging catalogue with a short biographical account on each woman included.
 Meskimmon, Marsha. *Domesticity and Dissent: The Role of Women Artists in Germany 1918–1938. Haüsliches Leben und Dissens.* Leicester: Leicestershire Museums Publication no. 120, 1992.

Other Sources

 Naggar, C. *Dictionnaire des Photographes.* Paris: Editions du Seuil, 1982.

3492 KULIK, ZOFIA (1947–)
 Polish photographer who manipulates images and uses photomontage to challenge the masculine political order. From 1970 to 1987, she collaborated with Przemysław Kwiek and their joint works were signed Kwiekulik.

Exhibitions

Morawińska, Agnieszka. *Voices of Freedom: Polish Women Artists of the Avant-garde, 1880–1990*. Washington, D.C.: National Museum of Women in the Arts, 1991. Includes a list of her main exhibitions and a bibliography.

3493 KUZNETSOVA, LYALYA (1946–)
Russian photographer.

Main Sources

Mrázková, Daniela, and Vladimir Remeš. *Another Russia: Through the Eyes of the New Soviet Photographers*. London: Thames and Hudson, 1986.

3494 LAFONTAINE, MARIE-JO (1950–)
Belgian video artist and photographer who has also produced monochrome paintings, sculpture and weavings.

See Performance and Video Art, Mixed Media and Installations section.

3495 LANGER, KLÁRA (1912–1963/73)
Hungarian photographer.

Exhibitions

The Hungarian Connection: The Roots of Photojournalism. Bradford: National Museum of Film, Photography and Television, 1987. Mentioned in text.

Other Sources

Gábor, Szilágyi, and Sándor Kardos. *Leletek: A magyar fotográfia történetéből*. Budapest: Képzómúvészeti Kiadó, 1983.

3496 LAUFFOVÁ, LUBICA (1949–)
Czech photographer.

Exhibitions

Československá fotografie 1968–1970. Brno: Moravská Galerie, 1971.
Československá fotografie 1971–1972. Brno: Moravská Galerie, 1973.

3497 LELE, OUKA (Pseudonym of BARBARA ALLENDE) (1957–)
Spanish photographer.

Exhibitions

Williams, Val. *Who's Looking at the Family?* London: Barbican Art Gallery, 1994.

Other Sources

Wells, Liz. "The Eyes of Europe." *Women's Art Magazine* 59 (1994): 29–32.

3498 LENDVAI-DIRKSEN, ERNA
German photographer who worked under the tenets of National Socialist art.

Publications

Deutschland: Landschaft und Baukunst. Berlin: Atlantis Verlag, 1931. Reprinted 1983, 63pp., 303 photographs. Contains commentaries on each of the photographs. The scenes show towns and the countryside and are less ideologically loaded than some of her later work.
Reichsautobahn: Mensch und Werk. Berlin: Volk und Reich Verlag, 1937, n.p., mainly illus. Photographs of road construction and the men building them.
Im Angesicht des Gebirges. Bild einer Landschaft im Jahrekreis. Bayreuth: Gauverlag, 1939, 70pp., mainly illus. Arranged into four sections corresponding to the seasons, the photographs show timeless landscapes and rural people.
Das Germanisches Volkgesicht: Flandern. Bayreuth: Gauverlag, 1942, 82pp., 70 illus. Celebrates the Aryan qualities of rural Flemish people. The portraits are of young and old while the landscapes are timeless in order to demonstrate the 1000-year Reich.
Vlaanderen's Germanisch Volksgezicht. Brussels: "De Burcht," J. Bernaerdts Uitgiver, 1943, 82pp., 70 illus. Flemish edition of previous publication.

Exhibitions

Künstlerinnen international, 1877–1977. Berlin: Schloss Charlottenburg, 1977.

3499 LEXAU, EMILIE (née SOPHIE EMILIE LEXAU) (1865–1932)
Norwegian photographer who ran a studio with Marie Brynildsen until c. 1910.

Other Sources

Bonge, S. *Eldre norske fotografer: fotografer og amator fotografer i Norge frem til 1920.* Bergen: Universitetsbiblioteket, 1980.

3500 LEX-NERLINGER, ALICE (1893–)
German graphic artist and photographer who used new techniques, including photomontage and the photogram, and whose work often contained a political dimension.

Exhibitions

Gleisberg, D. *Deutsche Künstlerinnen des zwanzigsten Jahrhunderts.* Attenburg: Staatlichen Lindendau Museum, 1963.

Other Sources

Meskimmon, Marsha, and Shearer West. *Visions of the 'Neue Frau': Women and the Visual Arts in Weimar Germany.* London: Scolar Press, 1995.

3501 LIBERG, MARIE (?–c. 1965)
Norwegian photographer who opened her own studio c. 1902.

Other Sources

Bonge, S. *Eldre norske fotografer: fotografer og amator fotografer i Norge frem til 1920.* Bergen: Universitetsbiblioteket, 1980.

3502 LIBERMAN, TATYANA (1964–)
Russian photographer.

Main Sources

Tolnay, Alexander, ed. *Contemporary Photographic Art from Moscow. Zeitgenössische Fotokunst aus Moskau.* Munich and New York: Prestel, 1995.

3503 LIEBERT, THORA WILHELMINA MAGDALENA (1846–?)
Finnish photographer, musician and actress who lived in Sweden from 1872.

Other Sources

Hirn, Sven. *Kameran edesta ja takaa, valokuvaajat suomessa 1839–1870.* Helsinki: Suomen Valukuvataiteen Museon Säätio, 1972.

3504 LIE, HENNY (1945–)
Dutch photographer.

Other Sources

Naggar, C. *Dictionnaire des Photographes.* Paris: Editions du Seuil, 1982.

3505 LIND, JENNY MARIE HELENE (née WAADELAND) (1875/80–1967)
Norwegian photographer who worked with her husband and continued after his death in 1950.

Other Sources

Bonge, S. *Eldre norske fotografer: fotografer og amator fotografer i Norge frem til 1920.* Bergen: Universitetsbiblioteket, 1980.

3506 LODEMEL, KRISTIANNE RASMUD (1874–1944)
Norwegian photographer.

Other Sources

Bonge, S. *Eldre norske fotografer: fotografer og amator fotografer i Norge frem til 1920.* Bergen: Universitetsbiblioteket, 1980.

3507 LOMAX, YVE (1952–)
 English photographer who questions dominant modes of representation.

Publications

"Yve Lomax: Better Than." *Camera Austria* 53 (1995): 3–19. Text in English and German. Text of a lecture given by Lomax on the occasion of her exhibition *Sometime(s)* at the Forum Stadtpark in Vienna.
 "Folds in the Photograph." *Third Text* 32 (1995): 43–58. Discusses the implications for photographic representation of Bergson's theory on the nature of multiplicity and relates this specifically to the work of Gilles Deleuze and Félix Guattari.

Main Sources

Anson, Libby. " Still." *Women's Art Magazine* 70 (1996): 27. Review of a two-person exhibition *Between Two Folds.*

Exhibitions

Sense and Sensibility in Feminist Art Practice. Nottingham: Midland Group Gallery, 1982.
 Difference: On Representation and Sexuality. New York: New Museum of Contemporary Art, 1984.
 Butler, Susan. *Shifting Focus.* Bristol: Arnolfini Gallery, 1989.

Other Sources

Brooks, Rosetta. "Through the Looking Glass, Darkly." *Aperture* 113 (winter 1988): 47–51. In the context of an account of the shift of British society into consumerism, the works of three photographers who examine issues of community and identity are discussed. They include Lomax and Trangmar.
 Butler, Susan. "Between Frames." *Aperture* 113 (winter 1988): 30–39.

3508 LOPEZ-HUICI, ARIANE (1945–)
 French photographer.

Other Sources

Naggar, C. *Dictionnaire des Photographes.* Paris: Editions du Seuil, 1982.

3509 LUND, JOHANNA PETERSEN (Alt. ECKERSBERG) (1857–1933)
 Norwegian photographer who trained with Louise Abel and was active until c. 1897.

Other Sources

Bonge, S. *Eldre norske fotografer: fotografer og amator fotografer i Norge frem til 1920.* Bergen: Universitetsbiblioteket, 1980.

3510 LUSKAČOVÁ, MARKÉTA (1944–)
Czech photographer.

Publications

"The Pilgrims." *Creative Camera,* October 1971, 346–349. Seven photographs which formed part of her exhibition on this subject in Prague in 1971. Brief text by Luskačová and an outline biography.

"Puck Fair, Ireland, 1972." *Creative Camera,* November 1973, 378–383. Six of her photographs published with no accompanying text.

"Strandleben, Very British." *Fotomagazin* 9 (September 1984): 24–30, mainly illustrations. A collection of her photographs of British beaches during the holiday season.

Main Sources

Farova, Anna. "Markéta Luskačová." *Camera,* August 1930, 30–34. Short biographical account and the first publication of Luskačová's photographs.

Exhibitions

Československá fotografie 1968–1970. Brno: Moravská Galerie, 1971.
Československá fotografie 1971–1972. Brno: Moravská Galerie, 1973.
Women of Photography: A Historical Survey. San Francisco: Museum of Art, 1975. Includes a short biographical account for each artist.
Markéta Luskačová: Pilgrims. London: Victoria and Albert Museum, 1983, 64pp., illus.
Markéta Luskačová: Photographs of Spitalfields. London: Whitechapel Art Gallery, 1991, 72pp., mainly illus.

3511 MAAR, DORA (née HENRIETTA THEODORA MARKOVITCH) (1907–1997)
French photographer.

Main Sources

L'Enfant, Julie. "Dora Maar and the art of mystery." *Woman's Art Journal* 17, no. 2 (fall 1996–winter 1997): 15–20.

Hopkins, Amanda. "The Eye's Muse and the Lens Artist." *The Guardian,* 26 July 1997, 19. Obituary.

Exhibitions

Paris 1937-Paris 1957: créations en France. Paris: Centre national d'art et de culture Georges Pompidou, 1981.

3512 MAGITO, HILDA JOSEFINA EUPHROSYNE (Alt. WECKMAN) (1844–1924)
Finnish photographer active in the 1860s; for a time, she worked with her cousin Karin Magito (q.v.).

Other Sources

Hirn, Sven. *Kameran edesta ja takaa, valokuvaajat suomessa 1839–1870.* Helsinki: Suomen Valukuvataiteen Museon Säätio, 1972.

3513 MAGITO, KARIN (née SELMA KATHARINA AURORA MAGITO; alt. MALLANDER)
Finnish photographer active for a short period in the 1860s with her cousin Hilda Magito (q.v.).

Other Sources

Hirn, Sven. *Kameran edesta ja takaa, valokuvaajat suomessa 1839–1870.* Helsinki: Suomen Valukuvataiteen Museon Säätio, 1972.

3514 MAINGOT, ROSALIND
Australian photographer who trained and worked in England.

Exhibitions

Mellor, David. *Modern British Photography, 1919–1939.* Oxford: Museum of Modern Art, 1978.

3515 MÁTÉ , OLGA
Hungarian portrait photographer.

Exhibitions

The Hungarian Connection: The Roots of Photojournalism. Bradford: National Museum of Film, Photography and Television, 1987. Mentioned in text.

Other Sources

Gábor, Szilágyi, and Sándor Kardos. *Leletek: A magyar fotográfia történetéből.* Budapest: Képzómúvészeti Kiadó, 1983.

3516 MAURER, DÓRA (1937–)
Hungarian photographer.

Exhibitions

Eiblmayr, Silvia, Valie Export, and Monika Prischl-Maier. *Kunst mit Eigen-Sinn. Aktuelle Kunst von Frauen: Texte und Dokumentation.* Vienna: Locker Verlag

in association with the Museum of Modern Art and Museum of 20th Century Art, 1985.

The Hungarian Connection: The Roots of Photojournalism. Bradford: National Museum of Film, Photography and Television, 1987.

A fotográfia hónapja: 12 kiállitás a Magyar fotográfia 150 éves történetéből. Month of Photography: 12 Exhibitions on 150 years of Hungarian photography. Budapest: Association of Hungarian photographers, and Szabad Tér Publishing Co., 1989. Mentioned in text.

3517 McCARTHY, SARAH

English photographer whose work is informed by the women's movement.

Exhibitions

Reichardt, Jasia, ed. *Zeit, Worte und die Kamera. Time, Words and the Camera. Fotoarbeiten englischer Künstler. Photoworks by British Artists.* Graz: Künstlerhaus, 1976.

Sense and Sensibility in Feminist Art Practice. Nottingham: Midland Group, 1982.

3518 MECKE, ROSWITHA (1954–)

German photographer.

Other Sources

Rumpf, Harald. *52 junge deutsche Fotografen.* Munich: Verlag H. Rumpf, 1981.

3519 MEDKOVÁ, EMILA (1928–)

Czech photographer.

Exhibitions

Československá fotografie 1968–1970. Brno: Moravská Galerie, 1971.
Československá fotografie 1971–1972. Brno: Moravská Galerie, 1973.

3520 MILLER, LEE (née ELIZABETH MILLER) (1907–1977)

American-born photographer who worked mainly in Europe from 1929.

Publications

"St. Malo" and "Paris." *Vogue,* October 1944, 51–78.
"Patterns of Liberation." *Vogue,* January 1945, 80.
"Colette." *Vogue,* March 1945, 50.
"Hitleriana." *Vogue,* June 1945, 74.
"Hungary." *Vogue,* April 1946, 64.
"Romania." *Vogue,* May 1946, 64.

"What they see in cinema." *Vogue,* August 1956, 46.
Amaya, M. "My Man Ray" [interview with LM]. *Art in America* (May–June 1975): 55.

Main Sources

Hubert, Renée Riese. *Magnifying Mirrors: Women. Surrealism and Partnership,* 199–230. Lincoln and London: University of Nebraska Press, 1994. Discusses the nature of relationships within the Surrealist group and its effect on the productivity of both partners.

Lyford, Amy J. "Lee Miller's Photographic Impersonations." *History of Photography* 18, no. 3 (autumn 1994): 205–210.

Exhibitions

Penrose, A. *The lives of Lee Miller.* London: Thames and Hudson, 1985, 216pp., illus. Biographical account written by her son.

Other Sources

Williams, Val. *Warworks: Women, Photography and the Iconography of War.* London: Virago, 1994.

3521 MINÁČOVÁ, ZUZANA (1931–)
Czech photographer.

Exhibitions

Československá fotografie 1968–1970. Brno: Moravská Galerie, 1971.
Československá fotografie 1971–1972. Brno: Moravská Galerie, 1973.

3522 MODOTTI, TINA
Italian photographer who worked in Mexico and Germany.

Publications

Richey, Roubaix Del'abrie. *The book of Robo: Being a collection of verses and prose writings by Richey with a biographical sketch by his wife, Tina Modotti Richey.* Los Angeles: n.p., 1923, 59pp.

Brenner, Anita. *Idols Behind Altars.* New York: Payson Clarke Ltd., 1929, 360pp., 110 illus. Amongst the illustrations are photographs of Mexico by Modotti. One section of the book is devoted to modern Mexican, particularly revolutionary, art.

Main Sources

Agostins, Valentina, ed. *Tina Modotti: gli anni luminosi.* Pordenone: Cinemazero Edizioni, 1992, 246pp., illus. Contains critical essays by several writers including Mulvey. Accompanied an exhibition held at the Villa Varda-Brugnera (Pordenone).

Ellero, Gianfranco. *Tina Modotti: in Carinzia e in Friuli.* Pordenone: Cinemazero, 1996, 148pp., illus. Contains a bibliography.This critical biography discusses at some length the theory that she was poisoned.

Lowe, Sarah M. "The Immutable Still Lives of Tina Modotti." *History of Photography* 18, no. 3 (autumn 1994): 205–210.

Exhibitions

Women of Photography: A Historical Survey. San Francisco: Museum of Art, 1975. Includes a short biographical account for each artist.

Mulvey, Laura, and Peter Wollen. *Frida Kahlo and Tina Modotti.* London: Whitechapel Art Gallery, 1982, 79pp., illus. Analytical comparison of artistic activities of these two artists in Mexico and their interventions in the political and cultural life of the times.

Lowe, Sarah M. *Tina Modotti: Photographs.* New York: Harry N. Abrams Inc. in association with Philadelphia Museum of Art, 1995, 160pp., many illus. Contains a through critical evaluation of her life and work and a full bibliography of publications on and by Modotti.

3523 MOHOLY, LUCIA (née SCHULTZ; alt. MOHOLY-NAGY) (1900–)
German photographer.

Exhibitions

Bauhaus photographie. Paris: Musée d'Art Moderne de la Ville de Paris, 1984.

Other Sources

Mellor, David, ed. *Germany: The New Photography, 1927–1933.* London: Arts Council of Great Britain, 1978.

3524 MOLNÁR, EDIT (1933–)
Hungarian photographer.

Other Sources

Naggar, C. *Dictionnaire des Photographes.* Paris: Editions du Seuil, 1982.

3525 MOLNÁR, KATA (1968–)
Hungarian photographer.

Other Sources

Az Év Fotói. Pictures of the Year. 1992. Budapest: Pelikán Könyvek, 1993.

3526 MONCK, MARGARET (née MARGARET ST. CLAIR SYDNEY THE-
SIGER; alt. GOLDMAN) (1911–1991)
English documentary photographer who specialised in subjects from the
East End of London, Clerkenwell and the dock areas.

Main Sources

Williams, Val. *The Other Observers: Women Photographers in Britain 1900
to the Present.* London: Virago, 1986.
————. "Margaret Monck." *The Independent,* 4 July 1991, 20. Obituary.

3527 MONSELLES, VERITA (1929–)
Italian photographer.

Exhibitions

Objetivo Italia: fotografía contemporánea italiana. Puebla: Universidad
Autonoma, 1991.

3528 MOON, SARAH (1940–)
English photographer.

Other Sources

Tausk, Peter. *Photography in the Twentieth Century.* London: Focal Press,
1980. Includes an outline biography and published books of photographs.

3529 MORLEY, SARAH (1958–)
English photographer.

Exhibitions

Bayer, Jonathan, and Alex Noble. *Image and Exploration: Some Directions in
British Photography, 1980–85.* London: Photographers' Gallery, 1985.

3530 MÖLLINGER, FRANCISKA (1817–1880)
Swiss/German photographer who was one of the first women photogra-
phers; also a graphic artist.

Other Sources

Adamson, Keith. "Women in Photography." *Photographic Journal* 125
(1985): 156–161.

Other Sources

Peters, Ursula. *Stilgeschichte der Fotografie in Deutschland, 1839–1900.*
Cologne: DuMont, 1979.

3531 MULAS, MARIA (c. 1935–)
Italian photographer.

Exhibitions

7 Biennale Donna. Vanessa Bell e Virginia Woolf: Disegnare la Vita.
Ferrara: Padiglione d'Arte Contemporanea, 1996.

3532 MUSPRATT, HELEN (1907–)
English photographer who carried out both studio portraits and two series
of documentary photographs.

Other Sources

Williams, Val. *The Other Observers: Women Photographers in Britain 1900
to the Present.* London: Virago, 1986.

3533 MÜLLER, JUDIT (1953–)
Hungarian photographer.

Other Sources

Az Év Fotói. Pictures of the Year. 1992. Budapest: Pelikán Könyvek, 1993.
Az Év Fotói. Pictures of the Year. 1993. Budapest: Pelikán Könyvek, 1994.

3534 NEY, ROSIE (née ROPÈSZI FÖLDI) (1897–1972)
Hungarian documentary photographer who worked in France.

Exhibitions

*A fotográfia hónapja: 12 kiállitás a Magyar fotográfia 150 éves történetéból.
Month of Photography: 12 Exhibitions on 150 years of Hungarian photography.*
Budapest: Association of Hungarian photographers, and Szabad Tér Publishing
Co., 1989.

3535 NÈGRE, MARIE-PAULE (1950–)
French photographer.

Other Sources

Naggar, C. *Dictionnaire des Photographes.* Paris: Editions du Seuil, 1982.

3536 NIÉPCE, JEANINE
French photographer.

Publications

Ce monde qui change. Lausanne and Paris: La Guide du Livre, 1970, 57pp.,
mainly illus. Documentary photographs mainly of France, but with some of

Belgium and North and South America, between the years 1958 and 1968. A large proportion are of the "évenements" of 1968.

Other Sources

Naggar, C. *Dictionnaire des Photographes*. Paris: Editions du Seuil, 1982.

3537 NOORDENBOS, CORINNE (c. 1949–)
Dutch photographer.

Exhibitions

Williams, Val. *Who's Looking at the Family?* London: Barbican Art Gallery, 1994.

3538 NORDENSTRENG, JULIA (née OLGA JULIE NATALIA NORDEN-STRENG) (1828–1883)
Finnish photographer.

Other Sources

Hirn, Sven. *Kameran edesta ja takaa, valokuvaajat suomessa 1839–1870.* Helsinki: Suomen Valukuvataiteen Museon Säätio, 1972.

3539 NOTHHELFER, GABRIELE (1945–)
German documentary photographer who works with her husband Helmut.

Other Sources

Tausk, Peter. *Photography in the Twentieth Century.* London: Focal Press, 1980. Includes an outline biography and published books of photographs.

3540 NYBLIN, AGNES (née JANSON) (1869–1945)
Norwegian photographer who was active for most of her life; for a period from 1897 she was a police photographer.

Other Sources

Bonge, S. *Eldre norske fotografer: fotografer og amator fotografer i Norge frem til 1920.* Bergen: Universitetsbiblioteket, 1980.

3541 NYBLIN, CASPARA FRANTZINE (née LARSEN) (1868–1954)
Norwegian photographer.

Other Sources

Bonge, S. *Eldre norske fotografer: fotografer og amator fotografer i Norge frem til 1920.* Bergen: Universitetsbiblioteket, 1980.

3542 ODILON, ALICE (1959–)
French photographer.

Exhibitions

Het Zelfbeeld: Images of the Self. Leiden: Stichting Burcht and Galerie Fotomania, 1987.

3543 OMENETTO, CRISTINA (1942–)
Italian photographer.

Exhibitions

Objetivo Italia: fotografía contemporánea italiana. Puebla: Universidad Autonoma, 1991.

3544 ORGERET, VALÉRIE (c. 1966–)
French mixed-media artist and photographer.

Exhibitions

Valérie Orgeret. St. Etienne: Académie des Beaux-Arts, 1992, 25pp., illus.

3545 PACKER, SUE (1954–)
English photographer.

Exhibitions

Bayer, Jonathan, and Alex Noble. *Image and Exploration: Some Directions in British Photography, 1980–85.* London: Photographers' Gallery, 1985.

3546 PALEY, MAUREEN (1954–)
English photographer.

Exhibitions

Bayer, Jonathan, and Alex Noble. *Image and Exploration: Some Directions in British Photography, 1980–85.* London: Photographers' Gallery, 1985.

3547 PARSONS, K. M.
English landscape photographer who worked for a time in Amsterdam and also provided photographic illustrations for books.

Other Sources

Williams, Val. *The Other Observers: Women Photographers in Britain 1900 to the Present.* London: Virago, 1986.

3548 PÁSZTOR, ERIKA
Hungarian photographer.

Exhibitions

A fotográfia hónapja: 12 kiállitás a Magyar fotográfia 150 éves történetéből.
Month of Photography: 12 Exhibitions on 150 years of Hungarian photography.
Budapest: Association of Hungarian photographers, and Szabad Tér Publishing Co.,
1989.

3549 PETÓ, ZSUZSA (1958–)
Hungarian photographer.

Other Sources

Az Év Fotói. Pictures of the Year. 1993. Budapest: Pelikán Könyvek, 1994.

3550 PEZOLD, FRIEDERIKE (1945–)
Austrian installation artist and photographer.

See Performance and Video Art, Mixed Media and Installations section.

3551 PIA, PAULE (1920–)
Belgian photographer.

Exhibitions

Paule Pia: Foto-portretten Vlaamse Kunstenaars. Antwerp: Provinciaal
Centrum Arenberg, 1972, n.p., illus. A leaflet rather than a catalogue, this lists the
forty-three portraits in the exhibition carried out between 1965 and 1972. The sitter
is shown accompanied by a relevant object which has been imposed across or adja-
cent to the face of the sitter.

3552 PLISSART, MARIE-FRANÇOISE
French photographer who produces photonarratives.

Publications

Droit de Regards. Paris: Editions de Minuit, 1985, 92pp., all illus., and 36pp.,
of an essay by Derrida.
With Benoit Peeters. *Correspondance.* Liège: Editions Yellow Now, 1981.
———. *Fugues.* Paris: Editions de Minuit, 1983, 122pp., all illus.
———. *Prague: un mariage blanc.* Paris: Editions Autremont, 1985, 90pp.,
mainly illus.
———. *Le mauvais oeil: roman photo.* Paris: Editions de Minuit, 1986,
76pp., mainly illus. The text appears in dialogue form at the base of the page and is
not always related to the images which appear there.

3553 POLLARD, INGRID (1953–)
 Guyana-born photographer living in England who combines image and text.

Publications

Wells, Liz, ed. *Viewfindings: Women Photographers: Landscape and Environment.* Tiverton: Available Light, 1994. As a contributor to this book, brief biographical details are included.

Main Sources

Di Bello, Patrizia. "Intimate Distance: Five Black Women Photographers." *Women's Art Magazine* 40 (1991): 24–25. Review of a touring exhibitions which first opened at the Photographers' Gallery, London.

Other Sources

Jones, Kellie. "Re-Creation." *Ten-8* 2, no. 3 (spring 1992): 96–105.
 Tawadros, Gilane. "Other Britains, Other Britons." *Aperture* 113 (winter 1988): 40–46.
 Taylor, John. *A Dream of England: Landscape, Photography and the Tourist's Imagination.* Manchester: Manchester University Press.
 Wells, Liz. "The Eyes of Europe." *Women's Art Magazine* 59 (1994): 29–32.

3554 POSENER, JILL
 English photographer whose work became informed by feminism.

Other Sources

Williams, Val. *The Other Observers: Women Photographers in Britain 1900 to the Present.* London: Virago, 1986.

3555 POWYS-LYBBE, URSULA (1910–)
 English photographer who used photomontage from 1937 in a series of works for the Tatler and moved to Australia after World War II.

Main Sources

Williams, Val. *The Other Observers: Women Photographers in Britain 1900 to the Present.* London: Virago, 1986.

3556 RAPP, MONIKA (1954–)
 German photographer.

Other Sources

Rumpf, Harald. *52 junge deutsche Fotografen.* Munich: Verlag H. Rumpf, 1981.

3557 RELANG, REGINA (1906–)
German photographer, a founder member of the Magnum Group. who
specialised in fashion photography.

Other Sources

Benteler, Petra. *Deutsche Fotografie nach 1945.* Kassel: Fotoforum,
Universität Kassel, 1978.
————, ed. *Fotografie von 1945 bis 1985.* Hamburg: Museum für Kunst und
Gewerbe, 1987.
Tausk, peter. *Photography in the Twentieth Century.* London: Focal Press,
1980. Includes an outline biography and published books of photograph

3558 RÉVAI, ILKE
Hungarian portrait photographer.

Exhibitions

The Hungarian Connection: The Roots of Photojournalism. Bradford:
National Museum of Film, Photography and Television, 1987. Mentioned in text.

3559 RICCI, CLAUDIA (1963–)
Italian photographer.

Exhibitions

Objetivo Italia: fotografía contemporánea italiana. Puebla: Universidad
Autonoma, 1991.

3560 RIEGO, JOSEFINA MARIA (c. 1843–?)
Swedish photographer active for a short period in the mid-1960s.

Other Sources

Hirn, Sven. *Kameran edesta ja takaa, valokuvaajat suomessa 1839–1870.*
Helsinki: Suomen Valukuvataiteen Museon Säätio, 1972.

3561 RIMMINGTON, EDITH (1902–1986)
English Surrealist painter and, from 1967, photographer.

See Painting section.

3562 RISCH, AGLAIA (1960–)
German photographer.

Other Sources

Rumpf, Harald. *52 junge deutsche Fotografen.* Munich: Verlag H. Rumpf,
1981.

3563 RISTELHÜBER, SOPHIE (1949–)
French photographer.

Other Sources

Naggar, C. *Dictionnaire des Photographes.* Paris: Editions du Seuil, 1982.

3564 ROBERTSON, GRACE (1930–)
English documentary photographer who worked for Picture Post.

Main Sources

Williams, Val. *The Other Observers: Women Photographers in Britain 1900 to the Present.* London: Virago, 1986.

Other Sources

Kee, Robert. *The Picture Post Album.* London: Barrie and Jenkins, 1989, n.p., mainly illus. Robertson is almost the only woman featured in this publication.

3565 ROOS, EUGENIE MARIA KRISTINA (née HÖCKERT) (1829–1897)
Finnish photographer who took up the profession when widowed in 1864.

Other Sources

Hirn, Sven. *Kameran edesta ja takaa, valokuvaajat suomessa 1839–1870.* Helsinki: Suomen Valukuvataiteen Museon Säätio, 1972.

3566 RÖSSLEROVA, GERTRUDE (née FISCHEROVA) (1894–1976)
Czech photographer best known for her studies of the male nude.

Other Sources

Tausk, Peter. *Photography in the Twentieth Century.* London: Focal Press, 1980. Includes an outline biography and published books of photographs.

3567 SANDELIN, ROSA (née AMALIA ROSALIE SPOLANDER) (1835–1901)
Finnish photographer active from 1864.

Other Sources

Hirn, Sven. *Kameran edesta ja takaa, valokuvaajat suomessa 1839–1870.* Helsinki: Suomen Valukuvataiteen Museon Säätio, 1972.

3568 SANKO, GALINA (1904–)
Russian photographer who became a photojournalist.

Other Sources

Tausk, Peter. *Photography in the Twentieth Century.* London: Focal Press, 1980. Includes an outline biography and published books of photographs.

3569 SAUR, FRANÇOISE (1949–)
French photographer.

Other Sources

Naggar, C. *Dictionnaire des Photographes.* Paris: Editions du Seuil, 1982.

3570 SCHILLER, KATA (1970–)
Hungarian photographer.

Other Sources

Az Év Fotói. Pictures of the Year. 1992. Budapest: Pelikán Könyvek, 1993.
Az Év Fotói. Pictures of the Year. 1993. Budapest: Pelikán Könyvek, 1994.

3571 SCHMEKEN, REGINA (1955–)
German photographer.

Other Sources

Rumpf, Harald. *52 junge deutsche Fotografen.* Munich: Verlag H. Rumpf, 1981.

3572 SCHMIDT, ANNA (Pseudonym of ZSUZSA KOVÁCS) (1902–1974)
Hungarian photographer who dealt with social themes.

Exhibitions

A fotográfia hónapja: 12 kiállitás a Magyar fotográfia 150 éves történetéból. Month of Photography: 12 Exhibitions on 150 years of Hungarian photography. Budapest: Association of Hungarian photographers, and Szabad Tér Publishing Co., 1989.

3573 SCHOFFERS, IRM (1927–)
German experimental photographer who studied with Marta Hoepffner (q.v.).

Other Sources

Evers, Ulrike. *Deutsche Künstlerinnen des 20. Jahrhunderts. Malerei—Bildhauerei—Tapisserie.* Hamburg: Ludwig Schultheis Verlag, 1983. Contains an individual bibliography.

3574 SCNELL-IVERSEN, ELSE MARIE (née EIDNAES) (1926–)
Norwegian photographer.

Other Sources

Bonge, S. *Eldre norske fotografer: fotografer og amator fotografer i Norge frem til 1920.* Bergen: Universitetsbiblioteket, 1980.

3575 SELLO, INGEBORG (1916–1982)
German photographer.

Exhibitions

Rosemarie Clausen, Ingeborg Sello: zwei Hamburger Photographinnen. Hamburg: Photosammlungen, Museum für Kunst under Gewerbe, 1988, 96pp., illus.

Other Sources

Benteler, Petra, ed. *Fotografie von 1945 bis 1985.* Hamburg: Museum für Kunst und Gewerbe, 1987.

3576 SEREBRIAKOVA, MARIA (1965–)
Russian photographer.

Main Sources

Tolnay, Alexander, ed. *Contemporary Photographic Art from Moscow. Zeitgenössische Fotokunst aus Moskau.* Munich and New York: Prestel, 1995.

3577 SHERIDAN, LISA
English photographer.

Publications

From Cabbages to Kings: The Autobiography of Lisa Sheridan. London: Odhams Press, 1955, 186pp., 55 illus.

Main Sources

Williams, Val. *The Other Observers: Women Photographers in Britain 1900 to the Present.* London: Virago, 1986.

3578 SIEVERDING, KATHARINA (1946–)
Czech-born photographer who works in Germany.

Exhibitions

Butler, Susan. *Shifting Focus.* Bristol: Arnolfini Gallery, 1989.
Künstlerinnen des 20. Jahrhunderts. Wiesbaden: Museum Wiesbaden in association with Verlag Weber & Weidermeyer GmbH, Kassel, 1990.

3579 SJOLIE, AGNES (active from 1898)
 Norwegian photographer.

Other Sources

Bonge, S. *Eldre norske fotografer: fotografer og amator fotografer i Norge frem til 1920.* Bergen Universitetsbiblioteket, 1980.

3580 SJONG, HULDA (née GROSTAD) (1879–1968)
 Norwegian photographer who made postcards.

Other Sources

Bonge, S. *Eldre norske fotografer: fotografer og amator fotografer i Norge frem til 1920.* Bergen Universitetsbiblioteket, 1980.

3581 SKOPOVÁ, ALENA (1951–)
 Czech photographer.

Exhibitions

Československá fotografie 1971–1972. Brno: Moravská Galerie, 1973.

3582 SMULDERS, MARGRIET (1955–)
 Dutch photographer.

Exhibitions

Williams, Val. *Who's Looking at the Family?* London: Barbican Art Gallery, 1994.

3583 SMYTH, NORAH
 English documentary photographer who worked with Sylvia Pankhurst (q.v. in Painting section) for the suffrage movement in the East End of London; she documented the early attempts at child care amongst the poor.

Main Sources

Williams, Val. *The Other Observers: Women Photographers in Britain 1900 to the Present.* London: Virago, 1986.

3584 SOLTÉSZ, ÉVA (1954–)
 Hungarian documentary photographer.

Exhibitions

A fotográfia hónapja: 12 kiállitás a Magyar fotográfia 150 éves történetéből. Month of Photography: 12 Exhibitions on 150 years of Hungarian photography. Budapest: Association of Hungarian photographers, and Szabad Tér Publishing Co., 1989.

3585 SPENCE, JO (1934–1992)
English photographer, whose work from the mid-1960s was informed by feminism and socialism; questioning the uses of photography, she photographed what had been omitted from the subject matter of other artists; she later collaborated with Rosy Martin.

Publications

Putting myself in the Picture. London: Camden Press, 1986.
"Photo Therapy: Psychic Realism as a Healing Art." *Ten-8* 30 (Autumn 1988).
"The Daughter's Gaze: Blaming, Shaming, Re-naming, and Letting Go." In Angela Kingston, *Mothers,* 27–29. Birmingham: Ikon Gallery, 1990.
Spence, Jo, with Patricia Holland. *Family Snaps: The Meanings of Domestic Photography.* London: Virago, 1991.

Main Sources

Cullis, Ann. "A Woman's Work is Never Done." *Women's Art Magazine* 59 (1994): 47–48. Review of the exhibition *Matters of Concern.*

Exhibitions

Kingston, Angela. *Mothers.* Birmingham: Ikon Gallery, 1990.

Other Sources

Taylor, John. *A Dream of England: Landscape, Photography and the Tourist's Imagination.* Manchester: Manchester University Press.
Williams, Val. *The Other Observers: Women Photographers in Britain, 1900 to the Present.* London: Virago, 1986.

3586 STRELOW, LISELOTTE (1908–)
German photographer who specialised from 1950 in portraits of famous artists and cultural personalities of the then West Germany.

Other Sources

Benteler, Petra. *Deutsche fotografie nach 1945.* Kassel: Fotoforum, Universität Kassel, 1979.
———, ed. *Fotografie von 1945 bis 1985.* Hamburg: Museum für Kunst und Gewerbe, 1987.
Tausk, Peter. *Photography in the Twentieth Century.* London: Focal Press, 1980. Includes an outline biography and published books of photographs.

3587 SUGÁR, KATA (1910–1943)
Hungarian photographer.

Exhibitions

The Hungarian Connection: The Roots of Photojournalism. Bradford: National Museum of Film, Photography and Television, 1987. Mentioned in text.

3588 SVABOVÁ, ZUZANA (1944–)
Czech photographer.

Exhibitions

Československá fotografie 1971–1972. Brno: Moravská Galerie, 1973.

3589 SZENES, ZSUZSA
Hungarian photographer.

Exhibitions

A fotográfia hónapja: 12 kiállitás a Magyar fotográfia 150 éves történetéből. Month of Photography: 12 Exhibitions on 150 years of Hungarian photography. Budapest: Association of Hungarian photographers, and Szabad Tér Publishing Co., 1989.

3590 TABRIZIAN, MITRA
English photographer.

Exhibitions

Ascherson, Neil. *Shocks to the System: Social and Political Issues in Recent British Art from the Arts Council Collection.* London: Royal Festival Hall, 1991.
Butler, Susan. *Shifting Focus.* Bristol: Arnolfini Gallery, 1989.

Other Sources

Jones, Kellie. "Re-Creation." *Ten-8* 2, no. 3 (Spring 1992): 96–105.
Tawadros, Gilane. "Other Britains, Other Britons." *Aperture* 113 (winter 1988): 40–46.

3591 TAPOLCSÁNYI, ÉVA (1958–)
Hungarian photographer.

Other Sources

Az Év Fotói. Pictures of the Year. 1992. Budapest: Pelikán Könyvek, 1993.
Az Év Fotói. Pictures of the Year. 1993. Budapest: Pelikán Könyvek, 1994.

3592 TESTUT, ANNE (1951–)
French photographer.

Exhibitions

Butler, Susan. *Shifting Focus.* Bristol: Arnolfini Gallery, 1989.

Other Sources

Wells, Liz. "The Eyes of Europe." *Women's Art Magazine* 59 (1994): 29–32.

3593 TRANGMAR, SUSAN (1953–)
English photographer.

Publications

Essay in *Suspended States*—see below.

Main Sources

Wells, Liz. "Shades of Uncertainty." *Women's Art Magazine* 45 (1992): 10–12.

Exhibitions

Butler, Susan. *Shifting Focus.* Bristol: Arnolfini Gallery, 1989.
Suspended States. Southampton: John Hansard Gallery, University of Southampton, 1992, 15pp., illus.

Other Sources

Brooks, Rosetta. "Through the Looking Glass, Darkly." *Aperture* 113 (winter 1988): 47–51. In the context of an account of the shift of British society into consumerism, the works of three photographers who examine issues of community and identity are discussed. They include Lomax and Trangmar.
Butler, Susan. "Between Frames." *Aperture* 113 (winter 1988): 30–39.
Taylor, John. *A Dream of England: Landscape, Photography and the Tourist's Imagination.* Manchester: Manchester University Press.

3594 TSEKHIMSKAIA, NATALIA
Russian photographer and mixed media artist.

Other Sources

Rosenfeld, Alla, and Norton Dodge, eds. *Nonconformist Art: The Soviet Experience, 1956–1986. The Norton and Nancy Dodge Collection.* London: Thames and Hudson in association with the Jane Voorhees Zimmerli Art Museum, State University of New Jersey, Rutgers, 1995.

3595 TUDEER, EMILIA (née KAROLINA EMILIA FREDERIKA GYLLING) (1835–1916)

Finnish photographer who spent part of the year travelling the country taking photographs.

Other Sources

Hirn, Sven. *Kameran edesta ja takaa, valokuvaajat suomessa 1839–1870.* Helsinki: Suomen Valukuvataiteen Museon Säätio, 1972.

3596 TUDOR HART, EDITH (née EDITH SUSCHITSKY) (1908–1978)
Austrian-born photographer who worked in England from 1933; trained at the Bauhaus, she combined modernist concerns with left-wing documentary work.

Main Sources

Williams, Val. *The Other Observers: Women Photographers in Britain 1900 to the Present.* London: Virago, 1986.

Exhibitions

Mellor, David. *Modern British Photography, 1919–1939.* Oxford: Museum of Modern Art, 1978.

3597 UJJ, ZSUZSA
Hungarian photographer.

Exhibitions

A fotográfia hónapja: 12 kiállitás a Magyar fotográfia 150 éves történetéból. Month of Photography: 12 Exhibitions on 150 years of Hungarian photography. Budapest: Association of Hungarian photographers, and Szabad Tér Publishing Co., 1989.

3598 VAN MANEN, BERTIEN (1942–)
Dutch photographer.

Other Sources

Naggar, C. *Dictionnaire des Photographes.* Paris: Editions du Seuil, 1982.

3599 VARVARA (Pseudonym of VARVARA HEYD) (1920–)
Danish photographer.

Other Sources

Naggar, C. *Dictionnaire des Photographes.* Paris: Editions du Seuil, 1982.

3600 VELLEDITS, ÉVA (1973–)
Hungarian photographer.

Other Sources

Az Év Fotói. Pictures of the Year. 1992. Budapest: Pelikán Könyvek, 1993.
Az Év Fotói. Pictures of the Year. 1993. Budapest: Pelikán Könyvek, 1994.

3601 VERA (Pseudonym of I. GROSCHOFF)
Swiss photographer of animals.

Publications

Sprung ins Leben. Text by Franz Roedelberger. Bern: Buchverlag Verbandrucherei AG., 1969, 260pp., 300 illus. Concerns the courtship, mating and upbringing of young animals and birds worldwide.
Zebi da Streifenfohlen: Im Trott und Galopp durch Afrika mit Vera und 20 Kamerajägern. Bern: Zwei-Bären Verlag der VDB, 1972, 65pp., mainly illus. Written from the zebra foal's viewpoint.
Ping und Pong, die lustige Pinguine: ein Sudpol Abentener für junge Tierfreunde. Bern: Zwei-Bären Verlag, 1974, 65pp., mainly illus.
Pussy in der Hundewelt: ein Spaziergang durch Gärten und Höfe. Bern: Zwei-Bären Verlag, 1976, 65pp., mainly illus.

3602 VIETZ, MARTA (1901–)
German photographer of fashion and portraits.

Other Sources

Meskimmon, Marsha, and Shearer West. *Visions of the 'Neue Frau': Women and the Visual Arts in Weimar Germany.* London: Scolar Press, 1995.

3603 VIVIENNE (Pseudonym of FLORENCE MELLISH, later ENTWISTLE) (1892–1982)
English portrait photographer.

Main Sources

Williams, Val. *The Other Observers: Women Photographers in Britain 1900 to the Present.* London: Virago, 1986.

3604 VON GRODDECK, CAROLA (1911–1989)
German photographer.

Other Sources

Meskimmon, Marsha, and Shearer West. *Visions of the 'Neue Frau': Women and the Visual Arts in Weimar Germany.* London: Scolar Press, 1995.

3605 VOS, GERDA (1949–)
German photographer.

Other Sources

Rumpf, Harald. *52 junge deutsche Fotografen.* Munich: Verlag H. Rumpf, 1981.

3606 VOYEUX, MARTINE (1948–)
French photographer.

Other Sources

Naggar, C. *Dictionnaire des Photographes.* Paris: Editions du Seuil, 1982.

3607 WAKELIN, JOAN
English documentary photographer.

Exhibitions

Women's Images of Men. London: Institute of Contemporary Art, 1980.

3608 WARBURG, AGNES (1872–1953)
English photographer of landscapes.

Other Sources

Williams, Val. *The Other Observers: Women Photographers in Britain 1900 to the Present.* London: Virago, 1986.

3609 WEISS, SABINE (1924–)
French photographer.

Other Sources

Naggar, C. *Dictionnaire des Photographes.* Paris: Editions du Seuil, 1982.

3610 WIDGREN, JULIA VIKTORINA ROSALIE (1842–1917)
Finnish photographer.

Other Sources

Hirn, Sven. *Kameran edesta ja takaa, valokuvaajat suomessa 1839–1870.* Helsinki: Suomen Valukuvataiteen Museon Säätio, 1972.

3611 WIGLEY, JANE NINA (c. 1821–after 1855)
English photographer and painter who worked in Newcastle-upon-Tyne and then in London, opening a studio there in 1847.

Main Sources

Heathcote, Bernard V., and Pauline F. "The Feminine Influence: Aspects of the Role of Women in the Evolution of Photography in the British Isles." *History of*

Photography 12, no. 3 (July–September 1988): 259–273. Short biographical account of this pioneer photographer.

Other Sources

Adamson, Keith. "Women in Photography." *Photographic Journal* 125 (1985): 156–161.

3612 WILDING, DOROTHY (1893–1976)
English portrait photographer.

Publications

In Pursuit of Perfection. London: Robert Hale, 1958, 189pp., 51 illus. Autobiography.

Main Sources

Paskin, Sylvia. "Modern Women: Dorothy Wilding's Portraits of the Rich and Royal." *Women's Art Magazine* 42 (1991): 19. Review of exhibition at the National Portrait Gallery, London.
Williams, Val. *The Other Observers: Women Photographers in Britain 1900 to the Present.* London: Virago, 1986.

Exhibitions

Mellor, David. *Modern British Photography, 1919–1939.* Oxford: Museum of Modern Art, 1978.
Pepper, Terrence. *Dorothy Wilding: The Pursuit of Pleasure.* London: National Portrait Gallery, 1991, 119pp., illus.

3613 WINDISCH-GRAETZ, STEPHANIE (1942–)
Belgian-born photographer who has lived in Switzerland from childhood; she specialises in figures and portraits.

Exhibitions

Hellich, Erika. *Photografien von Stephanie Windisch-Graetz.* Vienna: Schriften der Bibliothek des Österreichen Museums für angewandte Kunst, vol. 17, 1979, 14pp., illus. Text in German. The majority of works are portraits but some of the figures are dressed as characters and posed.

3614 WUNDERLICH, KARIN SZEKESSY
German photographer.

Other Sources

Benteler, Petra. *Deutsche fotografie nach 1945.* Kassel: Fotoforum, Universität Kassel, 1979.

————, ed. *Fotografie von 1945 bis 1985.* Hamburg: Museum für Kunst und Gewerbe, 1987.

Naggar, C. *Dictionnaire des Photographes.* Paris: Editions du Seuil, 1982.

3615 YEVONDE, MADAME (née YEVONDE CUMBERS) (1893–1975)
English photographer specialising in society portraits.

Publications

"Photographic Portraiture from a Woman's Point of View." *British Journal of Photography,* 29 April 1921, 251–252.

"Why Colour?" *Photographic Journal* 73 (March 1933): 116–120.

"The Future of Portraiture—If Any." *British Journal of Photography,* 29 May 1936, 340–341.

In Camera. London: John Gifford Ltd., 1940, 285pp., 15 illus. Autobiography.

Main Sources

Salway, Kate. *Goddesses and Others. Yevonde: A Portrait.* London: Balcony Books, 1990.

————. "Glamour, Labour and Experiment." *British Journal of Photography* 137 (24 May 1990): 24–25.

————. "Colour Combinations." *Women's Art Magazine* 61 (1994): 25–26. Review of exhibition *Be Original or Die: Madame Yevonde.*

Exhibitions

Sixty Years a Portrait Photographer. London: Royal Photographic Society, 1975.

Mellor, David. *Modern British Photography, 1919–1939.* Oxford: Museum of Modern Art, 1978.

Gibson, Robin, and Pam Roberts. *Madame Yevonde: Colour, Fantasy and Myth.* London: National Portrait Gallery, 1990. 119pp., illus. Three analytical essays trace her career and examine reasons for her success, the influences from other women photographers, her imagery and her techniques. Contains a bibliography and catalogue of her works at the National Portrait Gallery.

Other Sources

Williams, Val. *The Other Observers: Women Photographers in Britain 1900 to the Present.* London: Virago, 1986.

3616 YVA (Pseudonym of ELSE ERNESTINE NEULÄNDER) (1900–)
German photographer of portraits, fashion and advertising.

Other Sources

Meskimmon, Marsha, and Shearer West. *Visions of the 'Neue Frau': Women and the Visual Arts in Weimar Germany.* London: Scolar Press, 1995.

3617 ZIACH, KRYSTYNA (1953–)
 Polish-born sculptor and photographer who has worked in the Netherlands since 1979.

Exhibitions

Het Zelfbeeld: Images of the Self. Leiden: Stichting Burcht and Galerie Fotomania, 1987.

Sculpture

REFERENCE

See also Painting section for some publications which include a small proportion of sculptors.

3618 CAMARD, PIERRE, and ANNE BELFORT. *Dictionnaire des peintres et sculpteurs provençaux, 1880–1950.* Ile de Bendor: Editions Bendor for Fondation Paul Ricard, Paris, 1975, 444pp.

Over 700 painters and sculptors from the region of Provence are listed. A number of women are listed, although for some, even the basic biographical information is sparse or absent. Artists who exhibited in any of the major French artistic venues are included. Where information is available, entries have a short biography, the locations of works and a bibliography.

3619 CARANDENTE, GIOVANNI, ET AL. *Knaurs lexikon der moderne Plastik.* Munich and Zurich: Droemersche Verlagsanstadt, 1961, 325pp., illus.

Text in German by a team of international contributors. A dictionary of European sculptors, including Eastern Europe and American sculptors working in Europe. Entries are quite detailed and over thirty European women are included. The bibliography is very short.

3620 CLEMENT, CLARA ERSKINE. *Women in the Fine Arts from the 7th Century B.C. to the 20th Century A.D.* Boston: Houghton Mifflin, 1904; rev. ed. New York: Hacker Art Books, 1974.

Dictionary of women painters and sculptors active in Europe and America. Entries vary in length and some use Ellett's earlier text (q.v.) as the main source of information.

3621 DE PAMPLONA, FERNANDO. *Dicionario de pintores e escultores portugueses ou que trabalharam em Portugal.* 4 vols. Lisbon: Oficina Grafica, vol. 1: 319pp., 32pl, 1954; vol. 2: 291pp., 32pl, 1956; vol. 3: 435pp., 39pl., 1957; vol. 4: 319pp, 35pl., 1959.

Text in Portuguese. A useful source for women artists, although little information is given about each.

3622 *Dictionnaire de la sculpture moderne.* Dictionnaires F. Hazan n. 4. Paris: Fernand Hazan, 1960, 312pp., illus.

Text in French. Consists of alphabetical entries of artists of the twentieth century. Entries are of varying length and informative about the style of work, as well as biographical. Most artists have one work illustrated. A reasonable number of women from across Europe are included and German artists are particularly well represented. The majority work in avant-garde styles.

3623 DUNFORD, PENNY. *A Biographical Dictionary of Women Artists in Europe and America since 1850.* Hemel Hempstead: Harvester Wheatsheaf and Philadelphia: University of Pennsylvania Press, 1990, 340pp., illus.

Contains biographical accounts of 730 women artists of whom 550 are European. The majority are painters and sculptors. Each entry also contains indications of the location of works and a bibliography.

3624 EDOUARD-JOSEPH. *Dictionnaire biographique des artistes contemporains, 1910–1930.* 3 vols. Paris: Art et Editions, vol. 1: A–E, 478pp., illus., 1930; vol. 2: F–Ma, 478pp., illus., 1931. Librairie Grund, vol. 3: Mc–Z, 478pp., 1934.

An invaluable source for women artists working in France in the early decades of the century. Alphabetical listing of artists active in France in the early twentieth century. The length of entries varies considerably but all contain some information about the work in addition to a biography. Artists are included regardless of style, so the book embraces the complexities of artistic production at this time.

3625 GUNNIS, RUPERT. *Dictionary of British Sculptors, 1660–1851. 3rd expanded edition.* London: Murray and Sons, 1975, 515pp., illus.

Consists of biographical entries on British sculptors. In this early period there are only a small number of women, for whom this is a useful source.

3626 KJELLBERG, PIERRE. *Les bronzes du XIXe siècle: dictionnaire des sculpteurs.* Paris: Editions de l'Amateur, 1987, 688pp., 1000 illus.

Each entry includes some detailed biographical material in additional to information about sales and collections where works by the artists may be found. Most of the more famous women sculptors are included such as Bertaux, Bonheur, Bernhardt, Cazin and Syamour. A dictionary listing of foundries follows that of the artists.

3627 LAMI, STANISLAS. *Dictionnaire des sculpteurs de l'école française au XIXe siècle.* 4 vols. Paris: Librairie Ancienne Honoré Champion, vol. 1: A–C, 1914, 471pp.; vol. 2: D–F, 1915, 432pp.; vol. 3: G–M, 1919, 495pp.; vol. 4: N–Z, 1921, 378pp.

Text in French. Provides relatively detailed biographical and exhibiting information on French sculptors of the nineteenth century. It includes a number of women, among them Hélène Bertaux.

3628 *Lexikon der zeitgenössichen Schweizer Künstler. Dictionnaire des artistes suisses contemporains. Dizionario di artisti svizzeri contemporanei.* Stuttgart: Verlag Huner, 1981, 538pp.

Text in German, French and Italian. This book includes Swiss painters, sculptors, graphic artists and photographers born after 1900. The language of each entry is determined by that used by the artist. There is an outline biography, an indication of the type of work produced and lists of prizes won and exhibitions. Entries are brief and there are indices by place of residence and medium. A reasonable number of women are included.

3629 MACKAY, J. *Dictionary of Western Sculptors of Bronzes.* Woodbridge: Antique Collectors Club, 1978, 414pp., illus.

Includes a useful number of women sculptors from the nineteenth and twentieth centuries.

3630 MARTIN, JULES. *Nos peintres, sculpteurs, graveurs et dessinateurs. Portraits et biographies suivis d'une notice sur les Salons Français depuis 1673, les Sociétés des Beaux-Arts, la propriété artistique etc.* Paris, 1897.

Text in French. Provides information about women artists active in the late nineteenth century in France.

3631 OSSORIO Y BERNARD, MANUEL. *Galería biográfica de artistas españoles del siglo XIX. Continuacíon del Diccionario de Ceán Bermudez hasta el año 1882.* Madrid: Moreno y Royas, 2nd rev. ed.1883, 749pp., illus.

Contains biographical sketches of 3000 nineteenth-century Spanish painters and sculptors. There are relatively few women.

3632 PARRY-CROOKE, CHARLOTTE. *Contemporary British Artists.* London: Bergstrom and Boyle, 1979, 350pp., illus.

Photographic portraits of all 200 artists are followed by alphabetical entries for each. These contain a chronology and a short statement by the artist. Twenty-four women are included.

3633 PAZ, MARIO ANTOLIN (ED.). *Diccionario de Pintores y Escultores Españoles del siglo XX.* 2 vols. of ongoing project. Madrid: Forum Artis, 1994, vol. 1: A, 260pp.; vol. 2: B, 559pp., illus.
Text in Spanish. The beginning of a large project to provide a biographical dictionary of modern Spanish artists. Each entry contains a short description of the type of work the artist produces and biographical information is sometimes given. Some women are included.

3634 SPALDING, FRANCES, and JUDITH COLLINS (EDS.). *Twentieth century painters and sculptors. Dictionary of British art, vol. 6.* Woodbridge: Antique Collectors Club, 1990, 482pp., illus.
Each of the entries contains a brief biography, with a small number of entries also having references to a monograph. Contains the names of a great many women.

PUBLICATIONS

See also Ceramic and Glass sections in volume 1.

3635 *15 Schweizer Keramiker: Ausstellung der Nationen; 15 Ceramistes Suisses: Exposition des Nations; 15 Ceramisti Svizzeri: Mostra delle Nazioni.* Faenza: Palazzo delle Esposizioni, 1984, n.p., illus.
Text in German, French and Italian. A short introduction is followed by a page on each exhibitor; most of the exhibitors produce ceramic sculpture. Eight of the participants are women: Margreth Daepp, Pierette Favarger, Elizabeth Langsch, Renee Mangeat-Duc, Ruth Monnier, Sabine Nadler, Setsuko Nagasawa and Petra Weiss.

3636 *Abstraction-Création 1931–36.* Paris: Musée d'Art Moderne de la Ville de Paris, 1978, 309pp., illus.
Text in French. It should be noted that the exhibition opened at Münster before it went to Paris. A study of the flourishing period of abstract art of various kinds in the 1930s. A number of women were active in this period and abstraction came from a number of different philosophies and approaches.

3637 ALESSON, JEAN. *Les femmes artistes au Salon de 1878 et à l'Exposition Universelle.* Paris: Gazette des femmes, 1878, 31pp.
Text in French. After providing a list of women artists exhibiting at the Salon between 1874 and 1878, the author takes each medium/genre in turn and summarises the numbers of women in each and the subject and gives some critical evaluation. In 1878, 762 women exhibited. Overall, this provides access to names which are little known today and can therefore act as a platform for further research. There is little space given to artists at the Exposition Universelle.

3638 AUREGLI, DEDE, and CRISTINA MARABINI. *Figure dallo sfondo 3.* Ferrara: Galleria Civica d'Arte Moderna, 1988, 137pp., illus.

Text in Italian. In all, forty-nine women are included: thirty-eight Italians, two of whom are designers, and eleven women from other countries. The range of work is very wide but a majority are concerned in some way with the experience of being female and living in a female body.

3639 *Avanguardia russa dalle collezioni private sovietiche origini e percorso 1904–1934.* Milan: Palazzo Reale in association with Edizioni Bolis, 1989, 172pp., illus.

Text in Italian. The exhibition takes a broad view of avant-garde works in a number of media produced in Russia in the first three decades of this century. Most of the work is two-dimensional—painting and graphic art—but some painting on porcelain is also included.

3640 BARBER, FIONNA. "The art year in Ireland: Belfast." *Irish Arts Review Yearbook 1990–1991* (1991): 239–242.

Survey of exhibitions in Belfast during 1989–1990. Barber notes that early in 1990 "the work of women painters and sculptors began to come into its own in the public domain" and cites exhibitions by Deirdre O'Connell, Louise Walsh, Alice Maher and Barbara Freeman. Women who exhibited in private galleries included Noreen Rice, Jacinta Feenhy, Maura Sheehan and Moira McIver.

3641 BARRON, STEPHANIE, and M. TUCHMAN. *The Avant-garde in Russia: New Perspectives.* Los Angeles: County Museum of Art, 1980, 288pp., illus.

A scholarly consideration of Russian art during and after the Revolution. A number of women artists are included. Biographies are given.

3642 BARRON, STEPHANIE. *Degenerate Art: The Fate of the Avant-garde in Nazi Germany.* New York: H. Abrams in association with Los Angeles County Museum of Art, 1991, 417pp., illus.

Published in Germany as *Entartete Kunst: das Schicksal der Avantgarde im Nazi-Deutschland.* Munich: Hirmer, 1992. Several scholarly essays reconstruct on a room-by-room basis the 1937 exhibition from documents and surviving works of art. Artists are then presented alphabetically with biographical information and detailed notes on the works. Four women are included: Maria Caspar Filser, Jacoba van Heemskerck, Marg Moll and Emy Roeder.

3643 BEATTIE, SUSAN. *The New Sculpture.* New Haven and London: Yale University Press, 1983, 272pp., illus.

One of the few texts to document the existence of a group of late-nineteenth-century women sculptors in Britain. They all feature in the chapter dealing with the cult of the statuette and recur in the artists' biographies at

the end: Lilian Simpson, Florence Steele, Margaret Giles, Ruby Levick, Esther Moore, Gwendolen Williams and Ellen Rope.

3644 BECKETT, JANE, and DEBORAH CHERRY. *The Edwardian Era.* London: Barbican Art Gallery, 1987, 176pp., illus.

A scholarly analysis of British art in the early twentieth century, which saw the co-existence of Victorian art, early Modernism and the art of the suffrage movement. Women artists are relatively well represented.

3645 BLÜHM, ANDREAS, ET AL. *The Colour of Sculpture 1840–1910.* Amsterdam: Van Gogh Museum and Leeds: Henry Moore Institute in association with Waanders Uitgevers, Zwolle, 1996, 279pp., illus.

Six scholarly essays examine different aspects of the use of colour in nineteenth century European sculpture. The catalogue entries are followed by bibliographies for each artists in the exhibition. There are three women: Claudel, Fauveau and Marcello.

3646 BROOS, KEES. *Beelden in Glas; Glass Sculpture.* Utrecht: Stichting Glas, 1986, 120pp., illus.

Text in Dutch and English. Essays on the history of glass-making at Leerdam and the use of glass in modern art precede biographical outlines of the twenty artists in the exhibition. Only two are women: Marijke de Goey and Mieke Groot (see vol. 1).

3647 BUCK, LOUISA. *The Surrealist Spirit in Britain.* London: Whitford and Hughes, 1988, n.p., illus.

After an introductory essay on the Surrealist movement in Britain, there are detailed notes on each of the forty-seven exhibits, which are arranged alphabetically by artist. Several women are included: Agar, Colquhoun, Pailthorpe and Rimmington (qq.v.).

3648 CALVERT, GILL, JILL MORGAN, and MOUSE KATZ (EDS.). *Pandora's Box.* Bristol: Arnolfini Gallery, 1984, 120pp., illus.

This exhibition arose out of an earlier exhibition, *Women's Images of Men* (1980), and shares some of its organisers. Women artists were invited to submit works on the theme of Pandora's Box and offer varied reworkings of this myth. Each of the thirty-two women has written a statement about her reactions to the myth and the generation of the work exhibited. No biographical information is given.

3649 CHADWICK, WHITNEY, and ISABELLE DE COURTIVRON (EDS.). *Significant Others: Creativity and Intimate Partnership.* London: Thames and Hudson, 1993, 256pp., 76 illus.

Separate chapters consider the effects of a close relationship on creativity in art and literature. Five chapters include European women artists and

designers: Camille Claudel, Sonia Delaunay, Vanessa Bell, Leonora Carrington and Vita Sackville-West.

3650 CHADWICK, WHITNEY. *Women Artists and the Surrealist Movement.* London: Thames and Hudson, 1895, 256pp., illus.

An analysis of the interventions of women across Europe in the various manifestations of the Surrealist movement. It looks at their participation in the formal activities, at the groups and networks and at their imagery. Short biographies are given at the end with a bibliography.

3651 CHADWICK, WHITNEY. *Women, Art and Society.* London: Thames and Hudson, 1990.

Takes a sociological approach to the participation of women in mainstream art from the Middle Ages in Europe and America. Includes details of the activities and bibliographies of some of the principal figures but many others are also mentioned.

3652 CHERRY, DEBORAH. *Painting Women: Victorian Women Artists.* London: Routledge, 1993, 275pp., illus.

A scholarly examination of the cultural context of women artists in Victorian England. It examines their family backgrounds and education, travel abroad, female networks, exhibition venues and women's art organisations. It also considers the iconographic differences in the representation of women by women, as opposed to that by men. There is a select but useful bibliography. Much of this also applies to sculptors.

3653 COHEN, FRANÇOISE. *La matière pensée: Art textile: Michèle Morreau, Martine Salzmann, Jocelyne Toupet-Poutier, Fiep Zwann.* Le Havre: Musée des Beaux-Arts, 1986.

The introductory essay to this catalogue discusses the fibre art tradition and these artists produce sculptural work in fabric. There are biographical outlines and a statement by each artist, three of whom are French and one Dutch.

3654 *Das Verborgene Museum. Dokumentation der Kunst von Frauen in Berliner öffentlichen Sammlungen.* Berlin: Edition Hentrich, 1987, 364pp., illus.

See below under NEUE GESELLSCHAFT FUR BILDENDE KUNST E.V.

3655 DEEPWELL, KATE. *Ten Decades: Careers of Ten Women Artists Born 1897–1906.* Norwich: Norwich Gallery, Norfolk Institute of Art and Design, 1992, n.p., illus.

A scholarly and comprehensive essay analyses the art practice of ten British women over the decades of their careers and within the social and political contexts of the time. It considers, inter alia, educational and employment opportunities, travel and study abroad and the impact of World War II.

Under the individuals, there are chronologies and lists of exhibitions, public collections and publications.

3656 DUNFORD, PENNY. "Festival Landmarks 1990." *Women's Art Magazine* 39 (1991): 6.
Discusses the sculpture by women sited around the Gateshead Garden Festival of 1990. Considers the concept of public sculpture in a context such as this.

3657 DUNTHORNE, KATHERINE. *Artists Exhibited in Wales, 1945–1974.* Cardiff: Welsh Arts Council, 1976, 344pp., illus.
Alphabetical listing of artists who exhibited in Wales during the period stated. A number of women, from Wales and elsewhere, are included.

3658 DUPRÉ, FRANÇOISE. "La France et les autres: A Study of Colonial Discourse in 19th Century French Public Sculptures." *Women's Art Magazine* 39 (1991): 8.
Examines the allegorical female figures on the Musée d'Orsay, where they personify continents. Identifies differences which demonstrate the "otherness" of the Oceania figure and the already colonised Africa.

3659 ELLETT, ELIZABETH. *Women Artists in All Ages and Countries.* London: Richard Bentley and New York: Harper Brothers, 1859, 346pp., illus.
The earliest book on women artists. Organised chronologically, artists on whom there is much information are given an individual section while others are grouped together. Because of the time at which she was writing, Ellet had access to a considerable number of artists who were then well known but who even now have not fully reemerged. This remains interesting both as a historical document and as a useful source.

3660 FINE, ELSA HONIG. *Women and Art: A History of Women Painters and Sculptors from the Renaissance to the 20th Century.* Montclair & London: Allanfield & Schram/Prior, 1978, 241pp., illus.
Another of the pioneering texts to emerge from America in the 1970s which helped to establish the activities of women artists. Divided into nine chapters, each commences with an overview of issues related to the social context of women's art practice in the period/country under consideration, before biographical accounts of selected women artists are given.

3661 FLETCHER, JENNIFER, ET AL. *Women's Art Show, 1550–1970.* Nottingham: Castle Museum, 1982, 95pp., illus.
Essays on European women artists from the sixteenth and seventeenth centuries and on British artists in the nineteenth and twentieth centuries precede the catalogue entries. For each, a biographical outline of the artist accompanies information on the work exhibited.

3662 FRIIS, EVA (ED.). *Kunst under Krigen.* Copenhagen: Statens Museum for Kunst, 1995, 159pp., illus.

Text in Danish with an English summary. An examination of Danish art and film-making during World War II. Essays examine various categories of work including abstract painters, domestic scenes and native landscapes, monumental art and occupation culture. Six women are included: Olivia Holm-Møller, Helen Schou, Jane Muus, Helge Nielson, Astrid Noack and Soeren Hjorth Nielsen.

3663 FUSCO, PETER, and H. W. JANSON (EDS.). *The Romantics to Rodin: French nineteenth century sculpture from North American Collections.* New York: George Braziller Inc. in association with Los Angeles County Museum of Art, 1980, 368pp., illus.

Consists of a series of useful, scholarly essays on sculpture education, the public monument, portrait sculpture, subject matter and religious and tomb sculpture. Thesse are followed by catalogue entries for individual artists. Four women are included: Louise Abbema, Sarah Bernhardt, Marcello and Princess Marie Christine d'Orléans (qq.v.).

3664 GARB, TAMAR. "'L'art féminin': The Formation of a Critical Category in Late 19th Century France." *Art History* 12, no. 1 (March 1989): 36–65.

Examines definitions of feminine art in the critical languages of France at the end of the nineteenth century. The works of women artists which form the basis of this critical category are analysed together with their reception.

3665 GARB, TAMAR. *Sisters of the Brush: Women's Artistic Culture in Late Nineteenth Century Paris.* New Haven and London: Yale University Press, 1994.

Examines the history of the Union des Femmes Peintres et Sculpteurs in Paris from its foundation in 1881 and provides a remapping of late-nine-teenth-century art in Paris distinct from the masculine territories so often discussed. Hundreds of academic women painters are mentioned in addition to the founders of the UFPS, among whom is the sculptor Hélène Bertaux. Many different types of source material—medical and scientific writing, art criticism, educational texts, French feminism and the teachings of the Catholic Church—are used to demonstrate shifting identities and meanings in the area of cultural politics.

3666 GAUBE-BERLIN, JANINE (ED.). *La femme peintre et sculpteur du 17e au 20e siècle. 86e Exposition de la Société des Artistes Indépendents.* Paris: Grand-Palais, 1975, n.p., illus.

Organised chronologically, the catalogue documents about one hundred works of art from the seventeenth century to the 1790s. A biographical outline is given for each artist before details of the work are given. It provides information about many less familiar artists.

3667 GLEISBERG, D. *Deutsche Künstlerinnen des zwanzigsten Jahrhunderts.* Altenburg: Staatlichen Lindendau-Museum, 1963.

Text in German. An early exhibition of the work of German women artists in which thirty painters, sculptors and graphic artists are included. Two introductory essays examine the broad issues before individual artists are examined.

3668 GREEN, LORNA. "The Position of Women in 20th Century British Sculpture." *Women Artists' Slide Library Journal* 24 (August–September 1988): 10–12.

Discusses the author's researches into women sculptors through the questionnaire she sent to practitioners. The topics dealt with formal training, combining artistic practice with domestic commitments and their awareness of other women sculptors.

3669 HANOTELLE, MICHELINE. *Paris-Bruxelles, Rodin et Meunier: Relations des sculpteurs français et belges à la fin du XIXe siècle.* Paris: Editions du Temps, 1982, 250pp., illus.

Text in French. The author has included a number of academic women sculptors such as Marie Cazin, Sarah Bernhardt and Camille Claudel but the material on women overall is limited.

3670 HARRIES, MEIRION, and SUSAN. *The War Artists: British Official War Art of the Twentieth Century.* London: Joseph in association with the Imperial War Museum and the Tate Gallery, 1983, 328pp., illus.

An examination of the different aspects of war art and the official war artists' scheme during the two world wars. The work of the women artists is included and discussed.

3671 *Hayward Annual '78.* London: Hayward Gallery, 1978, 107pp., illus.

Curated by five women, this exhibition included sixteen women artists out of twenty-three. It resulted in part from the very minor appearances of women artists in previous major shows of British art and from a campaign to alter this. This background affected the critical reception of the exhibition and Griselda Pollock analysed the reviews in "Femininity, feminism and the Hayward Annual," reprinted in her anthology *Framing Feminism.*

3672 HÁRS, ÉVA, and FERENC ROMVÁRY. *Modern Hungarian Gallery Pécs.* Budapest: Corvina Kiadó, 1981, 395pp., illus.

After short histories of the Gallery and its constituent parts, there is a sequence of short texts, of some half page in length, on the work of each artist illustrated on the opposite page. Women included in the collection are Anna Lesznai, Valéria Dénes, Noémie Ferenczy (see vol. 1), Anna Margit, Magda Zemplényi, Piroska Szántó, Lili Ország, Ilona Keserü, Dóra Maurer and sculptors Erzsébet Forgács Hann, Márta Lesenyei and Eerzsébet Schaáar.

3673 HIMID, LUBAINA. *The Thin Black Line*. London: Institute of Contemporary Art, 1985, n.p. [8pp], illus.

An exhibition of eleven women artists of colour, working in a different media; one of them is the curator. The information on each varies but there is usually a chronology and a statement by the artist.

3674 HOFMANN, WERNER (ED.). *Eva und die Zukunft: das Bild der Frau seit der Französichen Revolution*. Munich: Prestel in association with Hamburg Kunsthalle, 1986, 463pp., illus.

Text in German. Examines images of women in art by theme such as Mother and Madonna, femmes fatales, partners and lesbians. Three scholarly essays examine different aspects of the topic including the sociohistorical context. Some 20 percent of the artists are women. Short biographies of the artists are included.

3675 ILIOPOULOU-ROGAN, DORA. *Three Generations of Greek Women Artists: Figures, Forms and Personal Myths*. Washington, D.C.: National Museum of Women in the Arts, 1989, 71pp., illus.

Exhibition of the work of eleven painters and sculptors born between 1920 and 1949. An introductory essay examines their ideas and themes, while individually there are outline biographies and lists of exhibitions. Some of the artists are based in America.

3676 IVANOVA, VENETA. *Savremma bulgarska skulptura*. Sofia: Izdatelstvo Balgarsk: Khudoznik, 1971, 85pp, 202 illus. and 128 photographs of artists.

Text in Bulgarian with summaries and lists of plates in English, German and Russian. A short introductory essay summarises the new sculpture in Bulgaria before the illustrations, which comprise the largest part of the publication. After these follow the photographs and biographical outlines of the artists whose work is included. Seventeen are women all born between 1905 and 1935.

3677 JOENSSEN, HANNE. *Danske kvindelige kunstnere fradet 19. og 20. aerhundrede repraesenteret pae Statens Museum for Kunst*. Copenhagen: Statens Museum for Kunst, 1980, 27pp., illus.

Text in Danish with an English summary. Presents works by thirty-seven women artists from the museum's permanent collection. A number have extensive exhibiting careers and some were well known outside their own country.

3678 KENT, SARAH, and JACQUELINE MORREAU (EDS.). *Women's Images of Men*. London: Writers and Readers Publishing, 1985, 199pp., illus.

A collection of thirteen essays by artists and critics on the issues which arose out of the series of three exhibitions held at the Institute of Contemporary Art in 1980. The first of those, entitled *Women's Images of*

Men, aroused considerable debate and involved the work of a number of the contributors to this book.

3679 *Keramik i rum: Francesca Lindh, Karen Park, Ulla Viotti.* Copenhagen: Kunstindustrimuseet, 1981, 30pp., illus.

Text in Danish with summaries of the discussion of the work of each artist in English and German. In addition there are biographical summaries. The artists produce ceramic sculpture.

3680 *Kunst door vrouwen.* Leiden: Stedelijk Museum De Lakenhal, 1987, 28pp., illus.

Text in Dutch. A short historical survey of twelve Dutch women artists from the seventeenth century onward. A short biography and notes on the exhibits are included for each artist.

3681 *L'art dans les années 30 en France.* Saint Etienne: Musée d'Art et d'Industrie, 1979, 141pp., 233 illus.

Gives a chronology of events in the decade. A chapter of the social context for art in the 1930s is followed by others on realism and figuration, surrealism, abstraction, photography, furniture, and architecture in Saint Etienne. The 469 exhibits include works by a limited number of women who were active in France during the 1930s: Marcelle Cahn, Sonia Delaunay, Yolande Fieure, Laure Garcin, Hannah Kosnick-Kloss, Marie Laurencin, Tamara de Lempicka, Chana Orloff, Suzanne Roger, Sophie Taeuber-Arp, Suzanne Valadon and Maria Elena Vieira da Silva, with the photographers Gisèle Freund, Florence Henri and Germaine Krull.

3682 LAMERS DE VITS, MARIA. *Les femmes sculpteurs et graveurs et leurs oeuvres.* Paris: Referendum littéraire, 1905, 212pp.

Text in French. The author's overtly feminist aim is to work for the equality of the sexes and, in order to contribute to this, she is presenting material on women artists. This is the first of two intended volumes; the second is to deal with painters. Initially she lists ninety-seven women sculptors and engravers who have either recently exhibited in Salons or whose work has been purchased by the State. There follow lists of women sculptors who have won medals, sculptures by women which have been erected in public places, women whose work has been bought by the state, towns or administrations, and women whose work is owned by public museums. This is an invaluable record of the activities of late-nineteenth-century women sculptors and engravers. The planned second volume appears not to have been published.

3683 *Les femmes artistes modernes.* Paris: Pavillon des Expositions and Buffet and Leclerc, 1937, 16pp.

Text in French. Many well-known artists participated in this early all-women exhibition. Most are by living artists who are represented by one or,

at the most, two works. Although it consists of only names and titles of works, it provides an interesting list of women active in Paris in the 1930s.

3684 MARSH, JAN. *Pre-Raphaelite Sisterhood.* 2nd ed. London: Quartet Books, 1992, 408pp., illus.
Analyses the contrasting fortunes of women within the first generation of Pre-Raphaelite painters in England. Some were wives of artists while others were artists; some, such as Lizzie Siddal, were both. Divided into three chapters—Youth, Marriage and Maturity—it avoids a traditional chronological approach in order to analyse the interweaving lives of this group of women. Maria Zambaco is one of the few sculptors to be included.

3685 MELLOR, DAVID. *The Sixties Art Scene in London.* London: Barbican Art Gallery in association with Phaidon Press, 1993, 239pp., illus.
Intended as a new analysis of two of the main focal points of the art scene in London, one culminating in the Situation grouping and St. Martin's School of Art in the early 1960s and the other in an oppositional force of dissent characterised by the use of nontraditional techniques and materials. Although the number of women included is relatively small, new material on Pauline Boty is made available here. Others included are Gillian Ayres, Tess Jaray, Lilian Lijn, Anne Martin, Linda McCartney and Bridgit Riley.

3686 MESKIMMON, MARSHA. *Domesticity and Dissent: The Role of Women Artists in Weimar Germany, 1918–1938. Haüsliches Leben und Dissens. Die Rolle der Künstlerlinnen auf Deutschland, 1918–1938.* Leicester: Leicester Museums, 1992, 128pp., illus.
Text in German and English. There are essays on Weimar culture and on the problems for realist women artists—painters, sculptors and graphic artists and photographers—operating within that culture. Artists are then introduced individually with a short biography. A select bibliography on individual artists is also provided.

3687 MESKIMMON, MARSHA, and SHEARER WEST. *Visions of the 'Neue Frau': Women and the Visual Arts in Weimar Germany.* London: Scolar Press, 1995, 187pp., illus.
An anthology of essays which grew out of the exhibition *Domesticity and Dissent: The Role of Women Artists in Germany, 1918–1938,* curated by Meskimmon (q.v.). They analyse the sociopolitical context for women artists and chapters examine the notion of the artist couple, women sculptors, women photographers, dancers, dealers and women in the film industry. All these are rigorously examined in the context of Weimar Germany.

3688 MORAWIŃSKA, AGNIESZKA. *Voices of Freedom: Polish Women Artists and the Avant-Garde.* Washington, D.C.: National Museum of Women in the Arts, 1991, 55pp., illus.

An essay surveys the activities of women artists in Poland from the nineteenth century and thus introduces more artists than the seventeen featured in the exhibition. Detailed chronologies, lists of exhibitions and bibliographies are provided for the seventeen, thus making material in Polish more widely known.

3689 *Mothers.* Birmingham: Ikon Gallery, 1990, 38pp., illus.

Organised around the experience of motherhood (as mother or daughter) for fifteen artists. A theoretical context is set in an essay by Hilary Robinson while two of the artists—Jo Spence and Cate Elwes—also provide written commentaries. Each artist includes a statement about her work.

3690 NEUE GESELLSCHAFT FUR BILDENDE KUNST E.V. *Das Verborgene Museum. Dokumentation der Kunst von Frauen in Berliner öffentlichen Sammlungen.* Berlin: Edition Hentrich, 1987, 364pp., illus.

Text in German. After five scholarly essays which examine different aspects of women's art practice over the past two centuries, there are biographical essays for each of the women represented in the collections of the Berlin Museums and who therefore are included in the exhibition. For the nineteenth- and early-twentieth-century artists there are longer essays but for contemporary artists there are photographs and a biographical outline. In all, over 100 women, most of whom are German, are featured in the catalogue.

3691 *New British Sculpture.* London: Air Gallery, 1986, n.p., illus.

Three women are included among the eight sculptors: Cornelia Parker, Hermione Wiltshire and Julia Wood. For each there are details of their training, a list of exhibitions, public collections and awards, followed by a statement.

3692 *Off the Shelf: Recent Sculptures by Cathy Acons, Val Murray and Lois Williams.* Rochdale: Art Gallery, 1986, 16pp., illus.

Consists of an examination of the imagery of the three sculptors who share a concern with gender roles and artistic practice as women.

3693 PAMPLONA, FERNANDO DI. *Um seculo de pintura e escultura em Portugal, 1830–1930.* Porto: Livraria Tavares Martins, 1943, 416pp., illus.

Text in Portuguese with a summary in French. A chronological survey of traditional art, concentrating on formal values. No biographical information on the artists is given but a large number of women are included and there is evidence of several female artist dynasties.

3694 PETERSEN, KAREN, and J. J. WILSON. *Women Artists: Recognition and Reappraisal from the Early Middle Ages to the Twentieth Century.* New York: Harper Row, 1976; London: Women's Press, 1978, 212pp., illus.

One of the first books to rescue women artists from obscurity. Within the chapters, which are chronological, each individual is given a separate biographical account. There is an extensive bibliography. This book laid the foundation for subsequent research.

3695 *Première biennale internationale de la petite sculpture.* Budapest: Mücsarnok Gallery, 1971, 174pp., illus.

Text in Hungarian and French. Although primarily a catalogue of exhibitors with little other information, this is useful in providing the names of several women sculptors from Eastern Europe. In all, twenty-seven countries were represented of which sixteen were in Europe including the former Yugoslavia and the former U.S.S.R. Photographs of all exhibitors are provided in addition to some of the sculpture. Women mentioned include: Elvia Alfgeme (Spain), Marta Lesenyeui and Erzsébet Schaár from Hungary, Vaska Emanouilova and Penka Mintcheva from Bulgaria, Nina Terno (Finland), Titsa Chrysohoidou (Greece), Barbro Bäckström (Sweden), Olita Abolina (Latvia) and Emmy van Leersum (Netherlands).

3696 *Présences Polonaises: l'art vivant autour du Musée Łodz.* Paris: Centre Nationale d'Art et de Culture Georges Pompidou, 1983, 335pp., illus.

Text in French. Women artists feature in two of the three sections, those on Constructivism (Kobro, Nicz-Borowiak, Zarnower and Themerson) and Contemporaries (Stangret and Szapoczinikow).

3697 PYKE, E. J. *Biographical dictionary of wax modellers.* Oxford: Clarendon Press, 1973, 216pp., 314 illus.

Lists of private and public collections containing wax models precede the biographical dictionary. A number of women were active in this sphere, particularly in the nineteenth century for which this is a unique source. Two supplements were privately published by the author in 1981 (57pp., illus.) and 1983 (12pp., illus.).

3698 READ, BENEDICT, and PEYTON SKIPWITH. *Sculpture in Britain Between the Wars.* London: Fine Art Society, 1986, 157pp., illus.

After a useful survey of the subject, which covers both modernist and traditional styles, the artists are featured in alphabetical order, with a brief biography. Nine women are included.

3699 ROBERTS, DIANE, and PAM JOHNSTON (EDS.). *Out of Isolation.* Wrexham, Clwyd: Library Arts Centre, 1985, 39pp., illus.

Exhibition of a group of eight women who all belonged to the collective Artemesia (after the Renaissance painter Artemesia Gentileschi), which gave like-minded women an opportunity to meet and discuss key issues. After an introductory essay by Griselda Pollock, each artist has an outline biography and a list of exhibitions and makes a statement.

3700 SASSEN, JAN HEIN (ED.). *A Century of Sculpture.* Amsterdam: Stedelijk Museum, 1992, 234pp., illus.
A selection of c. 100 works from the permanent collection of the museum. They are organised by chronological and stylistic sections. Nine women are represented: Käthe Kollwitz, Germaine Richier, Niki de St. Phalle, Magdalena Abakanowicz, Jagoda Buic, Susana Solano, Shirazeh Houshiary and two Dutch sculptors, Charlotte von Pallandt and Irene Fortuyn.

3701 SCHILDT, GORAN. *Modern Finnish Sculpture.* London: Weidenfeld & Nicolson, 1970, 64pp., illus.
Examines the work of Finnish sculptors this century. Several women are included.

3702 SCHMITTERLING, ASTRID. "The Politics of Space: Women Artists of the 20th Century." *Women's Art Magazine* 38 (1991): 4–6.
Review of the major exhibition of twentieth-century women artists from Europe and America which was held at Wiesbaden in 1990.

3703 *Sculpture by Women.* Birmingham: Ikon Gallery, 1983, n.p., illus.
Five women are featured in this exhibition: Elona Bennett, Sheila Clayton, Janet Hedges, Cornelia Parker and Lois Williams. For each there is a biographical outline, a list of exhibitions and a statement.

3704 *Sculptures polonaises contemporaines.* Paris: Musée d'Art Moderne de la Ville de Paris, 1980, n.p., illus.
Three women are included in this exhibition: Magdalena Abakanowicz, Alina Szapoczinikow and Magdalena Wiecek.

3705 *Scultori italiani dal neoclassicismo al Liberty.* Lodi: Lodigraf, 1990, 733pp., illus.
Text in Italian. All entries contain a full biographical account. There are few women but there are unlikely to be a large number working in sculpture in nineteenth-century Italy. Amalia Dupré, Adelaide Maraini Pandiani (qq.v.) and Mary Ighino are amongst those included.

3706 SELLARS, JANE. *Women's Works: Paintings, Drawings, Prints and Sculpture by Women Artists in the Permanent Collection.* Liverpool: Walker Art Gallery, 1988, 90pp., illus.
An exhibition of the work by women in the three Liverpool Galleries. The numbers represented are impressive, but few of the works are on permanent display. Nearly 150 are included here.

3707 SPIELMANN, MARION HARRY. *British Sculpture and Sculptors of Today.* London: Cassell & Co., 1901, 176pp., illus.

One of the few early studies of nineteenth-century British sculpture. Although most attention is given to male artists, thirteen women are discussed.

3708 *The Vigorous Imagination: New Scottish Art.* Edinburgh: Scottish National Gallery of Modern Art, 1987, 128pp., illus.
After several essays on aspects of recent Scottish art, including the resurgence of Glasgow, the work of seventeen artists is presented, of whom four are women: Sam Ainsley, Gwen Hardie, June Redfern and Kate Whiteford. Outline biographies and select bibliographies are included for each.

3709 *Trois sculpteurs soviétiques: A. Golubkina, V. I. Mukhina, S. Lebedeva.* Paris: Musée Rodin, 1971, n.p. illus.
Text in French. The introduction by M. Alpatov is followed by a detailed biographical account and information concerning the exhibited work for each of the three women sculptors.

3710 *Valentina Alimova, Nina Evlanova, Mariia Kuznetsova, Nora Levinson, Aleksandra Petrova: grafika skul'ptura: katalog vystavesk.* [Graphics and sculpture: catalogue]. Moscow: Moskovskaia organizatsiia soiuza khudozhnikov RSFSR, 1985, 55pp., illus.
Text in Russian. Each of the artists is treated separately and is given a biographical outline, a short essay on her work, a list of the works in the exhibition and several illustrations.

3711 VERGINE, LEA. *L'altra metà dell'avanguardia, 1910–40.* Milan: Mazzotta Editore 1980. French edition: *L'autre moitié de l'avant-garde, 1910–40.* Des Femmes, 1982, 313pp., illus.
Includes over 100 women who were involved in the avant-garde groups in Europe. Organised around movements, it begins with the Blue Rider and ends with Surrealism. A large section on abstract art enables the author to include those not directly connected to a movement.

3712 WEIMANN, JEANNE MADELEINE. *The Fair Women.* Chicago: Academy Press, 1981, 611pp., illus.
Examines the contribution of women to the World's Columbian Exposition of 1893. Several unique factors raised the profile of women's activity. There was a Women's Building where the artistic exhibits of women would be housed. For this building a competition was held among women architects. The organising committee consisted of several outstanding female organisers and fund-raisers. The interior of the building was decorated by women and included a mural by Mary Cassatt. The work of women from many countries was exhibited here and it is a useful reminder that international exhibiting was already established by this time.

3713 WITZLING, MARA (ED.). *Voicing Our Visions: Writings by Women Artists.* New York: Universe Books, 1991 and London: Women's Press, 1992, 390pp., illus.

Consists of extracts from writings by twenty women artists of whom nine are European or worked in Europe: Bonheur, Cassatt, Morisot, Bashkirtseff, Werefkin, Kollwitz, Modersohn-Becker, Hepworth and Leonora Carrington. Each extract is preceded by a lengthy biographical account which shows the development of her work and gives the context for the writings which may be journals, autobiographies or letters. There is also a select bibliography for each.

3714 *Women's Images of Men.* London: Institute of Contemporary Art, 1980, n.p., illus.

An analytical essay by Lisa Tickner is followed by outline biographies, lists of exhibitions and, in some cases, a personal statement for each of the individuals. Produced by a collective, this exhibition aimed to reverse the gaze, although the approaches were very varied.

3715 YABLONSKAYA, MIUDA. *Women Artists of Russia's New Age, 1900–1930.* London: Thames and Hudson, 1990, 248pp., illus. Trans. Anthony Parton.

Consists of a series of biographical accounts of women artists. In addition to the better-known figures of the revolutionary period there are informative sections on earlier and later figures. The author has chosen depth of treament rather than to include a larger number of artists. There are useful individual bibliographies, which include material in Russian.

3716 YARRINGTON, ALISON. "I Figure I'm a Woman." *Women's Art Magazine* 49 (1992): 13–15.

Discusses an exhibition of contemporary sculpture in which several women feature, and a parallel exhibition of later nineteenth-century sculpture in which none are included.

3717 ZART, and ZATIG. *Friss oder Stirb.* Bonn: Frauenmuseum, 1990, n.p., illus.

Text in German. Consists of work by nine women, most of whom produce objects by construction: Ilse Wegmann, Karin Eberlin, Anna von Holleben, Martine Metzing-Peyre, Heidi Pawelzik, Marianne Pitzen, Ise Schwartz, Tina Wedel and Inge Broska. An essay analyses their work before outline biographies and lists of exhibitions are given.

INDIVIDUALS

3718 ABAKANOWICZ, MAGDALENA (1930–)

Polish sculptor who moved from textiles to producing large-scale works in hessian, rope and wood.

Main Sources

Heartney, Eleanor. "Magdalena Abakanowicz: Fighting the Crowd." *Sculpture* 13, no. 5 (September–October 1994): 20–25.

Jefferies, Janis. "Magdalena Abakanowicz: Polish Ghosts." *Women's Art Magazine* 39 (1991): 22–23.

Rose, Barbara. *Magdalena Abakanowicz*. New York: Abrams, 1994, 224pp., illus. A thorough thematic analysis of the artist's work. Contains comprehensive lists of exhibitions and a full bibliography.

Exhibitions

Kondratiuk, Krystyna. *L'Art del tissu en Pologne de 1962 à 1972*. Paris: Manufacture Nationale des Gobelins, 1972.

Künstlerinnen International, 1877–1977. Berlin: Schloss Charlottenburg, 1977.

Jacob, Mary, and Jasia Reichardt. *Magdalena Abakanowicz*. Chicago: Museum of Contemporary Art in association with Abrams, New York, 1982, 188pp., illus. In addition to scholarly essays, this contains an autobiographical essay which deals with Abakanowicz's significant memories of her childhood. Includes a full bibliography and list of exhibitions from 1960.

Magdalena Abakanowicz. London: Marlborough Fine Art, 36pp., mainly illus. Contains a select bibliography.

Künstlerinnen des 20. Jahrhunderts. Wiesbaden: Museum Wiesbaden in association with Verlag Weber & Weidermeyer GmbH, Kassel, 1990.

Eidelberg, Martin, ed. *Design 1935–1965: What Modern Was*. New York: Abrams in association with the Musée des Arts Décoratifs, Montreal, 1991.

Morawińska, Agnieszka. *Voices of Freedom: Polish Women Artists of the Avant-garde, 1880–1990*. Washington, D.C.: National Museum of Women in the Arts, 1991. Includes a list of her main exhibitions and awards and a bibliography.

Sassen, Jan Hein, ed. *A Century of Sculpture*. Amsterdam: Stedelijk Museum, 1992.

Other Sources

Dunford, Penny. *A Biographical Dictionary of Women Artists in Europe and America since 1850*. Hemel Hempstead: Harvester Wheatsheaf and Philadelphia: University of Pennsylvania Press, 1990. Contains a bibliography.

Jarry, Madeleine. *La tapisserie: Art du XXème siècle*. Fribourg: Office du Livre, 1974.

3719 ACHESON, ANNE CRAWFORD (1882–1962)
Irish sculptor of figures, portraits and architectural works in wood, stone, concrete and metal.

Exhibitions

Irish Women Artists from the Eighteenth Century to the Present Day. Dublin: National Gallery of Ireland, Douglas Hyde Gallery and Hugh Lane Gallery, 1987.

Other Sources

Dunford, Penny. *A Biographical Dictionary of Women Artists in Europe and America since 1850.* Hemel Hempstead: Harvester Wheatsheaf and Philadelphia: University of Pennsylvania Press, 1990. Contains a bibliography.

3720 AHLBORN, LEA FREDERIKA (1826–1897)
Swedish sculptor and medallist.

Main Sources

Olsén, Brita. *Lea Ahlborn. En svensk medaljkonstnär under 1800–talet.* Stockhom, 1962.

Exhibitions

Kvinnor som målat. Stockholm: Nationalmuseum, 1975.

3721 ALALOU-JONQUIÈRES, TATIANA (Alt. ALALOU; JONQUIÈRES) (1902–1959)
Russian sculptor whose early work was figurative while her later work tended towards abstraction.

Exhibitions

Dufresne, Jean-Luc, and Olivier Messac, eds. *Femmes créatrices des années vingt.* Granville: Musée Richard Anacréon, 1988. Wide-ranging catalogue with a short biographical account on each woman included.

Other Sources

Carandente, Giovanni, ed. *Knaurs Lexikon der moderne Plastik.* Munich & Zurich: Droemersche Verlagsanstalt Th. Knaur Nachf., 1961. Includes an account of the development of her work.
Dunford, Penny. *A Biographical Dictionary of Women Artists in Europe and America since 1850.* Hemel Hempstead: Harvester Wheatsheaf and Philadelphia: University of Pennsylvania Press, 1990. Contains a bibliography.

3722 ATHES-PERRELET, LOUISE (c. 1865–)
Swiss sculptor, textile designer and engraver.

Other Sources

Clement, Clara. *Women in the Fine Arts.* Boston: Houghton Mifflin, 1904.
Dunford, Penny. *A Biographical Dictionary of Women Artists in Europe and America since 1850.* Hemel Hempstead: Harvester Wheatsheaf and Philadelphia: University of Pennsylvania Press, 1990.
Prather-Moses, A. *International Dictionary of Women Workers in the Decorative Arts.* New York: 1981.

3723 BARDEY, JEANNE (1872–1954)
 French sculptor and painter of portraits and, more rarely, flowers.

Other Sources

Hardouin-Fugier, Elizabeth, and Etienne Grafe. *The Lyon School of Flower Painting.* Leigh-on-Sea: F. Lewis, 1978, 88pp., illus.

3724 BECK, GERLINDE (1930–)
 German abstract sculptor.

Exhibitions

Das Verborgene Museum. Dokumentation der Kunst von Frauen in Berliner öffentlichen Sammlungen. Berlin: Edition Hentrich, 1987.

Other Sources

Evers, Ulrike. *Deutsche Künstlerinnen des 20. Jahrhunderts. Malerei— Bildhauerei—Tapisserie.* Hamburg: Ludwig Schultheis Verlag, 1983.

3725 BEIJERMAN, LOUISE ELIZABETH (1883–1970)
 Dutch sculptor of figures and portraits.

Exhibitions

Kunst door vrouwen. Leiden: Stedelijk Museum, De Lakenhal, 1987.

3726 BELASHOVA-ALEKSEEVA, EKATERINA FEDOROVNA (1906–after 1966)
 Russian sculptor who became the President of the Union of Artists in the former USSR.

Main Sources

Mandel, W. *Soviet Women.* New York: Anchor Books, 1975.

Other Sources

Dunford, Penny. *A Biographical Dictionary of Women Artists in Europe and America since 1850.* Hemel Hempstead: Harvester Wheatsheaf and Philadelphia: University of Pennsylvania Press, 1990. Contains a bibliography.
Milner, John. *A Dictionary of Russian and Soviet Artists, 1420–1970.* Woodbridge: Antique Collectors Club, 1993.

3727 BENEDINI AZZONI, GABRIELLA (Alt. BENEDINI) (1932–)
 Italian sculptor and painter.

Other Sources

Weller, Simone. *Il Complesso di Michelangelo: ricerca sul contributo dato dalla donna all'arte italiana del novecento.* Pollenza-Macerata: La Nuova Foglio [*sic*] Editrice, 1976.

3728 BENTIVOGLIO, MIRELLA (née BERTARELLI) (1922–)
Italian sculptor, performance artist, poet and critic.

Publications

See below in Quintavalle.

Main Sources

Pohl, Frances. "Language/Image/Object: The Work of Mirella Bentivoglio." *Woman's Art Journal* 6, no. 1 (spring–summer 1985): 17–22. Analyses the development of her work.

Rosenberg, Judy. "Visual Poetry; Feminist Sculpture." *Women Artists' News* 2 (1980): 8.

Exhibitions

Künstlerinnen International, 1877–1977. Berlin: Schloss Charlottenburg, 1977.

Pasquali, Marilena. *Figure dallo sfondo.* Ferrara: Padiglione d'Arte Contemporanea and Grafis Editore, 1984.

Quintavalle, Arturo. *Mirella Bentivoglio: Hyper Ovum.* Aosta: Torre del Lebbroso, 1987, 83pp., illus. Contains a list of her publications and exhibitions and a full bibliography.

Vescovo, Marisa. *Il Gioco delle Parti. 4 Biennale Donna.* Ferrara: Padiglione d'Arte Contemporanea, Palazzo Massari, 1990.

Other Sources

Dunford, Penny. *A Biographical Dictionary of Women Artists in Europe and America since 1850.* Hemel Hempstead: Harvester Wheatsheaf and Philadelphia: University of Pennsylvania Press, 1990. Contains a bibliography.

Weller, Simone. *Il Complesso di Michelangelo: ricerca sul contributo dato dalla donna all'arte italiana del novecento.* Pollenza-Macerata: La Nuova Foglio [*sic*] Editrice, 1976.

3729 BENT, MARGARET (1903–)
Norwegian sculptor.

Other Sources

Dunford, Penny. *A Biographical Dictionary of Women Artists in Europe and America since 1850.* Hemel Hempstead: Harvester Wheatsheaf and Philadelphia:

University of Pennsylvania Press, 1990. Contains a bibliography.

Gran, H., and P. Anker, eds. *Illustrert Norsk Kunstner Leksikon.* Oslo: Broen Bokhandel, 1956.

3730 BERGMANN-MICHEL, ELLA (1896–1972)
German sculptor.

Exhibitions

Künstlerinnen International, 1877–1977. Berlin: Schloss Charlottenburg, 1977.
Künstlerinnen des 20. Jahrhunderts. Wiesbaden: Museum Wiesbaden in association with Verlag Weber & Weidermeyer GmbH, Kassel, 1990.

Other Sources

Evers, Ulrike. *Deutsche Künstlerinnen des 20. Jahrhunderts. Malerei— Bildhauerei—Tapisserie.* Hamburg: Ludwig Schultheis Verlag, 1983. Contains an individual bibliography.

3731 BERNHARDT, SARAH (Pseudonym of HENRIETTE ROSINE BERNARD) (1844–1923)
French sculptor and painter who is best known as an actress; companion of the painter Louise Abberia (q.v.).

Publications

Memoirs: My Double Life. London: 1907. Reprinted 1969.

Main Sources

Meynell, Alice. "Madame Sarah Bernhardt." *Art Journal,* 1888, 134–139.
Richardson, J. *Sarah Bernhardt and her World.* New York: G. Putnam's Sons, 1977.
Rueff, S. *I knew Sarah Bernhardt.* London, 1951.

Exhibitions

Sarah Bernhardt: 1844–1923. London: Ferrers Gallery, 1973, 40 pp., illus. Contains a biographical essay and notes on the works exhibited, which include some by Bernhardt's friends.

Fusco, Peter, and H. W. Janson. *The Romantics to Rodin: French Nineteenth Century Sculpture from N. American Collections.* Los Angeles: County Museum of Art in association with George Braziller Inc., 1980.

Beaulieu, Germaine, et al. *La femme artiste: d'Elisabeth Vigée-Lebrun à Rosa Bonheur.* Lacoste: Musée Despiau-Wlerick et Dubalen Mont-de-Marsan, 1981. Includes a bibliography.

Dufresne, Jean-Luc, and Olivier Messac, eds. *Femmes créatrices des années vingt.* Granville: Musée Richard Anacréon, 1988. Wide-ranging catalogue with a short biographical account on each woman included.

Other Sources

Clement, Clara. *Women in the Fine Arts.* Boston: Houghton Mifflin, 1904.

Dunford, Penny. *A Biographical Dictionary of Women Artists in Europe and America since 1850.* Hemel Hempstead: Harvester Wheatsheaf and Philadelphia: University of Pennsylvania Press, 1990. Contains a bibliography.

Kjellberg, Pierre. *Les bronzes du XIXe siècle: dictionnaire des sculpteurs.* Paris: Editions de l'Amateur, 1987.

Krichbaum, J., and R. Zondergeld. *Künstlerinnen: von der Antike bis zur Gegenwart.* Cologne: DuMont, 1979.

Martin, Jules. *Nos peintres et sculpteurs, graveurs et dessinateurs.* Paris, 1897.

3732 BERTAUX, HÉLENE (née PILATE) (1825–1909)

French sculptor of figurative works who also devoted herself to improving the position of women in the art world, notably in the spheres of education and exhibition; she founded the Union des femmes peintres et sculptures.

Main Sources

Fayol, Marianne. *Mme. Léon Bertaux, Fondatrice de l'U.F.P.S.* Paris: Présentations pour le Salon des Femmes Peintres et Sculpteurs, 1979.

Garb, Tamar. "L'Art féminin: the Formation of a Critical Category in Late Nineteenth Century France." *Art History* 12, no. 1 (March 1989): 39–65.

Lamers de Vits, Maria. *Les femmes sculpteurs et graveurs et leurs oeuvres.* Paris: Referendum Littéraire, 1905. Bertaux is given some prominence in this publication because of her outstanding achievements.

Lepage, Edouard. *Une page de l'histoire de l'art au XIXe siècle: une conquête féministe: Mme Léon Bertaux.* Paris, 1911.

Yeldham, Charlotte. *Women Artists in Nineteenth Century France and England.* London and New York: Garland, 1984.

Other Sources

Dunford, Penny. *A Biographical Dictionary of Women Artists in Europe and America since 1850.* Hemel Hempstead: Harvester Wheatsheaf and Philadelphia: University of Pennsylvania Press, 1990. Contains a bibliography.

Kjellberg, Pierre. *Les bronzes du XIXe siècle: dictionnaire des sculpteurs.* Paris: Editions de l'Amateur, 1987.

3733 BIDDER, JOYCE (c. 1910–)

English sculptor of small-scale, often mythological, figures; companion of Daisy Borne (q.v.).

Exhibitions

Joyce Bidder and Daisy Borne. London: Fine Art Society, 1987, n.p., illus. Consists of a short essay and a list of works.

3734 BIENFAIT, ALINE (1941–)
Belgian-born painter and sculptor who works in France and Mexico.

Other Sources

Dunford, Penny. *A Biographical Dictionary of Women Artists in Europe and America since 1850.* Hemel Hempstead: Harvester Wheatsheaf and Philadelphia: University of Pennsylvania Press, 1990. Contains a bibliography.

3735 BLACKER, KATE (1955–)
English sculptor who works in France.

Main Sources

Kate Blacker: Some Works, 1980–1985. London: Coracle, 1985, n.p., mainly illus. Contains colour photographs of her work but no text.

Exhibitions

The Sculpture Show. London: Hayward Gallery, 1983.
Kate Blacker: Once Removed. Valence: Musée, 1985.
Eiblmayr, Silvia, Valie Export, and Monika Prischl-Maier. *Kunst mit Eigen-Sinn. Aktuelle Kunst von Frauen: Texte und Dokumentation.* Vienna: Locker Verlag in association with the Museum of Modern Art and Museum of 20th Century Art, 1985.
Sellars, Jane. *Women's Work.* Liverpool: Walker Art Gallery, 1988.
Kate Blacker. Southampton: John Hansard Gallery, University of Southampton, n.p, n.d. Text in French, English and Flemish. Discusses her work up to 1991.

Other Sources

Ceysson, B., et al. *25 ans d'art en France, 1960–1985.* Paris: Larousse, 1986. Includes a select list of exhibitions for each artist.
Dunford, Penny. *A Biographical Dictionary of Women Artists in Europe and America since 1850.* Hemel Hempstead: Harvester Wheatsheaf and Philadelphia: University of Pennsylvania Press, 1990. Contains a bibliography.

3736 BLAKE, NAOMI (1924–)
Czech-born sculptor who works in England.

Other Sources

Dunford, Penny. *A Biographical Dictionary of Women Artists in Europe and America since 1850.* Hemel Hempstead: Harvester Wheatsheaf and Philadelphia: University of Pennsylvania Press, 1990. Contains a bibliography.

3737 BONE, PHYLLIS MARY (1896–1927)
 Scottish sculptor of animals.

Other Sources

Dunford, Penny. *A Biographical Dictionary of Women Artists in Europe and America since 1850*. Hemel Hempstead: Harvester Wheatsheaf and Philadelphia: University of Pennsylvania Press, 1990. Contains a bibliography.
Lexikon der Frau. Zurich: Encyclios Verlag AG, 1953.

3738 BONFIGLIO, CLARA (1959–)
 Italian sculptor.

Exhibitions

Vescovo, Marisa. *Il Gioco delle Parti. 4 Biennale Donna*. Ferrara: Padiglione d'Arte Contemporanea, Palazzo Massari, 1990.

3739 BONHEUR, ROSA (née MARIE ROSALIE BONHEUR) (1822–1899)
 French animal painter and sculptor.

See Painting section.

3740 BORNE, DAISY (c. 1910–)
 English sculptor of small-scale figures and animals; companion of Joyce Bidder (q.v.).

Exhibitions

Joyce Bidder and Daisy Borne. London: Fine Art Society, 1987, n.p., illus. Consists of a short essay and a list of works.

3741 BRAGAGLIA GUIDI, STEFANIA (c. 1930–)
 Italian figurative sculptor.

Other Sources

Weller, Simone. *Il Complesso di Michelangelo: ricerca sul contributo dato dalla donna all'arte italiana del novecento*. Pollenza-Macerata: La Nuova Foglio [*sic*] Editrice, 1976.

3742 BRIEDIS, ALEKSANDRA YANOVNA (née KALNINA; alt. BRIEDE) (1901–after 1956)
 Latvian sculptor of figures.

Other Sources

Milner, John. *A Dictionary of Russian and Soviet Artists, 1420–1970*. Woodbridge: Antique Collectors Club, 1993.

3743 BROWN, DEBORAH (1927–)
Irish sculptor of abstract reliefs and free-standing works in fibreglass.

Exhibitions

Modern Irish Painting. Belfast: Ulster Museum, 1966.
Irish Women Artists from the Eighteenth Century to the Present Day. Dublin:
National Gallery of Ireland, Douglas Hyde Gallery and Hugh Lane Gallery, 1987.

Other Sources

Dunford, Penny. *A Biographical Dictionary of Women Artists in Europe and
America since 1850.* Hemel Hempstead: Harvester Wheatsheaf and Philadelphia:
University of Pennsylvania Press, 1990. Contains a bibliography.

3744 BUTENSHØN, RAGNHILD (1912–)
Norwegian figurative sculptor.

Other Sources

Dunford, Penny. *A Biographical Dictionary of Women Artists in Europe and
America since 1850.* Hemel Hempstead: Harvester Wheatsheaf and Philadelphia:
University of Pennsylvania Press, 1990. Contains a bibliography.
Gran, H., and P. Anker, eds. *Illustrert Norsk Kunstner Leksikon.* Oslo: Broen
Bokhandel, 1956.

3745 CAMERON, SHIRLEY (1944–)
English sculptor and performance artist who since 1982 has worked with
Evelyn Silver.

See Performance and Video Art, Mixed Media and Installations section.

3746 CAMP, SOKARI DOUGLAS (1958–)
Nigerian-born sculptor of dancers and masquerades who works in
London.

Main Sources

Cheddie, Janice. "Native Informer?" *Women's Art Magazine* 67 (1995):
23–24. Discusses the problematics of the forthcoming exhibition entitled *Play and
Display* at the Museum of Mankind, London, in which Douglas Camp is in danger
of being denied a full range of possible readings of her work.

Exhibitions

Conceptual Clothing. Birmingham: Ikon Gallery, 1987.
Sekiapu. London: Africa Centre, 1987.

Other Sources

Dunford, Penny. *A Biographical Dictionary of Women Artists in Europe and America since 1850.* Hemel Hempstead: Harvester Wheatsheaf and Philadelphia: University of Pennsylvania Press, 1990. Contains a bibliography.

3747 CARMEN, CATHY (1952–)
Irish sculptor.

Exhibitions

Irish Women Artists from the Eighteenth Century to the Present Day. Dublin: National Gallery of Ireland, Douglas Hyde Gallery and Hugh Lane Gallery, 1987.

3748 CAUER, HANNA (1902–)
German sculptor of statues, reliefs and portrait busts.

Exhibitions

Das Verborgene Museum. Dokumentation der Kunst von Frauen in Berliner öffentlichen Sammlungen. Berlin: Edition Hentrich, 1987.

Other Sources

Evers, Ulrike. *Deutsche Künstlerinnen des 20. Jahrhunderts. Malerei— Bildhauerei—Tapisserie.* Hamburg: Ludwig Schultheis Verlag, 1983.

3749 CAZIN, MARIE (née GUILLET) (1844–1924)
French sculptor of figures and painter of rural genre and landscapes.

Exhibitions

Beaulieu, Germaine, et al. *La femme artiste: d'Elisabeth Vigée-Lebrun à Rosa Bonheur.* Lacoste: Musée Despiau-Wlerick et Dubalen Mont-de-Marsan, 1981. Includes a bibliography.

Other Sources

Benedite, Léonce. *Les sculpteurs français contemporains, receuil de 104 oeuvres choisis.* Paris: H. Laurens, 1901 16pp., plus 32 plates. Cazin is the only woman included in the 104 sculptors.

Dunford, Penny. *A Biographical Dictionary of Women Artists in Europe and America since 1850.* Hemel Hempstead: Harvester Wheatsheaf and Philadelphia: University of Pennsylvania Press, 1990. Contains a bibliography.

Edouard-Joseph, R. *Dictionnaire biographique des artistes contemporains, 1910–1930.* Paris: Art et Editions, 1930–1934.

Kjellberg, Pierre. *Les bronzes du XIXe siècle: dictionnaire des sculpteurs.* Paris: Editions de l'Amateur, 1987.

Sparrow, Walter Shaw. *Women Painters of the World.* London: Hodder and Stoughton, 1905.

Yeldham, Charlotte. *Women Artists in Nineteenth Century France and England.* London and New York: Garland, 1984.

3750 CHARPENTIER, JULIE (1770–1845)
French sculptor.

Main Sources

Hamy, E.-T. "Julie Charpentier, sculpteur et préparateur de Zoologie (1770–1845)." *Bulletin du Musée d'Histoire Naturelle* 7 (1899): 329–334.

Exhibitions

Beaulieu, Germaine, et al. *La femme artiste: d'Elisabeth Vigée-Lebrun à Rosa Bonheur.* Lacoste: Musée Despiau-Wlerick et Dubalen Mont-de-Marsan, 1981. Includes a bibliography.

3751 CHEWETT, JOCELYN (1906–1979)
Canadian-born sculptor who worked in Eire and France.

Exhibitions

Irish Women Artists from the Eighteenth Century to the Present Day. Dublin: National Gallery of Ireland, Douglas Hyde Gallery and Hugh Lane Gallery,1987.

Other Sources

Carandente, Giovanni, ed. *Knaurs Lexikon der moderne Plastik.* Munich & Zurich: Droemersche Verlagsanstalt Th. Knaur Nachf., 1961. Includes account of the development of her work.
Dunford, Penny. *A Biographical Dictionary of Women Artists in Europe and America since 1850.* Hemel Hempstead: Harvester Wheatsheaf and Philadelphia: University of Pennsylvania Press, 1990. Contains a bibliography.
Krichbaum, J., and R. Zondergeld. *Künstlerinnen: von der Antike bis zur Gegenwart.* Cologne: DuMont, 1979.

3752 CIOBOTARU, GILLIAN (née WISE) (1936–)
English constructivist sculptor.

Exhibitions

British Painting 1952–1977. London: Royal Academy, 1977.
Haywood Annual, 1978. London: Hayward Gallery, 1978.
Women's Art Show, 1550–1970. Nottingham: Castle Museum, 1982.

Other Sources

Dunford, Penny. *A Biographical Dictionary of Women Artists in Europe and America since 1850.* Hemel Hempstead: Harvester Wheatsheaf and Philadelphia: University of Pennsylvania Press, 1990. Contains a bibliography.

Parry-Crooke, Charlotte. *Contemporary British Artists*. London: Bergstrom and Boyle, 1979.

3753 CLARKE, DORA (1890/5–after 1964)
English sculptor of figures and heads.

Other Sources

Dunford, Penny. *A Biographical Dictionary of Women Artists in Europe and America since 1850*. Hemel Hempstead: Harvester Wheatsheaf and Philadelphia: University of Pennsylvania Press, 1990. Contains a bibliography.

Mackay, J. *Dictionary of Western Sculptors in Bronze*. Woodbridge: Antique Collectors Club, 1978.

Waters, Grant. *Dictionary of British Artists Working 1900–1940*. Eastbourne: Eastbourne Fine Art, 1975.

3754 CLASSEN, GERTRUD (1905–1974)
German sculptor who worked in Berlin and portrayed the lives of working people.

Other Sources

Meskimmon, Marsha, and Shearer West. *Visions of the 'Neue Frau': Women and the Visual Arts in Weimar Germany*. London: Scolar Press, 1995.

3755 CLAUDEL, CAMILLE (1864–1943)
French sculptor of figure subjects.

Publications

See Cassar below.

Main Sources

Boué, Gérard. *Camille Claudel: le miroir et la nuit*. Editions de Catalogues Raisonnées. Paris: Editions de l'Amateur, 1995, 235pp., illus. A critical analysis of the artist with a detailed bibliography.

Cassar, Jacques. *Dossier Camille Claudel présenté par Jeanne Fayard*. Paris: Librairie Séguir/Archimbaud, 1987, 520pp., illus. Two thirds of the text consists of a bibliographical account while the final part includes reprints of many documents, articles written on her in the early part of the century, the preface by her brother to the 1951 catalogue and the texts of two radio broadcasts in 1956. It also includes a catalogue of her works.

Claudel, Paul. "Camille Claudel." *L'Occident*, August 1905, 81–85.

———. "Camille Claudel." *Moderne Revue* 13 (1907): 268. Both these articles were written by her brother.

Delbée, Anne. *Une Femme*. Paris: Presses de la Renaissance, 1982, 495pp., illus.

Fabré-Pellerin, Brigitte. *Le jour et la nuit de Camille Claudel.* Paris: Lachenal et Ritter, 1988, 256pp., illus. A biographical approach. Contains a bibliography.

Paris, Reine-Marie. *Camille Claudel.* Paris: Gallimard, 1984, 383pp., illus. Written by a descendant, this includes essays by Claudel's brother, Paul, and on Camille's mental condition written by two contemporary doctors. Contains a detailed bibliography.

Paris, Reine-Marie, and Arnaud de la Chapelle. *L'oeuvre de Camille Claudel: catalogue raisonné.* Paris: Editions d'Art et d'Histoire ARHIS, 1991, 302pp., illus. A catalogue raisonné with an introductory essay. This gives a broadly biographical account as a context for the detailed analysis of the work which follows.

Witherell, Louise R. "Camille Claudel Rediscovered." *Woman's Art Journal* 6, no. 1 (spring–summer 1985): 1–7.

Exhibitions

Beaulieu, Germaine, et al. *La femme artiste: d'Elisabeth Vigée-Lebrun à Rosa Bonheur.* Lacoste: Musée Despiau-Wlerick et Dubalen Mont-de-Marsan, 1981. Includes a bibliography.

Gaudichon, Bruno, Monique Laurent, and Anne Rivière. *Camille Claudel (1864–1943).* Paris: Musée Rodin, 1984, 145pp., illus. Contains an introductory essay, one of the first studies of this now famous artist, catalogue notes, a chronology and a full bibliography.

Kuthy, Sandor. *Camille Claudel—Auguste Rodin: Künsterpaare—Künstlerfreunde. Dialogues d'artistes—résonances.* Bern: Musée des Beaux-Arts, 1985, 186pp., illus. Text in French and German.

Paris, Reine-Marie. *Camille Claudel.* Washington, D.C.: National Museum of Women in the Arts, 1988, 114pp., illus. Contains a useful bibliography.

Pingeot, Anne. *'L'Age mûr' de Camille Claudel.* Paris: Musée d'Orsay, 1988, 87pp., illus.

Barbier, Nicole, and Hélène Maraud. *Camille Claudel.* Paris: Musée Rodin, 1991, 175pp., illus. Contains several essays on different aspects of her work, a bibliography and a list of exhibitions in which her work has featured.

Other Sources

Dunford, Penny. *A Biographical Dictionary of Women Artists in Europe and America since 1850.* Hemel Hempstead: Harvester Wheatsheaf and Philadelphia: University of Pennsylvania Press, 1990. Contains a bibliography.

Edouard-Joseph, R. *Dictionnaire biographique des artistes contemporains, 1910–1930.* Paris: Art et Editions, 1930–1934.

3756 COLACO, ANA DE GONTA
Portuguese sculptor of figures and portraits.

Other Sources

Di Pamplona, Fernando. *Um seculo de pintura e escultura em Portugal, 1830–1930.* Porto: Livraria Tavares Martins, 1943.

3757 COWAN, JUDITH (1954–)
English sculptor whose recent work is moving towards installations.

Main Sources

Beaumont, Mary Rose. "Judith Cowan, Amanda Faulkner." *Arts Review,* September 1987, 630–631.
Wyman Jessica. "Cool." *Women's Art Magazine* 70 (1996): 23. Review of *Passages and Incidents* (see below).

Exhibitions

Judith Cowan. Birmingham: Ikon Gallery, 1982.
Judith Cowan: Passages and Incidents. Cambridge: Kettle's Yard, 1996, n.p., illus.

Other Sources

Dunford, Penny. *A Biographical Dictionary of Women Artists in Europe and America since 1850.* Hemel Hempstead: Harvester Wheatsheaf and Philadelphia: University of Pennsylvania Press, 1990. Contains a bibliography.

3758 CROSS, DOROTHY (1956–)
Irish sculptor.

Exhibitions

Irish Women Artists from the Eighteenth Century to the Present Day. Dublin: National Gallery of Ireland, Douglas Hyde Gallery and Hugh Lane Gallery, 1987.

3759 D'ORLEANS, MARIE CHRISTINE CAROLINE ADÉLAIDE FRANÇOISE (1813–1839)
French sculptor who was the second daughter of Louis Philippe and also received lessons from Redouté.

Exhibitions

Fusco, Peter, and H. Janson. *The Romantics to Rodin: French Nineteenth Century Sculpture from North American Collections.* Los Angeles: County Museum of Art, 1980.
Un Âge d'or des art décoratifs. Paris: Grand Palais, 1991.

Other Sources

Ellet, Elizabeth. *Women Artists in all Ages and Countries.* New York: Harper and Brothers Co., 1859, 377pp.
Hardouin-Fugier, Elizabeth. *The Pupils of Redouté.* Leigh-on-Sea: F. Lewis, 1981.

3760 DA CUNHA, ADA
Portuguese sculptor.

Other Sources

Di Pamplona, Fernando. *Um seculo de pintura e escultura em Portugal, 1830–1930.* Porto: Livraria Tavares Martins, 1943.

3761 DADIE-ROBERG, DAGMAR (1897–)
Swedish sculptor of figures, including nudes.

Other Sources

Dunford, Penny. *A Biographical Dictionary of Women Artists in Europe and America since 1850.* Hemel Hempstead: Harvester Wheatsheaf and Philadelphia: University of Pennsylvania Press, 1990. Contains a bibliography.

Edouard-Joseph, R. *Dictionnaire biographique des artistes contemporains, 1910–1930.* Paris: Art et Editions, 1930–1934.

Mackay, J. *Dictionary of Western Sculptors in Bronze.* Woodbridge: Antique Collectors Club, 1978.

3762 DAHN, INGRID (1939–)
German abstract sculptor.

Other Sources

Evers, Ulrike. *Deutsche Künstlerinnen des 20. Jahrhunderts. Malerei— Bildhauerei—Tapisserie.* Hamburg: Ludwig Schultheis Verlag, 1983. Contains an individual bibliography.

3763 DAMER, ANNE SEYMOUR (1749–1828)
English sculptor.

Main Sources

Noble, Percy. *Anne Seymour Damer: A Woman of Art and Fashion, 1748–1828.* London: Kegan Paul, Trench, Trübner & Co. Ltd., 1908, 230pp., illus. Biographical account which includes extensive quotations from primary sources. Includes a list of all her works compiled from two early sources.

Other Sources

Ellet, Elizabeth. *Women Artists in all Ages and Countries.* New York: Harper and Brothers Co., 1859.

Fine, Elsa Honig. *Women and Art.* New York and London: Allanfield and Schram/Prior, 1978.

3764 DANKO, NATALIA YAKOVNIEVNA (Alt. DANKO-ALEXSEYENKO)
(1892–1942)
Ukranian-born ceramic sculptor of figures who worked in Russia and was
head of the State Porcelain Factory for over twenty years.

Main Sources

Ebin, Ju. *Natalia Yakovnievna Danko.* Moscow, 1955.
Ovsyannikov, Y. "Iesli di Natalya Danko Byela Dnevnik" [If Natalia Danko
had kept a diary]. *Panorama Iskusstv, no. 6.* (Moscow, 1983): 30–84. Archival
reconstructed diary of Danko.

Exhibitions

Vergine, Lea. *L'altra metà dell'avanguardia.* Milan: Mazzotta Editore, 1980.
L'autre moitié de l'avant-garde. Paris: Des Femmes, 1982.
*Avanguardia russa dalle collezioni private sovietiche origini e percorso
1904–1934.* Milan: Palazzo Reale, 1989.

Other Sources

Dunford, Penny. *A Biographical Dictionary of Women Artists in Europe and
America since 1850.* Hemel Hempstead: Harvester Wheatsheaf and Philadelphia:
University of Pennsylvania Press, 1990. Contains a bibliography.
Gollerbach, E. RSFSR. *La Porcelaine de la Manufacture de l'État.* Moscow,
1922, 54pp., illus. Text in Russian. Captions to the illustrations also in French and
German. Covers the period 1917–1921.
Mandel, W. *Soviet Women.* New York: Anchor Books, 1975.
Milner, John. *A Dictionary of Russian and Soviet Artists, 1420–1970.*
Woodbridge: Antique Collectors Club, 1993.

3765 DAVIDOVA-MEDENE, LEA (1921–1986)
Latvian sculptor mainly of portraits in granite.

Main Sources

Barenkova, A. *Lea Davidova-Medene.* Riga, 1968.

Other Sources

Dunford, Penny. *A Biographical Dictionary of Women Artists in Europe and
America since 1850.* Hemel Hempstead: Harvester Wheatsheaf and Philadelphia:
University of Pennsylvania Press, 1990. Contains a bibliography.
Mandel, W. *Soviet Women.* New York: Anchor Books, 1975.

3766 DE COOL, DELPHINE (née FORTIN; occasional pseudonym ARNOULD
DE COOL)

French painter, sculptor, lithographer and director of a women's art school.

See Painting section.

3767 DE FAUVEAU, FÉLICIE (1799–1886)
French sculptor.

Main Sources

Barbotte, Juliette. "La Dague de Félicie de Fauveau." *Revue du Louvre* 33, no. 2 (1983): 122–125.

Exhibitions

La Femme: peintre et sculpteur du XVIIe au XXe siècle. Paris: Grand Palais, 1975.
Blühn, Andreas, et al. *The Colour of Sculpture, 1840–1910.* Amsterdam: Van Gogh Museum and Leeds: Henry Moore Institute, 1996.

Other Sources

Ellet, Elizabeth. *Women Artists in all Ages and Countries.* New York: Harper and Brothers Co., 1859, 377pp.
Fine, Elsa Honig. *Women and Art.* New York and London: Allanfield and Schram/Prior, 1978.

3768 DE SAINT-PHALLE, NIKI (1930–)
French sculptor of highly coloured, fantastic, figuratively based works, often for outdoor settings; since 1980 she has lived in Italy.

Publications

Tarot Cards in Sculpture. Milan: Giuseppe Ponsio, 1985. Illustrates her sketches and final works for the sculpture garden in which works depict the characters of the tarot cards.

Main Sources

Schulze-Hoffmann, Clara, ed. *Niki de Saint-Phalle: Bilder—Figuren— Phantastiche Garten.* Munich: Prestel Verlag, 1987, 160pp., 181 illus. Text in German. The seven essays include one by the artist and another by Jean Tinguely.

Exhibitions

Niki de Saint-Phalle: exposition rétrospective. Paris: Centre national d'art et de culture Georges Pompidou, 1980, 100pp., illus.
Das Verborgene Museum. Dokumentation der Kunst von Frauen in Berliner öffentlichen Sammlungen. Berlin: Edition Hentrich, 1987.

Niki de Saint-Phalle: The Wounded Animals. London: Gimpel Fils, 1988, n.p., illus., including drawings done by the artist for this catalogue.

Niki de Saint-Phalle. Bonn: Kunst-und Austellungshaller der Bundesrepublik in association with Verlag Gerd Hatje, 1992, 310pp., illus. This retrospective exhibition was also seen in Paris and Glasgow.

Sassen, Jan Hein, ed. *A Century of Sculpture.* Amsterdam: Stedelijk Museum, 1992.

Other Sources

Ceysson, B., et al. *25 ans d'art en France, 1960–1985.* Paris: Larousse, 1986. Includes a select list of exhibitions for each artist.

Dunford, Penny. *A Biographical Dictionary of Women Artists in Europe and America since 1850.* Hemel Hempstead: Harvester Wheatsheaf and Philadelphia: University of Pennsylvania Press, 1990. Contains a bibliography.

Krichbaum, J., and R. Zondergeld. *Künstlerinnen: von der Antike bis zur Gegenwart.* Cologne: DuMont, 1979.

3769 DISKA (Pseudonym of PATRICIA DISKA) (1924–)
American-born sculptor who works in France.

Main Sources

Hichisson, M. "Patricia Diska: Sculptress." *Architectural Association Journal* 80, no. 892 (May 1965): 336–337.

Other Sources

Dunford, Penny. *A Biographical Dictionary of Women Artists in Europe and America since 1850.* Hemel Hempstead: Harvester Wheatsheaf and Philadelphia: University of Pennsylvania Press, 1990. Contains a bibliography.

Krichbaum, J., and R. Zondergeld. *Künstlerinnen: von der Antike bis zur Gegenwart.* Cologne: DuMont, 1979.

Watson-Jones, V. *Contemporary American Women Sculptors.* Phoenix, 1986.

3770 DOWNING, EDITH E. (1857–after 1910)
Welsh sculptor of reliefs, statuettes, and portrait busts.

Other Sources

Clement, Clara. *Women in the Fine Arts.* Boston: Houghton Mifflin, 1904.

Dunford, Penny. *A Biographical Dictionary of Women Artists in Europe and America since 1850.* Hemel Hempstead: Harvester Wheatsheaf and Philadelphia: University of Pennsylvania Press, 1990. Contains a bibliography.

Krichbaum, J., and R. Zondergeld. *Künstlerinnen: von der Antike bis zur Gegenwart.* Cologne: DuMont, 1979.

Lexikon der Frau. Zurich: Encyclios Verlag, 1953.

Mackay, J. *Dictionary of Western Sculptors in Bronze.* Woodbridge: Antique Collectors Club, 1978.

3771 DUJOURIE, LILI (1941–)
Belgian video artist and sculptor.

See Performance and Video Art, Mixed Media and Installations section.

3772 DUPRÉ, AMALIA (1845–1928)
Italian sculptor of religious subjects.

Main Sources

Aleardi, A. *Giotto fanciullo, statua di Amalia Dupré.* Treviso, 1886.
Conti, A. *Illustrazioni delle sculture e dei mosaici della facciata del duomo di Firenze.* Florence, 1887.

Other Sources

Scultori italiani dal neoclassicismo al Liberty. Lodi: Lodigraf, 1990.
Callari, L. *Storia dell'arte contemporanea italiana.* Rome, 1909.
Clement, Clara. *Women in the Fine Arts.* Boston: Houghton Mifflin, 1904.
Dunford, Penny. *A Biographical Dictionary of Women Artists in Europe and America since 1850.* Hemel Hempstead: Harvester Wheatsheaf and Philadelphia: University of Pennsylvania Press, 1990. Contains a bibliography.
Mackay, J. *Dictionary of Western Sculptors in Bronze.* Woodbridge: Antique Collectors Club, 1978.
Willard, A. *History of Modern Italian Art.* London, 1898.

3773 DURANT, SUSAN (c. 1820–1873)
English sculptor.

Main Sources

Art Journal, 1873, 80. Obituary.

Other Sources

Clement, Clara. *Women in the Fine Arts.* Boston: Houghton Mifflin, 1904.
Dunford, Penny. *A Biographical Dictionary of Women Artists in Europe and America since 1850.* Hemel Hempstead: Harvester Wheatsheaf and Philadelphia: University of Pennsylvania Press, 1990. Contains a bibliography.
Gunnis, Roger. *Dictionary of British Sculptors, 1660–1851.* London, 1851. Reprint 1868.
Mackay, J. *Dictionary of Western Sculptors in Bronze.* Woodbridge: Antique Collectors Club, 1978.
Yeldham, Charlotte. *Women Artists in Nineteenth Century France and England.* London and New York: Garland, 1984.

3774 DYCKERHOFF, ROSEMARIE (Alt. SACK-DICKERHOFF) (1917–)
German figurative sculptor.

Other Sources

Evers, Ulrike. *Deutsche Künstlerinnen des 20. Jahrhunderts. Malerei—Bildhauerei—Tapisserie.* Hamburg: Ludwig Schultheis Verlag, 1983. Contains an individual bibliography.

3775 EDGCUMBE, URSULA (1900–1984)
English sculptor and, later, painter.

Other Sources

Dunford, Penny. *A Biographical Dictionary of Women Artists in Europe and America since 1850.* Hemel Hempstead: Harvester Wheatsheaf and Philadelphia: University of Pennsylvania Press, 1990. Contains a bibliography.
Waters, Grant. *Dictionary of British Artists Working 1900–1940.* Eastbourne: Eastbourne Fine Art, 1975.

3776 ELVERY, BEATRICE (Alt. LADY GLENAVY) (1883–1968)
Irish sculptor and, later, painter.

Exhibitions

Irish Women Artists from the Eighteenth Century to the Present Day. Dublin: National Gallery of Ireland, Douglas Hyde Gallery and Hugh Lane Gallery, 1987.

Other Sources

"Studio Talk." *Studio* 22 (1901): 46.

3777 FESENMEIER, HELENE (1937–)
American-born painter and sculptor mainly of abstract works who lives in England.

Main Sources

Gooding, M. "Iconographies: Aitchison, Fesenmeier, Spero." *Art Monthly,* May 1987, 17.

Exhibitions

4 American Sculptors Working in Britain. Norwich: Sainsbury Centre for the Visual Arts, University of East Anglia, 1981.

Other Sources

Dunford, Penny. *A Biographical Dictionary of Women Artists in Europe and America since 1850.* Hemel Hempstead: Harvester Wheatsheaf and Philadelphia: University of Pennsylvania Press, 1990. Contains a bibliography.

3778 FIBICHOVÁ, ZDENA
Czech sculptor who works in concrete.

Exhibitions

Zdena Fibichová. Brno: Moravská Galerie, 1970, 12pp., illus. Text in Czech with German summary. Includes works from the period 1966–1970.

3779 FORANI, MADELEINE CHRISTINE (1916–)
Belgian sculptor influenced by South American and African art.

Other Sources

Carandente, Giovanni, ed. *Knaurs Lexikon der moderne Plastik.* Munich & Zurich: Droemersche Verlagsanstalt Th. Knaur Nachf., 1961. Includes an account of the development of her work.

Dunford, Penny. *A Biographical Dictionary of Women Artists in Europe and America since 1850.* Hemel Hempstead: Harvester Wheatsheaf and Philadelphia: University of Pennsylvania Press, 1990. Contains a bibliography.

Krichbaum, J., and R. Zondergeld. *Künstlerinnen: von der Antike bis zur Gegenwart.* Cologne: DuMont, 1979.

3780 FORGÁCS HAHN, ERZSÉBET (1897–1954)
Hungarian sculptor of figures tormented by inner anxieties who was active mainly after 1940.

Other Sources

Hárs, Éva, and Ferenc Romváry. *Modern Hungarian Gallery Pécs.* Budapest: Corvina Kiadó, 1981.

Németh, Lajos. *Modern Art in Hungary.* Budapest: Corvina Press, 1969.

3781 FORTUYN, IRENE
Dutch sculptor.

Exhibitions

Sassen, Jan Hein, ed. *A Century of Sculpture.* Amsterdam: Stedelijk Museum, 1992.

3782 FRINK, ELIZABETH (DAME) (1930–1993)
English sculptor of figures and animals.

Publications

Jan, Claudine. "The monumentality of Elizabeth Frink." *Women's Art Magazine* 39 (1991): 18–20. Interview.
"Interview with Elizabeth Frink." *The Independent,* 1 May 1993.

Main Sources

Kent, Sarah, Brian Robertson, et al. *Elizabeth Frink Sculpture: Catalogue Raisonné.* Salisbury: Harpvale, 1984. Contains a detailed bibliography.
Lucie-Smith, Edward. *Elizabeth Frink: Sculpture and Drawings since 1984.* London: Art Books International, 1994, 200pp., illus. Contains a catalogue raisonné which covers the period from the 1984 publication (see Sarah Kent above) to Frink's death.
———. *Elizabeth Frink: A Portrait.* London: Bloomsbury, 1994, 138pp., illus. The original intention of a collaborative autobiography could not be carried out when Frink's cancer struck. The text is therefore based on recordings of conversations with her over the previous two years.
Mullins, Edwin. *The Art of Elizabeth Frink.* London: Lund Humphries, 1972, n.p., 49 illus. Contains a short introduction, a biographical account and a bibliography.

Exhibitions

Women's Art Show, 1550–1970. Nottingham: Castle Museum, 1982. Contains a brief biography.
Kent, Sarah. *Elizabeth Frink: Sculpture and Drawings 1952–1984.* London: Royal Academy, 1985, 62pp., illus.
Elizabeth Frink. Glasgow: Compass Gallery, 1990.
Robertson, Brian. *Elizabeth Frink: Sculpture and Drawings 1950–1990.* Washington, D.C.: National Museum of Women in the Arts, 79pp., illus. The three essays contain a useful critical analysis of aspects of her work.

Other Sources

Carandente, Giovanni, ed. *Knaurs Lexikon der moderne Plastik.* Munich & Zurich: Droemersche Verlagsanstalt Th. Knaur Nachf., 1961. Includes an account of the development of her work.
Dunford, Penny. *A Biographical Dictionary of Women Artists in Europe and America since 1850.* Hemel Hempstead: Harvester Wheatsheaf and Philadelphia: University of Pennsylvania Press, 1990. Contains a bibliography.
Parry-Crooke, Charlotte. *Contemporary British Artists.* London: Bergstrom and Boyle, 1979.

3783 FULLER, MARIA AMALIA
Portuguese sculptor.

Other Sources

Di Pamplona, Fernando. *Um seculo de pintura e escultura em Portugal, 1830–1930.* Porto: Livraria Tavares Martins, 1943. In appendix for artists active in the 1930s.

3784 GENTIL, ISABEL (1904–)
Portuguese sculptor.

Other Sources

Di Pamplona, Fernando. *Um seculo de pintura e escultura em Portugal, 1830–1930.* Porto: Livraria Tavares Martins, 1943.

3785 GILI, KATHERINE (1948–)
English sculptor of forged metal works based on the figure.

Exhibitions

Haywood Annual 1979. London: Haywood Gallery, 1979.
Knight, V. *Have You Seen Sculpture From the Body?* London: Tate Gallery, 1984.

Other Sources

Dunford, Penny. *A Biographical Dictionary of Women Artists in Europe and America since 1850.* Hemel Hempstead: Harvester Wheatsheaf and Philadelphia: University of Pennsylvania Press, 1990. Contains a bibliography.

3786 GLEICHEN, FEODORA GEORGINA MAUD (COUNTESS) (1861–1922)
English-born sculptor of figures, portrait busts and medallions; sister of Helena Gleichen (q.v. in Painting section).

Main Sources

"Countess Gleichen." *The Times,* 23 February 1922. Obituary.

Other Sources

Clement, Clara. *Women in the Fine Arts.* Boston: Houghton Mifflin, 1904.
Dunford, Penny. *A Biographical Dictionary of Women Artists in Europe and America since 1850.* Hemel Hempstead: Harvester Wheatsheaf and Philadelphia: University of Pennsylvania Press, 1990. Contains a bibliography.
Spielmann, Marion Harry. *British Sculpture and Sculptors of Today.* London: 1901.

3787 GOLUBKINA, ANNA SEMENOVNA (1864–1927)
Russian figurative sculptor.

Main Sources

Kostin, V. *Anna Semionova Golubkina.* Moscow and Leningrad, 1947.
Yablonskaya, Miuda. *Women Artists of Russia's New Age, 1900–1935.* Ed. and trans. Anthony Parton. New York: Rizzoli & London: Thames and Hudson, 1990. Contains a chapter on each artist, while notes and an individual bibliography provide access to material in Russian.

Other Sources

Dunford, Penny. *A Biographical Dictionary of Women Artists in Europe and America since 1850.* Hemel Hempstead: Harvester Wheatsheaf and Philadelphia: University of Pennsylvania Press, 1990. Contains a bibliography.
Krichbaum, J., and R. Zondergeld. *Künstlerinnen: von der Antike bis zur Gegenwart.* Cologne: DuMont, 1979.
Mackay, J. *Dictionary of Western Sculptors in Bronze.* Woodbridge: Antique Collectors Club, 1978.
Mandel, W. *Soviet Women.* New York: Anchor Books, 1975.
Milner, John. *A Dictionary of Russian and Soviet Artists, 1420–1970.* Woodbridge: Antique Collectors Club, 1993.

3788 GORDINE, DORA (1906–1991)
 English sculptor of heads and figures in bronze.

Main Sources

"Dora Gordine." *The Independent,* 4 January 1992, 10. Obituary.

Exhibitions

Dora Gordine. London: Leicester Gallery, 1945.
Read, Benedict, and Peyton Skipwith. *Sculpture in Britain Between the Wars.* London: Fine Art Society, 1986.

Other Sources

Dunford, Penny. *A Biographical Dictionary of Women Artists in Europe and America since 1850.* Hemel Hempstead: Harvester Wheatsheaf and Philadelphia: University of Pennsylvania Press, 1990. Contains a bibliography.
Mackay, J. *Dictionary of Western Sculptors in Bronze.* Woodbridge: Antique Collectors Club: 1978.
Waters, Grant. *Dictionary of British Artists Working 1900–1940.* Eastbourne: Eastbourne Fine Art, 1975.

3789 GORDON-BELL, OPHELIA (née JOAN OPHELIA GORDON-BELL) (1915–1975)
 English sculptor and painter.

Main Sources

Heaton-Cooper, W. *Mountain Painter: An Autobiography.* Kendal, 1984. Written by Gordon-Bell's husband, this is the main source of information on Gordon-Bell.

Other Sources

Dunford, Penny. *A Biographical Dictionary of Women Artists in Europe and America since 1850.* Hemel Hempstead: Harvester Wheatsheaf and Philadelphia: University of Pennsylvania Press, 1990. Contains a bibliography.

Mackay, J. *Dictionary of Western Sculptors in Bronze.* Woodbridge: Antique Collectors Club: 1978.

Waters, Grant. *Dictionary of British Artists Working 1900–1940.* Eastbourne: Eastbourne Fine Art, 1975.

3790 GRILLI, FRANCA (c. 1938–)

Italian abstract sculptor who uses silver wire in her works.

Other Sources

Weller, Simone. *Il Complesso di Michelangelo: ricerca sul contributo dato dalla donna all'arte italiana del novecento.* Pollenza-Macerata: La Nuova Foglio [*sic*] Editrice, 1976.

3791 GRIMALDEN, ANNE (1899–?)

Norwegian sculptor who produced many outdoor monuments.

Exhibitions

Cinq artistes norvégiens. Paris: Petit Palais, 1954.

Other Sources

Gran, H., and P. Anker, eds. *Illustrert Norsk Kunstner Leksikon.* Oslo: Broen Bokhandel, 1956.

3792 GUBERTI, SILVIA (1940–)

Italian sculptor.

Exhibitions

Eiblmayr, Silvia, Valie Export, and Monika Prischl-Maier. *Kunst mit Eigen-Sinn. Aktuelle Kunst von Frauen: Texte und Dokumentation.* Vienna: Locker Verlag in association with the Museum of Modern Art and Museum of 20th Century Art, 1985.

3793 GUIDI, NEDDA (1927–)

Italian abstract sculptor and ceramicist.

Exhibitions

Künstlerinnen International, 1877–1977. Berlin: Schloss Charlottenburg, 1977.

Pasquali, Marilena. *Figure dallo sfondo*. Ferrara: Padiglione d'Arte Contemporanea and Grafis Editore, 1984.

Other Sources

Dunford, Penny. *A Biographical Dictionary of Women Artists in Europe and America since 1850*. Hemel Hempstead: Harvester Wheatsheaf and Philadelphia: University of Pennsylvania Press, 1990. Contains a bibliography.

Krichbaum, J., and R. Zondergeld. *Künstlerinnen: von der Antike bis zur Gegenwart*. Cologne: DuMont, 1979.

Weller, Simone. *Il Complesso di Michelangelo: ricerca sul contributo dato dalla donna all'arte italiana del novecento*. Pollenza-Macerata: La Nuova Foglio [*sic*] Editrice, 1976.

3794 HALLE, ELINOR
English sculptor, medallist and enameller.

Other Sources

Spielmann, Marion Harry. *British Sculpture and Sculptors of Today*. London: Cassell, 1901.

3795 HALSE, EMMELINE (1856–1930)
English sculptor of statues and reliefs in marble, plaster and terracotta.

Other Sources

Clement, Clara. *Women in the Fine Arts*. Boston: Houghton Mifflin, 1904.

Dunford, Penny. *A Biographical Dictionary of Women Artists in Europe and America since 1850*. Hemel Hempstead: Harvester Wheatsheaf and Philadelphia: University of Pennsylvania Press, 1990. Contains a bibliography.

Mackay, J. *Dictionary of Western Sculptors in Bronze*. Woodbridge: Antique Collectors Club, 1978.

Waters, Grant. *Dictionary of British Artists Working 1900–1940*. Eastbourne: Eastbourne Fine Art, 1975.

3796 HANKE-FÖRSTER, URSULA (1920–)
German sculptor.

Exhibitions

Das Verborgene Museum. Dokumentation der Kunst von Frauen in Berliner öffentlichen Sammlungen. Berlin: Edition Hentrich, 1987.

3797 HAVERS, MANDY (1953–)
English sculptor who has worked in leather producing torsos, usually male.

Exhibitions

Women's Images of Men. London: Institute of Contemporary Art, 1980.

3798 HEISE, KATHARINA (Used the pseudonym KARL LUIS HEINRICH-SALZE) (1891–1964)
German sculptor.

Exhibitions

Barron, Stephanie, et al. *German Expressionism, 1915–1925: The Second Generation.* Los Angeles: County Museum of Art, 1988.

Other Sources

Meskimmon, Marsha, and Shearer West. *Visions of the 'Neue Frau': Women and the Visual Arts in Weimar Germany.* London: Scolar Press, 1995.

3799 HEPWORTH, BARBARA (1903–1975)
English abstract sculptor.

Publications

A Pictorial Autobiography. Bath and New York: Adams and Dart, 1970.

Main Sources

Barbara Hepworth Reconsidered. Critical Forum Series vol. 3. Liverpool: Liverpool University Press and the Tate Gallery, 1996. Contains twelve scholarly essays and provides the most recent and rigorous consideration of Hepworth.

Bowness, Alan. *Barbara Hepworth: Drawings from a Sculptor's Landscape.* Bath: Cory, Adams & Mackay, 1966, 94 illus.

———. *The Complete Sculpture of Barbara Hepworth, 1960–1969.* London: Lund Humphries, 1971, 222pp., 205 illus. Consists of conversations between Hepworth and her son-in-law, Bowness, and documentation of her exhibitions and output of these prolific years.

Curtis, Penelope. "Through Thick and Thin." *Women's Art Magazine* 60 (1994): 12–14.

Gardiner, Margaret. *Barbara Hepworth: A Memoir.* Edinburgh: Salamander Press, 1982, 63pp., illus. Written by a friend who met her in 1930, this gives an account of Hepworth as a person.

Gibson, William. *Barbara Hepworth.* Ariel Books on Art. London: Faber and Faber, 1946, 51 illus.

Hammacher, A. *Barbara Hepworth.* World of Art. London: Thames and Hudson, 1968, 191 illus.

Jenkins, David Fraser. *Barbara Hepworth: A Guide to the Tate Gallery Collection, London and St. Ives, Cornwall.* London: Tate Gallery, 1982, 48pp., illus. Contains a complete catalogue of the works by Hepworth in this collection.

Nemser, Cindy. *Art Talk.* New York: Scribner's, 1975.

Read, Herbert. *Barbara Hepworth: Carvings and Drawings.* London: Lund Humphries, 1952, n.p., 160 illus. Contains six short passages of notes by Hepworth and a chronology from the 1920s.

Skeaping, John. *Drawn from Life.* London: Collins, 1977, 253pp. An account written by Hepworth's first husband.

Exhibitions

Barbara Hepworth. Otterlo: Kröller-Müller Museum, 1964, n.p., illus. Text in Dutch. Contains an introductory essay and catalogue entries.

Barbara Hepworth. London: Tate Gallery, 1968, 64pp., mainly illus. Contains three essays including one on the installation of her work at the Kröller-Müller Museum, Otterlo.

Barbara Hepworth. Plymouth: City Art Gallery, 1970, n.p., illus. Contains a short introduction by Edwin Mullins.

Barbara Hepworth: The Family of Man: Nine Bronzes and Recent Carvings. London: Marlborough Gallery, 1972, 72pp., illus. Includes a critical essay by Hammacher.

Barbara Hepworth: Late Works. Edinburgh: Royal Botanic Gardens and Scottish National Gallery of Modern Art, 1976, 48pp., illus. Contains a short introductory essay, a list of her solo and group exhibitions, films made about her and a bibliography.

Künstlerinnen International, 1877–1977. Berlin: Schloss Charlottenburg, 1977.

Wilkinson, Alan. *Barbara Hepworth.* Toronto: Art Gallery of Ontario, 1991, 48pp., illus. An exhibition of works from the Gallery's permanent collection.

Deepwell, Katy. *Ten Decades: Careers of Ten Women Artists born 1897–1906.* Norwich: Norwich Gallery, Norfolk Institute of Art and Design, 1992.

Curtis, Penelope, and Alan Wilkinson. *Barbara Hepworth: A Retrospective.* Liverpool: Tate Gallery and Art Gallery of Ontario, Toronto, 1994, 168pp., illus. Contains four critical essays and a chronology of public commissions.

Other Sources

Bachmann, Donna, and Sherry Piland. *Women Artists: A Historical, Contemporary and Feminist Bibliography.* Metuchen, N.J.: Scarecrow Press, 1978.

Carandente, Giovanni, ed. *Knaurs Lexikon der moderne Plastik.* Munich & Zurich: Droemersche Verlagsanstalt Th. Knaur Nachf., 1961. Includes an account of the development of her work.

Dunford, Penny. *A Biographical Dictionary of Women Artists in Europe and*

America since 1850. Hemel Hempstead: Harvester Wheatsheaf and Philadelphia: University of Pennsylvania Press, 1990. Contains a bibliography.

Uglow, Jennifer. *The Macmillan Dictionary of Women's Biography*. London: Macmillan, 1982.

3800 HERBERT, GWENDOLEN (1878–1966)
Irish sculptor.

Exhibitions

Irish Women Artists from the Eighteenth Century to the Present Day. Dublin: National Gallery of Ireland, Douglas Hyde Gallery and Hugh Lane Gallery, 1987.

3801 HERON, HILARY (1923–1976)
Irish sculptor.

Exhibitions

Irish Women Artists from the Eighteenth Century to the Present Day. Dublin: National Gallery of Ireland, Douglas Hyde Gallery and Hugh Lane Gallery: 1987.

Other Sources

Dunford, Penny. *A Biographical Dictionary of Women Artists in Europe and America since 1850*. Hemel Hempstead: Harvester Wheatsheaf and Philadelphia: University of Pennsylvania Press, 1990. Contains a bibliography.

3802 HESKE, MARIANNE (1946–)
Norwegian sculptor, video and installation artist, graphic artist and photographer.

Exhibitions

Fisher, Susan Sterling, Anne Wichstrøm, and Toril Smit. *At Century's End: Norwegian Artists and the Figurative Tradition, 1880–1990*. Høikodden: Henie-Onstad Art Centre, 1995. Includes a list of exhibitions and an individual bibliography.

3803 HICKS, NICOLA (1960–)
English sculptor of animals, often in straw and plaster.

Main Sources

Anson, Elizabeth. "Nicola Hicks: Fire and Brimstone." *Women's Art Magazine* 39 (1991): 14. Review of an exhibition at the Flowers East Gallery, London.

Beaumont, M. "The Hayward Annual." *Arts Review,* May 1985, 279.

Bhegani, B. "A Day in the Life of Nicola Hicks." *Sunday Times,* October 1986, 110.

Other Sources

Dunford, Penny. *A Biographical Dictionary of Women Artists in Europe and America since 1850*. Hemel Hempstead: Harvester Wheatsheaf and Philadelphia: University of Pennsylvania Press, 1990. Contains a bibliography.

3804 HILEY, MURIEL B. G. (1906–)
 Welsh sculptor of portrait busts, medals and reliefs.

Other Sources

Dunford, Penny. *A Biographical Dictionary of Women Artists in Europe and America since 1850*. Hemel Hempstead: Harvester Wheatsheaf and Philadelphia: University of Pennsylvania Press, 1990. Contains a bibliography.
 Dunthorne, Katherine. *Artists Exhibited in Wales, 1945–1976*. Cardiff: Welsh Arts Council, 1976.

3805 HILL, AMELIA ROBERTSON (née PATON) (1820–1904)
 Scottish sculptor of figures and animals.

Main Sources

Tytler, Sarah. *Modern Painters and Their Paintings*. London: Ibister, 1882.

Other Sources

Clement, Clara. *Women in the Fine Arts*. Boston: Houghton Mifflin, 1904.
 Dunford, Penny. *A Biographical Dictionary of Women Artists in Europe and America since 1850*. Hemel Hempstead: Harvester Wheatsheaf and Philadelphia: University of Pennsylvania Press, 1990. Contains a bibliography.
 Mackay, J. *Dictionary of Western Sculptors in Bronze*. Woodbridge: Antique Collectors Club, 1978.

3806 HILTUNEN, EILA (1922–)
 Finnish sculptor.

Other Sources

Carandente, Giovanni, ed. *Knaurs Lexikon der moderne Plastik*. Munich & Zurich: Droemersche Verlagsanstalt Th. Knaur Nachf., 1961. Includes an account of the development of her work.
 Dunford, Penny. *A Biographical Dictionary of Women Artists in Europe and America since 1850*. Hemel Hempstead: Harvester Wheatsheaf and Philadelphia: University of Pennsylvania Press, 1990. Contains a bibliography.
 Krichbaum, J., and R. Zondergeld. *Künstlerinnen: von der Antike bis zur Gegenwart*. Cologne: DuMont, 1979.
 Mackay, J. *Dictionary of Western Sculptors in Bronze*. Woodbridge: Antique Collectors Club, 1978.
 Schildt, G. *Modern Finnish Sculpture*. London: 1970.

3807 HORN, REBECCA (1944–)
 German performance and video artist, sculptor and film-maker.

See Performance and Video Art, Mixed Media and Installations section.

3808 HOUSHIARY, SHIRAZEH (1955–)
 Iranian-born abstract sculptor who lives in England.

Main Sources

Craddock, Sasha. "In and Out of Focus." *Women's Art Magazine* 61 (1994): 22. Review of solo exhibition *Sense of Unity.*

Exhibitions

Compton, M. *New Art.* London: Tate Gallery, 1983.
Current Affairs: British Paintings and Sculpture in the 1980s. Oxford: Museum of Modern Art, 1987.
Shirazeh Houshiary. Oxford: Museum of Modern Art, 1988.
Sassen, Jan Hein, ed. *A Century of Sculpture.* Amsterdam: Stedelijk Museum, 1992.

Other Sources

Dunford, Penny. *A Biographical Dictionary of Women Artists in Europe and America since 1850.* Hemel Hempstead: Harvester Wheatsheaf and Philadelphia: University of Pennsylvania Press, 1990. Contains a bibliography.
Newman, M. "New Sculpture in Britain." *Art in America,* September 1982, 104–114, 177, 179.

3809 HUGUES, JEANNE (née ROYANNEZ) (1855–c. 1914)
 French sculptor of figures and portrait busts.

Other Sources

Dunford, Penny. *A Biographical Dictionary of Women Artists in Europe and America since 1850.* Hemel Hempstead: Harvester Wheatsheaf and Philadelphia: University of Pennsylvania Press, 1990. Contains a bibliography.
Edouard-Joseph, R. *Dictionnaire biographique des artistes contemporains, 1910–1930.* Paris: Art et Editions, 1930–1934.
Martin, Jules. *Nos peintres et sculpteurs graveurs et dessinateurs.* Paris, 1897.

3810 IGLESIAS, CRISTINA
 Spanish sculptor.

Exhibitions

Cristina Iglesias. Amsterdam: Foundation De Appel, 1990, 24pp., mainly illus. Text in Dutch and English.

3811 ITASSE, JEANNE (Alt. BROQUET) (1867–?)
French sculptor of figures, portrait busts, memorials and reliefs.

Other Sources

Clement, Clara. *Women in the Fine Arts.* Boston: Houghton Mifflin, 1904.
Dunford, Penny. *A Biographical Dictionary of Women Artists in Europe and America since 1850.* Hemel Hempstead: Harvester Wheatsheaf and Philadelphia: University of Pennsylvania Press, 1990. Contains a bibliography.
Martin, Jules. *Nos peintres et sculpteurs, graveurs et dessinateurs.* Paris, 1897.

3812 JACQUEMART, NÉLIE BARBE HYACINTHE (Alt. JACQUEMART-ANDRE) (1841–1912)
French painter, best known for her portraits; also a sculptor and collector of art.

See Painting section.

3813 JAREMA, MARIA (1908–1958)
Polish abstract painter, sculptor, stage designer and graphic artist.

See Painting section.

3814 JENKIN, MARGARET (née GILES) (exhibited 1892–1912)
English sculptor of figures and memorials.

Other Sources

Beattie, Susan. *The New Sculpture.* New Haven, Conn. and London: Yale University Press, 1983.
Clement, Clara. *Women in the Fine Arts.* Boston: Houghton Mifflin, 1904.
Dunford, Penny. *A Biographical Dictionary of Women Artists in Europe and America since 1850.* Hemel Hempstead: Harvester Wheatsheaf and Philadelphia: University of Pennsylvania Press, 1990. Contains a bibliography.

3815 JETELOVÁ, MAGDALENA (1946–)
Czech sculptor of large-scale works (often based on domestic furniture) who has worked in Germany since 1984.

Main Sources

"Magdalena Jetelová—Riverside Studios, London." *Studio International* 198 (December 1985): 44–46.

Exhibitions

Compton, M. *New art at the Tate Gallery.* London: Tate Gallery, 1983.

Eiblmayr, Silvia, Valie Export, and Monika Prischl-Maier. *Kunst mit Eigen-Sinn. Aktuelle Kunst von Frauen: Texte und Dokumentation.* Vienna: Locker Verlag in association with the Museum of Modern Art and Museum of 20th Century Art, 1985.

Kalinovska, Milena. *Magdalena Jetelová: Sculpture.* London: Riverside Studios, 1985, n.p., mainly illus.

Magdalena Jetelová. London: Serpentine Gallery, 1985.

Magdalena Jetelová: Skulpturen. Göppingen: Stadtisches Galerie, 1990, 56pp., mainly illus. Text in German. Includes an essay by Werner Mayer. Separate sections are devoted to different subjects, such as chairs and tables.

Magdalena Jetelová: New Works Made at the Henry Moore Sculpture Trust Studio. Leeds: Henry Moore Centre for the Study of Sculpture, 1991, n.p., mainly illus. Shows the work resulting from her residency at Dean Clough, Halifax, in the autumn of 1990.

Badovinac, Zdenka. *Magdalena Jetelová.* Ljubljana: Mala Galerija/Moderna Galerija, 1991, n.p., illus. Contains a useful bibliography.

Magdalena Jetelová: zwei Räume. Vienna: Christine König Galerie, 1992, n.p., mainly illus. Text in German. Contains a short essay.

Magdalena Jetelová. Prague: Belvedere, 1993, 44pp., mainly illus. Text in Czech and English. Shows an installation of her work at Prague Castle, one of a series given to Czech artists living abroad.

Other Sources

Dunford, Penny. *A Biographical Dictionary of Women Artists in Europe and America since 1850.* Hemel Hempstead: Harvester Wheatsheaf and Philadelphia: University of Pennsylvania Press, 1990. Contains a bibliography.

3816 JEWELS, MARY (née TREGURTHA) (1886–1977)
English naïve painter of scenes based on her Cornish background.

Main Sources

Bowness, Alan. "Mary Jewels and Naïve Painting." *Painter and Sculptor* 1, no. 3 (autumn 1958).

Exhibitions

St. Ives, 1939–1964. London: Tate Gallery, 1985.

Other Sources

Dunford, Penny. *A Biographical Dictionary of Women Artists in Europe and America since 1850.* Hemel Hempstead: Harvester Wheatsheaf and Philadelphia: University of Pennsylvania Press, 1990. Contains a bibliography.

3817 JONZEN, KARIN (née LOWENADLER) (1914–)
Swedish sculptor of figures and portrait busts who was born and worked in England.

Publications

Karin Jonzen—Sculptor. London, 1976.

Exhibitions

Sellars, Jane. *Women's Works.* Liverpool: Walker Art Gallery, 1988.

Other Sources

Dunford, Penny. *A Biographical Dictionary of Women Artists in Europe and America since 1850.* Hemel Hempstead: Harvester Wheatsheaf and Philadelphia: University of Pennsylvania Press, 1990. Contains a bibliography.
Mackay, J. *Dictionary of Western Sculptors in Bronze.* Woodbridge: Antique Collectors Club, 1978.

3818 JUKES, BETH (née EDITH ELIZABETH JUKES) (1910–)
English sculptor.

Other Sources

Dunford, Penny. *A Biographical Dictionary of Women Artists in Europe and America since 1850.* Hemel Hempstead: Harvester Wheatsheaf and Philadelphia: University of Pennsylvania Press, 1990. Contains a bibliography.
Mackay, J. *Dictionary of Western Sculptors in Bronze.* Woodbridge: Antique Collectors Club, 1978.
Waters, Grant. *Dictionary of British Artists Working 1900–1940.* Eastbourne: Eastbourne Fine Art, 1975.

3819 KANERVO, MARJA (1958–)
Finnish sculptor.

Exhibitions

Akt 83: suomalaista nykytaidetta. Helsinki: Ateneum, 1983.

3820 KENNET, KATHLEEN YOUNG (LADY) (née BRUCE; alt. SCOTT) (1878–1947)
English sculptor of portrait busts, figures and memorials.

Publications

Self-portrait of an Artist. London: John Murray, 1949, 368pp., illus. Consists of extracts from her diaries and an autobiography, written in 1932 and edited after her death by her second husband, Lord Kennet.

Main Sources

Young, Louisa. *A Great Task of Happiness: The Life of Kathleen Scott.* London: Macmillan, 1995.

Other Sources

Dunford, Penny. *A Biographical Dictionary of Women Artists in Europe and America since 1850.* Hemel Hempstead: Harvester Wheatsheaf and Philadelphia: University of Pennsylvania Press, 1990. Contains a bibliography.

Mackay, J. *Dictionary of Western Sculptors in Bronze.* Woodbridge: Antique Collectors Club, 1978.

3821 KIENER-FLANN, RUTH (1924–)
German sculptor of abstract geometrical works.

Other Sources

Evers, Ulrike. *Deutsche Künstlerinnen des 20. Jahrhunderts. Malerei—Bildhauerei—Tapisserie.* Hamburg: Ludwig Schultheis Verlag, 1983. Contains an individual bibliography.

3822 KOBRO, KATARZYNA (1898–1951)
Russian-born Constructivist sculptor, of Russo-Latvian parents, who worked in Poland from 1922.

Publications

"Dla Iudzi niezdolnychà" *Forma* 3 (May 1935): 14. An untitled statement on her own work.

"Funckjonalizm." *Forma* 4 (1936): 9–13.

[Untitled statement.] *Glos plastykow,* 1937, 42–43.

Main Sources

Guriewicz, Jan. "Pragnienia a Rzeczywistošč." *Forma* 1 (March 1933).

Schipper, M. "Katarzyna Kobro: Innovative Sculptor of the 1920s." *Woman's Art Journal* 1, no. 2 (fall 1980–winter 1981): 19–24.

Utkin, Boleslaw. "Kompozycje przestrzenno-rzezbiarskie Katarzyny Kobro" [The spatial sculptural compositions of Katarzina Kobro]. *Ochrona Zabytkow* 25 (1972): 203–206. Summary in English.

Exhibitions

Constructivism in Poland, 1923–1936: Blok—Praesans—ar. Essen: Museum Folkwang, 1973. Text in German. Based around works and articles published in these Polish journals of the artistic avant-garde.

Die 20er Jahre in Osteuropa. Cologne: Galerie Gmurzynska, 1975.

Abstraction-Création 1931–1936. Paris: Musée d'Art Moderne de la Ville de Paris, 1978.

Vergine, Lea. *L'altra metà dell'avanguardia.* Milan: Mazzotta Editore, 1980. *L'autre moitié de l'avant-garde.* Paris: Des Femmes, 1982.

Présences Polonaises. L'Art vivant autour du Musée Łodz. Paris: Centre national d'art et de culture Georges Pompidou, 1983.

Gresty, Hilary, and Jeremy Lewison. *Constructivism in Poland 1923–1936.* Cambridge: Kettle's Yard Gallery in association with the Muzeum Stuki, Łodz, 1984. Includes a biographical essay.

Three Pioneers of Polish Avant-garde. Funen: Art Museum, 1985.

Künstlerinnen des 20. Jahrhunderts. Wiesbaden: Museum Wiesbaden in association with Verlag Weber & Weidermeyer GmbH, Kassel, 1990.

Morawińska, Agnieszka. *Voices of Freedom: Polish Women Artists of the Avant-garde, 1880–1990.* Washington, D.C.: National Museum of Women in the Arts, 1991. Includes a list of her main exhibitions and a bibliography.

Bois, Yves-Alain. "Kobro's Disjunctive Syntax." In *Inside the Visible: An Elliptical View of 20th Century Art—In, Of and From the Feminine,* ed. Catherine de Zegher. Ghent: The Kanaal Foundation, 1996.

Other Sources

Dunford, Penny. *A Biographical Dictionary of Women Artists in Europe and America since 1850.* Hemel Hempstead: Harvester Wheatsheaf and Philadelphia: University of Pennsylvania Press, 1990. Contains a bibliography.

Krichbaum, J., and R. Zondergeld. *Künstlerinnen: von der Antike bis zur Gegenwart.* Cologne: DuMont, 1979.

3823 KOENIG, GHISHA (1921–1993)
English sculptor of small-scale figures, often factory workers, to form narrative scenes.

Main Sources

Brett, Guy. "The Artist on the Factory Floor: Ghisha Koenig." *The Guardian,* 19 October 1993, 2:19. Obituary.

Katz, Agi. "Ghisha Koenig." *The Independent,* 19 October 1993, 28. Obituary.

Steyn, Juliet. "Ghisha Koenig—obituary." *Women's Art Magazine* 56 (1994): 28.

Exhibitions

Art For Society. London: Whitechapel Art Gallery, 1978.

Brett, Guy. *Ghisha Koenig—Sculpture 1968–1986.* London: Serpentine Gallery, 1986.

Other Sources

Dunford, Penny. *A Biographical Dictionary of Women Artists in Europe and America since 1850.* Hemel Hempstead: Harvester Wheatsheaf and Philadelphia: University of Pennsylvania Press, 1990. Contains a bibliography.

3824 KOLLWITZ, KÄTHE (née SCHMIDT) (1867–1945)
German graphic artist and sculptor known for her commitment to a social and political art.

See Graphic Art section.

3825 KORTEWEG, NEELTJE (1944–)
Dutch sculptor.

Exhibitions

Tout droit—droit au but: neuf femmes constructivistes. Paris: Institut néerlandais, 1976.

3826 KÖKER, AZADE (1940–)
Turkish-born sculptor who has worked in Germany since 1973.

Exhibitions

Das Verborgene Museum. Dokumentation der Kunst von Frauen in Berliner öffentlichen Sammlungen. Berlin: Edition Hentrich, 1987.

3827 KRACHT, YVONNE (1931–)
Dutch sculptor.

Exhibitions

Tout droit—droit au but: neuf femmes constructivistes. Paris: Institut néerlandais, 1976.

3828 KROL, FRANSJE (1948–)
Indonesian-born abstract sculptor who has been based in the Netherlands since 1968.

Exhibitions

Kunst door vrouwen. Leiden: Stedelijk Museum, De Lakenhal, 1987.

3829 LAHTINENEN, MARJO (1944–)
Finnish sculptor.

Exhibitions

Akt 83: suomalaista nykytaidetta. Helsinki: Ateneum, 1983.

3830 LAMPE-VON BENNIGSEN, SILVIE (1892–1982)
German sculptor based in Munich.

Other Sources

Meskimmon, Marsha, and Shearer West. *Visions of the 'Neue Frau': Women and the Visual Arts in Weimar Germany.* London: Scolar Press, 1995.

3831 LE BROQUY, MELANIE (1919–)
Irish sculptor of stylised, simplified figures.

Exhibitions

Irish Women Artists from the Eighteenth Century to the Present Day. Dublin: National Gallery of Ireland, Douglas Hyde Gallery and Hugh Lane Gallery: 1987.

Other Sources

Dunford, Penny. *A Biographical Dictionary of Women Artists in Europe and America since 1850.* Hemel Hempstead: Harvester Wheatsheaf and Philadelphia: University of Pennsylvania Press, 1990. Contains a bibliography.

3832 LEBEDEVA, SARAH DMITRIEVNA (1881/92–1967/8)
Russian sculptor of portraits and figures.

Main Sources

Yablonskaya, Miuda. *Women Artists of Russia's New Age, 1900–1935.* Ed. and trans. Anthony Parton. New York: Rizzoli & London: Thames and Hudson, 1990. Contains a chapter on each artist, while notes and an individual bibliography provide access to material in Russian.

Other Sources

Dunford, Penny. *A Biographical Dictionary of Women Artists in Europe and America since 1850.* Hemel Hempstead: Harvester Wheatsheaf and Philadelphia: University of Pennsylvania Press, 1990. Contains a bibliography.

Mandel, W. *Soviet Women.* New York: Anchor Books, 1975.

Milner, John. *A Dictionary of Russian and Soviet Artists, 1420–1970.* Woodbridge: Antique Collectors Club, 1993.

3833 LESENYEI, MÁRTA (1930–)
Hungarian sculptor.

Other Sources

Hárs, Éva, and Ferenc Romváry. *Modern Hungarian Gallery Pécs.* Budapest: Corvina Kiadó, 1981.

3834 LEVENTON, ROSIE (1949–)
English sculptor who uses mixed media to create environments and installations.

See Performance and Video Art, Mixed Media and Installations section.

3835 LEVICK, RUBY WINIFRED (Alt. BAILEY) (active 1894–1921)
Welsh sculptor of figures, statuettes for gardens and reliefs.

Main Sources

Martin Wood, D. "A Decorative Sculptor: Miss Ruby Levick (Mrs G. Bailey)." *Studio,* March 1905, 100–107.

Other Sources

Beattie, Susan. *The New Sculpture.* New Haven, Conn. and London: Yale University Press, 1983.
Clement, Clara. *Women in the Fine Arts.* Boston: Houghton Mifflin, 1904.
Dunford, Penny. *A Biographical Dictionary of Women Artists in Europe and America since 1850.* Hemel Hempstead: Harvester Wheatsheaf and Philadelphia: University of Pennsylvania Press, 1990. Contains a bibliography.
Mackay, J. *Dictionary of Western Sculptors in Bronze.* Woodbridge: Antique Collectors Club, 1978.

3836 LIGETI, ERIKA (1934–)
Hungarian sculptor.

Other Sources

Németh, Lajos. *Modern Art in Hungary.* Budapest: Corvina Press, 1969.

3837 LIJN, LILIANE (1939–)
American-born abstract sculptor concerned with light who works in England.

Publications

"Light Matters." *Women's Art Magazine* 62 (January–February 1995): 6–9.

Exhibitions

Hayward Annual '78. London: Hayward Gallery, 1978. Contains a bibliography.
Women's Art Show, 1550–1970. Nottingham: Castle Museum, 1982. Contains a brief biography.

Other Sources

Dunford, Penny. *A Biographical Dictionary of Women Artists in Europe and America since 1850.* Hemel Hempstead: Harvester Wheatsheaf and Philadelphia: University of Pennsylvania Press, 1990. Contains a bibliography.
Parker, Roszika, and Griselda Pollock. *Framing Feminism.* London: Pandora, 1987.

3838 LINDSEY, VIOLET, (née MARION MARGARET VIOLET LINDSAY; alt. MARCHIONESS OF GRANBY and DUCHESS OF RUTLAND) (1856–1937)
English sculptor and watercolourist.

Main Sources

"Violet, Duchess of Rutland." *Apollo* 18 (1932): 40–41.

Exhibitions

Casteras, Susan, and Linda H. Peterson. *A Struggle for Fame: Victorian Women Artists and Authors.* New Haven, Conn.: Yale Center for British Art, 1994.

Other Sources

Clement, Clara. *Women in the Fine Arts.* Boston: Houghton Mifflin, 1904.
Sparrow, Walter Shaw. *Women Painters of the World.* London: Hodder and Stoughton, 1905.
Wood, Christopher. *Dictionary of Victorian Painters.* Woodbridge: Antique Collectors Club, 1978. (There are two separate entries under Rutland and Lindsay.)

3839 LIVI, LIVIA (1934–)
Italian figurative sculptor.

Other Sources

Weller, Simone. *Il Complesso di Michelangelo: ricerca sul contributo dato dalla donna all'arte italiana del novecento.* Pollenza-Macerata: La Nuova Foglio [*sic*] Editrice, 1976.

3840 LOGINA, ZENTA (1908–1980)
Latvian painter and sculptor who used geometrical abstractions to convey cosmological themes.

Other Sources

Rosenfeld, Alla, and Norton Dodge, eds. *Nonconformist Art: The Soviet Experience, 1956–1986. The Norton and Nancy Dodge Collection.* London: Thames and Hudson in association with the Jane Voorhees Zimmerli Art Museum, State University of New Jersey, Rutgers, 1995.

3841 LOUISE CAROLINE ALBERTA (PRINCESS) (Alt. DUCHESS OF ARGYLL) (1848–1939)
English sculptor and watercolour painter.

Main Sources

Clayton, Ellen. *English Female Artists.* London: Tinsley, 1876.

Wake, J. *Princess Louise: Queen Victoria's Unconventional Daughter.* London, 1987.

Other Sources

Clement, Clara. *Women in the Fine Arts.* Boston: Houghton Mifflin, 1904.
Dunford, Penny. *A Biographical Dictionary of Women Artists in Europe and America since 1850.* Hemel Hempstead: Harvester Wheatsheaf and Philadelphia: University of Pennsylvania Press, 1990. Contains a bibliography.
Longford, Elizabeth. *Darling Loosy: Letters to Princess Louise, 1856–1939.* London: Weidenfeld and Nicolson, 1991. Contains some comments on her artistic training with Mary Thornycroft (q.v.).
Read, Benedict. *Victorian Sculpture.* London, 1982.

3842 LUGOSSY, MARIA (1950–)
Hungarian sculptor of abstract, geometrical works in metal and glass.

Main Sources

Frank, J. "Charm, Irony, Drama." *New Hungarian Quarterly* 70 (1977).
————. "Motion, Space, Kinetics." *New Hungarian Quarterly* 85 (1982).

Exhibitions

Contemporary Visual Art in Hungary. Glasgow: Third Eye Centre, 1985.

Other Sources

Dunford, Penny. *A Biographical Dictionary of Women Artists in Europe and America since 1850.* Hemel Hempstead: Harvester Wheatsheaf and Philadelphia: University of Pennsylvania Press, 1990. Contains a bibliography.

3843 LUKSCH-MAKOWSKAIA, ELENA (Alt. MAKOWSKY) (1878–1967)
Russian sculptor and painter who worked in Austria after her marriage in 1900 and later in Germany.

Other Sources

Evers, Ulrike. *Deutsche Künstlerinnen des 20. Jahrhunderts. Malerei— Bildhauerei—Tapisserie.* Hamburg: Ludwig Schultheis Verlag, 1983. Contains an individual bibliography.
Schweiges, W. *Wiener Werkstätte: Kunst und Handwerk, 1903–32.* Vienna: Christian Brandstätter Verlag, 1982.

3844 LUNDGREN, TYRA (1897–1979)
Swedish sculptor, painter and designer of ceramics.

See volume 1.

3845 LUZANOVSKI-MARINESCO, LYDIA (1899–)
Ukrainian sculptor who studied in Romania and France where she worked from the mid-1920s.

Other Sources

Dunford, Penny. *A Biographical Dictionary of Women Artists in Europe and America since 1850.* Hemel Hempstead: Harvester Wheatsheaf and Philadelphia: University of Pennsylvania Press, 1990. Contains a bibliography.

Edouard-Joseph, R. *Dictionnaire biographique des artistes contemporains, 1910–1930.* Paris: Art et Editions, 1930–1934.

Mackay, J. *Dictionary of Western Sculptors in Bronze.* Woodbridge: Antique Collectors Club, 1978.

3846 LYDIAT, ANNE (1947–)
English sculptor of both abstract works and those which recall domestic objects.

Main Sources

Harrison, Josie. "Anne Lydiat: The Shadow Carrier." *Women's Art Magazine* 41 (1991): 22. Review of exhibition at the Cleveland Gallery, Middlesborough.

Lucas, Pauline. "Home and Away." *Women's Art Magazine* 60 (1994): 28. Review of the exhibition *Shadow Play* in Nottingham.

Exhibitions

Waiting for the Seventh Wave: Recent Works by Anne Lydiat. Birmingham: Ikon Gallery, 1987, 24pp., illus. Contains four short but focussed essays examining her imagery, ideas and the links with feminism. Contains an outline biography with some exhibitions listed.

3847 LYMBERAKI, AGLAIA (1923–)
Greek sculptor.

Exhibitions

Iliopoulou-Rogan, Dora. *Three Generations of Greek Women Artists: Figures, Forms and Personal Myths.* Washington, D.C.: National Museum of Women in the Arts, 1989.

3848 MADDEN, ANNE (Alt. LE BROCQUY) (1932–)
English-born sculptor, painter and graphic artist who moved to Ireland as a child.

Exhibitions

Irish Women Artists from the Eighteenth Century to the Present Day. Dublin: National Gallery of Ireland, Douglas Hyde Gallery and Hugh Lane Gallery, 1987.

Other Sources

De Breffny, Brian, ed. *Ireland: A Cultural Encyclopaedia*. London: Thames and Hudson, 1983.

3849 MAIER-BUSS, INGEBORG (1940–)
German abstract sculptor.

Other Sources

Evers, Ulrike. *Deutsche Künstlerinnen des 20. Jahrhunderts. Malerei—Bildhauerei—Tapisserie*. Hamburg: Ludwig Schultheis Verlag, 1983. Contains an individual bibliography.

3850 MANCOBA, SONIA FERLOV (1911–)
Danish abstract sculptor.

Main Sources

Nørredam, M. "Primitivisme i dansk kunst." *Louisiana Revy* 26, no. 3 (May 1986): 16–26, 56.

Exhibitions

Paris 1937-Paris 1957: création en France. Paris: Centre national d'art et de culture Georges Pompidou, 1981.
Cobra, 1948–1951. Rotterdam: Museum Boymans-van Beuningen, 1966.
Surrealismen i Danmark 1930–1950. Copenhagen: Statens Museum for Kunst, 1986.

Other Sources

Dunford, Penny. *A Biographical Dictionary of Women Artists in Europe and America since 1850*. Hemel Hempstead: Harvester Wheatsheaf and Philadelphia: University of Pennsylvania Press, 1990. Contains a bibliography.

3851 MANNER, MARIANA (1943–)
Swedish graphic artist, painter and sculptor.

See Graphic Art section.

3852 MARAINI, ADELAIDE (née PANDIANI) (1843–?)
Italian sculptor of figures, portrait busts and reliefs.

Other Sources

Scultori italiani dal neoclassicismo al Liberty. Lodi: Lodigraf, 1990.
Clement, Clara. *Women in the Fine Arts*. Boston: Houghton Mifflin, 1904.
Dunford, Penny. *A Biographical Dictionary of Women Artists in Europe and*

America since 1850. Hemel Hempstead: Harvester Wheatsheaf and Philadelphia: University of Pennsylvania Press, 1990. Contains a bibliography.

Mackay, J. *Dictionary of Western Sculptors in Bronze.* Woodbridge: Antique Collectors Club, 1978.

3853 MARCELLO (Pseudonym of the Duchess of CASTIGLIONE-COLONNA; née ADELE D'AFFREY) (1836–1879)

Swiss sculptor of mythological and historical figures who exhibited across Europe.

Main Sources

D'Alcantara, Comtesse. *Marcello Adèle d'Affrey, Duchesse de Castiglione Colonna, 1836–1879.* Geneva, 1961.

Exhibitions

Fusco, Peter, and H. W. Janson. *The Romantics to Rodin: French Nineteenth Century Sculpture from N. American Collections.* Los Angeles: County Museum of Art in association with George Braziller Inc., 1980.

Bessis, Henriette. *Marcello Sculpteur.* Fribourg: Musée d'Art et d'Histoire, 1980, 240pp., illus. Contains a detailed catalogue of the sculptures at Fribourg, a list of the exhibitions and Salons in which she participated and a full bibliography.

Beaulieu, Germaine, et al. *La femme artiste: d'Elisabeth Vigée-Lebrun à Rosa Bonheur.* Lacoste: Musée Despiau-Wlerick et Dubalen Mont-de-Marsan, 1981. Includes a bibliography.

Marcello (1836–1879). Adèle d'Affrey, Duchesse de Castiglione-Colonna. Fribourg: Musée d'Art et d'Histoire, 104pp., illus. Three scholarly and informative essays examine the sociohistorical context, the sources on Marcello and her work. The catalogue notes follow.

Marcello. Adèle d'Affrey, duchesse de Castiglione-Colonna. Paris: Musée Rodin, 1980, 31pp., illus. Contains introductory essays by Monique Laurent and Henriette Bessis together with a biographical outline.

Other Sources

Clement, Clara. *Women in the Fine Arts.* Boston: Houghton Mifflin, 1904.

Dunford, Penny. *A Biographical Dictionary of Women Artists in Europe and America since 1850.* Hemel Hempstead: Harvester Wheatsheaf and Philadelphia: University of Pennsylvania Press, 1990. Contains a bibliography.

Janson, H. W. "Rodin Was Not the Only One." *Portfolio* 2 (1980): 40–45. Arises from the exhibition of French nineteenth-century sculpture, *The Romantics to Rodin,* for which Janson was one of the curators. Janson refers to Marcello as the "most important woman sculptor of the nineteenth century" and her statue *Pythis* is illustrated on page 42.

3854 MARSEEN, ULRIKE (1912–)
Danish sculptor, painter and critic.

Other Sources

Dunford, Penny. *A Biographical Dictionary of Women Artists in Europe and America since 1850.* Hemel Hempstead: Harvester Wheatsheaf and Philadelphia: University of Pennsylvania Press, 1990. Contains a bibliography.

3855 MARTIN, MARY ADELA (née BALMFORD) (1907–1969)
English sculptor of abstract, geometrical reliefs.

Publications

Listed in full in Compton below.

Exhibitions

British Painting 1952–1977. London: Royal Academy, 1977.
Women's Art Show, 1550–1970. Nottingham: Castle Museum, 1982. Contains a brief biography.
Compton, Michael. *Mary Martin.* London: Tate Gallery, 1984, 60pp., illus. Essays analyse her work, her writings (extracts are included, and her working methods). A full list of statements and writings by Martin and a detailed bibliography are given.
Kenneth and Mary Martin. London: Annely Juda Fine Art, 1987, 128pp., illus. Includes a detailed bibliography and list of solo and group exhibitions.
Sellars, Jane. *Women's Works.* Liverpool: Walker Art Gallery, 1988.

Other Sources

Dunford, Penny. *A Biographical Dictionary of Women Artists in Europe and America since 1850.* Hemel Hempstead: Harvester Wheatsheaf and Philadelphia: University of Pennsylvania Press, 1990. Contains a bibliography.

3856 MATTON, IDA (1863–1940)
Swedish sculptor, medallist, landscape painter and graphic artist.

Other Sources

Clement, Clara. *Women in the Fine Arts.* Boston: Houghton Mifflin, 1904.
Dunford, Penny. *A Biographical Dictionary of Women Artists in Europe and America since 1850.* Hemel Hempstead: Harvester Wheatsheaf and Philadelphia: University of Pennsylvania Press, 1990. Contains a bibliography.
Edouard-Joseph, R. *Dictionnaire biographique des artistes contemporains, 1910–1930.* Paris: Art et Editions, 1930–1934.
Mackay, J. *Dictionary of Western Sculptors in Bronze.* Woodbridge: Antique Collectors Club, 1978.

3857 McKEOGH, AILEEN (1952–)
Irish sculptor whose relief sculptures are concerned with landscape.

Exhibitions

Irish Women Artists from the Eighteenth Century to the Present Day. Dublin: National Gallery of Ireland, Douglas Hyde Gallery and Hugh Lane Gallery, 1987.

Other Sources

Dunford, Penny. *A Biographical Dictionary of Women Artists in Europe and America since 1850.* Hemel Hempstead: Harvester Wheatsheaf and Philadelphia: University of Pennsylvania Press, 1990. Contains a bibliography.

3858 MEIER-DENNINGHOFF, BRIGITTE (1923–)
German sculptor.

Other Sources

Carandente, Giovanni, ed. *Knaurs Lexikon der moderne Plastik.* Munich & Zurich: Droemersche Verlagsanstalt Th. Knaur Nachf., 1961. Includes an account of the development of her work.

3859 MELA, NATALIA (1923–)
Greek sculptor of stylised forms often based on animals; she has also designed for the theatre.

Exhibitions

Iliopoulou-Rogan, Dora. *Three Generations of Greek Women Artists: Figures, Forms and Personal Myths.* Washington, D.C.: National Museum of Women in the Arts, 1989.

3860 MELLIS, MARGARET (1914–)
Scottish painter and, later, sculptor of reliefs.

See Painting section.

3861 MERZ, MARISA (c. 1945–)
Italian conceptual sculptor and graphic artist.

Other Sources

Weller, Simone. *Il Complesso di Michelangelo: ricerca sul contributo dato dalla donna all'arte italiana del novecento.* Pollenza-Macerata: La Nuova Foglio [*sic*] Editrice, 1976.

3862 MOLL, MARG (née MARGARETHE HAEFFNER) (1884–1977)
German sculptor and painter.

Exhibitions

Das Verborgene Museum. Dokumentation der Kunst von Frauen in Berliner öffentlichen Sammlungen. Berlin: Edition Hentrich, 1987.

Barron, Stephanie. *Degenerate Art: The Fate of the Avant-Garde in Nazi Germany.* Los Angeles: County Museum of Art in association with H. Abrams, New York, 1991.

Other Sources

Dunford, Penny. *A Biographical Dictionary of Women Artists in Europe and America since 1850.* Hemel Hempstead: Harvester Wheatsheaf and Philadelphia: University of Pennsylvania Press, 1990. Contains a bibliography.

Evers, Ulrike. *Deutsche Künstlerinnen des 20. Jahrhunderts. Malerei— Bildhauerei—Tapisserie.* Hamburg: Ludwig Schultheis Verlag, 1983. Contains an individual bibliography.

Meskimmon, Marsha, and Shearer West. *Visions of the 'Neue Frau': Women and the Visual Arts in Weimar Germany.* London: Scolar Press, 1995.

3863 MONTALBA, HENRIETTA SKERRET (1856–1893)
English sculptor and painter of portraits and genre; sister of Clara, Ellen and Hilda Montalba.

Main Sources

"Miss Henrietta Montalba." *Art Journal,* 1893, 363. Obituary.

Hepworth-Dixon, M. "Henrietta Montalba—a Reminiscence." *Art Journal,* 1894, 215–217.

Exhibitions

See under Clara Montalba in Painting section.

3864 MONTORGUEIL, LAURE COUTAN (née MARTIN) (1855–1915)
French sculptor.

Exhibitions

Beaulieu, Germaine, et al. *La femme artiste: d'Elisabeth Vigée-Lebrun à Rosa Bonheur.* Lacoste: Musée Despiau-Wlerick et Dubalen Mont-de-Marsan, 1981. Includes a bibliography.

3865 MOWBRAY, JOANNA (1955–)
English abstract sculptor.

Other Sources

Dunford, Penny. *A Biographical Dictionary of Women Artists in Europe and America since 1850.* Hemel Hempstead: Harvester Wheatsheaf and Philadelphia: University of Pennsylvania Press, 1990. Contains a bibliography.

3866 MUKHINA, VERA IGNATEVNA (1889–1953)
Latvian sculptor who was orphaned at 13 and brought up in Russia; she produced figures and portrait busts and received many honours in the Soviet Union.

Main Sources

Yablonskaya, Miuda. *Women Artists of Russia's New Age, 1900–1935.* Ed. and trans. Anthony Parton. New York: Rizzoli & London: Thames and Hudson, 1990. Contains a chapter on each artist, while notes and an individual bibliography provide access to material in Russian.

Exhibitions

Art and Power: Images of the 1930s. London: Hayward Gallery, 1996, 60pp., illus.

Other Sources

Dunford, Penny. *A Biographical Dictionary of Women Artists in Europe and America since 1850.* Hemel Hempstead: Harvester Wheatsheaf and Philadelphia: University of Pennsylvania Press, 1990. Contains a bibliography.
Mandel, W. *Soviet Women.* New York: Anchor Books, 1976.
Milner, John. *A Dictionary of Russian and Soviet Artists, 1420–1970.* Woodbridge: Antique Collectors Club, 1993.

3867 NETZ-PAULIK, LILO (1922–)
German sculptor whose work is sometimes sited in public spaces.

Other Sources

Evers, Ulrike. *Deutsche Künstlerinnen des 20. Jahrhunderts. Malerei— Bildhauerei—Tapisserie.* Hamburg: Ludwig Schultheis Verlag, 1983. Contains an individual bibliography.

3868 NEY, ELIZABET (née FRANZISCA BERNARDINA WILHELMINA ELIZABET NEY) (1833–1907)
German sculptor of literary, historical and mythological figures and portraits who worked in America from 1870.

Main Sources

Cutrer, E. *The Art of the Woman: The Life and Work of Elizabet Ney.* Nebraska, 1988.
Fortune, J., and J. Burton. *Elizabet Ney.* New York: 1943.
Goar, M. *Marble Dust: The Life of Elizabet Ney. An Interpretation.* Austin, 1984.

Exhibitions

There is an Elizabet Ney Museum at Austin, Texas.

Other Sources

Bachmann, Donna, and Sherry Piland. *Women Artists: A Historical, Contemporary and Feminist Bibliography.* Metuchen, N.J.: Scarecrow Press, 1978.

Dunford, Penny. *A Biographical Dictionary of Women Artists in Europe and America since 1850.* Hemel Hempstead: Harvester Wheatsheaf and Philadelphia: University of Pennsylvania Press, 1990. Contains a bibliography.

Garrihy, A., and Pamela Gerrish Nunn. "Woman, Sculpture and Heroism in the 19th Century." *Feminist Art News* 2, no. 2 (May 1985): 14–18.

Rubinstein, Charlotte. *American Women Artists from Early Indian Times to the Present Day.* Boston: G. K. Hall, 1982.

3869 O'CONNELL, DEIDRE (1956–)
 Irish sculptor.

Exhibitions

Irish Women Artists from the Eighteenth Century to the Present Day. Dublin: National Gallery of Ireland, Douglas Hyde Gallery and Hugh Lane Gallery, 1987.

3870 OPPENHEIM, MERET (1913–1985)
 Swiss Surrealist sculptor and installation artist.

Main Sources

Chadwick, Whitney. *Women Artists of Surrealism.* London: Thames and Hudson, 1985.

Hubert, Renée Riese. *Magnifying Mirrors: Women, Surrealism and Partnership.* Lincoln and London: University of Nebraska Press, 1994, pp. 63–86. Discusses the nature of relationships within the Surrealist group and its effect on the productivity of both partners.

Exhibitions

Künstlerinnen International, 1877–1977. Berlin: Schloss Charlottenburg, 1977.

Meret Oppenheim: Arbeiten von 1930–1978. Hamburg: Levy [Gallery], 1978, n.p., mainly illus. Contains a brief introduction.

Vergine, Lea. *L'altra metà dell'avanguardia.* Milan: Mazzotta Editore, 1980. *L'autre moitié de l'avant-garde.* Paris: Des Femmes, 1982.

Meret Oppenheim. Paris: Musée d'Art Moderne de la Ville de Paris, 1984, 83pp., illus. Contains an interview with Oppenheim, several introductory essays, a biographical account, a list of her exhibitions and a bibliography.

Künstlerinnen des 20. Jahrhunderts. Wiesbaden: Museum Wiesbaden in association with Verlag Weber & Weidermeyer GmbH, Kassel, 1990.

Other Sources

Bachmann, Donna, and Sherry Piland. *Women Artists: A Historical, Contemporary and Feminist Bibliography.* Metuchen, N.J.: Scarecrow Press, 1978.

Caws, Mary Ann, Rudolf Kuenzli, and Gwen Raaberg, eds. *Surrealism and Women.* Cambridge, Mass.: MIT Press, 1991.

Dunford, Penny. *A Biographical Dictionary of Women Artists in Europe and America since 1850.* Hemel Hempstead: Harvester Wheatsheaf and Philadelphia: University of Pennsylvania Press, 1990. Contains a bibliography.

3871 ORLOFF, CHANA (1888–1968)
Russian-born figurative sculptor and graphic artist who lived in France and, later, Israel and was influenced by Cubism.

Main Sources

Coutard-Salmon, Germaine. "Chana Orloff." *Le Club français de la médaille,* 81 (1983): 62–66.

Flouquet, P. L. "L'Inquiétude technique et le sens de l'universel dans l'oeuvre de Chana Orloff." *Bâtir* 2 (January 1933): 56–57.

Gamzou, Haim. *Chana Orloff: With memoirs of Orloff on Modigliani, Pascin, Soutine and Georges Kars.* Tel Aviv: Massada, 1951. In Hebrew.

Loucheim, Aline. "Spotlight on Sculptresses: Callery, Hesketh, Orloff." *Art News,* May 1947: 24.

Marcilhac, Felix. *Chana Orloff.* Paris: Editions de l'Amateur, 1991, 319pp., illus. The definitive publication to date on Orloff. Three chronological sections analyse what the author sees as the three phases of her work. The final section consists of a catalogue raisonné of her sculpture. There is also a chronology, a list of exhibitions and a bibliography.

Rey, Robert. "Les portraits sculptés de Madame Chana Orloff." *Art et Décoration* 41 (February 1922): 57–60.

Salmon, André. "Chana Orloff." *L'Art d'aujourd'hui* 5 (1925): 11–14.

Exhibitions

Les femmes artistes modernes. Exposition de peintures, sculptures, 1937. Paris: Buffet & Leclerc, 1937.

Chana Orloff. Paris: Galérie de France, 1946, 5pp., illus.

Gamzou, Haim. *Chana Orloff: Retrospective.* Tel Aviv: Museum of Tel Aviv, 1968, 40 illus. Exhibition of 120 sculptures and 60 drawings. Text in Hebrew and English.

Chana Orloff: sculpture et dessins. Paris: Musée Rodin, 1971, n.p., illus. Introduction by Cécile Goldscheider with three pages of biography, a chronology and a list of exhibitions.

Dufresne, Jean-Luc, and Olivier Messac, eds. *Femmes créatrices des années vingt.* Granville: Musée Richard Anacréon, 1988. Wide-ranging catalogue with a short biographical account on each woman included.

Other Sources

Carandente, Giovanni, ed. *Knaurs Lexikon der moderne Plastik.* Munich & Zurich: Droemersche Verlagsanstalt Th. Knaur Nachf., 1961. Includes an account of the development of her work.

Dunford, Penny. *A Biographical Dictionary of Women Artists in Europe and America since 1850.* Hemel Hempstead: Harvester Wheatsheaf and Philadelphia: University of Pennsylvania Press, 1990. Contains a bibliography.

Edouard-Joseph, R. *Dictionnaire biographique des artistes contemporains, 1910–1930.* Paris: Art et Editions, 1930–1934.

Krichbaum, J., and R. Zondergeld. *Künstlerinnen: von der Antike bis zur Gegenwart.* Cologne: DuMont, 1979.

Mackay, J. *Dictionary of Western Sculptors in Bronze.* Woodbridge: Antique Collectors Club, 1978.

3872 PACHECO, ANA MARIA (1943–)
Brazilian-born figurative sculptor who has worked in England since the mid-1970s.

Main Sources

Hourahan, Shelagh. "The Magic and Theatre of Ana Maria Pacheco." *Women's Art Magazine* 45 (1992): 18–19.

Exhibitions

Women's Images of Men. London: Institute of Contemporary Art, 1980.

3873 PAN, MARTA (1923–)
Hungarian sculptor.

Other Sources

Carandente, Giovanni, ed. *Knaurs Lexikon der moderne Plastik.* Munich & Zurich: Droemersche Verlagsanstalt Th. Knaur Nachf., 1961. Includes an account of the development of her work.

Ceysson, B., et al. *25 ans d'art en France, 1960–1985.* Paris: Larousse, 1986. Includes a select list of exhibitions for each artist.

3874 PAPASPYROU, RENA (1939–)
Greek sculptor.

Exhibitions

Iliopoulou-Rogan, Dora. *Three Generations of Greek Women Artists: Figures, Forms and Personal Myths.* Washington, D.C.: National Museum of Women in the Arts, 1989.

3875 PASTRA, NAUSICA (1920–)
Greek sculptor of geometrical abstract forms.

Exhibitions

Iliopoulou-Rogan, Dora. *Three Generations of Greek Women Artists: Figures, Forms and Personal Myths.* Washington, D.C.: National Museum of Women in the Arts, 1989.
Nausica Pastra. St. Etienne: Academie des Beaux-Arts, 1992, n.p., illus.

3876 PENALBA, ALICIA (1918–1982)
Argentinian-born abstract sculptor who worked in Paris from 1948.

Exhibitions

Alicia Penalba. Ferrara: Gallerie Civiche d'Arte Moderna, 1984, n.p., illus.

Other Sources

Ceysson, B., et al. *25 ans d'art en France, 1960–1985.* Paris: Larousse, 1986. Includes a select list of exhibitions for each artist.

3877 PIFFARD, JEANNE (1892–?)
French sculptor of figures, birds and animals.

Other Sources

Dunford, Penny. *A Biographical Dictionary of Women Artists in Europe and America since 1850.* Hemel Hempstead: Harvester Wheatsheaf and Philadelphia: University of Pennsylvania Press, 1990. Contains a bibliography.
Edouard-Joseph, R. *Dictionnaire biographique des artistes contemporains, 1910–1930.* Paris: Art et Editions, 1930–1934.
Mackay, J. *Dictionary of Western Sculptors in Bronze.* Woodbridge: Antique Collectors Club, 1978.

3878 PINIŃSKA-BEREŠ, MARIA (1931–)
Polish sculptor.

Exhibitions

Morawińska, Agnieszka. *Voices of Freedom: Polish Women Artists of the Avant-garde, 1880–1990.* Washington, D.C.: National Museum of Women in the Arts, 1991. Includes a list of her main exhibitions and a bibliography.

3879 PLUHAR, INGEBORG (1944–)
 Austrian sculptor.

Exhibitions

Ingeborg G. Pluhar. Roland Goeschl. 1963–1966. Vienna: Atelier beim Ambrosi-Museum, 1994, 90pp., illus. Contains a list of exhibitions and a bibliography. Goeschl is her husband.

3880 PONCHELET, MARIE (1940–)
 French sculptor and performance and installation artist.

See Performance and Video Art, Mixed Media and Installations section.

3881 POUPELET, JANE (1878–1932)
 French sculptor of figures (especially women) and of animals.

Exhibitions

Les femmes artistes modernes. Exposition de peintures, sculptures, 1937. Paris: Buffet & Leclerc, 1937. She was amongst the recently deceased members who were included.

Dufresne, Jean-Luc, and Olivier Messac, eds. *Femmes créatrices des années vingt.* Granville: Musée Richard Anacréon, 1988. Wide-ranging catalogue with a short biographical account on each woman included.

Other Sources

Dunford, Penny. *A Biographical Dictionary of Women Artists in Europe and America since 1850.* Hemel Hempstead: Harvester Wheatsheaf and Philadelphia: University of Pennsylvania Press, 1990. Contains a bibliography.

Edouard-Joseph, R. *Dictionnaire biographique des artistes contemporains, 1910–1930.* Paris: Art et Editions, 1930–1934.

Mackay, J. *Dictionary of Western Sculptors in Bronze.* Woodbridge: Antique Collectors Club, 1978.

3882 PRAEGER, ROSAMUND (née SOPHIA ROSAMUND) (1867–1954)
 Irish botanical painter and sculptor who became President of the Royal Ulster Academy.

See Painting section.

3883 PRAX, VALENTINE (Alt. ZADKINE) (1899–1981)
 French sculptor.

Exhibitions

Dufresne, Jean-Luc, and Olivier Messac, eds. *Femmes créatrices des années vingt.* Granville: Musée Richard Anacréon, 1988. Wide-ranging catalogue with a short biographical account on each woman included.

3884 PROTTI, LUISA (1960–)
Italian sculptor.

Exhibitions

Vescovo, Marisa. *Il Gioco delle Parti. 4 Biennale Donna.* Ferrara: Padiglione d'Arte Contemporanea, Palazzo Massari, 1990.

3885 PRUSSOG-JAHN, LUCIE (1900–)
German sculptor who took as her main subject the situation of the working classes.

Exhibitions

Meskimmon, Marsha. *Domesticity and Dissent: The Role of Women Artists in Germany 1918–1938. Haüsliches Leben und Dissens.* Leicester: Leicestershire Museums Publication no. 120, 1992.

3886 PULLINEN, LAILA (1933–)
Finnish sculptor of abstract works in which she often combines different materials.

Publications

With Liehu, Rakel. *Laila Pullinen.* Helsingfors: Förgsaktiebolaget Otava, 1994, n.p., mainly illus. Text in Swedish and Finnish. Produced in conjunction with an exhibition in the Konsthall at Helsingfors.

Other Sources

Dunford, Penny. *A Biographical Dictionary of Women Artists in Europe and America since 1850.* Hemel Hempstead: Harvester Wheatsheaf and Philadelphia: University of Pennsylvania Press, 1990. Contains a bibliography.

Schildt, G. *Modern Finnish Sculpture.* London: Weidenfeld & Nicholson, 1970.

3887 PYLKKAENEN, HELENA (1945–)
Finnish sculptor.

Exhibitions

Akt 83: suomalaista nykytaidetta. Helsinki: Ateneum, 1983.

3888 QUERNER, URSULA (1921–1969)
German figurative sculptor.

Exhibitions

Ursula Querner, 1921–1969. Hamburg: Museum für Kunst und Gewerbe, 1970, n.p., illus. Memorial exhibition.

Other Sources

Dunford, Penny. *A Biographical Dictionary of Women Artists in Europe and America since 1850.* Hemel Hempstead: Harvester Wheatsheaf and Philadelphia: University of Pennsylvania Press, 1990. Contains a bibliography.
Krichbaum, J., and R. Zondergeld. *Künstlerinnen: von der Antike bis zur Gegenwart.* Cologne: DuMont, 1979.

3889 RAPHAEL, ANTONIETTA (Alt. RAPHAEL MAFAI) (1895/1900–1975)
Lithuanian-born painter and sculptor who studied in England and worked in Italy from c. 1925.

See Painting section.

3890 RAPIN, AIMÉE (c. 1860–?)
Swiss painter of portraits and sculptor of bas-reliefs who worked with her feet.

Other Sources

Clement, Clara. *Women in the Fine Arts.* Boston: Houghton Mifflin, 1904.
Dunford, Penny. *A Biographical Dictionary of Women Artists in Europe and America since 1850.* Hemel Hempstead: Harvester Wheatsheaf and Philadelphia: University of Pennsylvania Press, 1990. Contains a bibliography.

3891 REA, BETTY (née BEVAN) (1904–1965)
English figurative sculptor.

Exhibitions

Deepwell, Katy. *Ten Decades: Careers of Ten Women Artists born 1897–1906.* Norwich: Norwich Gallery, Norfolk Institute of Art and Design, 1992.

Other Sources

Dunford, Penny. *A Biographical Dictionary of Women Artists in Europe and America since 1850.* Hemel Hempstead: Harvester Wheatsheaf and Philadelphia: University of Pennsylvania Press, 1990. Contains a bibliography.

3892 REGINA (née REGINA PRASSEDE CASSOLO; alt. BRACCHI) (1894–1974)
Italian Futurist sculptor.

Exhibitions

Anni trenta: arte e cultura in Italia. Milan: Comune di Milano in association with Mazzotta Editore, 1982.

Vergine, Lea. *L'altra metà dell'avanguardia.* Milan: Mazzotta Editore, 1980. *L'autre moitié de l'avant-garde.* Paris: Des Femmes, 1982.

Other Sources

Dunford, Penny. *A Biographical Dictionary of Women Artists in Europe and America since 1850.* Hemel Hempstead: Harvester Wheatsheaf and Philadelphia: University of Pennsylvania Press, 1990. Contains a bibliography.

Katz, M. "The Women of Futurism." *Woman's Art Journal* 7, no. 2 (fall 1986–winter 1987): 3–13.

Weller, Simone. *Il Complesso di Michelangelo: ricerca sul contributo dato dalla donna all'arte italiana del novecento.* Pollenza-Macerata: La Nuova Foglio [*sic*] Editrice, 1976.

3893 RICHIER, GERMAINE (1904–1959)
French sculptor of Existential figures and menacing insect forms.

Main Sources

Gale, Ian. "Inside the Bronze Menagerie." *The Independent,* 8 June 1993, 19. Discusses the development of Richier's work in the context of a visit to her studio.

Exhibitions

Paris 1937–Paris 1957: créations en France. Paris: Centre national d'art et de culture Georges Pompidou, 1981.

Dufresne, Jean-Luc, and Olivier Messac, eds. *Femmes créatrices des années vingt.* Granville: Musée Richard Anacréon, 1988. Wide-ranging catalogue with a short biographical account on each woman included.

Künstlerinnen des 20. Jahrhunderts. Wiesbaden: Museum Wiesbaden in association with Verlag Weber & Weidermeyer GmbH, Kassel, 1990.

Sassen, Jan Hein, ed. *A Century of Sculpture.* Amsterdam: Stedelijk Museum, 1992.

Prat, Jean-Louis. *Germaine Richier.* Venice: Fondazione Maeght, 1996.

Other Sources

Bachmann, Donna, and Sherry Piland. *Women Artists: A Historical, Contemporary and Feminist Bibliography.* Metuchen, N.J.: Scarecrow Press, 1978.

Carandente, Giovanni, ed. *Knaurs Lexikon der moderne Plastik.* Munich &

Zurich: Droemersche Verlagsanstalt Th. Knaur Nachf., 1961. Includes an account of the development of her work.

Ceysson, B., et al. *25 ans d'art en France, 1960–1985.* Paris: Larousse, 1986. Includes a select list of exhibitions for each artist.

Dunford, Penny. *A Biographical Dictionary of Women Artists in Europe and America since 1850.* Hemel Hempstead: Harvester Wheatsheaf and Philadelphia: University of Pennsylvania Press, 1990. Contains a bibliography.

Mackay, J. *Dictionary of Western Sculptors in Bronze.* Woodbridge: Antique Collectors Club, 1978.

Tufts, Eleanor. *Our Hidden Heritage: Five Centuries of Women Artists,* New York and London: Paddington Press, 1974.

Uglow, Jennifer. *Macmillan Dictionary of Women's Biography.* London: Macmillan, 1982.

3894 RIES, THÉRÈSE FEODOROVNA (1874–?)

Russian sculptor of figures and portrait busts who worked in Austria.

Other Sources

"Studio Talk." *Studio* 17 (1899): 127–128.

Clement, Clara. *Women in the Fine Arts.* Boston: Houghton Mifflin, 1904.

Dunford, Penny. *A Biographical Dictionary of Women Artists in Europe and America since 1850.* Hemel Hempstead: Harvester Wheatsheaf and Philadelphia: University of Pennsylvania Press, 1990. Contains a bibliography.

Mackay, J. *Dictionary of Western Sculptors in Bronze.* Woodbridge: Antique Collectors Club, 1978.

3895 ROEDER, EMY (1890–1971)

German sculptor of portraits, animals and figures.

Exhibitions

Gleisberg, D. *Deutsche Künstlerinnen des zwanzigsten Jahrhunderts.* Altenburg: Staatlichen Lindendau Museum, 1963.

Das Verborgene Museum. Dokumentation der Kunst von Frauen in Berliner öffentlichen Sammlungen. Berlin: Edition Hentrich, 1987.

Barron, Stephanie. *Degenerate Art: The Fate of the Avant-Garde in Nazi Germany.* Los Angeles: County Museum of Art in association with H. Abrams, New York, 1991.

Meskimmon, Marsha. *Domesticity and Dissent: The Role of Women Artists in Germany 1918–1938. Haüsliches Leben und Dissens.* Leicester: Leicestershire Museums Publication no. 120, 1992.

Other Sources

Carandente, Giovanni, ed. *Knaurs Lexikon der moderne Plastik.* Munich & Zurich: Droemersche Verlagsanstalt Th. Knaur Nachf., 1961. Includes an account of the development of her work.

Dunford, Penny. *A Biographical Dictionary of Women Artists in Europe and America since 1850.* Hemel Hempstead: Harvester Wheatsheaf and Philadelphia: University of Pennsylvania Press, 1990. Contains a bibliography.

Evers, Ulrike. *Deutsche Künstlerinnen des 20. Jahrhunderts. Malerei—Bildhauerei—Tapisserie.* Hamburg: Ludwig Schultheis Verlag, 1983. Contains an individual bibliography.

Krichbaum, J., and R. Zondergeld. *Künstlerinnen: von der Antike bis zur Gegenwart.* Cologne: DuMont, 1979.

Mackay, J. *Dictionary of Western Sculptors in Bronze.* Woodbridge: Antique Collectors Club, 1978.

Meskimmon, Marsha, and Shearer West. *Visions of the 'Neue Frau': Women and the Visual Arts in Weimar Germany.* London: Scolar Press, 1995.

3896 ROPE, ELLEN MARY (1855–1934)

English sculptor particularly of relief work and in architectural schemes.

Main Sources

A. F. "The Art Movement: The Work of Miss Ellen M. Rope." *Magazine of Art,* 1900, 323–326.

Kendall, B. "Miss Ellen Rope: Sculptor." *Artist,* December 1899, 206–212.

Maclean, F. J. "The Art of Ellen Mary Rope." *The Expert,* 13 July 1907, 251–252.

Other Sources

Beattie, Susan. *The New Sculpture.* New Haven and London: Yale University Press, 1982.

Clement, Clara. *Women in the Fine Arts.* Boston: Houghton Mifflin, 1904.

Dunford, Penny. *A Biographical Dictionary of Women Artists in Europe and America since 1850.* Hemel Hempstead: Harvester Wheatsheaf and Philadelphia: University of Pennsylvania Press, 1990. Contains a bibliography.

Spielmann, Marion Harry. *British Sculpture and Sculptors of Today.* London, 1901.

3897 ROSA, ROSÁ (Pseudonym of EDITH VON HAYNAU; alt. ARNALDI) (1884–after 1980)

Austrian painter, graphic artist, sculptor, designer of ceramics and poet.

See Painting section.

3898 RUEDA, MARISA (1941–)

Argentinian-born sculptor who has worked in England since 1974.

Exhibitions

Women's Images of Men. London: Institute of Contemporary Art, 1980.

3899 RYAN, VERONICA (1956–)
West Indian-born sculptor working in England who uses natural objects to explore issues of human experience.

Exhibitions

The Thin Black Line. London: Institute of Contemporary Art, 1985.
Veronica Ryan—Sculpture. Bristol: Arnolfini Gallery, 1987.
Veronica Ryan. Manchester: Castlefield Gallery, 1987.

Other Sources

Dunford, Penny. *A Biographical Dictionary of Women Artists in Europe and America since 1850.* Hemel Hempstead: Harvester Wheatsheaf and Philadelphia: University of Pennsylvania Press, 1990. Contains a bibliography.

3900 RYYNÄNEN, EVA (née ASENBRYGG) (1915–)
Finnish sculptor of figures and animals in wood.

Other Sources

Dunford, Penny. *A Biographical Dictionary of Women Artists in Europe and America since 1850.* Hemel Hempstead: Harvester Wheatsheaf and Philadelphia: University of Pennsylvania Press, 1990. Contains a bibliography.

3901 SAMU, KATALIN (1934–)
Hungarian sculptor.

Other Sources

Németh, Lajos. *Modern Art in Hungary.* Budapest: Corvina Press, 1969.

3902 SANTOS, MARIA MANUELA ALMEIDA MADUREIRA DOS (1930–)
Portuguese sculptor and ceramicist.

Other Sources

Tannock, Michael. *Portuguese Artists of the Twentieth Century: A Biographical Dictionary.* Chichester: Phillimore & Co. Ltd., 1988.

3903 SAX, URSULA (1935–)
German abstract sculptor.

Exhibitions

Das Verborgene Museum. Dokumentation der Kunst von Frauen in Berliner öffentlichen Sammlungen. Berlin: Edition Hentrich, 1987.

3904 SCHAÁR, ERZSÉBET (1908–1975)
Hungarian sculptor.

Other Sources

Hárs, Éva, and Ferenc Romváry. *Modern Hungarian Gallery Pécs.* Budapest: Corvina Kiadó, 1981.
Németh, Lajos. *Modern Art in Hungary.* Budapest: Corvina Press, 1969.

3905 SCHAUMANN, RUTH (1899–1975)
German sculptor.

Other Sources

Meskimmon, Marsha, and Shearer West. *Visions of the 'Neue Frau': Women and the Visual Arts in Weimar Germany.* London: Scolar Press, 1995.

3906 SCHÄFFLER-WOLF, INGEBORG (1928–)
German abstract sculptor.

Other Sources

Evers, Ulrike. *Deutsche Künstlerinnen des 20. Jahrhunderts. Malerei—Bildhauerei—Tapisserie.* Hamburg: Ludwig Schultheis Verlag, 1983. Contains an individual bibliography.

3907 SCHOU, HELEN (1905–)
Danish sculptor.

Exhibitions

Friis, Eva. *Kunst under Krigen.* Copenhagen: Statens Museum for Kunst, 1995.

3908 SEEFRIED-MATEJKOVÁ, LUDMILA (1938–)
Czech figurative sculptor who worked in Berlin from the early 1970s.

Exhibitions

Künstlerinnen International, 1877–1977. Berlin: Schloss Charlottenburg, 1977.
Das Verborgene Museum. Dokumentation der Kunst von Frauen in Berliner öffentlichen Sammlungen. Berlin: Edition Hentrich, 1987.

Other Sources

Dunford, Penny. *A Biographical Dictionary of Women Artists in Europe and America since 1850.* Hemel Hempstead: Harvester Wheatsheaf and Philadelphia: University of Pennsylvania Press, 1990. Contains a bibliography.

Evers, Ulrike. *Deutsche Künstlerinnen des 20. Jahrhunderts. Malerei—Bildhauerei—Tapisserie.* Hamburg: Ludwig Schultheis Verlag, 1983. Contains an individual bibliography.

3909 SERRUYS, YVONNE (1873/4–1953)

Belgian sculptor and painter; also a designer of glass. She worked in Belgium and France.

Other Sources

Dictionnaire des Peintres Belges du XIVe siècle à nos jours. Brussels: La Renaissance du Livre, 1995.

Arwas, Victor. *Glass: Art Nouveau to Art Déco.* London: Academy Editions, 1977.

Hilschenz, Helga. *Das Glas von Jugendstils: Katalog der Sammlung Hentrich im Kunstmuseum Düsseldorf.* Munich: Prestel, 1973.

Hammel, Maurice. "Les Salons de 1914: la sculpture." *Les Arts* 150 (1914): 9–13. Illustrates a work of a girl dancing with a scarf; there is a brief mention of the artist.

Maignan, M. "Cours de décoration: cinquième leçon: des concours." *L'Art Décoratif* 27 (1912): 69–76. Serruys is mentioned favourably on pp. 74–75.

3910 SHERIDAN, CLARE (née CLAIRE FREWEN) (1885–1970)

English sculptor especially of portraits, which included Churchill, Lenin and Trotsky.

Publications

To the Four Winds. 1957. Autobiography

Main Sources

Cole, Margaret. *Women of Today.* New York, 1938. Originally published 1938.

Leslie, Anita. *Clare Sheridan.* New York: Doubleday, 1977, 318pp., illus. A detailed and anecdotal biography by Sheridan's second cousin. It describes her rebellion from aristocratic society, her affair with Charlie Chaplin and how she came to sculpt the leaders of the USSR and—almost—Mussolini.

Other Sources

Dunford, Penny. *A Biographical Dictionary of Women Artists in Europe and America since 1850.* Hemel Hempstead: Harvester Wheatsheaf and Philadelphia: University of Pennsylvania Press, 1990. Contains a bibliography.

Mackay, J. *Dictionary of Western Sculptors in Bronze.* Woodbridge: Antique Collectors Club, 1978.

Uglow, Jennifer. *The Macmillan Dictionary of Women's Biography.* London: Macmillan, 1982.

3911 SINTENIS, RENÉE (1888–1965)
German sculptor.

Main Sources

Crevel, René. *Renée Sintenis*. Paris: Gallimard, 63pp., illus.

Exhibitions

Gleisberg, D. *Deutsche Künstlerinnen des zwanzigsten Jahrhunderts.* Attenburg: Staatlichen Lindendau Museum, 1963.
Künstlerinnen International, 1877–1977. Berlin: Schloss Charlottenburg, 1977.
Das Verborgene Museum. Dokumentation der Kunst von Frauen in Berliner öffentlichen Sammlungen. Berlin: Edition Hentrich, 1987.
Meskimmon, Marsha. *Domesticity and Dissent: The Role of Women Artists in Germany 1918–1938. Haüsliches Leben und Dissens.* Leicester: Leicestershire Museums Publication no. 120, 1992.

Other Sources

Carandente, Giovanni, ed. *Knaurs Lexikon der moderne Plastik.* Munich & Zurich: Droemersche Verlagsanstalt Th. Knaur Nachf., 1961. Includes an account of the development of her work.
Evers, Ulrike. *Deutsche Künstlerinnen des 20. Jahrhunderts. Malerei—Bildhauerei—Tapisserie.* Hamburg: Ludwig Schultheis Verlag, 1983. Contains an individual bibliography.
Meskimmon, Marsha, and Shearer West. *Visions of the 'Neue Frau': Women and the Visual Arts in Weimar Germany.* London: Scolar Press, 1995.
Schauer, Georg. *Deutsche Buchkunst 1890 bis 1960.* Hamburg: Maximilian-Gesellschaft, 1963.

3912 SPITERIS, JEANNE (1922–)
Greek sculptor.

Other Sources

Carandente, Giovanni, ed. *Knaurs Lexikon der moderne Plastik.* Munich & Zurich: Droemersche Verlagsanstalt Th. Knaur Nachf., 1961. Includes an account of the development of her work.

3913 SQUATRITI, FAUSTA (1941–)
Italian abstract sculptor.

Exhibitions

Pasquali, Marilena. *Figure dallo sfondo.* Ferrara: Padiglione d'Arte Contemporanea and Grafis Editore, 1984.

Vescovo, Marisa. *Il Gioco delle Parti. 4 Biennale Donna.* Ferrara: Padiglione d'Arte Contemporanea, Palazzo Massari, 1990.

Other Sources

Weller, Simone. *Il Complesso di Michelangelo: ricerca sul contributo dato dalla donna all'arte italiana del novecento.* Pollenza-Macerata: La Nuova Foglio [*sic*] Editrice, 1976.

3914 STAEGER, MILLY (Alt. STEGER) (1881–1948)
German sculptor.

Main Sources

Stonge, Carmen. "Ida Gerhardt, Milly Steger and Maria Slavona." *Woman's Art Journal* 15, no. 1 (spring–summer 1994): 3–10.

Exhibitions

Gleisberg, D. *Deutsche Künstlerinnen des zwanzigsten Jahrhunderts.* Attenburg: Staatlichen Lindendau Museum, 1963.
 Das Verborgene Museum. Dokumentation der Kunst von Frauen in Berliner öffentlichen Sammlungen. Berlin: Edition Hentrich, 1987.

Other Sources

Evers, Ulrike. *Deutsche Künstlerinnen des 20. Jahrhunderts. Malerei—Bildhauerei—Tapisserie.* Hamburg: Ludwig Schultheis Verlag, 1983. Contains an individual bibliography.
 Meskimmon, Marsha, and Shearer West. *Visions of the 'Neue Frau': Women and the Visual Arts in Weimar Germany.* London: Scolar Press, 1995.

3915 SYAMOUR, MARGUERITE (née GEGOUT-GAGNEUR) (1861–?)
French sculptor of mythological and allegorical figures and groups.

Main Sources

Lamers de Vits, Maria. *Les femmes sculpteurs et graveurs et leurs oeuvres.* Paris: Référendum Littéraire, 1905. Lists her works in public collections and museums.

Other Sources

Clement, Clara. *Women in the Fine Arts.* Boston: Houghton Mifflin, 1904.
 Dunford, Penny. *A Biographical Dictionary of Women Artists in Europe and America since 1850.* Hemel Hempstead: Harvester Wheatsheaf and Philadelphia: University of Pennsylvania Press, 1990. Contains a bibliography.
 Kjellberg, Pierre. *Les bronzes du XIXe siècle: dictionnaire des sculpteurs.* Paris: Editions de l'Amateur, 1987.

Mackay, J. *Dictionary of Western Sculptors in Bronze.* Woodbridge: Antique Collectors Club, 1978.

Martin, Jules. *Nos peintres et sculpteurs, graveurs et dessinateurs.* Paris, 1897.

3916 SZAPOCZINIKOW, ALINA (1926–1973)

Polish sculptor who worked in Paris from the 1950s.

Exhibitions

Restany, Pierre. *Alina Szapocznikow.* Paris: Musée d'Art Moderne de la Ville de Paris, 1973. Retrospective exhibition.

Présences Polonaises. L'Art vivant autour du Musee Łodz. Paris: Centre national d'art et de culture Georges Pompidou, 1983.

Morawińska, Agnieszka. *Voices of Freedom: Polish Women Artists of the Avant-garde, 1880–1990.* Washington, D.C.: National Museum of Women in the Arts, 1991. Includes a list of her main exhibitions and a bibliography.

Other Sources

Ceysson, B., et al. *25 ans d'art en France, 1960–1985.* Paris: Larousse, 1986. Includes a select list of exhibitions for each artist.

3917 TAEUBER, SOPHIE HENRIETTE (Alt. TAEUBER-ARP) (1899–1943)

Swiss artist who produced geometrical constructivist compositions in painting and sculpture. She began by studying textile design and worked in several media, including performance for the Dada group in Zurich.

Main Sources

Hubert, Renée Riese. *Magnifying Mirrors: Women, Surrealism and Partnership.* Lincoln and London: University of Nebraska Press, 1994, pp. 31–62. Discusses the nature of relationships within the Surrealist group and its effect on the productivity of both partners.

Marter, Joan. "Three Women Artists Married to Early Modernists." *Arts Magazine* 54 (1979): 88–95.

Scheidegoer, Ernst. *Zweiklang: Sophie Taeuber-Arp, Hans Arp.* Zurich: Sammlung Horizont, 1960.

Staber, Margit. *Sophie Taeuber-Arp.* Lausanne: Editions Rencontre, 1970, 128pp., illus.

Exhibitions

Sophie Tauber-Art. Paris: Centre Nationale d'Art et de Culture Georges Pompidou, 1964, 67pp., illus. Contains a series of short reminiscences of the artists by Jean Arp and Hugo Ball, poems written for her by Arp and Paul Eluard and two passages written by Taeuber-Arp.

Abstraction-Création 1931–1936. Paris: Musée d'Art Moderne de la Ville de Paris, 1976.

Harris, Anne Sutherland, and Linda Nochlin. *Women Artists 1550–1950.* Los Angeles: County Museum of Art, 1976.

Sophie Taeuber-Arp. Strasbourg: Musée d'Art Moderne in association with Imprimérie des Dernières Nouvelles, 1977, 54pp., illus.

Paris 1937–Paris 1957: créations en France. Paris: Centre Nationale d'Art et de Culture Georges Pompidou, 1981.

Lancher, Carolyn. *Sophie Taeuber-Arp.* New York: Museum of Modern Art, 1981, 53pp., illus.

Vergine, Lea. *L'altra metà dell'avanguardia.* Milan: Mazzotta Editore, 1980. *L'autre moitié de l'avante-garde.* Paris: Des Femmes, 1982.

Bollinger, Hans, Guido Magnaguango, and Raymond Meyer. *Dada in Zurich.* Zurich: Kunsthaus, 1985.

Sophie Taeuber-Arp: Reliefs, Collagen, Gouachen, Zeichnungen. St. Gallen: Erker Galerie, 1985, 18pp., illus.

Kuthy, Sandor, ed. *Sophie Taeuber-Hans Arp: Kunstlerpaare, Kunstlerf Dialogues d'artistes, résonances.* Bern: Rolandsech Kunstmuseum, 1988, 171pp., illus. One of a series of exhibitions on artist couples. Contains a bibliography.

Sophie Taeuber-Arp. Paris: Musée d'Art Moderne de la Ville de Paris, 1989, 142pp., illus.

Künstlerinnen des 20. Jahrhunderts. Wiesbaden: Museum Wiesbaden in association with Verlag Weber & Weidermeyer GmbH, Kassel, 1990.

Sophie Taeuber-Arp, 1889–1943; Jean Arp, 1887–1966. Dresden: Albertinum, 1994, 167pp., illus. Contains an extensive bibliography.

Gohr, Sirgfried, ed. *Sophie Taeuber-Arp, 1889–1943.* Tübingen: Kunsthalle in association with Hatje Verlag, Stuttgart, 1993, 175pp., illus.

Bois, Yves-Alain. "Sophie Taeuber Arp against Greatness." In *Inside the Visible: An Elliptical View of 20th Century Art—In, Of and From the Feminine,* ed. Catherine de Zehgher. Ghent: The Kanaal Foundation, 1996.

Other Sources

Bachmann, Donna, and Sherry Piland. *Women Artists: A Historical Contemporary and Feminist Bibliography.* Metuchen, N.J.: Scarecrow Press, 1978.

Dunford, Penny. *A Biographical Dictionary of Women Artists in Europe and America since 1850.* Hemel Hempstead: Harvester Wheatsheaf and Philadelphia: University of Pennsylvania Press, 1990. Contains a bibliography.

3918 TAYLOR, WENDY
 English sculptor.

Main Sources

Lucie-Smith, Edward. *Wendy Taylor.* London: Art Books International, 1992, 139pp., many illus. Chronicles the first twenty-five years of her career. Includes a chronological catalogue of works and a list of her commissions.

Exhibitions

Hayward Annual 1978. London: Hayward Gallery, 1978.

3919 THORNYCROFT, ALYCE MARY (née ALICE) (1844–1906)
English painter and sculptor of figurative, often literary subjects; daughter of Mary and sister of Helen and Theresa (qq.v.).

See under Mary Thornycroft

3920 THORNYCROFT, MARY (née FRANCIS) (1809–1895)
English sculptor of figures and groups who carried out many commissions for the Royal family; mother of Alyce, Helen and Theresa (qq.v.).

Main Sources

"Industry. From the Statue by Mrs Thornycroft." *Art Journal,* 1861, 56.
"The Skipping Rope. From the Statue by Mrs Thornycroft." *Art Journal,* 1861, 125.
McCracken, Penny. "Sculptor Mary Thornycroft and Her Artist Children." *Woman's Art Journal* 17, no. 2 (fall 1996–winter 1997): 3–8.
Manning, Elfrida. *Bronze and Steel: The Art and Life of Thomas Thornycroft.* Shipton-on-Stour: Privately published, 1932. A biographical account by his granddaughter.
Manning, Elfrida. *Marble and Bronze: The Art and Life of Hamo Thornycroft.* London: Trefoil Books, 1982. A biographical account by Hamo's daughter which includes material on his mother Mary and sisters Alyce, Helen and Theresa.
Stephens, F. G. "The Late Mrs Mary Thornycroft." *Magazine of Art,* June 1895, 305–307. Obituary.

Exhibitions

Women's Art Show, 1550–1970. Nottingham: Castle Museum, 1982. Contains a brief biography.

Other Sources

Dunford, Penny. *A Biographical Dictionary of Women Artists in Europe and America since 1850.* Hemel Hempstead: Harvester Wheatsheaf and Philadelphia: University of Pennsylvania Press, 1990. Contains a bibliography.
Nunn, Pamela Gerrish. *Victorian Women Artists.* London: Women's Press, 1987.
Yeldham, Charlotte. *Women Artists in Nineteenth Century France and England.* London and New York: Garland, 1984.

3921 TOSI, FRANCA (c. 1931–)
Italian abstract sculptor.

Other Sources

Weller, Simone. *Il Complesso di Michelangelo: ricerca sul contributo dato dalla donna all'arte italiana del novecento.* Pollenza-Macerata: La Nuova Foglio [*sic*] Editrice, 1976.

3922 TURNER, WINIFRED (1903–1983)
 English figurative sculptor.

Exhibitions

Penny, Nicholas. *Alfred and Winifred Turner.* Oxford: Ashmolean Museum, 1988, 63pp., illus. Consists of a detailed scholarly analysis of her work.

Other Sources

Dunford, Penny. *A Biographical Dictionary of Women Artists in Europe and America since 1850.* Hemel Hempstead: Harvester Wheatsheaf and Philadelphia: University of Pennsylvania Press, 1990. Contains a bibliography.

3923 URSULA (Pseudonym of URSULA SCHULTZE-BLUHM) (1921–)
 German painter, sculptor and mixed media artist.

Other Sources

Evers, Ulrike. *Deutsche Künstlerinnen des 20. Jahrhunderts. Malerei—Bildhauerei—Tapisserie.* Hamburg: Ludwig Schultheis Verlag, 1983. Contains an extensive individual bibliography.

3924 UZÈS, ANNE DUCHESS OF (née DE MORTEMART) (1847–1933)
 French sculptor.

Exhibitions

Dufresne, Jean-Luc, and Olivier Messac, eds. *Femmes créatrices des années vingt.* Granville: Musée Richard Anacréon, 1988.

Other Sources

Clement, Clara. *Women in the Fine Arts.* Boston: Houghton Mifflin, 1904.
Ellet, Elizabeth. *Women Artists in all Ages and Countries.* New York: Harper and Brothers Co., 1859, 377pp.
Martin, Jules. *Nos peintres et sculpteurs, graveurs et dessinateurs.* Paris, 1897.

3925 VAN PALLANDT, CHARLOTTE (1898–)
 Dutch sculptor.

Exhibitions

Sassen, Jan Hein, ed. *A Century of Sculpture.* Amsterdam: Stedelijk Museum, 1992.

3926 VANCHERI, ANNA (c. 1936–)
Italian abstract sculptor.

Other Sources

Weller, Simone. *Il Complesso di Michelangelo: ricerca sul contributo dato dalla donna all'arte italiana del novecento.* Pollenza-Macerata: La Nuova Foglio [*sic*] Editrice, 1976.

3927 VAUTIER, RENÉE (1908–)
Of Swiss parents, this sculptor was born and lived in France.

Other Sources

Carandente, Giovanni, ed. *Knaurs Lexikon der moderne Plastik.* Munich & Zurich: Droemersche Verlagsanstalt Th. Knaur Nachf., 1961. Includes an account of the development of her work.

3928 VEZELAY, PAULE (Pseudonym of MARGARET WATSON-WILLIAMS) (1892–?)
English abstract painter and sculptor who constructed boxes containing linear wire elements.

See Painting section.

3929 VIGNON, CLAUDE (pseudonym of NOÉMIE CADIOT) (1828–1888)
French sculptor.

Exhibitions

Beaulieu, Germaine, et al. *La femme artiste: d'Elisabeth Vigée-Lebrun à Rosa Bonheur.* Lacoste: Musée Despiau-Wlerick et Dubalen Mont-de-Marsan, 1981. Includes a bibliography.

3930 VON BRUCHHAUSEN, GISELA (1940–)
German sculptor.

Exhibitions

Das Verborgene Museum. Dokumentation der Kunst von Frauen in Berliner öffentlichen Sammlungen. Berlin: Edition Hentrich, 1987.

3931 VON MARTIN, PRISKA (1912–)
German sculptor.

Other Sources

Carandente, Giovanni, ed. *Knaurs Lexikon der moderne Plastik.* Munich & Zurich: Droemersche Verlagsanstalt Th. Knaur Nachf., 1961. Includes an account of the development of her work.

3932 VON RATHLEF-KEILMANN, HARRIET (1888–1933)
German sculptor.

Other Sources

Meskimmon, Marsha, and Shearer West. *Visions of the 'Neue Frau': Women and the Visual Arts in Weimar Germany.* London: Scolar Press, 1995.

3933 VON ZUMBUSCH, NORA EXNER (1879–1915)
Austrian painter, sculptor and graphic artist.

See Graphic Art section.

3934 WALDBERG, ISABELLE (née FARNER) (1911–)
Swiss sculptor of abstract works in metal wire.

Exhibitions

Vergine, Lea. *L'altra metà dell'avanguardia.* Milan: Mazzotta Editore, 1980. *L'autre moitié de l'avant-garde.* Paris: Des Femmes, 1982.

Other Sources

Carandente, Giovanni, ed. *Knaurs Lexikon der moderne Plastik.* Munich & Zurich: Droemersche Verlagsanstalt Th. Knaur Nachf., 1961. Includes an account of the development of her work.
Dunford, Penny. *A Biographical Dictionary of Women Artists in Europe and America since 1850.* Hemel Hempstead: Harvester Wheatsheaf and Philadelphia: University of Pennsylvania Press, 1990. Contains a bibliography.
Krichbaum, J., and R. Zondergeld. *Künstlerinnen: von der Antike bis zur Gegenwart.* Cologne: DuMont, 1979.
Mackay, J. *Dictionary of Western Sculptors in Bronze.* Woodbridge: Antique Collectors Club, 1978.

3935 WALLACE, OTTILIE (née McLAREN) (1875–1947)
Scottish sculptor, particularly of war memorials.

Other Sources

Dunford, Penny. *A Biographical Dictionary of Women Artists in Europe and America since 1850.* Hemel Hempstead: Harvester Wheatsheaf and Philadelphia: University of Pennsylvania Press, 1990. Contains a bibliography.

3936 WALSH, LOUISE (1962–)
Irish sculptor who examines women's traditional roles in her work.

Exhibitions

Irish Women Artists from the Eighteenth Century to the Present Day. Dublin: National Gallery of Ireland, Douglas Hyde Gallery and Hugh Lane Gallery, 1987.

Other Sources

Dunford, Penny. *A Biographical Dictionary of Women Artists in Europe and America since 1850*. Hemel Hempstead: Harvester Wheatsheaf and Philadelphia: University of Pennsylvania Press, 1990. Contains a bibliography.

3937 WALTON, CECILE (1891–1956)
Scottish painter, sculptor and illustrator of figurative subjects.

Main Sources

Stephens, J. "Cecile Walton and Dorothy Johnstone." *Studio* 94 (1924): 80–84.

Exhibitions

Sellars, Jane. *Women's Works*. Liverpool: Walker Art Gallery, 1988.
The Last Romantics: The Romantic Tradition in British Art: Burne-Jones to Stanley Spencer. London: Barbican Gallery, 1989.

Other Sources

Dunford, Penny. *A Biographical Dictionary of Women Artists in Europe and America since 1850*. Hemel Hempstead: Harvester Wheatsheaf and Philadelphia: University of Pennsylvania Press, 1990. Contains a bibliography.
Waters, Grant. *Dictionary of British Artists Working 1900–1940*. Eastbourne: Eastbourne Fine Art, 1975.

3938 WATSON, MARY SPENCER (1913–)
English sculptor of figures and animals.

Exhibitions

Read, Benedict, and Peyton Skipwith. *British Sculpture Between the Wars*. London: Fine Art Society, 1986.
Compton, Susan. *Mary Spencer Watson: Sculptor*. Dorchester: Dorset County Museum, 1991, n.p., illus. Contains the fullest account of her life and work.

Other Sources

Dunford, Penny. *A Biographical Dictionary of Women Artists in Europe and America since 1850*. Hemel Hempstead: Harvester Wheatsheaf and Philadelphia: University of Pennsylvania Press, 1990. Contains a bibliography.
Mackay, J. *Dictionary of Western Sculptors in Bronze*. Woodbridge: Antique Collectors Club, 1978.

Waters, Grant. *Dictionary of British Artists Working 1900–1940.* Eastbourne: Eastbourne Fine Art, 1975.

3939 WEJCHERT, ALEXANDRA (1920–)
Polish-born painter, architect and sculptor of abstract works who lives in Ireland.

Exhibitions

Irish Women Artists from the Eighteenth Century to the Present Day. Dublin: National Gallery of Ireland, Douglas Hyde Gallery and Hugh Lane Gallery, 1987.

Other Sources

Dunford, Penny. *A Biographical Dictionary of Women Artists in Europe and America since 1850.* Hemel Hempstead: Harvester Wheatsheaf and Philadelphia: University of Pennsylvania Press, 1990. Contains a bibliography.

3940 WESTHOFF, CLARA (Alt. RILKE; RILKE-WESTHOFF) (1878–1954)
German sculptor who later turned to painting.

Exhibitions

Sauer, M. *Die Bildhauerin Clara Rilke-Westhoff—Leben und Werk.* Bremen, 1987.
Other Sources

Dunford, Penny. *A Biographical Dictionary of Women Artists in Europe and America since 1850.* Hemel Hempstead: Harvester Wheatsheaf and Philadelphia: University of Pennsylvania Press, 1990. Contains a bibliography.
Evers, Ulrike. *Deutsche Künstlerinnen des 20. Jahrhunderts. Malerei—Bildhauerei—Tapisserie.* Hamburg: Ludwig Schultheis Verlag, 1983. Contains an individual bibliography.
Krichbaum, J., and R. Zondergeld. *Künstlerinnen: von der Antike bis zur Gegenwart.* Cologne: DuMont, 1979.
Lexikon der Frau. Zurich: Encyclios Verlag, 1953.

3941 WETZEL, GERTRUD ANGELIKA (née PLANCK) (1934–)
German sculptor.

Other Sources

Evers, Ulrike. *Deutsche Künstlerinnen des 20. Jahrhunderts. Malerei—Bildhauerei—Tapisserie.* Hamburg: Ludwig Schultheis Verlag, 1983. Contains an individual bibliography.

3942 WHITEREAD, RACHEL (1963–)
English sculptor who works in London and Germany.

Publications

See Meschede below.

Main Sources

Choon, Angela. "Rebels of the Realm." *Art and Antiques* 17 (1994): 56–63. Discusses Whiteread before looking at the work of several other women mixed media artists.

Graham-Dixon, Andrew. "This is the House that Rachel Built." *The Independent,* 2 November 1993, 25. Discusses Whiteread's *House*, a temporary piece of public sculpture which aroused considerable debate.

Lingwood, James. *House: Rachel Whiteread.* London: Phaidon in association with Arcangel, 1995, 144pp., illus.

Exhibitions

Rachel Whiteread. Einhoven: Stedelijk Van Abbemuseum, 1992, 52pp., illus.

Rachel Whiteread: Plaster Sculptures. London: Karsten Schubert Gallery, 1993, 55pp., illus.

Meschede, Friedrich. *Rachel Whiteread: Gouachen—Gouaches.* Stuttgart: Cantz in association with the Daad-Galerie, 1993, 95pp., illus. Text in German and English. Contains an essay on the substantiality of the drawing in the works exhibited and a full bibliography, including her publications.

Rachel Whiteread: Shedding Life. Liverpool: Tate Gallery, 1996, 112pp., illus. Consists of four scholarly essays which analyse her work.

3943 WICKY-DOYER, LYSBETH (1906–)
 Dutch sculptor.

Other Sources

Carandente, Giovanni, ed. *Knaurs Lexikon der moderne Plastik.* Munich & Zurich: Droemersche Verlagsanstalt Th. Knaur Nachf., 1961. Includes an account of the development of her work.

3944 WIEGMANN, JENNY (Alt. MUCCHI-WIEGMANN; WIEGMANN-MUCCHI) (1895–1969)
 German figurative sculptor whose themes were mainly religious but increasingly derived from social history; she lived in Italy from c. 1933.

Exhibitions

Vergine, Lea. *L'altra metà dell'avanguardia.* Milan: Mazzotta Editore, 1980. *L'autre moitié de l'avant-garde.* Paris: Des Femmes, 1982.

Das Verborgene Museum. Dokumentation der Kunst von Frauen in Berliner öffentlichen Sammlungen. Berlin: Edition Hentrich, 1987.

Meskimmon, Marsha. *Domesticity and Dissent: The Role of Women Artists in*

Germany 1918–1938. Haüsliches Leben und Dissens. Leicester: Leicestershire Museums Publication no. 120, 1992.
Jenny Wiegmann-Mucchi, 1895–1969. Berlin: Galerie Bodo Niemann, 1992, 40pp., mainly illus. Text in German. Illustrates the work over her whole career and lists all her exhibitions from 1946.

Other Sources

Dunford, Penny. *A Biographical Dictionary of Women Artists in Europe and America since 1850.* Hemel Hempstead: Harvester Wheatsheaf and Philadelphia: University of Pennsylvania Press, 1990. Contains a bibliography.
Edouard-Joseph, R. *Dictionnaire biographique des artistes contemporains, 1910–1930.* Paris: Art et Editions, 1930–1934.
Evers, Ulrike. *Deutsche Künstlerinnen des 20. Jahrhunderts. Malerei—Bildhauerei—Tapisserie.* Hamburg: Ludwig Schultheis Verlag, 1983. Contains an individual bibliography.
Mackay, J. *Dictionary of Western Sculptors in Bronze.* Woodbridge: Antique Collectors Club, 1978.
Meskimmon, Marsha, and Shearer West. *Visions of the 'Neue Frau': Women and the Visual Arts in Weimar Germany.* London: Scolar Press, 1995.
Weller, Simone. *Il Complesso di Michelangelo: ricerca sul contributo dato dalla donna all'arte italiana del novecento.* Pollenza-Macerata: La Nuova Foglio [*sic*] Editrice, 1976.

3945 WILDING, ALISON (1948–)
English sculptor who creates metaphors for states of mind or relationships between objects or people.

Exhibitions

Crighton, F. *Eight Artists: Women.* London: Acme Gallery, 1980.
The Sculpture Show: British Sculpture 1983. London: Hayward Gallery, 1983.
Cooke, L. *Alison Wilding.* London: Serpentine Gallery, 1985, 32pp., illus.
Watson, Gray. *Alison Wilding: Sculptures.* London: Karsten Schubert, 1987, 29pp., mainly illus.
Alison Wilding. Ljubljana, Slovenia: Mala Galerija, 1988, 16pp., illus.
Alison Wilding: Immersion; Exposure. Liverpool: Tate Gallery, 1991, 76pp., mainly illus. Includes an essay and an interview with Wilding.
Bare: Alison Wilding—Sculptures 1982–1993. Newlyn: Newlyn Art Gallery, 1993, 44pp., illus. An essay analyses her work during the period covered by the exhibition and a full list of exhibitions is included.
Echo: Alison Wilding. Nottingham: Angel Row Gallery, 1995, 20pp., illus.

Other Sources

Dunford, Penny. *A Biographical Dictionary of Women Artists in Europe and*

America since 1850. Hemel Hempstead: Harvester Wheatsheaf and Philadelphia: University of Pennsylvania Press, 1990. Contains a bibliography.

Newman, M. "New Sculpture in Britain." *Art in America,* September 1982, 104–114, 177–179.

3946 WILLIAMS, EVELYN (1929–)

English sculptor who often depicts women and whose images at times comment on social problems; she also produces reliefs in papier maché or clay on the surface of her paintings.

Main Sources

Battersby, Christine. "The Female Sublime." *Women's Art Magazine* 58 (1994): 8–11. A shortened version of the catalogue essay in Williams's exhibition *Antimonies* at the University of Warwick.

Beaumont, M. "Evelyn Williams." *Arts Review* 36, no. 15 (3 August 1984): 386.

Cawkwell, Sarah. "Out of the Archive: Evelyn Williams." *Women Artists' Slide Library Journal,* August–September 1988, 18–19.

Exhibitions

Evelyn Williams: A Retrospective Exhibition, 1945–1972. London: Whitechapel Gallery, 1972, n.p., illus. Includes a short essay on her work.

Women's Images of Men. London: Institute of Contemporary Art, 1980.

Evelyn Williams. Birmingham: Ikon Gallery, 1985.

Other Sources

Dunford, Penny. *A Biographical Dictionary of Women Artists in Europe and America since 1850.* Hemel Hempstead: Harvester Wheatsheaf and Philadelphia: University of Pennsylvania Press, 1990. Contains a bibliography.

3947 WILLIAMS, GWENDOLEN (née LUCY GWENDOLEN WILLIAMS) (1870–1955)

Welsh sculptor who specialised in bronze statuettes.

Exhibitions

Sellars, Jane. *Women's Works.* Liverpool: Walker Art Gallery, 1988.

Other Sources

Beattie, Susan. *The New Sculpture.* New Haven, Conn. and London: Yale University Press, 1983.

Dunford, Penny. *A Biographical Dictionary of Women Artists in Europe and America since 1850.* Hemel Hempstead: Harvester Wheatsheaf and Philadelphia:

University of Pennsylvania Press, 1990. Contains a bibliography.

Mackay, J. *Dictionary of Western Sculptors in Bronze.* Woodbridge: Antique Collectors Club, 1978.

Rees, T. *Welsh Painters, Engravers and Sculptors.* Cardiff, 1912.

Waters, Grant. *Dictionary of British Artists Working 1900–1940.* Eastbourne: Eastbourne Fine Art, 1975.

3948 WILLIAMS, LOIS (1953–)

Welsh sculptor whose works allude to commonplace objects.

Main Sources

Greenan, Althea. "A Thief of Object's Use." *Women's Art Magazine* 65 (May–June 1995): 28–29. Review of two exhibitions.

Exhibitions

Pandora's Box. Bristol: Arnolfini Gallery, 1984.
Out of Isolation. Wrexham: Library Arts Centre, 1986.
Conceptual Clothing. Birmingham: Ikon Gallery, 1987.
Along the Lines of Resistance: An Exhibition of Contemporary Feminist Art. Barnsley: Cooper Gallery, 1988.

Other Sources

Dunford, Penny. *A Biographical Dictionary of Women Artists in Europe and America since 1850.* Hemel Hempstead: Harvester Wheatsheaf and Philadelphia: University of Pennsylvania Press, 1990. Contains a bibliography.

3949 WILMINK, TRUUS (1943–)

Dutch sculptor.

Exhibitions

Tout droit—droit au but: neuf femmes constructivistes. Paris: Institut néerlandais, 1976.

3950 YTREBERG, KRISTIN (1945–)

Norwegian sculptor and installation artist who was born in Canada but trained and works in Norway.

Exhibitions

Fisher, Susan Sterling, Anne Wichstrøm, and Toril Smit. *At Century's End: Norwegian Artists and the Figurative Tradition, 1880–1990.* Høvikodden: Henie-Onstad Art Centre, 1995. Includes a list of exhibitions and an individual bibliography.

3951 ZAMBACO, MARIA TERPITHEA (née CASSAVETTI) (1843–1914)
Greek artist who worked in England in the Pre-Raphaelite circle as a painter and later as a sculptor, particularly of medallions.

Main Sources

Attwood, P. "Maria Zambaco: Femme Fatale of the Pre-Raphaelites." *Apollo* 124, no. 293 (July 1986): 31–37.

Other Sources

Dunford, Penny. *A Biographical Dictionary of Women Artists in Europe and America since 1850.* Hemel Hempstead: Harvester Wheatsheaf and Philadelphia: University of Pennsylvania Press, 1990. Contains a bibliography.
Fitzgerald, P. *Edward Burne-Jones: A Biography.* London, 1975.
Marsh, Jan. *Pre-Raphaelite Sisterhood.* London: Quartet Books, 1985.

3952 ZANARDELLI, ITALIA (née FOCCA) (1872/4–1944)
Italian painter and sculptor.

Other Sources

Clement, Clara. *Women in the Fine Arts.* Boston: Houghton Mifflin, 1904.
Dunford, Penny. *A Biographical Dictionary of Women Artists in Europe and America since 1850.* Hemel Hempstead: Harvester Wheatsheaf and Philadelphia: University of Pennsylvania Press, 1990. Contains a bibliography.
Krichbaum, J., and R. Zondergeld. *Künstlerinnen: von der Antike bis zur Gegenwart.* Cologne: DuMont, 1979.

3953 ZIACH, KRYSTYNA (1953–)
Polish-born sculptor and photographer who has worked in the Netherlands since 1979.

Exhibitions

Het Zelfbeeld: Images of the Self. Leiden: Stichting Burcht and Galerie Fotomania, 1987.

Index of Names

Index of Names

Index of Names

Index of Names

Index of Artists and Designers by Country

Denmark

Index of Artists and Designers by Country